African Art

African Art

from the Barbier-Mueller Collection, Geneva

Edited by
Werner Schmalenbach

With essays by
Enrico Castelli, François Neyt, Louis Perrois, Christopher D. Roy,
Werner Schmalenbach, William Siegmann, and Gaetano Speranza

Photographs by
Roger Asselberghs

Prestel

This book was originally published in German to accompany the exhibition *Afrikanische Kunst aus der Sammlung Barbier-Mueller, Genf,* held at the Kunstsammlung Nordrhein-Westfalen, Düsseldorf, the Schirn Kunsthalle, Frankfurt am Main, and the Haus der Kunst, Munich, in 1988-89. A French edition was published for the showing at the Fondation Maeght, Saint-Paul, in 1989.

The authors

Philip Allison (P. A.), Marie-Louise Bastin (M. L. B.), Paula Ben-Amos (P. B. A.), Daniel P. Biebuyck (D. P. B.), Monica Blackmun Visonà (M. B. V.), S. E. Gilbert Bochet (G. B.), Arthur P. Bourgeois (A. P. B.), René A. Bravmann (R. A. B.), Sarah Brett-Smith (S. B. S.), Enrico Castelli (E. C.), Herbert M. Cole (H. M. C.), Joseph Cornet (J. C.), Ariane Deluz (A. D.), Germaine Dieterlen (G. D.), Henry J. Drewal (H. J. D.), Marie-Claude Dupré (M. C. D.), Ekpo Eyo (E. E.), William Fagg (W. F.), Perkins Foss (P. F.), Timothy Garrard (T. G.), Anita J. Glaze (A. J. G.), Pierre Harter (P. H.), Evan M. Maurer (E. M. M.), Malutshi Mudiji-Selenge (M. M. S.), François Neyt (F. N.), Keith Nicklin (K. N.), Tamara Northern (T. N.), Denise Paulme (D. P.), Louis Perrois (L. P.), John Picton (J. P.), Christopher D. Roy (C. R.), Arnold Rubin (A. R.), Roy Sieber (R. S.), William Siegmann (W. S.), Gaetano Speranza (G. S.), Robert Farris Thompson (R. F. T.), Jan Vansina (J. V.), Marie-Noël Verger-Fèvre (M. N. V. F.), Anne-Marie Vion (A. M. V.), Susan Vogel (S. V.), and Zdenka Volavka (Z. V.)

© 1988 by Prestel-Verlag, Munich

Translations from the French: Jeffrey Haight
Translations from the German: Russell Stockman

The publishers would like to acknowledge the help of Maria Kecskési, Ian Robson, and Carol Thompson in preparing the text of this book.

Cover
Figure of the Yoruba tribe, Nigeria (cat. no. 77)

Published by PRESTEL-VERLAG,
Mandlstrasse 26, D-8000 Munich 40,
Federal Republic of Germany

Distributed in continental Europe and Japan by Prestel-Verlag,
c/o Verlegerdienst München GmbH & Co.KG, Gutenbergstrasse 1,
D-8031 Gilching, Federal Republic of Germany

Distributed in the USA and Canada by te Neues Publishing Company,
15 East 76th Street, New York, NY 10021, USA

Distributed in the United Kingdom, Ireland, and all other countries by Thames and Hudson Limited,
30-34 Bloomsbury Street, London WC1B 3 QP, England

Composition by Fertigsatz GmbH, Munich, using "Aldus Buchschrift" of Linotype GmbH, Frankfurt am Main
(system: Linotron 202)
Color separations by Brend'amour, Simhart GmbH & Co., Munich
Maps by Astrid Fischer, Munich
Printed by Karl Wenschow-Franzis-Druck GmbH, Munich
Bound by R. Oldenbourg GmbH, Kirchheim near Munich
Printed in the Federal Republic of Germany

ISBN 3-7913-0849-1 (English edition)
ISBN 3-7913-0848-3 (German edition)

Contents

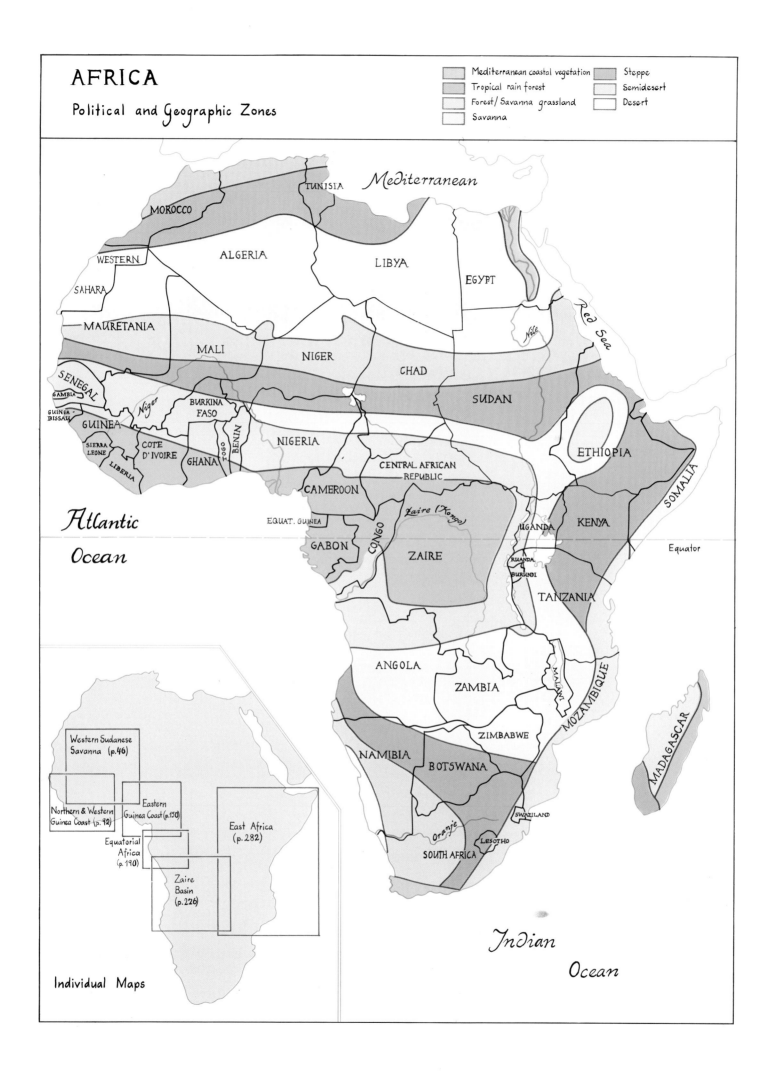

AFRICA

Political and Geographic Zones

Mediterranean coastal vegetation	Steppe
Tropical rain forest	Semidesert
Forest / Savanna grassland	Desert
Savanna	

Mediterranean

MOROCCO
TUNISIA
WESTERN
SAHARA
ALGERIA
LIBYA
EGYPT
Nile
Red Sea
MAURETANIA
MALI
NIGER
CHAD
SUDAN
SENEGAL
GAMBIA
GUINEA-BISSAU
Niger
BURKINA FASO
ETHIOPIA
GUINEA
SIERRA LEONE
COTE D'IVOIRE
TOGO
BENIN
NIGERIA
Niger
SOMALIA
LIBERIA
GHANA
CENTRAL AFRICAN REPUBLIC
CAMEROON
Zaire (Kongo)
KENYA
UGANDA
EQUAT. GUINEA
Atlantic
CONGO
GABON
ZAIRE
RWANDA
BURUNDI
Ocean
Equator
TANZANIA
ANGOLA
MALAWI
ZAMBIA
MOZAMBIQUE
MADAGASCAR
NAMIBIA
ZIMBABWE
BOTSWANA
SWAZILAND
Orange
LESOTHO
SOUTH AFRICA

Indian

Ocean

Western Sudanese
Savanna (p. 46)

Northern & Western
Guinea Coast (p. 92)

Eastern
Guinea Coast (p. 150)

Equatorial
Africa
(p. 190)

East Africa
(p. 282)

Zaire
Basin
(p. 226)

Individual Maps

The Barbier-Mueller Museum

The objects presented in this book all come from a single collection, the result of many years of patient work by two men of great enthusiasm and dedication.

The first of these men, Josef Müller, had a veritable passion for the fruits of man's creative genius, whatever the mode of expression, period, or geographical provenance. His youthful ambition had been to become a painter, and from the beginning of this century, he fervently strove to understand and, when possible, to acquire works by the best of his contemporaries. But the financial crisis of 1929 arrived and deprived him of the greater part of his resources, and he then directed his craving for discovery and his aesthetic sensitivity to more modest objects; in this field he did pioneering work, relying only on his own taste and sense of quality to guide him in his acquisitions. Chance encounters, and a patient combing of the Paris flea market every Saturday, in the end produced an enormous accumulation of objects of all kinds, whose only common denominator was that they appealed to him. The sense of balance that presided over the arrangement of these disparate elements was such that the collection became virtually a work of art in itself. Authentic masterpieces stood side by side with "quaint" sculptures, traditional pottery, or jewelry made of precious and not so precious metals – works which might be dismissed as trivial until some special quality was revealed through comparison with similar objects.

On Josef Müller's death in 1977, this huge collection, strongly imbued as it was with the personality of its creator, posed a serious problem for those who inherited the responsibility for it. It was housed – not really "exhibited" – in various rooms of the Müller home, and had only been seen by a limited number of visitors. Modesty of means had dictated this makeshift arrangement, and it was Josef Müller's personal touch that had given it a kind of homogeneity. Now that he was gone, it became clear that a new conception of the collection was essential.

This is where Jean-Paul Barbier took over. On becoming acquainted with Josef Müller, his son-in-law – initially interested chiefly in old books – had gradually yielded to the fascination of African sculpture, whose extraordinary expressive richness, astonishing dynamism, and overflowing inventiveness he soon learned to appreciate. He began to seek out such works himself, and he soon assembled his own collection – naturally benefiting from the valuable points of comparison provided by his father-in-law's collection in Solothurn. But, while Josef Müller enjoyed the solitude of his house, where apart from friends of the family, only a few visitors had the opportunity of seeing the "museum," Jean-Paul Barbier soon felt the need to share the wonder of his discoveries with others. Then came the sad news of the closing of an extraordinary little museum – also private – in New York, the Museum of Primitive Art; in a delightful private mansion Nelson Rockefeller had for several years presented to the public objects of the African and Oceanian tradition, admitting only those objects that deserved to be called works of art and were not merely of curiosity value or of purely ethnographic interest. My husband and I agreed that this was the right approach to "primitive" statuary, and we decided to open our own museum in Geneva, in June 1977. Very soon, its activities took on a scope that we had hardly foreseen.

There were only limited possibilities in Geneva, and we began to look for ways of reaching a larger public. Over the past ten years, several large exhibitions made up exclusively of objects from our own collection (as is our policy) have made extensive tours of the major American museums, notably those of Brooklyn, Los Angeles, Dallas, Seattle, and Boston. In Switzerland the museum of Solothurn, Josef Müller's birthplace, has mounted several exhibitions and thus gained something of a name in the field of "primitive" art. Other exhibitions have been shown in Austria.

Another particularly satisfying experience in recent years has been our participation in the prestigious exhibition "Primitivism" at the Museum of Modern Art in New York, where, for the first time, an effort was made to achieve a synthesis encompassing various forms of ethnic and Western art. Repercussions from this exhibition have been considerable; and for many it provided the opportunity to discover the great artistic value of these "primitive" works.

For me, the present book is a new stage in this story of a shared passion, a long story that began when I was first introduced to the beauty and originality of African sculpture. Werner Schmalenbach has known and loved this art for many years. Knowing his enthusiasm and his high artistic standards, we are proud to have been invited to be a part of this beautiful adventure, the initiative for which came from him. This collaboration will cement the bonds of our personal friendship, which is based on shared interests and emotions, and we hope it will win many new friends for this art we love.

MONIQUE BARBIER-MUELLER

Werner Schmalenbach

Toward an Aesthetic of Black African Art

Anyone attempting to formulate an aesthetic of the art of Black Africa is immediately beset by a number of grave doubts. Is he justified, for example, in taking certain objects out of the cultural continuum of these regions and calling them art, in effect treating them as something totally foreign to the thinking of those who created them? And can he really view this art, if such he chooses to call it, as a single, coherent entity, ignoring the fact that the vast continent has given birth to a whole multitude of quite different regional and local "styles," each of them – to further complicate the issue – the result of historical developments for the most part obscured by the mists of time? Finally, he necessarily excludes large areas of the continent from his deliberations. White Africa, for one, that is to say, the entire Mediterranean sphere with its own long layerings of history; East Africa, whose largely cattle-breeding cultures have produced virtually no visual art at all, compared at any rate with the abundance of images in other parts of Africa; and southern Africa. And what about the various hunting cultures, "prehistoric" in their level of development – still in existence until very recently – whose rock paintings strewn across the continent constitute an artistic legacy of great importance? In the discussion of the aesthetics of African art that follows, I consciously omit all of these, just as I ignore the ancient dynastic cultures, most notably that of Benin with its highly developed bronze art. I focus primarily on the vast agricultural regions, the areas that have fostered the development of wood sculpture, and in so doing concentrate on an art that is rooted in ancient traditions, even though it is often of relatively recent creation. The works in question date almost without exception from the late nineteenth and early to middle twentieth centuries, for earlier travelers in Africa took no interest at all in such objects, let alone an aesthetic one, and at most brought them home as exotic curiosities. Moreover, the vicissitudes of climate along with termites and other pests – not to mention Christian missionaries and now and again upstart African cults or the gradual restructuring of society all over Africa, which has markedly undermined the basis of traditional artistic production – have managed to cut short the life spans of wood carvings. If I neglect objects fashioned of other materials, such as metals, ivory, plant fibers, or clay, I do so in part for the sake of clarity, and in part because of the fact that the traditional rural art of Africa is primarily sculpture in wood.[1]

One is indeed justified in lifting art out of its social and cultural context, but to do so nonetheless creates problems. For those who made them and used them, the overwhelming majority of art works from Africa are ritual objects, and for this reason ethnologists have traditionally collected and studied them, along with all manner of other objects, simply as artifacts of daily life. Conventional museums of ethnology made no special provisions for art. Only gradually, and long after people had begun to view this art as something quite special, elevating it above the common run of ethnographic material, has change come about. The ethnologists – with good reason – have tended to argue against such special treatment. However, our own "vital" need to recognize "primitive" art as an aesthetic achievement of the highest order, and to present it as such, is certainly legitimized by history, and has largely won out over the scientific objections of yesterday, well founded though they may have been.

Have we not done the same thing with the art of every other civilization? Who would dispute the placement of a sculpture from Egypt, from India, from early Greece, or from the Middle Ages, altogether detached from its specific cultural context, in a setting devoted solely to art? The artistic products of all these historical epochs derive from a unique set of cultural conditions, most having been created for religious ends or for the aggrandizement of rulers. Isolating them as "art," we ab-

[1] The present tense is used throughout in referring to traditional African art, although it is today largely a thing of the past.

stract these too from their original functions. But for that matter we do the same with the art of every subsequent age as well. By placing it in a museum we always abstract or falsify it to the extent that when creating it the artist had quite different intentions – manifest or implicit – from those fulfilled in museums. In a museum context what matters is "simply" the artistic value ascribed to the work, quite apart from any of its other qualities. If this were not the case, we should have to display the works of the entire history of art in their respective historical surroundings, and to be historically accurate, art museums would have to think of themselves as historical museums – thereby taking a step backward into the reasoning of the nineteenth century, certain signs of which have in fact begun to reappear of late.

Our isolation of art from the fabric of daily life is already – irreversibly? – taken for granted. We have been especially unscrupulous in this regard with those centuries in which the concept of "art" had already evolved and established itself, roughly those since the Renaissance. There has been somewhat more hesitation in the case of epochs still innocent of "art," when those things we now label as such were viewed simply as handicrafts meant to serve specific ends. This is especially true of our approach to "primitive"[2] cultures. May we presume to treat some of the handiwork of Black Africa as "art," something for which there is not even a name in the indigenous cultures? To be sure, it has often been pointed out that the African languages do have words meaning "beautiful" – often synonyms for "good" – and that Black Africans clearly exhibit an aesthetic sensibility. Yet this is scarcely surprising; otherwise such indisputably aesthetic creations would not exist. The presence of bodily ornament or often quite elaborate hairstyles certainly points to a true aesthetic disposition, yet by no means justifies the concept of artistic creation in the name of "art." And though it is not at all uncommon for wood-carvers to enjoy great respect and for certain outstanding ones to be sought out by admirers from far away, the objects they produce are in their own estimation handcrafted utensils, not art, even when they happen to display uncommon "quality" or are undoubtedly imbued with special, highly effective powers.

Thus it is only in our modern understanding that the art of Black Africa has taken on the cachet of "art" – much more recently, that is, than that of the ancient civilizations. To a certain extent we have simply appropriated it as art, though our doing so can hardly be considered a violation inasmuch as we have added nothing to these objects that they did not already possess. We have taken from these works something that was intrinsic to them: a religious element, so to speak, or at the very least their practical function. Our criteria in judging them are not, to be sure, those of their creators. The "quality" of a figural cult object is something altogether different for the members of an African tribe, even if they do have the ability to recognize and value such concepts as aesthetic qualities as well – even if, as various tests have revealed, aesthetic judgments made by Africans often correspond with our own. Still, the significance of an object in an African context differs from its significance to us. In an African context, aesthetic effect is of less concern than ritual efficacy. A piece of sculpture, no matter how "beautiful" it may be, is simply discarded once it has served its purpose. What once gave it value was the life-force which animated it, rather than the material form which it had been given.

It is quite natural, then, that we have tended to treat the "primitive" art of Africa like that of other cultures, lifting it out of the context in which it was created and designating it as "art," and consequently collecting and presenting it as such, whether in museums, exhibitions, or books. Increasingly, we tend to scorn those collections in which such a separation has not been made and art objects continue to be mixed in with more general ethnographic material. It matters not that sharp boundaries between the two are impossible to draw. One is instinctively more inclined to classify figural pieces as art sooner than other objects, no matter how highly ornamented they may be, and yet we are fully aware that such a distinction in no way corresponds to the African's own thinking, however he may categorize things in practice. We are dealing here not so much with separate genres as with different realms of experience.

Though it is equally illegitimate to separate the art of the early ancient civilizations from their overall cultural environment, we have had no qualms about doing so for a long time now. If we did not begin to do the same with the art of "primitive" peoples

2 The word "primitive" is placed within quotes because even today it has for many people a negative ring. For the friends of "primitive" art it has long since lost this connotation. Many terms used by art historians – for example, "Gothic" – are false, yet they are now accepted. The French have no qualms about speaking of the "primitives of the fifteenth century," for example, and no one sees anything patronizing about it. If we appreciate the greatness of the art of the "primitives" we show that we do not regard this art as primitive.

until relatively recently, it is simply because their art had yet to be "discovered" by the Western world. As is well known, this did not happen – though there had been some isolated intimations of it beforehand – until the beginning of our own century, when a young generation of artists, mainly in France and Germany, took up its cause. This new generation was more radical than ever before in its exclusive commitment to form and expression, and these were precisely what they could admire in "primitive" art: an extraordinary formal power and an extraordinary expressiveness. It was inevitable that, at a time when in European art a new vitalism was coming to the fore, altering perception of the external forms of things, these young artists should stumble upon an art in which the idea of power is all-important. It may appear that with this use of the word "power" I am implying that this is a quality common to all "primitive" art, and certainly such a suggestion deserves to be challenged. Is there indeed something that distinguishes such art – for the purposes of our present argument let us restrict ourselves to Black African art – from the art of other, so-called "higher" cultures? Can one identify a characteristic typical of the art of all the various regions, ethnic groups, and societies of Africa? This is one of the questions the art historian is forced to ask, as with other phenomena in the history of art, yet given the vast discrepancy in historical development among African cultures, which complicates the picture enormously, and faced with the great diversity of artistic styles accommodated under the rubric "Negro sculpture," it is easy enough to lose heart in one's search for an answer. All the more because ethnology, whose research during the past few decades has become increasingly specialized, now adopts a highly skeptical stance toward any attempt at generalization, preferring to credit only what special insights have been derived from research in the field. But must we refrain from general, fundamental pronouncements simply because of the enormous profusion of evidence, and for fear of their being forever suspect as mere speculation? To my mind it is not only legitimate but even essential to emphasize the fundamental characteristics of any sphere of art. Scholars have certainly never hesitated to make general statements about the art of the European Renaissance, to take a quite different and, in this respect, much more critical example, despite the fact that with its extreme diversity of individual styles – from Giotto to Titian, from Jan van Eyck to Dürer – Renaissance art is anything but homogeneous. One simply cannot avoid searching for some quality common to all African art, in other words, a common aesthetic – especially if one is not merely concerned with African art alone but rather with the art of every civilization from Altamira to the present day. One has to pin down some trait that is specifically African, no matter how difficult it may be to provide an adequate definition of it. And if indeed there is something specifically African in the art of this continent – or to put it somewhat more precisely, in the figural wood sculpture of Black Africa – then one ought to be able to identify it in spite of the myriad differences and nuances.

Unquestionably, the diversity is vast. The range of styles is extreme, not only from region to region or from one ethnic group to the next, but often even within a single society. It extends from virtual geometric stylization at one end of the scale to something approaching naturalism at the other. On the one hand, the geographic distribution can be discerned for these two extremes, as exemplified by the carving from the western Sudan on the one hand and that of the area – not too far removed – stretching from the Cote d'Ivoire to Nigeria on the other (figs. 1, 2). They also, however, often appear side by side, as we may see in the quite dissimilar mask types of the Baule from the Cote d'Ivoire (figs. 3, 4) and in many other ethnic groups. Regrettably, it seems virtually impossible to deduce one or the other artistic tendency from simple geography, to assume, for example – as would seem logical – that in the savanna one will encounter a greater degree of abstraction, in the rain forest somewhat more naturalism. Such clear-cut distinctions, though tempting, are soon enough shattered. A simple glance at the art of the western Sudan and of Zaire reveals that quite different styles evolve in savanna regions, that of the former region being more "geometric," that of the latter more softly sculptural. In addition, direct correlation between a community's social structure and its specific artistic style is not always obvious. Admittedly, in regions with a tradition of dynastic power it is still possible to see traces of this social structure in twentieth-century sculpture; but this too can

manifest itself in either direction: toward naturalism or toward geometric abstraction. Both are encountered among Nigeria's Yoruba, for example, whose indebtedness to the art of ancient Benin is quite obvious, or among the Kuba in central Zaire, another land where a strong monarchy gave rise to an art intended to enhance the dignity of the court. Lastly, one comes across numerous outside influences on African art. Islam, for example, has been largely responsible for African art's tendency toward abstraction. Differences in social standing, either within a single group of people or within larger sets of social organization, are revealed not so much in terms of style as in "quality" of workmanship; the "better" and "major" sculptures are found to be in the hands or under the aegis of the more important personages, while the ordinary people make do with works less carefully finished. Occasionally one does find that different types of figures or masks are associated with different degrees of status within the social hierarchy, but here again such distinctions have nothing to do with the diametrically opposed variations in style.

Necessarily, then, any aesthetic of Black African art has to encompass diametrically opposed, stylistically polar extremes of naturalism and geometric abstraction. The two boundaries are fixed and inviolable. The only way to discover just why this is so is to determine the actual function of art in Africa. What does this art really do? Does it serve a variety of ends, or is there common to all African art – or at least that art most typical of Black Africa, its figural wood sculptures and masks – a single, fundamental, and aesthetically relevant function? The assumption that all of this art is rooted in religion is much debated nowadays, and frequently rejected as being overly romantic. It is true, of course, that there is an element of art in countless African household objects whose functions are wholly profane. Nevertheless, it is probable that behind these carved figural objects – or at least their prototypes – religious motivations were paramount. African dolls, for example, are often not merely toys, but simultaneously fertility charms. For many objects what is crucial is the demonstration of social prestige: they enhance status and "image." But even here it seems wrong to draw a clear line between such motives and the religious sphere, for the entire social framework is infused and secured by religion. One often reads, for example, that the

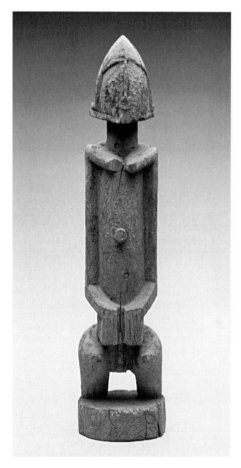 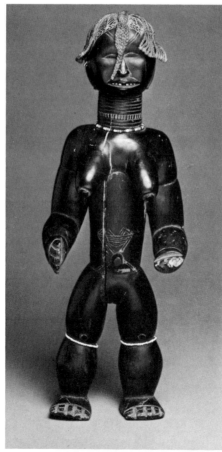

Fig. 1 Figure of the Dogon, Mali. (Photo: Barbier-Mueller archive, Geneva)

Fig. 2 *Lü mè* female figure. Dan/Kran, Liberia. Cat. 51. (Photo: P. A. Ferrazzini)

Fig. 3 Mask. Baule, Cote d'Ivoire. (Photo: Barbier-Mueller archive, Geneva)

Fig. 4 Mask. Yaure (?), Cote d'Ivoire. Cat. 66. (Photo: Barbier-Mueller archive, Geneva)

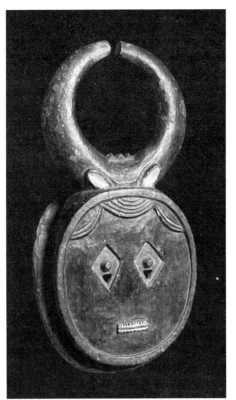

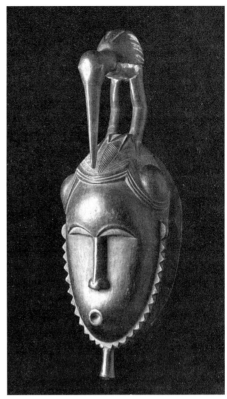

3 Almost without exception, modern ethnologists reject the term "fetish," firstly because it has no substantive meaning (Portuguese *feitiço*, "made, manufactured"), and secondly because this expression used to be applied to all figural objects from Africa, and with a negative connotation to boot. In the course of time the word "fetish" became restricted to charms and other magical objects; in this sense it was adopted by scientific ethnology. It is hard to see why it should now be dropped, particularly as such expressions as "nail fetish" and "mirror fetish" are still commonly accepted.

female figures found supporting ceremonial seats among the Luba in southeastern Zaire (Cat. 175) – a region noted for its ancient aristocratic tradition – are merely a display of majesty. Is this enough? Is it not possible that just as the monarch's pomp and ceremony have a highly sacral character, these "caryatids" also mean more than just courtly representation? Presumably, the notion of protection is important here, as in many other "profane" examples. It is possible to point to exceptions to the rule of religious function, and one is justified in doing so especially in those cases – as in the ancient kingdom of Benin – where art assumes the forms of other centrally organized political states. The form of figural art in Africa is mainly determined – above all stylistically – by its religious, cultic, ritual, and magical function.

Such functions are extremely varied, though of course they can often be classified under general categories, such as ancestor worship, belief in spirits, witchcraft, and magic. Each object has a quite specific task, though this too is obscured somewhat in that a large number are in fact multifunctional, being employed for more than one purpose. An ancestor figure, for example, may at times be employed as a charm, a "fetish."[3] And a number of masks serve various purposes, both sacred and profane. Charms can be "good" or "evil," conciliatory or hostile, or both at once. In every case they answer to specific needs. Art in Black Africa occupies an important place in the huge socio-religious security system with which people shield themselves from the many threats to which their lives are exposed. It serves, in whatever way and in whatever artistic forms, to make life safer. All existential threats, including illness and death, are attributed to the influence of spiritual forces, and accordingly African art attempts to appease these – or appeal to opposing forces. Despite the endless variety of roles this art assumes, one should never forget this most fundamental one, or fail to draw from it certain conclusions regarding the art itself. To put it another way: a work of art may depict whatever you will, but at the same time it is busy conjuring something.

In Africa, the communities in which art serves its various purposes are generally not very large. To be sure there have been great empires at times, but even under these it is unlikely that communal life in the villages underwent significant change. While an art serving to glorify the court came into being in the ruler's capital, local cult conventions, and accordingly local artistic conventions, remained virtually untouched by it, for nowhere was strict political conformity imposed as it was in the

ancient empires of the Near East. A juxtaposition of smaller social groupings, only loosely controlled by the central authority and scarcely touched by any claim to prestige, continued to serve as the basic framework of life and of artistic production. It is for this reason that one encounters virtually no monumental art in Africa – though of course the fact that this is a continent of wood rather than stone is a contributing factor. The rare exceptions are the result of specific historical developments. Whatever art was created in the villages alongside the more imposing "state art" cannot be studied, for it has not survived. In contrast to the monumental immobility of the art of the Near East and of Egypt, Africa presents us with portable wood sculpture, modestly scaled, rarely even life-size, an art wholly appropriate to the insularity of its social groupings and to the limited spheres of influence of its religions.

The mobility of African art corresponds to the "mobility" of religious factors. Nowhere on the continent can one speak of a "major" pantheon, with the single exception of the Yoruba culture in Nigeria, which nevertheless preserves its share of "animist" concepts beneath a veneer of polytheism. In Africa one encounters countless deities, but not actual gods in some remote heaven. The forces of the universe are perceived as a constant presence, either as a menace or as guardians, as a comfort or as disruptive influences; they are anything but remote. They live in closest proximity to the people, in a nearby tree, in a rocky outcrop, in streams, in the souls of the dead, and often in the wood figures carved for them. Every last member of the tribe, each member of the community, is directly affected by their machinations, and even though priests and ritual specialists exercise their roles as intermediaries, they do not constitute some powerful priesthood capable of keeping such forces at bay. These forces are directly perceived as everyday presences, they attend one's every movement, and all of this has a definite effect on the art produced to appease them.

Thus it is not the function of African art to serve as a reflection of some far-off pantheon or even of a powerful priesthood – or ruling secular authority – but rather to help make life more secure. To fulfill its function it must be effective in every sense. It has to contain a certain power capable of influencing things outside itself. Therefore it is not enough to say that a figure simply represents one or another of the higher powers, in the way that a medieval sculpture seeks to portray a particular saint. A figure's effectiveness cannot be said to derive solely from the specific attributes of the power represented, nor from such general attributes as authority, dignity, or nobility, which is evident in abundance. Rather, such effectiveness comes from the presence of forces, perceived as being more or less tangible and believed to reside in the figure. Much the same can be said of masks and those who wear them. Again, they not only represent specific beings, they *are* such beings, they actually personify them for the duration of the dance – or at least a part of the essence of the being depicted enters into them, inhabits them in quite another way than does the human being hiding behind the mask. Whatever the concrete function of such masks and figures, it may well be that the immanence and efficacy of supernatural beings and forces is a fundamental characteristic of Black African sculpture, one that completely sets it apart from the art of other, "higher" cultures and thus helps to define it.[4] This art is always poised between image and immanence. And though it is impossible to draw a line between the two with any certainty, some such boundary clearly exists; one step too far in the direction of realistic representation, and the immanence is lost.

An aesthetic of Black African art has to address this aspect of immanence, not only because it makes itself felt in the very form of these objects – which will be described below – but also because it persists as a distinguishing trait even for us, admirers of these works but strangers to the beliefs they embody. Our "purely" artistic perception of these cult objects is colored by the very same sense of numinous potency that the native artist had in mind as he carved them. Their indwelling power survives as an element in our aesthetic appreciation of them. Above and beyond their purely formal power, African sculptures contain a vital energy, a natural force that gives them a particular artistic suggestive power. Or at least this would appear to be the case when we analyze our own response to them. Since we are immune to the many "forces" that the peoples of Africa accept as part of reality, there must be some other reason for our perception of such suggestive power in this art as in no other. Of course, it is conceivable that in spite of this immunity, we are in fact susceptible to such forces,

4 I outlined this thesis in my book *Die Kunst Afrikas* (translated as *African Art* [New York, 1954]), and later enlarged upon it in a lengthy essay, which was published in the journal *Acta Tropica* (vol. 15, no. 4 [1959]) and in a very abridged version in the catalogue of the Munich exhibition *Weltkulturen der Erde* (Major Cultures of the World) of 1972. I have substantially modified the original thesis for the present publication.

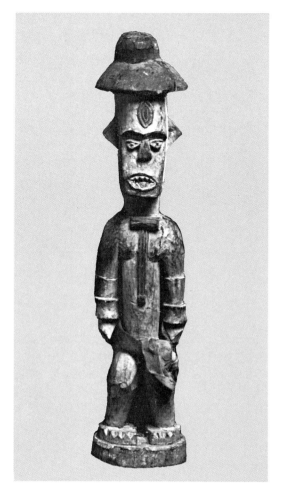

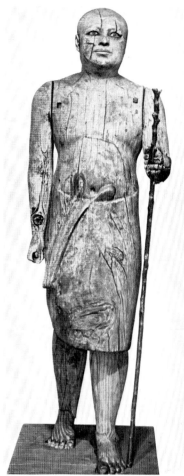

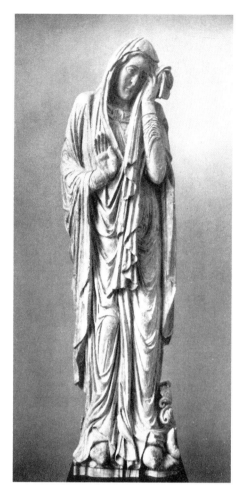

Fig. 5 Figure of the Isokho, Nigeria. (Photo:
Barbier-Mueller archive, Geneva)

Fig. 6 Male figure. Egypt, c. 2440 B. C.
(Photo: From Propyläen-Kunstgeschichte,
vol. 15 [Oldenburg, 1975])

Fig. 7 Figure of the Virgin. Naumburg,
c. 1250. (Photo: From P. Metz, *Bildwerke der
christlichen Epochen* [Munich, 1966])

which would explain why so many people in our own culture are truly upset by
figures and masks from Africa, as though they were not merely depictions of mysterious beings but rather creations with a potent and menacing life of their own.

This particular suggestive power may be traced at least in part to the natural life-
force residing in the wood itself, for though it is not expressly emphasized by sculptural form, neither is it altogether suppressed. Indeed, the very bone and sinew of the
wood play a definite role in the impact of African sculpture. An element of nature
persists, one that has not been fully transformed into art, and it matters not whether
one sees these forces as "natural" – as we do – or as supernatural. The point becomes
clear when one compares an Egyptian wood statue from the Old Kingdom (fig. 6). We
see an image of a man in the wood. The nature of the wood itself is largely effaced by
the manner in which it has been worked; it is perceived only on the surface, which
was once doubtless painted. The same is true of medieval wood carvings (fig. 7),
though these are rooted in religion just like those of Africa. Here, too, the wood's own
involvement is slight, inasmuch as the carving has effectively transformed it into
something else, such as folds of drapery. African sculptures (fig. 5) are never portrayals of men in wood, quite apart from the fact that they depict other beings altogether –
albeit in human form. They are wood figures, carved in analogy to the human figure.
The wood's own organic integrity is preserved and serves as a distinct hindrance to
the organic portrayal of the human body. The material itself precludes anything
approaching naturalism.

This is not to say that the African carver is not interested in the surface of his work.
On the contrary, he frequently treats it in ways that even work against the wood,
polishing it, blackening it, oiling it, or using whatever colors are at hand – not to
mention the traces of libations and all the rest that constitutes what collectors of
African sculptures prize as "patina," including the countless unintentional scars
caused by former use. The famous masks of the Dan in Liberia or the Baule on the
Cote d'Ivoire are not only blackened, but often even polished to an almost metallic-
looking sheen, so that the only traces of carving to be seen are on the inside, where

their aesthetic effect is nil. It is not its surface treatment that constitutes the wood's resonance so much as its very substance, which to the African mind is filled, like every other substance in nature, with an immanent life-force, a force that is not merely passive but continuously at work. This potency, which must be considered a central element in African art, touches us as well, far more than it does in works from other cultures, where the vitality of the wood has been subdued in the process of its transformation into sculpture. It is often noted that in many African sculptures one can still perceive the trunk or branch from which they were carved, but this is of only marginal importance; what matters is how the wood's life-force infuses the figure, an effect enhanced by the verticality of the wood block, with its dynamic momentum not completely silenced. Significantly enough, we even tend to respond aesthetically to the vertical cracks by which the wood manifests its vitality as something independent of the form imposed on it, even spoiling that form. (Of course, for the "native" user such imperfections only detract from the object's value.) In every case, then, quite apart from the specific iconographic significance intended, we sense the vitality of the wood as a natural material – and so does the African. There is no disputing that the wood always evokes the idea of living, working forces, or that these forces remain undiminshed by the forms the African carver imposes on his living material. They are not lost even for "unbelievers" like ourselves, but rather contribute in an essential way to the overall aesthetic effect.

Thus it would seem that one basic trait of "primitive" art, or in this case the art of Black Africa, and a trait that distinguishes it from the art of all other cultures, is that there is a kind of power incorporated in these wood figures and masks (I use the word "incorporated" in its literal sense, not the everyday meaning implied when we claim that a work of art "incorporates" some idea, an ideal, or what you will); and at the very least it is the power latent in the wood itself, the explosive forces of growth, which tend to contribute a kind of tension to these objects that is lacking in stone sculpture. The Africans perceive this power as supernatural, which is why they frequently adhere to specific rituals when felling the tree or carving the piece of wood selected. It might be objected that in many cases a ritual specialist has to perform a complicated ceremony in order to invest a figure with life and power, which implies that beforehand it was only inert substance. But perhaps this is a contradiction only to our way of thinking. Certainly the notion of forces at work in all of nature, and accordingly in trees and pieces of wood, is universally held in these societies. It matters not whether we label such a notion animism, animatism, vitalism, or dynamism, as the distinctions between these terms are vague at best. It follows, then, that potent, active forces are incorporated in the cult objects we refer to as art even when the prime function of the works in question has nothing to do with these forces. True, one could argue against positing the incorporation of power or forces as a fundamental principle of African art – as opposed to the idea of representation – particularly inasmuch as the people who make and use the objects themselves always explain their purpose in different terms. Given the large number of functions the objects are intended to serve, any simple generalization of the kind put forward here seems somewhat suspect. Yet it is obvious that there is always something more at work in the sculptures than what they depict, whatever their intended function. And it is primarily this "something more" that makes them so effective. African sculpture blends iconographic problems and their formal solutions with a very specific vitality, one deriving in part from the wood and therefore from the African's affinity with nature and its forces. Despite a fundamental comprehension of nature, the African is not content with simple, unworked chunks of wood, but chooses to give them a form analogous to the human form, based on certain anthropomorphic – or zoomorphic – notions of various spiritual beings. In so doing he takes a definite step toward "representation," event though the special influence he wishes his figures to have is always present as a potency incapable of depiction. Hence the dialectic in all African art between power and representation, immanence and image. A given work is never exclusively one or the other. Anyone who sees in it only the representation of something has missed its specific force, has overlooked the very quality that makes this art so arresting for us. Conversely, anyone who perceives in it only the embodiment of power fails to appreciate the importance of its manifold religious and

mythological allusions. These are of significance for the individual figures and the various types of masks, but they do not constitute a basic element in the aesthetic of African art. The "representational" element is fundamental only inasmuch as the human – or animal – form is always involved.

Since this art is intent on expressing other concepts, its representational interest is limited. And in this context it is worth noting that individual portraits are quite unthinkable. At times, to be sure, a sculptor may employ distinctive features reminiscent of a specific individual, someone recently deceased, for example, and his entire village recognizes them as such. True portraits, however, are nonexistent. Scholars have occasionally tried to correlate masks to the faces of the people from the carver's own region. Such attempts, needless to say, and their occasionally "positive" results, are based on a fundamental misunderstanding of the nature of African art. Studies of this kind reveal an underlying desire for "naturalistic" physical resemblances, and thereby betray a concept of art associated with the period preceding the "discovery" of this new art. In the art of the preclassical epochs, that is to say the periods that preceded Greek and Roman antiquity and the Renaissance, we have long since ceased to look for portrait likenesses. No one presumes that the pharaoh Chephren really looked like he does in his famous statue, or that Emperor Henry II is accurately portrayed in reliefs and illuminated books of his time. The age of individualism – and with it the age of the true portrait – would only come much later. And in terms of historical development, African art is also "earlier" than that of antiquity or the Renaissance. Even in Benin, a more highly developed culture than that at issue here – despite the fact that it precedes it in time – the portrait was inconceivable.

Such considerations raise the issue of the individuality of the African artist, a question frequently debated. Those who hold to the idea that art in Africa is essentially anonymous and collective are generally considered "romantic" in this day and age, as scholars put increasing amounts of effort into the search for individual carvers. In a sense this is justified, for in fact there are quite a number of "famous" artists who are either still alive or well remembered. And clearly it is in the interest of scholarship to gather all the available evidence, including the names of individual artists wherever they can be recovered. On the other hand, such data must be carefully weighed. To assign too much importance to them is to impose, once again, our own "Western" values on this art. Furthermore, we do not expect to discover the names of creative artists in early civilizations, not only because they are irretrievably lost but also because such a quest is in itself irrelevant in this case. In Africa, as everywhere else, each object of art is obviously the work of a specific carver, and because of the particular quality of their works a number of sculptors make a certain name for themselves, at the very least as teachers of a new generation. Now and again we, too, are able to appreciate the genius of a particular carver, and we can often recognize the style of a particular workshop or the hand of a particular artist. But this has nothing to do with the idea of the individual artistic personality as we encounter it either in Classical antiquity or particularly since the Renaissance. It was no accident that in his history of Renaissance culture Jakob Burckhardt gave the opening chapter the title "Individualism." An individual as creator of objects does not necessarily mean creative individualism. Names, even when they have been recorded, are just as irrelevant in the art of Africa as they are in medieval illumination or the Russian icon. The monks who gave us these latter works were individuals, to be sure, and naturally it is possible to distinguish between them in terms of artistic accomplishment. In none of them, however, do we discover an artistic striving that ineluctably consumes a whole personality. One of the most tantalizing questions for art historians is to explain how "suddenly," but with apparent historical necessity, individual names emerge from the mists of artistic anonymity, and not only names but personal signatures as well: a case in point is Greek vase-painting of the late archaic period. Those who attach too great a significance to the names of African sculptors that have been preserved fail to appreciate such lessons of history. It is also worth mentioning that, not surprisingly, the African region in which the search for individual artistic identities has been most fruitful is Nigeria, an area that can look back on a remarkably rich cultural heritage.

In view of the dialectic apparent in all African art between immanent power and depiction of the human form, along with other obvious reasons, it is understandable

why virtually no two-dimensional art is found in those regions in which figures and masks are produced. The few exceptions, notably in Nigeria, Ghana, and the Cote d'Ivoire may once again be explained by the fact of their dynastic past. Power is best incorporated in three-dimensional forms. When depiction as such, or even the narration of events, is given priority, art tends toward two-dimensionality. We see this especially wherever art is called upon to help glorify the state; obvious examples of this are not only Egypt and Assyria, but also – in Black Africa itself – Benin. Typically, Benin accorded particular importance to the relief as a medium for both narration and courtly display. Elsewhere in Africa, as well, art is often used to bolster a dignitary's claim to authority, but in such cases mere display is only secondary. Of paramount importance is the "physical" presence, whether of the being depicted or of otherwise invisible powers, and to communicate that presence only three-dimensional forms will do.

The vast majority of African sculpture conveys an air of calm, a fact that would seem to belie its underlying dynamism. In fact, however, this calm is a necessary precondition of dynamism. The depiction of physical activity, persons doing things, or people interacting with each other, is so uncommon that it need only be noted as the exception to the rule. Even masks, for all their greater vitality and fantasy, are essentially static; indeed, they appear all the more rigid in the midst of the violent movements of the dance. Among the qualities contributing to the repose of African figures are their frontality and symmetry, from which there is little deviation. When ethnologists first began to concern themselves with "primitive" art, they tended to see these formal qualities as essential to it, whereas in truth both symmetry and frontality are much more characteristic of the art of ancient civilizations. Throughout the history of art, these traits are nearly always associated with power and authority. In African cultures as well, they connote authority, dignity, and nobility, but here they reflect even more the natural posture of the human figure in repose. Sovereign authority of the kind that dominates the art of the old feudal cultures – once again including Benin – is not the chief concern. African figures nearly always stand or sit in repose, largely because their activity is of another order than that of the human body. The power at work in them has no need of physical strength; if it did, it would no longer be effective as a different power altogether. If these figures were engaged in movement, and especially if seen performing specific actions, it would certainly detract from their mysterious potency, if not entirely neutralize it. Yet it is not enough to characterize these figures as mere vessels for spiritual forces or active substances, for to do so would be to ignore their dynamic nature. On the one hand, the presence of any kind of power presupposes a passive body; on the other hand, that presence must also be expressed effectively. The essence of this art is therefore not repose alone, but rather a kind of ambivalence between repose and unrest. Physical calm is required by the presence of a disruptive being or of any operative force; at the same time, however, the power contained within the figure – including that of the wood itself – must not appear to be neutralized by the air of physical calm, but must be perceived as a potential force.

This necessity determines the immobility of the figure, clearly enough, and in addition it influences the manner in which the figure is shaped. A different kind of expression is called for here, which means that the ordinary, physical modes of expression such as gesture and mime are of no use at all. The standard language of gestures is wholly foreign to this art, yet its essential expressiveness is undeniable.[5] Wherever anything like a gesture appears in African art, it is only symbolic, and accordingly as devoid of movement as the rest of the figure. Examples of this are the "fetish" figures from the region of the Lower Congo (fig. 8), with their spear arms raised in "menace." It is significant that there is no sign of tension in African figures, even when their musculature is clearly defined. Indeed, if one imagines them as actual men instead of sculptures they seem strangely powerless, feeble, even meek. Other figures display a high degree of physical dynamism, but this does not disrupt their air of repose, the effect being created "merely" by the articulation of the volumes (Cat. 84). The human face, of course, is always available as a medium for spiritual expression, yet African carvers treat the face as well in a non-dynamic manner that is also stereotypical, that is to say, traditional and repetitive. Animated facial expressions

5 The expressive nature of African art has occasionally been disputed in recent times. This is due partly to a confusion of "expressive" and "expressionistic," and partly to a confusion of expressivity with a kind of savagery. "Expressivity" in art simply denotes the modification of natural forms in order to create an expression transcending nature. The art of Black Africa can certainly be described in such terms.

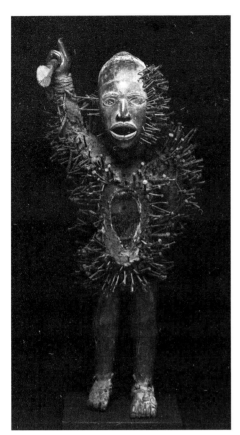

Fig. 8 Power figure. Kongo, Zaire. Cat. 148.
(Photo: P. A. Ferrazzini)

Fig. 9 Mask. Urhobo, Nigeria. Cat. 82.
(Photo: Barbier-Mueller archive, Geneva)

Fig. 10 Mask. Ngere, Cote d'Ivoire / Liberia.
(Photo: P. A. Ferrazzini)

are just as unthinkable here as tension in the muscles of the body. Certain figures, and especially masks, have a frightening appearance (fig. 9), one appropriate to their specific function. Even so, their features are never so distorted that equilibrium is lost. The physical calm of the "statuary" figures (even the small-scale ones have a statuesque air) is frequently reflected in their faces. The eyes are often closed, so as to suggest a certain inwardness, a heightened spirituality. Many have an almost Buddha-like serenity about them as a result of the introverted facial expression (fig. 10), but whereas statues of the Buddha reflect the triumph over inner agitation, in these figures the agitation is still present in essence, an unsubdued force. Occasionally, the faces of masks or figures appear to have an Asiatic or even a European cast. One sees it in the masks of the Punu in Gabon, for example, or of the Igbo in eastern Nigeria, and in the masks and figures of the Baule. It is important not to be misled by this, for nothing of the kind is intended. Such faces merely reflect a particular concept of ideal beauty or a specific aspect of spirituality. In masks, even more than figures, there appears to be a great span of expression between introversion and extroversion, though here again one wonders just to what extent our "Western" notions are responsible for such distinctions. As so often happens in Africa, the two opposing types of face can be found within a single region, most strikingly, for example, among the Dan, Ngere, and Wé of Liberia.

At some point one is forced to ask whether the aesthetic of masks in Africa might be altogether different from that of carved figures. Most writers appear to assume so, pointing out that it is impossible to understand masks properly if they are set apart from the related costumes, the motions of the dance, the music, or the totality of the ceremony for which they were made. But is this really so? It is certainly true that masks are one element of all this – at least during a ritual performance – although they do not play a role otherwise. Nevertheless, they too are self-contained objects, created as such and therefore, even in isolation, with an aesthetic of their own. The sculptor has his job to do, and he does it according to traditional rules, regardless of whether it is a figure or a mask, or of whether a single carver creates them both. Moreover, as suggested above, we are in the habit – quite legitimately, I might add – of isolating from its environment virtually anything that we come to regard as a work of art, and masks are no exception. To our way of thinking, masks are also art objects, which display – even when not in use – their own forms, their own expressions, their own beauty and power – in short, their own aesthetic value. Indeed, we are rather more inclined to appreciate such qualities when the prescribed costume and other attendant paraphernalia are not at hand. For us, masks are just like figures, namely art objects, not from the point of view of their intended use, perhaps, but certainly with regard to the manner in which they are created. At most we may tend to falsify their

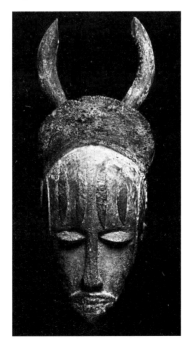

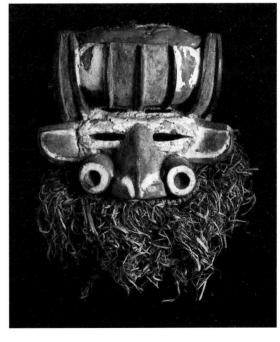

function, but not their sculptural form. When we divorce masks from their function, we only lose something of the contrast they provide, being wholly static themselves, to the frenzied hubbub of the ceremonial. We certainly do justice to both their sculptural form and their expression when we recognize that, quite like figures, their outward calm is inseparable from a kind of intrinsic unrest.

It is not always that the African is satisfied that his wood figure, simply in itself, is filled with vitality and power – though he doubtless gives little thought to such matters, it being highly unlikely that the issues of strength and potency so crucial to this discussion ever occur to him; especially as the overall concept of a purely "representative" art means nothing to him. He often consciously attempts to enhance the efficacy of his figures in all sorts of ways. He may, for example, make use of human anatomy itself, exaggerating certain parts of it so as to suggest specific powers, and to allude to particular religious or mythological notions. Special prominence is frequently given to the breasts, the navel, the genitals, and especially the head. Or he may affix all manner of potent "foreign bodies" to his figure: teeth, fur, cowrie shells, beads, bits of metal, nails, or whatever else strikes his fancy. When he immerses his figures in various substances, or rubs them with oil, soot, pigments, blood, and the like, in preparation for the libations, he is not only performing a kind of ritual homage or adding decorative elements, but deliberately increasing their power. The best example of this sort of accumulation of power is the magical figure, the so-called "fetish," which can be imbued with magical power by any number of different techniques. We have insisted that in African figures there is always an innate potency not fully absorbed by their form, potency that contributes to their overall aesthetic effect: nowhere is this more apparent than in the case of "fetishes." Of course some scholars have claimed that such objects ought not to be considered art at all, belonging rather to the realm of magic. Yet one cannot deny that they too elicit an aesthetic response, thanks both to their form and to their expression. It is possible that those who prefer not to consider "fetishes" as works of art are motivated by the fact that they find such objects ugly and repellent. If so, they are guilty of narrowing the concept of art to a restricted notion of beauty.[6] Admittedly, the borderline between the work of art and the cult object is difficult to establish. Some objects may be rightly assigned to the province of magic since no creative will has been involved. Even though many of the large and also the small nail and mirror "fetishes" from the Lower Congo display a relatively casual formal design, and despite the fact that a ritual specialist has often had as much to do with their creation as has the wood-carver, they are nonetheless highly expressive, and this expressiveness is not something independent of the design of these works but rather a quality deriving directly from it.

If it is true that it is not only the visual effect that is important in Black African sculpture, but above all its actual effectiveness which it owes to a particular "force" – at the very least that of the wood, the natural medium in which it is carved – then it follows that in their entire formal makeup the figures must reflect this aspect. This is not merely the representation of human anatomy. We must also note how the figures' proportions are commonly distorted – the first sign of "artistry," signifying from the outset that what is here created is something more than simply a man. We find quite drastic departures from the canon of natural proportions, even audacious physical deformities, as in the Cameroon grasslands (Cat. 110-13), in Mumuye art (eastern Nigeria) (Cat. 107-8), and elsewhere; most strikingly in the masks of many ethnic groups. Extreme distortions, however, are not the rule in figure-carving. Properly proportioned bodies are distinct rarities in African sculpture, and for this reason they strike us as "unnatural" when we do come across them. This is not to say that Africa has created some new set of proportions to which all works must adhere; there is no such thing as an African canon, any more than there are other orthodox formal laws. Even within a given type of figure, one frequently encounters considerable variation in the relative sizes of parts of the body. Certain ratios nevertheless recur with marked regularity. For whatever reason, a figure may often have an overlarge head, an elongated neck, a torso as erect as a column, distinctly protruding buttocks, very short legs, and strikingly large feet – a rhythmic composition encountered again and again in the figural sculpture of Africa, in far-flung regions of that vast continent.

6 Some authors admit that they are disinclined to speak of an aesthetic of Black African art – apparently because they equate "aesthetic" with "beautiful" or "not repulsive," by analogy with the use of "unaesthetic" in popular speech. If one says that the art of Black Africa sometimes produces "ugly" or "unaesthetic" objects, this aspect (when it is not purely subjective and therefore irrelevant anyway) is of course part of an African aesthetic. The distinction between "aesthetic" and "unaesthetic" has nothing to do with the discussion of *an aesthetic*, quite apart from the fact that it does not hold true for African objects.

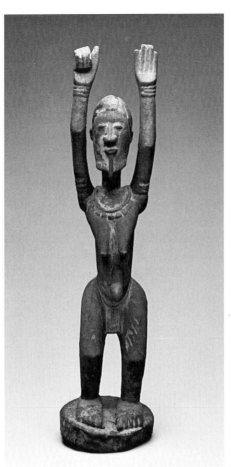 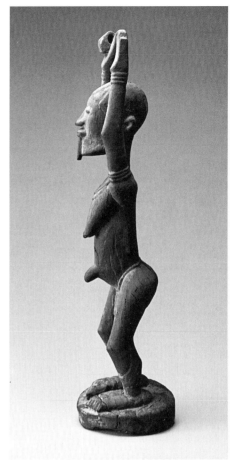

Aesthetic decisions may determine the ultimate rhythmic disposition of the figure, but underlying it are purely practical considerations inherent in the technique of the craft. When beginning a sculpture, the carver first divides his block of wood with an ax or knife into separate sections corresponding to the main divisions of the human body, albeit with altered proportions. This initial division continues to affect the structure of the figure to varying extents right up to the moment of its completion. One sees the effect of this principle of design both in those regions where art shows a tendency to be quasi-geometrical, or as some would have it, "cubist" and abstract – in the area of the Western Sudan, for example, or among the Songye in Zaire – and in others where rounded forms and a "smooth" technique of molding shapes come very close to naturalism. In all art, what matters is not what level of accuracy in the depiction of nature an artist has attained, but rather at what point he is content to go no further. For the African carver it is enough if the original articulation is preserved in his figures, and not obscured by precise anatomical detail. His first, crude blocking-out remains all-important, or at the very least a determining factor in the final design. But this does not explain why the artist permits it to be so, any more than the accepted techniques of the craft explain why proportions are distorted, even though these techniques can be identified behind the distortions. If naturalism were desired, the technical means for achieving it are certainly available.

African sculpture is capable of reproducing every anatomical detail, but always there is a limit that must be respected: the body can never be treated as a functioning organism (figs. 11, 12). The natural interaction of the body's parts must be checked, so that – even without the aid of special substances – an extrinsic power can come into play. It is for this reason that the individual parts of the body are always more or less sharply set off from one another. Discontinuity, not continuity, is the governing principle. The separation of volumes is a fundamental characteristic of African sculpture, and in this it is not so very different from the art of ancient civilizations. What does set it apart is that, for all the discontinuity of its details, the organic continuity of its medium, wood, is uncompromised. There is a connection, then, between the organic dynamism of the wood and the non-organic articulation of the body.

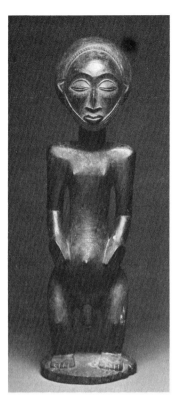
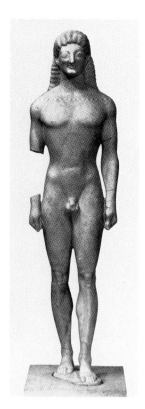
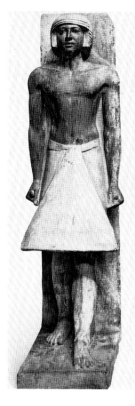
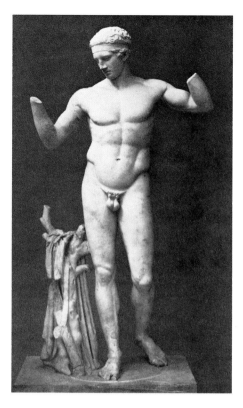

Moreover, the vital, growing force of the wood tends to work against the separation of volumes as it rises upward, flowing through the boundaries between the discontinuous elements. Or, put another way, the dynamics of form function in opposition to the dynamics of the wood. The resistance of the wood must be overcome, step by step, to create the forms, but its vital force remains unbroken.

The segregation of the volumes is more or less distinct, more so in some figures than in others, but always to an extent that upholds such demarcation as a basic principle of African sculpture. Again and again one notes how the individual parts of the body are treated as relatively autonomous forms: the head with its prominent chin, the neck, the shoulders, the upper arm and forearm, the hands, the breasts, the torso, the buttocks, the thighs, the calves, the feet. This characteristic structure, often markedly "architectonic," is emphasized by the exaggeration of specific details. Facial features, for example, are likewise treated as autonomous elements, wholly separate from each other, even in cases where a highly organic surface treatment is attained. One sees this among the ethnic groups of the Cote d'Ivoire (see Cat. 53 ff.) and in the art of the Luba on the upper reaches of the Zaire. The eyes are treated as independent forms, and are themselves broken down into quite distinct parts. The nose often constitutes a dramatically projecting, stereometric element, one that is likewise composed of isolated parts, in this case the bridge and the sides. Often there are quite elaborate coiffures and tattooing scars as additional elements. All of this makes for sculptural clarity, strong formal structure, and rhythmic unity, but always in strict negation of the organic unity of the body. Since there is no stream of life pulsing through these figures, evidence of physical relaxation, of being "at ease," is almost never encountered. Again and again one comes to the same conclusion, namely that power is stored here instead of being channeled in accordance with the interplay of bodily forces. For this reason one rarely has the feeling that the figure stands in the way real people do. Standing, that is a distribution of weight between a bearing leg and a free leg, which we observe in its most extreme form in the classical contrapposto of Greek antiquity, is simply not "depicted." In Africa it is again not so much the body portrayed that does the standing as it is the wood figure (fig. 13), and wood figures often manage to stand more securely if their legs are bent at the knee. For a real person, such a posture would be anything but secure. Here, however, it always serves to improve the figure's stability, and is therefore unconsciously interpreted by our brain as being "right," instead of being non-naturalistic. Belonging to the same

Fig. 13 Male ancestor figure. Hemba, Zaire. Cat. 178. (Photo: P. A. Ferrazzini)

Fig. 14 Male figure. Egypt, c. 2400 B. C. (Photo: From Propyläen-Kunstgeschichte, vol. 15 [Oldenburg, 1975])

Fig. 15 Male figure. Greece, c. 550 B. C. (Photo: From Propyläen-Kunstgeschichte, vol. 1 [Oldenburg, 1967])

Fig. 16 Male figure. Greece, c. 420 B. C. (Roman copy). (Photo: From Propyläen-Kunstgeschichte, vol. 1 [Oldenburg, 1967])

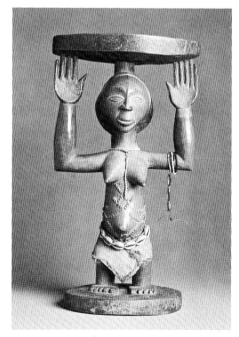

Fig. 17 Caryatid stool. Hemba, Zaire. Cat. 176. (Photo: P. A. Ferrazzini)

train of "logic" is the frequently observed fact that the arms hanging down on either side of the torso hang not in a loose, natural way, but as if they were "standing" downward. One often sees this in the sculpture of ancient Egypt as well, of course (fig. 14), but there – in contrast to Black Africa – one senses the physical force extending downward from the arm muscles into the clenched fists, senses it as an organic force, albeit not yet released. Much the same might be said of the statues of young athletes in pre-Classical Greece (fig. 15), after which there is a progressive relaxation of tension culminating in the natural ease – though still bound by a formal canon at first – of the fifth century B. C. (fig. 16). The crucial question in this long process, the issue of the relationship between burden and bearer, between weight and support, is nowhere addressed in African art. It is not even an issue in those cases where "caryatids" are called upon to support a throne; they do not actually bear it, often only touching it with their fingertips (fig. 17). Weight in African sculpture is always just that of the wooden object, which supports itself.

Returning to the notion of segregation of volumes, or a style that is essentially additive, one basic reservation must be made. This additive combining of parts, in itself necessarily static, is to some extent enlivened by the dynamism of the wood, and also by the activism manifested in its formal treatment. The separate parts therefore come to relate to each other not only in a rhythmic, measurable manner; they are at the same time all part of the one "piece of wood," so that this piece of wood itself acts as a unifying counterforce. Another unifying element is of course the artist's "hand," his use of his various implements. As a result, there is always a tension between the metric and dynamic aspects; indeed, the balance can tip more toward the one or toward the other not just from region to region, but even from object to object. It is for this reason that it is virtually impossible to speak of strict laws of form anywhere in Africa. Various authors have repeatedly sought to discover such laws within the plethora of different styles. They have distinguished between such basic concepts as pillar sculpture and sculpture in the round, and tried to assign the objects of a given region to one or the other category. They have introduced – a questionable application of modern terminology – such polar stylistic notions as realism and cubism. Concentrating on facial form alone, they have distinguished between a concave and a convex style, and attempted to discern cultural similarities between regions, however remote, in which one or the other style predominates. Most frequently, perhaps, they have made much of the contrast between two quite distinct stylistic approaches, one more carefully modeled and rounded, one geometric and abstract. While it is true that this antithesis provides general reference points for the variety of African art, one should not make too much of it. For one thing, the abstract end of the scale presents extreme contrasts of its own: one only needs to compare the art of the Dogon (fig. 18), Bamana, Mossi, and other peoples of the Western Sudan on the one hand with the metal-plated reliquary figures of the Kota in Gabon (fig. 19) on the other – the latter, incidentally, are found in close geographical proximity to the decidedly rounded figures of the Fang. It is not only on account of such pluralism that the concept of style is of such limited use in Black Africa. In Africa, stylistic rules do not have the authority they enjoy in other cultures. The repetition of a given kind of figure or mask through one generation after another is a phenomenon of typology, not one dictated by style. For a particular type, to be sure, certain formal laws must be followed, but these rules of form do not necessarily extend to other types of objects. A carver is required to model his figure or mask in such and such a way, not because of some overriding stylistic consciousness, but because specific types have been developed in response to cult needs; an additional factor is the comparatively short life of the objects, which means a continual need for replacements, modeled on the forerunner that has been destroyed or discarded. These types are for the most part precisely defined; individual initiative has only very limited scope. It is such types, rather than stylistic norms, that tend to corset the "artist's" imagination. However, there are stylistic features that are more or less pronounced from one region to another.

But is there in fact such a thing as artistic imagination in Africa, if a sculptor has virtually no opportunity to produce anything new of his own? Even in those cases where a Black African artist has become "famous" or contributed something new, his

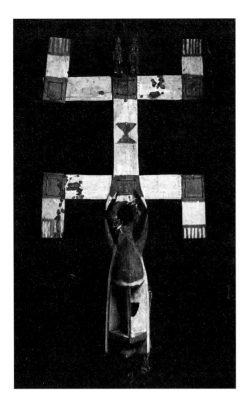 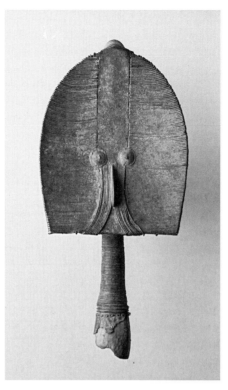

Fig. 18 Sculpture of the Dogon, Mali. (Photo: P. A. Ferrazzini)

Fig. 19 Bwété reliquary figure. Kota-Mahongwé, Gabon. (Photo: Barbier-Mueller archive, Geneva)

dependency on prescribed forms and types is still more apparent than his individual freedom. Consider, for example, the familiar antelope-shaped mask ornaments produced by the Bamana in Mali. Variations exist in abundance, yet the basic form is clearly prescribed. One finds this same adherence to prescribed form even in the Luba artist – presumably more than one person – commonly extolled as the "Master of Buli," yet enthusiasts point to him as an example of a kind of African individualism that simply does not exist, however exceptional his work may be. Even today we know nothing of the mysterious and doubtless very long-drawn-out processes through which the many types of figures and masks have evolved – maybe we never will unravel the mystery. Everything must have had a beginning, but to speak of genuine artistic innovation in Africa is wholly misleading. The origins of the numerous types of sculpture are hidden from us, but in a sense this only serves to make the extraordinary inventiveness apparent in their formal concepts the more impressive. It is well known that Picasso admired such formal ideas in African objects more than quality of individual works. And it is true that these formal concepts can always be found, even where the "artist's" work is clumsy or altogether worthless. A number of masks, particularly, reveal an astonishing conceptual audacity, often reflecting a very radical departure from nature – more so, as a rule, than do the figures. Such independence from nature, however, such boldness in the face of it, has nothing to do with independence or boldness on the part of the artist. It is simply part of the concept to which he holds. Freedom from nature in this case means primarily a freedom of form, and this is simply not individual freedom, for the formal idea remains fixed. The concept only serves as a guide, and individual interpretations can occur, occasionally even something of exceptional "quality," in rare cases a hint of individual audacity.

So in the end the individual comes into play here as well, and he brings his particular talents and skills. It is the individual who not only provides variations from the given prototype, but infuses a work with its own unique power and feeling, which cannot be explained in this context any better than in other forms of art. And because the scope for individual artistic initiative is here so restricted, the supreme expressiveness, beauty, "noblesse," and magic of certain sculptures strike us as all the more miraculous. None of this can be rationalized. African art affects us in much the same way as, for example, the craftsmanship of earlier centuries in Europe. When faced with an ancient wooden utensil, a woven cloth, a work of wrought iron, an earthenware vessel, one has to wonder just what mysterious factors gave rise to such "inno-

cent" formal perfection, as it were, only to be subsequently lost beyond recall. In the history of European art this "innocence" persists up until the moment of the "Fall," namely the discovery of art as art. Up until that time, the cultural context simply did not acknowledge art apart from craft. The same innocence extends beyond that historical turning point, in the field of so-called "folk art." There must be something of this innocence that explains the mysterious beauty found in African masks, figures, and other carved objects. It is as though their creator were endowed with an innate feeling for form, however much it has been developed through teaching and practice, a feeling that reveals itself both in the object's overall shape and in its smallest details.

In Black Africa this sense of form hardly ever gets out of hand; very rarely does one encounter excess. We have described African art in terms of its fundamental balance between repose and unrest, inactivity and activity, the metric and the dynamic. We must now add to all of this some mention of its fundamental severity, its seriousness, its great restraint. As one studies this art, one seldom thinks of "barbaric" violence or savagery in relation to it but rather of an inherent nobility. Even when it seeks to frighten – as might most likely be the case with certain masks – it maintains its strict formal composure. Symmetry is in large part responsible for this sense of composure, and it is rarely abandoned even in masks. Moderation is ever present, excess virtually unknown. This distinctly metric-stereometric-character distinguishes African sculpture quite clearly from that of Oceania, or at least of Melanesia, though there as well it is correct to say that "power" is more important than "representation." Sheer fantasy of the sort that characterizes the art of the Sepik in New Guinea is virtually never encountered in Africa, notwithstanding the many fantastic concepts to be found on that continent. The fundamental dynamism of African art is combined with a strict formal control. This dualism of power and formal control is doubtless one of the main reasons why, around 1905, the artists of Europe suddenly found the sculpture of Black Africa so impressive.

Louis Perrois

Toward an Anthropology of Black African Art

"Black Art" and African Art

The "imaginary museum" is, in the final analysis, the most fully elaborated, subtlest form of ethnocentrism practiced by "high" cultures. As Jean Laude has emphasized: "The danger of imaginary museums lies in the fact that they dull our capacity to grasp the original characteristics of an art; they reduce the arts of all countries and all times to a few common, but fallacious, denominators. The meaning proper to each art, which involves not only its function but also the group of values surrounding it, is lost in an undifferentiated mass, in a glitter of purely retinal effects."[1]

This specialist's point, certainly true of the relationship between "Black art" and modern European art, should also be kept in mind generally; for the temptation to reprocess exotic art remains strong, despite the fact that, after fifty years of exhibitions, books, studies, and scientific reflection, we might have had reason to hope that we were about to achieve a view that corresponded to lived realities. Obviously, we must recognize that different peoples live, think, and create differently; yet the progress of this outlook is slower than might be expected. In art histories, even those that include the "primitive arts," our terms of reference remain ancient Greek sculpture and European painting, each considered the "classic" standard *par excellence.* Evolutionary belief also dies hard, and it can take on very modern forms in the present-day world, in which technological progress is still considered the ultimate condition of survival.

We are certainly free to appreciate this or that object or style; but this should not lead us to elevate individual judgment into a form of vision to be imposed upon others – though such is too often the case with collectors and collections (especially private ones). If the legitimacy of individual choice is not at issue, its relevance to the study of art is never immediately apparent. Likewise, we rarely recognize just how relative are the representative nature or the objective value of museum collections, even though we know that the way in which they are brought together, if relatively systematic, is actually determined by economic circumstances. The relationship between the material conserved and its contextual reality should be sought far beyond our initial aesthetic response, in a specific, orderly research effort; yet this approach is still too rarely practiced.

We must not confuse a taste for exotic objects, in which personal dreams certainly play a part, with the knowledge of what those objects really mean to the people who created them and used them. Our fascination with "primitivism" probably arises from a desire to escape the cultural shackles of a civilization perceived as too stifling; we should recognize, however, that "primitive" expressions – apparently so free and spontaneous, even instinctive – are, in their lived reality, highly restrictive for those involved. We may contemplate faraway arts, but we can never live them. Exotic escape is a means of fleeing the stresses of our society; but distant cultures have their own forms of stress, certainly different from ours, but often even more demanding. Calling to mind the individual or collective terrors of the period in our own medieval history that is contemporary with Romanesque sculpture may give an idea of the psychological pressures of a spiritual world in which magic and witchcraft are omnipresent.

Jacqueline Fry offers an inclusive yet cautious definition of African arts: "Provisionally, we may understand by 'traditional arts' of sub-Saharan Africa the production of objects or performances whose artistic quality is rooted in a world vision or a technical history developed on African soil itself."[2] To Fry, it is foolhardy to claim to

1 Laude, 1985, p. 69.
2 Fry, 1985, p. 81.

recognize principles of artistic traditions in an area that encompasses three-quarters of a continent. In his introduction to Jacqueline Delange's book, Michel Leiris holds that an inclusive approach to African arts should be perceived less as an immediately grasped "history of arts and styles" than as "the quest for a statement of the materials relevant to such a history," both in space and time.[3]

To this undistorted view of inclusiveness in our hastily sketched panorama of Black African arts we should add an awareness of their diversity, if only to avoid the narrow idea of "Black art" that is fixed in contemporary Western cultural usage. In this respect, Fry quite rightly observes that the contemporary arts of industrialized countries present astonishing similarities to traditional African arts "in their multidisciplinary approach, in the importance of installation and performance, in the sustained exploitation of the most diverse materials, in the use of collage and montage, in the preeminence of sign, the union of the literal and the metaphorical, in the practice of a community aesthetic, in their critical intentions, etc."[4] All this corresponds to an international artistic neo-primitivism, yet not to the discovery of an "elsewhere, which still remains unfocused for it." In fact, given modern research possibilities and the means available for fieldwork at the very heart of African culture, the persistent lack of communication between worlds that exist side-by-side without ever really seeking to understand each other is truly puzzling.

The fashion of exhibitions, books, and discussions that, over the past several decades, have regularly "rediscovered" "Black art" stems in fact from our unconscious fear of the necessity of revising our certitudes in the face of cultures different from our own. Hence, also, the attraction of an ardent aestheticism that is rendered all the more powerful by being rooted in the world of fashionable and intellectual culture.

Objects appear "naked" only in our museums and catalogues; in reality, they have been, and sometimes still are, at the center of complex surroundings that both justify and support them. It is an error of perspective, one consistently denounced by all practicing Africanists, to cut these objects off forever from these lived surroundings, whether from convenience or (on occasion) from principle, by arguing that we have nothing more to learn from Africa, since it changes just as fast as we do. A vast amount of information about traditional African cultures and, in some regions, about still flourishing plastic arts remains to be collected and analyzed.

A harmonious collaboration between ethnology and aesthetics is what most needs to be achieved in actual practice, however difficult experience has shown this to be. On this question, Jean Laude concludes:

> In choosing the arts of preliterate societies as its field of analysis, aesthetics is faced with facts that it can understand only with the help of ethnographic research. Now the analysis of these facts, supported by ethnology, is not simply a part of ethnology's specific field of study, to be reconstructed according to its specific methods; it also allows ethnology to pose and, as the case may be, to resolve problems that at first glance seem to go beyond its particular areas of investigation. Collaboration is necessary between the ethnologist and the aesthetician – a collaboration that is simultaneous, since problems are never posed separately and distinctly. A moment exists when the ethnologist must turn himself into an aesthetician; if he fails to do so, he will lose certain aspects of the idea of "value" which is also part of his research.
>
> Ethnologists have justifiably been suspicious of aesthetics. The considerable volume of works devoted to "Black art," forever repeating the same generalities or setting up fragile theories, is well suited to provoke such suspicions, and, as we now know, *one* "Black art" does not exist.
>
> What would we say if, at a furious pace, our African friends published works entitled "white art," with about a hundred reproductions drawn from painting and sculpture of every European country and period?"[5]

This question has been more or less definitively summarized in the exhibition and the enormous companion volume produced by William Rubin in 1984, *"Primitivism" in 20th Century Art*. It was also treated remarkably by Jean Laude in his thesis *French Painting (1906–1914) and Black Art*, published in 1968.

"Black art" is a known and recognized field of study. What should now hold our attention is the complex, multiform subject of the African arts themselves. A number of studies based upon in-depth research both into objects and into their native contexts have been published since the 1930s; that of Marcel Griaule on the Dogon masks of Mali, for example, was a pilot work, published in 1938 but unfortunately inade-

3 Leiris and Delange, 1967.
4 Fry, 1985, p. 81.
5 Laude, 1985, p. 78.

quately repeated for the multitude of other styles flourishing from western to southern Africa. Monographs in this field have remained rare. Likewise, Jacqueline Fry stresses the fact that Western attention has been drawn especially to wooden sculpture, to the detriment of other works too quickly considered subsidiary. A glance at the table of contents of a "classic" catalogue of African arts reveals:

in Mali: sculpture of the Dogon and the Bambara (Banmana);
in Guinea: sculpture of the Baga;
in Burkina Faso (formerly Upper Volta): sculpture of the Bobo and the Mossi;
in the Cote d'Ivoire (formerly Ivory Coast): sculpture of the Senufo, the Dan, and the Baule;
in Ghana: sculpture of the Asante;
in Nigeria: the ancient arts of the Nok, Ife, and Benin,
and sculpture of the Yoruba, Igbo, Ibibio, Ijo,
Ejagham and, in the north, the Jukun, Chamba, and Tiv;
in Cameroon: sculpture of the Grasslands (Bamileke, Bamun);
in Gabon: sculpture of the Fang, Kota, Kwele, Tsogho, and Punu-Lumbo;
in the Congo: sculpture of the Mbochi, Kuyu, Bembe, and Teke;
in Zaire: sculpture of the Kongo and Yombe, the Luba, Songye, Kuba, Lulua, Pende, Yaka, and Lega;
in Angola: sculpture of the Chokwe.

Little by little, each of these headings has been recognized as too schematic to characterize an entire region, especially by those who have taken the time to travel and see at first hand the problems posed by the objects, styles, traditions, history, and other details of living social contexts. From this perspective, entire regions have until recently remained largely unknown: Kenya, with the production of the Turkana, Pokot, Masai, and Mijikenda; Tanzania, with the Makonde; Zambia, with the Shona; South Africa, with the Zulu; and other rather out-of-the-way or inaccessible regions, like Guinea, the Cote d'Ivoire, Nigeria, Cameroon, Gabon, Equatorial Guinea, Angola, and Zaire.

The diversity of African artistic production becomes evident as soon as our view of the objects (and not only of wooden sculpture) and our analysis of contexts are organized from the combined perspective of history and anthropology. While making no pretense whatever to exhaustiveness, studies that treat a particular region allow the "discovery" of a cultural richness that seems astonishing, even unhoped for, in the context of our current disenchantment with faraway places. The arts of Burkina Faso, the Cote d'Ivoire, Nigeria, Gabon, and Zaire – among others – have been reexamined, analyzed, and identified with far greater precision and have been placed in their proper historical perspective.

One may, of course, question the theoretical and ideological foundations of such studies, which, though more detailed, are no less ethnographic than are monographs on rituals. The question, in fact, is to know whether African "art" objects should be subjected to the anthropological approach or whether that approach might now be replaced by an intellectual and aesthetic one. For several years, the problem of African aesthetic considerations within an African milieu – a problem to which we shall return – has been at the center of this debate. Familiarity with the objects and material elements of these cultures, whether in museums or in the field, reveals an abundance of aesthetic solutions – forms, structures, volumes, decorations – both for sacred objects and for merely functional objects that range from a columnar style, which scarcely changes the material, to a sometimes mannered naturalism that shows an obvious concern for detail and for refined surfaces.

At another level, forms may be structured according to very different and deliberate production patterns. This variety is even more striking with masks, which range from the idealized naturalism of the Dan, the Guro, and the Punu-Lumbo to explosive geometric designs like those of the Jukun and the Songye. And then what should we make of the "decorative" arts – sculpted architectural elements, weapons, personal ornaments, furniture, and so on – where a superabundance of motifs, conveying as many symbolic messages, constitutes an almost infinite field of study of thousands of different ethnic universes?

Artistic Assumptions: Performances and Objects

Artistic activity in Black Africa is not restricted to plastic creation alone, that is, to those objects that are considered worthy of being classified as works of art in the West. African "arts" find highly diversified means of expression, for the artistic impulse is always combined with some functional preoccupation: body decorations, furniture or architecture, metallurgy or pottery, painting or sculpture.

Aesthetic universes, largely traced from the collective features of the civilizations that produce them, are complex totalities, all-encompassing cultural expressions, even though their forms, in areas where oral traditions predominate, are often ephemeral. The various combined expressions that appear – dance, instrumental music, song, poetry, body ornamentation, architecture, decoration, and sculpture – seek to achieve a certain mastery of a cosmic milieu comprising man, nature, and the supernatural at once. From the practice of African arts in Africa itself, it is clear that artistic perform-ances – in which objects play only a limited role – are themselves more important than the symbolic supports they employ; hence, it is important to see them from an all-encompassing perspective, though this perspective is almost always absent outside Africa. Even though it is a commonplace today to affirm that African arts have a dimension of total theater, from convenience and sometimes from principle, we persist in wanting to isolate objects within a phantasmagoric gaze that, we hold, helps locate their universal value. The "beautiful," however, is not only an eminently cultural notion related to particular norms; it is also, within a given context, understood simply as a balancing of elements, some of which are materialized, while others are expressed through euphoria, suffering, or the inspiration of festivals and rites. Sculpture, in fact, is merely the most accessible – and most transportable – of these elements.

Art in Everyday Life

In Africa, as elsewhere, man has always needed to give significance both to his own body and to the familiar objects that he manipulates, for various – and never exclu-sively aesthetic – reasons. Personal ornamentation (or what we consider such: paint-ing one's face white, for example) is both a means of expression and a system of protection. It may consist of scarifications and paintings or of voluntary mutilations and deformations; either method may be reinforced by the addition of various forms of jewelry, made of prestigious materials or possessing therapeutic effects. From what we know of them since the nineteenth century, certain societies seem never to have been creative in the plastic arts; but their absence (understandable in nomadic popula-tions, for example) is often compensated for by the practice of ornamentation or by forms of expression linked to an oral tradition. Such practices and expressions be-come, in fact, the preferred supports for the group's operative symbols. Personal ornamentation and the arts of the body imply considering the body itself as the material to be remodeled: hence certain practices of mutilation (particularly of teeth) or of scarification, which can constitute a veritable *bas-relief* sculpture. Such re-creation of the face or belly (usually of women) is akin to making masks, and "belly masks" do indeed exist among the Makonde of Mozambique.

Though the use of masks and statuary is generally reserved for men only, ritual painting and coiffures are equally masculine and feminine. The interest of the nomadic Fulani men in the personal ornamentation required during the annual festi-val of *gerewol* (when young girls select their suitors) is well known. Coiffures are everywhere objects of careful attention, and ancient hairstyles are represented in sculpture. Until the 1920s, the Fang wore a type of wig made from braided plant fibers and decorated with cowries and later with shirt buttons (the local "currency"); the wig was attached to the wearer's hair and ornamented with small chains and brass rings that decorated nose and ears. Among both the Igbo of Nigeria and the Kota of Gabon, women wore distinguishing coiffures that corresponded to their initiatory hierarchical status.

The practice of personal ornamentation is clearly occasional, arising from the need, existing only in specific circumstances, to appear adorned with a particular symbol.

Nevertheless, inconspicuous, essentially protective ornamentation was carried at all times: hidden tattoos or scarifications, motifs woven into underclothes (especially in Mali), a variety of talismans, sometimes even coiffures or jewelry.

In the past, all common objects, however humble – tools, cooking utensils and containers, clothing, musical instruments, arms, chairs, headrests, staffs, and so forth – were decorated; their decorations were intended to beautify as much as to signify ownership, function, or social or ritual importance. Study of ritual materials demonstrates that all objects (not simply masks and statues) have been fashioned from the double perspective of technique and symbol, neither functioning without the help of the other.

Pottery is everywhere the women's prerogative. In West Africa, the potter is always the blacksmith's wife, though this association is less strict elsewhere. Since the potter's wheel is unknown in Africa, the techniques used are modeling, coiling, or molding on a form. Containers may attain a height of more than three meters: the clay granaries of the dry savannas in northern Nigeria and Cameroon, for example, are in fact only large ceramic pots with partitioned interiors, made, in the absence of firing, of sun-dried earth. The decoration is incised, modeled, or painted, and some surfaces are subsequently polished. Pots, ranging from small bowls to the large jars used for millet beer, are fired in an open fire.

If weaving, especially in West Africa, is men's work, spinning cotton remains a feminine activity. Since little wool is worked, cotton is the dominant raw material in the Sahelian region, raffia in the forest areas. Cotton weaving, still practiced today despite the massive importation of printed cloth, produces narrow strips that must be sewed together before being embroidered. Raffia art is much less elaborate, except in the Kasai region of Zaire, where, as among the Kuba, some pieces are veritable masterpieces of abstract art. Decoration of all these materials – cotton, wool, or raffia – may take place in the weaving itself, may be added by embroidery, or may be achieved by dying some or all of the cloth by a variety of techniques, one of the best know being *batik* (Cameroon).

Basketmaking techniques and those used in weaving esparto, rush, osier, and stems and leaves are directed toward a final product clearly more functional than aesthetic. Yet here too a concern for symbolic decoration, sometimes very pronounced, is evident, whether in weaving, in the decoration of gourds through dying and pyrogravure among the Fulani, or in the Hausa's treatment of leather objects. Work in ivory and bone, essentially limited to forest areas, provides both small objects – figures or mask-shaped amulets – and, among the Kongo and the Lega, more important ones like horns and headrests.

A flowering of the metals arts has resulted from the pervasive practice of metallurgy. A variety of techniques and materials are involved: casting of bronze, for example, by the lost-wax process; plating, with gold in West Africa, with copper in Equatorial Africa; forging and hammering of iron, exemplified in Central Africa by magnificent weaponry with finely chiseled decorations. Iron working has also produced ritual objects, like the staffs decorated with geometric motifs made by the Dogon, the Fon, and especially the Yoruba.

The art of furniture making comes closest to that of sculpture itself, in objects both large and small: cosmetic or medicine boxes, staffs, small furniture like the headrests and chairs of the Shona and the Chokwe, stools, fan and whisk handles, window shutters and door panels, and so on. Some of these objects are masterpieces of elegance, with a patina that gives them an exceptional refinement. All are part of African arts, for the same reason as the purely ritual objects that are usually displayed. They bear witness to a sure taste for beautiful objects that delight both the eye that contemplates them and the hand that caresses them.

Archaeology has uncovered the ruins of a number of African cities built in stone. In southern Mauritania, Koumbi Saleh was possibly the ancient capital of the empire of Ghana. Ouri and Ain-Fara are in the Dar Four in present-day Sudan; Engaruka and other ruins of stone surrounding-walls are in Tanzania and Kenya. Other sites are in Zambia, Zimbabwe, Mozambique, and the northern part of the South African Transvaal. The most remarkable architectural complex is the great ellipse, the "stone house," of Zimbabwe; in this land of the Shona, ruled by the *monomotapa* (lord of

the mines), a veritable city of stone was constructed, comprising a palace, houses, and a surrounding-wall nine meters high and four-and-a-half meters thick. These structures, dating from the twelfth through the fifteenth centuries, were made with squared blocks of granite, without mortar. More recent traditional structures are made of more fragile, less durable materials – dried brick and rammed earth in the savanna regions, wood and bark in forest zones. Sometimes decorated with painted motifs or treated as *bas-reliefs*, these houses, especially in southern Benin and western Cameroon, may also have doors and windows framed with added sculpted elements. Along with the common form of rural housing, here and there sumptuously decorated chiefs' residences were built. The palace of the *oba* of Benin (sixteenth to nineteenth century) in southern Nigeria had walls and support posts covered with bronze plaques depicting scenes at court; this form of art was, however, very unusual.

The importance of the "beautiful" and the "well-made" for objects that might otherwise be considered only functional is attested to by the abundance of this type of art in everyday life, though its production is greatly reduced today; it is prevalent everywhere in Africa, but especially in regions which have produced great sculpture. It is possible, in fact, to speak of a veritable "craft aesthetic," corresponding to the high level of mastery achieved by African weavers, basketmakers, smiths, iron workers, potters, builders, and sculptors. These lesser arts, often overshadowed, were actually much more a part of people's daily lives than were masks and statues, which either had to be kept hidden or were scarcely visible in the supernatural blur revealed to humans. These arts made up the fabric of village life and as such carried the whole operative symbolism of daily life. Through detailed study, they bring us back to the lived reality of traditional African societies.

Objects: Production in the Plastic Arts

It is not possible here to provide a detailed panorama of Black African production in the plastic arts. Several volumes would hardly suffice for such a task. It is possible, however, to sketch the major outlines of a stylistic map of African sculpture. This sketch will help place each of the objects included here not only in space but also in its socio-cultural context and symbolic universe.

West Africa: The Upper and Middle Niger; the "Sudanese" Savannas

In this region of dry, tropical climate, an area of millet cultivation, several great empires have developed over the centuries. The sculpture of the Sudanese peoples, stretching from Mali in the Burkina Faso to northern Nigeria, is austere and angular; the cubist geometry of its volumes attests to a sure taste for abstraction; its shapes and decorations merely suggest meanings that are made explicit elsewhere, especially in the oral tradition.

The DOGON of the Bandagiara cliffs in Mali are well known to ethnography through the studies of Marcel Griaule and his co-workers and to art through the work of Jean Laude. They have conserved down to the present day a complex cultural heritage in which mythology has a determining place. Their sculpture has a socio-religious inspiration and is intended to neutralize, if not to master, forces of life and death. Dogon sculptors, who, like all African artisan groups, are members of a caste, are also blacksmiths. They make anthropomorphic and zoomorphic masks that are always in schematic shapes; the masks are used during mourning ceremonies and are reputed to facilitate recuperation of the deceased's vital powers. Figurative sculpture generally represents ancestors and evokes important mythical episodes. Although masks are exhibited to everyone, statues must be kept hidden.

Originating, like the Dogon, in the Mande heartland, the BAMANA, who for centuries dominated part of Mali, have a wooden sculpture particularly remarkable, at least in earlier objects, for purity of line; in recent times, this style has degenerated. Statues of ancestors and twins are found among the Bamana, as is the considerable

number of masks corresponding to six initiatory societies, the best known of which are the *ntomo* and *kore*. Antelopes representing Tyi Warra surmount headdresses and are used during dances associated with agricultural fertility rites.

The SENUFO of the northern Cote d'Ivoire produce much more figurative sculpture than the peoples of the Middle Niger, who are more given to making masks, especially the Mossi and the Bobo of Burkina Faso. Highly appreciated in the West for their decorative effects, Senufo statues were used to honor ancestors.

For two decades, Mali has been the source of a range of terra-cotta figures unearthed in archaeological (and, unfortunately, often clandestine) excavations. Labeled "Djenne style," these objects have very expressive, asymmetrical shapes; they date from the eleventh through the seventeenth century.

The Coast and Gulf of Guinea: The Western Atlantic Forest

Settled populations are found throughout the band of forest that stretches along the African coast from Guinea, Sierra Leone, and Liberia to the Cote d'Ivoire and Ghana, some in villages, others in more-or-less important chieftaincies. Major sources of food are yams, bananas, and rice.

The BAGA of Upper Guinea are divided into independent villages linked together only by the Simo, an initiatory brotherhood that makes use of masks and figures. The *nimba* is a representation of fertility, woman, and the earth; the *bansonyi*, a sinuous form painted with brightly colored motifs, evokes a spirit of the forest as a snake that appears only once in a generation, at the moment when an age group goes through its initiation. In their family worship, the KISSI reuse the figures and soft stone heads that are found on the ground in ancient plantations and whose origin is at present unknown. From Liberia to Ghana, the role of evoking the clan's ancestors is usually given to masks. Likewise, masks are associated with the institution of the Poro, which is also found among the MENDE, the LOMA, the DAN, and the WE. Although of differing shapes, the masks are typically either idealized portraits of a very pure form, like those of the Dan, or tormented faces with expressionistic volumes, like those of the Wé.

Further east, where the forest clears and the climate stabilizes, not only chieftaincies but also centrally organized kingdoms developed, kingdoms that rank among the most elaborate forms of African civilization. More than other African groups, the BAULE appear to consider sculpture an "art" and to appreciate it as such. Emigrés from the Asante, who later turned to farming, the Baule have conserved an aristocratic tradition, which may in part account for the refinement of their sculpture. Most everyday objects are carefully decorated. Figures, usually idealized commemorative portraits or funerary statues, are among the most finely made in Black Africa and, from a certain point of view, among the most beautiful. The Gu mask, representing the creator, is a human face with serene features and carefully polished surfaces. Jewelry, made of brass, copper, or wood plated with gold leaf, exhibits a taste for beautiful things and prestigious personal ornamentation. The weights used for weighing gold are directly related to those of the Asante.

The ASANTE of Ghana, who enjoyed a long royal tradition, developed commercial ties very early with European sailors who came to buy gold and slaves from them. Though they produced little sculpture properly speaking, they did make a number of highly decorated, symbolic objects like the royal stool, which is made of wood covered with a gold-leaf decoration representing the unity of the people. Wooden figures, *akua ba*, are worn by pregnant women. The weights used for weighing gold are especially remarkable: some are inspired by geometric designs; others represent hunting scenes; still others offer very expressive treatment to characters drawn from proverbs.

A number of city-states were found further east, in Benin and Nigeria. Abomey was the capital of the Fon, who reached their apogee in the eighteenth century. Here, artisans worked under the direct control of the king, and all their work, whether sculpture, architectural decoration, furniture, or jewelry, was intended to exalt his deeds and power; art was tied directly to the symbolism of power. The YORUBA of

present-day Nigeria, a population of several million people, constituted a unified kingdom with its capital at Ife. The Yoruba have a pantheon that counts several hundred "gods," each with priests and devotees; they belong to secret initiation societies, one of the most active of which is the Gelede. Their masks and sculpted works are polychromatic. They appeased the spirit of deceased twins with small figures called *ibeji,* which they cared for as though they were living children. The terra-cottas and bronzes from Ife, some going back to the twelfth century, are idealized portraits of major dignitaries. The technical traditions of Ife's iron workers were subsequently handed on to Benin, where they have been perpetuated through portraits of royalty and other important figures at the court of the *oba* (king) and on plaques intended to decorate walls and support posts of the palace. Benin's great period was in the sixteenth century; a period of decadence began in the eighteenth, accelerating until the capture of Benin's capital in 1897, the date that marks the dynasty's final collapse.

A number of peoples, among them the IGBO, the IBIBIO, and the EJAGHAM (EKOI), live in southeast Nigeria and in the Cross River valley, a region of rivers and dense forests; they are organized in village communities of a segmented type. They have demonstrated a great sculptural dynamism, as much in architecture and decoration as in sculpture itself. In recent years, production of wooden sculpture has given way to an art of terra-cotta or of monumental and quite astonishing polychromatic works in cement. The art of the EJAGHAM and the ANYANG, extending to southern Cameroon, is one of a transitional zone between West and Central Africa; it extends, in fact, to the Cameroon Grasslands in the Batibo region, which is thought by specialists to have been the original homeland of the Bantu. West Cameroon, a country of savanna-covered high plateaus, is inhabited by a large number of groups (generally of multi-ethnic origin) organized in chieftaincies, the most important of which are the BAMILEKE to the south, the BAMUN in the east, and the NSO-OKU-KOM group in the northwest. Although grassland sculpture does not have a strictly "tribal" character, a number of influences are discernible in it. Statuary and decorative art exalt the prestige of the chief, the *fon,* while masks express the countervailing power of initiation societies like the Ku'ngang and the Kemjye. For its plastic effects grassland art employs a range of powerful volumes that are presented in a highly expressive, even caricatural, manner and are tied to the need for constant symbolic expression. Decoration, usually beaded on statuary and royal furniture, is very important; it represents animals – spiders, snakes, panthers – to which the group's essential values are attached.

Central Africa: The Ogowe Basin; From Southern Cameroon to the Congo

Central and southern Africa is the domain of the BANTU, whose languages, moving from the northwest toward the southeast, spread over half the Black continent in the course of several centuries.

For over a century, formerly seminomadic peoples with a segmental social structure, most importantly the Kota, the Tsogho, and the Fang, have been settled in the vast and dark, hot and wet tropical forest that spreads out through Gabon and the Congo at the equator. The KOTA, occupying all of eastern Gabon, are related to several Congolese groups, including the Mbete; they make wooden reliquary figures, some of very abstract, almost two-dimensional morphology, decorated with plaques or with brass or copper threads. The two most remarkable Kota substyles are those of the MAHONGWE and the OBAMBA. A great many types of mask are found between central Gabon and the Atlantic coast, all associated with either mourning rituals or rites of initiation. All are also morphologically related, from the most schematic – the Vuvi style – to the most realistic – the Punu-Lumbo style, long known as "mpongwe"; called "white masks," their essential characteristic is the white painting of the face.

The FANG are divided into several distinct, though related, tribal groups, which are themselves divided into a large number of quasi-autonomous clans. They produced a unitary statuary with largely homogeneous forms, despite the fact that different

features are discernible at the level of several sub-styles: the Ngumba, Mabea, and Bulu in southern Cameroon; the Ntumu and Mvai in the Ntem basin; the Okak in Equatorial Guinea; the Betsi and Nzaman from Libreville to Ndjole, Mitzic, and Makokou. Fang statuary is characterized in African art by its classic, monumental appearance and its great sobriety of decoration. The wooden, heart-shaped faces of figures on Fang Byeri boxes constitute a plastic theme found again among the KWELE in the northern Congo and the LEGA of northeastern Zaire. But if shapes are comparable, the objects' functions differ completely. Fang statues protect reliquary boxes housing ancestors' relics; Lega statues are emblematic symbols of eminent members of the Bwami, an initiation society of both men and women. The Fang have also produced masks within the framework of secret societies, some of which, like the Ngil, have legal ends, while others, like the Ngontang, have therapeutic ones.

The TEKE of the Congo, living along the edge of the forest, have flat, circular masks with abstract decorations (called the Teke Tsaaye style) and reliquary figures usually used in magic rituals. The statues and baubles of the KUYU, in the Likouala region, constitute a transitional style between the work found in Zaire and that of the peoples of the Ogowe basin.

The Zaire Basin: From the Congo to the Region of the Great Lakes

The vast region that stretches from the Angolan and Congolese coast to the north-south trench of great lakes in eastern Africa includes both the great forest within the sweep of the Zaire River and the open forest and savannas further to the south. This is a zone of great culture, both in the historic events that have taken place there over the centuries and in the works of art that remain as witnesses to those events. Several great kingdoms developed here: the Atlantic coast was the fief of the Mani-Kongo, the Kasai valley the domain of the Kuba; further east, in Upper Zaire, was the region of the Luba; to the southwest, in western Katanga, the peasant, segmented society of the Lunda-Chokwe.

Royal Arts of Central Africa

Between the fourteenth and the sixteenth century (depending upon the region), the matrilineal, peasant substratum of the Congolese forest was transformed by what Luc de Heusch has called "the cycle of sacred royalty," the origin of which has been located in the pastoral dynasties of eastern Africa. The KONGO, whose kingdom, centered on the vast Yombe forest, is thought to go back to the fourteenth century, had very early contacts with Portuguese explorers and missionaries. It was Diego Câo who discovered the mouth of the Nzadi (which he understood as "Zaire") and prompted the powerful king Mfumu Nzinsa Nkuwu to convert to Christianity. The king took the name Dom Joâo in 1491; his son, Dom Alfonso I, established diplomatic relations with Pope Julius II in 1512 and received a coat of arms from the king of Portugal. The Catholic religion, however, was understood as merely another source of spiritual "power"; it was never really able to affect ancestral beliefs and practices.

The oldest known Kongo artistic productions are the *ntadi*, soft-stone statues found in ancient cemeteries and dating, in some cases, from the sixteenth century. *Ntadi* are thought to be statues of chiefs. More recently, realistic and finely carved wooden statues were created in honor of ancestors. The "mother and child" theme is favored here more than elsewhere in Africa and is frequently presented in a dynamic, asymmetrical, often completely anecdotal style. Finally, Kongo art is illustrated by innumerable power-charged sculptures, *nkisi*, still used not very long ago by the *nganga* (masters at manipulating invisible forces, "fetishers") in their therapeutic rituals. Kongo power figures are among the most striking objects of Black African art.

A remarkable artistic development resulted from the KUBA theocracy in the Kasai valley, where wood sculptors, including the king himself, constituted the most important artisan caste. The Kuba are a federation of seventeen groups dominated by the Bushoong, "the people of the throwing knives," although the lesser chieftaincies are

autonomous. Kuba art is more political than religious; objects refer to the lives of men and groups, chiefs and kings, more than to ancestors. The Bushoong king was considered "god on earth," and about twenty Bushoong royal statues are known. Their relative age is difficult to estimate; the homogeneity of style that they display could hardly have been maintained since the seventeenth century, and it is probable that Bushoong kings, like those of the Bamileke, occasionally felt the need to renovate their gallery of ancestors.[6] The king's power was likewise expressed by masks used in rituals of initiation or mourning. Kuba decorative art is of exceptional quality, and most objects of everyday life, whether made of wood or iron, earth or fiber, are decorated with motifs that have since been duly named and catalogued.

The LUBA of southeastern Zaire comprise a vast complex of aristocratic chieftaincies in which art, usually associated with ancestor worship and magic, is particularly highly developed. Linguistically, the Luba divide into three branches: the Luba of the Kasai (detached from the branches to the east); those of Katanga, the Luba-Shankadi; and the Luba-Hemba, the furthest east. The Luba empire was founded in the sixteenth century by the warrior-invader Kongolo-Mukulu; his assassin and successor, Kalala Ilunga, founded royal power on divine right. Luba art is particularly elaborate and refined, showing a pronounced taste for rounded volumes and smooth, polished surfaces – a taste well adapted to the most frequently treated subject, woman. Several Luba substyles have been identified, notably by Frans Olbrechts, Albert Maesen, and François Neyt. The most important are those of the Shankadi in the south and the Hemba in the northeast; the former is characterized by a sometimes angular schematism, while the latter involves more realistic objects treated on an ample scale and in rounded forms. Some artists have left clearly recognizable works; the "master of Buli," for example, was the creator of a whole series of objects, including caryatid stools that figure among the outstanding masterpieces of African art.

Certain neighboring groups, such as the Boyo and the Bembe, have produced an almost "cubist," if massive, statuary, characterized by geometricized volumes within a structure of willfully distorted proportions, both in the body masses and the rendering of detail. The LULUA, or BENA LULUA, of the Kasai and the SONGYE both belong more or less to the vast Luba complex. For the *tshibola* fertility cult the Lulua have produced fine and elegant figurative sculptures with light relief scarifications chiseled all over faces and bellies; for their secret societies they also make larger ancestor statues and masks, like the *nkaki,* with its enormous hook nose. The Songye, or Yembe, who occupy the region north of the Luba-Shankadi, are a people preoccupied with magic. Songye art is highly operative; the *manga* figurative sculptures are laden with multiple ingredients and magic "medicines" – horn, shells, skins, fur, feathers, and so on – that usually hide the wood completely. The rigorously stylized, geometric forms are exemplified by the *kifwebe* masks, which have a judicial function.

The LUNDA-CHOKWE of western Katanga and east-central Angola also constituted a powerful kingdom in the seventeenth century. The Chokwe are descendants of dispossessed Luba princes and their followers who emigrated when their king ceded his insignia to his daughter's husband, an errant Luba hunter named Tshibinda Ilunga Katele; this chance of history, which took place in the seventeenth and eighteenth centuries, explains the Luba's wide dispersion. The Chokwe's centralized social structure favored the rise of the plastic arts, especially at the court of Mwata Yamvo, a descendent of the hunter-hero who founded the kingdom. Ancestor statues, staffs, chairs with sculpted rungs and backs, all bear witness to a creative vigor that disappeared only in the nineteenth century, when the Luba empire collapsed. Cornet calls these works "baroque," because of their confident manner of reshaping reality. The Chokwe have wood or fiber masks, brought out at circumcision festivals *(mukanda);* they also practice the art of metal working, in iron, copper, and brass.

Central Africa: Art of Hunting and Peasant Peoples

Located out of the way of the great kingdoms, a considerable number of peoples, organized by lineages and in villages, practiced hunting and subsistence farming. The Mbala, the Ndengese, the Yaka, and the Pende are the most important. MBALA art

6 Cornet, 1972, p. 135.

recalls the Kongo realism of lower Zaire and announces the geometric rigor of the Yaka. The two preferred themes of the Mbala are "the musician" and "mother and child." The NDENGESE, part of the southern Mongo, live north of the Kuba, with whom they have clear historical ties; they make a monumental statuary of great quality. In the Kwilu-Kwango region, the YAKA have produced very strangely shaped masks for their initiation festivals: an oversized nose stretches out like a tongue and touches the forehead; the multi-pointed coiffure stands out above a face with enormous, coffee-bean eyes. Through the use of exaggerated shapes, bright colors, and added feathers and fibers, the *ndemba* mask becomes a complex structure whose abstract, figurative, sometimes even erotic, elements serve to illustrate myths. Faces of this style, nose upturned, are also present in power figures and ancestor statues. Yaka art provided a model for the neighboring SUKU; their rather more sober work is exemplified by the Hemba mask, which places serene features beneath tufted coiffures reminiscent of those found on *mbete* statues in the Congo and Gabon. The PENDE are primarily sculptors of masks that are characterized by triangular faces and eyes with drooping lids; each work is a caricatural portrait of a member of the group. A special mastery of sculptural miniaturization is also evident in Pende works like the *ikhoko*, protective ivory amulets in the form of chiefs' masks.

The TABWA, who inhabit the southern part of Lake Tanganyika's west bank, produce an art that was scarcely known until it became the subject of recent studies, especially those of Allen Roberts. To him, their art is "used ceremonially in order to perpetuate and glorify the existing order."[7] Statues represent men as well as women; they sometimes show a chief carried on others' shoulders. Tabwa style, related in form to the Luba, is characterized by discreet curves and surfaces decorated with scarifications made with rows of dots. The Tabwa also make anthropomorphic masks and masks representing large-horned cattle.

Eastern and Southern Africa

Essentially both pastoral and warlike, societies of eastern and southern Africa have produced an art about which relatively little is known, but which seems related to the "decorative" tendencies of the Fulani and the Zande further west.

The Nilotic peoples of the Upper Nile region make large statues in honor of their dead. The Bari have a rather rough statuary, while that of the Gato and the Konso in Ethiopia is somewhat more elaborate. Along the Kenyan coast, the Giriama and the Duruma are known for their finely chiseled funeral posts decorated in low relief, as well as for masks. A rough, barely anthropomorphic statuary is found between Lake Victoria and Lake Tanganyika in northwestern Tanzania, among the Sukuma and the Kéréwé, for example. Bukoba masks, with their large eyes and huge mouths bristling with frightening teeth, recall the masks of the Ngbaka of eastern Cameroon. In contrast, the style of the Nyamwesi is more refined and decorative and presents themes with sculpted figures, much like those of the Bamileke of Bandjoun. The same is true of the statuary of the Venda.

SHAMBALA and ZARAMO styles are found along the coast north and south of Dar-es-Salaam; the Zaramo make articulated statues reminiscent of Kéaka-Anyang and Fang objects.

The art of the MAKONDE, who live in southern Tanzania and (the majority) in Mozambique, is highly diversified, offering statuary, masks, and elaborately treated pieces of furniture; there is a strong sensuality in the representation of the human body. This rich traditional art has now been superseded by an art "industry" that is worthy of interest, even though it is motivated by the tourist trade.

Decorative art in the region of the Great Lakes developed within aristocratic societies and is illustrated above all by basketmaking, fiber arts, beadwork, and leather crafts.

To the south of Lake Nyasa, in both Malawi and Mozambique, the NGURU, the TONGA, and the RGWE have produced a statuary of geometric volumes recalling certain styles of eastern Zaire, in which William Fagg has detected the application of a principle of "concave cubism".[8]

7 Roberts, 1986.
8 Fagg, 1965, p. 121.

Further south, the Shona of Zimbabwe are known for their highly decorated head-rests. Leaving aside the ancient statuary of Zimbabwe (including the famous and mysterious "birds"),[9] art in southern Africa is expressed more through beads, iron, leather, and feathers than through sculpture proper, whether in wood or stone, although some Nguni, Tswa, and Zulu pieces are known. The protective dolls of the Zulu, made of beaded gourds and pieces of sewn leather, are worth noting.

This brief overview of Black African styles of sculpture demonstrates on the one hand the great diversity of materials used and forms created and, on the other hand, the invariable link between the works and their context, even if important gaps in documentation still remain in this area.

Practically all these objects can be related to a precise function, and thus testify to civilizations, ways of life, and beliefs deriving from the distant or recent past; they are frames of reference through which changes therein and cultural associations can be understood. An appreciation of the morphological aspects of African art is also indispensable – is, in fact, the best introduction to the historical study of styles, since form is simultaneously creative, beautiful, meaningful, and operative.

Some styles, as we have seen, are much better known than others, thanks both to the number of objects that have been catalogued and studied and to the amount of information available about the environments that produced them. But artworks of great creative quality have been discovered in all parts of Africa, notable for their level of inspiration and for their spiritual effect on the viewer.

Art and Man

We usually know little or nothing about the person who created, or who once used, the object that we admire in an exhibition of African art. Yet a statue or a mask is, in fact, but part of a comprehensive system of symbols in which the actors are human beings – artists, priests, dancers, and so forth. And whatever transcendental significance an object may come to possess, its creator is first of all confronted with very down-to-earth questions of materials and techniques.

Mastery of Materials

The best known and most numerous African sculptures are made of wood, but many important pieces are of ivory, metal, or stone. Sometimes these materials have been used concomitantly in the same milieus or regions, or by the same peoples, though by different specialists.

Wood is used everywhere in Africa, as much in the dry tropical zones as in the forested equatorial regions, where many different usable varieties are found. From wood are made, first of all, all sorts of everyday furnishings and implements – seats, architectural elements, staffs with their various kinds of pommel, containers, and kitchen utensils, such as mortars; then, masks, statues, and objects intended for ritual use. Woodworking is essentially an activity of sedentary, agricultural peoples; the nomads and shepherds of the dry regions are more likely to make trinkets or practice the art of body ornamentation. The wood varieties chosen vary according to local resources, but functionality is also a decisive factor: soft, light woods are preferred for masks, while dense woods with fine grain, even if not very heavy, are sought after for statues and furnishings that call for greater strength. This is not an absolute rule, however, and exceptions are not unusual.

The great majority of sculpted works are made from single pieces of wood, and the cylindrical shape of the initial block – a log – may sometimes be seen in the finished object. In eastern Africa, a columnar style has been identified, characterized by very rough treatment of the wood, in which the representation of human shapes is hardly more than suggested; some of these sculptures nonetheless possess an astonishing expressive power. Among certain groups – for example, the Ijo of southern Nigeria,

9 The area where these were found was probably settled by several successive peoples: Suto, Shona, Rotse, Venda, etc. (see Leiris and Delange, 1967, p. 377).

the Fang of southern Cameroon, and the Zaramo of the Tanzanian coast – some objects are assembled from several parts; these include marionette-statues, designed to be animated during rituals of invocation of the dead, and masks found in the Cote d'Ivoire that have an articulated lower jaw, intended once again to reinforce the living appearance of the sculpture.

Sculpture is an important activity restricted to a few, and almost everywhere it is practiced out of sight of women and children. Until it is consecrated by its first public and official use, an object has no special value and can be handled without any particular precautions, since it is not yet "charged" with the power of a symbol.

As to technique, the sculpture is roughed out with the help of a well-sharpened, broad-bladed knife, or with a machete; the carving is done directly and spontaneously, through visual approximations and successive alterations, unaided by any model or precise geometric reference. The finer modeling is done with an adze, then with a short knife; abrasive leaves are used for the final polishing of the surface, often very important for the desired effect.

Usually made of a naturally light-colored wood, the sculpture is given an artificial patina, with plant or mineral dyes, fats such as palm oil, or resins. Masks are coated with plant pigments made from ground seeds or with mineral pigments derived from clays ranging in color from white to red ocher and dark gray. Black is often obtained through pyrogravure. Older objects, such as seats and headrests, attain through years of use a brilliance that can approach a lacquered appearance. This is not a patina that is specially applied to the object; rather, it is a reminder of those who previously used it – always identifiable relatives, sometimes "ancestors." Hence, this patina has a more emotional context, one that is completely independent of the symbolic import of the object, which is its only recognized "value."

African sculptures in stone – often steatite, which is easily carved – are almost all anthropomorphic. The better-known styles come from northern Guinea, Sierra Leone, southern Nigeria, lower Zaire, northwestern Angola, and Zimbabwe. Made by civilizations that have since disappeared, many of these figures are reused in agrarian and funeral rites or used as tutelary figures.

Ivory is used primarily to make jewelry – for example, bracelets and pendants (including the miniature masks of the Pende of Zaire) – household objects like boxes and drinking cups, musical instruments such as ceremonial horns, and small amulet sculptures that serve as hunting charms, protective talismans, and so on. It is a precious, much sought-after material, which is difficult to sculpt but which often acquires a magnificent patina; the most remarkable pieces come from the kingdoms of Benin and the Kongo. Ivory, being a luxurious, prestigious material, is used primarily by peoples who occupy the upper echelons of highly developed hierarchical societies.

Terra-cotta sculptures are unusual nowadays, especially in forest regions. In contrast, functional pottery is found throughout the continent, and the vessels, which range from plates to large-capacity beer jars, are frequently marked with graphic symbols whose meaning extends far beyond a desire for simple artistic decoration.

Work in clay is an ancient tradition in Africa, as is shown by the sites of Mopti and Djenne in Mali and of Ife and Nok in Nigeria, by the lands of the Soo in northern Cameroon and Chad, and Komaland in northern Ghana. Terra-cottas uncovered in archaeological contexts are usually anthropomorphic; some are thought to date from the first few centuries A. D. The oldest known African sculptures, from the first millennium B. C., are those of Nok civilization in northern Nigeria. Agne objects from the Cote d'Ivoire, like Mangbetu objects from northeastern Zaire, are more recent.

Metals have likewise been used extensively, not only for the arms and tools made everywhere in Africa since the neolithic period, but also in the plastic arts of centralized chieftaincies and feudal kingdoms. The Baule and the Asante of the Cote d'Ivoire and Ghana created objects of personal ornamentation made of gold, for example, pendants, bracelets, solid gold necklaces, molded by the lost-wax process (also used for brass, copper, and bronze), and prestige objects – such as staffs, regalia, and coronation thrones of wood plated with gold leaf. Bronze was used primarily in southern Nigeria, as seen in the notable specimens from Ife and Benin, some of which date from the seventeenth century. Brass was used for the weights needed for weigh-

ing gold and for a variety of ornaments. And among the Dogon and the Bamana in Mali, the Senufo in the Cote d'Ivoire, and the Fon in Benin, iron was sometimes forged for artistic and symbolic purposes.

Professional Artists: Sculptors and Blacksmiths

An artist for whom sculpture is the primary activity can subsist only in a society in which he is provided for by the community. Thus, he might be a court sculptor enjoying the patronage of a powerful king who supports artists not for aesthetic or cultural reasons but to enhance his own prestige, insofar as all sculptural activity is oriented toward the representation of symbols furthering the maintenance of the existing social order. Such was the case at the court of the *oba* of Benin in Nigeria and at that of the king of the Kuba in Zaire.

As a rule, the status of artist to the king or chief was a nonhereditary position that was acquired by virtue of personal talent. Recognized artists, especially sculptors and metalworkers, were organized in corporations with strict statutes. Professional artistic activity also existed in communities less organized than the kingdoms and chieftaincies, yet sufficiently hierarchical and self-contained – for example, at the village level – to allow a gifted individual to attain, solely through his creative gifts, a privileged status permitting him to practice his art full time; such was the case, for example, in the Dan area in the western Cote d'Ivoire.

Informal Creation: the Artist-Peasants

The sculptor in wood or ivory, the blacksmith, the potter – all, in segmented village societies, are merely artisans; but, depending upon their degree of success, they sometimes reach a level that can, *a posteriori*, be qualified as artistic.

In West Africa, for example, Mali, Guinea, the Cote d'Ivoire, and in the Congo, the sculptor is also the blacksmith, although his two activities are not thought of as being especially associated with the manipulation of the sacred, which remains the preserve of the *nganga,* the diviner-healer. Work at the forge, however, requires that the blacksmith and his assistants (exclusively boys) observe certain ritual precautions arising from the symbolic interpretation given to the transformation of ore into usable metal. In Dogon and Bamana myths, the smith is always a civilizing culture hero, the provider of the primordial technology essential to man's life and to the mastery of his environment.

The anonymity of African artists stems essentially from European ignorance of the realities of the local environments from which the works derive. Some recent investigations have revealed that true artists, like leaders in war and healers, have influenced the traditions of each community. Still, it must be realized that the work itself outweighs the artist who fashioned it, insofar as the object is, beyond its appearance, a reservoir of forces and a ritual instrument. The creation of forms is an attempt to bind invisible powers, and in this light the identity of the craftsman is of only secondary interest, all the more so since the sculptor is not usually a major initiate or a priest. The stonemasons of medieval cathedrals, despite having left a few unobtrusive clues to their names, have also remained anonymous, engulfed in the immensity of the works they created. It can be argued that the work itself, through the qualities assigned to it, achieves an autonomy that forces the person who created it into the background, just as it does those who have used it. The formalized symbols, which refer to an established and vital collective system, become the expressions of an entire people.

As to the question of authenticity, often raised in regard to more modern specimens of Black African art, here again, it is the analysis of the relationship of the work to its milieu that makes possible a judgment independent of "aesthetic" considerations. An object that has been made locally for a given community and with an identifiable function – ritual or otherwise – is an authentic object, whatever its appearance or "plastic" qualities. "Fakes," or even copies, such as those intended for European

travelers, were made in former times, too; and there are some extraordinary temporary creations that are nonetheless completely "authentic," for example, the Bwiti statues and marionettes of the Fang in Gabon.

Knowledge of their ethnographic and linguistic contexts is one of the preconditions for the proper perception of African works of art, but this does not mean we may not look for aesthetic qualities or feel ourselves drawn toward them by the intangible force of empathy.

African sculptures are forms of expression charged with meaning. The argument is sometimes put forward that they are a kind of "hieroglyphic," a language full of allusions, even esoteric; such theory contrasts with the view, held at the beginning of the twentieth century that denied this art all logical meaning and allowed it only the qualities associated with "spontaneity," as if African creation were a matter of individual inspiration, outside any sophisticated system of thought.

African art can be classified in well identified styles, and should be seen through the prism of traditions and myths. It constitutes the indispensable symbolic basis for the collective survival of African peoples. It is worth noting that socioreligious changes have always brought with them changes in the formulation of symbols and thus in their artistic realization (types of objects, shapes, colors, and so forth).

Symbolic Traditions and Dynamism of Styles

African plastic art cannot be seen as an entity in itself, detached from the socioreligious cosmos of which it is one expression among several of equal importance – for example, dance, music, trance, myths, gestures, and signs. Hence, the aesthetic of visual forms takes its place among a whole cluster of spiritual processes whose ultimate goal is mastery of the invisible forces that control the world of the living and of the dead, of the village, and of the often hostile nature that surrounds it.

How, then, can an "African" aesthetic be envisaged apart from the philosophy and spirituality that place it within an all-encompassing perspective? The problem is to determine the nature of these cultural cosmoses, and to identify within them the particular texture of the operative systems – family relationships and initiatory societies, social relationships and forms of behavior, myths, traditions, representations, rituals, and so on. A comprehensive anthropological study is required, which must treat the aesthetic factor along with the others (a method practiced all too rarely) in order to see beliefs and representations of these beliefs in the same perspective as the society and the symbols that it forges for itself in order to survive – what is useful and what pleases, technology and arts.

These cosmoses sometimes have boundaries that are clearly recognizable in space and time, but this is exceptional; more often, they are surrounded by a halo where influences meld with one another. It is difficult to delimit what are termed "ethnic groups," since peoples always descend from ancient ties of which only the most recent, totally circumstantial manifestation is visible today. Closer investigation shows that what seems clearly defined from a distance – for example, the world of the Dogon, the Bamana, the Mossi – appears hazy when seen up close and does not fall into a convenient slot. The Fang-Beti area of Equatorial Africa, for example, is inhabited by about ten "ethnic groups" with more or less different languages and behavior patterns, who are nonetheless related when viewed in the broader regional perspective of Central Africa. Under such circumstances, it becomes difficult to delimit precisely styles and substyles that might be considered specific and exclusive expressions of these groups. It is more appropriate to envision the history of styles as a multicellular organism possessing a dynamic that is continuous in space and time, its various elements subject to osmotic interaction.

Cultural upheavals, whether sudden or insidious, syncretisms, borrowings, and stylistic *non sequiturs* are always occurring, even if evidence for them is not visible within the time frame of a particular analysis. Styles whose morphological analysis reveals constants and variables are also styles that are born, develop, flourish, decline, and disappear. For the time being, our fragmentary knowledge of African civiliza-

tions, especially of their history, thwarts any extensive elaboration of this stylistic dynamism. It is clear, however, that the "tribalist" approach has long been predominant merely for want of a better one; it is time for European and African researchers to abandon this approach and to turn toward the investigation of the richness of the reality described above.

The study of African plastic art implies a research strategy of multiple approaches, the most important of which are history, linguistics, analysis of the environment, and anthropology. All these disciplines can help in interpreting symbolic systems and thus provide access to the visual representations that express them.

Social Necessity or Creative Freedom: A False Alternative

After this brief look at the nature of Black African plastic art, one may ask whether this art was, or is, a structural necessity or merely an epiphenomenon. Is art an ancillary feature or a vital component of the everyday reality of African society?

It seems clear that, insofar as an object is expected to serve a specific purpose in the framework of society, an artist cannot create something "beautiful" if it fails to function as it should. The sculptor's freedom (like the dancer's and the musician's) is restricted by his patron's limits of comprehension, since the finished product is part of the system of signs – themes, forms, colors, decorations – supposedly understood by the initiates and accepted by everyone else. From this perspective, sculpture is a form of "writing"; one may write well or not so well, but the essential thing is to communicate the content of the message. The work of art is thus a medium of communication. African art is not hermetic, even if the meaning behind it is hidden.

Do all African languages have specific words to denote "beauty"? At any rate, they all have words to characterize what is "right," "good," "agreeable," and "effective"; evidently, they also have words for what is "bad" or "ill-omened," in regard to both people and things.

All societies undoubtedly need the mediation of symbols in order to master the environment in which they develop. Practical action presupposes conceptualization. Beliefs and the behavior patterns stemming from them constitute a response, which is always more or less collective, given by thinking people to their environment. Hence, the appropriation of symbolic forms by a small group – by artists and, especially, by the initiates – is a means of acquiring power over the collectivity. Masks exist in order to frighten; ancestral sculptures jealously guard the relics. The more the world is considered intricate and terrible, the greater the power of the *nganga*.

"Art" objects are therefore also instruments of social power. Bamileke beaded thrones, the *oba* portraits from Benin, Nigl masks of the Fang: all are, in the hands of the few who control them, concrete reminders (however symbolic) of the universal dependence on the order imposed by those who manipulate its structures. Artistic expression is always at the center of the relationship between spiritual and social forces, and it changes in response to the fluctuations of that relationship; it is here, in fact, that the driving force behind the dynamic of style is located. Under such conditions (the word "totalitarian" has been used to describe some traditional societies), although creative spontaneity within the framework of a particular system of symbols undeniably exists, any spontaneity of pure aesthetic contemplation is inconceivable, each object – never completely "profane" – being perceived *in situ* in a more or less immediately functional perspective. The adequacy of shapes and decoration must be appreciated within their all-encompassing system before the aesthetic quality of a sculpture can be judged; if, for example, a Congo *nkisi* is highly "charged" with magic, the question of whether it is also beautiful may be dismissed.

Aesthetic judgment is totally secondary and rarely expressed; in any case, it is completely blended into a socioreligious perspective from which, practically speaking, it can never be isolated. From this fact comes the universal regard that the African public has for objects of its own cultures and for the problems stemming from them on the level of "cultural development," especially the conservation and proper display of traditional patrimonies.

Formal beauty exists in Black Africa – and in what a masterful way! – but it is always experienced. Appreciation of the beautiful involves personal participation, often action, but not reflective contemplation. The African public participates fully and never remains passive about what concerns it directly. Hence the misconception that the West's infatuation with "Black art" has engendered.

Not only the objects – masks, figurative sculpture, decorated stools, jewelry – but also music and dance testify to the African's instinctive love of festivals and "performances" that contrast with the routine and the difficulties of everyday life.

The necessity of mastering the forces of the natural and the supernatural environment, of life and of death, has crystallized in very diverse signs, ranging from rhythms and shapes to volumes and colors. In fact, these esoteric messages mask man's existential anguish in the face of the beyond. In this sense, art is the most fully elaborated symbolic expression of man's will to live. And it is perhaps this that speaks to us across cultural boundaries, even when the exact meaning of the messages escapes us more often than not.

CATALOGUE

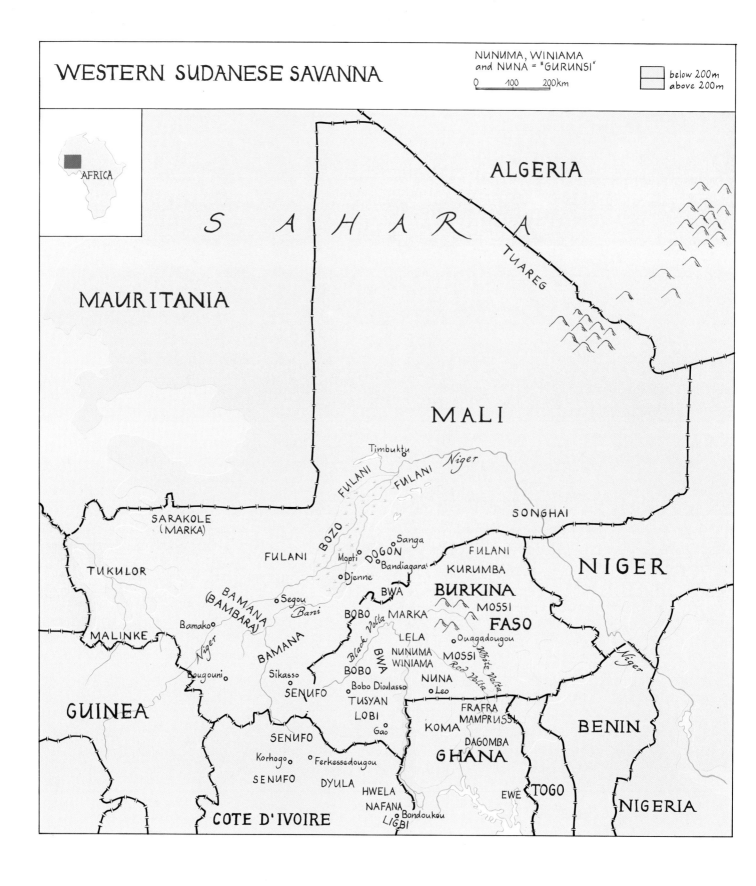

WESTERN SUDANESE SAVANNA

NUNUMA, WINIAMA
and NUNA = "GURUNSI"

0 100 200km

below 200m
above 200m

AFRICA

S A H A R A

ALGERIA

MAURITANIA

MALI

TUAREG

Timbuktu

Niger

FULANI

FULANI

SONGHAI

NIGER

SARAKOLE
(MARKA)

BOZO

Sanga

DOGON

FULANI

TUKULOR

FULANI

Mopti

Bandiagara

KURUMBA

Djenne

BURKINA

BAMANA
(BAMBARA)

Segou

Bani

BWA

MARKA

MOSSI

FASO

Bamako

LELA

Ouagadougou

Niger

MALINKE

BAMANA

BOBO

BWA

NUNUMA
WINIAMA

MOSSI

Leo

Bougouni

Sikasso

BOBO

NUNA

Bobo Dioulasso

SENUFO

TUSYAN

FRAFRA

GUINEA

LOBI

MAMPRUSSI

BENIN

Gao

KOMA

SENUFO

DAGOMBA

Korhogo

Ferkessedougou

GHANA

SENUFO

DYULA

EWE

TOGO

NIGERIA

HWELA

NAFANA

Bondoukou

COTE D'IVOIRE

LIGBI

Black Volta

White Volta

Red Volta

Christopher Roy

The Sudanese Savanna

The word "Sudan" comes from the Arabic "bilad-es-sudan" (the land of the Blacks) and refers to the vast area of Black Africa. The Sudanese Savanna is the broad area of Africa south of the Sahara that stretches from the Atlantic in the west to the Red Sea in the east. The Sudan is bounded on the north by the Sahara Desert and on the south by the forests of the Guinea Coast and Central Africa. Finally, the Sudan can be divided into three major cultural areas: Western Sudan from Cap Vert to the Upper Niger; the Central Sudan, including Lake Chad and the Benue River Valley; and the Eastern Sudan, from Lake Chad to the Red Sea and the Ethiopian Highlands. The area is an enormous plain, drained by some of the great rivers of Africa, including the Gambia, the Volta Rivers, the Niger, and the Nile. Largely suitable for agriculture, it has supported a dense human population. It is an area of enormous geographical and human diversity, which has produced many of the greatest kingdoms of Africa, and much of the world's great art.

In the Sudan there is a short rainy season, usually lasting from June to September (or longer in the south, close to the coastal forests). All agricultural activity except harvesting is carried out during this period. As in all agricultural areas, farmers are too busy during the growing season to concern themselves with anything but cultivation. From October to May almost no rain falls, except for a few scattered showers late in the dry season that signal the arrival of those warm air masses from the south that eventually bring violent thunderstorms. In the past ninety years the entire region has experienced a steady decrease in annual precipitation, punctuated by three great droughts, the latest of which, from 1970 to 1976, caused severe famine and, in some areas, resulted in significant population movements. The change of seasons is very important for understanding the use to which art is put in the Sudan, for almost everywhere masks and other public performances, together with most craft activity, including pottery and weaving, take place during the dry season when farmers are free from work in the fields. This is also the hottest time of the year: daytime temperatures are often above 40° centigrade (105° Fahrenheit), and it is not much cooler at night. The landscape is desolate, with gray or red dust and dust-covered vegetation stretching to the horizon. Families retreat to the shade of their dwellings, and livestock huddle in the sparse shade of the few scorched trees. Dust devils dance across the fields and, as the level of the wells drops, women must walk miles for a muddy bucketful of water. With the first heavy and frequent rains in June, the landscape is transformed, as roads become lined with dense green walls of millet and sorghum stalks seem to submerge the villages in a sea of vegetation.

The area consists of open grasslands with scattered stands of shea nut or karite *(Butyrospermum parkii)*, locust bean or nere *(Parkia biglobosa)*, and West African mahogany *(Kaya senegalensis)*, as well as occasional baobab *(Adansonia digitata)* and kapok *(Eriodendron anfranctuosum)* trees. The staple crops have been pearl millet, sorghum, sesame, and cotton, all of which were grown here before the fifteenth century. With the arrival of New-World crops, maize (corn), tobacco, and peanuts were added. Millet is the staple food, being ground into a flour which is mixed with boiling water to make a gruel that is high in fiber and low in protein. Sorghum is used primarily for brewing mildly alcoholic beer, a staple of all social and religious ceremonies. Hunting and gathering are important occupations during the dry season, when the farmers' fields are empty. Women and children gather wild fruit, nuts, leaves, roots, and edible insects, which may provide the protein needed to supplement millet gruel. Men hunt small game with throwing sticks and larger mammals with guns, while entire communities cooperate in fishing expeditions to rivers or small

lakes. Fish and game are preserved by smoking, and are traded to forest peoples far to the south.

The buildings of the Sudan are quite different in style from those in forest areas. Rural farmsteads consist of large round, mud-brick buildings with conical thatched roofs (fig. 20). Several of these may be linked by walls that enclose a circular compound residence. Many people also build rectangular mud-brick buildings with flat, pounded clay roofs. Again, several such buildings, joined by common walls, form a clan or lineage dwelling. There are numerous variations, including buildings on a circular plan with flat clay roofs built by peoples in the southern Burkina Faso, northern Ghana, Togo, and the Benin area. Several peoples throughout the Sudan decorate the exterior surfaces of their homes with elaborate geometric painted patterns. In cities and towns rectangular multistory buildings with flat roofs, elaborate wooden doors, and windows that are a legacy of Moslem culture are common. Spectacular mosques also reflect the Moslem impact on architecture (fig. 20).

The peoples of the Sudan, from Dakar to the Red Sea, speak languages belonging to the Niger-Kordofanian, Nilo-Saharan, and Afroasiatic families. In the Western Sudan the vast majority speak languages from one of three subfamilies of the Niger-Congo family: West Atlantic, including Wolof, Bassari, and other languages in Senegal; Mande languages, including Bamana, Dyula, Bobo, and others; Voltaic, including Mossi (Moore), Senufo, Lobi, Bwa, and *gurunsi* languages. Dogon is primarily Voltaic, although it contains many Mande elements. The most common non-European *linguae francae* are Wolof, Dyula, and Hausa. Linguistic relationships are important to an understanding of the art of the region because they are reflected in such cultural characteristics as sculptural styles and the use and significance of art. For example, the Dogon have often been associated by scholars with Mande peoples who also live in Mali, especially the Bamana. In fact, their art shows strong similarities in use, meaning, function, and style to that of their Voltaic neighbors, the Nuna, Winiama, and especially the Mossi. This cultural relationship dates to 1500, when the Dogon were driven by invading Mossi cavalry from Yatenga to the cliffs of Bandiagara (fig. 21).

Long before the first Europeans arrived in the area in the mid-nineteenth century, the peoples of the Sudan had created great political states, including Ghana (eighth-eleventh centuries), Mali (thirteenth-sixteenth centuries), Songhai (fifteenth-sixteenth centuries), Mossi (fifteenth-nineteenth centuries), and the Hausa states. In several of these states the written records kept by Arab chroniclers have been preserved, so we know, for example, that Timbuktu was an important center of trade and learning until it was sacked by the Mossi in the mid-thirteenth century. Al-Fazari described the state of Ghana, "The Land of Gold," in the late eighth century, while al-Bakri gave an account of Ghana and trans-Sahara trade routes in 1068. The history of the Empire of Mali was written by al-Umari before 1350, and al-Sa'di included a description of Timbuktu in the *Ta'rikh al-Fattash*. The anonymous *Kano Chronicles* contain accounts of the Hausa city-states in northern Nigeria.

Archaeological evidence of cultures in the Sudan before 1500 is sparse: excavations at Nok, north of the Niger-Benue confluence, indicate a culture which was already thriving in 500 B.C.—200 A.D. Radiocarbon dates from the Tellem caves in eastern

Fig. 20 Mosque in the region of Djenne, Mali. Some mosques in the area are several hundred years old and are regularly restored. (Photo: Monique Barbier-Mueller)

Fig. 21 The cliffs of Bandiagara, Mali, with villages of the Dogon. (Photo: M. Renaudeau, Agence Hoa-Qui, Paris)

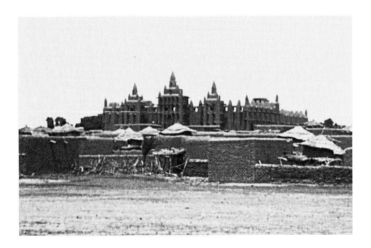

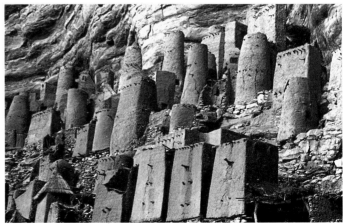

Fig. 22 Funerary urns (near Djenne) belonging to the civilization that developed in the Inland Niger Delta in Mali, between Segou and Timbuktu, from the eleventh to the sixteenth century. (Photo: The National Geographic Magazine)

Mali suggest that the area was occupied by the eleventh century, while excavations show that the Ghana trading cities of Awdaghust and Kumbi-Saleh were still inhabited as late as the thirteenth century. In the past decade a large number of clay and bronze figures have emerged from the Inland Delta of the Niger River, artifacts of an ancient culture now called Djenne, that flourished from the eighth to the seventeenth century. The figures present a broad range of iconographic types, including large warriors mounted on horses, kneeling male and female figures, humans covered with what appear to be pustules, groups of figures surrounding a larger female (pl. 3), and, in particular, humans covered with snakes (pls. 1,2). The Djenne figure style is remarkably close to the syle of very old Dogon figures. Local informants state that most of the objects were found on ancient burial sites. Archaeological work is now being undertaken in the area (fig. 22).

In the sixteenth century the great Songhai state controlled the Niger Bend until the Moroccan invasion and defeat in 1591. To the east the Hausa states were centered on Katsina, Kano, and Kebbi. The area around Lake Chad was controlled by the kingdoms of Kanem and Bornu, whose history was described by Ibn Fartuwa in about 1580. With the decline of Songhai at the end of the sixteenth century, the Mossi kingdoms of Wagadugu and Yatenga came to control the area south of the Niger Bend.

The Sudan was the most important trading area between Africa and Europe until the end of the fifteenth century. Well before the arrival of the camel in about 200 A.D. kola, gold, ivory, slaves, "Moroccan" leather, and ostrich plumes were traded north across the Sahara, and salt from Taudeni and Tagaza went south into the forests of the Guinea Coast, along with tin, copper, iron bars, metal pots and pans, horses, and firearms. With the arrival of the Portuguese in the 1480s and 1490s, and of the Dutch, French, English, Danes, and Germans soon thereafter, the direction of trade reversed, toward ports along the coast, and trans-Sahara trade was eclipsed by coastal trade.

The influence of Islam, spread primarily along trade routes by Moslem merchants, but also by holy wars in the nineteenth century, has waxed and waned in the area. The great *jihad* of Uthman dan Fodio was launched in 1803, creating the Sokoto Caliphate throughout Hausaland. In the mid-nineteenth century the *jihads* of Ahmadu Seku in Masina and al-Haj Umar in Kaarta created two great Moslem states in the upper Niger. The largest Moslem populations are concentrated in the cities, while rural villages have been less affected. With some exceptions, the spread of Islam has had an adverse effect on the production and use of traditional sculpture, although occasionally old masquerades were incorporated into Moslem practices.

The slave trade had a profound impact on the Sudan, for many of the small, militarily weak peoples in the southern regions close to the forest, especially the Nuna, Kasena, Lobi, and Tamberma, were raided constantly by their more powerful neighbors, the Mossi, Bamana, and Asante. Slaves were shipped to the Americas in

large numbers, depleting the population in extensive areas of the Sudan. Traces of Voltaic languages have been identified in Bahia, Brazil.

The colonial period in the Western Sudan extended just over sixty years, beginning in 1883-97 with explorations and conquests by the British from the Guinea Coast and by the French eastward along the Senegal River. Conquest was stimulated by the Berlin Conference of 1884-85, at which the European powers mapped out their spheres of influence in Africa. In many areas African resistance to French and British occupation was fierce and protracted, and many Africans lost their lives. Samori carried on guerilla warfare against the French in southern Mali and the northern Cote d'Ivoire from 1885 to 1898. Early in 1914 the Bobo rose up in protest against French taxation and conscription for trench warfare in France, and were suppressed with heavy artillery and machine guns. Similar uprisings broke out sporadically throughout the area. Most of the Sudanese colonies achieved independence in 1960.

The sculptural style of the Sudan west of the Niger River is dominated by the work of two major groups: 1) the Mande-speaking peoples, who live primarily in western Burkina Faso, Mali, and the northern Cote d'Ivoire, in the valley of the upper Niger River, and 2) the Voltaic-speaking peoples of Burkina Faso (formerly Upper Volta), of northern Togo and Ghana, in the basin of the upper Volta Rivers.

The Upper Niger River style is characterized by the use of simple geometric shapes, which Susan Vogel has suggested reflect the architectural shapes of Sundanic villages, and by the use of a T-shaped meeting of the nose and brow, with the eyes often high in the intersection on flat, broad cheeks. Colors are generally dark, either black or natural wood-brown, although many groups produce colorful cloth masquerades, and the Bobo paint their masks red, white, blue, green, and yellow. Figures are tall and attenuated, with cylindrical torsos flanked by arms that are held at the sides, upper arms parallel to the torso, and forearms at a sharp angle, almost parallel to the ground. Scarification patterns are burned into the wood with a heated blade, and the entire surface of the carving may be seared black. In contrast, the sculptors of the Upper Volta Rivers style break up the surfaces of masks and figures with dramatic combinations of red, white, and black geometric patterns, especially a distinctive system of concentric circles around the eyes – the "Upper Volta target motif." Masks are freshly painted before each performance, so that even ancient masks show brilliant new colors. The Mossi, Bwa, Winiama, and Nuna in Burkina Faso, the Nafana of Ghana, and the Dogon in nearby Mali carve masks with tall, two-dimensional planks that rise above the face. Throughout the Western Sudan groups produce horizontal masks that combine the powerful features of several animals. In both stylistic areas women have worn their hair in a distinctive sagittal-crest, a feature frequently represented in carved figures.

Among Mande-speakers, masks are used primarily in the initiations of men into successively higher initiatory grades, although they also appear in the funerals of society members. Among Voltaic-speakers masks are owned by families and clans, and appear at the funerals of elder male and female members of the family. They may also play a role in the initiation of young men and women into the secrets of masks' performances, and they act as characters in stories about the history of the clan. Figures are used in both areas for a multitude of purposes, including the encouragement of human, animal, and agricultural fertility, the commemoration of ancestors, and especially the contacting of supernatural protective spirits that watch over the family or community.

It is important to remember that, although sculptural traditions that were described in the nineteenth century have disappeared in some areas of Africa where groups are receptive to European and Moslem culture, in many parts of the Sudan conservative groups have vigorously resisted acculturation, so it is still possible to visit communities in which ritual life goes on today very much as it did a hundred years ago.

The Lost Civilizations of Mali

The vast, flood-prone region that begins north of Segou and spreads out between the Bani and the Niger as far as Mopti and Timbuktu, the city that since earliest times was the final stage for caravans that linked the Black world and the Mediterranean coast, is known as the Inland Niger Delta. Here, the empire of the Ghana saw its capital, Koumbi Saleh, destroyed by the forces of Islam back in 1076; Ghana was succeeded and surpassed in splendor by the empire of the Mali, from whom the present country takes its name. On a pilgrimage to Mecca, one Malian ruler left a deep impression on the peoples lining his route with his sumptuous display of wealth.

After the middle of the fifteenth century this state, founded by Mande chiefs, began to lose its northern territories, including the rich Timbuktu, key to trade with Morocco and trans-Saharan traffic. By the end of the century, the Songhai ruler Sonni Ali Ber (1464-92) had freed his people from the tutelage of the Moors and Mali, conquering Timbuktu, Gao, and Djenne. His successors were zealous Moslems yet during the Islamization of the region an extraordinary art developed, purely traditional and non-Islamic, an art known primarily through the so-called Djenne terra-cottas.

Officially sponsored excavations have uncovered terra-cottas and metal objects formerly buried under several meters of alluvial soil, but the mystery of the conception of these objects, several of which are presented here, has not yet been explained. It is a matter of conjecture whether they served a protective function, whether they were ancestral effigies, or perhaps votive offerings; it appears certain, however, that serpents played a central role in the belief of the people of Djenne, since many of these figures are profusely covered with reptiles. Thermoluminescent analysis dates these figurines over a period of several centuries, the oldest originating in the eleventh and twelfth centuries, the most recent about 300 years ago.

These works, whose most remarkable characteristic – extremely rare in traditional African art – is the suggestion of movement, were created in a rather remarkable cultural milieu where "animistic" villagers lived in symbiosis with city-dwellers who adhered to a strict Islamic law. But within West Africa such a cultural environment as this is hardly unique, since even today, precisely in the Djenne area, the animistic Bozo live together with the long-Islamized Fulani. A. M. V.

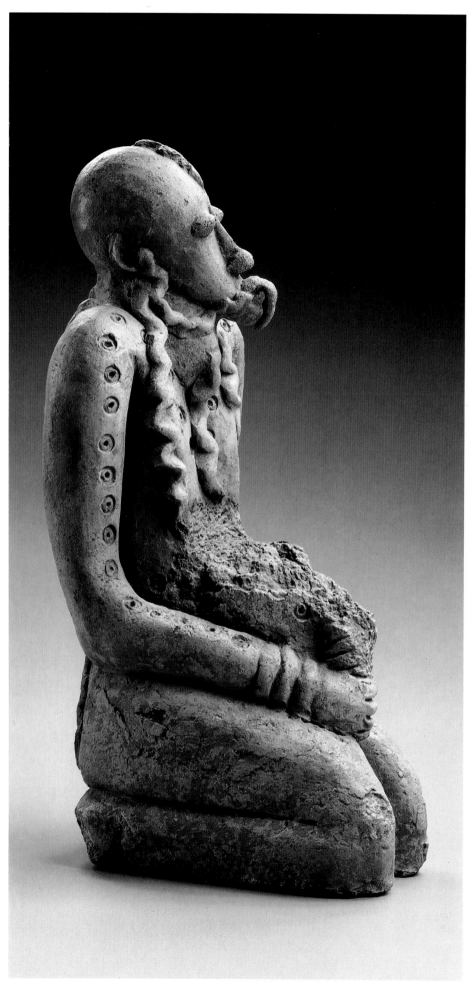

1 Figure
Region of Djenne, Mali

Terra-cotta; height, 42.5 cm

In the terra-cotta art of the Inland Niger Delta, human figures are often shown in a variety of kneeling or squatting postures. This figure represents a man kneeling with hands clasped around one knee. He wears three bracelets on each wrist, and his arms are decorated with an impressed circle-and-dot motif. A number of snakes crawl over his body, on his head and neck (perhaps issuing from his mouth and ears), and on his chest and back. This may have been a shrine figure made in connection with the serpent cult of the Djenne region. T. G.

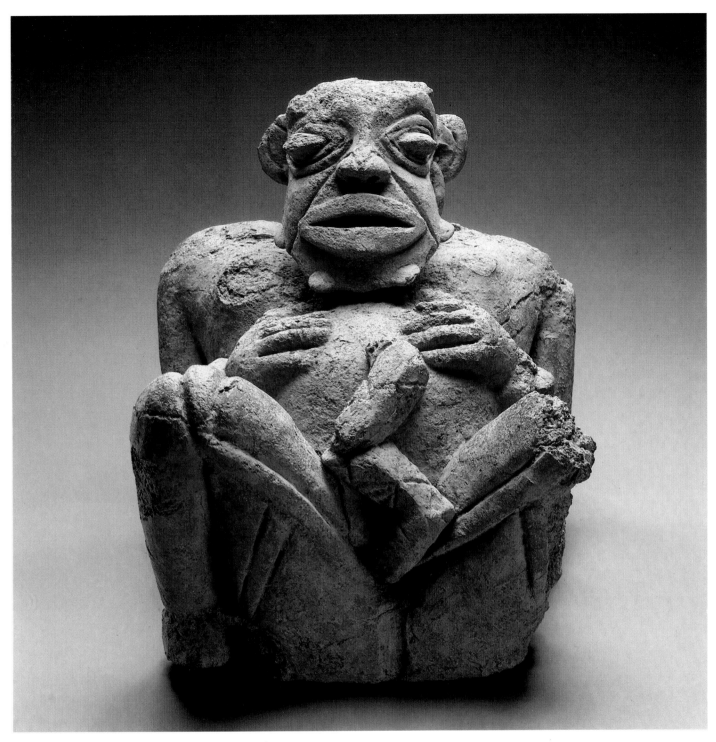

2 Figure

Region of Djenne, Mali

Terra-cotta; height, 39 cm

This extraordinary and unusually large figure depicts a pregnant woman reclining with hands on her abdomen. Her legs are open and she appears to be giving birth to a snake (represented in stylized form by a zigzag). This may have been a shrine figure for the serpent cult or for cults that are known to have flourished in the Mali region early in this millennium. The eleventh-century writer al-Bakri referred to the existence of serpent worship in ancient Ghana (Ouagadougou), adding that many offerings were made to these reptiles. Serpents also figure prominently in ancient myths of origin in the region. They appear frequently in the art of Djenne, represented either singly, on waterpots, or in association with humans. T. G.

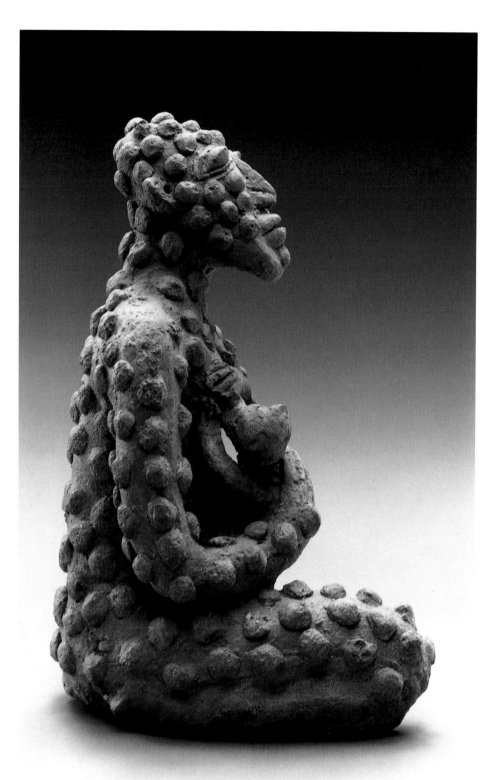

4 Figure
Region of Segou, Mali

Terra-cotta; height, 44.3 cm

The finely modeled figure represents a man seated with his legs to one side, a pose common in human statuary from the Inland Niger Delta. He is shown wearing a cloth around the waist, a large bracelet on each wrist, and a heavy neck-ring. The precise significance of the figure is unknown, but it may have been intended as a shrine piece.

This terra-cotta differs considerably in style from those found in the vicinity of Mopti and Djenne. Other works in this distinctive style have been found to the southwest, at sites near Segou and at Bankoni, a suburb of Bamako. They appear to be similar in age to terra-cottas from the Djenne region; some have produced thermoluminescence dates falling in the fourteenth, fifteenth, and sixteenth centuries.

T. G.

3 Figure
Region of Djenne, Mali

Terra-cotta; height, 26.7 cm

The figure depicts a kneeling woman suckling a child. She wears neither bracelets nor any other ornaments, but her ears are pierced for earrings. The entire surface of the woman's body is covered with small applied pellets of clay.

The archaeologists Roderick and Susan McIntosh have reported the finding near Djenne of a pair of male and female figures whose bodies were similarly covered with applied clay pellets. They suggest that these pellets may have been intended to indicate body painting or even disease. The first possibility seems unlikely, for on the present figure the pellets extend to the crown of the head. They might, however, represent the boils accompanying plague or some other epidemic disease, and if so, this figure could have been made as a means to protect a household from pestilence. T. G.

Lit.: *African Arts*, Feb. 1979.

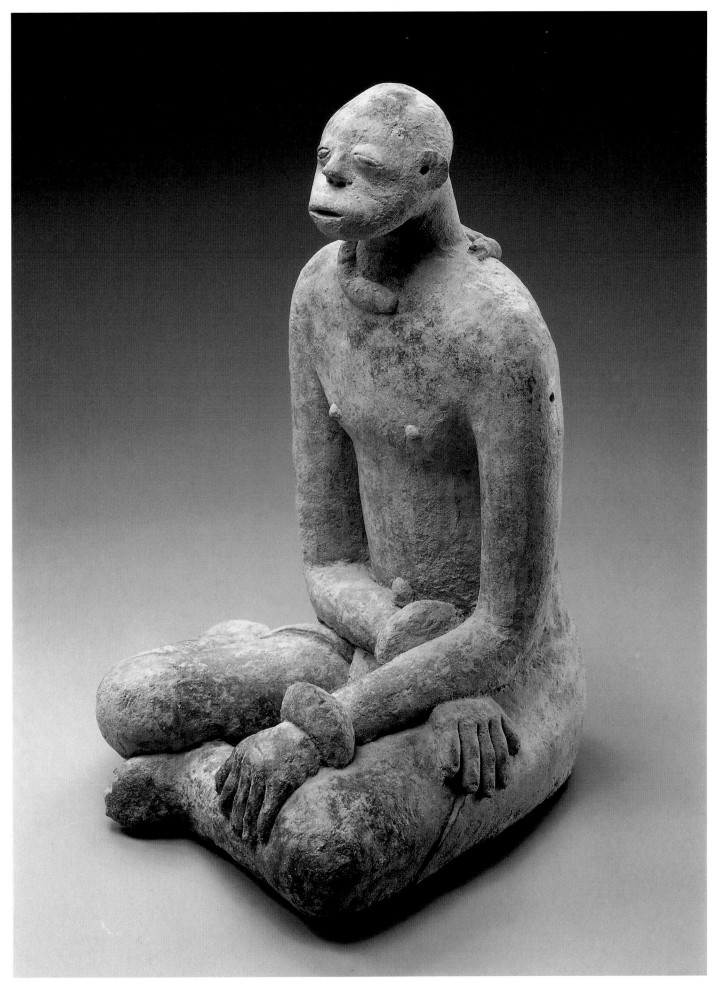

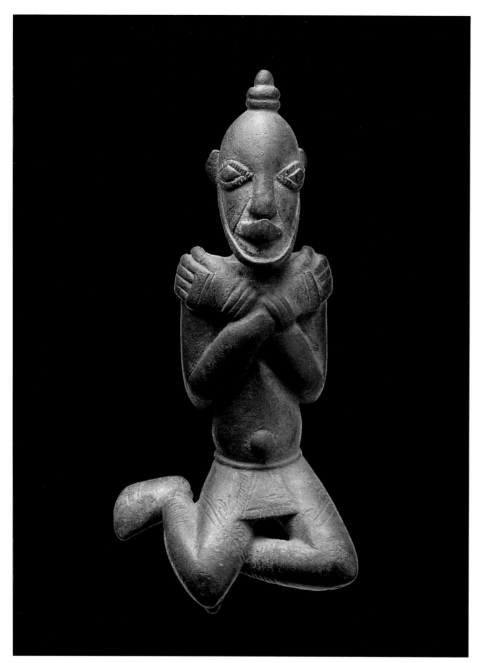

5 Pendant

Djenne, Mali

Bronze; height, 9.6 cm

This magnificent small pendant comes from one of the numerous ancient sites in the Middle Niger region of Mali. It represents a bearded man sitting with legs to one side and with arms crossed over his chest. He wears a small loin-cloth, and has three bracelets on each wrist, while his hair is dressed into a top-knot.

The significance of the figure's squatting pose is unknown, but it recurs in many terra-cottas from the region dating from about the twelfth to the sixteenth century. By analogy, this pendant may be dated to the same period. It is thus co-terminous with the finest classical bronzes of Ife and early Benin.

The pendant is superbly modeled and has been cast by the lost wax process. Today this process is almost unknown in the Djenne region, but the increasing number of ancient bronzes that are coming to light there testify that it was once extensively employed for making bracelets, pendants, bells, horse-trappings, and other orna-ments. T.G.

The Dogon

According to Dogon legend, the Tellem once inhabited the Bandiagara cliffs where many Dogon villages are now located. The Dogon attribute certain sculptures found in the sacred niches of the high cliffs to this legendary people (pls. 6 and 7). The Tellem are thought to have arrived in the area at the end of the first millennium B. C. Great users of masks, the Dogon are believed to have arrived from the south during the fifteenth century, displacing the Tellem, who emigrated eastward to become the ancestors of the Kurumba.

It has not proved easy to distinguish Tellem works from Dogon: Tellem figures, which are covered with a thick sacrificial patina, possess an obvious stylistic kinship with those of the Dogon; likewise, certain themes from Dogon mythology – for example, the primeval spirit *Nommo,* represented with uplifted arms – are found in sculpture attributed to the Tellem. This kinship has been explained by the hypothesis that in many villages the Tellem were assimilated by the invaders, and were not all driven from the country.

The discovery of a large number of terra-cotta figures in the Inland Niger Delta, west of the area inhabited by the Dogon (see the preceding section), presents further points of interest. Some of these figures represent riders remarkably similar to those portrayed in Dogon wood sculptures; and many figures have their temples decorated with square or checkered scarifications of the sort frequently seen among the Dogon. Certain Dogon figures give the impression of having been copied from the terra-cottas of the Inland Delta, although the terra-cottas show men and women in motion, while Dogon art presents the ancestor or spirit in a static pose, either standing or seated. If we postulate a Djenne-Dogon cultural kinship, we can explain the immobility of Dogon art by the use of a different material. Technically, in fact, the modeling of terra-cotta consists of adding material to the basic form, while the sculpting of wood, dependent from the start upon the cylindrical shape of the block of raw material, proceeds by removing bits here and there. In any case, even if the figures lack movement, Dogon art presents a variety of themes in no way inferior to that found in the Djenne terra-cottas, and its images occasionally appear to illustrate similar stories. Certain Dogon figures representing Dyougou Sirou, incestuous son of the god Amma, covering his eyes after committing his crime, appear to have their counterpart in the Djenne terra-cottas, though it is not clear that their meaning is the same.

It is not known what ethnic group was responsible for the so-called Djenne civilization, and thus no explanatory hypothesis can be framed based on historical information. It is worth pointing out, however, that even today the Dogon maintain close ties with the Bozo, who reside along the Niger in the Djenne region and who are known to have lived there for at least seven or eight centuries.

A. M. V.

Fig. 23 Procession of *Canaga* masks among the Dogon (Photo: M. Huet, Agence Hoa-Qui, Paris)

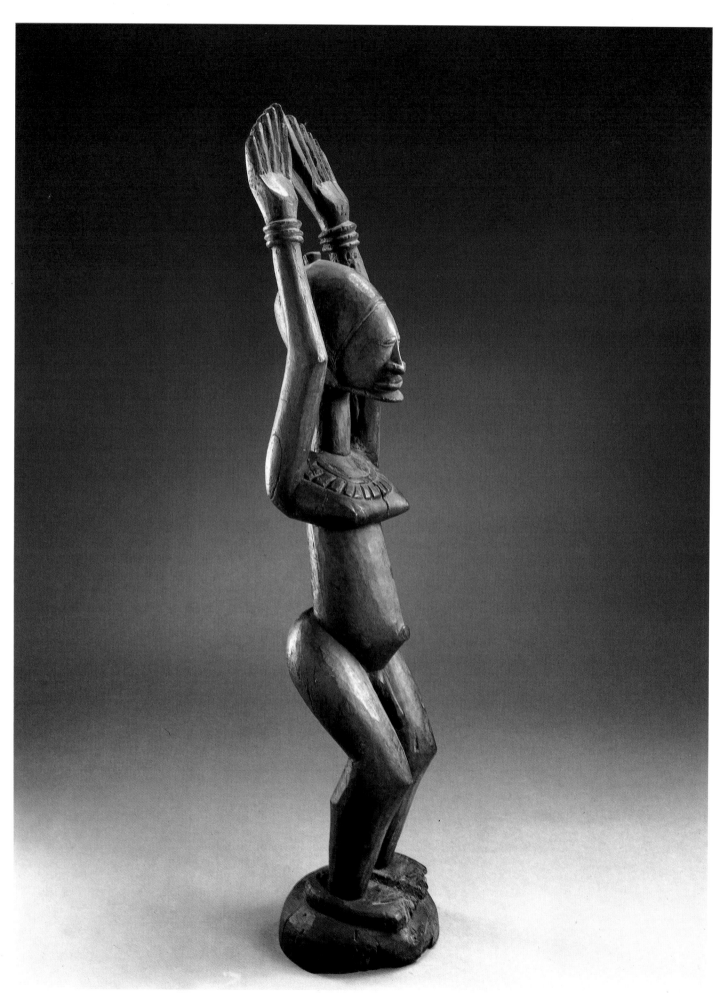

6/7 Tellem Figures
Dogon, Mali

Male figure: Wood; height, 118 cm
Female figure: Wood; height, 76 cm

These two sculptures, representing figures with arms upraised, have both been attributed to the Tellem because of their flat-bead necklaces; according to Germaine Dieterlen, the Dogon only use round-bead necklaces. The same author adds that the figures with upraised arms "always represent the beseeching of Amma to send the rain necessary for all life." But "it is also a gesture of contrition for an infringement of ritual law that has caused the drought."

The larger of the two sculptures, a man, opens his hands, palms turned forward. The woman, in contrast, closes her right hand and opens her left, a gesture that is exactly reproduced in another sculpture to be seen in the Rietburg Museum in Zurich, a sculpture covered with a thick red patina like the one here.

The fluidity of forms seen in these two works is not found in other Dogon sculptures that can be classified as more recent, and that evolve toward an angular schematization probably resulting from Malinke or Bamana influences. An inventory of Dogon regional styles has yet to be made. A. M. V.

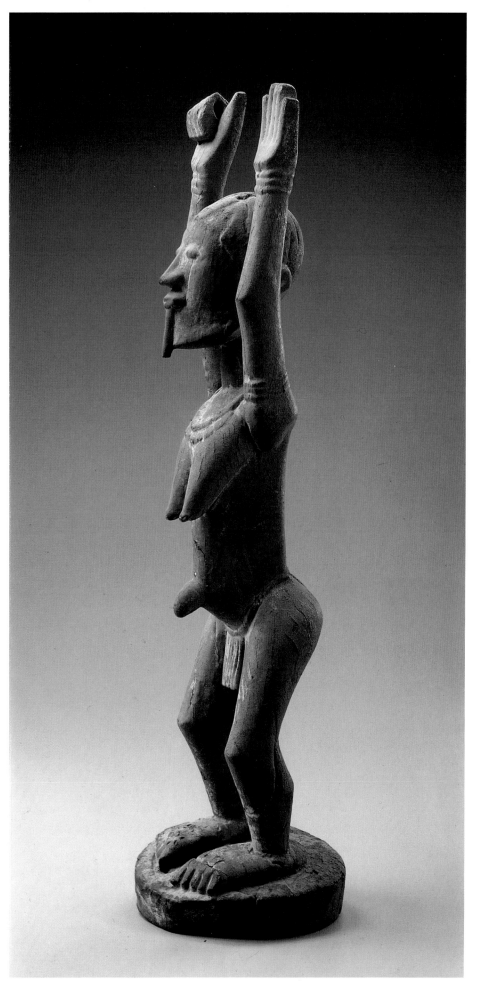

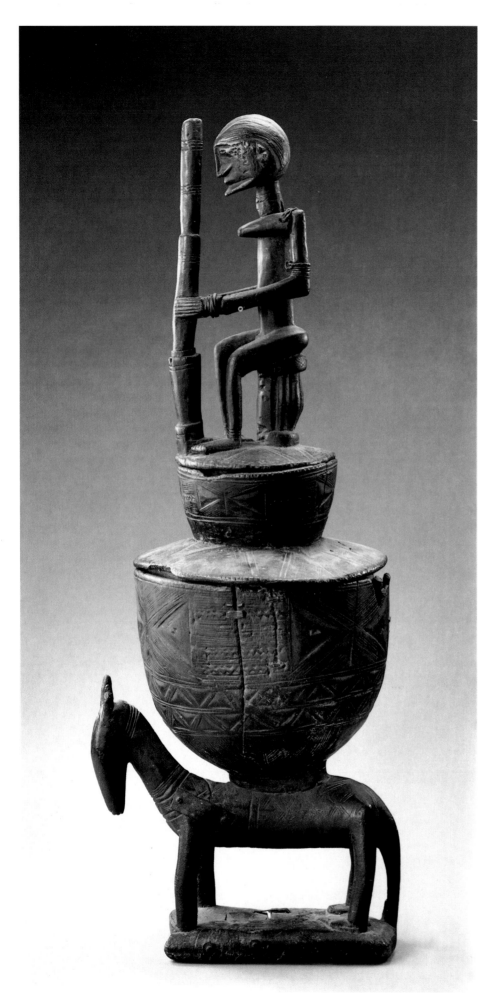

8 Hogon's Ceremonial Container

Dogon, Mali

Wood; height, 96 cm

This sculpted wooden container was made to be offered to the wife of the *hogon*, the religious head of the region and high priest of the cult of Lébé. The Dogon brought the Lébé cult, which concerns itself with the well-being of cultivated plants, with them when they migrated from the Mande heartland. The container is made of two superimposed cups on the back of a horse, surmounted by a seated female figure. The horse represents the Nommo who pulled "the ark of the world" to the water. The female figure represents the *hogon's* wife, "seated in a place of honor," like her husband. She is pounding millet in a mortar, for she alone may prepare food for the *hogon*, then carry it to him in his own dish. At his installation, the *hogon* receives a similar vessel, though it usually consists of three superimposed cups, with a cover surmounted by a rider.

The wooden cups are engraved with a number of signs having a symbolic value associated with Dogon cosmogony. These objects are made in a prescribed manner from false mahagony, and are only used for agrarian ritual ceremonies.

G.D.

9 Pendant

Dogon, Mali

Bronze; height, 5.5 cm

This small bronze pendant represents a male figure as indicated by its beard of twisted metal. Evelyn Fischel (1982, p. 128) has remarked that the figure's masculinity is confirmed by the three pairs of bracelets, each consisting of a threefold hoop: Among the Dogon, three is a symbol for maleness.

The snake that twists along the man's chest possibly recalls the great reptile that is the incarnation of the seventh Nommo, the divine ancestor Lébé Sérou; the Dogon maintain a cult in his honor, of which the *hogon* is the priest. This figure should probably be considered an image of Lébé, the mediator between serpent and man and between man and serpent. Lébé contains within himself the sum of life necessary for humans and for the land, for "in his saliva is found the power of moisture, the sonorous mist spit forth from every mouth. . . . " A. M. V.

Lit.: Fischel, 1983, p. 128; Griaule and Dieterlen, 1965, p. 31.

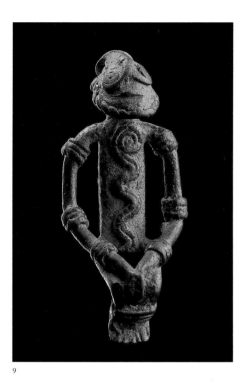

9

10 Bound Figure

Dogon (?), Mali

Bronze; height, 21.8 cm

This relatively large bronze represents a male figure with his hands tied behind his back and his ankles also tied. Dieterlen thinks that this could be "the representation of a slave in irons . . . Enemies taken in battle were chained in this way and put on show in the courtyard of the victorious village's chief."

The Dogon origin of this work has not been definitively proved. Fischel has studied another piece, obviously by the same hand, in which the bound man is seated rather than standing. She notes that the earlier attribution of the piece to the Dogon is not certain and, pointing out that the theme of the bound prisoner is present in Djenne terra-cottas, suggests that until new evidence is found a Djenne hypothesis is more credible. Hélène Leloup, who previously owned the bronze, has put forward a different view. She knows the Dogon country well, having already visited the area in the fifties; she owned the piece for almost twenty years. To her, there is not the slightest doubt that the figure is Dogon; she acquired it along with other objects of Dogon origin, which lends weight to her attribution.

A. M. V.

Lit.: Fischel, 1983, p. 150.

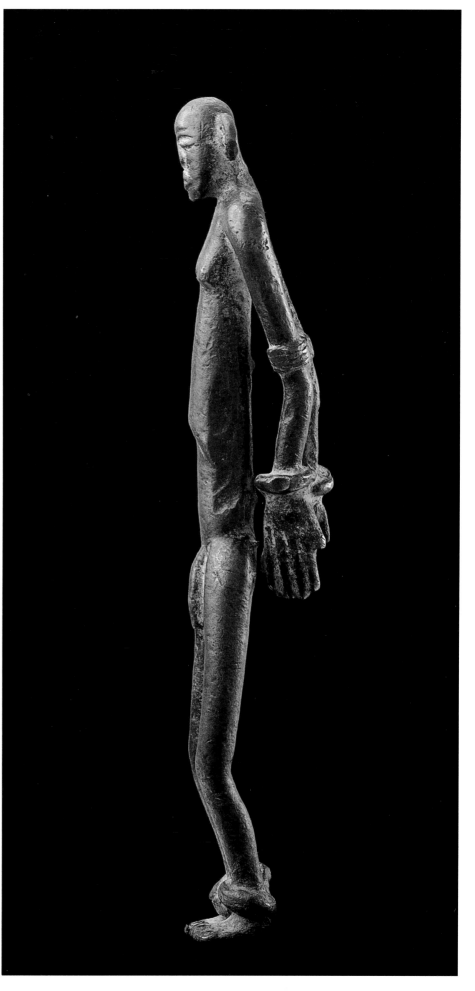

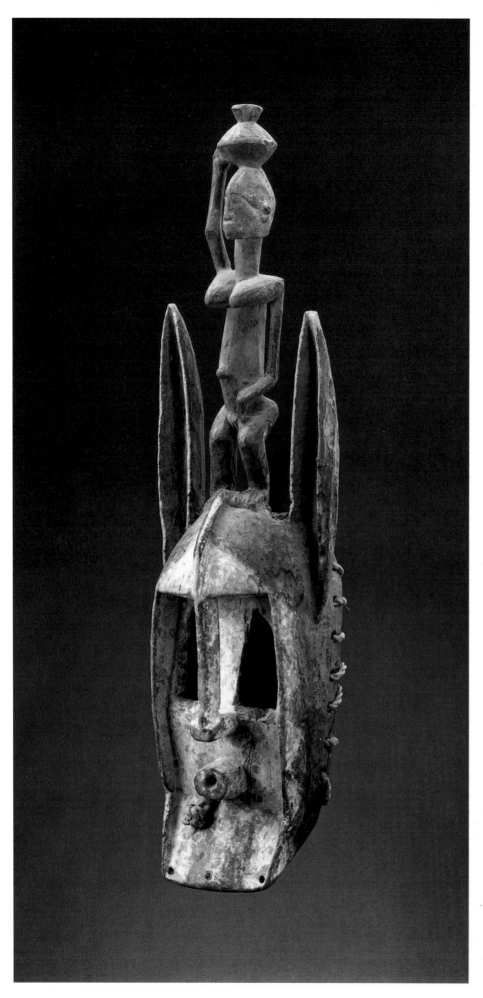

11 *Walu* Mask, Oryx

Dogon, Mali

Wood, plant fibers; height, 63 cm

The morphology of this mask connotes two different but associated stages of Dogon cosmology. The vertical horns surmounting the anthropomorphic face are those of an oryx, an animal thought to have played an important role since man's earliest time on earth. It was created in heaven and descended on the ark that carried the first Nommo, the mythical progenitor of mankind, his "sons" – that is, four pairs of male and female twins – and all the living creatures that were to multiply on the planet, which until then had been inhabited only by the fox. Born before its term of Amma, its creator, the fox had formed the earth by tearing away a piece of its placenta. The oryx was charged by Amma to watch over the path of the sun, which had been formed from what was left of the fox's placenta and which the fox wanted to get back, in order to have the twin sister it lacked. The fox dug holes in the ground in order to defend itself, and the oryx fell and severely injured its legs. It was cared for by one of the eight ancestors, but to no avail; limping painfully, it made a long journey to see the blacksmith, who had descended from heaven after the ark, and sought healing at his hands. Nevertheless, it died of its wounds; but its mate, which had followed it, gave birth to a kid beside the blacksmith and thus assured the continuation of the species.

The female figure surmounting the face of the mask represents Yasa, the Nommo's twin sister, who descended to earth after him with the blacksmith. In her pitcher she carries the rainwater that fell from heaven, formed the first lake, and made the development of life on earth possible.

This mask combines two symbols that appear in the altar of the smiths; the oryx, the animal that became the principal taboo of this international artisan caste, and Yasa, who, after a variety of vicissitudes, went to the pond to rejoin Nommo, her husband and twin, who had become master of water on earth. It is an interesting variant of the oryx mask, which usually does not include a female figure. The mimicry of the wearer of the mask is clearly reminiscent of the actions of the mythical animal. At first, he dances butting furiously with his horns, as though he were chasing the fox. At a given moment, he falls to the ground, and the "healer" mask, which represents the samaritan ancestor, approaches and pretends to care for him. Then the wounded oryx gets up and, leaning on sticks, limps out of the public square. G. D.

12 Equestrian Figure

Dogon, Mali

Wood; height, 46 cm

According to Dieterlen, "the hairstyle and the flat-stone necklace confirm the Tellem origin of this statuette." She adds: "The Dogon made similar riders, always representing the Nommo on horesback; but coiffure and ornamentation are different."

Jean Laude (1973, fig. 46) reproduces a very similar equestrian figure. The horse wears a flat-stone necklace, and the rider has the same hairstyle and holds his arms in an identical position (the hands of the piece shown here have been broken off). According to Laude, it is probably the portrait of a *hogon* (priest).

Here, the horse is saddled, although this is not the case with the Djenne terra-cotta riders that may be considered the archetypes of the wooden riders of the Dogon (or the Tellem, if the distinction between the two can be maintained). In addition, the quadruped here is clearly a horse, which is not always the case; Dogon sculptures are known in which the mount is an ass or a mule, recognizable by its long ears.

The most important study devoted to the theme of the rider among the Dogon is certainly that of Laude, who makes the obvious point that the horse must have been particularly prevalent among the Dogon of the plains, since the cliffs of Bandiagara hardly lent themselves to the use of such an animal. And the Dogon of the plains had frequent contact with the Mossi and the Fulani, to whom they attributed the introduction of the horse among themselves. Unfortunately, it is still not clear which of the Dogon sculptures in our museums should be attributed to the plain-dwellers and which to the cliff-dwellers.

Laude writes: "The horse was the first animal to leave the ark. Sometimes, with its rider, it is identified with the ark itself." As we shall see in Plate 13, the ark is represented with the head and tail of a horse. A. M. V.

Lit.: Laude, 1973, fig. 46; 1978, p. 98 ff.; Grunne, 1980, p. 43.

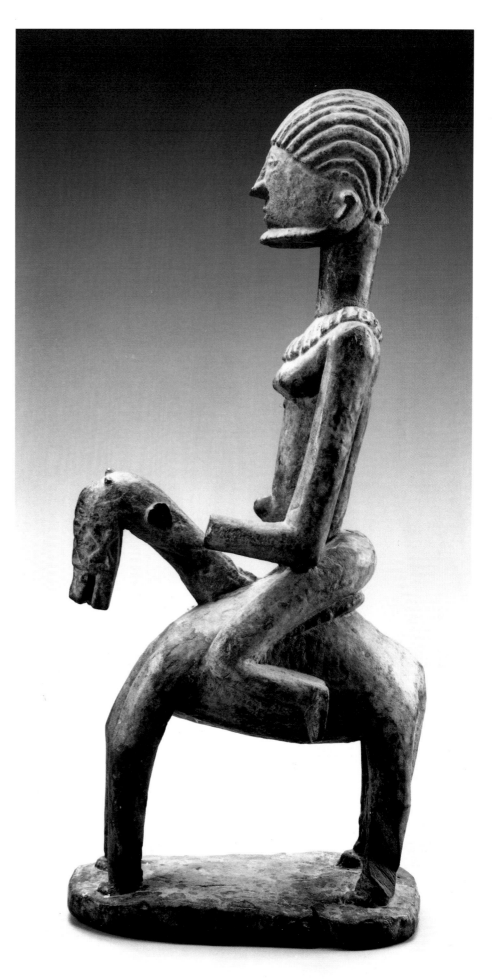

13 Ceremonial Container
Dogon, Mali

Wood, sculpted from a single block; length, 16.4 cm

Among the Dogon, the "ceremonial container of the ancestors", also called "ark of the world," is kept in the lineage's family house. It represents the ark in which the first Nommo, the mythical progenitor of mankind, descended to earth, along with his "sons" – four pairs of male and female twins – and everything made in heaven by Amma, the creator. It is cut in a strictly prescribed manner from the wood of a special variety of fig-tree; of considerable dimensions, it is ornamented with figures carved in the round. These figures represent primordial ancestors, their arms upraised imploring rain; they frame a crocodile, executor of the Nommo's noble works, who combats the fox and watches over the safety of the planet. The head and tail of a horse constitute two sculpted handles, since, after the ark landed on the earth, the Nommo was changed into a horse and pulled the ark along the ground to the lake that had been formed by the first rainfall. The chevron frieze that ornaments both sides of the coffer represents the path of the water falling from the sky and forming meandering rivulets along the ground.

Usually kept out of sight, the object is brought out and used only once a year, at the annual ceremony of the winter solstice, which brings the lineage group together. The ceremony commemorates the descent of the ark; it consists of two sacrifices, one offered at the altar of Amma, the other at that of the ancestors. Pieces of meat, first raw, then cooked, are placed in the "dish"; after a long prayer pronounced by the most honorable elder they are distributed to the participants according to precise rules . G. D.

14 Granary Door
Dogon, Mali

Wood, iron; height, 80.5 cm

Dogon granaries are often adorned with exquisitely carved wooden doors. Decorations vary according to the particular type of building, as does the symbolism of the sculpted figures. Shown here is the door of a "family granary," which is located in the courtyard of the principal residence of an extended lineage, which may make up a quarter of the inhabitants of a village. This residence is inhabited by the lineage elder, who is succeeded after his death by the oldest of those who follow him, by primogeniture. Among other things, the house shelters the altar of the ancestors, where the funeral urns of the founders of the lineage are kept.

The granary stores the crops of all who wish to place their provisions under the guardianship of the lineage elder, who is charged, among other things, with carrying out the various rites consecrated to the "souls" of cultivated plants.

The door is made of two wooden panels held together by iron bands. The bolt-case is surmounted by a pair of figures representing the founder of the lineage and his wife. Beneath them a zigzag horizontal line suggests the movement of snakes; the primordial ancestors, who were created immortal, transformed themselves into snakes at the end of their human life. At the bottom of the case, carved in the round, eight seeds are evoked, the seeds of the alimentary plants given to men by God, Amma, at the dawn of their life on earth.

Above and below the lock we see three rows of male and female twins as symbols of fertility, the birth of children being considered a source of joy and a promise of riches. The right-hand panel shows the five generations of the "unbegotten"; the system of kinship and marriage evolved by the Dogon is based on the first five mythical generations, and contains prescriptions for the naming of children, for alliances between tribes, and for totemic observations. To this day, the number five is the symbol of the kinship system of the lineage, and at the annual communal ceremony, which includes libations at the altar of the ancestors, the lineage elder must, after a prayer, list the names of all the dead of the five preceding generations. So that none be forgotten, he adds: "May all those who have passed on also come and drink." G. D.

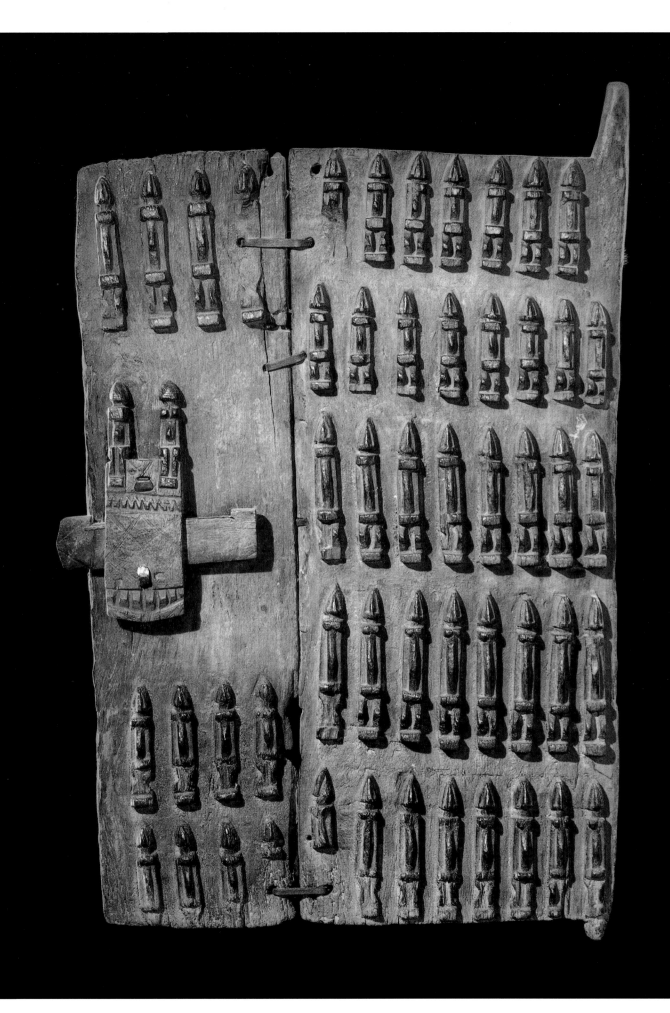

The Bamana

The first historical reference to the Bamana, or Bambara, appears at the end of the sixteenth century in the chronicles of Es-Sadi. Since they were unwilling to accept Islam, their name was often used in ancient chronicles to designate non-Muslims, as a synonym for "idol worshipers."

The language of the Bamana belongs to the Mande or Manding group. They have lived from agriculture since time immemorial;

Fig. 24 Masked Bamana dancer wearing an antelope headdress. (Photo: From Huet, 1978)

but the splendor of the kingdom of Segou, whose Bamana inhabitants were ruled by Fulani, was founded on the slave trade. Of Segou, Mungo Park, the first European to visit the Bamana country, wrote: "The view of this extensive city, the numerous canoes upon the river, the crowded population and the cultivated state of the surrounding country, formed altogether a prospect of civilization and magnificence, which I little expected to find in the bosom of Africa."

The social structure of the Bamana, inseparable from their religion, is founded upon each individual's membership in a secret society. According to Viviana Pâques: "The Komo (the best known of these initiatory men's societies) is a hierarchical society involving obligations and prohibitions; its functions include the installation of political and religious dignitaries, the making and consecration of cult and power objects, furtherance of the knowledge of poisons and antidotes, and the warding off of evil sorcerers."

Hence, it is within the ritual framework of the secret societies that the Bamana make and use figures and masks. These include the well-known dance headdress crowned with an antelope figure (fig. 24).

Ascetic and often brutal, as realistic as the neighboring Dogon are philosophical and reflective, the Bamana have produced an art that tends not at all toward sensuality. As Sarah Brett-Smith has noted: "Not for these slavers and ex-slaves the rounded abundance of the Senufo or Akan; the human body becomes a series of straight lines. Even the impossibly conical breasts stand stiffly at right angles to the body." Moreover, the Bamana share this austerity with other west Sudanese peoples, whose art is usually qualified as "abstract" or "geometric" in contrast to cheerful naturalistic styles of the Guinea Coast or Zaire. A. M. V.

Lit.: Tauxier, 1942; Park, 1799; Pâques, 1954; Brett-Smith, 1987.

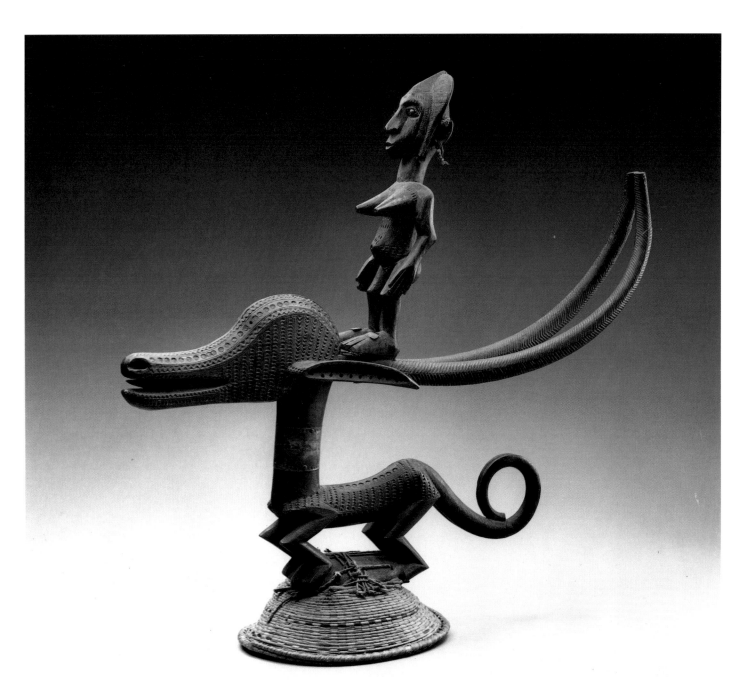

15 Tyi Warra Headdress

Bamana (Bambara), Region of Beledugu, Mali

Wood, fiber, and iron nails; height, 55 cm

Tyi Warra headdresses are normally carved in pairs; both male and female appear at the beginning of the rainy season accompanying farmers to the fields to encourage them in their efforts. At harvest time two young men from the farmers' association, or *ton*, that owns the headdresses perform with them in celebration of the village's most successful farmer.

Traditionally, Bamana men hoed their fields in groups, and every young man aimed to out-distance his competitors as he worked down the field. Public opinion selected the strongest farmer. Such a man, for whom the Tyi Warra dance at harvest time, need never fear isolation; every family in the village will vie to have him as their son-in-law, since they can depend on his ability to offer them substantial "gifts" of grain. The link between farming prowess (only a successful farmer will be wealthy enough to afford several wives) and sexual rewards is bluntly emphasized by the young girl poised on the antelope's horns. It is as if the artist speaks for the Tyi Warra association, saying, "Farm like a wild beast [*warra*] and we will give you a woman."

Farming well is more than the pathway to marriage; the Bamana believe that breaking up the soil with a hoe and raking it into mounds to receive seeds is an action analogous to sex. Like sex, farming is too serious a matter to be left to individual decision making – it becomes a ritual as well as a practical procedure and must thus be supervised by the Tyi Warra masqueraders. For the Bamana, both human survival and human reproduction depend on the ability and endurance of the farmer who breaks his back under the relentless sun. S. B. S.

Lit.: Zahan, 1980.

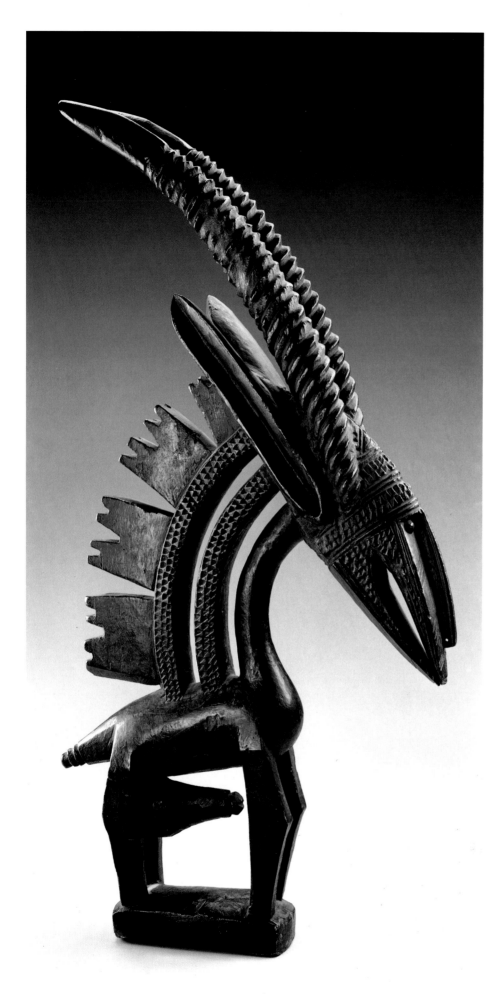

16 Tyi Warra Headdress

Bamana (Bambara), Mali

Wood and pigment; height, 78 cm

Segou-style Tyi Warra represent the roan antelope (*hippotragus equinus*, Bamana name: *dage*), an animal which symbolizes the Bamana man's farming prowess. The *dage* is a large, horse-like antelope of noble carriage with powerful, curving horns. Bamana hunters track the *dage* for its delicious meat, but the antelope is often elusive, leaving its pursuer behind even when gravely wounded. Such elusiveness is also typical of the Bamana farmer who agrees to plant a new strain of millet when he has no intention whatsoever of sowing the strange new grain.

The *dage*'s speed and physical strength (they can weigh more than 300 kgs.) is combined with a startling timidity well conveyed by the Barbier-Mueller sculpture. The artist has brilliantly described the hesitancy, and perhaps even the sadness, of an animal on the alert for its pursuer, conveying the fragility of life in the harsh Sahel environment. Like the antelope, the Bamana farmer must remain ever alert to evade the alternate waves of flooding and drought that imperil his life. Poised to meet any emergency, he must alter his farming tactics to meet every change in the weather, just as the antelope zigzags to and fro to escape the hunter. In some years a Bamana farmer may sow five times to reap even a small harvest; one small mistake and the family starves the next year. The farmer's muscular strength can vanish in a few months of famine, just as the *dage* falls reeling from the hunter's shot. Both human and animal life are surprisingly fragile.

Bassani assigns the Barbier-Mueller piece to a workshop located along the Bani river between Segou and Koutiala in largely Minianka territory. Strong similarities to Koutiala-style Tyi Warra suggest such an origin, but the rounded profile and the three-dimensional character of the Barbier-Mueller antelope link it to Malinke carving and perhaps even to the Guinea Coast via Segou. Until further research locates this style more precisely, the Segou area remains the most likely place of origin. S. B. S.

Lit.: Bassani, 1982-83.

17 Figure

Bamana (Bambara) or *Malinke*, southern Mali

Iron, oxidized; height, 53 cm

This figure is probably the most important Bamana piece in the Barbier-Mueller museum. According to several informants, the sculpture represents a woman of noble birth (*horon*) with a hairstyle that was called *kobidani* in the early twentieth century. *Kobida* was the name given to any house built with bricks made in a mold rather than by hand. The name implied both novelty and great beauty in design; it may have been applied to the hairstyle in recognition of its popularity.

Kobidani may have been a noblewoman's hairstyle, but this category of iron sculpture, called *guan nege* (literally, "furnace iron"), was the exclusive property of those blacksmith families who inherited the right to smelt iron.

Each *guan nege* had its own personal name, in this case, *dibi* ("darkness, obscurity"). However, the informants did not know whether the name for their *guan nege* was also that of the Barbier-Mueller example. *Dibi* is a fairly common personal name for a sacred object, rather like Joe or Sam, and, in this case, seems merely to indicate the extreme secrecy that surrounded these objects and their use. S. B. S.

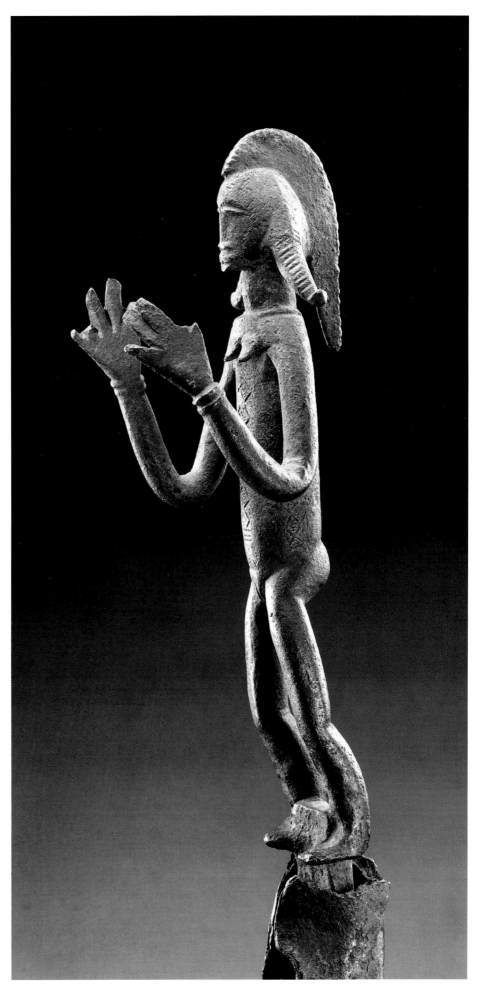

The Peoples of Burkina Faso

Burkina Faso, formerly Upper Volta, is inhabited by a mosaic of peoples who are today well known through the works of specialists like Christopher Roy, author of the introduction to this section. Dr. Roy has recently published an overall survey of *The Art of the Upper Volta Rivers*, which must henceforth be considered the standard work on the subject, although it does not treat a number of ethnic groups that have already been the object of extensive investigation and documentation, for example, the Lobi (Meyer, 1981) or the Kurumba (Schweeger-Hefel and W. Stande, 1972).

THE KURUMBA

The Kurumba are found in northern Burkina Faso, neighbors of the Moslem Fulani, whose settlements are found over a wide area of the western Sudanese savanna and as far as the edges of the desert. The Dogon (see p. 57) believe that the Kurumba are the descendants of the legendary Tellem whom they are said to have driven out of what is today Dogon country. The Kurumba, who speak a Gur (Voltaic) language, are actually divided into two groups: one is strongly imbued with Mossi culture, from which it has borrowed the use of board masks; the other has retained its own traditions, including the building of village assembly halls with sculpted wooden posts that recall those of the Dogon *togu na*.

The best known of the Kurumba masks is an antelope-shaped headdress that, since World War II, has been commercially produced on a large scale. Kurumba women are skilled potters and, like the potter-women of the Mossi, they make enormous jars that are decorated with patterns similar to the scarification marks worn by their owners; the jars are used to store valuable possessions such as rolls of cloth (fig. 25).

Fig. 25 Large earthenware jar that belonged to a Kurumba woman, whose abdominal scarifications are reproduced on it. Height, 63 cm. Barbier-Mueller Collection

THE MOSSI

The Mossi live south of the Kurumba, in the area around Ouagadougou and the headwaters of the White and Red Volta. Roy has described them as "a diverse people composed of the descendants of the farmers *(nyonyosé)* who lived in the basin of the White Volta River, and of the invading horsemen from the south *(nakomsé)* who imposed themselves as rulers and created the states of Ouagadougou, Yatenga, Boulsa, Risiam and others in about 1500. They number about 2,200,000 and speak a Voltaic language."

About seventy percent of the Mossi have remained faithful to their traditional religion, a fact that explains the survival of masquerades and their continued use of figurative sculpture. The figure shown in plate 18 was once part of a mask of the *karan-wemba* type (fig. 26); this mask is a variant of the large *karanse* mask, which has an almond-shaped face, two holes for the eyes but no nose or mouth, a line in relief running through the center, and a large, flat, dentate board at the top. The whole composition is very close in conception to the plank-type Dogon masks, and sometimes has a female figure in front of or replacing the vertical superstructure. This type of work is typical of the kingdom of Yatenga in northeast Mossi territory.

In the old kingdom of Ouagadougou, masks were smaller; like the one shown in plate 19, the majority represent horned animals, often totems of a clan.

THE GURUNSI

To the south and southwest of the Mossi live the peoples to whom their neighbors give the pejorative name *gurunsi*: the Nuna, the Winiama, the Nunuma, the Lela, etc. (Dittmer, 1961). About 200,000 of these *gurunsi* live in Burkina Faso, all speaking Voltaic

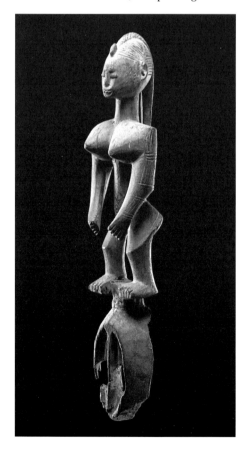

Fig. 26 *Karan-wemba* mask of the Mossi. Height, 63 cm. Barbier-Mueller Collection

(Gur) languages. They appear to have emigrated from northern Ghana at the beginning of the fifteenth century, when the recently discovered Komaland civilization (see p. 90) flourished there in the valleys of the Sisili and the Kulpawn. *Gurunsi* farmers were frequently raided and sold as slaves by their more powerful, Mossi neighbors. The Nuna, Nunuma, and Winiama are great sculptors. Their polychrome masks have influenced those of the neighboring Bwa, and the masks of the Lela have influenced those of the Mossi. These masks all represent spirits in animal form, sometimes recognizable, sometimes imaginary. "The majority of the *gurunsi*," according to Roy, "live in concentrated village communities, without any traditional system of chiefs."

THE BWA

The Bwa live to the west of the *gurunsi* extending beyond the Mali border; the center of the Bwa territory lies within the loop formed by the Black Volta. The northern Bwa have sometimes been called *Bobo-Oulé* ("red Bobo" in the Dyula language) although they are unrelated to the true Bobo, their western neighbors, whom the Dyula call *Bobo-Fing* (black Bobo). In Burkina Faso live 175,000 Bwa, in Mali 125,000. Living from agriculture, they speak a Voltaic language. Like other ethnic groups in Burkina Faso, three-quarters of the Bwa are animists.

The Bwa are divided into endogamous castes of peasants, smiths and their potter-wives, and griots; the latter are musicians who provide the musical accompaniment for masked performances (fig. 27).

Living in densely populated, high-walled, and easily defended villages, the Bwa pay allegiance to no higher authority, unlike the Mossi, who are organized into kingdoms. The Bwa's independence is also seen in their firm resistance to foreign interference, although they were compelled to pay tribute to the Bamana kingdom of Segou and later to the Fulani empire.

It is above all the southern Bwa, those close to the *gurunsi*, who use wooden masks, but all the Bwa make magnificent masks of leaves (fig. 28). The wooden masks represent either animals of the

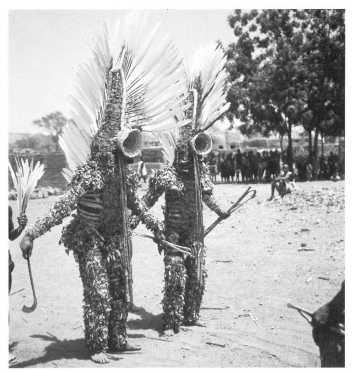

Fig. 28 Bwa masks made of leaves, fiber, and feathers. (Photo: M. Huet, Agence Hoa-Qui, Paris)

bush or spirits in supernatural forms. Some masks are figurative; others, like the *nwantantay* (plate 19), are schematic in conception and are surmounted by a large, painted vertical plank. Masquerades in which masks of leaves appear are a part of the cult of Do, principle of life and renewal, whose rites serve to purify the village and to regenerate the human community. Wooden masks are considered a heresy in some groups, but in others they play a part in family ceremonies such as burials or the conclusion of a period of mourning.

"The ritual ceremonies are individually organized by clan," writes Roy, who adds: "It is important to realize that the plank masks, the most striking of the wooden masks, do not attempt to reproduce a real, existing being. They are forms inhabited by supernatural forces acting on behalf of the clans that possess them. As the initiates are taught, the motifs decorating the masks are symbols of the myths that trace the history of the clans."

THE BOBO

The Bobo live to the west of the Bwa; they speak a Mande language, not a Voltaic one like the Bwa, with whom, as we have seen, they are often confused. Their culture appears closer to that of the Bamana, their northern neighbors in Mali, than to that of the adjacent ethnic groups of Burkina Faso, although their villages resemble those of the Bwa and the *gurunsi* who, like them, live by agriculture.

The Bobo have many types of masks, each with a specific name, significance and function, whether made of wood or leaves (Le Moal, 1980); here we can only give a brief outline of this complex subject. Sometimes the wooden masks represent horned animals. Sometimes, as with the *karan-wemba* masks of the Mossi, they have a schematized face, two flat surfaces being pierced with eye-holes on either side of a line in relief running down the middle,

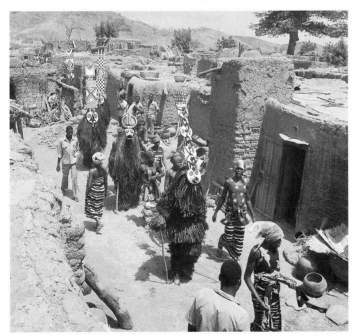

Fig. 27 Masks in a Bwa village. (Photo: M. Huet, Agence Hoa-Qui, Paris)

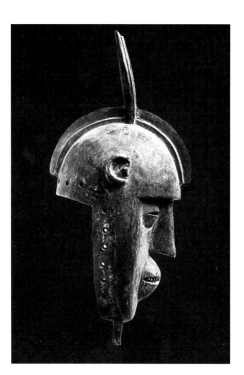

Fig. 29 *Bolo* mask of the Bobo. Height, 62 cm. Barbier-Mueller Collection

a conception that links the style of the Bobo to that of the Dogon. *Bolo* masks (fig. 29) are restricted to the northern Bobo, whose style is more akin to that of the Bamana.

Generally, the masks are brought out at times of agrarian rites, initiation ceremonies, or funerals (fig. 30). According to Roy, "the masks made of leaves represent the initial form of Dwo," whose worship may be compared to that of Do among the Bwa; in the beginning, Dwo and Do were the sons of the creator God, who sent one of his children to men in order to help them.

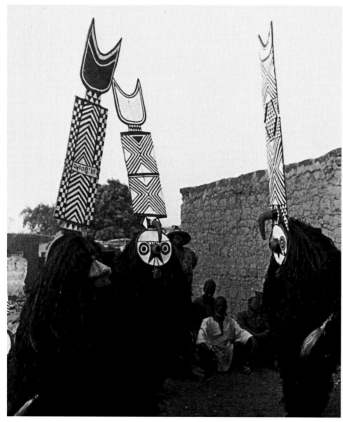

Fig. 30 Bwa masks during a funeral dance. (Photo: From Roy, 1985)

THE LOBI

Finally, in the region where the Black Volta winds through southwestern Burkina Faso, the majority of the population is made up of the Lobi, who emigrated from Ghana about 1770 (Meyer, 1981); sixty percent of this ethnic group live in Burkina Faso, the remainder in Cote d'Ivoire. The Lobi do not have masks, but they make a great many sculptures, sacred objects called *bateba* (fig. 31), figures which should not be considered effigies of ancestors, although they apparently have a status between supernatural beings and humans. Some types of figures are made in pairs; these represent twins, not man and wife. The Lobi are skilled metalworkers, and they make a great deal of jewelry, amulets and talismans of brass and bronze, created by the lost-wax process. A. M. V.

THE TUSYAN

The Tusyan are a small group of about 22,000 that lives in the extreme southwestern area of Burkina Faso between Orodara and Banfora. They are surrounded by the Sembla and Bobo who live to the northeast, the Karaboro and Tyefo (Senufo groups) to the southeast, the Turka and Syemu to the west, and the Senufo to the north. The Syemu are very closely related to the Tusyan.

Their major town is Toussiana, on the road from Bobo-Dioulasso to Banfora. Other large villages are Kurignon, Tapoko, and Tagaledougou. About half of the population of the town of Orodara, in Syemu country, is Tusyan.

Like most of the groups in Burkina Faso, the Tusyan are heterogeneous, with numerous variations in cultural characteristics despite their small population. The northern Tusyan are the oldest inhabitants of the area, and call themselves Tento. The southern Tusyan, near Toussiana, call themselves Win. However, the Djula name "Tusyan" (people of Toussiana) is used widely.

The Tusyan are closely related to the Senufo, and they speak *winwen*, a Voltaic language very similar to that of their Voltaic neighbors. Their villages, kinship patterns, political systems, and religious beliefs are similar to those of the Senufo-related groups who are their neighbors to the west. C. R.

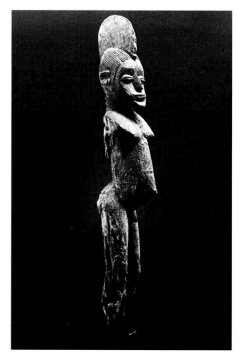

Fig. 31 *Bateba* figure of the Lobi, Burkina Faso. Height, 69 cm. Barbier-Mueller Collection

18 Figure

Mossi, Burkina Faso

Wood; height, 67 cm

This female figure, cut from a *wemba* Mask, bears the sagittal hairstyle, ladder-shaped facial scars, pendulous breasts, and flattened planes of the face that are characteristic of the Mossi style.

Free-standing figures are owned by Mossi chiefs, the descendants of the horsemen from northern Ghana who invaded the area of the Upper Volta Rivers and imposed their rule on several farmer groups at the end of the fifteenth century. Figures are displayed at annual political ceremonies to represent the generations of royal ancestors on whom the living chief and his subjects depend for well-being throughout the year. Figures are called *ninande* (sing., *ninana*, "carved figure"). They are kept in the ancestral spirit house (*kimse-roogo*) of the chief, and are displayed once a year in his official courtyard, where the business of the kingdom is conducted.

C. R.

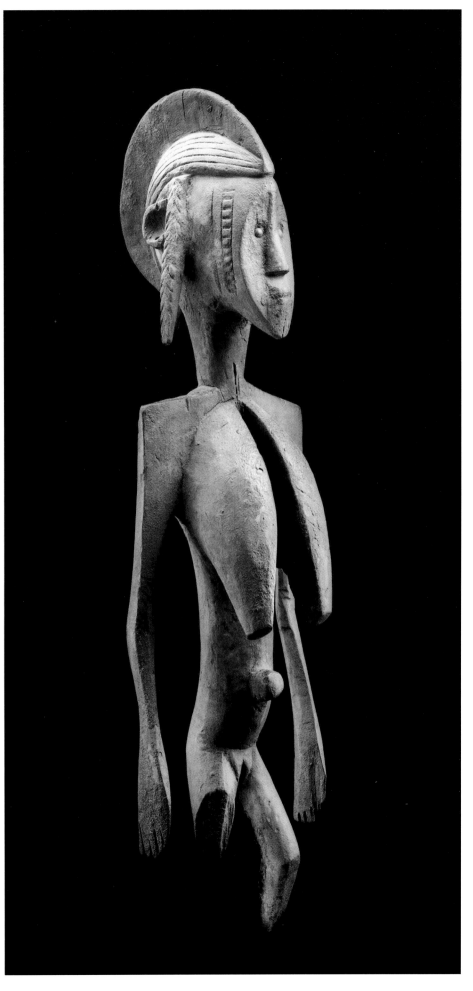

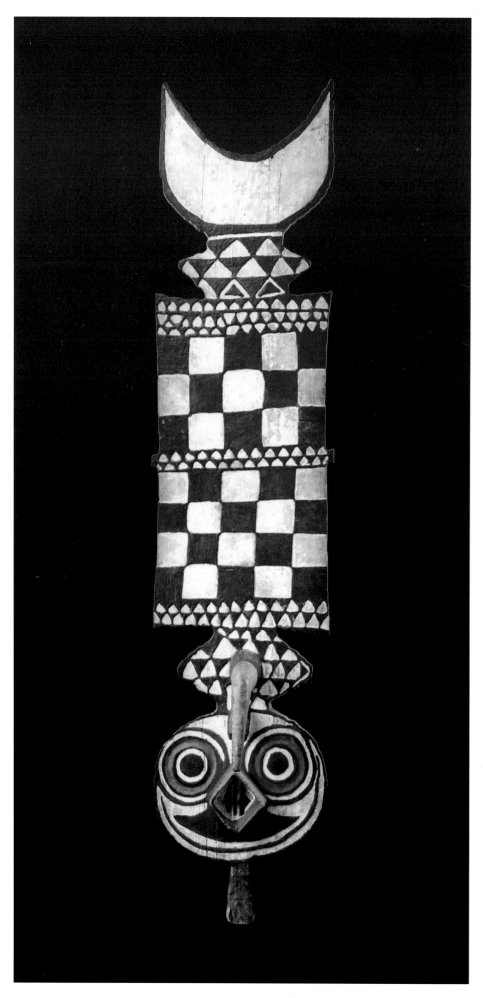

19 *Nwantantay* Plank Mask
Bwa, Burkina Faso

Wood and pigment; height, 203 cm

Masks of this type are made in this style by the southern Bwa in the Kademba area, which includes the towns of Boni, Dossi, Bagassi, and Pa.

Throughout Bwa country, masks of leaves are used in the cult of Do, the god of new life in the spring. Only in the south have some Bwa clans acquired the use of wooden masks from their Nuna and Winiama neighbors to the east. Masks of wood have nothing to do with the cult of Do. They are used in initiations, funerals, market-day performances, and other contexts. Great plank masks such as this one represent supernatural flying spirits from the bush that provide their blessings and protection to the families that own them. C. R.

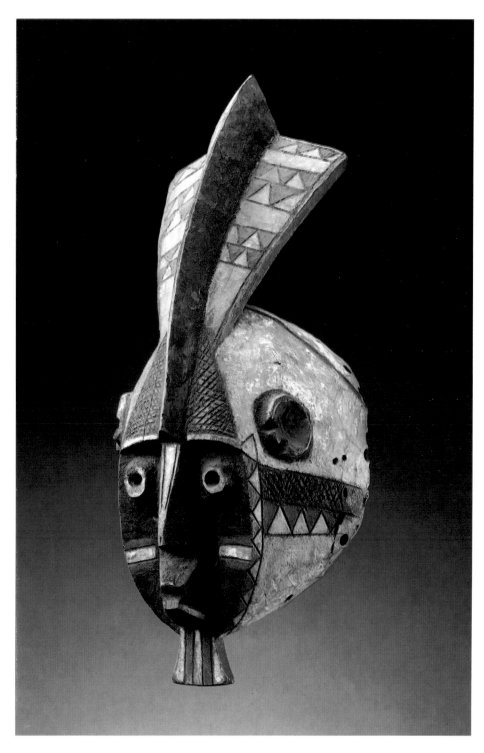

20 *Wan-Balinga* Mask
Mossi, Burkina Faso

Wood and pigment (lower projection restored);
height, 38.5 cm

This mask comes from the area of Mossi country southwest of the White Volta River, in the traditional kingdom of Ouagadougou, an area that was occupied by the Lela and the Nuna before the Mossi kingdoms were founded in about 1500. The descendants of the ancient Lela and Nuna farmers were amalgamated into the newly-formed Mossi society as a social substratum called *nyonyose*. Only the *nyonyose* use masks in the Mossi area.

This is the type called *wan-balinga*, the Fulani woman. It represents a character that appears in the myth of origin of the clan that owns the mask, usually saving the founder of the clan from death by starvation or thirst. The mask appears with a thick costume of black fibres that cover the performer to his ankles. It is decorated with large gold earrings and colorful scarves like those worn by Fulani women. C. R.

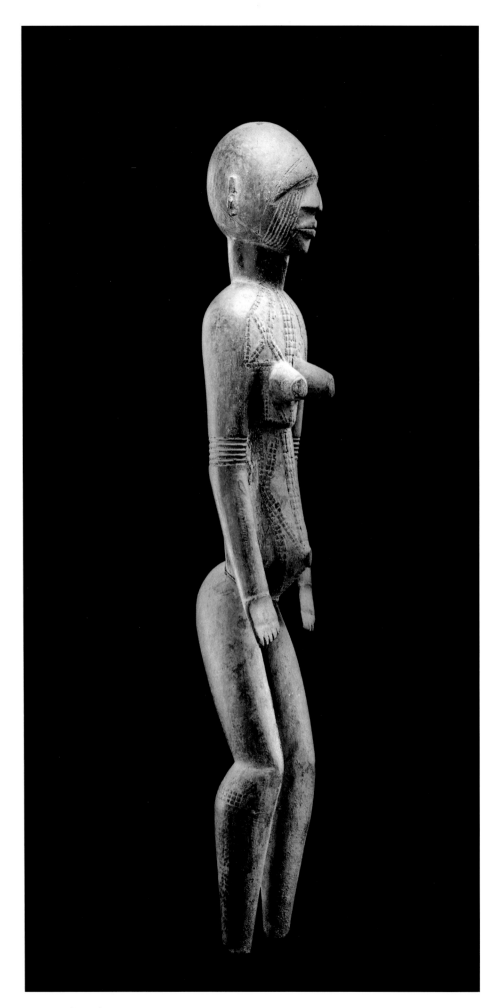

21 Diviner's Figure

Nuna, Burkina Faso

Wood; height, 83 cm

Among the Nuna and other groups in central Burkina Faso, wooden figures are owned by men called *vuru* who control a number of spirits from the wild, uncultivated bush. These spirits can be made visible in the form of wooden figures like this one, placed on shrines in the deepest, most inaccessible corners of the ritual specialist's home. Sacrifices are made on the figures and on other magical objects in order to acquire the protection of the spirit for clients: all such figures become covered with a thick layer of blood, feathers, and millet gruel.

This figure is in the style of the southern Nuna, near the town of Leo. The full, rounded head and limbs, the pose, and the face and body scars are typical of Nuna sculpture. The Nuna are one of several groups in central and southern Burkina Faso who are called *gurunsi* – a pejorative name given them by the Mossi. C. R.

22 Hornbill Mask

Tusyan, Burkina Faso

Wood, abrus seeds, cowrie shells, kaolin, and black fiber; height, 67 cm (without fringe)

Tusyan masks of this type, called *loniaken*, have small, round eyeholes carved close together high on the face and surrounded by wax, into which red seeds are set. A similar cross of seeds divides the face diagonally into quarters. The sides and lower edge are pierced with holes for attaching a fiber fringe. Some examples bear mirrors on the face that form large eyes.

The masks are worn during initiations held only once a generation (the last performance with masks took place in April 1933). They were carved by a blacksmith during the initiation period, and then became the personal property of each initiate.

Initiation has been held in two major steps: every young man and woman is initiated at the lowest level in ceremonies held every two years. Those who are not initiated may not marry. During the initiation each boy receives an initiatory name that is never used in the village and is kept secret from women and children. In order of decreasing importance, these names include the heron, song bird, hare, stork, partridge, kingfisher, panther, cat, monkey, bush pig, bush buffalo, and elephant. The name that the young man receives may be represented by the crest that surmounts his mask. C. R.

Lit.: Hébert, 1961, p. 717.

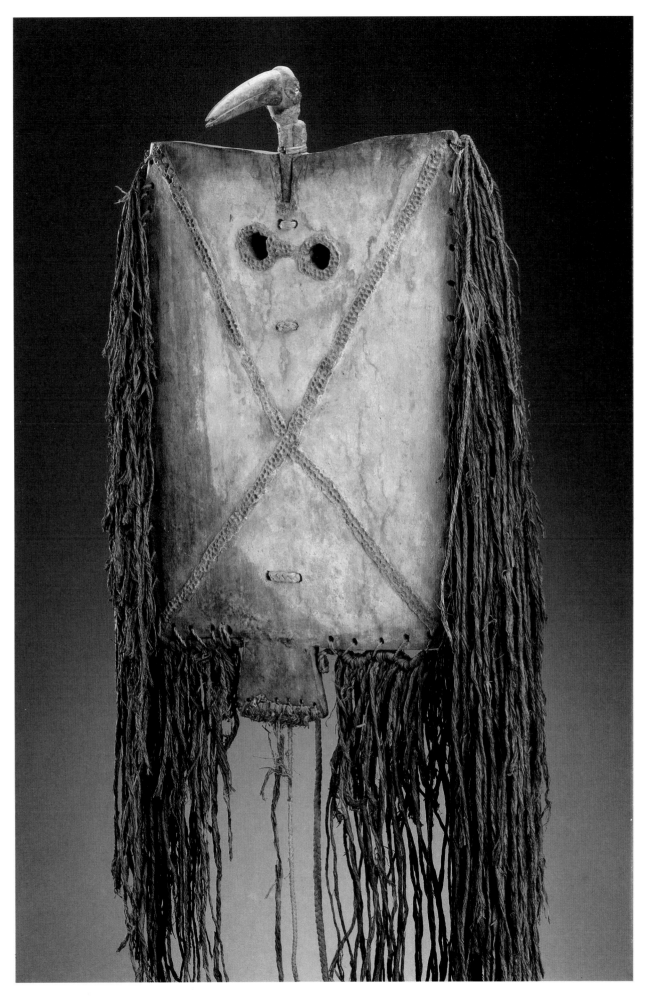

The Senufo

An established term since the first French presence in Senufo lands in the late nineteenth century, the name "Senufo" basically means "speakers of [Senufo] language," and derives from the Malinke word *fo*, "to speak," and Senufo language words such as *syëën*, meaning "person" and "speech." Formerly occupying more territory than is now the case, the Senufo peoples once lived nearly as far north as San in Mali and, along with the closely related Dogon, were probably part of the cultural conglomerate that over a millennium ago occupied lands now associated with the Inland Niger Delta culture. Today the Senufo number around one-and-a-half million people, including the northern language branches in Mali (about 683,000) and Burkina Faso (100,000), and the central and southern branches of the Senufo in the Cote d'Ivoire (over 700,000).

Senufo traditional culture is based on subsistence agriculture supplemented by hunting and inextricably linked with western Sudanic blacksmith technology. The *fononbele* (blacksmiths), in particular, have been an integral part of central Senufo culture, the setting for most of the pieces in this exhibition. Equally "Senufo" in language and cultural history are the *kulebele* (wood-carvers) who, over the past 170 years or more, have slowly shifted from Senufo patrons in southeastern Mali to those living in the northern Cote d'Ivoire. Blacksmith and *kulebele* sculptors (fig. 32) are both represented in the Barbier-Mueller collection. Senufo arts celebrate the ethics of hard work and submission to deity and properly instituted authorities (temporal and spiritual), particularly as these pertain to family and age-grade hierarchy and leadership and to commitment to the shared beliefs and goals of the community. A. J. G.

Fig. 32 Senufo dancer wearing a so-called "fire-spitting" mask. (Photo: M. Huet, Agence Hoa-Qui, Paris)

23 Figure

Senufo, Cote d'Ivoire

Wood; height, 118 cm

A very beautiful example of Fodombele sacred sculpture, this female "Child of Poro" (literal translation of the Fodoro language name, *pombia*) and her male partner were once the proud inheritance of one of the two principal sacred grove societies in the ancient village of Lataha, a few miles from Korhogo. Lataha is one of three important enclaves of Fodombele situated among the *cebara* dialect speakers of Central Senari and near what was to become the seat of the Tyebara paramount chiefs, now known as Korhogo. The people of Lataha are, in fact, a northern extension of the main settlements of Fodombele, located primarily in Dikodougou district, and belong to the Southern Senufo language family.

The Fodombele "Children of Poro" (*pombibele*, pl.) pairs are intended primarily for the commemorative funerals of important elders of the Pondo society. They appear in rituals that serve to initiate the deceased into the society of ancestral spirits and, simultaneously, to recall the ancestral lineage of those who have gone before – ultimately, the first ones, the primordial couple created by God. The Fodombele primordial couples are one of the few cases where one can accurately use the term "rhythm pounder" to refer to the large-scale primordial couple figures once found widely throughout Senufo land. In most instances the setting for such pairs is a purely architectural one. Fodombele pairs are carried in procession by Pondo society initiates, who swing them slowly from side to side, occasionaly striking the ground in response to the musical patterns of horn and drums. A. J. G.

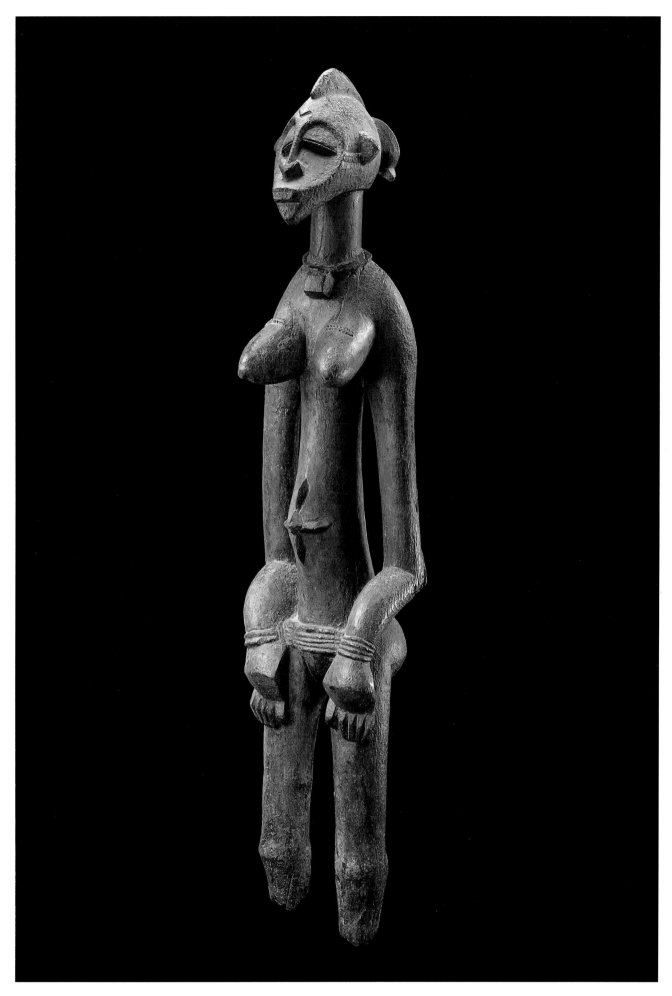

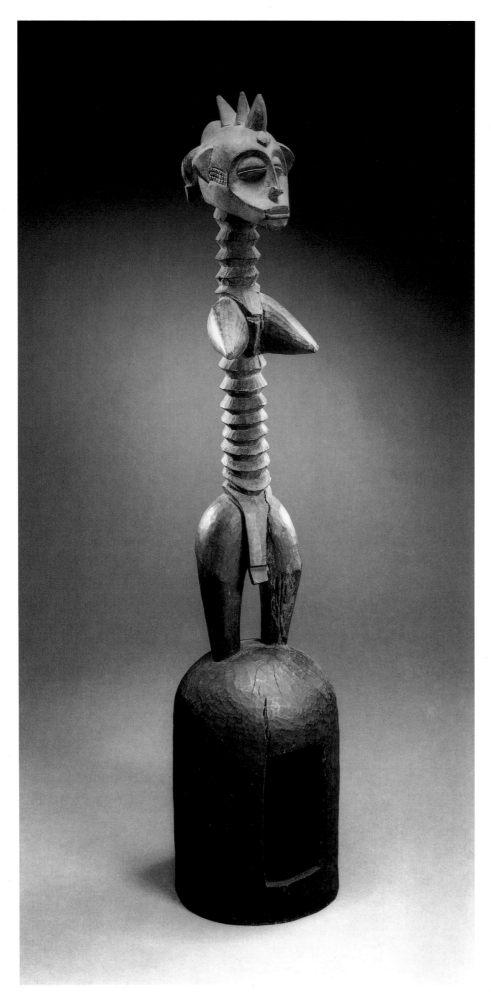

24 Helmet Mask with Figure
Senufo, Cote d'Ivoire

Wood; height, 102.5 cm

The Barbier-Mueller piece is one of a small group of such masks that were brought out of the Ivory Coast mainly in the 1950s, this one in about 1950. The first known pair was obtained by Maesen in 1939 from a "village near Korhogo," the ethnic group unspecified. Although Holas identified it in 1957, the Goldwater text confuses the issue by naming the "Kiembara faction" (that is, Tyebara, *cebara*) as the provenance. Briefly, the mask type appears to be restricted to a few Fododon (Fodombele) villages in the environs of Korhogo. The major part of this Southern Senufo language group lives in the Dikodougou district, where there is no evidence of this mask type in their traditions.

The one truly remarkable feature and the stylistic hallmark of these coupled helmets is the innovative and thought-provoking treatment of the neck and torso. First to be noted is the basic form of the two-faceted neck "ring," a Western Sudanic formal convention at least eight hundred years old, as evidenced by the armbands on some Inland Niger Delta terra-cottas. The rhythmic repetition of this module, with its lively zigzag contours, is in a sense the epitome of Senufo style, which is marked by exceptional plasticity combined with an energetic counterpoint of curve and angle. A not inconsiderable number of Senufo figure sculptures incorporate this module or a multiplication of it in substitution for the more common columnar neck style. What is unique in this highly localized tradition is the sculptors' extension of the motif into the torso, resulting not only in a form of visual interest, but in one that inherently points to the realm of Senufo thought.

Not used at ordinary funerals, these masquerades appear only at the "Great Funeral" (*kuumo*), an all-community festival to commemorate the important elders who have died over a four- or five-year period. The masquerade couple and their escorts encircle the entire village, a fusion of image and act that symbolizes the continuity between the living and the multiple ancestral dead, and honors those village men and women recently "initiated" into the realm of the dead. A. J. G.

Lit.: Goldwater, 1964; Holas, 1978.

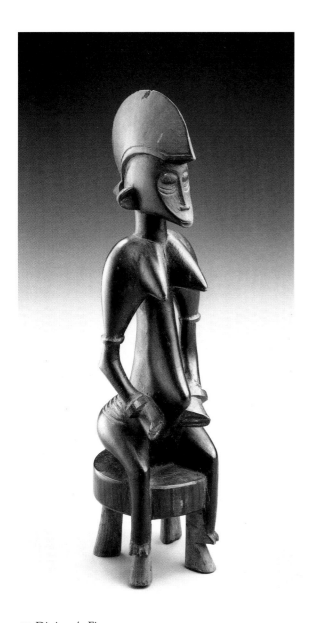

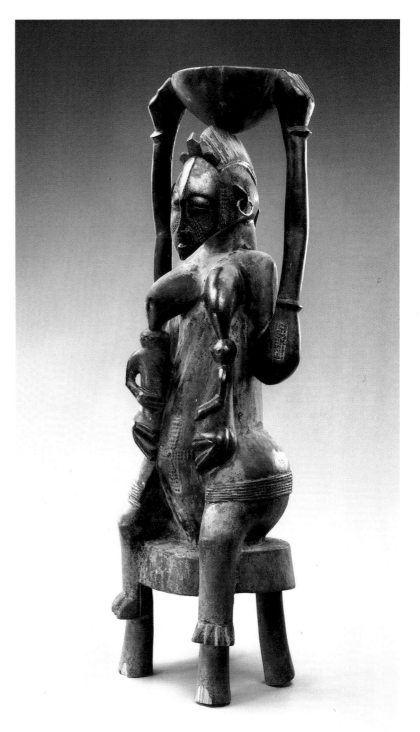

25 Diviner's Figure

Senufo, Cote d'Ivoire

Wood with Inagaki base; height, 31 cm

This elegant divination figure was probably once accompanied by a male partner, either standing or in equestrian pose. It may be noted that there exist in a few private collections equestrian figures in the same family workshop style and possibly by the same hand. The couple both represents and houses named spirits believed to maintain special communication with the diviner as a result of his or her continual sacrifices, abstinences, and other ritual observances. The pair of sculptures is carefully arranged by the diviner in a meaningful realtionship with other divination objects each time he or she receives a client. The style is classical *kulebele*, specifically, an ancient style that *kulebele* sculptors tend to associate with the Niéné area, that is, the upper Bagoé River Valley to the west of Kouto and Kolia in the northern Cote d'Ivoire A. J. G.

26 Nursing Female Figure

Senufo, Cote d'Ivoire

Wood; height, 65 cm

The figure has been generously oiled with shea butter by an untold number of Poro initiate classes, and then at some point liberally covered with a chalk-based white paint. A symbolically charged color, white is sacred to Sandogo (society of women diviners) and, in the context of Poro, evokes the supernatural resources of women as defensive agents against sorcery. There are also remnants of red ocher ritual paint spots typically used by Poro societies of the Senambele farmers. Subtly hidden in the bowl support on the figure's head is an upside-down antelope horn of the type used to contain magical substances. In brief, this is no ordinary mother, offering mere food, but an awesome woman of emblematic stature who holds magical knowledge and power as a crown above her head. A. J. G.

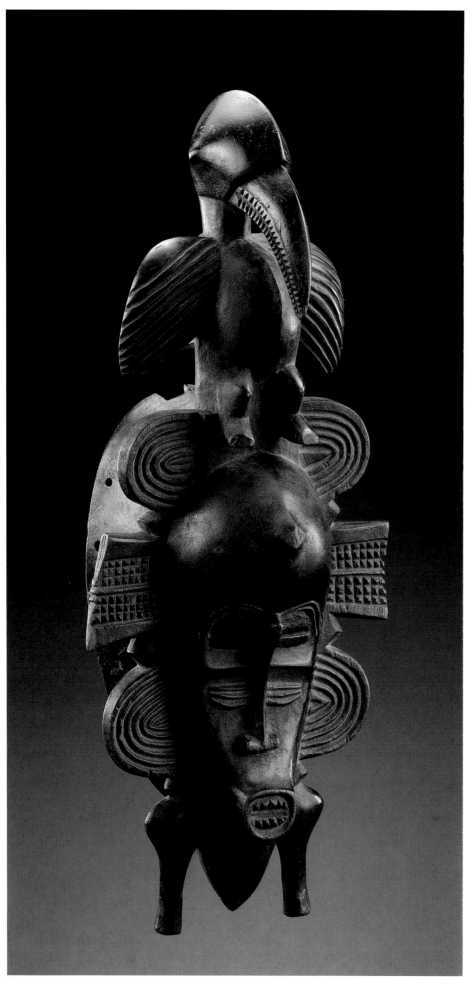

27 Face Mask

Senufo, Cote d'Ivoire

Wood; height, 37.5 cm

This very beautiful example of the Senufo face mask, called *kpeliyë'ë* by the *kulebele* sculptors, presents some intriguing features as regards style and provenance. Although the hornbill is the single most common center crest motif in *fononbele* (blacksmith) face masks, this rather plump and stylish version, with its elegantly tailored wings and its comfortable perch, reflects *kulebele* aesthetic taste rather than the more severely iconic approach favored in blacksmith circles. Further, the exquisite care and precision of the workmanship suggests that the mask was more likely to have been commissioned for use by initiates with Sacred Grove prerogatives (Dyeli or Tyelibele, Fodombele, and the *kulebele* senior classes) rather than by a junior grade class of blacksmith initiates.

Two stylistic features focus attention on the *kulebele* and what might be called the three-corner region, where Mali, Burkina Faso, and the Cote d'Ivoire meet. First, the treatment of the hornbill's beak, with its serrated, notched, or dentate bill, is an iconographic feature that is found especially among the Gur groups of the "three-corner" region, including the Bwa and Nuna groups in Burkina Faso and the Senufo of the Bagoe River Valley below the Mali frontier. Furthermore, the Barbier-Mueller mask is closely related to a Senufo mask collected by Lem in 1934 in the Sikasso region in southeastern Mali (the Sucite dialect area). The hornbill of Lem's mask has the same scale and position, as well as the same finely chiseled grooves on the down-turned wings. Both sculptors use a chip-carved grid filler and a half-disk filled with concentric grooves for the side ornaments, all executed in the same technically precise manner. These similarities indicate that the Barbier-Mueller mask was carved by a *kuleo* (singular of *kulebele*) master working within a pariticular family style, one descended in direct line from a branch of the *kulebele* whose style may be traced back to the beginnings of *kulebele* migration from Mali into the northern Cote d'Ivoire. Thus, Lem's mask could have been carved by a member of a *kulebele* settlement in the southeastern corner of Mali, while this one could have been carved by a *kuleo* trained within the same family style but in workshops that had moved to more recent settlements in the Cote d'Ivoire.

A. J. G.

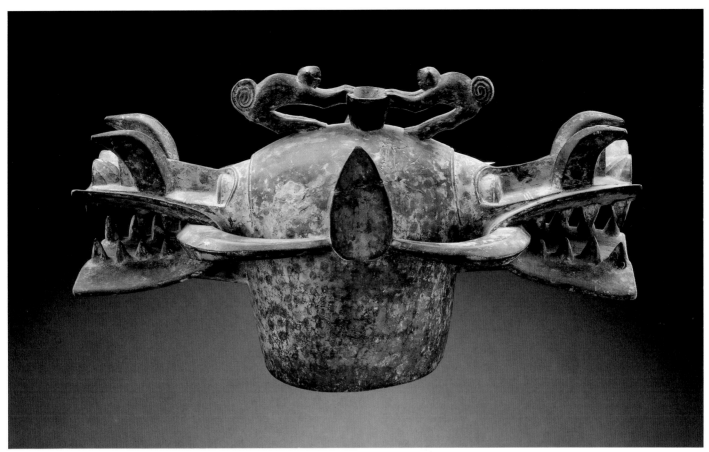

28 *Waniugo* Janus Mask

Senufo, Cote d'Ivoire

Wood, traces of pigment (these masks were frequently repainted); breadth, 74 cm

Though tempered here by the roundedness of the forms (an indication of Nafara origin), the menacing appearance of this *waniugo* jaw mask – bristling with teeth and tusks – tends to overshadow the little bowl on top held by two chameleons. This arrangement is essential, however, since it determines the mask's function. Wrapped in a leaf, the potent substance *wah* was placed in the bowl to give the mask its power *(war)*; the *war* emanating from the mask is supposed to have extraordinary effects, provoking illness, adultery, or death, triggering off lightning, influencing the stars.

The *waniugo* is only one component of a complex known as *waho*, which is created by the combination of the mask, the costume of strips of cotton cloth often painted with geometric designs, the wearer who animates the mask and strikes effective poses, the drummers and bell-ringers who accompany him, and the interplay with other masks of the same type.

Because of their reputation for aggressiveness, a great many of the small male *wabele* societies, who used these masks, were broken up between 1950 and 1955, as the *masa kura* cult spread; the movement never recovered from this setback. However, it appears that these secret societies, despite their heterogeneity all associated with the *poro* initiation cult, did not pursue any evil designs. It is more likely that, following the Senufo vision of a double universe, the function

of the *wabele* was, through the fear that they inspired, to gain the collaboration of the supernatural powers in the preservation of a well-ordered social system, powers that were the product of research that set out to explore the "great universe", where, in contrast to the trustworthy, predictable, and determined "human perimeter," causality is uncertain and anything is possible. The function of the *wabele* was in agreement with the perfectly structured system of organization that characterizes the Senufo world. G. B.

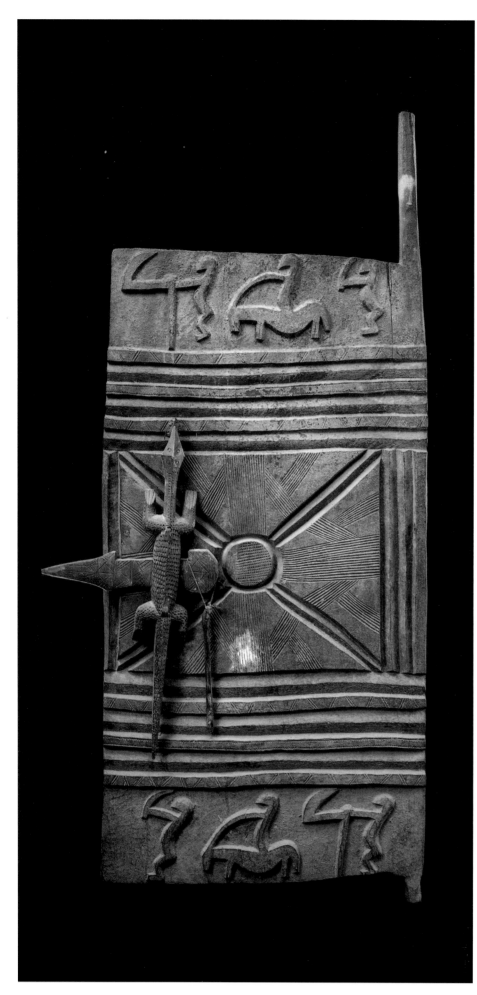

29 Bas-relief Door

Senufo, Cote d'Ivoire

Wood; height, 160 cm (with hinge pins) and 130 cm (without hinge pins)

Virtually the entire corpus of Senufo bas-relief doors comes from the Bagoe River Valley, along the Tingrela-Boundiali axis where the *kulebele*, or *kulele* (sing. *kules*), have dominated sculptural production for most of the twentieth century. Most doors were commissioned by *katyëënëfölö* ("owners of occult knowledge"). Bas-relief door sculpture is one of the more specialized skills among *kulebele* carvers and is therefore practiced by a relatively small percentage of their number. Three master-sculptors known to have established considerable reputations in this field were the master Yaagalo Koné of Ouazomo (the "Yalokoné" first reported by Maesen), who was in his prime in the 1920s, the master Sabarikwo, also born in Ouazomon, and the master Nyaamadyo Koné of Kolia. All three worked in a closely related style and all traveled widely throughout the region.

The Barbier-Mueller door is somewhat outside that particular family style, but a door by the same hand is in the collection of the National Museum, Abidjan. Both doors feature an especially fine sense of graphic design. The treatment of the central panel is simpler and less three-dimensional than those carved by the three masters mentioned above, and there is a restful quality to this unknown sculptor's handling of proportion, linear rhythms, and space. The delicately engraved lines against the central ground form a pattern of interlaced bands of V-shapes overlaid by a cross of vertical and horizontal bands that meet to form a crosshatch for the inner circle of the door. The panel itself is bordered by six repeating horizontal bands of subtly alternating depth, on which a running zigzag pattern is lightly etched. The remaining space above and below the abstract panel and borders is given over to a modest pictorial scene of three warriors. The overall sense of restraint contrasts noticeably with the more ornate styles of Yaagoalo and Nyaamadyo. However, the style of the warrior figures indicates some connection with the Kolia/Ouazomon group, both being characterized by the same energetic cursive rhythms in the warriors' silhouettes. The maternal nephew of Nyaamadyo explained that it was impossible for a *kuleo* to carve a bas-relief door without one or two year's apprenticeship to a master of the genre. The nature of the connection, which may involve yet a third workshop common to both, is not yet known. A. J. G.

Lit.: Holas, 1978, pl. 99; Goldwater, 1964, fig. 57.

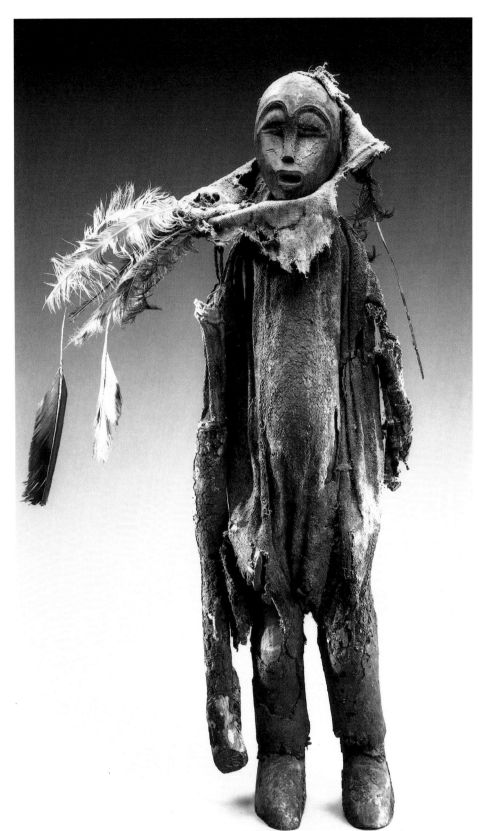

30 *Kafigelejo* Figure

Senufo, Cote d'Ivoire

Wood, feathers, and quills; height, 73 cm

Virtually every single Senufo ethnic group, village, and secret society created a visual tradition that is uniquely their own. This may be something that escapes outside notice or, as in the case of the *kafigelejo* figure type represented here, it may be so striking in formal values and imagery that it captures the attention and imagination of Western eyes. Certainly, an appreciation of the expressive qualities of *kafigelejo* sculpture has required new twentieth-century perceptions of what can be legitimate artistic media. This particular piece is a somewhat off-beat example of the type, which at its best projects a visually powerful image.

The *kafigelejo* is an occult spirit figure that is believed to have redoubtable powers of judgment, punishment, and wickedly aggressive sorcery. According to Richter, this cult object is said to be "uniquely Kulebele" and is used only by an initiated elite of Kulebele elders. Its name, which includes the injunction "tell the truth!," indicates the judicial aspect of the supernatural sanctions directed against offenders and enemies. An aura of mystery, cloaked dangers, and ominous forces is creatively achieved by a combination of stylistic and iconographic devices. The carved figure is always covered with a costume that closely resembles a generic Senufo fiber masquerade of woven country cloth, usually with ritual paint spots or circles and featuring a triangular sack mask. This masquerade type invariably carries sticks and a club or small whip, insignia identifying the mask's policing authority and serving as the very instruments of enforcement. The "weapons" of the *kafigelejo* are intended as instruments of supernatural power that can be directed against a specific victim, a theme reinforced by what was once a fearsome accumulation of spell-casting feathers and quills attached to the sack mask. This piece has obviously been stripped of its mask, an act that has destroyed part of the original aesthetic effect but that has, at the same time, revealed the unexpected simian features of the inner figure. A. J. G.

Lit.: Richter, 1980, p. 57 f.; Glaze, 1975.

The Inhabitants of the Bondoukou Region

The Bondoukou region, located in the northeastern Cote d'Ivoire (formerly Ivory Coast), is inhabited by several ethnic groups that do not occupy clearly defined territories and whose cultures often intermingle.

THE DYULA

Speaking a Mande language, these Moslem traders and clerics have been largely responsible for the spread of Islam throughout the Volta Basin. In the northeastern Cote d'Ivoire they have dominated the commercial life of communities such as Bondoukou and Bouna for over four hundred years.

THE LIGBI

Another important Moslem Mande people, Ligbi merchants penetrated to the very edges of the Cote d'Ivoire and the Ghanaian forest by the late sixteenth century, when they became actively involved in the gold and kola nut trade. Today they form an important population in the Bondoukou region.

THE HWELA

An ancient Akan people indigenous to the Cote d'Ivoire-Ghanaian border just north of the forest, the Hwela were deeply influenced by the Dyula and Ligbi and gradually converted to Islam. Their major communities today are Sorhobango in the Cote d'Ivoire and Namasa, twenty-five miles to the east of Bondoukou, in Ghana.

THE NAFANA

A Gur culture, the Nafana are a Senufo-related people who are immigrants to the Bondoukou region and the neighboring district of Banda in Ghana. A farming people, they are at present found in villages north of Bondoukou and as far east as the Banda Hills.

THE KULANGO

From the area around Bouna in the northeastern corner of the Cote d'Ivoire, the Kulango, another Gur culture, have gradually spread into the Bondoukou region. Primarily farmers, they were actively engaged in the gold extraction industry in this region during the eighteenth and nineteenth centuries. R. A. B.

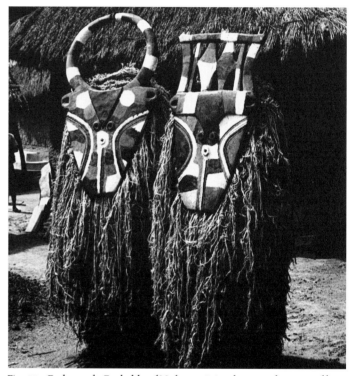

Fig. 33 Bedu mask. Probably of Nafana origin, these masks are used by various ethnic groups in the Bondoukou region. (Photo: R. Bravmann)

31 Bedu Mask

Hwela, Cote d'Ivoire

Wood; height, 152 cm

In many villages north of the town of Bondoukou in the eastern Cote d'Ivoire one encounters impressively scaled masks known as Bedu. They are among the largest masks in Africa, yet the tradition is one of the youngest, for according to local accounts, the Bedu was inspired by Nafana sculptors at Ouliké in the 1930s. Patterned upon an older masquerade, the "great inland fetish" Sakrobundi or Sakarabounou, an anti-witchcraft cult suppressed in the 1920s by colonial officials and missionaries, the Bedu emerged as a highly public manifestation free of the sinister trappings of its predecessor. Celebrating traditional family and village values, Bedu proved irresistible, spreading rapidly among neighboring Nafana, Kulango, and Hwela communities to help allay the anxieties resulting from colonial rule.

Of the two Bedu in the Barbier-Mueller collection, this male mask, with large graceful horns that enclose a small crescent shape within their sweep, is almost certainly the work of Sirikye, an important Hwela sculptor in the Cercle de Bondoukou in the 1960s. It is virtually identical to the male Bedu that Sirikye carved for his own village of Sorhobango, and shares with that mask a careful weighting of the face and horned superstructure, generous and bold patterns of black, ocher, and white paint, and highly concentrated eyes and mouth, framed in earth tones, that rivet the viewer's attention.

R. A. B.

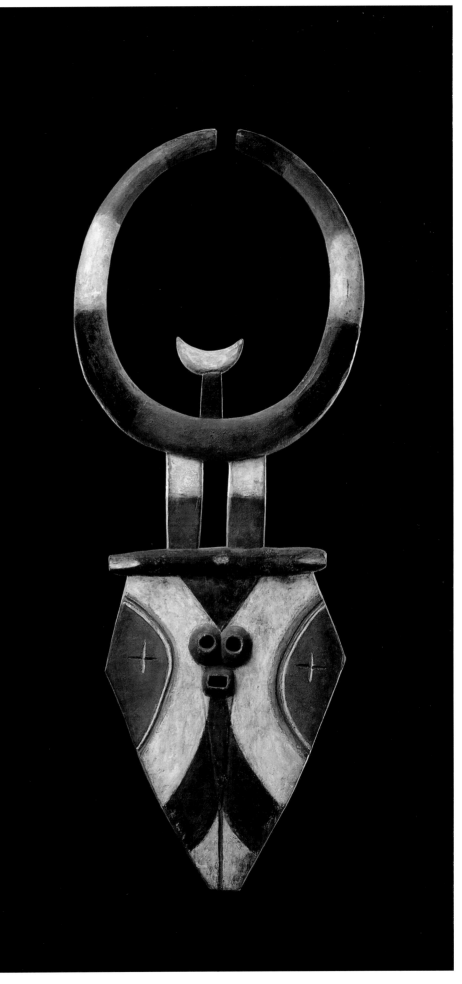

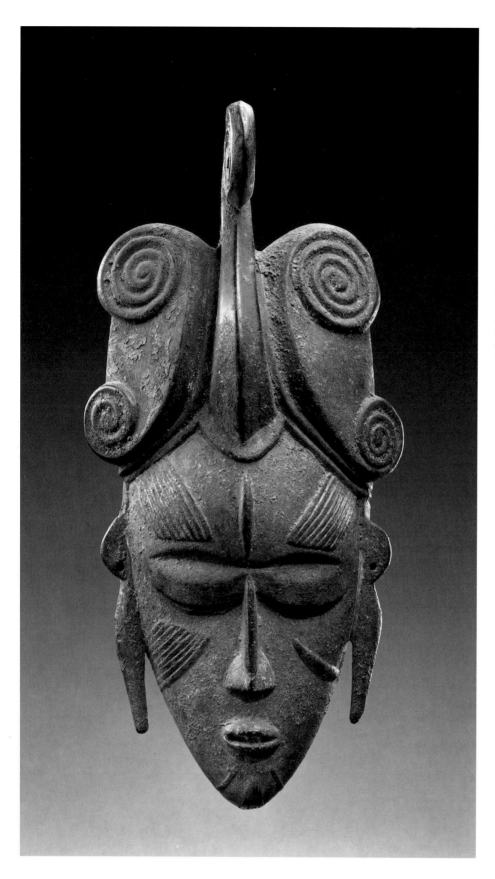

32 Face Mask

Ligbi, Cote d'Ivoire

Wood; height, 33.8 cm

To the east and south of Senufo country live three representatives of Mande civilization – the Dyula, Ligbi, and Hwela. Ancient Moslem populations, they have come to dominate the religious and economic life of towns such as Kong, Bouna, and Bondoukou. Within many of these communities is a masking tradition called Do (or Lo). This face mask is strikingly similar in form to the Senufo mask known as *kpeliyë'ë.* The classic example pictured here is distinguished by its ample and refined coiffure, finely detailed scarification marks, and an overall poetic handling of its feminine features. Do or Lo masks are danced in order to celebrate critical moments during the Muslim calendar year. Regularly oiled, repainted, and beautified with gold and silver jewelry, such masks are prominently paraded during the week of celebration and feasting that follows the end of Ramadan, the month-long Islamic fast. R. A. B.

33 Hornbill Mask

Ligbi, Cote d'Ivoire

Wood, white and blue pigments and oil paint, fiber and cloth; height, 28.8 cm

This mask of the Do society was photographed in 1967 by Réné Bravmann in the Ligbi village of Bondo-Dyoula, northwest of Bondoukou; masks representing the calao, or rhinoceros bird, have not been found elsewhere.

In the other villages where Do masquerades still took place, on either side of the Ghana border, few masks of human or animal shapes have survived: two masks existed in two villages, one Ligbi, the other Hwela; six masks existed in another Nafana village. But ten masks were seen in the Ligbi village of Bondo-Dyoula: a warthog (*leu*), two nobles or ancient Muslims (*horingyo*), a sheep (*saragigi*), a thrush (*kokogyinaka*), two buffaloes (*siginkuru-ayna*), a husband of a young girl (*fendyoana*), and two hornbills (*yangaleya*).

Appreciated for its benevolent attributes, the hornbill mask (*yangaleya*) concludes the ceremony by dancing alone. The spirit which pervades the audience when this mask appears is of long-lasting benefit to the community.

Bravmann notes the rapid disappearance of the Do masks, attested since the second half of the last century. They are repainted regularly and are used only by Islamic groups – the Dyula, the Ligbi, the Hwela – either to terminate Ramadan or for funerals of important figures in the Islamic religious hierarchy. They are looked down upon by the Kulango, who consider them good only for amusement – though this has not prevented anthropomorphic masks inspired by the *kpelie* type (plate 32) being attributed to these same Kulango, to the Jimini, or even to the southern Senufo.

The Ligbi say that their masks were provided by the Mande and the Senufo from the town of Satama Sokoura, located in the Jimini area. The Islamic peoples of the Bondoukou region generally appear to have used Mande masks and not to have sculpted their own. A. M. V.

Lit.: Bravmann, 1973, p. 151, 166.

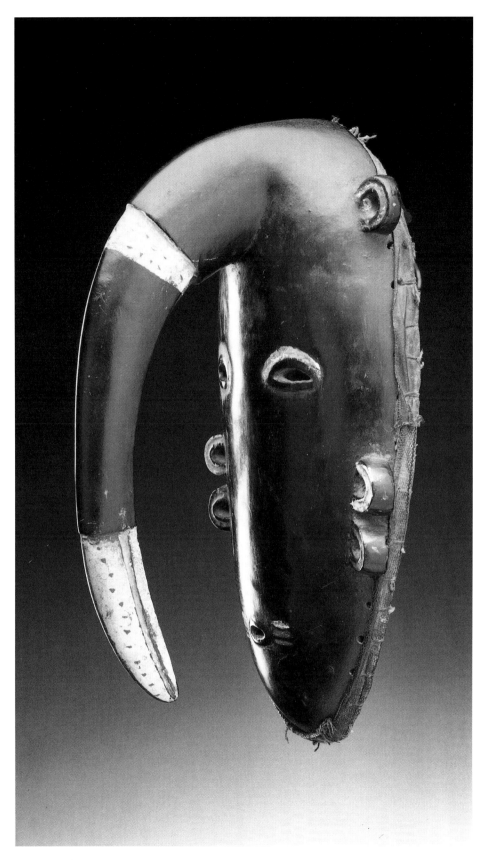

In the Komaland: An Unknown Civilization in Northern Ghana

Low earth mounds of varying diameter, encircled by large stones, are found in various countries of western Africa, notably in Senegal, Gambia, Burkina Faso, and Ghana. Mounds of this sort in northern Ghana, varying in diameter from four to eighteen meters, have been shown to be funeral monuments. A profusion of funerary artefacts has been found in the diggings, generally terracotta objects – human figures, animals, dishes – and small grinding stones. The area of the excavations lies between the Sisili and Kulpawn rivers, two tributaries on the right bank of the White Volta. It is inhabited by the Koma, who are related to the Mamprussi and speak, like them, a Voltaic language.　　　A. M. V.

Lit.: Thilmans, et al., 1980; Mauny, 1967; Anquandah and van Ham, 1986, p. 29.

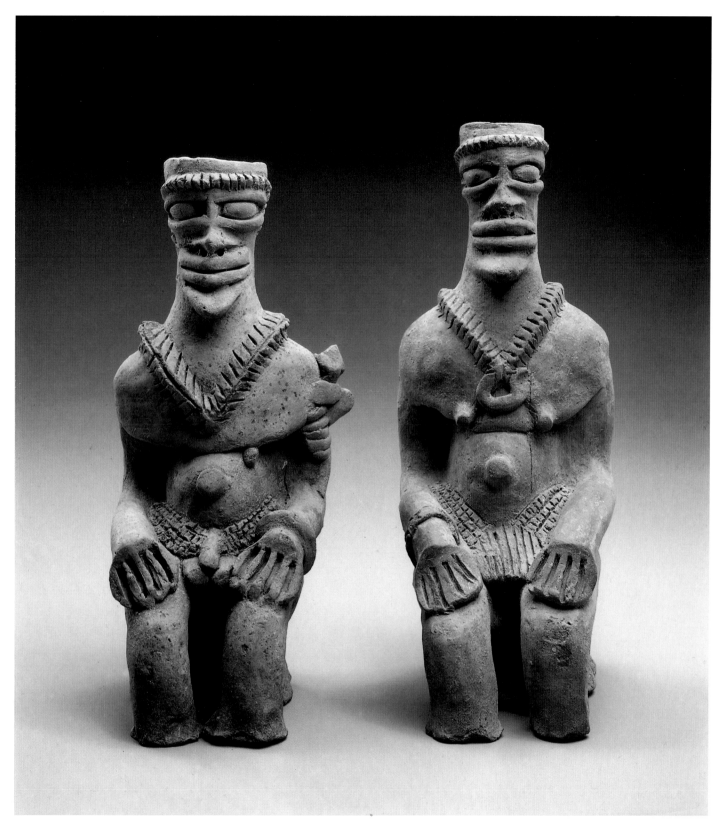

34 Pair of Memorial Effigies

So-called *Komaland culture*, Ghana

Terra-cotta; height, 23 cm and 25 cm

These two figures, which form a pair, were acquired in Paris; their provenance is not known. To date, we have no evidence of similar figures being found in mounds located outside Koma-land. Thermoluminescence dating of the ten pieces in the Barbier-Mueller collection gives ages varying between 200 and 500 years. The Koma of today do not believe that they are related to the builders of the mounds, and they call the terra-cottas *kronkonbali* ("olden-day children"). The unknown makers of the terra-cottas undoubtedly took an active part in mercantile exchanges between the coast, the Sahel, and the Sahara. Such contacts are attested by the cowrie shells, originally from the Indian Ocean, worn by certain figures and by the richness of the jewelry depicted on them. A. M. V.

Lit.: Thilmans, Descamps and Khayat, 1980; Anquandah and van Ham, 1986.

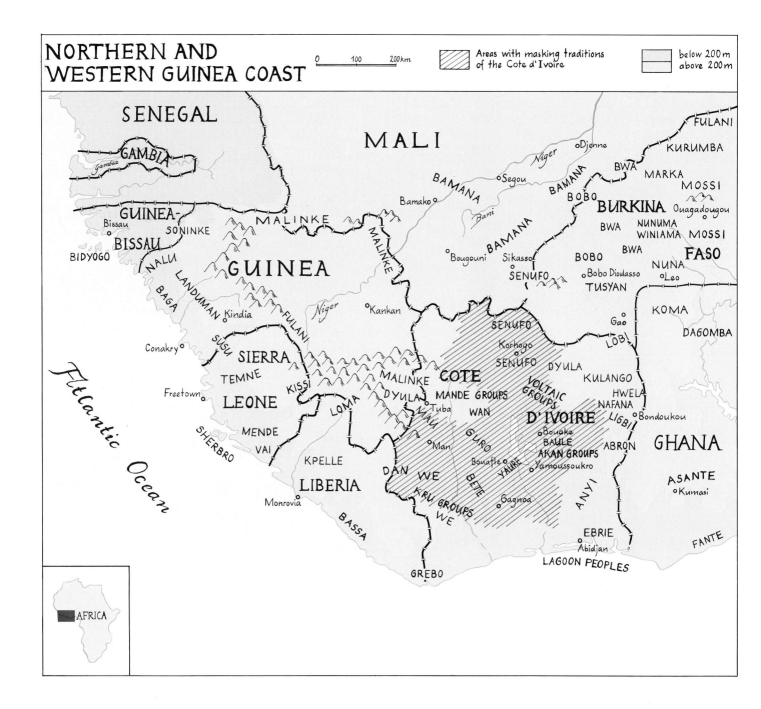

NORTHERN AND WESTERN GUINEA COAST

0 100 200km

Areas with masking traditions
of the Cote d'Ivoire

below 200m
above 200m

SENEGAL

MALI

GAMBIA

Gambia

GUINEA-

Bissau

BISSAU

SONINKE

BIDYOGO

NALU

MALINKE

BAGA

LANDUMAN

Kindia

FULANI

Conakry

SUSU

SIERRA

TEMNE

LEONE

Freetown

KISSI

LOMA

MENDE

VAI

SHERBRO

KPELLE

LIBERIA

Monrovia

BASSA

DAN

WE

KRU GROUPS

WE

GREBO

Niger

Bamako

BAMANA

Bani

Bougouni Sikasso

SENUFO

Niger

Kankan

MALINKE

MALINKE

DYULA

MANDE GROUPS

Tuba

WAN

GURO

Man

BETE

Bouafle

YAURE

Gagnoa

COTE

D'IVOIRE

SENUFO

Korhogo

SENUFO

DYULA

VOLTAIC
GROUPS

Bouake

BAULE

AKAN GROUPS

Yamoussoukro

ANYI

EBRIE

Abidjan

LAGOON PEOPLES

Niger Djenne

Segou

BAMANA

BOBO

BURKINA

BWA

BOBO

Bobo Dioulasso

TUSYAN

Gao

LOBI

KULANGO

HWELA

NAFANA

LIGBI

Bondoukou

ABRON

FULANI

KURUMBA

BWA MARKA

MOSSI

Ouagadougou

NUNUMA

WINIAMA MOSSI

FASO

NUNA

Leo

KOMA

DAGOMBA

GHANA

ASANTE

Kumasi

FANTE

Atlantic Ocean

AFRICA

GUINEA

William Siegmann

North and West Guinea Coast

Fig. 34 Figurehead of a Bidyogo dugout canoe from the Bissago Islands. Sculpted buffalo heads like this one are also represented in initiation masks among the Bidyogo. (Photo: From Bernatzik, 1933)

The term "Guinea Coast" derives from early reference to the stretch of seacoast running from Cape Verde to the Bight of Benin, a distance of some 3,500 kilometers.

As one moves from the seacoast toward the interior, it is evident that there is a broad unity to this entire region: it is a single environmental zone. For the most part, the area between the seacoast and the Guinea highlands belongs (or belonged until recently) to the tropical rain forest and mixed forest-savanna mosaic. The geography of the region has influenced its history, migration patterns, and political and social organization in a variety of ways and, consequently, has also affected the development of its principal artistic traditions.

It is impossible to give a unified picture of the art in an area so vast and populated by hundreds of different ethnic groups; indeed, the differences between the artistic creations within the region are as enormous as those between the types of political and social organization to be found there.

West Guinea Coast

The westernmost extension of the Guinea Coast region is inhabited by the ethnic groups of Guinea-Bissau (fig. 34), Guinea, and the coastal strip of Sierra Leone. The principal ethnic groups are the Bidyogo, Baga, Nalu, Landuma, and Temne. All of these groups speak West Atlantic languages, although there are major linguistic subdivisions among them.

The area has strong historical ties to the nearby Futa Jallon region in Guinea and the not-too-distant Savanna regions. The influence of the Savanna can be seen in the presence of cast brass and iron staffs of Soninke origin in Sierra Leone and Guinea Bissau, as well as in the extensive use of polychrome and bas-relief geometric carving on many sculptures. Indeed, the links with the Savanna are so strong that many art historians often couple the western Guinea Coast with the Sudanese Savanna region rather than with that of the Guinea Coast.

A multiplicity of motifs can be distinguished, including monumental masks, often with animal allusions, caryatid drums and stools, human figures, either seated or in action, and ceremonial ladles and lidded bowls decorated with figures. The vast majority of these sculptures is directly associated with the various socio-religious societies found in the region.

Southern Sierra Leone and western Liberia are inhabited principally by the Sherbro, Bullom, Krim, and Gola, who speak Mel (Southern West Atlantic), and by the Mande-speaking Vai and Mende. Prior to the sixteenth century, this region shared strong cultural ties with the northern coastal region. The Sapi ancestors of the present Mel-speaking inhabitants produced the archaeological stone carvings found in the region (commonly called *nomoli* in Mende or *pomdo* in Kissi) as well as the "Afro-Portuguese" ivories from Sherbro Island. Both of these traditions were terminated by the invasions of the "Sumba-Mani" Mande-speakers in the sixteenth century. Stylistically, they are more closely related to works from the northern coastal region than to the contemporary art of the region.

The most important art works produced here in the nineteenth and twentieth centuries are wooden helmet masks (fig. 35). Both men's and women's masks are known, but women's masks are not only much more numerous but also far more significant socially. They are the only example of the use of wooden masks by women documented in sub-Saharan Africa. Women's masks, and the vast majority of men's,

Fig. 35 Masks of the Bundu initiation society of the Mende in Sierra Leone. (Photo: From *Customs of the World*, ed. W. Hutchinson [New Dehli, 1912-14; repr. 1985], vol. 2, p. 771).

are black in color, although isolated examples of polychrome men's masks are known. Costumes are invariably made of raffia fiber. Figures, staffs, and fiber masks are of secondary importance. The style is basically naturalistic, with soft and rich detailing carved in low relief on forms that are somewhat swollen.

To the northeast, in the heavily forested highlands of northern Liberia and southeastern Guinea, and in the adjacent savanna areas, live the Loma (Toma), Bandi, Mau, and Koranko – all Mande-speakers – and the Mel-speaking Kissi. These groups have all had strong historical links with their Manding neighbors to the north, links that are clearly reflected in the forms of their sculpture and in their social organization.

Figurative sculpture is rare and rudimentary. It is normally associated with divination or personal protection, and never publicly exhibited. All of the region's sculpture is characterized by a marked angularity of forms. The dominant mask form is a three-part sculpture, usually quite large and flat, with an elongated mouth and horns projecting from the rear, all carved from a single piece of wood. Some masks are worn on the back, but most are worn horizontally or at a slight angle over the face. The masks often have additional elements, including fur, feathers, and "medicine" bundles containing metal or stones, to give added "power." The costumes of these masks are complex, often including elaborately worked leather elements along with cloth and raffia.

In those areas of the Loma and Kpelle (Guerze) where true face masks are found they have been borrowed from the peoples of the central forest region to the southeast, but show the angular forms characteristic of other Loma and Kpelle sculpture.

All masks in the region are communally owned and controlled by the men's societies, of which the Poro is the most widespread and dominant.

To the south, in the Cavalla River basin, lies an area that is one of the most prolific art-producing regions in Africa, with an enormous range of mask types as well as a multiplicty of other sculptural forms, including figures, figurative gameboards, ladles, elaborately decorated wooden bowls, and other household utensils, together with figurative brass objects and vast amounts of brass jewelry. The dominant sculptural form, however, is undoubtedly the face mask (fig. 37). Nearly a dozen different ethnic groups, including the Dan, Ma, Tura, Kono, Wé, western Bété, Niabwa, Grebo, and Bassa (fig. 36), have all adopted and adapted this form and produced a bewildering number of variations.

Fig. 36 Bassa helmet mask. In addition to face masks, groups like the Bassa, who speak a Kru language, have borrowed the helmet masks of the Mende and the Vai, who live further north along the coast. Height, 36 cm. Barbier-Mueller Collection

Fig. 37 Dan mask from Liberia. (Photo: From Thompson, 1974, p. 161, fig. 198)

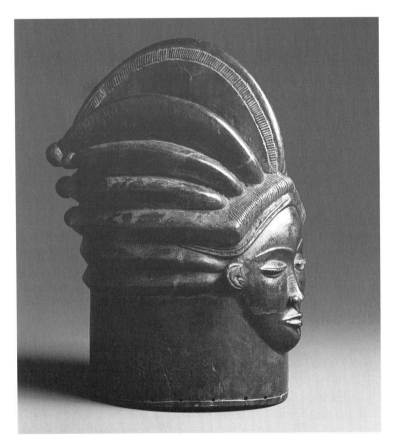

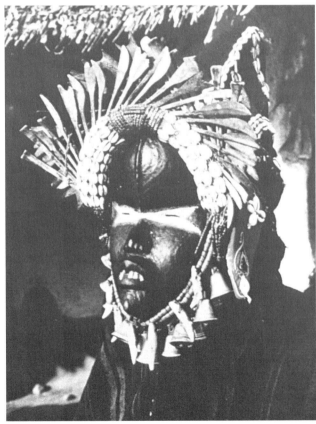

Fig. 38 Akan royalty (northeastern Cote d'Ivoire) performing a ceremonial dance during the yam festival. (Photo: Monique Barbier-Mueller)

Broadly speaking, the mask types fall into two categories: an oval-shaped, slit-eyed, delicately featured "feminine" form and a generally larger, more angular "masculine" form with round or tubular eyes and often with a large, elongated or open mouth and overhanging brow. Each ethnic group produces variations on these themes and there is much cultural borrowing. Form only broadly follows function, and the range within ethnic groups is so great that the distinctions between individual artists and workshops are often as important as those between different ethnic groups. The masks are owned by individuals and lineages rather than by collective societies such as the Poro, which exists only on the extreme northwestern periphery of this stylistic region.

Central Guinea Coast

Moving eastward into the central portion of the Cote d'Ivoire (formerly Ivory Coast), we are presented with a series of interesting stylistic problems. This region includes the eastern boundary areas of the West Atlantic rain forest and the extentions of the northern savanna. It is home to the Guro, Wan, eastern Bété, Yaure, Baule, and Lagoon ethnic groups. These groups belong to four major language divisions and have radically different types of social and political organization, ranging from acephalous village democracies to strongly hierarchical monarchies. The northern groups (Wan, Guro, and Bété) concentrate almost exclusively on wooden masks that are mostly seen in pairs, the male form frequently combining round eyes, horns, large open mouths, and animal features, and the female form having slit eyes and small mouths. Masks often appear in ensembles of both humanoid and animal-like forms, frequently polychromed.

The masks, the rarer examples of figurative sculpture, and heddle pullies for weaving show a tendency to realism that includes a love of minute three-dimensional detailing.

The wood sculpture of the Baule and Lagoon groups shares such stylistic features as naturalism and intricate detailing with that of the Guro and Wan, but focuses less on masks than on figurative sculpture for personal rather than communal use.

The fact that the Baule have borrowed so heavily from their northern neighbors in their woodcarving traditions presents a fascinating art historical case, since in all other forms of artistic expression they remain much more closely tied to their Akan kinsmen to the east. The Baule, too, possess rich traditions of brass casting, court regalia covered with gold foil, cast-gold jewelry, and terra-cotta sculptures – things most commonly associated with the political hierarchy that dominated the Akan states (fig. 38).

The use of terra-cotta sculpture and pottery in funerary rites is widespread among the Akan groups, and a wide range of substyles is known. Examples have been dated to the early seventeenth century and, since the tradition has continued well into the twentieth century, they provide an important case study for artistic continuity and development in a single area over an extended period.

East Guinea Coast

Another area in which ample documentation and numerous historical examples enable an initial attempt at tracing the history of stylistic developments to be undertaken is that of the Yoruba and related groups.

The Yoruba number more than twelve million and are by far the largest ethnic group in Africa with a sculptural tradition. They have been a highly urbanized population for many centuries, and some of their cities, such as Owo and Ife, have been centers of artistic production for more than seven hundred years. Indeed, it is often suggested that the similarities between Yoruba and Nok sculpture represent a stylistic continuity over a period of 2,500 years.

Be that as it may, the Yoruba have developed artistic traditions (fig. 39) remarkable in Africa for their homogeneity over a vast area. Yet numerous substyles may be

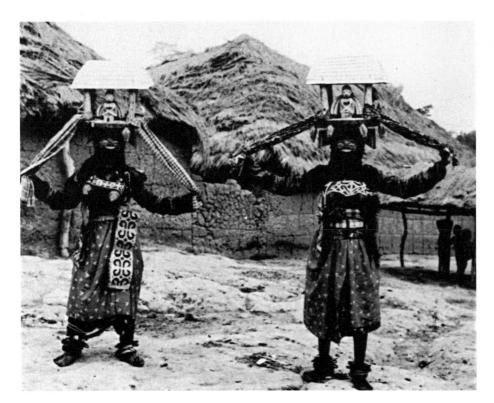

Fig. 39 Two Gelede masks in Yoruba country. (Photo: William Fagg)

Fig. 40 Door of a Yoruba palace, in the Osi-Ilorin style, probably sculpted around 1920. The horse as status symbol has here been replaced by the bicycle, also a prestigious possession. Height, 167 cm. Barbier-Mueller Collection

recognized; indeed, more regional, workshop, and individual styles are identified by name in the Yoruba area than in all of the rest of sub-Saharan Africa.

The unity underlying the art of the Yoruba is most probably to be accounted for by the fact that their religious life is dominated by a number of cults that are found universally among Yoruba-speaking peoples. The most important of these cults focus on Shango and Eshu. The *ibeji* cult of twins is also universal. Similarly, the need to provide a justification for political authority through myths of common origin and descent has reinforced these patterns in the political sphere as well, so that political paraphernalia, such as that of the Ogboni society or the beaded crowns of Yoruba kings, also show a continuity of style and function.

The sheer bulk of Yoruba art is astounding and its range equally impressive. Beadwork, ivory carvings, brass castings, and wrought-iron sculptures abound in addition to the dominant medium of woodcarving. Wood carvings exist in a multitude of forms, and range from small figures a few centimeters in height that are used in divination to the monumental Epa masks of the northern Yoruba country, which have huge superstructures and may weigh as much as 50 kg and stand at a height of two meters (fig. 40).

It is not without good reason that the Yoruba have been among the most studied groups of the Guinea Coast and that their iconography is better known than that of almost any other West African group.

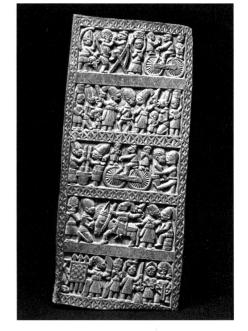

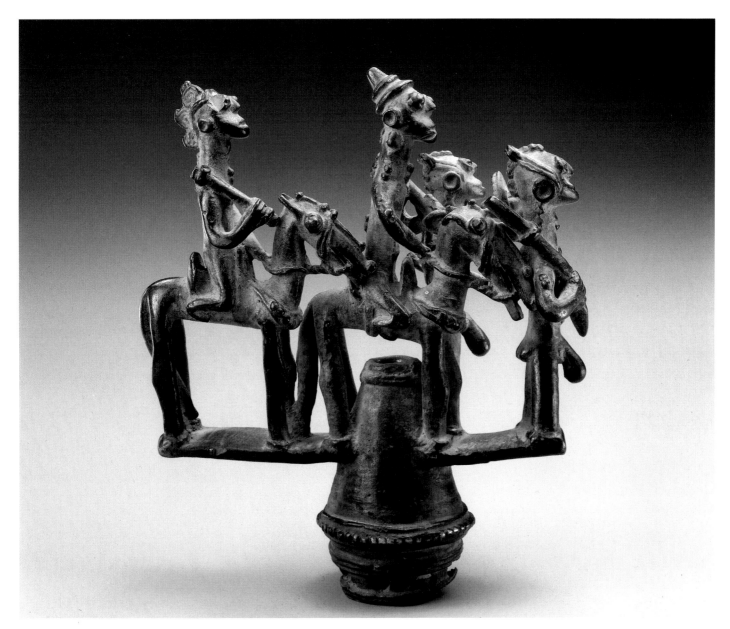

35 *Sono* (Iron Staff)

Soninke, Guinea-Bissau

Bronze, dark gray-green patina; height including staff,
135 cm; height of horsemen, 17 cm

This group of armed men, both mounted and on
foot, surmounts a long iron staff (not shown),
which is decorated at regular intervals with
bronze rings; the rings were once embellished
by protrusions shaped like human heads, one of
which has been preserved.

The grouping served as an insignia of power
among the Soninke, the name given to the
Mande people that emigrated from Mali before
the sixteenth century, settling in Guinea-Bissau
and Casamanca. The name *sono*, given to this
sort of object by the Fulani of the region, may
simply be a derivative of Soninke. Stylistically,
these ornamented staffs probably reflect Malian
traditions, although they have also been used by
the non-Islamic Fulani.

Avelino Teixeira da Mota has shown that the
cire perdue casting method is no longer practiced
in Guinea-Bissau. A *sono* in the Pigorini
Museum in Rome, acquired in 1882, is described
by the museum as a Mande work probably rep-
resenting the god of war protecting King
Mamedi Paté, chief of the Fulani. This informa-
tion is somewhat contradictory: on the one
hand, the name "Mamedi" – more commonly
Mamadi or Mamadou, the local variants of
Mohammed – appears to indicate that the
sovereign in the Pigorini description was a Mus-
lim; on the other hand, the fact that he pos-
sessed a scepter decorated with his personal god
of war suggests that he was an animist.

Whatever the case, we know that about 1880
King Mamadi Paté of Coiada was defeated by
another Fulani chief; and Coiada was a Soninke
chiefdom ruled by Fulani chiefs. It is hardly sur-
prising that the chiefs borrowed some of their
regalia from their subjects; nor is it surprising
that the *sono* represent mounted riders, since
such riders constitute an extremely common
theme in the art of Mali, where the Soninke
originated.

About ten pieces of this kind are known; sev-
en, including the example illustrated in this vol-
ume, are reproduced by Bassani in his article on
the Sono. It is impossible to determine the age of
our exhibit precisely; but it is probably at least a
century older than its counterpart in the Pigorini
Museum – which would place it in the seven-
teenth or eighteenth century. A. M. V.

Lit.: Bassani, 1979.

The Baga

The designation "Baga" is often applied to the Landuma and the Nalu as well as to the Baga in the narrow sense of the term. These peoples inhabit the swampy littoral region of the Republic of Guinea between the Bissan border and Conakry, the southern part of the aptly named "Low Coast"; viewed from the air, the point where water ends and land begins is indistinguishable, hidden beneath the tangled growth of mangroves. The shore, a paradise for mosquitoes and crabs, is indented by the estuaries of numerous rivers that descend from the nearby Futa Djatton hills; though an environment difficult for human survival, the region is a fertile one of polders reclaimed from the marshland and transformed into rice fields. The inhabitants cultivate rice by ridge planting and transplanting, using an ingenious technique that requires a spade about two-and-a-half meters long, with an oar-shaped blade tied to the shaft. The silting up of the littoral is the chief danger threatening the country.

By their own account, the inhabitants arrived in the region no more than a few generations ago. But the first Portuguese voyagers, at the end of the sixteenth century, already mentioned the presence of "Bagoes" along the coast, and this swampy region has probably provided refuge for various peoples since time immemorial. This process of migration continues today. The Fulani leave the mountains between the rainy seasons and drive their salt-hungry livestock down to the wetlands. Many of the younger generation leave their villages for the urban areas in order to escape from the control of their elders; those who remain discard their native language to speak Sussu; and those who convert to Islam or to Christianity abandon their traditional customs and no longer celebrate the ceremonies of their fathers.

The Baga and the Nalu use very large masks (fig. 41).

Fig. 41 Large *banda* masks of the Nalu, Guinea. (Photo: M. Huet, Agence Hoa-Qui, Paris)

36 *Nimba* Mask

Baga, Guinea

Wood, upholstery tacks and French coins; height, 135 cm

Perhaps the most monumental mask found in Africa, sometimes weighing 60 kilos, the *nimba* is an enormous wooden bust which surmounts a four-pronged support under a long fiber skirt when the mask appears. It culminates in a large head with a hooked nose. Qualitative differences between various examples are seen in the proportioning of head and neck and in the refinement and precision of the molding of the ears, the nose, and the crest that runs across the top of the head to the base of the neck. When worn, part of the bust and the dancer's body are covered by a long mantle of fibers; the wearer is able to see through two holes pierced between the breasts.

The *nimba* appears at harvest time; it is an image of fecundity to which families appeal for a good harvest and plentiful offspring. Travelers in the last century saw the *nimba* being carried about in the marshes and tall grasses of the Baga rice paddies. Widespread throughout the littoral, the *nimba* was adopted from the Nalu; but sharing their traditions and seeing them altered does not bother this heavily Islamized people: the great *nimba* of the Musée de l'Homme in Paris wears an Islamic cloth amulet on its nose.

D. P.

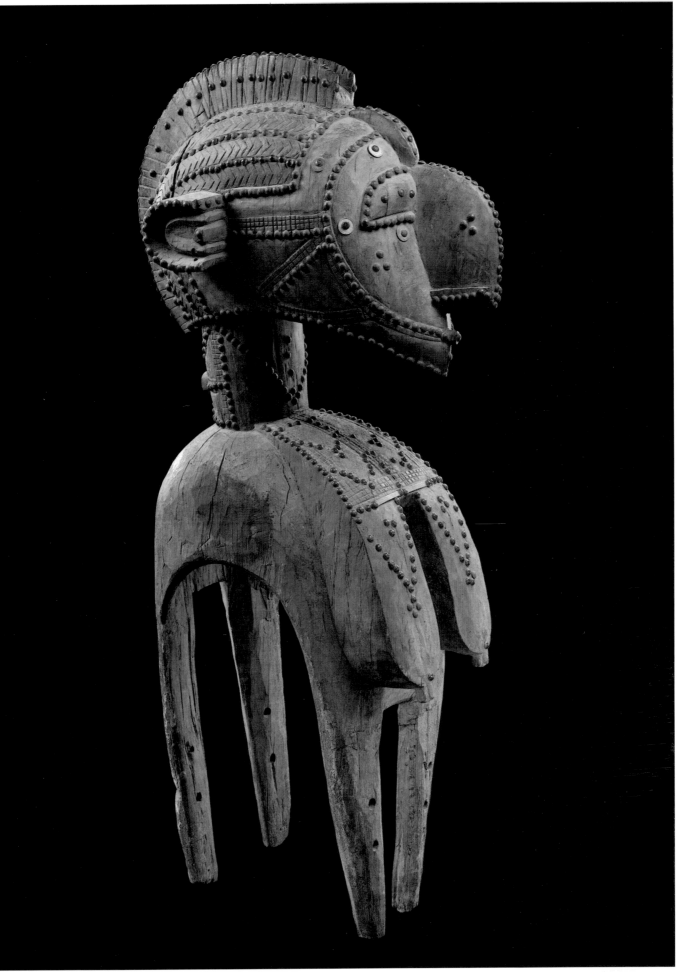

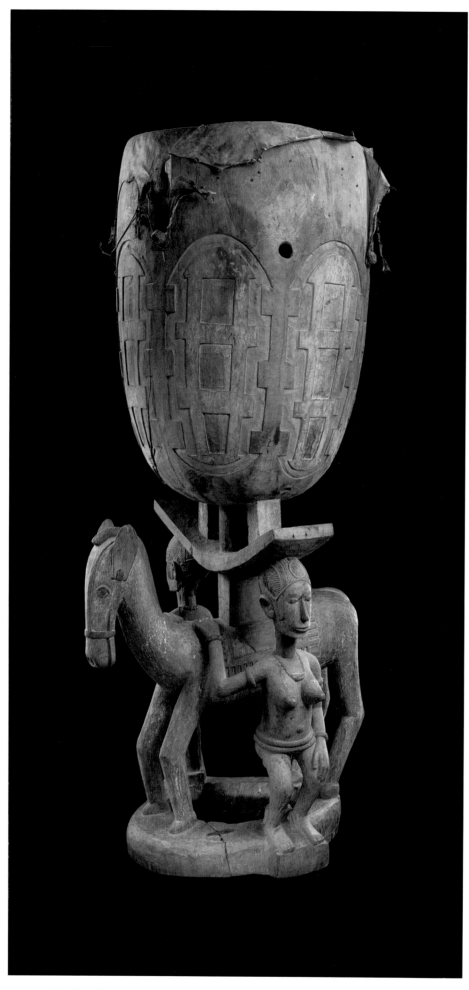

37 Drum

Baga, Guinea

Wood, traces of red, white, blue and black pigment;
height, 172 cm

Throughout West Africa the large skin-covered
drum, its shape reminiscent of the tree trunk
from which it was carved, serves male domi-
nated social institutions, underscoring their
political power. The instrument is brought out
and played only for certain ceremonies, such as
the initiations of boys or the funerals of old
men. Among the Baga, the base is sculpted (a
practice rare elsewhere), featuring one or more
female caryatids or a horse. Although the depic-
tion of a horse in a region infested by the tsetse-
fly, where the animal cannot thrive, may seem
surprising, it should be remembered that the
horse is associated with power everywhere in
Africa, appearing as an attribute of victors or of
political chiefs or their representatives. These
sculptures may possibly be a reminiscence of the
mountain regions from which the ancestors of
the present inhabitants of the littoral are
thought to have been expelled several centuries
ago. D. P.

38 Snake Emblem (*Bansonyi*)

Baga Foré, Guinea

Wood, red, black, and white polychrome, inlaid
European mirrors; height, 215 cm

The shape of the *bansonyi* – a long, sinuous,
decorated and painted vertical form – recalls its
origin, the evocation of the mythical python.
Two *bansonyi* make their appearance among the
Baga Foré during the boys' initiation festival;
they are decorated with streamers and are sup-
ported by a scaffolding carried by several men
hidden under palm leaves and pieces of cloth.
Representing "husband" and "wife", the pro-
tective spirits of each half of the village, the *ban-
sonyi* fight a duel (though its outcome will not
affect the necessary unity of the community).
After signaling the opening of the festival, the
spirits disappear into the sacred grove. D. P.

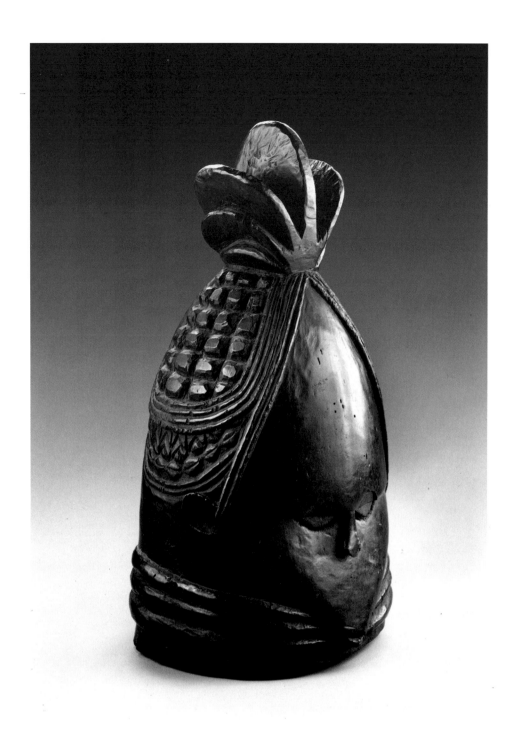

39 Helmet Mask

Mende or *Vai*, Sierra Leone

Wood; height, 45.5 cm

The mask shown here is one of the ritual objects of the Sande, or Bundu, female secret societies; it is designed to represent woman at her most seductive, both beautiful and rich. The rolls of fat on the nape of the neck are signs of prosperity. The masks, like the initiates' bodies, were repeatedly rubbed with palm oil, to make the wood, like the skin, softer and glossier.

Each chapter of the Sande society is directed by an experienced woman, the *majo*. The cells compete against each other, and a new cell can be founded by a woman whose authority is generally recongnized. Like the Poro, the Sande teaches its initiates to observe certain rules of conduct. Removal of the clitoris was formerly required of young initiates; this practice seems to have been replaced by that of making slight incisions.

Neighboring peoples were impressed by the carved helmet masks of the Mende. Accordingly, some masks found among the Bassa, a Kru people, are very similar in conception, although the faces are treated naturalistically and the coiffures do not show the complexity characteristic of the type of mask shown here. Indeed, it is difficult to attribute this mask definitively to a particular one of the peoples of the border region between Liberia and Sierra Leone – the Mende, the Vai, or even the De, a people who speak a Kru language and who have been absorbed by the growth of Monrovia, the Liberian capital. A. M. V.

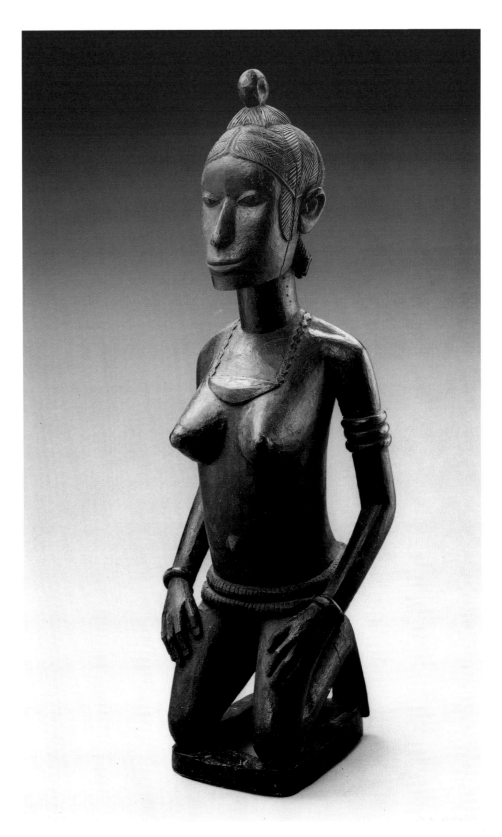

40 Figure

Baga, Guinea

Wood; height, 66 cm

In contrast to the hook-nosed *nimba*, a number of female figures with long, straight noses and thin lips are found along the coast of Guinea-Bissau and the Republic of Guinea; these figures seem to suggest a European, possibly Portuguese, influence. Of unknown origin, this type of sculpture often presents the woman kneeling; sometimes it supports the drum that is struck during the funeral ceremonies for dignitaries of the Simo society. D. P.

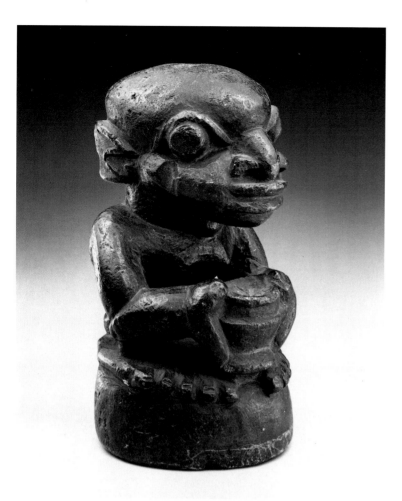

41 Figure

Kissi, Sierra Leone

Steatite; height, 19 cm

The figure is mounted on an unidentifiable four-legged animal. It may be a horse, if what the man holds in his hands are reins, represented by what appear to be thick ropes, which could also be taken for the horns of the animal. A. M. V.

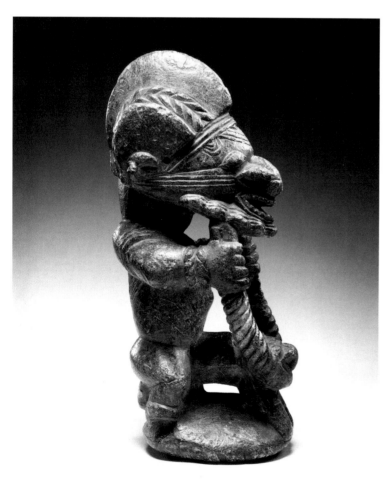

42 Figure

Kissi, Sierra Leone

Steatite; height, 27 cm

Stone sculptures are found throughout the southeastern half of Sierra Leone and in adjacent portions of Guinea and Liberia. Large numbers have appeared in areas now occupied by the Mende and Kissi, who call them *nomoli* and *pomdo* respectively. They are most frequently discovered either during the process of clearing fields or while digging for diamonds or wells. Dating presents problems, but the sculptures have strong stylistic similarities to "Afro-Portuguese" ivories of the sixteenth and seventeenth centuries. It is generally believed that both the stones and the ivories were made, not by the present inhabitants, but by the Sapi, who inhabited the region prior to the invasions of the Mani in the sixteenth century. Many substyles are known. The present example is of a type found most frequently in the western portion of the area. It holds a bowl, possibly an offering, and was most probably connected originally with a memorial shrine. W. S.

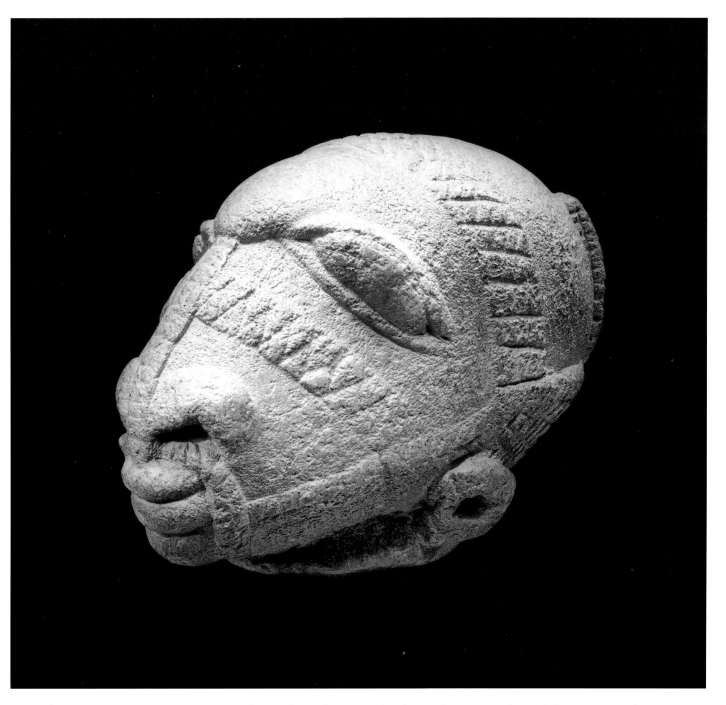

43 Head

Sapi (?) (Proto-Temne), Sierra Leone

Stone; length, 24 cm

Life-size stone heads are called *mahen yafe* ("Spirits of the Chief") by the Mende of Sierra Leone, who find them buried in the ground. They are normally presented to chiefs or Poro society elders, who use them in divination, be- lieving them to be associated with spirit forces. Evidence suggests that, like the *nomoli* and *pomdo*, they were originally made by the Sapi. They usually have elaborate coiffures, often, as in this case, showing a combination of shaved, tufted, and possibly plaited areas. Similar hair styles are described in early seventeenth-cen- tury sources, where they are apparently associ- ated with the Sapi aristorcracy. The elaborate jewelry, including earrings and nose rings, is also similar to that described in these sources. Although many of the heads appear bound and gagged, it is unlikely that they represent sacrifi- cial victims, as was previously thought; rather, they are probably chiefs ritually bound at the time of their installation – a practice still ob- served among the Temne, who are descendants of the Sapi. W.S.

The Bassa

The Bassa are one of the largest of the Kru-speaking peoples and number just under 300,000. They inhabit an area of central Liberia stretching roughly 250 kilometers along the seacoast south of Monrovia and 175 kilometers into the interior. They practice shifting cultivation, with rice as the dominant crop in the interior and cassava more prominent near the coast. They are patrilineal and patrilocal, living in small settlements seldom numbering more than two hundred inhabitants. They have been strongly influenced by their Mande-speaking neighbors, especially the Dan and Kpelle. Like them and unlike most of their Kru-speaking relatives, the Bassa have both men's and women's initiation societies and practice both circumcision and clitoridectomy. They are chiefly noted for the carving of wooden masks (fig. 42) and figures. These are in a distinctive style that nevertheless shows strong affinities to that of the Dan. W. S.

Fig. 42 Geh Naw masked dancer of the Bassa. (Photo: Ministry of Information, Culture and Tourism, Republic of Liberia)

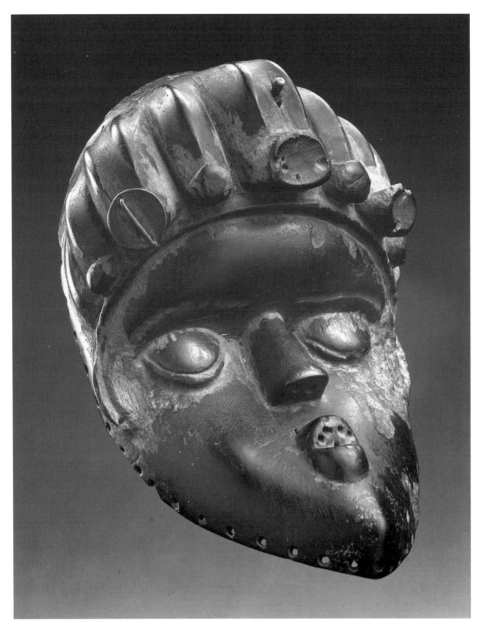

44 Geh Naw Mask

Bassa, Liberia

Wood and a coin; height, 20 cm

The Geh Naw masks of the Bassa men's society, the Chu den zo, are usually smaller than the human face and are not meant to be worn directly over it (see fig. 42). Instead, they are attached obliquely to a rattan basketry frame so that the mask rests over the wearer's forehead. The person who wears the mask looks out, not through the eyes, which are seldom pierced, but through a slit in the cloth that is suspended from the mask and headdress. The Geh Naw masks are public entertainers who perform when the boys return from the bush schools, but also on many other occasions, such as the visits of important guests or on public holidays. They perform an exceptionally smooth, gliding dance which makes them appear to be floating on a cushion of air. The mask is intended to convey a sense of grace and serenity, the latter emphasized in the present example by the heavy-lidded or closed eyes. W. S.

The Loma (or Toma)

The Loma number approximately 200,000 and are more or less equally divided between Liberia and Guinea. In Guinea they are often known by a Mande form of the name, Toma.

Loma belongs to the southern branch of the Mande language family. Most of the area inhabited by the Loma is high-altitude rain forest and they practice shifting cultivation of upland rice. The Loma are patrilineal, and their traditional political structures were based on village chiefdoms. The two principal societies with universal membership are the Poro for men and the Sande for women. Virtually all masks are associated with the Poro society. Mask styles vary from region to region. Figurative sculptures are rare and, in contrast to masks, usually privately owned; nearly all of them are associated with either divination or anti-witchcraft protection. W. S.

45 Mask

Loma, Liberia

Wood, cloth, and magical material; height, 75 cm

Virtually all Loma masks are used within the context of the Poro initiation society. While some Loma masks perform publicly, others, such as this type, are used exclusively by this men's society and may be seen only by initiates. Loma masks are often striking in their stark simplicity of form, economy of line, and heavy sacrificial patina. This example has a heavy incrustation of kola nut, which was chewed and then spat upon the mask during the sacrifice, and of blood and smoke. The mask represents a powerful bush spirit reminiscent of the West African forest buffalo, one of the strongest and most dangerous of beasts. Between the horns is a cloth-covered "medicine bundle" intended to augment the mask's power. The treatment of the eyes is unusual. Often, the eyes are not represented at all and they are almost never actually cut out of the wood. While it is possible that this mask was worn on the head, it is more likely that, like others of the type, it was meant to be worn on the back attached to a raffia costume.
 W. S.

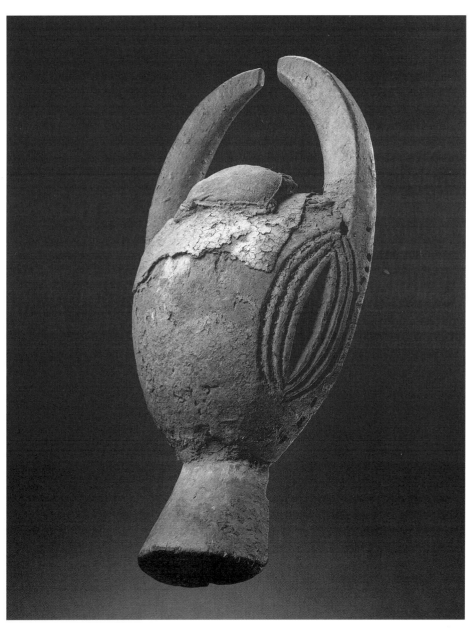

The Grebo

The coastal Grebo live in southeastern Liberia, on the border of the Cote d'Ivoire. They speak a Kru language like the Bassa, their western neighbors, and the Wé and the Bété, their relatives in the Cote d'Ivoire. They earn their living by fishing in rivers and the ocean and as sailors and merchants.

The forest Grebo of the interior cultivate rice and various root crops; they are organized in a patrilinear society with a strong matrilinear tradition. Their art reveals borrowings from the neighboring Dan and Wé (fig. 44).

The Dan

This agricultural folk lives in a region of mountains and wooded savanna in the western Cote d'Ivoire, near the cities of Man and Danané, and in adjacent regions in Liberia. They speak a language derived from the Mande group and are considered to be the Mande of the south; they number about 350,000, and 270,000 in the Cote d'Ivoire.

The Dan live essentially in villages and are organized in patrilinear lineage groups; children live with their fathers, and marriage is governed by the rule of double exogamy, which prohibits unions between cousins in both the maternal and paternal lines. For the most part, they have remained faithful to ancestral rites (fig. 43), and they possess numerous sacred objects, principally masks.

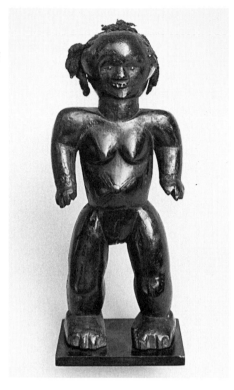

Fig. 44 Grebo figure from the coastal region near the border of Liberia and the Cote d'Ivoire. Height, 29.5 cm. Barbier-Mueller Collection

The Bété

Living in the southwest of the Cote d'Ivoire, the Bété speak a Kru language and have a patrilinear social organization. Numbering about 200,000, they live chiefly from agriculture. Their territory is bordered on the east by the Bandama river, on the west by the Sassandra. Only the groups farthest west in Bété country, near the cities of Daloa and Issia, have masks, which are derived from those of their neighbors, the Wé (Guéré and Wobé) and the Niabwa (fig. 45). M. N. V. I.

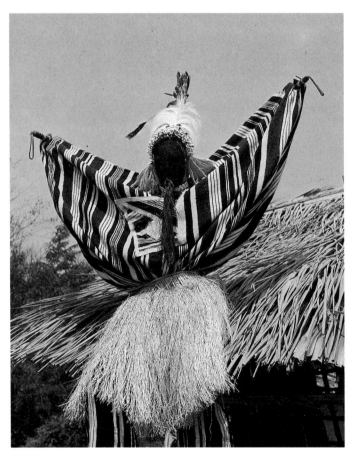

Fig. 43 Masked dancer of the Dan, Liberia. (Photo: M. Huet, Agence Hoa-Qui, Paris)

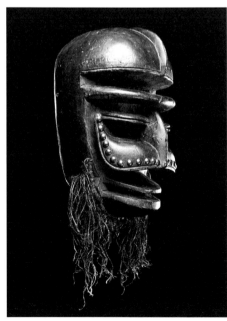

Fig. 45 Bété mask. The Bété's use of masks, which probably does not predate the first quarter of this century, was adopted from neighboring tribes. Height, 30 cm. Barbier-Mueller Collection

46 Mask with Female Face

Grebo, Liberia

Wood, red, white, and brownish paint, inlaid glass beads; height, 52 cm

The delicacy of this female mask offers a striking contrast to its male counterpart, which is comprised of a group of gemoetric shapes representing different facial elements, jutting out from a flat surface. The male mask is frequently held to be typical of Grebo art: in such bold plastic works is found the exuberance of the sculpted works of the Grebo's southern neighbors, the Kran, or the Wé of Liberia – an exuberance here pushed to the point of abstraction. In the softness of the female mask is found the idealized vision of the human face typical of Dan masks, from which certain of its traits are borrowed: the eyebrows of elegantly scored oblique incisions, the small, slightly-opened mouth with finely carved teeth. The elegance of the top-piece should also be noted: it is made up of two strands of the coiffure, shaped like buffalo horns (a motif often interpreted more coarsely in male masks to reinforce their brutal appearance); at their ends these strands join a central braided strand that is perhaps meant to represent a type of palm-leaf with braided fibers. This device is placed in a Grebo girl's hair by her intended and worn as a sign of engagement. The inlay of glass beads replaces the painted dots scattered over the face of the male mask. Polychromy is common to both types. The meticulous hollowing out of the lower half of the mask seems to be a distant echo of the style found in northern Dan country. Such delicacy is not however evidenced by other masks from the interior of Grebo land; closer to the plastic representations of the female face found among the Wé, they are coarser in shape than the Dan masks from which they are derived. This specimen was acquired in the coastal region, and possibly reveals other influences. M. N. V. F.

Lit.: Meneghini, 1974.

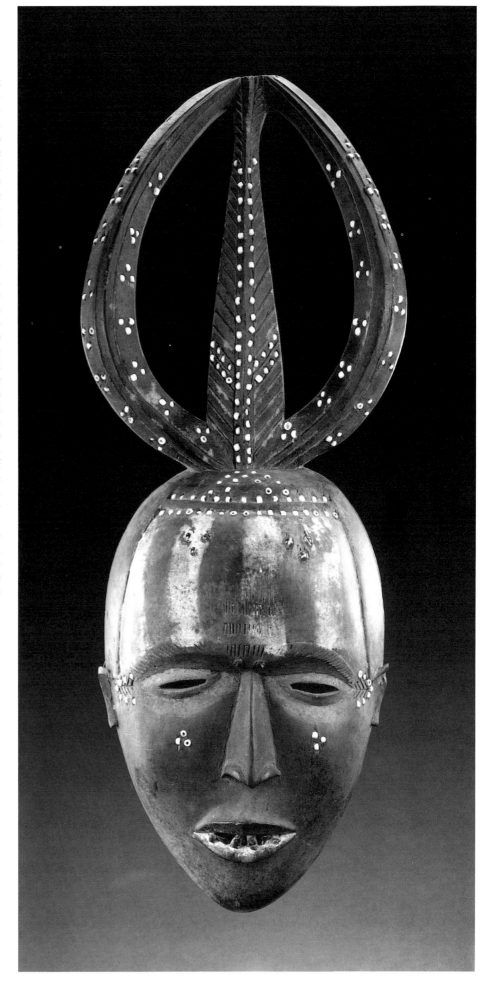

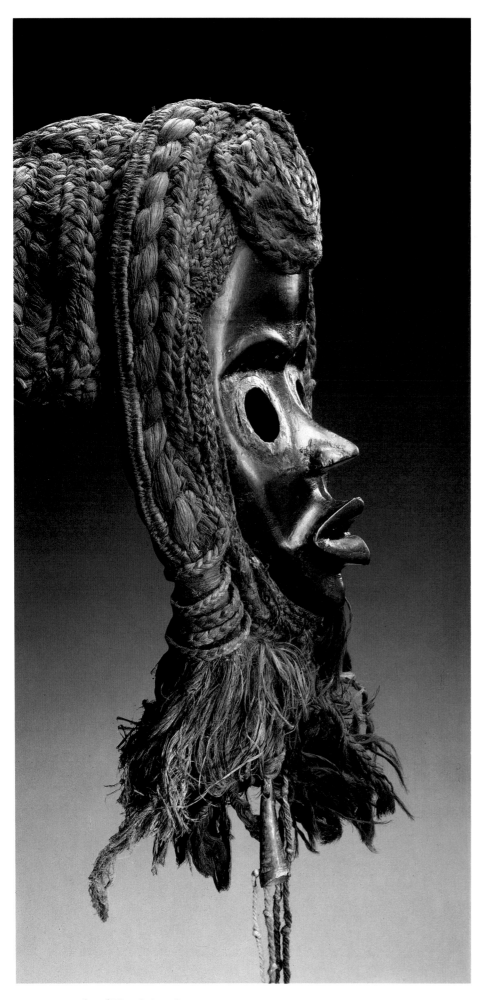

47 *Gunyegè* Mask

Dan, Liberia/Cote d'Ivoire

Wood, fibers; height, 36 cm

This very beautiful example of a Dan mask has a human face with a high, curved forehead and fine features. The perfectly concave shape of the inside surface indicates that it comes from the northern Dan area. The large, rounded eye sockets, which permit a wide field of vision, are a throwback from the "runner" mask (plate 48), whose low ranking in the hierarchy of masks permits the wearer's eyes to be visible.

Another category of mask also has this same characteristic: the fire-watch mask *zakpei gè* (Fischer and Himmelheber 1984, p. 45). In savanna country, when the harmattan blows during the dry season, all household fires must be extinguished between sunrise and sunset. The *zakpei gè* keeps watch on the housewives, who usually build a fire under a ceramic cooking pot supported on three large stones. The cooking fire is built in front or inside of a conical thatched roof house. A careless cook whose negligence threatens to burn down the village will find herself sternly reprimanded by a few blows from the flexible switch carried by the mask in its hand; her cooking pot will be tipped over; and some object, recoverable by her husband only through payment of a stiff fine, will be confiscated.

The braided fiber wig sometimes found on fire-watch or runner masks is not visible, since the heads of both masks are covered by a headband; sometimes, on fire-watch masks, this band is surmounted by a crown of leaves; sometimes, on runner masks, by a coiffure decorated with sheepskin. Both masks often have a short fiber beard. M. N. V. F.

Lit.: Fischer and Himmelheber, 1984, p. 45.

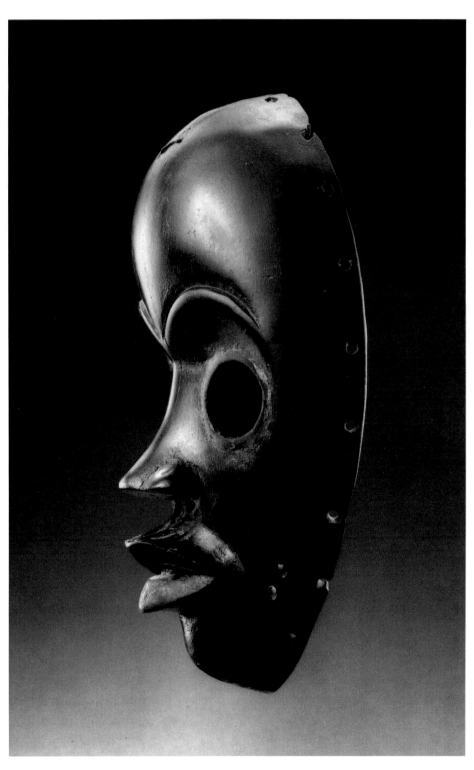

48 Racing Mask
Dan, Liberia/Cote d'Ivoire

Wood; height, 22 cm

This mask is an example of the style of the northern Dan country. The regular oval is divided into two equal parts with large, round eye sockets. The perfectly concave and smooth inside surface allows it to be worn over the face; strips of cotton are threaded through the perforations along each side and tied behind the head. The costume is made up of a hood reaching down to the shoulders, a coiffure, a shirt, pants, fiber bracelets for the arms and ankles, and a short fiber skirt.

Chasing a barefoot and barechested unmasked runner who has started slightly ahead of him, the masked figure runs round the houses and between the rocks in a race that will end at its starting point, in the victory either of the pursuer – if he has been able to seize his adversary by the nape of the neck – or of the unmasked runner, who will then put on his own mask and costume and match himself against an unmasked runner from the first team. In the wooded savannas bordering on northern Dan country, contests are organized every Sunday during the dry season. There may be a dozen contestants divided into two teams; the runner who carries off the most victories is acclaimed by the spectators. In the past, the village chief would be so proud of his "champion," the winner of several contests, that he might give him a wife as reward. Runner masks were often carved in the image of a champion, in the hope of infusing the wearer with some of his strength. According to the organizer of a contest held in Mangouen, in the subprefecture of Biankouma, Cote d'Ivoire, on November 18, 1984, chases of this sort used to give the elders the opportunity to judge the warrior qualities of the young men. M. N. V. F.

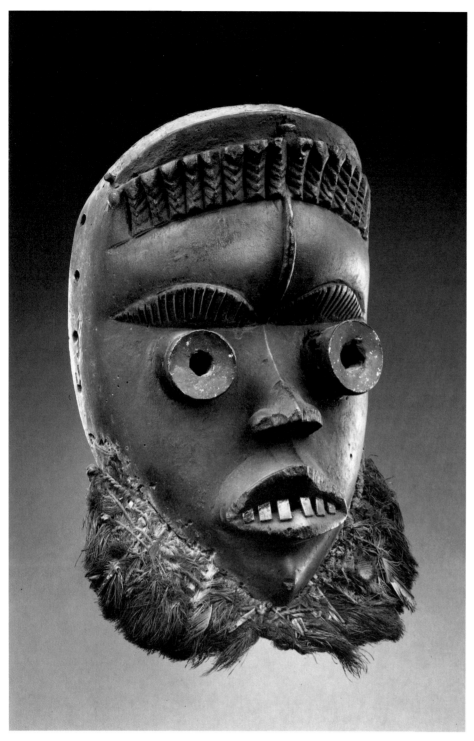

49 Actor's Mask
Dan, Liberia/Cote d'Ivoire

Wood, fibers, and feathers; height, 26 cm

This mask presents a protruding forehead divided by a central vertical ridge that corresponds to the forehead ornament still worn by some old men in the border region of Liberia and Cote d'Ivoire. The serrated crown surmounting it represents a row of small antelope *duiker* horns, reputed to be filled with a magic substance that can undo the evil effects of sorcerers. In profile, the ends of the cylindrical eyes and the lozenge-shaped mouth, decorated with metal teeth, are on the same plane as the forehead; the jarring features connote a male face.

A mask with identical characteristics has been seen in Gboaleu (subprefecture of Zouan-Hounien), a village on the left bank of the Cavally, the boundary between Liberia and Cote d'Ivoire. Tinan, "the hyena," mimes serveral tales well-known by the villagers; his frenetic agitation when evoking the busy woman (his fly-whisk plays the role of the hoe) contrasts with the lazy woman's nonchalance as she yawns, stretches, and shoos flies instead of devoting herself to work in the fields. Another pantomime is also very popular: Mr. Spider goes at dusk to hunt frogs with his (pretty) mother-in-law, played by a partner; in the darkness, he takes liberties that provoke great bursts of laughter from the spectators, even though they know the scene by

heart. Tinan wears a wig of multicolored cotton rags; his beard is made of white feathers and is decorated with iron bells. His chest is covered by a kind of cape of homemade cotton cloth that covers his arms and hands and hangs down over a long fiber skirt. Two rather elderly women act as Tinan's servants. His partner gives a brilliant demonstration of his talents as a dancer. Musicians accompany the show with three slender split-bamboo gongs struck with sticks, a larger gong, and a gourd rattle. M. N. V. F.

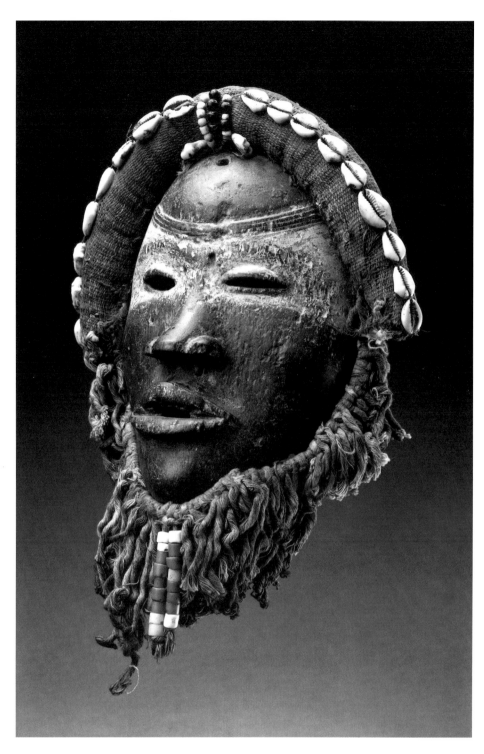

50 Mask

Dan, Liberia/Cote d'Ivoire

Wood, cotton, fibers, cowrie shells, beads, traces of
white paint (kaolin); height, 19.5 cm

The high, curved forehead of this mask is deco-
rated transversely with four parallel raised lines
just above the eyebrows and the root of the
nose; under the coating of kaolin, the eyebrows
are notched with vertical cuts in a style fre-
quently found among the Dan women of
Liberia. To make themselves more attractive,
the women have vertical incisions made very
close together in their eyebrows, creating a
hatching effect; the hairs do not grow back over

the scars. The kaolin with which they paint their
eyes is a sign of participation in a religious festi-
val, white being the color of ancestors and of
joy.

The fiber beard decorating the mask's chin is a
symbol of power rather than a mark of virility.
The mask represents not a man or a woman but
rather a spirit of the bush, the guardian of the
circumcision camp where boys go through their
social apprenticeship and are initiated into the
dance practices and ritual songs. During the re-
treat, a man wearing the mask goes to the village
and, joking with the mothers, asks them for food
for the boys and their instructors. At the end of
the initiation period, he leads the newly initiated

boys back to the village in a festive procession. If
one of them has died at the camp, the "bush
spirit" will stop in front of the house of the
mother (who has continued to provide food for
her son) and will seize a piece of crockery and
throw it to the ground, saying: "Nana [the great
spirit of the initiation camp] has eaten your
son." In such cases, the customary tears of grief
are not allowed.

During village festivals today, the bush spirit
may also come asking for gifts for himself and
his companions; hence its name "begging
mask." M. N. V. F.

Lit.: Fischer and Himmelheber, 1984, p. 103.

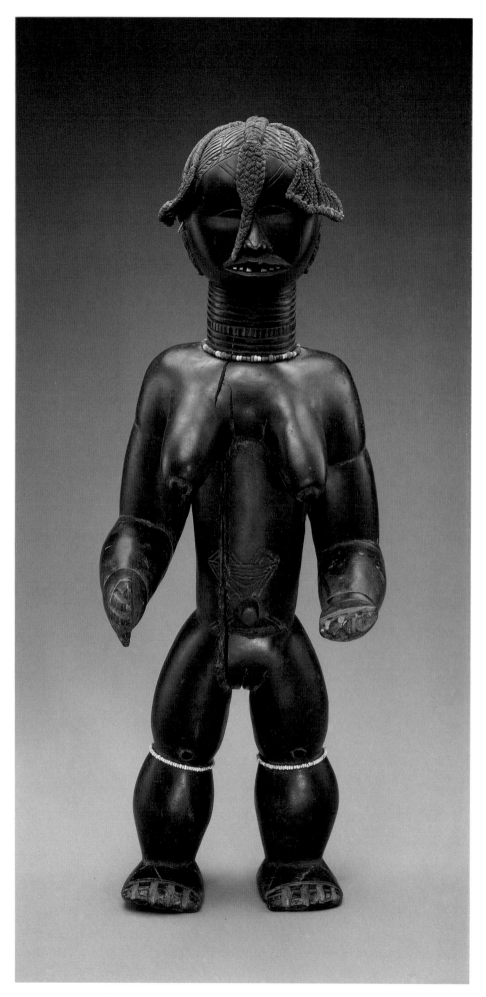

51 *Lü mè* Figure

Dan/Kran, Liberia

Wood, fiber; height, 53 cm

The style of this figure indicates an origin somewhere near the boundary of Dan and Kran territories in Liberia, near the Cote d'Ivoire border. It wears a braided fiber wig superimposed on engraved linear and chevron-shaped motifs indicating hair. Between the folds of the neck, a line of vertical hatching evokes a necklace; a real necklace of multicolored glass beads encircles the neck. On the cylindrical trunk, a tattoo of triangles frames the prominent navel; another tattoo, chevron-shaped, decorates the left side of the back. The torso is planted on massive legs of well-defined volume that narrow at the joints; large feet serve as a base. A bead bracelet encircles each knee. The bent arms, the hands held forward, and the rounded breasts impart a certain vitality to this rather realistically proportioned figure. In contrast to the well-molded body that is faithful to characteristics of Dan sculptures, the vigorous stylization of the face is surprising: it recalls traits of certain Kran masks.

These figures, called *lü mè* (wooden people)[1] in Dan dialect, are rare among the sculpted works of this region. They are generally commissioned works, portraits of the first – or preferred – wife of a chief, for example. An object of prestige to its owner, such a figure would be presented to the villagers with great pomp, then carefully stored away, to be brought out only for important guests. It might also be cared for by a woman who, for her pleasure, washes it, dresses it, and renews the kaolin on its eyes. Of the other known figures of this type, some carry a child on their back; other, rarer examples represent male figures. M. N. V. F.

[1] The vernacular terms in the Dan dialect are used by Fischer and Himmelheber, 1984.

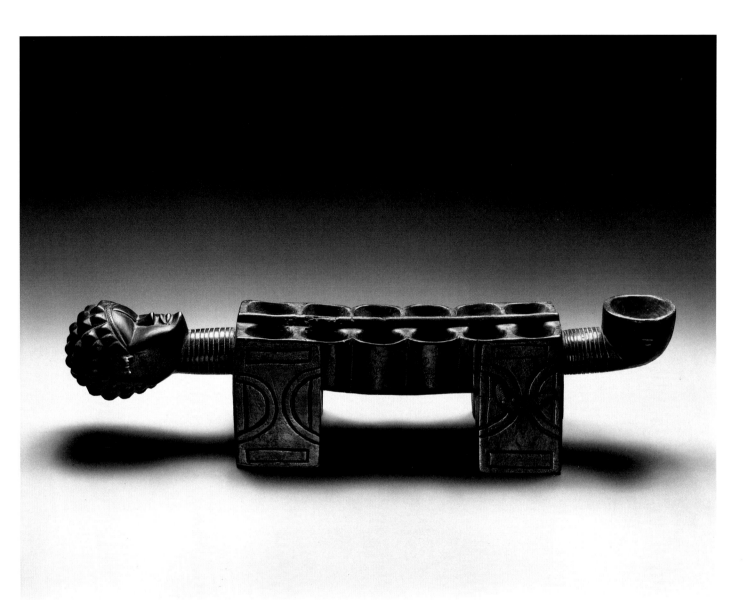

52 *Ma kpon* Game

Dan, Liberia

Wood, metal, beads (native repair to one leg);
length, 72 cm

The word *mancala,* derived from the Arab verb *ngala* ("to move" something), is the conventional term used by anthropologists to designate a particular category of board game. In West Africa, the term most frequently used for the game with twelve squares or compartments is *hawélé*; but it varies according to ethnic group, the Wobé (northern Wé) call it *kpo,* the Dan *ma kpon.* The players sit one on each side of the board, which is often (though not always)

mounted on four legs. Two rows of six compartments each are hollowed out in the top of the board, and forty-eight counters are distributed equally among them; the counters may be seeds, pebbles, pieces of metal, nuts or – most often – the soft, shiny-surfaced fruit of the *ma* vine, about the size of a marble. Each player, moving according to strict rules, tries to acquire all his opponent's counters.

The most frequently encountered model looks like a board lengthened on one or both sides by a cup intended to hold unused seeds. Some of these game boards are veritable works of art, with carved human or animal heads sometimes substituted for one or both of the bowls. In this

example, a sculpted female head, similar to those of Dan figures, takes the place of the bowls. It is adorned with an elaborate coiffure of multiple strands divided into small squares by perpendicular notches; rings ornamented with beads decorate the pierced ears; and the two shafts that join the head and the bowl to the board display parallel grooves suggestive of the necklaces that are an important aesthetic element for Dan women. The only reason given by most sculptors for replacing the bowl by a head is the desire to enhance the beauty of the object.

M. N. V. F.

Lit.: Fischer and Himmelheber, 1984, p. 138.

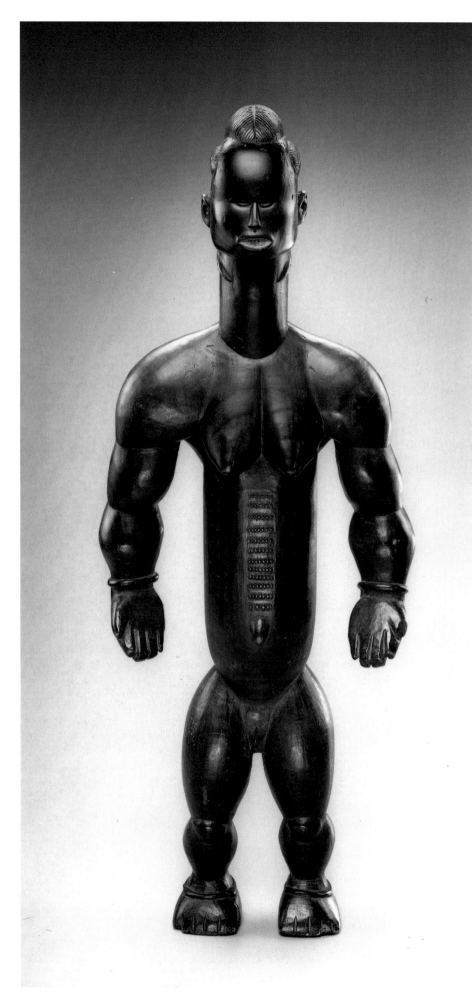

53 Figure

Bété, Cote d'Ivoire

Wood; height, 79 cm

The typical features of the Bété style are seen in this female figure: elongated trunk and neck; small breasts; the back scored with a deep central furrow; short stocky legs that narrow at the joints; rounded knees; large hands; broad-based feet; a sculpted tripartite coiffure surmounting a rectangular face; straight nose and open mouth; ears in high relief; a long, cylindrical neck decorated at the back with several rows of scarifications; additional scarifications above the prominent navel and running the length of the furrow of the back; and representations of wrist and ankle bracelets.

Figurative sculpture is rare in the Bété area and is unknown in the Daloa region, close to eastern Wé country. It is thought to have been used in the Gagnoa region not too far from the Guro area to the north; one that is probably a representation of a deceased ancestor was found near Ouragahio. In the past, when someone died, the male heirs cut a length of bamboo cane corresponding to the stature of the deceased; intended to receive his vital fluid, this cane, sometimes wrapped in a white cloth, was kept by a close relative. At commemorative ceremonies held in the deceased's honor, it was carried by an old woman at the head of the procession of weeping women. The Bété call this bamboo staff *kôlé*; sometimes it was replaced by a figure, called *konei, yousrakpo,* or *isrokpo* by the various tribal groups. M. N. V. F.

Lit.: Holas, 1968, p. 135, plate III.

The Guro

The Guro are farmers inhabiting the central Cote d'Ivoire to the west of the Baule, with whom they have certain stylistic and cultural affinities that undoubtedly stem from reciprocal influence. The Guro came from the north six or seven centuries ago; they speak a Mande language, as do their neighbors the Yaure and the Gagou, who have also come under Baule influence. Other neighbors have different linguistic affiliations: the Malinke to the northwest and the Dan to the west. The Baule speak an Akan dialect, and the Bété and the Wé a Kru language. The name "Guro" was given them by the Baule; they call themselves *kwe* or *kouéni*.

Guro masks manifest regional variations in style. Sculptures strongly influenced by Bété art are found in the west and south. The Zamblé-Gu mask pair of the northern region is probably most representative of original Guro art (fig. 46). In the Bouaflé district a highly refined style developed, whose influence can be seen among the neighboring Yauré; their masks feature broken or sinuous lines on the forehead, elements of the elaborate coiffures of Guro women. A. M. V.

Lit.: Tauxier, 1924, p. 97.

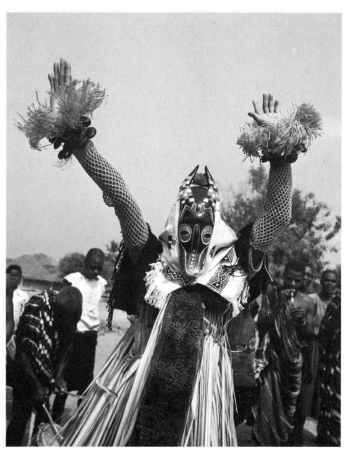

Fig. 46 Guro Zamblé mask. (Photo: M. Huet, Agence Hao-Qui, Paris)

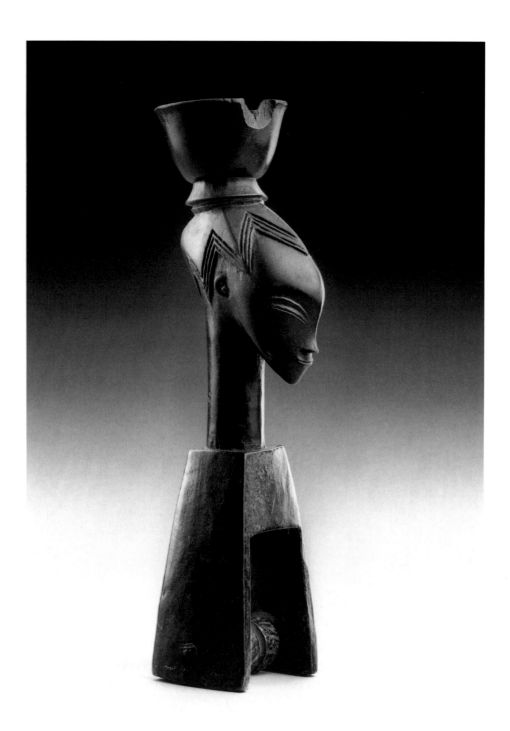

54 Heddle Pulley

Guro, Cote d'Ivoire

Wood; height, 21 cm

Heddle pulleys from the Cote d'Ivoire are often surmounted by human or animal figures. Such devices allow for the alternative play of the loom reeds, each of which supports half the warp threads between which the shuttle and the weft threads pass. The treatment of this pulley indicates that it comes from northern Guro country, where weaving is an activity restricted to men. It represents a young woman, the weaver's girl-friend, since the hairstyle indicates an unmarried woman. On her head is a bowl containing the food that she brings the weaver who, following tradition, has set up his work area outside the village, whose pulley, an evocation of his friends, gives him encouragement and keeps him company. A. D.

55 Figure

Guro, Cote d'Ivoire

Wood, traces of white, black, and red polychrome;
height, 80 cm

This figure represents the soul and shade (*milei*)
of a female ancestor. The diviner addresses the
figure in order to communicate with the world
of the dead predicting the future circumstances
of village life. The highly ornamented sculpture
embodies the spirit of a deceased loved one; it
plays a role similar to the *in memoriam* photo-
graphs of Western society. The figure's form
reflects the traditional Guro ideal of beauty. The
ivory bracelets and crested coiffure, unsuitable
for carrying burdens, indicate that she is either
rich herself or the daughter of a rich man. The
tattooed "fishes" (*po*) symbolize the food she is
able to take to the other world; they also have an
erotic value. A. D.

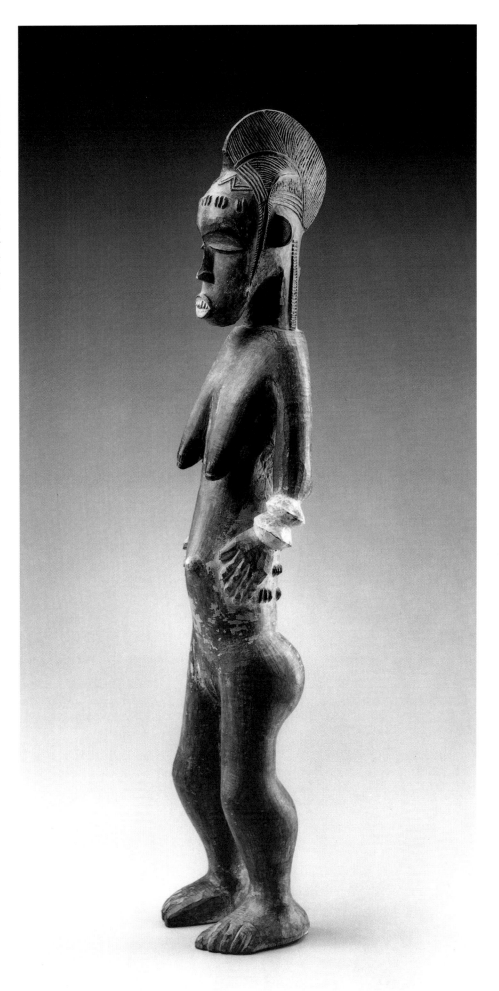

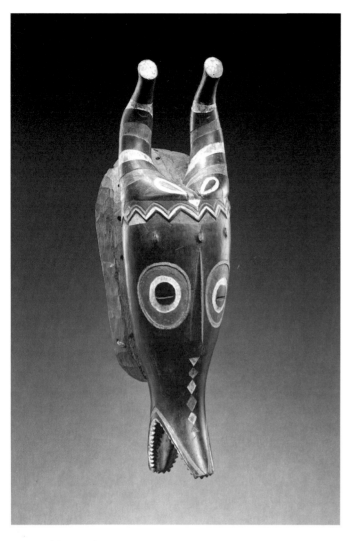

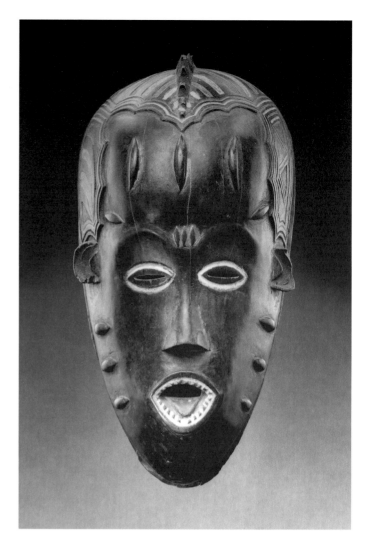

56 Zamblé Mask

Guro, Cote d'Ivoire

Wood; height, 42 cm

Zamblé and Gu (gou) are the best known, most frequently used dance masks of a cult practiced by several northern Guro clans. They are part of a family of masks characterized by ambivalent genealogical relationships. The father or elder brother is old Zahouli (not reproduced here), a grotesque mask with puffed-out cheeks; to him the sacrifice is offered. Zamblé is of fluctuating gender. When Zahouli is present, Zamblé is his wife/sister, and Gu is their daughter; but when Zamblé is absent, Zamblé is considered a man, and Gu is his wife. Zamblé appears in the guise of an antelope (*zuru*). This animal is often considered the forbidden/the ancestor, and it is doubly metaphorical: with its open mouth and hanging tongue, the *zuru* mask evokes the leopard whose skin covers the back of the Zamblé dancer; at another level, the smell of the antelope's flesh recalls that of humans.

Women are forbidden to touch Zamblé, although they are allowed to see him. Until the 1960s, the dancer used to imitate the gait of the *zuru* antelope; since then, more stereotyped and rapid steps have been introduced. Zamblé frequently dances in public, and dance competitions are organized between villages. When her husband Zamblé is victorious in

57 Gu Mask

Guro, Cote d'Ivoire

Wood; height, 26 cm

the competition between two villages, Gu appears and orders the end of the dance; then she goes round the village with Zamblé, making fun of the losers, here by sticking out her tongue.

Gu is always represented as a rich woman, a fact attested to by her scarifications, the number and arrangement of which show that she is the daughter of a free man. Two times three, the male number, decorates her cheeks; two times three also figures on her forehead. Each lateral scarification adds one to three, producing the female number, four; seven, which evokes sexual completeness, is repeated twice. In addition, the coiffure is in four sections (called *canaris*, or ceramic pots, by the Guro; see plate 47) that are braided over her forehead in two times seven waves; and the crest dividing the top of the head has seven indentations. A. D.

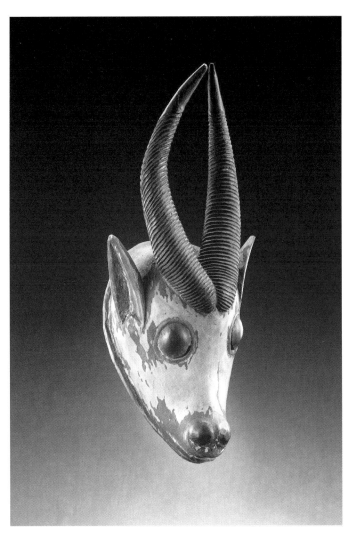

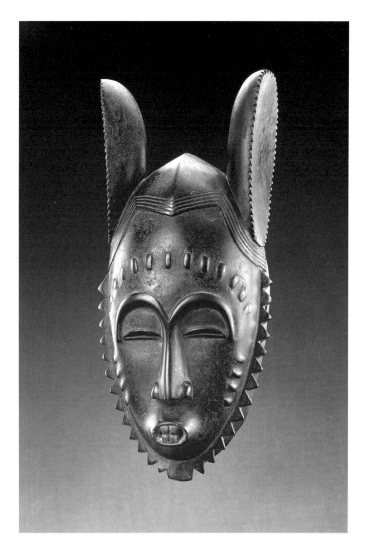

58 Djé Animal Mask

Guro, Cote d'Ivoire

Wood, traces of white, black, and red polychrome; height, 33 cm

This Djé mask from the southwestern Guro region (subprefectures of Daloa, Sinfra, or Bouaflé) represents a *goro* antelope (waterbuck); the wearer imitates the gait of the animal. A. D.

59 Djé Mask

Yaure, Cote d'Ivoire

Wood; height, 31 cm

This Yauré mask belonged to "the keeper of the cult." It enshrines the power of the bush spirit (*djé*), and never leaves the sacred wood, where it appears during important sacrifices. A. D.

The Baule

The Baule inhabit the geographic center of the Cote d'Ivoire. According to tradition, they are a branch of the Asante that was led into exile by Queen Abla Pokou in the eighteenth century. However, it is more likely that the Baule are an ancient race, related to the proto-Guro and the Lagoon Peoples; they intermixed with wandering Akan tribes, picking up their language and a number of their cultural institutions. The use of gold-plated staffs of office, for example, is fairly recent (fig. 47). The Baule borrowed the use of masks from the neighboring Guro, with whom they share certain characteristics of style (the Akan do not use masks).

Baule figurative sculptures are well-known, although they are often incorrectly described as effigies of ancestors. According to Susan Vogel, the sculptures are of two types. The first represent spirits of nature, called *asie usu*, that wander about in the bush; some are depicted as hideous, others as very beautiful and radiant in gold. These spirits can possess human beings and use them as

Fig. 47 Baule mask with sculpted gold-plated staffs, insignia of authority. (Photo: M. Huet, Agence Hoa-Qui, Paris)

mediums, called *komien*. During the divination sessions, the *komien* display figurative sculptures of the spirits; the pleasing appearance of the sculptures is intended to propitiate the *asie usu*, who have a potentially repellant character that should not be unleashed.

The other type of Baule sculpture comprises the male and female images *blolo bian* and *blolo bla*, who are spouses from the other world. Each Baule man or woman is supposed to have a wife or husband whom he or she left behind to come to the realm of the living; if a Baule is led to believe – through bad dreams, for example – that the supernatural spouse is displeased with him, he must set up an altar and make offerings to the angry spirit. These offerings include a sculpted portrait; the "spouse of the beyond" will indicate what sort of sculpture should be made.

Vogel notes that the beauty of the figures is an integral part of their function. The expression "as beautiful as a sculpted figure" shows that "beauty is necessary for a figure to be efficacious."

Alain-Michel Boyer maintains that it is extremely difficult to distinguish an *asi usu* from a *blolo-bian/bla* figure. "Entering an unfamiliar house, a Baule would be able to tell one from the other only with extreme difficulty." However, because it is considered the more beautiful, the figurative sculpture of the spouse of the other world is the object of particular attention. It is oiled, clothed, and decorated with jewelry; and often, as a result of this attention, it can be distinguished from a spirit sculpture, which does not have the same glossy patina.

Boyer also mentions *aboya* figures (see pl. 70), which are not portraits of spirits of the bush but rather of "aides" *(amu)* of the gods. These sculptures represent beings that are half-human and half-monkey; they carry bowls in which offerings of eggs are placed. Because of their coating of coagulated blood, they are considered frightening by the Baule. The *aboya* is a god of the Ngbla, a divinatory cult that takes over from the *komien* when these mediums are powerless in the face of some grave event.

For political reasons, the institution of chieftancy is losing its importance, and the chief is now designated by a body of the local Party. The government clearly intends to destroy the great chieftaincies, and this will certainly result in a considerable modification of Baule traditions. A. M. V.

Lit.: Vogel, 1980; Boyer, 1983, pp. 23, 28 ff.

60 Divination Figure

Baule, Cote d'Ivoire

Wood; height, 44 cm

Faint traces of white paint and a few splashes of blood on the surface of this figure reveal that it was used by a *komyen*, or spirit medium. Carved figures constitute the abodes of nature spirits that periodically possess a diviner and allow him or her to foretell the future and to analyze the source of misfortunes.

Other figures are known by this artist, whose works are characterized by an interest in repeating textured bands – seen here in the fingers, the armlets, and in the scarifications on the neck. The same artist also carved figures in uniform, working his favorite dense, linear neck scarification into a high collar. Although clothed figures have mistakenly been called *colon* figures, they do not represent Europeans, but rather Baule who had acquired the prestigious foreign clothing of the day. S. V.

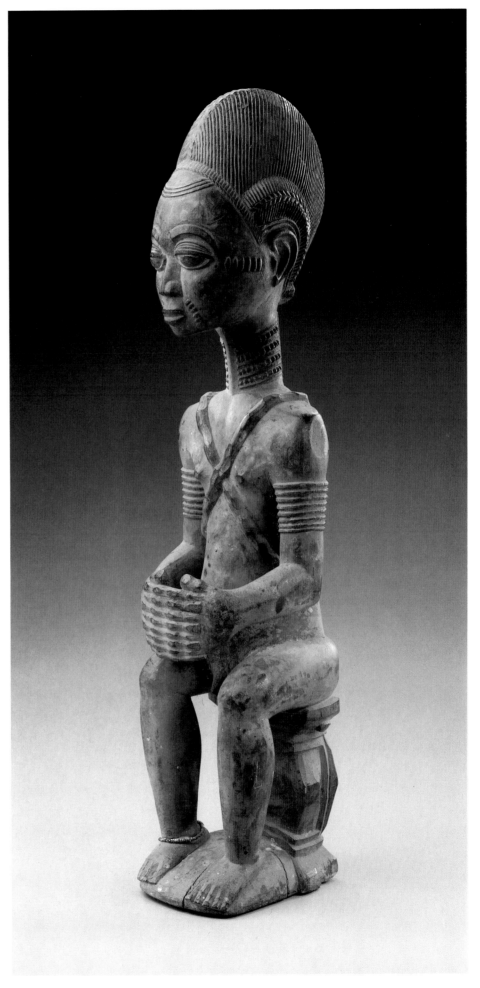

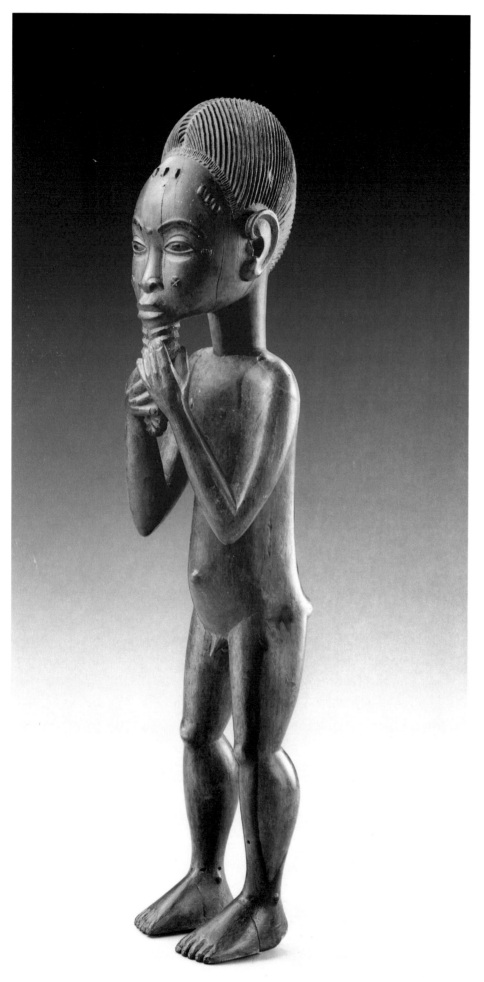

61 Figure
Baule, Cote d'Ivoire

Wood; height, 38 cm

The natural proportions of this figure, its straight legs and wide-open eyes with clearly marked pupils are characteristic of twentieth-century Baule sculpture. Earlier figures tend to have a short, more or less deeply flexed leg and lowered eyes.

This artist masterfully contrasts the smooth surfaces and gentle vertical curves of the body with the more active diagonal lines and bold texturing of the head and hands. The radiating fingers do not intersect in a simple way but, together with the radiating lines of the beard, form a complex pattern that resembles those found in gold work. S. V.

62 Figure Seated on an Animal

Baule, Cote d'Ivoire

Wood and beads; height, 49 cm

This large male figure shows almost every attribute of power and wealth known to the Baule. He is seated on an animal that seems to be a leopard, a symbol of power. Three small antelope horns have been carved in his hair, probably indicating his spiritual powers since they are of a type often filled with medicines. A subtle sign of his wealth and well-being is his soft body, which suggests fatness, good health, and plentiful food. In a world where food cannot be taken for granted, this is a mark of his favored status in the spirit world, without which good harvests are impossible; it also indicates his position within his community, where he can command the labor of others.

To Western eyes, the fluid contours of the body look attractive for other reasons; they contrast with the vigorously textured, linear hair and beard, and give the sculpture a sensuous, languid heaviness. S. V.

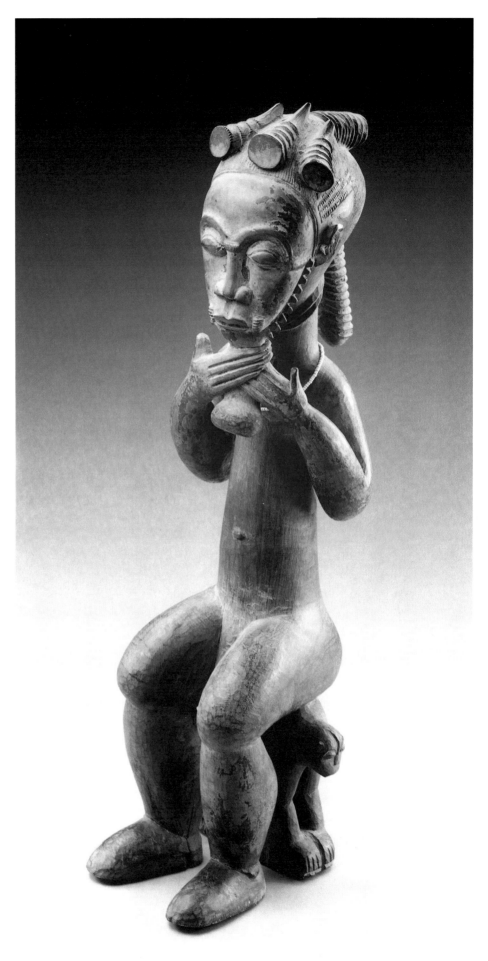

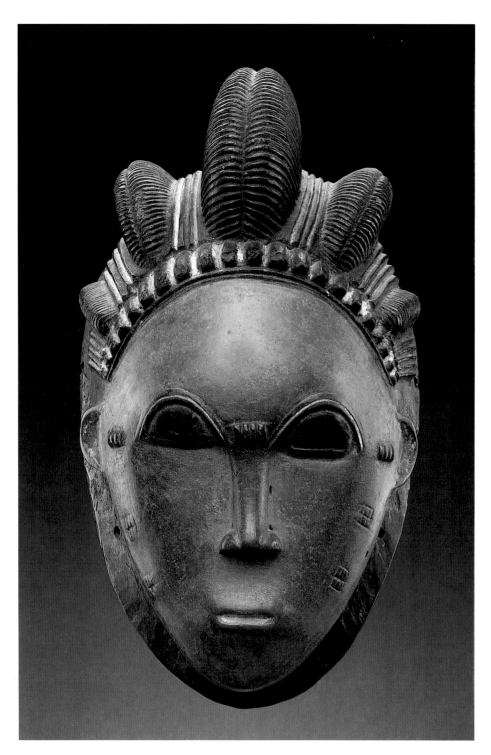

63 Portrait Mask

Baule, Cote d'Ivoire

Wood and pigment; height, 30 cm

The last masks to appear in the course of the Mblo masquerade are portraits representing named individuals who embody an ideal in Baule culture typified by this mask.

Physical beauty is almost always equated with the embellishment of natural endowments. Scarification and coiffures, particularly those as elaborate as the hairstyle here, are thus signs of beauty. The red paint on the face of this mask probably depicts light skin, a quality the Baule admire. The downcast eyes and closed lips imply respect and composure, two moral qualities that the Baule esteem greatly. Although portrait masks depict a person in his or her prime, their performance suggests a dignified elder. S. V.

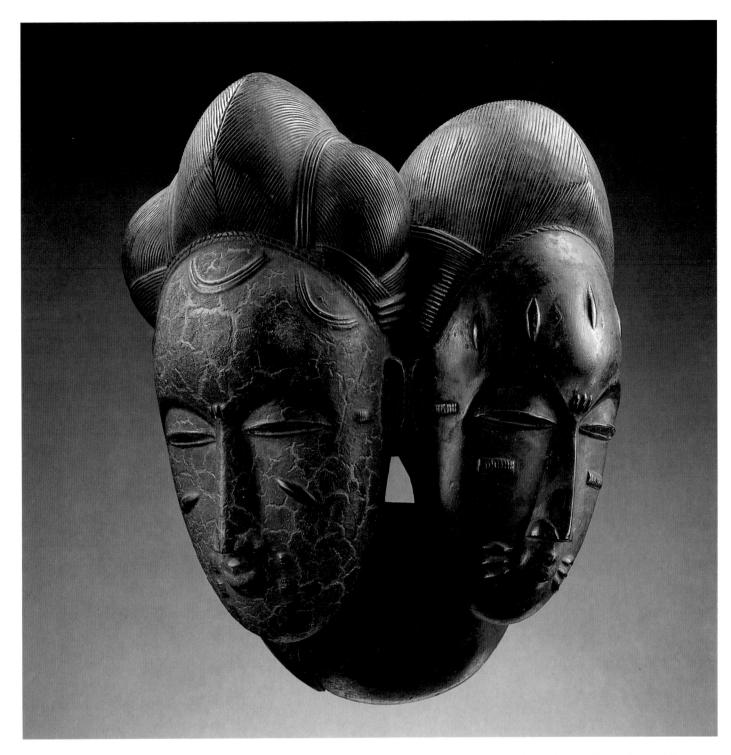

64 Twin Mask

Baule, Cote d'Ivoire

Wood; height, 29 cm

Twins are among the figures in the Baule universe that populate the entertainment dances known by various names, including Mblo. The Baule welcome twin births, and masks representing twins recall a happy occurrence.

The artist who carved this mask closely followed Baule canons of artistic excellence by taking exceptional care to vary all the elements of the decoration that he applied to the two identical faces. All the coiffure and scarification elements capable of variation are, in fact, different in both faces. Only the mark at the corners of the eyes and at the base of the nose, which the Baule call simply "mark" (*ngole*), is the same on both faces. The use of two colors to differentiate the faces is common, although the use of a given color for a given sex varies. In the case of twin masks, both are perfectly likely to be of the same sex.

S. V.

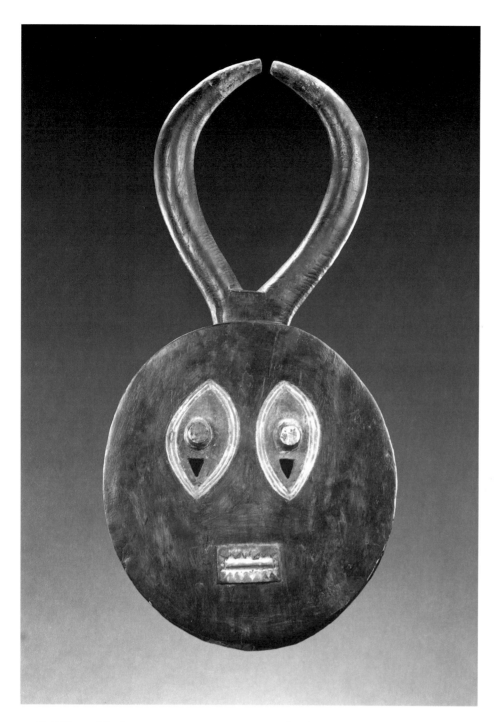

65 Goli Dance Mask

Baule, Cote d'Ivoire

Wood and pigment; height, 42 cm

Simplest of all the four pairs of masks that can appear in the Goli dance, this disk mask represents Kple Kple, the junior male of the series. The extreme lack of ornament or carved detail in masks of this type leaves the artist very little scope for the kind of virtuosity the Baule most admire. For us, however, it is the very simplicity of the form that makes the mask attractive, because it allows us to concentrate on the subtle and expressive elements – the purity of outline and the slight tilt of the eyes. This is an especially austere Kple Kple mask in that it has no deckled edge, no ribbing on the horns, and no ears. S. V.

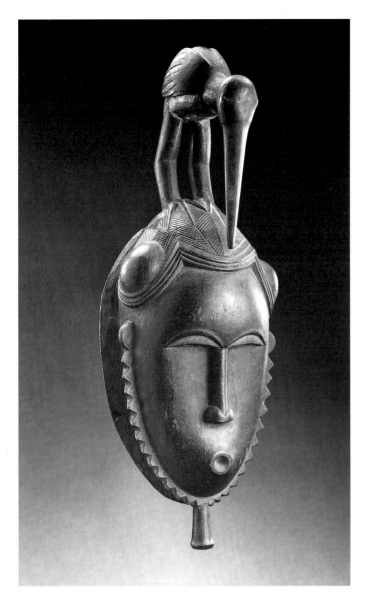

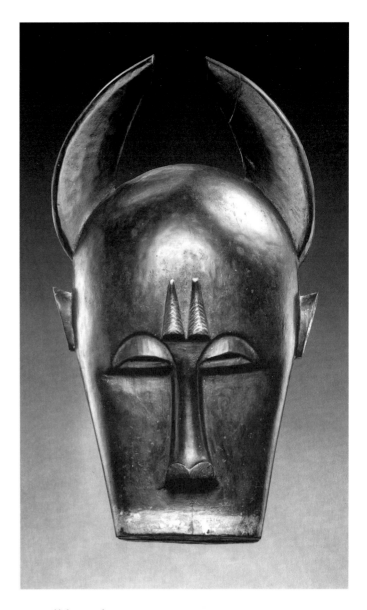

66 Djé Mask

Yaure (?), Cote d'Ivoire

Wood, traces of polychrome; height, 43 cm

This Djé mask could have been made by the Yaure, the Guro, or the Ayahou, an ethnic group living northeast of Bouaflé and separating the Guro from the Baule. It is worn by the best young dancer of the *djé* cult, whose task it is to urge the others on during competitions between dancers from several villages. He sings: "I fly off like a bird, I kill with my beak like an eagle." A. D.

67 Buffalo Mask

Baule, Cote d'Ivoire

Wood and traces of kaolin; height, 38 cm

One of the oldest mask dances in Baule country is an entertainment dance variously called Gbagba, Ambomon, or Adjemble, and often classified as Mblo ("small face mask"). The performance includes masks portraying many human and animal characters from everyday life.

This mask represents a buffalo, one of the largest animals hunted by the Baule. It performs with unmasked, but costumed, young men or boys who mimic hunting and eventually "kill" the masked persona and carry him off in triumph. This skit provides some lessons in hunting and gives young people an opportunity to parody their elders in a typically African method of social control. S. V.

68 Door

Baule, Cote d'Ivoire

Wood; height, 146 cm

Carved doors are hardly ever seen today in Baule country, although they were once found both on courtyard entrances and sleeping houses. The carving seems to have been purely decorative, but some doors do bear motifs that allude to proverbs.

This is an exceptionally fine door with an unusual composition. The high-relief carving and the subtle alteration of the angles of the two fish betray the hand of a master. The high-relief plumpness of the fish probably gave the Baule more than purely aesthetic pleasure, because it recalls the delicious meal that fish (and potentially all animals) represent. The circular forms that make up the background suggest water through which these two energetic creatures are vigorously swimming. S. V.

69 Vessel for Mouse Divination

Baule, Cote d'Ivoire

Wood; height, 16.5 cm

Mouse divination uses a living field mouse, kept in a vessel like this one, that disarranges a set of small batons in a manner that can be read by the diviner. The Baule consider this a very reliable form of divination, although it cannot give detailed answers to questions.

This vessel has four figures carved in relief, two males and two females, probably represent-ing clients of the diviner. Interestingly, they do not alternate according to sex, and the areas of complex texturing fall between figures of the same sex. One of the male figures holds something in his hands, perhaps two eggs, a common offering to spirits. S. V.

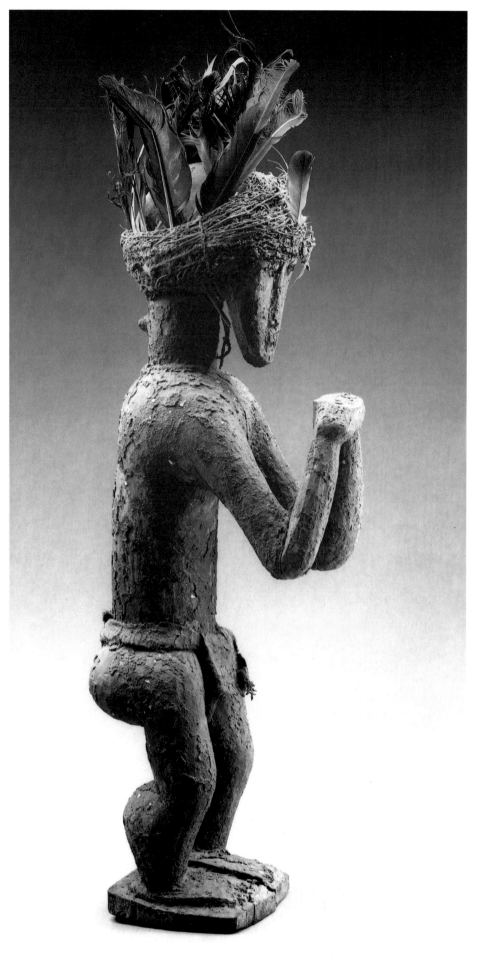

70 Figure
Baule, Côte d'Ivoire

Wood, feathers, and fiber; height, 87 cm

The posture of this human figure is similar to that seen in Baule monkey figures; the latter are relatively common in the Baule repertoire, but human examples are rare. Like the monkey figures, they appear to be used for cults connected with warfare and divination, although their use and meaning varies from place to place in the Baule territory. Women are often, but not invariably, forbidden to see such figures.

An encrusted surface like this one signals to the Baule the presence of something with potentially dangerous spiritual powers. Any object covered with such a surface is considered by the Baule to be ugly, powerful, and dangerous. Ironically, the very roughness of this figure, its vigorous stance, and its wild feathers are what recommends it to us. S. V.

The Lagoon Peoples

In the southeastern corner of the Cote d'Ivoire there are twelve ethnic groups known collectively as the Lagoon Peoples. Each population speaks a language only distantly related to that of its neighbors, but some cultural institutions are found throughout the region (fig. 48). These peoples are bordered on the east by the Nzima, and on the north by the Anyi and Baule. M. B. V.

Fig. 48 Ebrie notable (member of the Lagoon Peoples) wearing gold pendants much like those of the Baule. (Photo: Doran Ross)

71 Figure

Ebrie, Cote d'Ivoire

Wood, necklace of hollow-cast brass beads, and waistband of glass beads; height, 24.5 cm

Objects in the style of this figure are customarily assigned to the Akye (Attie) or Tshaman (Ebrie) peoples. However, artists have always traveled widely throughout the southeastern Cote d'Ivoire, and these works could have come from any of the twelve Lagoon groups.

This statue was probably owned by diviners, who claimed to use it to convey messages to supernatural beings. In the past, such figures were the tangible reminders of the clairvoyants' links with the spirit world and legitimized their position as healers. However, these pieces may also have been made for other purposes, since "people of wood" (as statues are called in the Lagoon area) have traditionally been used in a variety of contexts. Some are displayed during sacred or semisecular dances, while others take the place of a deceased twin or give physical form to the spouse whom a man or woman left behind in the otherworld (their "spirit lover").

Sacred statues are still believed to contain supernatural forces. While this may account for the somewhat unsettling effect created by the exaggerated, compressed curves of the present figures, its wide hips, full breasts, and bulbous limbs also reflect Lagoon conceptions of mature feminine beauty. M. B. V.

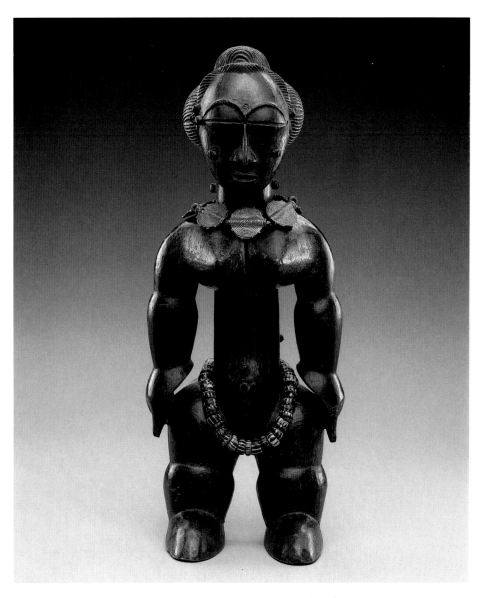

The Akan Peoples

The central and coastal regions of Ghana are occupied by peoples of the large Akan family, the best known of whom are the Asante and, further south, the Fante. Other branches of the Akan, like the

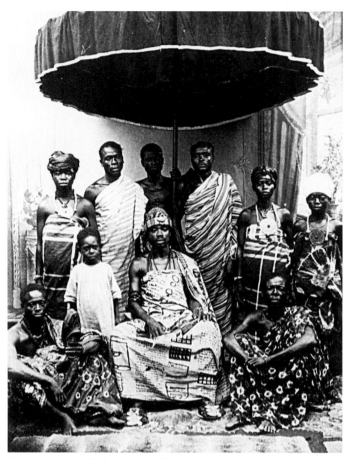

Fig. 49 Asante chief surrounded by notables in the Kumasi region, c. 1930. Note the gold disks worn by the women on the right. (Photo: Basler Missions-Archiv)

Anyi and the Abron (Brong), settled in the Cote d'Ivoire, where a number of ethnic groups, particularly the Lagoon Peoples, who came from the north long ago, have been influenced by the Akan migrations to a greater or lesser degree. In the region south of Bondoukou, for example, the Abron have a culture patterned on that of their Asante relatives; they wear *kente* cloth and, during their festivals, gold jewelry bought in Ghana. All Akan peoples are yam growers. Hence, it is possible to determine the attenuation of Akan influence on their neighbors by the importance of rituals involving the yam – the Lagoon Peoples, for example, do not celebrate the typical yam festival of the Akan.

The Asante impressed the first European travelers by the profusion of gold ornaments they wore, like their coastal neighbors. The Asante sovereign (fig. 49) resides in Kumasi and receives homage from a number of chiefs. Despite a difficult period at the turn of the century, when the king was deported by the British, traditions have been remarkably well preserved. Surrounded by counselors, who carry gold-plated wooden "speakers" staffs, the king, his hands adorned with large rings, sits motionless during official festivals, displaying the stool of pure gold that is the emblem of Akan royalty.

As with all Akan peoples, stools have an important role and a sacred character, being found at the center of many rituals. The Abron of the Cote d'Ivoire sprinkle blood on ancestral stools every year during the festival that celebrates the ripening of the yams. And Asante nobles own stools of a variety of shapes that attest to their rank.

The Asantes' talent as goldsmiths and their trade in gold dust, regulated by the king, gave rise to a whole system of weights and measures. The weights used in the gold trade are miniature sculptures, cast by the lost-wax method; they constitute a valued part of Asante art, which has also produced protective figures (pl. 73) and large ceremonial drums. In an earlier period, human heads of terra-cotta were made by Akan peoples in southern Ghana to adorn graves (pl. 72); in their serene beauty, some of these may be compared to the famous sculptures of Ife. A. M. V.

72 Royal Memorial Head
Southern Akan, Ghana

Terra-cotta; height, 24 cm

Terra-cotta heads such as this were made by the southern Akan as memorials to deceased chiefs and queen mothers. They are idealized "portraits." Some formed part of elaborate assemblages in which the central figure was surrounded by courtiers and attendants. These assemblages were set out in some remote and tranquil place where periodic ceremonies were held to honor the deceased.

This rich tradition of clay portraiture flourished among the southern Akan from the seventeenth to the nineteenth century. It is found in the coastal districts, from Winneba in the east to the Cote d'Ivoire lagoons in the west, and also as far inland as Adanse and Kwahu. It was, however, virtually unknown to the Asante and northern Akan.

The present head is in one of the finest Akan styles. It comes from the old forest kingdom of Twifo or from the nearby kingdom of Wassa, close to the Pra river, and probably dates to the period 1650–1800. T. G.

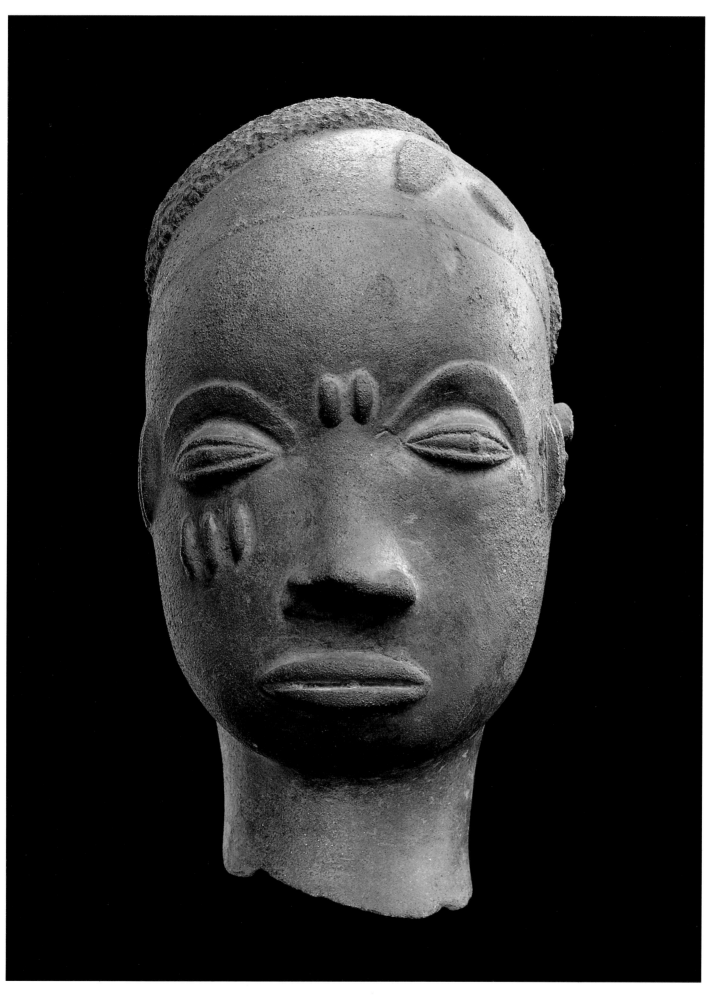

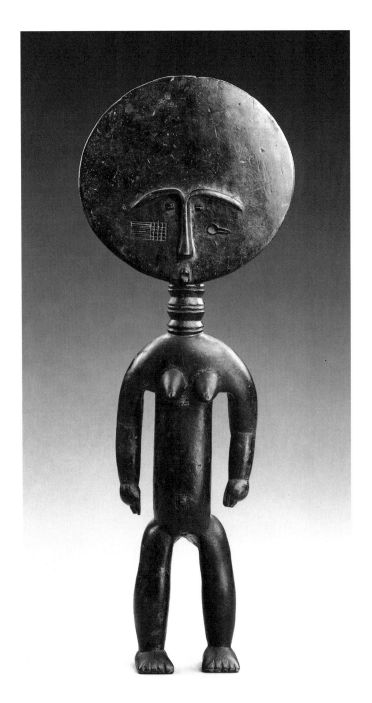 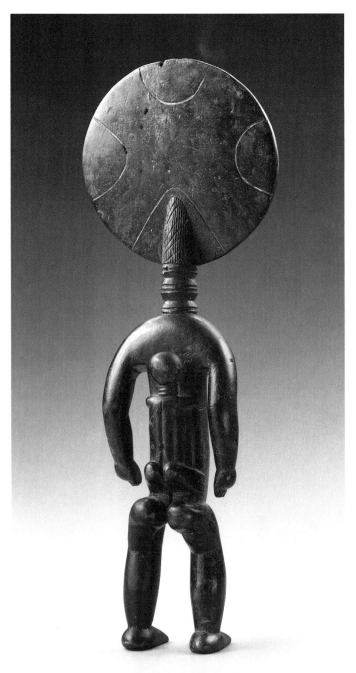

73 Akuaba Figure

Akan, Ghana

Wood (left leg and left edge of head restored);
height, 44.5 cm

Figures of this type are found throughout the Akan area. Their name means literally "Akua's child" (*Akua ba*). According to legend, a woman named Akua became pregnant and had a beautiful daughter by carrying one of these figures. Until recently, many Akan women used them to induce fertility or, if pregnant, to ensure the birth of a daughter. The figure is carried on the back like a living child until the desired result is obtained. This custom is probably ancient, though not reported or described until 1885.

The present carving, with naturalistic limbs, is typical of an Asante style that has developed within the last fifty years. Most older *akuaba* figures are of highly stylized form, with more rudimentary arms and no legs. The disk-shaped head is characteristic of central Akan carving; figures from the Fante and Brong regions often have rectangular or cone-shaped heads. T.G.

The Edo Kingdom of Benin

The Edo Kingdom of Benin is situated in a tropical forest region of southern Nigeria. Oral traditions suggest that, by the thirteenth or fourteenth century, the Edo people were united into a powerful kingdom which, by the fifteenth century, had embarked on a course of aggressive military expansion in the region. During this period of conquest Portuguese explorers made contact with them, recording for the first time the name "Benin," which has been used ever since to refer to the kingdom. For four hundred years Benin traded with the Portuguese and other European nations until, in 1897, it fell to British colonial expansion and was later incorporated into the wider political framework of Nigeria. Its capital, Benin City, is now the administrative center of Bendel State. P. B. A.

74 Pendant Mask

Edo Kingdom of Benin, Nigeria

Bronze; height, 17.9 cm

In the period between the mid-fifteenth and early seventeenth centuries, the Edo Kingdom of Benin embarked on a course of military expansion that established its dominion over neighboring peoples in all four directions. Leaders in these areas who became vassals of the Benin king were presented with insignia of their allegiance, including bronze pendant masks such as the present example. There are similar masks still in the possession of Yoruba, Igala, and Igbo chiefs and priest chiefs; they continue to serve as symbols of authority. Photographs indicate that these masks are worn as pendants, suspended from the neck. They share such stylistic features as downcast eyes, a long nose with semicircular nostrils, and parted, protruding lips. Above each eye are four marks which in present-day Benin are considered an indication that the bearer is a foreign male. While the dating of Benin pieces is conjectural, the stylistic resemblance of this pendant to other sculpture assigned to the period of expansion suggests that it originated at that time. P. B. A.

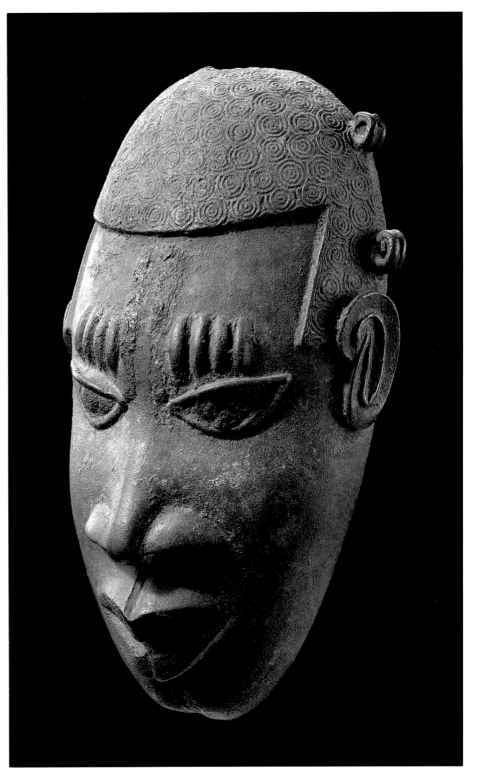

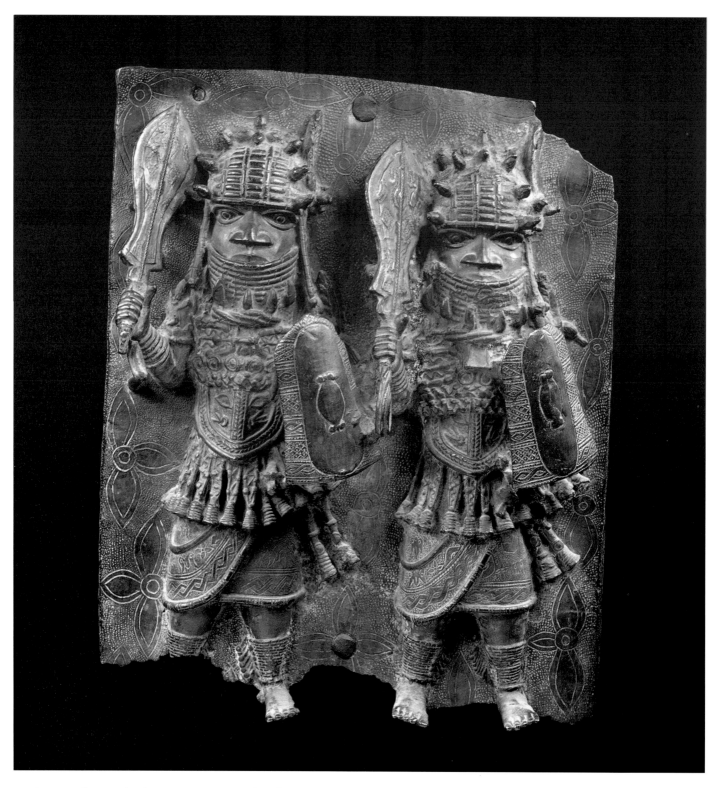

75 Plaque with two Chiefs

Edo Kingdom of Benin, Nigeria

Bronze (lost-wax cast); height, 40 cm

This plaque represents two chiefs in ceremonial war regalia. It belongs to a corpus of about nine hundred plaques that were probably made between the late fifteenth and the early seventeenth century and were used as decoration in the royal palace. An early eighteenth-century Dutch visitor's account describes a courtyard of the palace with its "wooden pillars, from top to bottom covered with cast copper on which are engraved the pictures of [Benin] war exploits and battles."

The chiefs are wearing coral-bead headdresses, chokers, armlets, and anklets, all of which are marks of high status. The stylized leopard face of cloth or leather and the leopard-tooth necklace are references to the king of the forest animals, whose ferocity is capable of driving away enemies. In their left hands, the chiefs hold wooden shields covered with leather and, in their right, a ceremonial dancing sword, the *eben*.

The appearance of the coral-beaded regalia and the special sword indicate that the chiefs represented here are participating in a ceremony rather than engaging in actual military activities, yet the magical powers employed and the dangers faced when performing in royal rituals are said today to be analogous to those found in warfare. P. B. A.

The Yoruba

Today, there must be in the region of fifteen million people, mostly in Nigeria but some in the Benin Republic too, who would claim to be Yoruba. The word refers to a series of mutually unintelligible dialects spoken by people who, in the pre-colonial period, were grouped into some fifty kingdoms that formed variable alliances in time of war but that were never united, except in the sense that their kings all claimed descent from the god Oduduwa, who climbed down from the sky at Ife to make the world. The use of the word "Yoruba," derived from a Hausa word for the Kingdom of Oyo, to describe these diverse entities is a development of the colonial period and can be ascribed partly to the use of Standard Yoruba as a medium of education – in a form derived from the Oyo dialect, it was used to translate the Bible – and partly from the formation of a Yoruba political party, the Action Group, after World War II. The pre-colonial bases for this sense of Yoruba identity are much harder to discern, although one factor was probably the mythology of kingship. The artifacts described below may well provide several insights into pre-colonial Yoruba culture, despite the fact that all are products of the colonial era.

The Gelede association is located in the southwest of the Yoruba-speaking region, in Nigeria and the adjacent parts of the Benin Republic. It extends no further east than Lagos, the Egbado quarter of Abeokuta, and the Oyo village of Ijio on the border with the Ketu Gelede kingdom. Similar mask forms are found elsewhere, but not the Gelede cult and its association.

In the towns and villages of southwestern Yoruba country the annual festival of the Gelede association, held during the dry season when there is time to spare from agricultural work, is the major event and entertainment of the year. The performances take place in two stages. At night, Efe masqueraders sing, while Gelede masqueraders dance on the afternoons that follow (fig. 50). In most communities there is only one major Efe performer who sings from within the mask, whereas in every community there are several sets of Gelede masks that always dance in pairs. The Efe songs are probably the most significant element of the entire festival: everything else is essentially a preparation for, and an embellishment of, them. The songs include praise of the *orisha* and of "Our Mothers," in whose honor the festival is staged, as well as of

Fig. 50 Gelede mask among the Yoruba of Benin. (Photo: M. Huet, Agence Hoa-Qui, Paris)

past and present performers. The wearing of a mask does not transform the performer into some kind of non-human presence, and there is no secrecy as to the identity of the performers. Rather, the use of the mask has to be understood by reference to a story about Orunmila – the *orisha* (god, deity) that animates the divination system – who journeyed safely to and from the secret forest grove of the "Mothers" protected by a mask, a cloth, and ankle rattles. By wearing masks, the performers obtain both protection from and by the "Mothers." The performance is, after all, in honor of the "Mothers," Orunmila having covenanted with death and returned safely, and the songs are intended to please the "Mothers" as much as to entertain the community as a whole. Efe singers are thus regarded as enjoying the protection of the "Mothers." J. P.

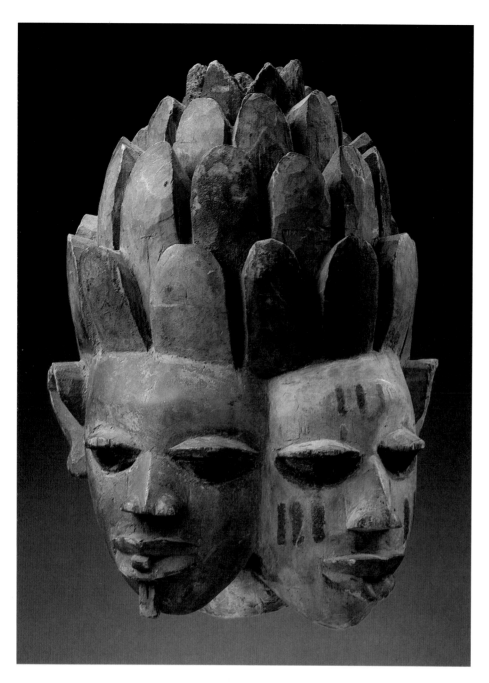

76 Gelede Mask

Yoruba, Nigeria

Wood; height, 36 cm

The identity of this mask is unclear, despite the fact that several double-faced Yoruba masks are known. They are usually said to represent twins, but this does not seem likely in the present case, since the two faces are quite different in color and marking, and one also wears a bead inserted through the lower lip. The contrast of red and white is appropriate to the cult of Shango, whose devotees wear strings of alternating red and white beads. Furthermore, the "hair" may well represent the *edun ara*, the neolithic axes that embody the power of Shango and provide the focal point of cult ritual (Shango iconography does include depictions of devotees possessed, showing an *edun ara* upon the forehead). The style and coloring of the mask suggest that it is from the Anago region of southwestern Yoruba country, in or near Ago-Shasha, perhaps.

Gelede masks present an enormous variety of imagery. Certain larger or more elaborate types are restricted to use by Efe performers, their precise form varying from one part of the Gelede performing area to another. Other mask types are used for specific purposes in Gelede cult and performance. These apart, it is hard to see any order or system in what is represented, and indeed, to attempt to systematize the profusion of imagery may well be to miss the point of it altogether. There are a number of well-known stereotypes that occur wherever Gelede is found, while others depict prominent deceased members of the associations. For the rest, one has the impression that the carvers may exercise their creative and inventive powers with more or less complete freedom, drawing upon whatever is at hand that seems worthy of comment, whether serious or not: cult devotees, Muslims, airplanes, motorcars, sexual intercourse, banana trees, animal species of one kind or another, the Christian Calvary . . . the list of subjects is seemingly endless. From a cult point of view, the essential requirement is a mask of appropriate size to set upon the wearer's head (and the performers are always male, whatever the subject matter). Beyond this, there is no evident expectation of conformity to a well-defined iconographical scheme. 								J. P.

77 Veranda Post

Yoruba, Nigeria

Wood, with traces of European white paint;
height, 142 cm

This veranda post was carved by Oshamuko of
Osi-Ilorin village sometime in the 1920s. (An-
other post of identical provenance showing a
horseman is also in the Barbier-Mueller collec-
tion.) Oshamuko worked as an assistant to the
better-known Areogun, although he also pro-
duced work independently. His sculpture is
clearly similar in style to that of Areogun and,
indeed, is often confused with it by European
and American commentators. There is rarely
any doubt in the minds of the owners of works
by these two masters, however. In general,
Oshamuko's work tends to be leaner and more
elongated. With regard to figures of a mother
giving a drink of water to her child, one of the
more obvious differences between Areogun and
Oshamuko is that the latter always places the
child's head lower than its buttocks, as can be
clearly seen here. The post itself was commis-
sioned by Atobatele of Iporo sometime between
1920, when he became village head, and his death
in 1928. In 1964 it was seen still in place on the
veranda of Atobatele's house. The present black-
and-white oil-based paint has been applied since
then.

Wooden veranda posts such as this are among
the typical forms of Yoruba sculpture, particu-
larly in the eastern and northeastern areas,
where sculptural forms tend to become increas-
ingly architectural and large-scale. Veranda
posts are to be found ornamenting the palaces of
kings, the temples of gods, and the houses of
well-to-do people, and their purpose does appear
to be primarily decorative. Sometimes the sub-
ject matter illustrates some ritual practice, but
this does not give the form any particularly sac-
red character. In the veranda posts of Areogon
and Oshamuko the images that recur time and
again are the warrior on horseback, the supplic-
ant woman with an offering to a diviner or
priest, and, as here, the mother and her child.

Oshamuko died in about 1945 and was thus
survived by Areogun (the older master lived
from c. 1880 to 1954). Areogun's son, George
Bandele, who continues to work as a sculptor at
Osi-Ilorin thanks to the encouragement of Fr.
Kevin Carroll, was taught to carve by
Oshamuko, not by his father. This was due
partly to a local tradition that a master does not
have his own son as an apprentice and partly to a
certain hostility between father and son (hostil-
ity that was cleared by Fr. Carroll). Oshamuko
and Bandele are both known among the carvers
of this area for their ambidextrous use of the
adze.

Osi-Ilorin belongs to the Opin group of vil-
lages in the northeast of the Yoruba-speaking
area, a group culturally similar to Ekiti although
it came under the control of the Ilorin Emirate in
the 1850s. Iporo is a northern Ekiti village be-
tween Ishan and Otun. J. P.

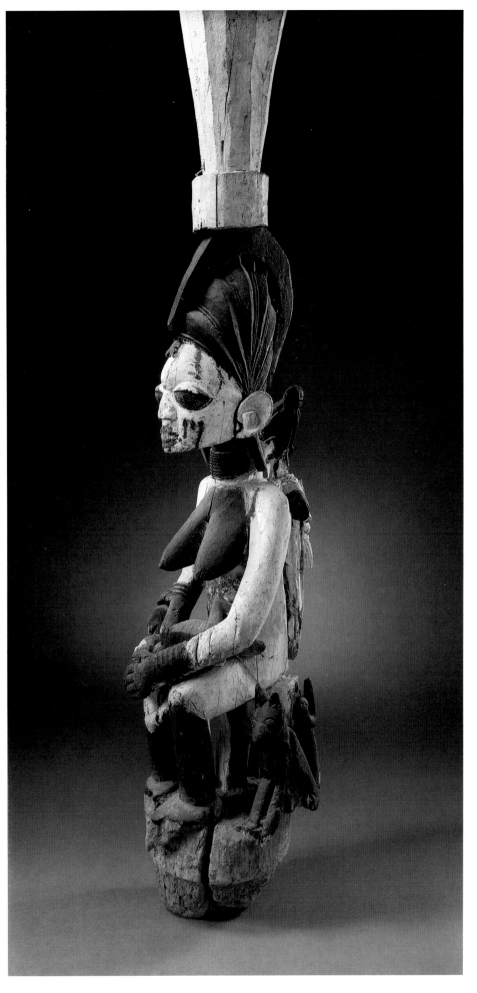

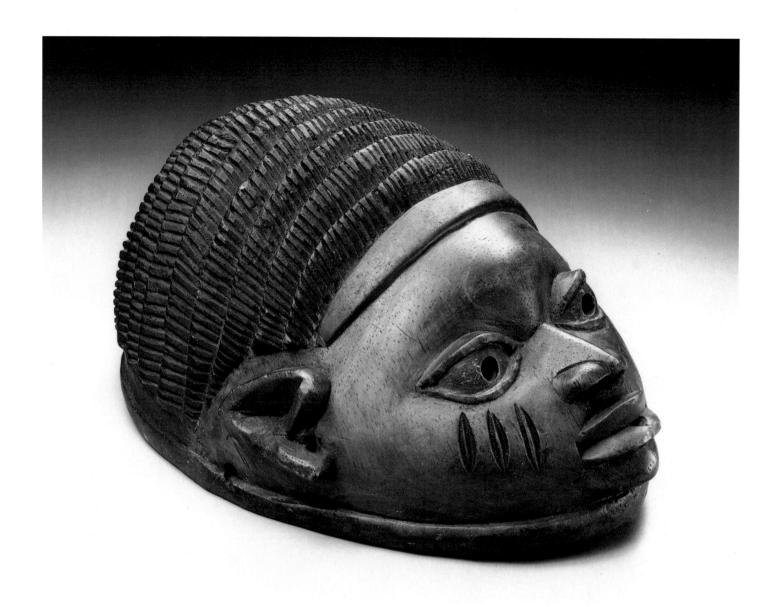

78 Gelede Mask

Yoruba, Nigeria

Wood; height, 30.5 cm

This mask shows a woman's plaited hairstyle and perhaps represents the Gelede form in one of its simplest versions. The afternoon performances, in which Gelede masqueraders dance in identical pairs, present a series of contrasting male and female stereotypes. Sometimes this is represented in the mask itself, as here, but finds expression primarily in the costumes and style of performance. Male stereotypes are characterized by extensive costuming which is bulky when the dancer is still but which flies out when he performs his wild movements. Female stereotypes are more restrained in both performance and costume. These representations of gender stereotypes are a particularly attractive part of the entertainment offered to the "Mothers" and the entire community.

Who are the "Mothers"? From one point of view, of course, nobody knows, as this use of the word is understood as a euphemism for witch; and witchcraft is a secret nocturnal activity to which no one would openly admit. Within Yoruba cultural traditions women are regarded as possessing a dual mystical potential: as mothers they have the power to create and nurture life, but as "Mothers" they also have that destructive potential usually designated as witchcraft – and although there is a Yoruba word that can be translated as "witch/witchcraft", it is safer to use the euphemism. On the one hand, women as witches are unpredictable in their angry and envious depredations, causing various intractable afflictions including the most feared of all – premature death. On the other hand, they underpin the moral order by their search for suitable victims. Not every woman is regarded as a witch, but all have this potential.

J. P.

79 Gelede Mask

Yoruba, Nigeria

Wood; height, 37.5 cm

This mask is for the afternoon Gelede performance. It is very probably the work of Duga of Meko, a town in Nigeria close to the border with the Benin Republic and part of the Ketu kingdom. In the present century Meko has been (and indeed, still is) the center of a vigorous school of carvers, and Duga (c. 1880–c. 1960) was undoubtedly one of its great masters. On this mask a cockerel is biting a snake which is biting the cockerel, an image that doubtless refers to one or more Yoruba proverbs.

J. P.

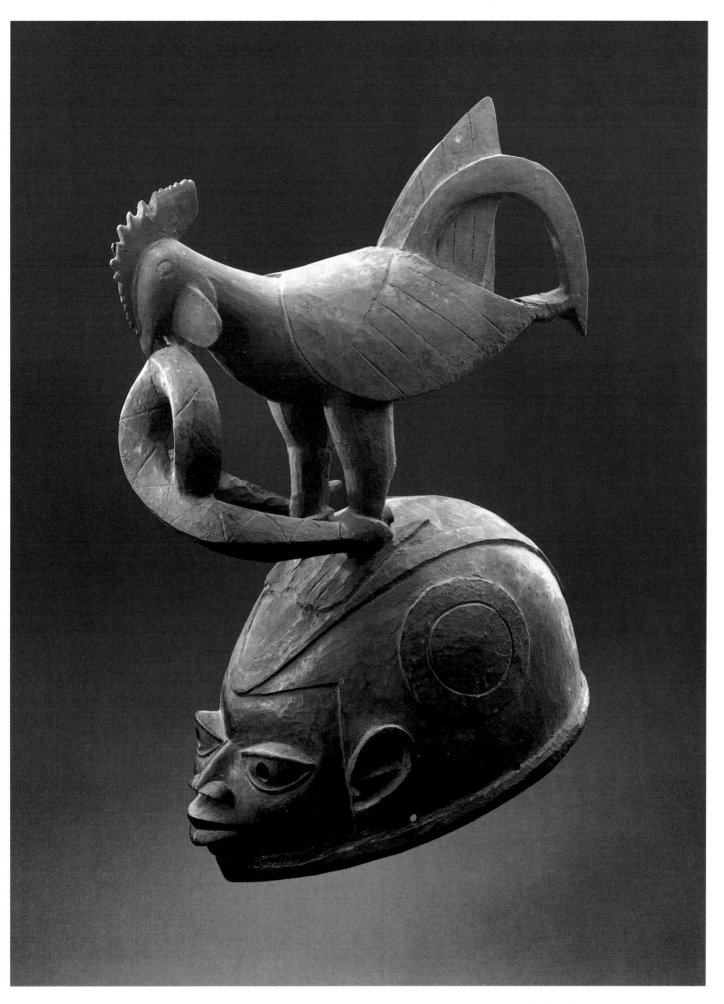

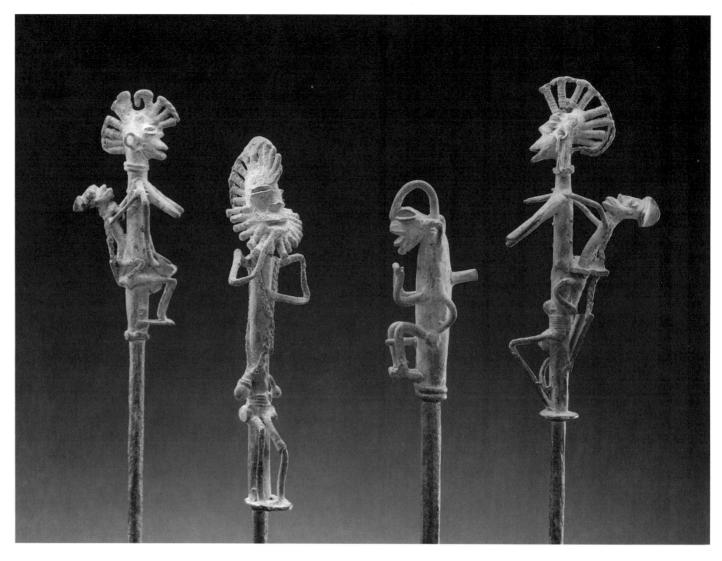

80 Figures on Staffs

Yoruba, Nigeria

Bronze (figures) and iron (staffs); heights,
(A) 118/22 cm, (B) 114/21.5 cm, (C) 122.5/13 cm,
(D) 135/16.5 cm

During my fieldwork among the Yoruba in 1959 I went up to a small and remote Igbomina village, Idofin Igbanna, where by good fortune I chanced upon a ceremony in a cleared area outside the village. At the center of the ritual was a mass of staffs of the same type as these, which I had never seen before. They were, however, clearly of the same production as the brasses seen in Obo-Ile and Obo-Ayegunle near Osi, although these do not normally attain to such proportions. These objects were stuck in the ground, upright, in front of some elders of the cult. Meanwhile a large wooden figure of a woman was being processed around the gathering on the head of a small girl. It was called Aridegbe (for which R. C. Abraham gives the information that it is a male name meaning "he whom one sees and who becomes one's friend"); it would seem therefore to be an apotropaic figure.

I did not see staffs of this kind again until I happened to see a quantity of them in a Dutch dealer's shop many years later. Subsequently offered to and acquired by the Barbier-Mueller Museum, these are presumed to be the only examples of this art in the Western world, and are without any doubt among the finest of Yoruba castings. W. F.

Lit.: Fagg and Plass, 1964, p. 28.

81 Shango Staff

Yoruba, Nigeria

Wood; height, 59 cm

This type of Shango staff is known as *oshe shango*. Shango is the Yoruba *orisha* associated with the thunderstorm, thunder and lightning being manifestations of his power. Each of the Yoruba *orisha* can be regarded as having a dual role. In relation to the individual cult member, the *orisha* provides a complete service, with health, longevity, children, and worldly wealth granted in return for devotion. In relation to the community, the role of each *orisha* is more specific: for example, Shango's association with the storm led to his cult priests functioning as rainmakers. The annual festival of an *orisha* is thus staged by the cult members on behalf of the community in order to restore and renew the beneficient relationship between the community and the *orisha*.

Material representations of the power of the *orisha* form the core and basis of Yoruba cult practice. Shango's power is embodied in the *edun ara*, the neolithic axheads often turned up by farmers by accident – something that we should regard as proof of earlier inhabitants, but which Yoruba cult tradition views as evidence that lightning has struck the ground in that

place. Every Shango shrine contains one or more bowls in which *edun ara* are kept. The word *oshe* refers to the specific baton form of the Shango cult. At its simplest, this comprises a wooden haft, with a single or (as here) double axlike shape carved at one end and often identified as a representation of *edun ara*. It has to be admitted that this is not more than an inference on the part of commentators outside the cult and, indeed, outside Yoruba tradition; it is not an identification made explicit by the cult devotees themselves. On the other hand, it does seem a plausible explanation, since each devotee is presented with a least one such baton at his or her initiation and carries it when – and only when – possessed by Shango. A representation of the *edun ara* would thus be a fitting embodiment of the presence of Shango in the devotee at that moment.

The carved image forming the haft of the present baton is of an unmarried girl kneeling in supplication. She wears only the waist beads that are worn by girls from infancy onward and that married women keep covered by a skirt so that they can be seen only by her husband. Images carved on *oshe shango* are invariably female, sometimes clothed (and thus presumably married), sometimes leading a ram, the principal sacrifice to Shango. This imagery can be expected to have several layers of meaning, none of them made explicit by Shango devotees. One possible interpretation is that the image of a woman signifies the relationship of the devotee (of whichever sex) to the *orisha* (again, of whichever sex) by analogy with the relationship of wife to dominating husband, a relationship manifested most obviously when the devotee is in a state of possession by the *orisha*.

Some accounts of the cult and mythology of Shango refer to him as an early king of Oyo, the mighty savanna Yoruba kingdom that dominated much of the area from the fifteenth to the nineteenth century, and state that he was deified despite the fact that he committed suicide. This part of the story may represent a latter-day misunderstanding of a poetic reference to Shango as *oba koso*, a term capable of two interpretations. On the one hand, Koso is simply the place in Oyo where the chief shrine of the cult is located and where, according to its priests, Shango disappeared into the ground. The reference merely describes him as its king (*oba*). On the other hand, *ko so* also means "does not hang," and it may be that, assisted by some eager missionary catechist, a confusion of the two readings gave rise to a new myth that has been widely disseminated despite disclaimers from Shango's priests.

J. P.

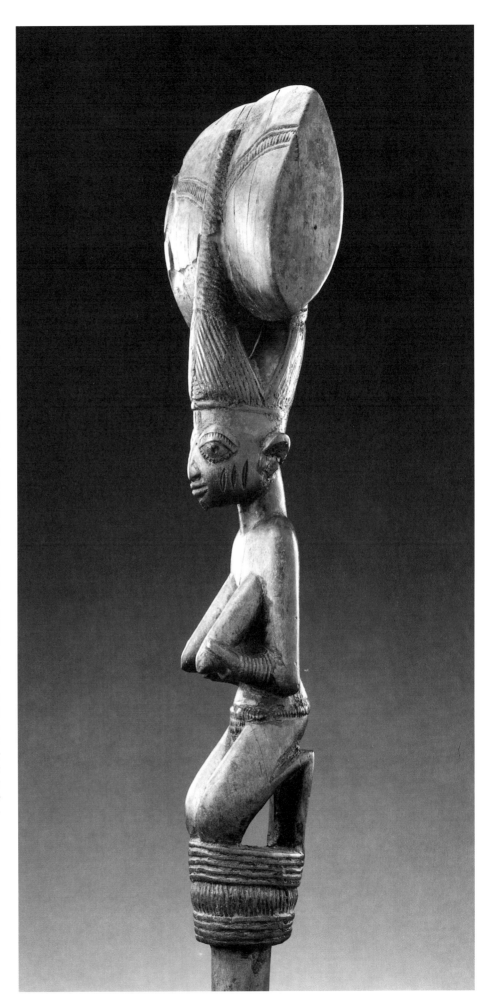

The Urhobo

The Urhobo, who live south of Benin, have strong artistic connections with their neighbors, the Bini, Igbo, Itsekiri, and Ijo. They possess two main sculptural traditions: wood and clay figures (often life-size) commemorating ancestral, spiritual, and personal forces, and wooden masks that are danced at festivals for water- and land-based spirits (fig. 51). P. F.

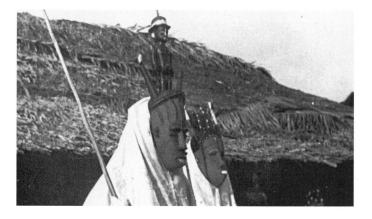

Fig. 51 Urhobo masks representing the children of the water spirit Ohworu. (Photo: William Fagg, 1950)

82 Mask

Urhobo, Nigeria

Wood; height, 46 cm

This type of mask appears in numerous southern Urhobo village groups in conjunction with Ohworu, a powerful water spirit brought north from western Ijo communities by itinerant Urhobo fishing families. Ohworu is one of the "children of the spirit" (*emedjo*) who bring the "blessings of the deep water" to the villages when the tributaries of the Niger River have reached their maximum height. In 1971, the communities of the Ogor village group, fifteen kilometers south of Ughelli, identified masks similar to this one as "girl with youthful body" (*omotokpokpo*). The allusion is to a "bride" (*opha*), a young woman of marriageable age who, according to tradition, benefits from the protective guardianship of Ohworu. The crest above the forehead, and the curved appurtenances atop it, recall the elaborate hairstyles worn by the "brides" when they are presented to the village. P. F.

Lit.: Foss, 1973 and 1976.

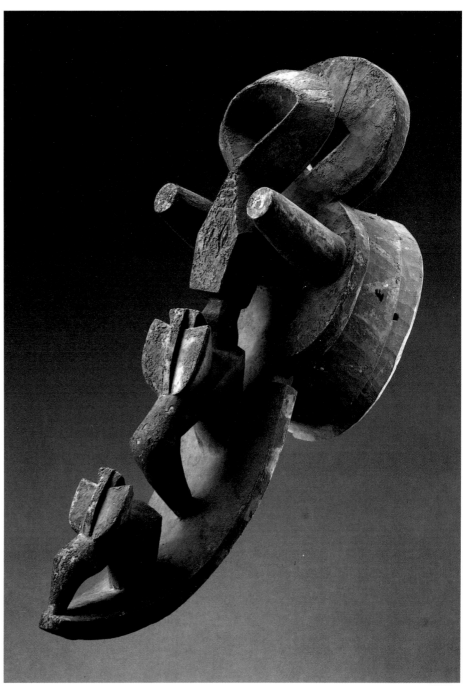

83 Igodo Headdress

Ijebu Yoruba, Nigeria

Wood; length, 64 cm

Ijebu Yoruba living along the coast celebrate water spirits with an elaborate program of masquerades called Agbo. They adapted Agbo from the Ijo of the Niger Delta, who are renowned for their Ekine masquerades in honor of the "water people" (*owu*), spirits that "own" portions of creeks, controlling their water level, currents, waves, and the depth of their fish shoals.

Ijo sculptural style is especially evident in the present mask's angular forms, the tubular eyes, and the curved, boardlike projection in front. This particular type of headdress is known as *igodo*. The shape of *igodo* masks plays on the form of a paddle and on that of a boat's prow, evoking the closeness between water-oriented people and spirits of the deep. A python coils above. Its head projects between two cylindrical eyes to create the nose of an abstracted face. In front of the python, two birds peck at the paddle/prow. The animals allude to watery realms in different ways. According to Ijo belief, the python is the mythic progenitor of all water spirits, while the birds are a generalized reference to the fishing eagle (*ogolo*). The latter car-

ries messages from the water spirits to humans. The mask's surface shows traces of triangular patterning and color, a treatment designed to convey the distinctive shimmering and variegated qualities of reptilian skin.

In performance, maskers wear the headdress horizontally in an attempt to recreate how humans first saw the water spirits "floating on the surface of the water." Agbo spectacles thus affirm the presence of spiritual forces and seek their support for human prosperity and progeny. H. J. D.

Lit.: Drewal, 1986; Horton, 1960 and 1963.

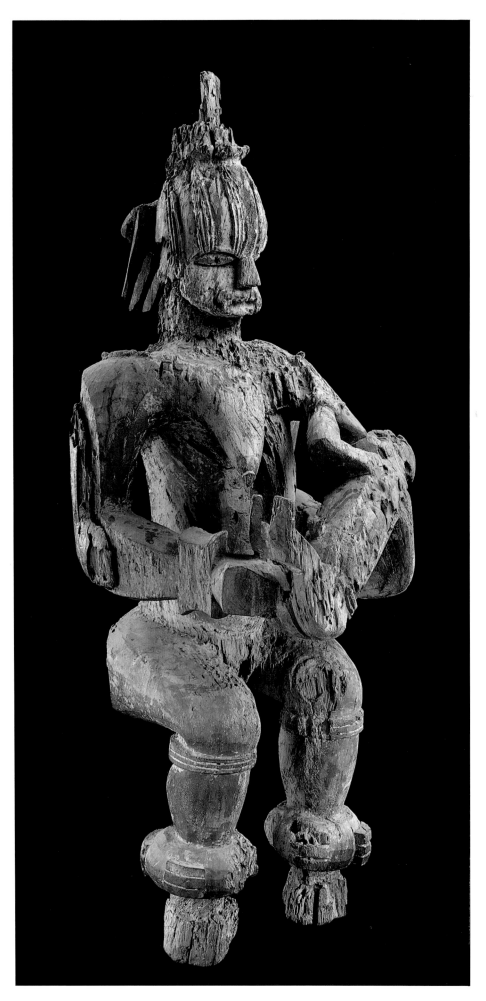

84 Mother with Child

Urhobo, Nigeria

Wood, with traces of kaolin; height, 142 cm

Prominent in most groups of Urhobo statues commemorating forest spirits (*edjo re akare*) is the figure of a nursing mother, who underscores the importance of procreation and maternity in the spirit world. This particularly splendid example depicts a larger than life-size woman holding an infant to her left breast. With knees bent, spine dramatically arched, and elbows drawn back tautly, she assumes a classic Urhobo dance posture. Bands of ivory at ankles and wrists emphasize her royal demeanor. The beads at her chest and knees associate her with a prominent society of titled elders. Her hairstyle, called *ighueton*, is worn by women who have recently given birth. In May 1968 this figure stood with ten other pieces in a shrine honoring Owedjebo, the founder-hero of Eherhe, in the Agbarho village group, twenty-five kilometers northwest of Ughelli. The statue dates from about 1875. P. F.

Lit.: Foss, 1976.

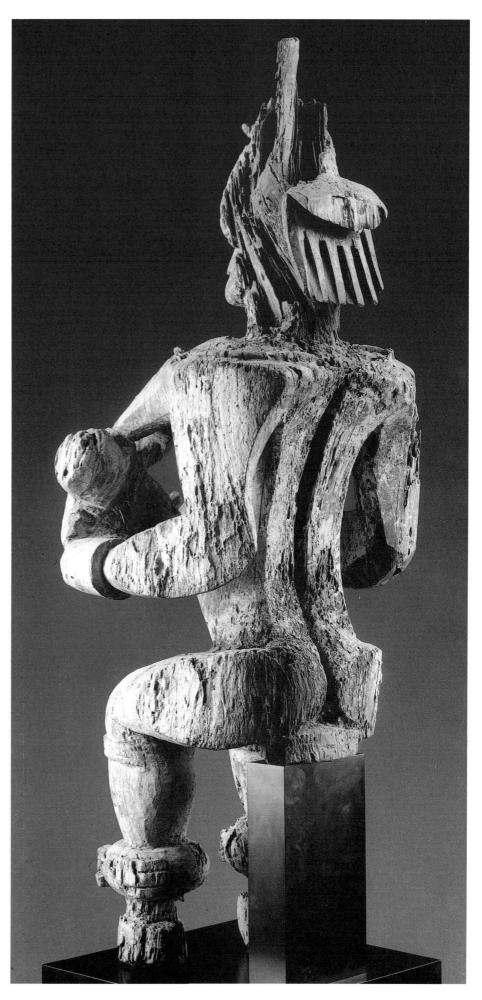

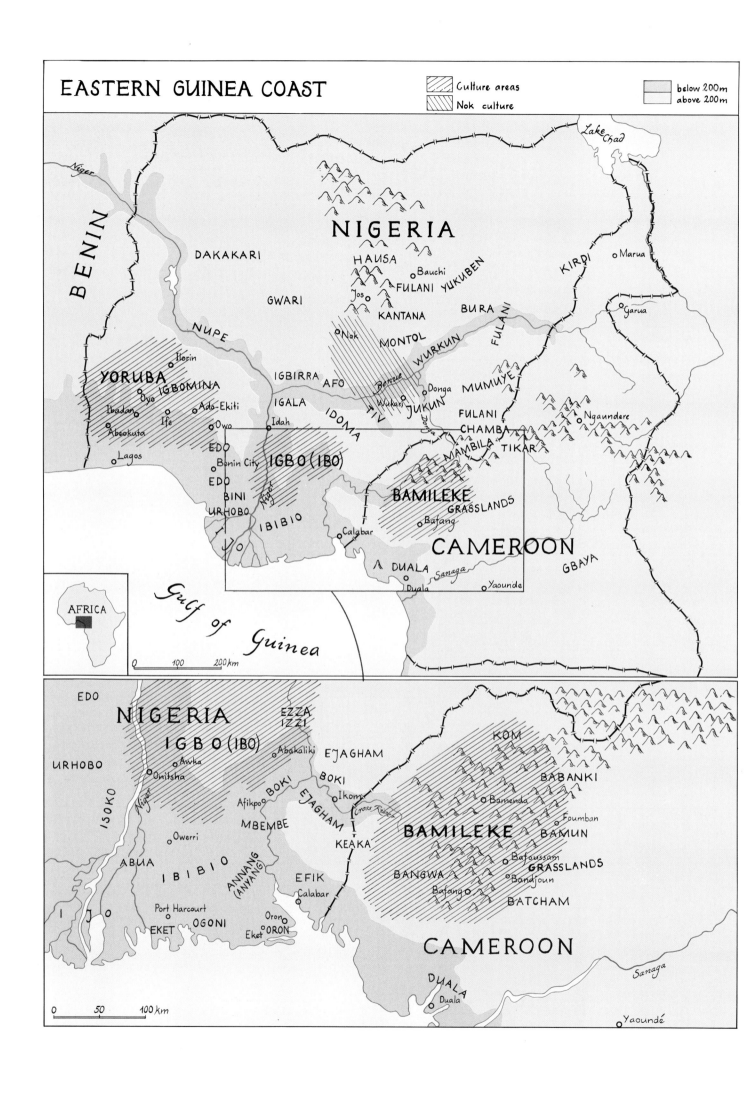

EASTERN GUINEA COAST

Culture areas
Nok culture

below 200m
above 200m

NIGERIA

BENIN

Niger

DAKAKARI

HAUSA
Bauchi
Jos
KANTANA
Nok
MONTOL

FULANI YUKUBEN
BURA

KIRDI
Marua

Garua

GWARI

NUPE

YORUBA
Ilorin
IGBOMINA
Oyo
Ibadan
Ife
Ado-Ekiti
Abeokuta
Owo
Lagos

IGBIRRA AFO
IGALA
Idah
Benin City
EDO
EDO
BINI
Niger
URHOBO
IJO
IBIBIO
Calabar

IDOMA
TIV
Benue
Wukari
JUKUN
Donga
WURKUN
FULANI

MUMUYE
Ngaundere

FULANI
CHAMBA
MAMBILA
TIKAR

IGBO (IBO)

BAMILEKE
GRASSLANDS
Bafang

CAMEROON
DUALA
Sanaga
Duala
Yaounde

GBAYA

Lake Chad

AFRICA

Gulf of Guinea

0 100 200 km

NIGERIA

EDO

URHOBO

ISOKO

Niger

IGBO (IBO)
Awka
Onitsha

EZZA
IZZI
Abakaliki

EJAGHAM
BOKI
BOKI
Ikom
Afikpo
MBEMBE
EJAGHAM
KEAKA

Cross River

KOM

BABANKI
Bamenda
Foumban
BAMUN

BAMILEKE

BANGWA
Bafang
Bafoussam
Bandjoun
GRASSLANDS
BATCHAM

ABUA
IBIBIO
ANNANG
(ANYANG)
Owerri
IJO
Port Harcourt
EKET
OGONI
EFIK
Calabar
Oron
Eket
ORON

CAMEROON

DUALA
Duala
Sanaga
Yaoundé

0 50 100 km

William Siegmann

East Guinea Coast

Although the Niger River delta is often used as a demarcation line between the northern and eastern Guinea Coast regions, it is difficult to discover two distinct styles meeting along this line. On the other hand, the division is of some use in noting that the linguistic and ethnic diversity to the east of the river is greater than in any area of comparable size in the west. The eastern area is one of very high population densities – among the highest in Africa – and of great linguistic diversity, with ethnic groups often localized in relatively small geographic units.

In the northernmost section of this region, the Benue River valley and the mountainous enclaves of the Jos plateau, there are a number of ethnic groups who have little in common with the peoples to the south. They are, however, united in forming an area which has retained a rich carving tradition in the face of heavy incursions by the Fulani in the nineteenth century and of repeated attempts to convert them to Islam. Among these groups are the Jukun, Tiv, Chamba, Mumuye (fig. 52), Mama, and Bura. Apart from the Jukun, who developed a complex state called Kororofa between the thirteenth and the mid-eighteenth century (fig. 53), these groups were mainly acephalous.

A bronze industry once flourished in the Jukun area, apparently associated with symbols of leadership. Today, the dominant art forms are figurative sculpture and occasional masks that are characterized by a high degree of abstraction and stylization.

South of the Benue lies the Cross River region. Its art is remarkable both for stylistic diversity and for the multiplicity of the media used, which include ivory, bronze, and stone, as well as wood. Widespread discoveries of copper alloy castings (pl. 86) in recent years point to a complex of interrelated bronze industries. The earliest dated example that has so far come to light is from the mid-seventeenth century, but stylistic affinities with Igbo-Ukwu bronzes suggest that they existed even earlier and may go back as far as 1000 A. D. (fig. 54).

Another tradition of considerable antiquity is that of the *akwanshi*, monoliths of basalt, limestone, and sandstone boulders, found in the northern Ekoi area (pls. 87,

Fig. 52 Mumuye mask of the Vabô type in Monkin, near Zinna. (Photo: William Rubin, September 1965)

Fig. 53 The king of the Jukun in his capital Wukari, at the beginning of this century. (Photo: From *Customs of the World*, ed. Walter Hutchinson [New Dehli, 1912-14; repr. 1985], vol. 2, p. 811)

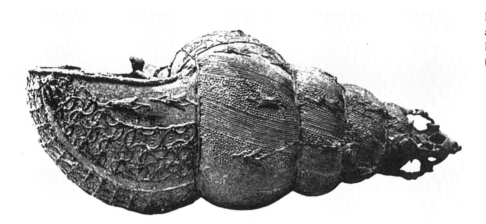

Fig. 54 Shell-shaped bronze container probably from the archaeological site of Igbo Isaiah, next to Igbo-Ukwu. Length, 30.5 cm. (Courtesy of Thurston Shaw)

88). They are now believed to have been created over a period of some three hundred years, ending at the turn of the present century. Decorated with human figures carved in low relief, they are among the most significant products of stone carving in Africa.

The skin-covered masks and headcrests (pl. 90) found in the same area are believed to have originated among the Ekoi or Ejagham (fig. 55). Such masks have spread throughout the Cross River area and that of the southwestern Cameroon border, and are used in conjunction with the warriors' or hunters' societies that are so important a part of life in this region. They represent human and animal heads in a basically naturalistic style, sometimes with additional elements such as horns. Antelope skins are stretched over the masks to give them a lifelike appearance, something that is often further emphasized by inlaid eyes of iron and teeth made of bone.

To the west, in the Niger Delta, lies an area of extreme complexity characterized by societies such as the Idoma, Igbo, Urhobo, Ogoni, and Ibibio whose political integration is limited either to individual communities, each with a headman and council of elders, or to small districts with an age-grade organization or common chief.

The emphasis on local autonomy is reflected in the art of the region: many of the groups have no single style, but have evolved numerous different ones that often vary from one village to another.

It is not uncommon for there to be greater stylistic similarity between different ethnic groups than within the various areas inhabited by the same ethnic group. Thus, on the one hand, many Idoma masks and headcrests bear a strong resemblance to certain Igbo masks, sharing with them a preference for rounded and simplified naturalistic forms painted in polychrome, while, on the other hand, the white-faced masks used by the Mmwo society of the Igbo stand in sharp contrast to the extremely abstract Maji yam masks of the Afikpo Igbo. Similarly, there is often little sharing of subject matter between areas inhabited by the same ethnic group. For example, among the Igbo, in addition to a wide range of mask types, some areas, such as Onitsha, are known for very large wooden figures not found in other places.

Another form of sculpture that occurs in the region is that of the *ikenga* figures, which are owned personally by household heads and used in conjunction with the cult of the hand to bring strength, good luck, and protection to the household. The Igbo repertoire also includes marionettes, figures on door jambs of community houses, and pottery figures, as well as clay figures modeled for the *mbari* houses.

The Ibibio, who live to the west of the Cross River, number more than a million. They use masks and figures, often with moveable jaws or limbs, that exhibit either an expressive naturalism or, as in carvings surmounted by one or more human or animal heads or skulls, a sense of the macabre.

Further to the southwest live the Ijo, Brass, and Kalabari, who inhabit the swampy coastal region of the Lower Niger Delta. They are fishermen as well as farmers, and are noted above all for their bold, abstract, horizontal masks, which often represent aquatic creatures in a strongly three-dimensional manner. The Ijo are also well known for their ancestral shrines, which include screens composed of figurative sculptures fitted together and painted to form unified tableaux.

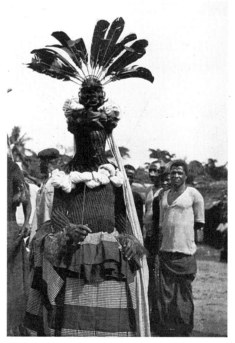

Fig. 55 Ejagham dancer of the Cross River region wearing a wooden headcrest covered with leather and a costume of fibers and cloth. (Photo: A. Talbot, before 1912)

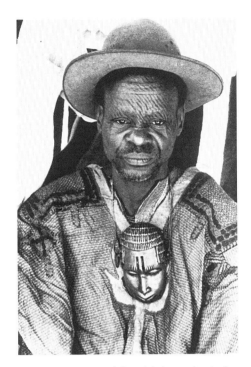

Fig. 56 A viceroy of the Igala king, the Atah of Idah, wearing as a pendant a bronze mask typical of an early period of Benin art. (Courtesy of Thurston Shaw)

The rolling green uplands of the grassland areas of northwestern Cameroon (see p. 180) is a region of great linguistic diversity, whose numerous political units range from relatively small chiefdoms to such large and powerful kingdoms as Bamun and Tikar. They share a pattern of strictly hierarchic societies, with the classes of royalty and noble retainers, and large slave populations.

The vast bulk of the art of this region was associated with the secret societies belonging to royalty and noble retainers. The royal workshops produced a wide range of objects in this connection, including sculptured clay pipes, cast brass figurative pipes, and elaborately embroidered textiles. Much of the sculpture is architectural: royal palaces received decorated supporting posts and door frames with figural compositions arranged in vertical or horizontal rows. Stools, thrones, drums, and bowls were similarly intended to create a spectacular effect for the courts rather than to fulfill religious needs, and this may well account for the dominance of large sculptures, bold in conception and dramatic, forceful, even aggressive in effect.

Fagg has pointed out that, on the one hand, each chiefdom seems to have developed its own distinctive style of sculpture, while at the same time, the many close relationships between the chiefdoms helped create a number of common tendencies in technique and subject matter. The result is a greater stylistic unity than in any other region with a comparable linguistic and ethnic diversity.

No survey of the arts of the Guinea Coast can hope either to do justice to the complexity of the art produced by so large a number of ethnic groups or to comprehend fully the underlying social organization of such disparate groups as the Yoruba, Ibibio, Baga, and Bamun. Nevertheless, it is quite clear that the region has long been one of immense creativity in a multitude of media and that it possesses a record of artistic achievement unsurpassed by any other area of Africa.

The Nok Civilization

The Nok civilization covered a large area on both sides of the Benue River, including territories occupied today by a variety of ethnic groups such as the Tiv and the Ham (or Jaba). Most of the famous terra-cottas were found during opencast tin-mining at fairly deep levels; other objects were discovered in river beds and beneath tree roots. Broken terra-cottas were sometimes discovered alongside iron objects, which indicates that the Nok culture was not neolithic. A small monkey head, found in 1928, is the oldest work of plastic art to have been found in Black Africa. The famous Jema head was discovered in 1943.

A. M. V.

Lit. : Fagg, 1977.

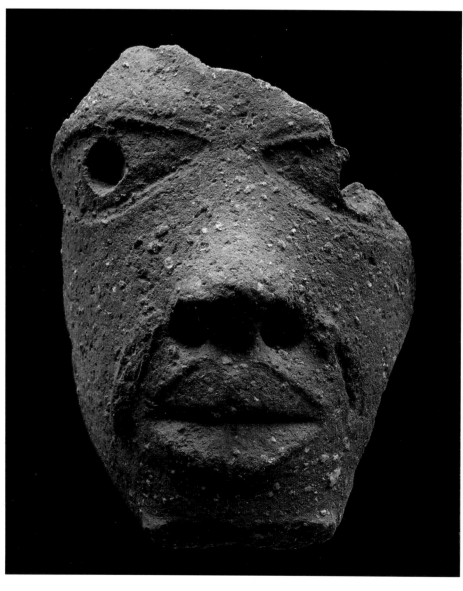

85 Head (fragment)

Nok, Nigeria

Terra-cotta; height, 15 cm

It is unfortunately impossible to assign an exact origin to this broken "Nok" piece. Entire figures do exist, but heads are generally the survivors of the destruction produced by the weight of the soil, the force of erosion, and the roughness of mine work. Indeed, the heads are the most resistant parts of the sculptures, which are hollow. Radiocarbon dating – a process more precise than thermoluminescence dating – has been made possible by coal remains inside some pieces. The fabrication of terra-cotta pieces appears to have begun about the seventh century B. C. and continued until about the third century A. D. This example falls easily within that time range, since thermoluminescence analysis suggests that it is about 2000 years old.

A. M. V.

The Cross River Region

The entire Cross River region abounds in cultures that, though diverse, are unified by certain shared traditions that give rise to the creation of similar objects, produced with multiple and fascinating variations. The most important of these objects are the crest masks covered with skin, representing human heads (see pl. 90). Apparently of Ejagham (Ekoi) origin, these masks have been borrowed by the Igbo and the Ibibio to the west, the Boki to the north, and the Keaka, Annang, and Widekum to the east. Masks of this sort are found in Cameroon, too.

Among the Ejagham, the predominant notion of different natural forces is sometimes difficult to distinguish from that of spirits or demigods that preside over human destinies. P. A. Talbot writes: "The term 'Njomm', which can only be translated as 'Juju,' is so elusive as to defy definition, but as far as may be gathered from the vague conception of the Ekoi, it covers all uncomprehended, mysterious forces of nature. These vary in importance from elementals, so powerful as to hold almost the position of demigods, to the 'Mana' (to use the Melanesian term) of herb, stone, or metal."

The same author adds: "The skull is a great *Juju.*" In the photograph that he reproduces of a figure called *Ojjen,* the dancer, who is taking part in a masquerade, wears a human skull – or, as Talbot calls it, "a dried head" – on his head (fig. 57). A headcrest of this type, made from real human bones, was found among the Bangwa of Cameroon and is conserved in the Berlin Museum of Ethnology.

A. M. V.

Lit.: Nicklin, 1974; Talbot, 1912, pp. 48, 224; Harter, 1986, fig. 359.

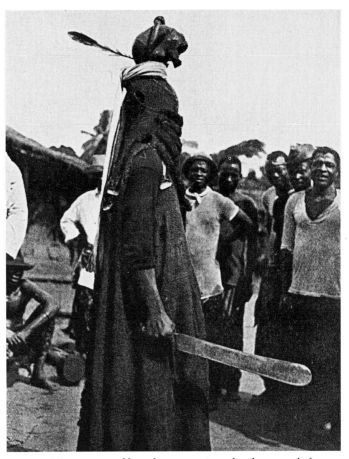

Fig. 57 *Ojjen,* portrayed by a dancer wearing a headcrest made from a real human skull. (Photo: A. Talbot, c. 1912)

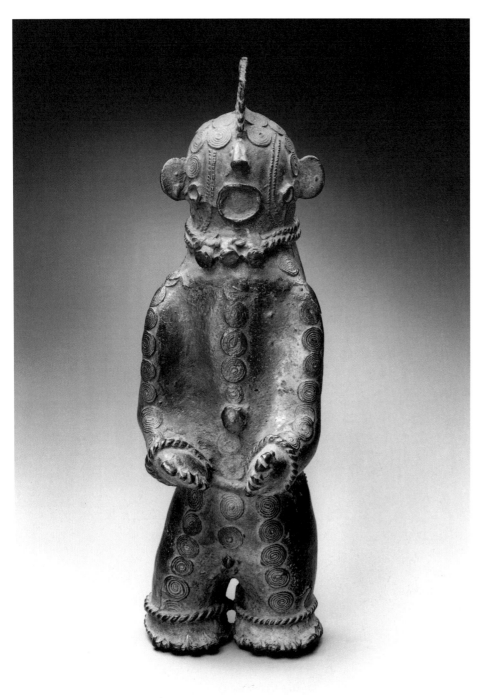

86 Figure
Igbo (?), Lower Cross River, Nigeria

Bronze (lost-wax cast); height, 25.5 cm

It is now known that the "Cross River bronzes" were made by itinerant Igbo smiths, coming from such places as Abiriba and Awka, and also by non-Igbo Cross River peoples, including the Yakö and Anyang Ibibio. Although the bronze-casting in southeast Nigeria goes back to the ninth century, the earliest authenticated date for a Cross River bronze is the mid-seventeenth century. The tradition seems to have died out in the earlier years of the present century. The Cross River bronzes appear to have been made largely by the lost-wax process, a technique that permits efficient execution of the kind of minute surface detail seen in the Barbier-Mueller piece.

They exhibit a great variety of forms, including standing anthropomorphic figures; hippopotami and other quadrupeds of unknown, possibly mythical, animal character; skeuomorphs of horn; gourd palmwine drinking vessels; and "tulip-shaped" or "waisted" bells of the type shown at the neck of the present figure. The double vertical lines of dots on either side of the face are probably intended to portray "tribal" marks, while the circular mark on both cheeks is a rather unusual feature in the known range of Cross River scarification marks and is more often found today in body painting. K. N.

Lit.: Allison, *Cross River*, 1968; Fagg, 1960; Mansfeld, 1928; Neaher, 1976 and 1979; Nicklin, 1977, 1980, and 1983; Nicklin and Fleming, 1980; Nicklin and Salmons, 1984; Partridge, 1905; Talbot, 1912.

87 Carved Stone Monolith (*Akwanshi*)
Ejagham (?), Cross River region, Nigeria

Stone; height, 46 cm

88 Carved Stone Monolith (*Akwanshi*)
Ejagham (?), Cross River region, Nigeria

Stone; height, 114 cm

Stone sculptures rarely appear in Africa south of the Sahara, although works in steatite – a material which can be worked almost as easily as wood – are fairly common locally. Large numbers of roughly shaped, hard-stone monoliths are known from southern Ethiopia, and barely a dozen remarkable sculptures in granite and quartz have come to light in the Yoruba country of southwestern Nigeria. Yet in a restricted area of the Cross River State in eastern Nigera some three hundred hard-stone sculptures have been recorded. They stand in the lands of eleven small subsections of the Ejagham or Ekoi, a Bantoid people who inhabit sparsely the tropical rainforest country of the middle Cross River, on the border between Nigeria and Cameroon.

The stones, known locally as *akwanshi*, are found in some forty different groups, the largest of which number up to as many as thirty-four individual stones. They have often been set up in the central meeting place of the village, and ten of the groups are arranged in a fairly regular circle.

The majority of *akwanshi* are carved from a hard basalt, but some are of a local limestone and a few of sandstone. The volcanic basalt tends to fracture in a regular columnar shape, and water-worn boulders from the river beds have been selected and worked into cylindrical and conical forms using stone tools. The stones are frequently adorned with stylized human features and with decorations related to tribal marks and body-painting designs that are often centered round a prominent navel boss. The cylindrical body, surmounted by an ovoid head, gives an unmistakably phallic appearance to some *akwanshi*. The largest of the stones are some two meters high.

Priest-chiefs, whose influence was spiritual rather than temporal, were a traditional institution amongst the Ejagham, and the *akwanshi* appear to have been memorials to a succession of such sacred ancestors. Carving of these memorials probably ceased at the beginning of the present century, when the imposition of British colonial rule put a stop to tribal warfare and disrupted traditional forms of authority and government. *Akwanshi* may well have been carved and erected over a period of some four hundred years; within such limits it is only possible to guess at the age of individual carvings.

Catalogue number 88 is a fine example of the more elaborately decorated *akwanshi*. Partly buried in the earth, only the upper, carved section of the stone would have been visible. Catalogue number 87 may be the broken top section of a larger figure or simply an individual portrait head. In 1961 I photographed a very

similar head standing in a group with five others in the center of the Nselle village of Njemitop. In 1972 a large group was broken up nearby, on Nselle land, and some of the stones removed; broken pieces from some of these were subsequently offered for sale in Europe. P. A.

Lit.: Allison, 1962; Allison, *Stone Sculpture*; Allison, *Cross River*.

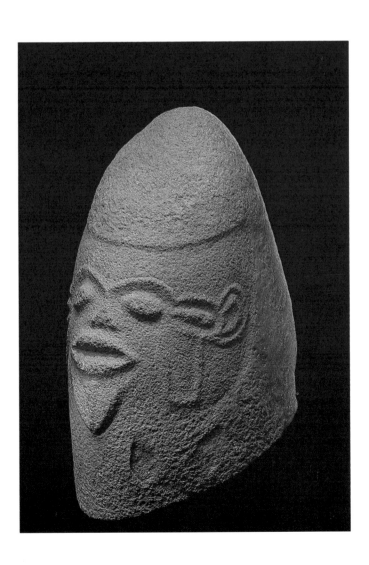

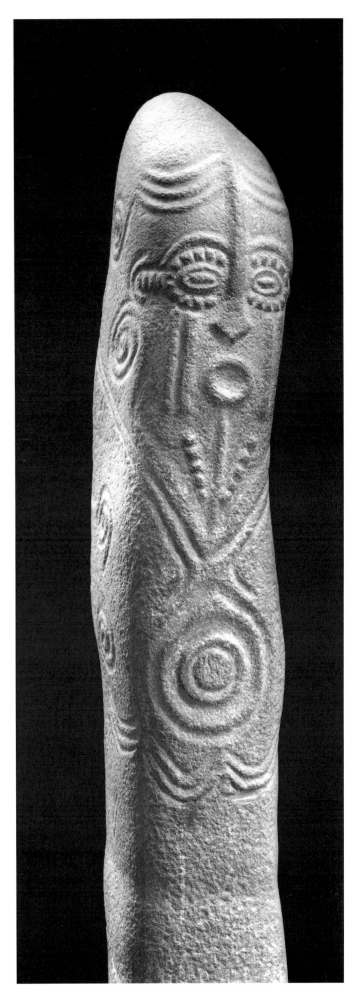

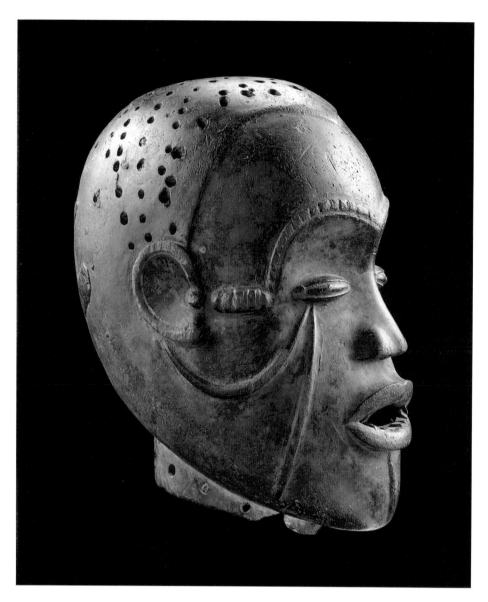

89 Part of a Dance Headcrest

Boki, Nigeria

Wood; height, 20.5 cm

Though its exact origin is difficult to pinpoint, this sculpture probably comes from the mid-course of the Cross River; the famous dance crests representing human heads (often covered with skin) attached to an osier basket also come from this region.

The Boki, or Bokyi, of the mid-Cross region have long been notable for making crests with human faces that are not covered with antelope skin, although Nicklin has shown that they do in fact have and use skin-covered masks in the rituals of several societies. While crests of several skin-covered faces are found among different ethnic groups of the Cross region, what seems to be unique to the Boki is the making of two-headed crests that are not skin-covered, the heads being separately sculpted, then attached to the same base, either side-by-side and facing forward, or back-to-back.

In this example, the curved scarifications joining eye and ear are familiar from other double crests; the presence of a round hole at the back of the head may indicate that a second head was attached to this one; both would have been mounted on an osier basket that has been lost. Without additional information about the circumstances of its discovery, what warrants an attribution of this piece to the Boki is the absence of animal skin covering the wood, which has acquired a patina through use. Its refinement and sensitive treatment serve to enhance its evident maliciousness, a characteristic common to many small crests, often accentuated by an open mouth with wooden teeth. A. M. V.

Lit.: Elisofon and Fagg, 1958, fig. 191.

90 Dance Headdress

Ejagham, Middle Cross River, Nigeria

Wood, human hair, metal, and antelope skin;
height, 33.5 cm

This naturalistic skin-covered headdress belongs to the Middle Cross River substyle and, as the "ladder" ethnic marks between the eyes and ears indicate, was made by the Ejagham. Its gentle feminine features display a very distinct realism. The forehead, nose, and lips (parted to show the inset metal teeth), the balancing of the head on a vertical axis upon the neck, and the open eyes (the left eye has lost its wooden pupil) combine to make the headdress one of the most beautiful of its kind. The attachment of human hair, dressed in the fashion of a city lady blessed with long hair and further embellished with a strip wrapped in metal that falls over her forehead, lends the piece an almost unparalleled realism. This type of mask usually has either hair depicted by wooden pegs or real hair that is less abundant than in the present case.

The headdress is made of soft wood, over which fresh, uncured antelope skin was stretched. The flared base of the neck was designed to fit atop a normal-size human head, and a wicker base attached to it by four loops. A textile costume was fitted to the underside of the wickerwork base, covering the masquerader's head and face and reaching down to the ankles.

A distincitve art form in the Cross River area, skin-covered headdresses were used for a number of purposes in certain secret societies of the region. Among the Boki, Keith Nicklin has described three such societies: the warriors' society (Ekang), the hunters' society (Bekarum), and the women's society (Egbebe). This piece was in all probability used in an Ejagham women's society whose role was to oversee the education of girls when they attained puberty, in preparation for marriage. The headdress may therefore represent a marriageable girl, ideal both in terms of beauty and gentility. E. E.

Lit.: Bleir, 1980; Nicklin, 1974.

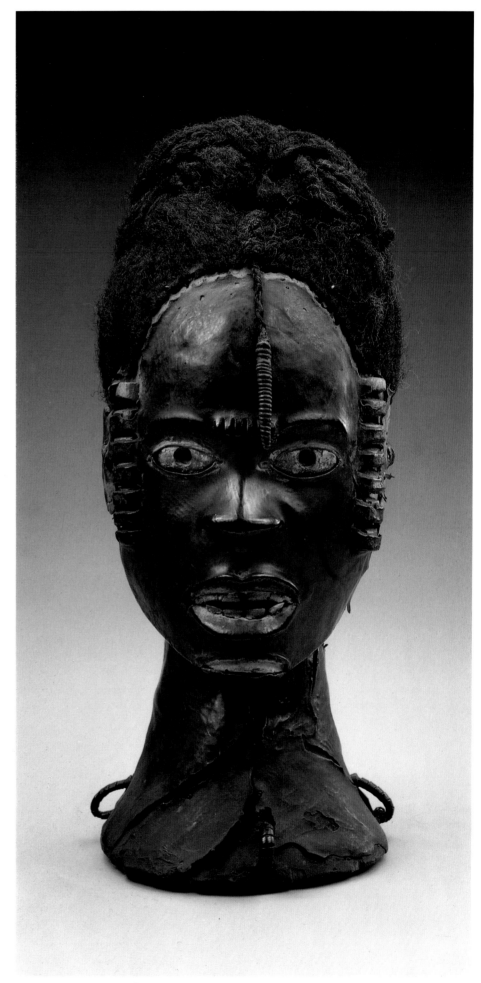

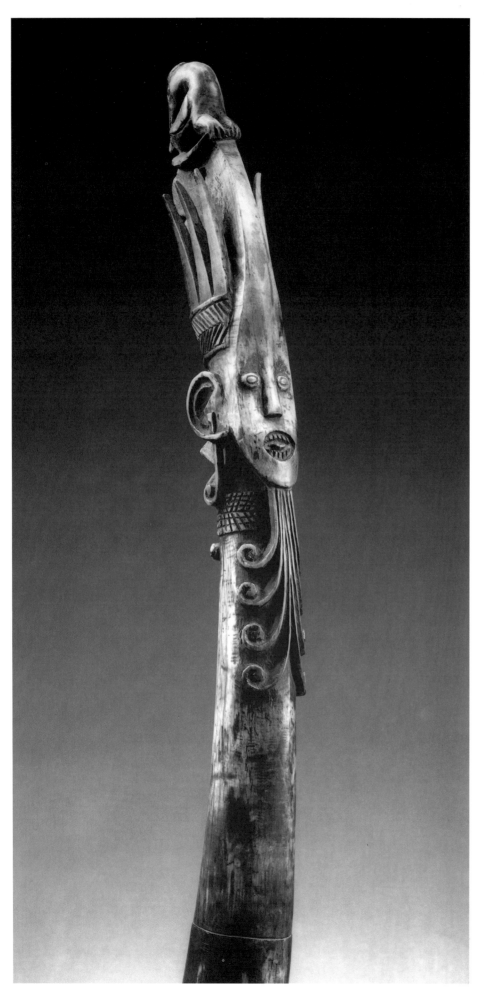

91 Ivory Horn with Sculpture of a Human Head

Annang (?), Nigeria (?)

Ivory (this horn had a mouthpiece that has been lost); height, 65 cm

This curious sculpture was acquired by Josef Müller in the 1930s, and a note in his handwriting indicates that, when sold to him, it was represented as coming from Assam (northeast India). And indeed, although the human face forming the central part of the decoration of the top of the piece offers some analogies with other known sculptures of the Cross River region, the beard ending in spirals, the curved ear ornament, and the figure's coiffure do not appear to be African. The whole piece creates a somewhat "oriental" impression.

Yet we should not jump to conclusions. After all, it was previously believed that Punu and Lumbo masks from Gabon, with their white faces and slanting eyes, were of Japanese origin.

In the present case, Andreas Lommel (1976) compares the eyes of this object to those of Ejagham (Ekoi) sculptures and argues that the incongruous spirals resemble Tikar ornaments of neighboring Cameroon. He follows René Bravmann in attributing this piece to the Annang chieftaincy of Widekum – a provenance yet to be confirmed, however.

By a process of elimination, it may be argued that the Mongoloid tribes living in Assam and neighboring Birmanie have never produced art works of this sort. And the Naga, who live on the borders of Assam, have a well-documented art in which there is nothing reminiscent of this horn. Bravmann was the first to identify a similar piece in Seattle as Annang; it has a copper mouthpiece and a ring of worked silver, neither of which is found in the specimen shown here.

Léon Siroto is of a different opinion. In his review of Lommel's book, he notes that three other ivory horns of this type exist (in Berlin, Munich, and Seattle) and that "they have been a source of embarrassment to Africanists" ever since Luschan published one of them in his book on Benin antiquities. The Berlin piece, when it was acquired by the museum in 1898, was classified as Dahomean, but Luschan did not hesitate to attribute it to the prestigious kingdom of Benin. Siroto emphasized that the air-hole and the beveling to hold the metal mouthpiece are typically Asiatic. A. M. V.

Lit.: Lommel, 1976, no. 204; Barbier, 1984; Bravmann, 1973, no. 74; Siroto, 1977, p. 83.

The Igbo and Their Neighbors

The Igbo occupy the East Central State and parts of the Mid-Western State of the Nigerian Federation. Their principal neighbors are the Ijo to the southwest, the Edo to the west, on the right bank of the Niger, the Igala and the Idoma to the north, the Ejagham and other Cross River groups to the east and southeast, and, farther south, the Ibibio and the Ogoni.

The Igbo speak languages of the Kwa group, like all their neighbors except a few ethnic groups – for example, the Ejagham, who should be considered half-Bantu. The Yoruba, another major Nigerian people, also belong to the Kwa language group.

THE IGBO

Unlike the Yoruba, the Igbo have not created either kingdoms or large cities. Their mythology includes both a supreme divinity, named Chuku or Chineke, and lesser gods that are identified with stars and the earth and whose cult involves ancestor worship and worship of the yam.

Ancestors appear as *mmwo* masks during important rituals. Two of these white masks, photographed before World War I and published in G. Basden's 1938 book, *Niger Ibos*, are reproduced here (fig. 58). Masks of many different forms are used by the various Igbo groups.

Fig. 58 Two Igbo dancers wearing the *mmwo* mask. (Photo: From Basden, 1938, facing p. 368)

THE IGALA

The Igala, numbering about 400,000, occupy an area near the confluence of the Benue River and the Niger. The Igala and their eastern neighbors, the Idoma, speak a number of Kwa-based dialects related to those of the Tiv and the Jukun, farther up the Benue. Indeed, whatever cultural features they may share with the Igbo, the Igala and the Idoma belong to the complex world, rich in sculptural invention, of the Benue River; like the Cross River, the Benue serves as a link uniting the Cameroon Grasslands with eastern Nigeria.

The Igbo-Ukwu Excavations

Important finds were made at Igbo-Ukwu in Igbo country; further excavations, organized by Thurston Shaw, brought to light a whole treasure of very fine bronze objects, some of which have been conclusively dated to the tenth century (fig. 54, p. 152).

Some small human masks discovered in the course of the excavations have vertical scarifications that indicate contacts with the civilization of Ife, on the other side of the Niger, which flourished around that time.

The Igala are ruled by a king, and some neighboring Igbo groups, following their example, have set up small kingdoms. The Igala king, the Atah of Idah, still possesses a bronze pendant mask from Benin of the type illustrated here (fig. 56, p. 153); it appears to indicate an ancient tie of vassalage to Benin, since the *oba* made such presents to chiefs who paid tribute to them.

François Neyt has described the nine royal masks, kept by the king's counselors, each representing a clan. The masks symbolized the monarch's authority, and each had its particular power. These masks show no sign of Igbo influence.

THE IDOMA

The Idoma, numbering 500,000, occupy the center of the state of Benue; they appear to have migrated to their present territory about 500 years ago. Ancestor worship has a predominant place in their daily life; the cult of the *alekwu*, spirits of the ancestors who return from time to time, is the fundamental institution of Idoma religion. In addition, worship of spirits of nature *(anjenu)* is widespread and has prompted the making of figures that are placed in sanctuaries (pl. 93).

The Idoma use headcrests with human heads that probably originate, as noted previously, from the Ejagham of the Cross River. Some are stylistically very close to Igbo crests; but the Idoma's many original works – often admired, but not well represented here – should not on that account be forgotten.

THE IBIBIO

Living between the Igbo and the coast, the Ibibio are divided into a number of sub-groups such as the Annang and the Oron. Their principal cult is named *ekpo* (literally, "dead ancestor") and is practiced in a male initiation society. Ekpo Eyo writes: "There are two types of masks – the grotesque and the refined. When the grotesque masks are worn, masquerades have a dangerous character and their authoritarian nature invests them with an immunity that permits the dancers to confront anyone. The refined masks are worn by dancers of uncertain status, and non-initiates may take part in the masquerades." A. M. V.

Lit.: Baumann and Westermann, 1962, p. 452; Eyo, 1977, pp. 190, 194; Neyt, 1985, fig. II, pp. 10, 94.

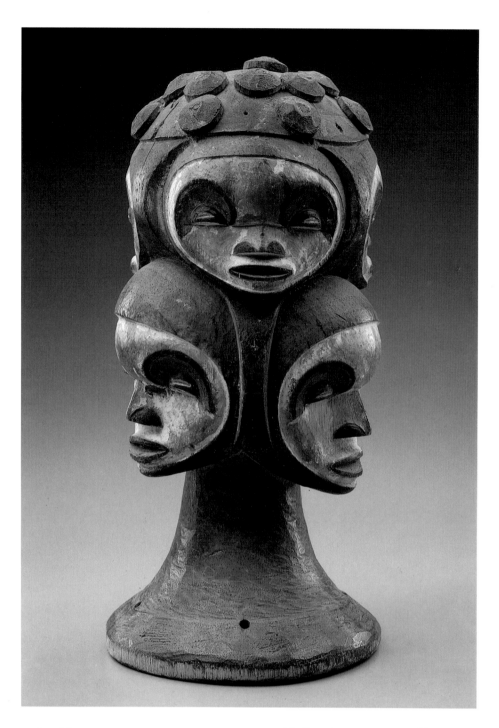

92 Headdress

Idoma, Nigeria

Wood and pigment; height, 29 cm

This crest mask closely resembles one that I found in the Idoma village of Upu in September 1958, and that is now in the Nigerian Museum. It was the only piece of its type that I saw in Idoma country, although further examples have since appeared in Europe and America. Most of these come from the same workshop or, as in the present case, are by the same hand as the piece in the Nigerian Museum. That example was called *ungulali* (flute) because, as I was told, "if people hear the flute, they know that the mask is coming." The mask appeared at the funerals of important persons, at Christmas, and, together with all other masks, at harvest time. The knobs on the top of the present mask probably represent some sort of ripe fruit, since many examples of this type have birds pecking at fruit, possibly as a symbol of the harvest. This example appears to have lost its birds. My informant referred to the piece in the Nigerian Museum as a play mask, that is, a type used for entertainment rather than for traditional rituals. It is uncertain whether *ungulali* was the name of that particular example or of the genre itself.

The Nigerian Museum mask had been purchased in about 1954 from the family of Ochai, a famous local carver, and has been assigned to him — mistakenly, I believe. I found several other masks not in Ochai's style that had been purchased from his family, and I suspect that the family traded on his reputation by buying and selling masks by other artists. E. E.

Lit.: Neyt, 1985, III, pp. 5, 42-44, 46-49; Fagg, 1980, p. 94.

93 Spirit Figure (*Anjenu*)

Idoma, Nigeria

Wood, metal earrings, metal chain, buttons of
European fabrication, and cloth; height, 73 cm

This handsome figure most probably comes
from the Idoma, who live south of the Benue
River to the east of the Igala. Female figures
often refer to a protective spirit force called *an-
jenu* that lives in water or in the bush and may
appear in dreams. The spirit was described to me
as helpful in three contexts: success in making
money (as in trading), illness, and, most fre-
quently, human fertility. If a man wishes his
wife to have a child, he will go to a person, often
a priestess, who has an *anjenu* figure. He prom-
ises a goat to the spirit after his wife has given
birth.

The most characteristically Idoma aspect of
this figure is the face, which resembles the
white-faced masks of this ethnic group. The row
of scars in front of the ears and the vertical scar
running from the forehead to the tip of the nose
are typical Idoma features, as are the blackened
lips outlining the mouth and the clearly indi-
cated teeth. The body scarification is, however,
unusual. The face alone might lead one to attri-
bute the sculpture to the south-central region of
the non-Idoma speaking Akweya, but I know of
no other examples from that area that match this
figure's body markings. R. S.

Lit.: Kasfir, 1979.

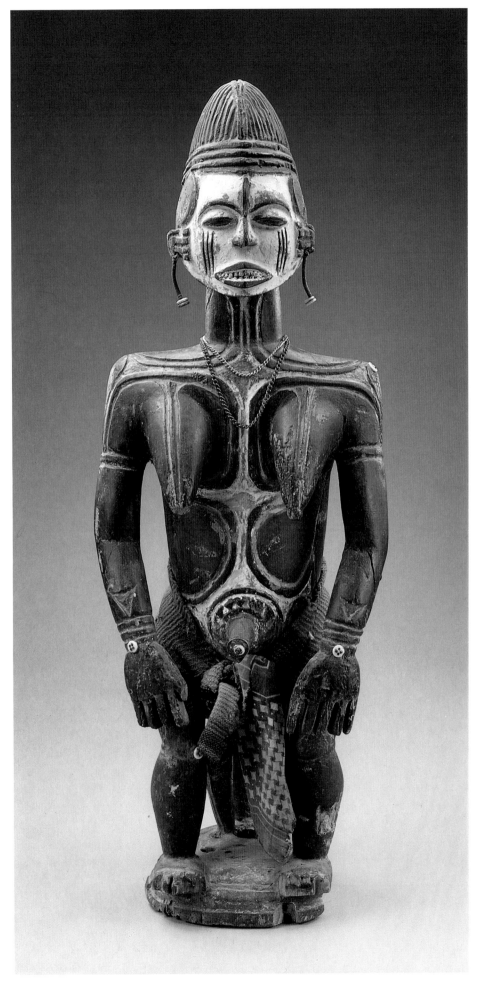

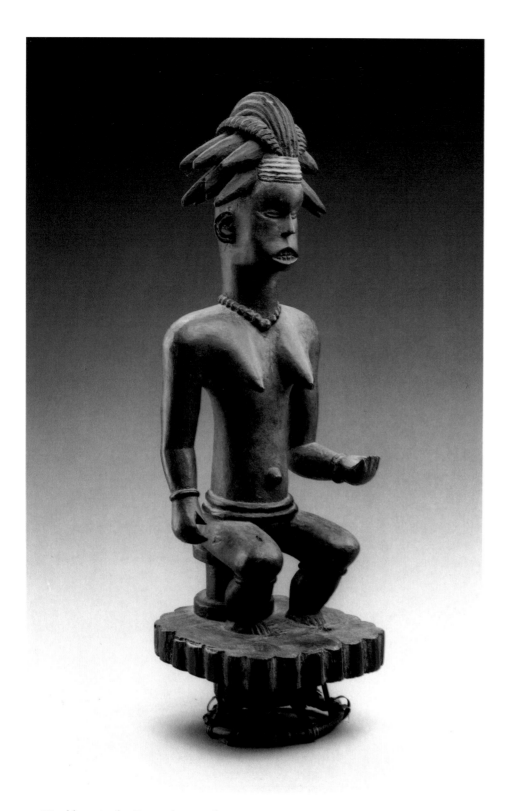

94 Headdress in the Form of a Female Figure

Igbo (?), Nigeria

Wood and osier; height, 52 cm

The attribution of this well-carved female figure to the Ogbom cult practiced in southeast Igbo country is probable, but not wholly certain. The rather naturalistic figure is depicted with an elegant hairstyle, neck, waist, and calf beads, and bracelets. Her asymmetrical pose, with left hand raised as if to hold something, is not typical of Ogbom figures, most of which are also shorter. Yet seated young women were favored subjects for Ogbom displays, which honored the earth deity and called attention to her crucial role in human and agricultural productivity. Ogbom headdresses were worn by men, while women entered the arena to dance and sing around the maskers. Ogbom carvings have not been used since the early 1940s, although dances of that name continued to be performed in Nsulu at least into the 1970s. In earlier days Ogbom was danced by Ibeku, Olokoro, Oboro, Ngwa, and Ozu-Item peoples.　　　　　H. M. C.

Lit.: Cole and Aniakor, 1984, pp. 174-76; Murray, 1951; Amankulor, 1977.

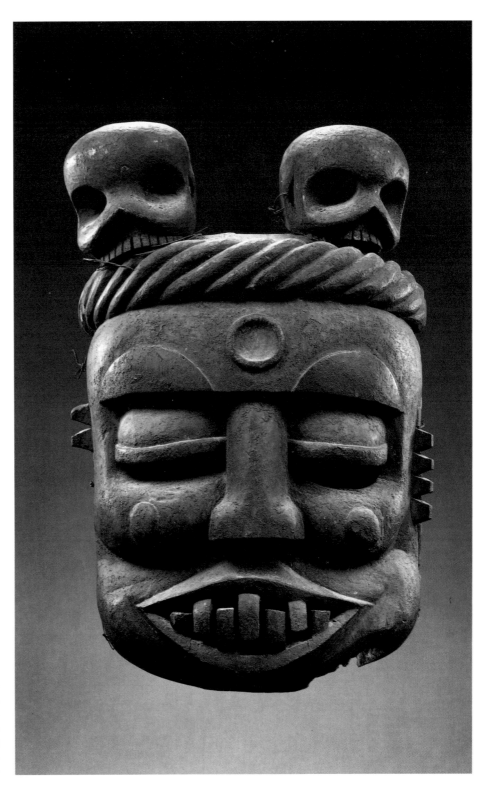

95 Face Mask

Annang, Nigeria

Wood; height, 60 cm

This is a face mask from the Annang area be-
tween the Ikono clan in northeastern Ibibio
country and the Ngwa Igbo in southeast Ni-
geria. It is of the kind used by the men's ances-
tor cult, Ekpo, and of the type known as *idiok*
(expressing qualities of ugliness and fierceness).
It would thus represent a wandering ghost, rath-
er than a spirit that has reached its proper rest-
ing place in the afterlife. Representations of two
human skulls atop the mask reinforce its
deathly, hostile nature. When Ekpo masquerad-
ers are abroad in the course of their annual cere-
monial cycle, part of their role in the social con-
trol of the community is especially the intimida-
tion of non-members (including women) and of
transgressors of communal mores. Ekpo mas-
queraders comprise a stern and potentially
dangerous type of police force. Among the An-
nang and Ibibio peoples, depiction of the open
mouth in mask form conveys threat of aggres-
sion – as in this piece, where the message is
reiterated by the unpleasantly large and uneven

teeth. Ethnic scarification marks typical of the
area are shown on both temples of the mask
(incomplete on one side). The circular mark in
the center of the forehead may, however, relate
to membership of Idiong, the diviners' cult.
During initiation into Idiong a person would
have circles drawn on various parts of the body
in white pigment, the center of the forehead
sometimes being highlighted as a source of mys-
tic vision important in divination. The twisted
circlet around the head of the present mask in
fact depicts the chief insignia of Idiong member-
ship, the *mkpono* ring, which every Idiong
member must wear when practicing his special

art. The mask can be localized more precisely by
means of the broad and rather shallow treatment
of the facial features, which is typical of the Ikot
Abia Osom area of Otoro clan, near Ikot Ekpene.
It is a good example of this area's 1930s style,
which, in Kenneth Murray's phrase, is "less
bold in shape" than older works from the re-
gion. In effect, it is a precursor of the large,
relatively clumsily executed works that evolved
in later decades, as Ikot Abia Osom emerged as
principal purveyor of mass-produced sculpture
to the craft stalls of Ikot Ekpene. K. N.

Lit.: Murray, 1951.

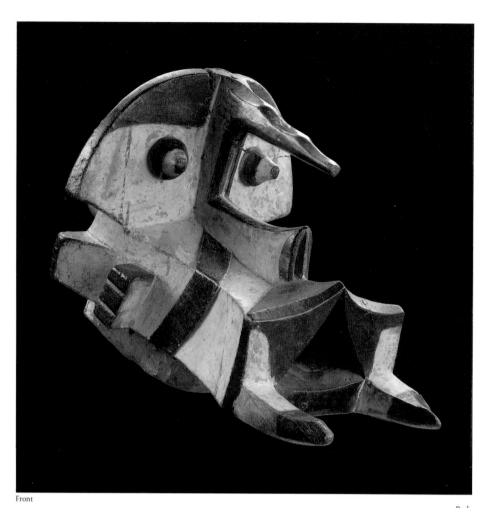

Front

96 Crest Mask

Igbo, Nigeria

Wood and pigment; width, 59 cm

Ogbodo enyi (Spirit Elephant) is a solo mask owned by five or six age grades in many north-eastern Igbo villages and by some non-Igbo neighbors. Masks are of graded size and power; smaller versions are danced by youths, larger and more powerful spirits by elders who also control the outings of lesser ones. The size of the present mask places it in the middle range. Once aggressive and apparently violent in terms of social regulation, these masks have become primarily entertainers in recent decades. They come out at dry-season festivals when they help to purify a village: the younger age grades liter-ally clear up and clean. Fomerly they – at least, the powerful ones – ran with their supporters throughout the entire community, a consider-able test of endurance in a region of dispersed settlements.

An imaginatively conventionalized elephant head, with its trunk transformed into a forehead spike, this mask, like many of its type, has a carved human head on the rear side. Such integrally carved heads are said by some to be "portraits," but other informants see them only as decoration. H. M. C.

Lit.: Cole and Aniakor, 1984, pp. 153-59, pl. 29.

Back

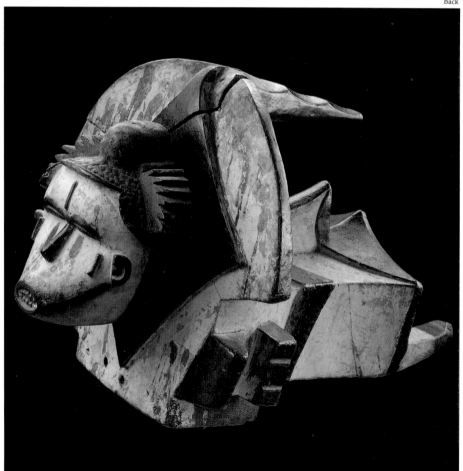

97 Mask

Igbo, Nigeria

Wood and pigment; height, 45 cm

Masks quite similar to this one, and by the same hand, have been documented as male characters in Okperegede performances among the Ezza and Izzi Igbo, while others apparently found their way into Idoma country. I believe, how-ever, that the carver was an Igbo. The mask bears diagonal cheek marks that recall the tat-toos and raised temple scars still worn by Igbo elders in this area. Okperegede dances, led by a large slit gong, were performed by four to nine maskers representing men and women of varied age and personality. Both field-documented masks by this hand played vigorous, high-step-ping youths who danced opposite a beautiful maiden, trying to impress her with their agile virtuosity. Okperegede, as seen in 1983, was an entertaining play mounted as part of Otutara, a festival of ancestral remembrance. The dancing leads up to the appearance of a fierce, multifaced legendary warrior who intimidates and outclas-ses lesser male maskers and protects his lovely daughter from flirtatious displays. H. M. C.

Lit.: Neyt, 1985.

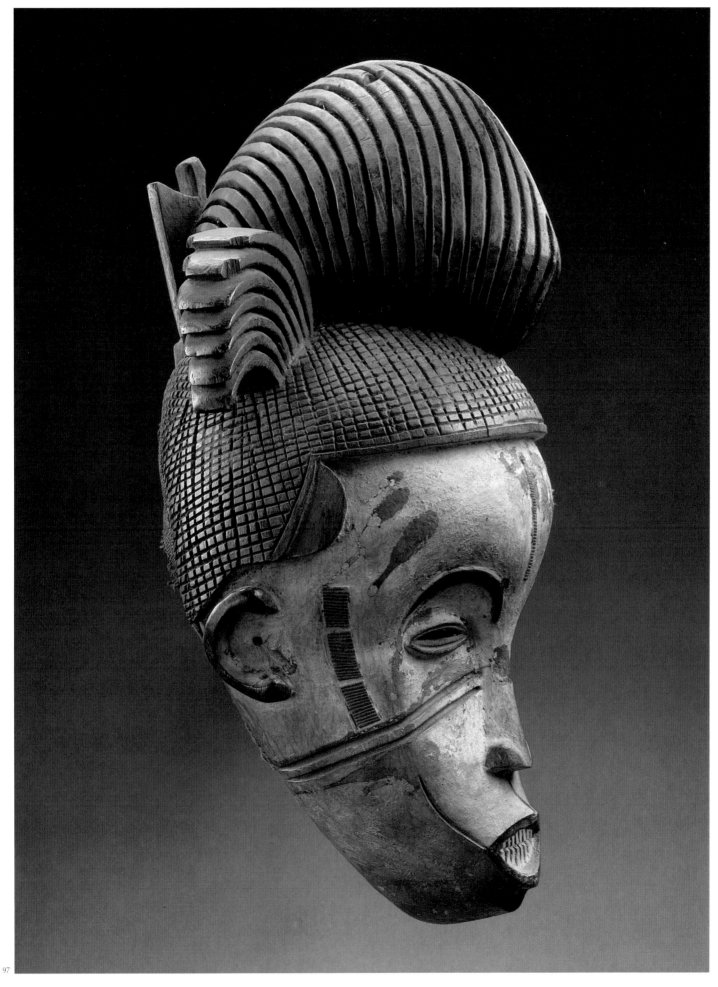

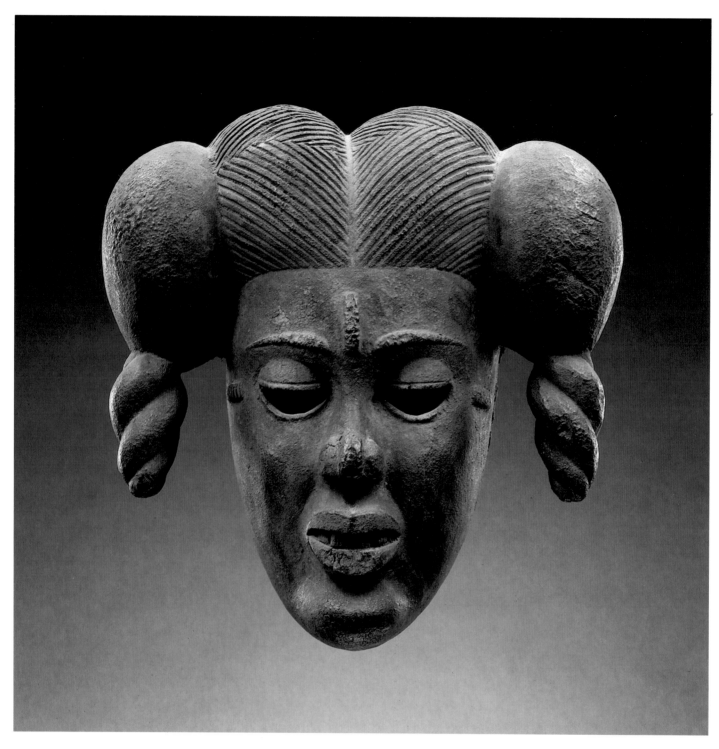

98 Face Mask

Annang, Nigeria

Wood; height, 23 cm

The Annang are situated in the southern part of what is now Nigeria's Cross River State, to the west of other Ibibio-speaking peoples and east of the Ngwa Igob and Ogoni. They are generally regarded as the most artistically prolific of the peoples in the region, and many fine pieces (often described simply as Ibibio) are dispersed widely throughout the collections of the Western world. The present mask is from the southwestern portion of Annang territory, specifically, from Utu Etim Ekpo, near Abak. It comes from the renowned Chukwu School of sculptors, as is indicated by the rather bulbous nose and chin and the somewhat elongated face, with its crisply delineated eye and lip margins. The mask is typical of this location's style in the 1920s and 1930s, and may be the work of the great Akpan Chukwu himself, who died in the early 1950s. We may profitably compare this face mask with a cap mask illustrated by G. I. Jones, who describes it as an example of the "modern Kwa Ibo [Igbo]" style. In his paper on the sculpture of the Umuahia area Jones argues in favor of replacing tribal by geographical criteria in the classification of this artistically diverse region. The Kwa Ibo is the major river system for much of Annang and Ibibio country. Thus, in addition to the fact that recent fieldwork enables us to localize the present mask in terms of clan, village group, school, and possibly "hand," we may also place it within Jones's ("modern") Kwa Ibo (Igbo) style, in the subdivision he terms "naturalistic mode." We are far less certain of the mask's function, however. It could either have been intended for use as a representation of the face of a "fair" (*mfon*) spirit of the men's ancestor cult, Ekpo, or have been employed in a more secular or recreational play. K. N.

Lit.: Forde and Jones, 1950; Jones, 1973, p. 60, fig. 5; Salmons, 1977, p. 13.

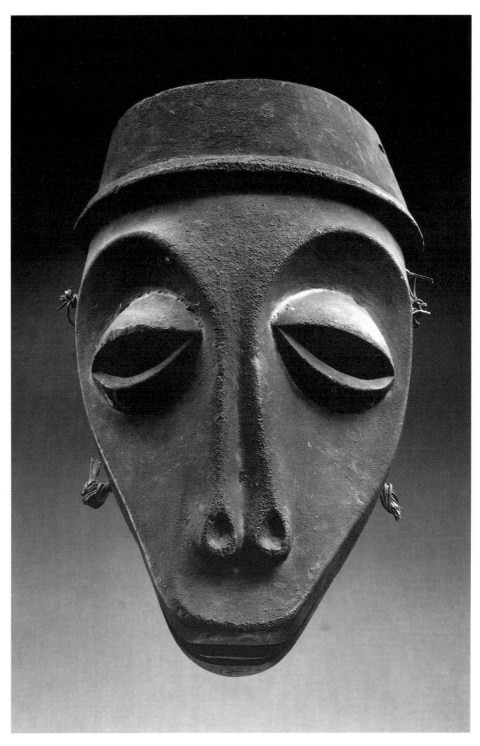

99 Face Mask

Ogoni, Nigeria

Wood; height, 32 cm

An interesting substyle of face mask seems to have developed, perhaps around the turn of the century, in the southern Annang, southwestern Ibibio, eastern Ogoni, and Andoni areas of southeast Nigeria. It originally depicted the fierce, ugly (*idiok*) form of the Annang/Ibibio men's ancestor cult, Ekpo, in animal form – cow, goat, or sheep. The lower jaw of such masks is usually moveable, and animal horns are frequently represented. Examples have been published by Jones and by Nicklin and Salmons. In his description of the "Ogoni specific style" Jones maintains that Ogoni masks are "very different" from those of the Ibibio. I have already taken issue with this view, seeing, with William Fagg, a definite stylistic affinity between certain Ogoni and Ibibio masks, irrespective of similarities or divergencies of function. Several writers have pointed out that in southeast Nigeria artistic influences often follow trading patterns.

During the nineteenth century, and for a long time before, Annang and Ibibio traders had strong economic links with Ogoni and Andoni country: this was the heartland of the infamous slave trade and of "legitimate" commerce in palmoil. Recent fieldwork by Salmons in, for example, Utu Etim Ekpo reveals that Annang artists received commissions from Niger Delta clients and would often travel in person to the Delta settlements to satisfy the demand for their work. More recently, established artists have preferred to work at home, the customers traveling to them to place orders for wooden sculpture. What emerges is the picture of a constant flow of artistic influences within the area in

question over a considerable period of time, an exchange centered upon the role of the Imo River as a major waterway for transport and communication. As Fagg remarks, "Ogoni masks are sometimes hard to distinguish from those of the Ibibio." While I place this mask at the Ogoni end of the Ogoni-Ibibio spectrum, I would also argue the case for recognizing an Imo River substyle of wooden face mask for this region, of which the present piece is an excellent example. K. N.

Lit.: Fagg, 1968, nos. 154, 157; Jones, 1984, p. 179, fig. 88, p. 189; Nicklin and Salmons, 1984, pp. 30, 34, fig. 18.

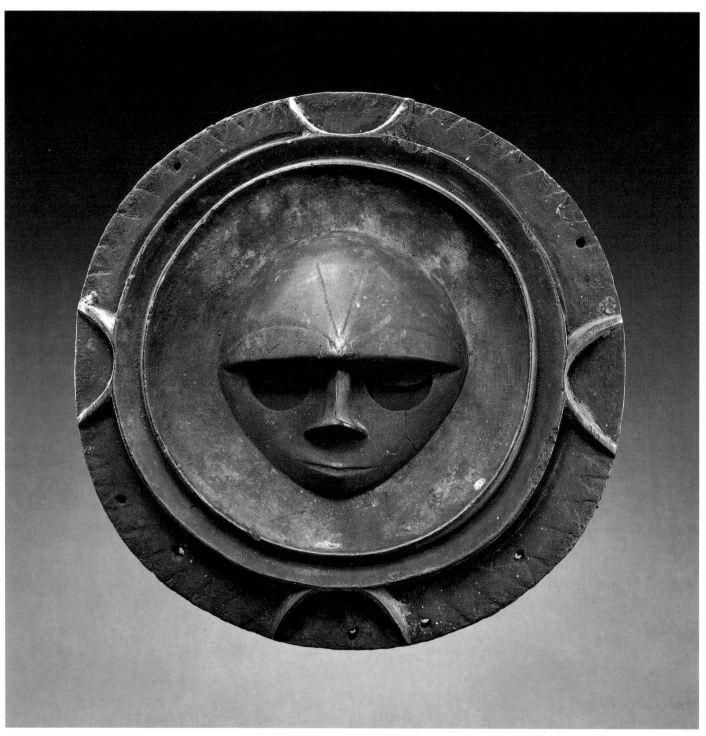

100 Face Mask

Ibibio, Nigeria

Wood; diameter, 28 cm

Despite the tantalizingly brief nature of the evidence, the time is perhaps ripe for reassessment of a distinctive substyle of Ibibio face mask, of which the present piece is an excellent example. Following the publication of Fr. François Neyt's *L'art Eket*, the provenance of round wooden Ibibio face masks has generally been given as Eket. However, data now available, admittedly scant, indicates that the distribution of this Ibibio substyle extends eastward into Oron territory. More specifically, Murray, in his unpublished notes on Nigerian culture, has referred to "an Okobo substyle in masks: small, round, moonlike faces on a roughly circular panel." Okobo lies to the north of the main Oron area and, although it has generally been placed under Oron for the purposes of administrative convenience, its material culture and art show certain distinctive deviations from that of neighboring groups, including the Oron, Uruan, and Nsit. In his as yet unpublished history of the peoples of eastern Nigeria, Jones classifies Okobo as a separate "tribe" from that of Oron, and identifies two constituent moieties, the Odu Okobo and the Okobo Eta. However, such is the state of ignorance concerning the art of southern Ibibio country that it is not clear as to which institution utilized the "round, moonlike" masks. Clues available at present suggest that the institution in question is more likely to be Ekong (a prestigious entertainment play) than Ekpo (the ancestor cult). K. N.

Lit.: Eyo, 1977; Jones, "History"; Murray, "Research Notes"; Neyt, 1979; Nicklin, *Ekpu*.

Some Peoples of the Benue

The Benue River has already been mentioned in the discussion of the art of the Idoma and the Igala, neighbors of the Igbo. A number of little-known ethnic groups are found on either side of the Benue in the direction of Cameroon; interspersed with these groups, Fulani Moslems have settled and have contributed to the conversion to Islam of an important segment of the inhabitants of these remote regions. Deterioration of export controls in the late 1960s has led to the appearance of much sculpture in unfamiliar styles.

THE TIV

Arnold Rubin writes: "The Tiv are thought to have begun their migration toward the north, in the direction of the Benue, about 400 years ago. They came from the Ogoja region, the northern fringe of the Cross River basin. Previously called 'Munshi,' the Tiv today number 750,000 people. Although this people lives in close contact with groups whose activity on the level of art results from an ancestor worship translated by masquerades, the veneration of the recently deceased is not known to the Tiv in any form, and few, if any, Tiv masks have been carefully documented."

In fact, until the beginning of the 1970s, Tiv sculpture was unknown, with the exception of objects incorporating skulls and human bones used as amulets, implements such as spoons, chairs, snuff-boxes, and axes, and a few large, enigmatic statues.

Fig. 59 Posts with anthropomorphic carvings in a Tiv village. (Photo: F. Neyt)

THE MUMUYE

According to Meek, the Fulani gave the name "Mumuye" to a number of ethnic groups inhabiting the Adamawa plateau, near the Cameroon border. The dialects of these groups are a branch of the Chadian languages, related to the Chamba.

The Mumuye have a number of points in common with the Jukun, from whom they seem to have borrowed two important religious traditions. Before the British period, they had no central authority, although they all acknowledged the priest of the Yoro district as the "supreme rainmaker."

Mumuye villages do not exceed 200 to 300 people. Each family group has a chief who acts as keeper of the ancestors' skulls. A supreme deity, named La, does exist, although he has no special following; he is identified with the sun. The Mumuye worship two mysterious spiritual principles that cannot be termed gods: Vadôs and Vabô. The worship of Vabô involves the use of masks (fig. 52, p. 151), as well as the erection of effigy posts surmounted by a head with large, drooping ears, typical of the Mumuye style.

THE CHAMBA

The Chamba live scattered on either side of the Cameroon border. They were once under the authority of the Jukun king of Wukari, then under that of the Fulani. The Nigerian Chamba of the Douga region are organized in patrilinear clans.

The ancient religion has been contaminated through the absorption of Jukun forms of worship. Ancestral spirits are revered by the Chamba, and an annual festival associated with fertility rites is held. A. M. V.

THE JUKUN

Primarily through the researches of C. K. Meek and Leo Frobenius around Wakari during the first three decades of the twentieth century, the sculpture of the Jukun-speaking peoples of the Benue River Valley of Nigeria was understood to comprise fabric, fiber, and strikingly abstract carved wooden masks used in the commemoration and veneration of ancestors. The existence of similar objects, exclusive of carved wooden figures, used for the same purpose among the scattered Jukun enclaves further up the Benue came to light during the 1960s.

The Jukun of the Upper Benue appear to have accorded a kind of cultural and ritual primacy to their neighbors – particularly the Mumuye in the south and the congeries of peoples known as Wurkun north of the river. The style of Jukun figures exhibits a richly plastic orchestration of the forms of the body and the space in which they evolve. They resemble the sculptures of the Mumuye, but diverge strikingly from the "pole-sculpture" conception typical of Wurkun works. A. M. V.

Lit.: Meek, 1931, I, pp. 334, 446, 449; Baumann and Westermann, 1962, p. 460; A. Rubin, Letter to the author.

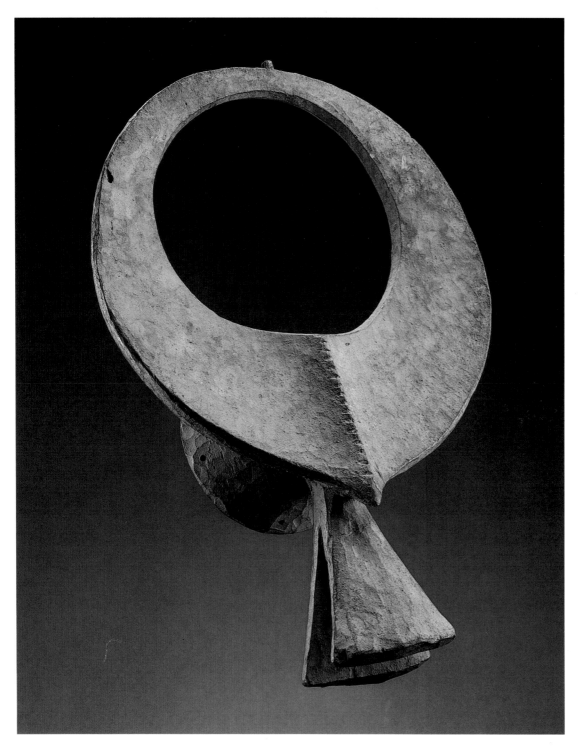

101 Bush Cow Crest

Kantana, Nigeria

Wood; length, 53 cm

Highly abstract carved wooden crests of this type, based on the heads of the Cape Buffalo and several varieties of antelopes, are usually attributed to the Kantana (formerly called Mama). However, essentially identical sculptures were also used by other populations living in the linguistically heterogeneous area around Wamba, in the difficult and broken terrain typical of the south-central margins of the Jos plateau. The populations involved included Mada, Kulere, Rindri, and Sha, among others. In each village, these crests focused the observances of Mangam, a loosely organized association of males that derived its authority from "the ancestors" and was primarily concerned with maintaining social order and enhancing agricultural yields. The remarkable dispersion of the Mangam complex may have been one result of people from different groups coming together to take advantage of the expanding opportunities for seasonal labor that accompanied the emergence, during the late eighteenth/early nineteenth century, of a major salt-rendering industry in the area south and east of the town of Lafia. A. R.

102 Figure

Tiv, Nigeria

Wood; height, 110 cm

According to some accounts, male and female pairs of relatively large carved images were incorporated into domestic shrines called *ihambe icigh* or *ihambe twer*, which also included medicinal plants and other elements. Set up outside the house of a compound head's senior wife, the shrines were oriented toward increasing human and agricultural fertility. More recently, it has been suggested that such large, relatively naturalistic images are used to control *azov* (sprites or fairies) that are influential in human affairs. A. R.

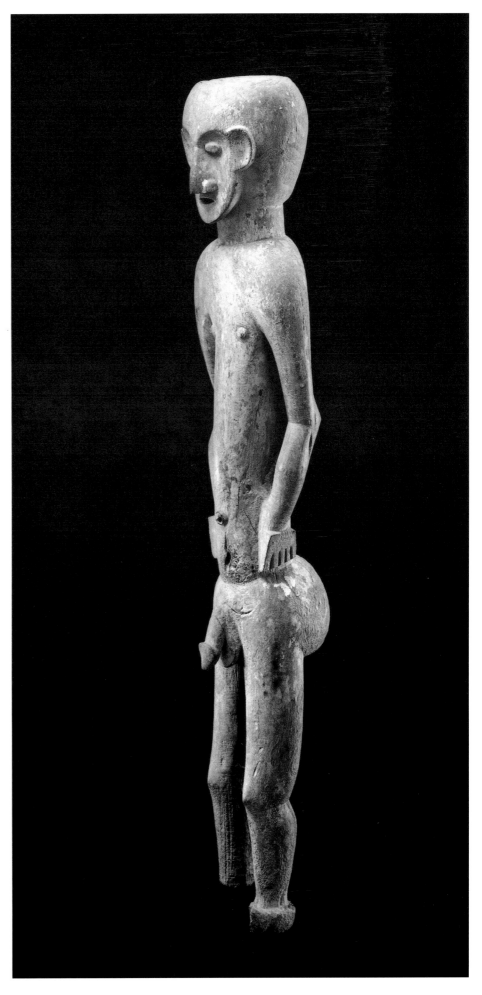

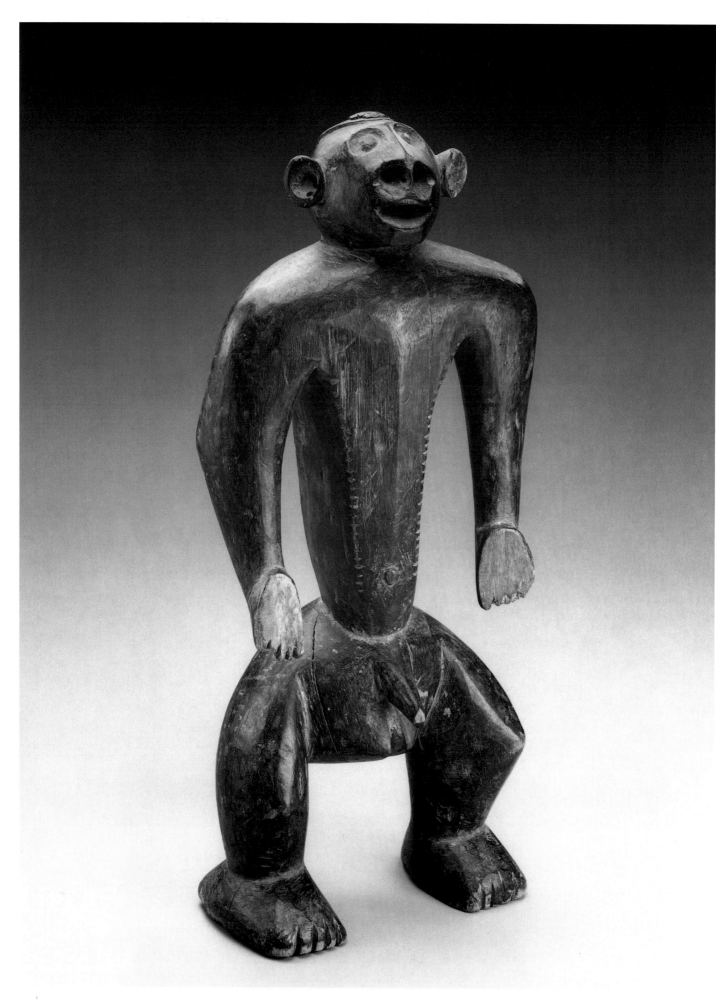

103 Figure

Kantana or *Montol*, Nigeria

Wood and pigment; height, 48 cm

During the early years of the twentieth century, the area between Pankshin and Shendam, encompassing the central section of the southern margin of the Jos plateau, was regarded by Hausa traders and English colonial administrators alike as a stronghold of lawless, warlike cannibals. This stigmatization, if true, would seem to have precluded more constructive forms of interaction among its peoples. As with the pan-tribal distribution of Mangam masquerades among the similarly characterized peoples around Wamba, however, ethnohistorical evidence indicates that the Pankshin-Shendam area was similarly permeated by a culturally significant, widely shared institution: the healing association called Komtin, Komtoeng, Kwompten, or some other variation thereof. The complex has been noted among the Montol, Goemai, Torod (Yergum), Kanam, N'gas (Angas), Chip, Gworam, Tal, Jorto, Miriam, Dimmuck, Lardang, and Piapum, and may have been even more widely distributed.

Although there seems to have been some measure of local variation, the following pattern was more or less typical: individuals afflicted with certain illnesses would seek the intercession of the association, in the form of divination, herbal remedies, curing rites, and performances of its songs and dances. A recovered patient would fete the troupe with a celebratory feast, and usually become a member. The central symbol of each troupe was a carved wooden figure.

The present sculpture has been attributed to the Montol, presumably on the basis of its resemblance to Montol works belonging to Sieber's "earlier" phase. The style it exhibits was apparently distributed beyond the Pankshin-Shendam area, however, as indicated by a small group of works attributed to the Kantana and other peoples living around Wamba. No information as to the function of this latter group of figures has been forthcoming. The Wamba-area figures in question generally exhibit relatively massive shoulders and a powdery-red surface, in contrast to the scorching or grayish, granular "sacrificial" patina typical of examples from the Montol and their neighbors. A. R.

Lit.: Sieber, 1961.

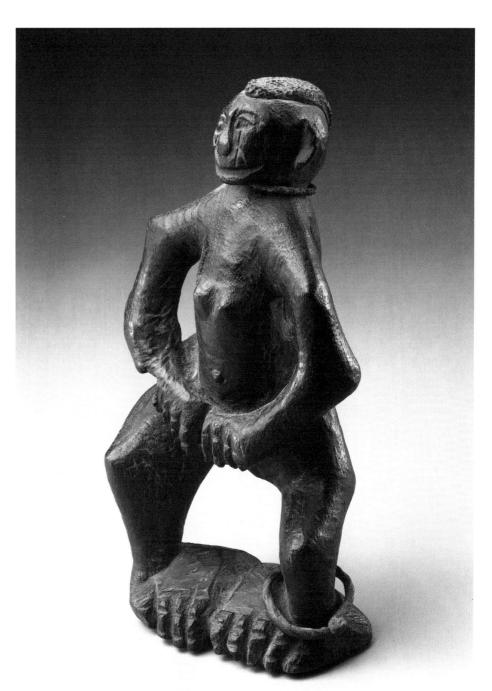

104 Figure

Bura (?), Nigeria

Wood and metal ring; height, 21.5 cm

This sculpture may be attributed to the Bura on the basis of a figure in the collection of the Museum of Mankind, London, that was published by William Fagg.

The Bura are a small, predominantly agriculturist, Chadic-speaking group in northern Nigeria. Each village is an "independent political unit under the headship of the senior member of the oldest established clan."

Fagg suggests that the Museum of Mankind figure was associated with the ancestor cult, yet wood carvings are not mentioned in the limited published literature on the Bura, although iron amulets are described by Meek. Stylistically, both the Museum of Mankind and the Barbier-Mueller figures are characterized by widely spread legs and strongly articulated arms. The Museum of Mankind figure has eyes of inlaid abrus seeds, which is not the case in the present sculpture. Further, the facial scarification of the two works differs. That of the London figure resembles the marks of both the Bura and the Pabir (a nearby group). The facial scarification of the Barbier-Mueller figure is unlike any published as belonging to northern Nigeria by either Meek or Adepegba. Thus the figure is here most tentatively assigned to the Bura, and further parallels must be sought. R. S.

Lit.: Meek, 1931, I, pp. 141-42, 162-64; Fagg, 1965, p. 46; Adepegba, 1976, pl. VII.

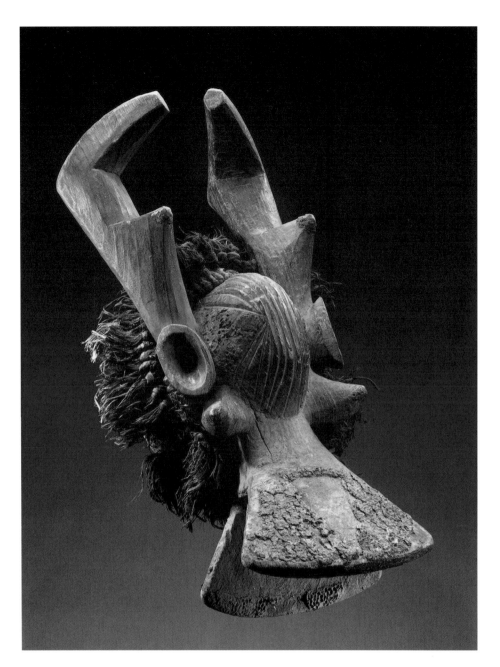

105 Mask

Yukuben, Nigeria

Wood, fiber, and, formerly, abrus seeds; height, 63 cm

The densely forested, hilly area between Takum and the Cameroon border is occupied by peoples whose arts are little known, including the Kpan (Takum Jukun), Kutep, and Yukuben. They speak fairly closely related languages of the Jukunoid group. The area was traversed by a network of trade routes, along which moved kola, ivory, and slaves from the Cameroon Grasslands to the emporia of north Nigeria.

A few strikingly abstract, "horizontal" masks from the Kutep, based on bovine or antelope motifs, now in German museums, were collected early in the present century. Such masks, and these motifs, are extensively distributed among peoples living in the Nigeria-Cameroon borderland, including the Kpan, Mambila, Mumuye, and Chamba. Some Yukuben masks also belong to this complex; as with those of the Kutep, their surfaces are typically ornamented with large areas of bright red *abrus precatorius* seeds pressed into wax or gum. Further, whereas Kutep masks, called *iki*, perform to celebrate success in communal dry-season hunts, those of the Yukuben, called *augum*, are connected with the agricultural cycle and control of witchcraft.

A. R.

106 Figure
Jukun, Nigeria

Wood; height, 92.5 cm

In the Jukun communities, the spirits of found-
ing ancestors, embodied in male-female pairs of
figures, were maintained in shrines in the form
of symbolic compounds. The images received
daily prayers for the well-being of the commun-
ity, accompanied by libations of millet beer and,
occasionally, blood sacrifices. The beer and blood
were sometimes poured directly over the fig-
ures, resulting in a thick, dark patina. The fig-
ures were also central to special annual cere-
monies following the harvest whose secondary
function was to revitalize the priest-chief of the
community. Most male figures were shown as
ithyphallic. A.R.

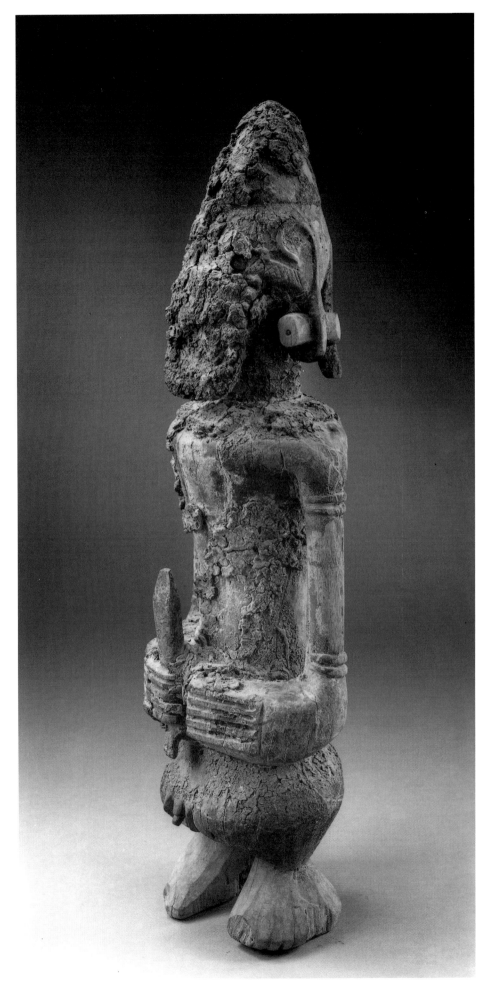

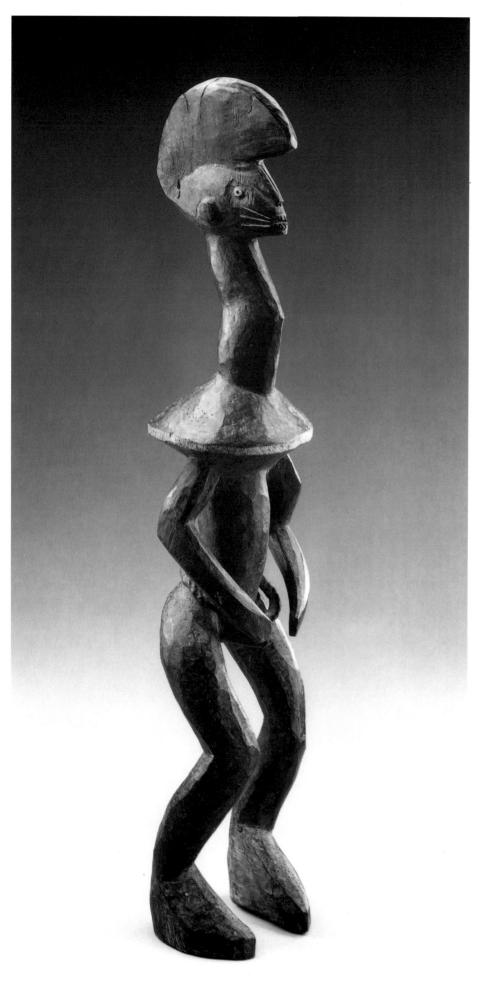

107 Figure
Mumuye, Nigeria

Wood and pigment; height, 73.5 cm

Sculptures of this kind were initially misattributed to the Chamba neighbors of the Mumuye. Fieldwork carried out during the early 1960s – unfortunately limited, but, so to speak, "in the nick of time" – clarified their origin and yielded some information as to how they were used: as ornaments to the status of elders; as tutelaries for divination and healing procedures; and, in fact, in a rather wide range of other contexts. This diversity of functions appears to be paralleled by a comparable range of forms, a truly astonishing set of variations on the dynamic interplay of complex angular masses with the space in which they are situated. Unfortunately, given the accelerated pace of cultural change in the region and the fact that so few works made for a traditional clientele are still *in situ*, the significance of these variations, whether local, individual, functional, or chronological, may never be known. A. R.

108 Pipe

Mumuye, Nigeria

Wood and terra-cotta; height, 45 cm

Tobacco was widely smoked and/or taken as snuff in traditional Africa. Leaving aside the smoking of cannabis, which may be older in eastern Africa, the New-World origin of tobacco entails a sixteenth-century *terminus post quem* for the introduction of the practice and its associated material culture. Furthermore, given the fact that pipe bowls in particular – usually ceramic or metal – frequently survive in archaeological contexts, scholars in a variety of fields are coming to appreciate the value of smoking and pipes in charting trade routes and other large-scale and small-scale interactions between peoples.

For the individual smoker, however – African or otherwise – the deeply personal, intimate, recreational nature of the practice is often reflected in the embellishment of the paraphernalia associated with it. Such embellishments were frequently also associated with differences in status. During the mid-1960s, I saw pipestems incorporating schematized figures – previously unreported – among the Mumuye of northeastern Nigeria. These engaging works seemed to be part of a larger complex of objects incorporating figurative motifs (such as "sitting sticks" and stools) whose intent was the enhancement of prestige. While some of these "curiosities" may have been aimed at the Euro-American art market, others – particularly well-used pipes – were clearly made for local clients. This idiosyncratic complex of prestige-oriented material, while rooted in traditional forms, may reflect the breakdown of the collective, essentially egalitarian values around which Mumuye society was previously organized. A. R.

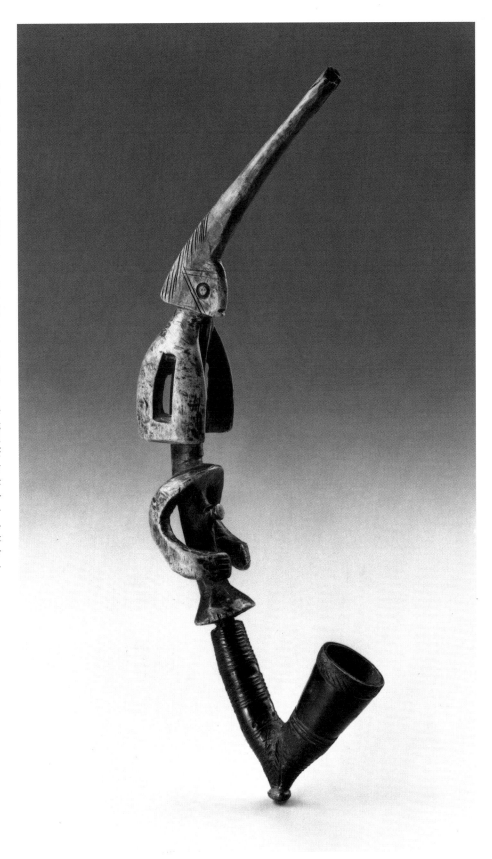

Northwestern Cameroon

Important ethnic and historical ties exist between the region of the Upper Benue in Nigeria and the neighboring provinces in Cameroon.

THE MAMBILA

As a result of colonial divisions, some of which were quite recent, the Mambila found themselves on both sides of the Nigeria-Cameroon border, southwest of the Adamaw mountains. The Mambila in Cameroon are farmers who inhabit the border zone of the Northwestern Province; their villages are autonomous, and their society is egalitarian.

Mambila sculptural art, which is austere and very expressive, includes chairs, masks, and figurative sculpture. The figures are thick-set and powerful, with heads characterized by open mouths and large, deeply-set eye sockets; their function is to protect the village group. They are painted, and every year their colors – black, red, and white – are touched up.

Other anthropomorphic and zoomorphic figures are also made, in wood and in terra-cotta. Masks are frequently stylized and include fantastic representations of men and birds. The mygale spider and the river crab also play an important role in this culture, which, despite a century and a half of Fulani domination, has not been significantly transformed.

Mambila styles have affinities not only with those of the Jukun and the Chamba in Nigeria but also with those of the Cameroon Grasslands.

THE GRASSLANDS

Settlement and History

The very early settlement of the Grasslands is corroborated by the numerous discoveries of historians and archaeologists. Finds of stone-age objects suggest that a homogeneous civilization existed from the Bamileke plateau to Igbo territory in Nigeria. And bone remains date the refuge of Shum Laka, near Bamenda, between 8000 and 4000 B.C. The ancient hunters of this area might be the distant ancestors of the present-day population.

Also very ancient is the iron industry, which is thought to predate the Christian era; it survived for hundreds of years, and was abandoned in some chieftaincies only in the twentieth century. The reigning dynasty in Babungo is descended from lineages of smiths, and the hundreds of smelting furnaces once in use there have left more than 200,000 cubic meters of waste.

As a result of the traditional organization in centralized chieftaincies, Grasslands history is primarily concerned with royal, or at least noble, lineages. Oral traditions go back to the fifteenth century, which saw the arrival from other regions of the "founders" of most of the present-day chieftaincies.

It is worth noting that linguistic studies show an autochthonous core comprising almost sixty percent of the basic vocabulary of the so-called Grassfield languages. Recent studies suggest that the earliest population was of Pygmy origin, and that the plateaus were then occupied by leaderless tribes before small, more structured states emerged around a few specific chiefs. These probably came from the neighboring plains: the Ndobo and the Tikar from the Mbam valley to the northeast; the Banyang and the Widekum

from the Cross River on the borders of Nigeria, to the southwest; the Mbo and the Ngala-Duala from the Mbo plain; the Tiv from the Katsina valley; and the Chamba from Faro, far to the north. The homogeneity of contemporary Grasslands population – and the lack of distinctive tribal features – may well have resulted from the gradual and peaceful intermixing of the autochthonous population, who constituted a clear majority, with these successive waves of immigrants.

The region of high plateaus in western Cameroon – called either "Grassland" or "Grassfield" depending on the author – is one of the great centers of art and culture in sub-Saharan Africa. Neither Islam nor Christianity, nor Western civilization, has seriously disrupted the traditions, social structures, and essential beliefs of the peoples of these highlands, which explains the survival of active centers of traditional art down to the present. A serious study of the cultural foundations of this region is also interesting inasmuch as many Africanists believe the Grassland to be the original habitat of the Bantu peoples, who today are spread throughout central, western, and southern Africa.

Though covering hardly one tenth of the land area of the country, the Grasslands are inhabited by more than a third of the population of Cameroon and in some parts have a population density of 400 persons per square kilometer.

Topography

The region is composed of a group of volcanic plateaus ranging in altitude from 1,200 to 1,800 meters; they are inhabited by the Bamenda, the Bamun, and the Bamileke (fig. 60). High mountains rise from these plateaus, including the Bambut range (2,740 meters), which divides the Grasslands into two parts. At a lower altitude are found smaller plateaus inhabited by the Mbo and the Tikar; here the climate is cool and healthy and the lands are often very fertile. Some upland savannas remain uncultivated. Botanists believe that the region was previously covered by forests, which were gradually destroyed by the farming and cattle-raising activities of those who inhabited the area. The richness of the soil and the variety and importance of plant cultivation have made the Grasslands the breadbasket of Cameroon.

Fig. 60 Bamileke chief's house in the village of Bafuen. (Photo: From Frobenius, 1933, pl. 146)

The Grasslands are divided into a multitude of independent, centralized chieftaincies, some of which are large, populous, and powerful, while others are minute, though just as concerned about their prestige. The chieftaincy is usually the religious, political, and social unit of an entire region; called *gung*, it is a kind of small, self-contained state, with a territory defined by known boundaries and its own specific institutions. Ruled by a *fon* who is considered sacred, the chieftaincy cannot be considered an ethnic group, since the *fon* usually has authority over peoples of different origins who essentially have in common their allegiance to the same power, the chief and the men's societies.

The *fon* is the supreme arbiter of the group's equilibrium; his power, though very extensive, is not as absolute as might be supposed, since he is in fact essentially the spokesman and armed support of the traditional societies that step in to select him from the royal group. The *fon* is master of the elements, lord of the soil, the supreme judge, the governor of the community; he is, in short, the very symbol of the *gung*. Hence he must appear powerful, just, prosperous, and fecund. And royal statuary, whose task is to reinforce this image, presents figures with ample faces and bellies.

All important decisions are taken either in the chief's council of ministers or in the council of the notables *(mkem)*. Any opposition of the *fon* to decisions of the councils, or any lapse from tradition on his part, may result in his disappearance.

Social organization is founded above all upon the initiatory societies and a hierarchy of titles; the *mkem* constitute the framework of the Grassland peoples' social system. Each society has its members, meetings, festivals, and masks, and holds a demonstration on the market place at least once a year.

Religious beliefs are linked to the territory of the chieftaincy and the ancestors who define and defend it. Although they believe in a supreme being, the villagers are animistic and worship numerous tutelary divinities. Through the mediation of these spritits and the ancestors, man addresses the supreme being in prayer and sacrifices. These rituals demand painted, woven, or sculpted figures.

Art, especially sculpture, but also music and dance, is the preferred means to express the symbols of the *fon*'s power, the royal ancestors, the titular hierarchy, the omniscience of the *mkem*, and so forth. Astonishingly diverse, Grasslands art might well be characterized as a social art. L. P.

109 Headdress

Mambila, Cameroon

Wood and pigment; height, 30 cm

Present-day knowledge about Mambila art is embarrassingly thin and superficial. Mambila masks come into action at the conclusion of two-yearly planting and harvesting cycles, when they are danced by and for men to the apparent exclusion of women.

This mask, worn atop the head, has a supportive role in that it accompanies a higher-ranking helmet mask. Apparently representing the human face in the concave form associated with the faces of wooden ancestor figures, the mask has the protruding tubular eyes commonly seen on Mambila animal masks. The color scheme of red, black, and white is characteristic of much of Mambila art. In this example, the red color of camwood powder dominates by emphasizing the central concave planes of the face, which are delicately delineated in black to assume a heart shape culminating in the tipped-up nose point.

Camwood powder is a precious material that is applied – mixed with water or palm oil – to people and things in ritual contexts. It derives from a tree of the Western Forest zone and is obtained by the Mambila at great expense through trade via the Grassfields. In the neighboring Grassfields camwood powder is the primary sign for affirmation of lineage solidarity. It is plausible that its use for people and cult artifacts among the Mambila has the same significance. T. N.

Lit.: Schwartz, 1976.

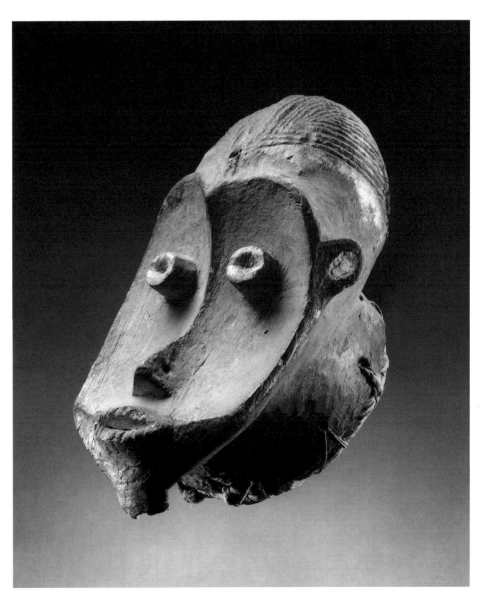

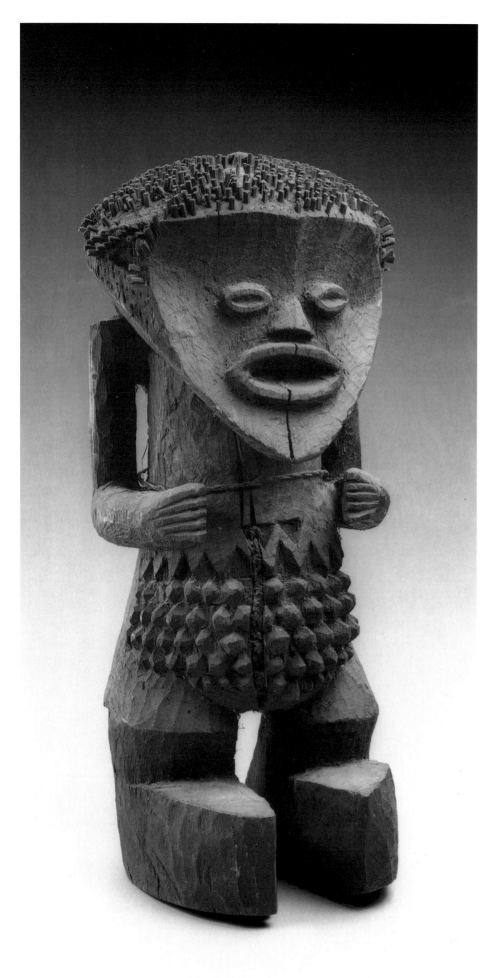

110 Ancestor Figure

Mambila, Cameroon

Wood and pigment; height, 45 cm

Mambila ancestral spirits are believed to be in-
strumental forces in the welfare of the living.
While generally idealized as benevolent and the
source of moral authority, ancestors neverthe-
less may also have an ambivalent and fickle
quality. Thus, they must be placated and their
goodwill humored to provide the good things in
life: fertility, health, prosperity. Ancestor fig-
ures are the concrete abode for ancestral spirits;
they are offered and treated with magical and
medicinal substances to dispose them well to-
ward their living descendants. This typical fig-
ure exemplifies an expression of intensity and
vigor that is realized through compressed vol-
umes of form. It appears to harbor a store of
energy that is both beneficial and dangerous to
the living. T. N.

111 Figure

Gbaya, Eastern Cameroon

Wood; height, 31.5 cm

The Gbaya are an ethnic group, numbering in the 200,000s, that inhabits the tropical rainforest of eastern Cameroon. They live in compact autonomous villages and have a patrilineal descent system.

Gbaya sculpture is rare, and only a few examples are represented in collections. Gbaya culture was subject to a comprehensive field study by the veteran ethnologist of southern Cameroon and northern Gabon, Günther Tessmann. His monograph of 1934 confirms the rarity of Gbaya figural sculpture *in situ* as well.

The few known Gbaya figures are male and, according to Tessmann, depict ancestors. Certain details of these figures, such as naval scarification, lip-, nostril-, and earplugs, accurately reproduce a male initiate's body decoration at the close of his initiation. This has led to their interpretation as instructional models in rites of initiation. Tessmann's data on these figures as depictions of ancestors does not preclude their use as figures of instruction in the initiatory process. Ancestors as generators of the prevailing social order and customs (including initiation) are an appropriate model for the education of youths.

The present figure does not entirely conform to Gbaya norms of style and iconography. It is a female figure with the wooden earplug of a male initiate. The Gbaya hairdress of multiple tresses represented by incised horizontal lines with a vertical center-divide on the figures has here been replaced by a caplike form with uniformly incised crosshatching. Some normative stylistic features have been retained, but exaggerated, such as the sharply cut-off shoulder and the forward-sweeping arms, which, however, should not be detached from the body as is the case here. This statuette has lost its neck – a clear feature of earlier Gbaya figures – and it has shortened, squat legs, resulting in body proportions that make the figure appear derivative. It also displays articulated hands and toes, a further uncommon feature. In general, it appears that the figure has been laundered by a contemporary aesthetic that has given preference to a certain smoothness and finesse over the starkly expressive quality of earlier Gbaya figures. T. N.

Lit.: Tessmann, 1934; Kecskési, 1982.

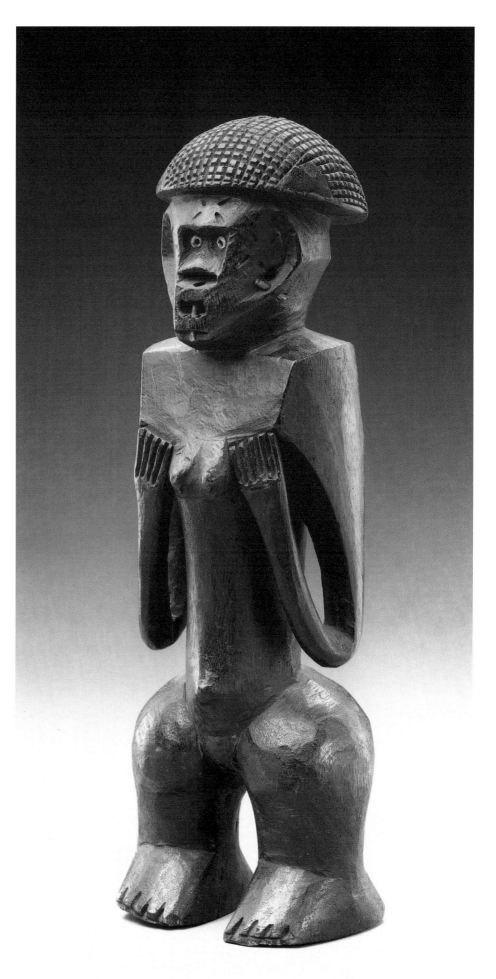

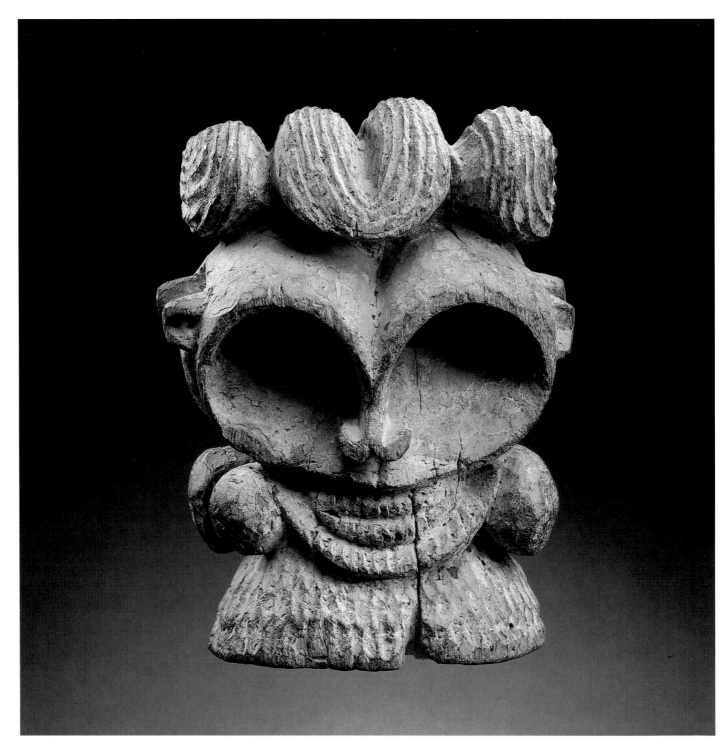

112 Janus-Faced Crest Mask

Bangwa, Cameroon

Wood, with traces of kaolin; height, 41.5 cm

In the small kingdoms collectively referred to as (western) Bangwa, the Night Society exercises the functions of the typical regulatory society, an institution that is found throughout the Grassfields kingdoms as an agency of governance. The inner and highest ranking lodge of the Bangwa Night Society has nine members who are charged with the maintenance and enforcement of social order. They exercise their office under the guise of masks: nine masks for nine officers of each Night Society. The present mask is an example of a Night Society mask.

Like all regulatory societies, the Night Society counts as its major responsibilities the pursuit of criminals, eradication of pollution caused by witchcraft and sorcery, and punishment of the lesser transgressions to which social relationships are subject in our imperfect world. The measure of power vested in the nine officers is awesome and their masked appearance is terrifying to the population.

The Night Society's primary instruments, its *sacra*, are its dangerous masks. These are perceived as incarnating a supernatural power that makes them dangerous to the initiated and uninitiated alike. The masks are kept in remote huts of menial servants, and ritual precautions are required for anyone in close contact with them.

While they are made to be worn on the head, Bangwa have expressed apprehension about the intimate association between so vital a body part as the head and the mask. More recently, these masks have therefore been carried on the shoulder, the head being veiled by a cloth. The Night Society's regular meetings take place at midnight; the masks attend to their policing duties also in the secrecy of night. Night masks participate publicly in the commemorative death celebrations for title holders such as the king and the Society's officers.

The grotesque features of these masks are directly related to their fear-inspiring mandate. The mask representation derives from the human face and head, but its features are deliber-

ately distorted and exaggerated to acquire that awesome and supernatural dimension that sets them apart from the normal human world. Its back-to-back faces with four eyes can see in several directions at once, an allusion to the vigilant character of the Night Society, which, like all regulatory societies, provides the watchful eyes for the king and kingdom. T. N.

Lit.: Brain and Pollock, 1971, p. 131 ff.; Northern, 1984, p. 62 ff.

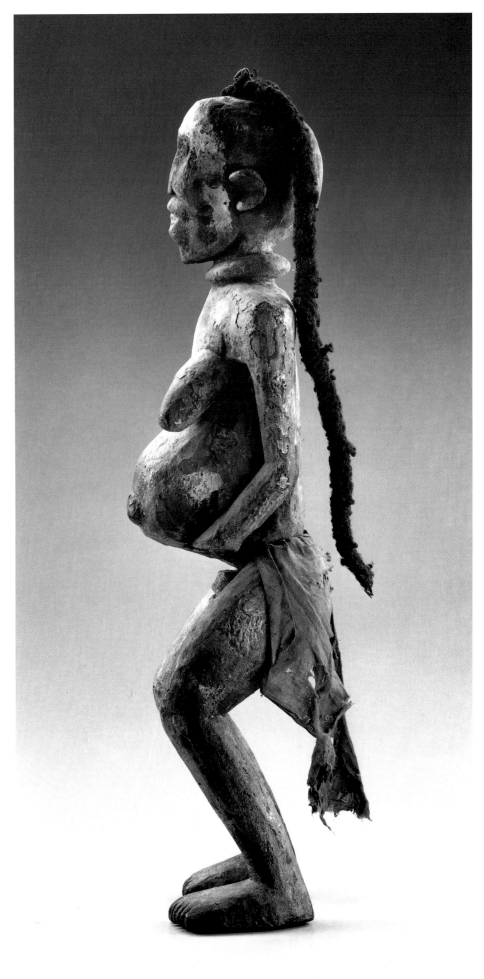

113 Ku N'gan Fecundity Figure
Bamileke, Cameroon

Wood, hair, raffia fiber; height, 82 cm

This figure represents a *magné*, a mother of twins giving birth. The head of the first child appears at the vulva; the second is still inside the swollen belly supported by the left hand. That this is a N'gan figure is confirmed by the long braid, reminiscent of the wigs on the society's masks, made of tufts of hair and tied to the top of the head with a raffia fiber cord. That it was a ritual object is shown by the white traces of *mbeu* (a mixture of kaolin powder, trachyte, and ground seeds) between the breasts, around the face, and on the shoulder blades and backbone. The dramatic effect created by the mouth open as if to scream is sobering, as it is directly relevant to the major grasslands problems of sterility and death in childbirth.

This figure belonged to a member of the secret Ku N'gan society, which specialized in problems of infertility; he would show it secretly to a barren woman who sought him out, then have her strike the figure's forehead with a bag of magic substances while chewing some *mbeu*, which she had to spit out on to her breasts or spread on other parts of her body with her finger. If the woman died in labor, the child responsible for her death was removed from her body by members of the society and given to her family, to stop any search for the guilty party. Mother and child were then buried far apart, and an offering was placed at the foot of the figure. Although one would expect figures of this sort to be in common use, the one shown here appears to be only the third that is known. P. H.

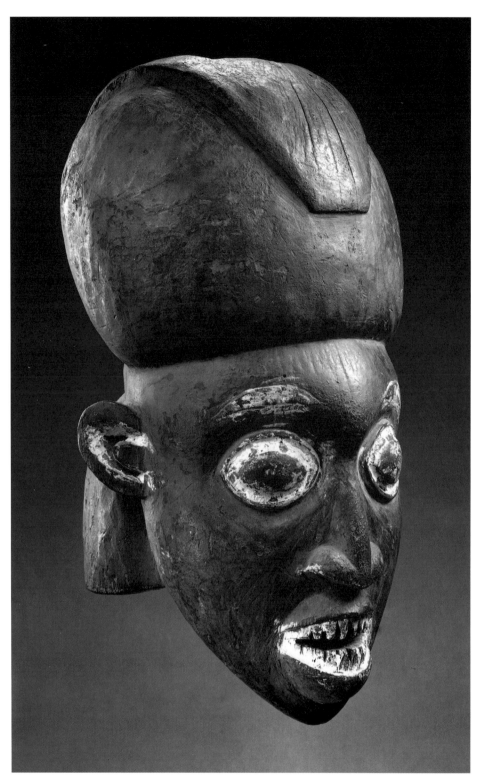

dancer, whose face is covered by a transparent cloth through which he can see. Ngoin's traditional vestment, enveloping the dancer's body, is of blue and white resist-dye royal cloth. The mask daintily carries a fly whisk, emblem of prestige, and dances, or rather moves, in conservative, slow steps that befit her noble image.

T. N.

Lit. : Northern, 1984, pp. 62 ff., 146 ff.

114 Ngoin Mask

Western Grasslands, Cameroon

Wood and pigment; height, 50 cm

This massive female mask represents a type that is widely distributed throughout the kingdoms of the western Cameroon Grassfields. She performs as part of a sizeable mask group – affiliated with either the palace regulatory society or a wealthy lineage compound – in the context of commemorative death celebrations for male title holders of the kingdom. The mask is identified as female by the elliptic or tongue-shaped hair-dress typically worn by wives of the king. In this example, the hairdress is applied over a head-dress probably representing the royal male prestige cap, whose use may also be accorded certain titled royal women, such as the king's mother or his titled sister. The female mask, Ngoin, with her iconic allusion to royal womanhood symbolizes the role of women as complementary to that of men. The masquerade usually includes several Ngoin to complement a set of male human masks, but one Ngoin typically follows the male leader-mask in the dance sequence. The mask is worn towering atop the head of the male

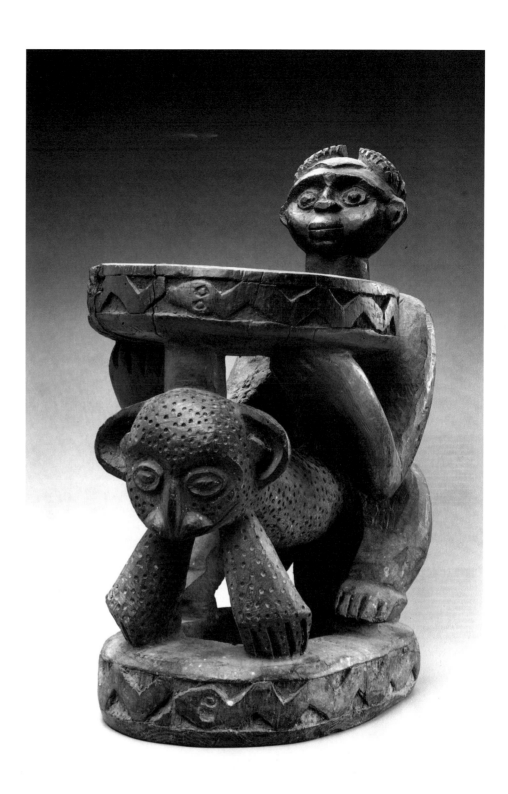

115 Prestige Stool

Kingdom of Oku (?), Cameroon

Wood; height, 54.5 cm

In the kingdom of the Cameroon Grassfields the prestige stool is the primary symbol of royal office and, accordingly, the "enstoolment" ceremony of a king marks the official beginning of his reign. Royal stools, like regalia, typically display the significant symbols in human and animal form that most pertinently embody the dominant beliefs and values of the culture. The male human figure depicted in the present example bears the prestige cap characterizing royal memorial ancestor figures. Such figures symbolize the belief in the legitimacy and perpetuity of the dynasty by reference to the kingdom's founding ancestor. This image is represented here in conjunction with – actually, riding – a leopard. The leopard has survival qualities of contained aggression, swiftness, cunning, and agility that are deemed appropriate for a king. Thus, the leopard has become the most important royal referent symbol; in effect, he is considered to be the *alter ego* of the king. Another high-ranking royal animal symbol is the mythical serpent, which is associated with the found-ing of several Grassfields kingdoms, including that of Oku. Two serpents are depicted here head to tail in low relief around the seat and the base of the stool. In their totality these three icons of equivalent symbolic value dramatically reinforce each other and manifest the ritual and secular authority invested in the office of king-ship. When the king was seated on this stool in the presence of his subjects, these icons conceptually and literally legitimized and supported his royal authority and power. T. N.

Lit.: Northern, 1984, pp. 33 ff., 42 ff., 46-47, 54, 102 ff.

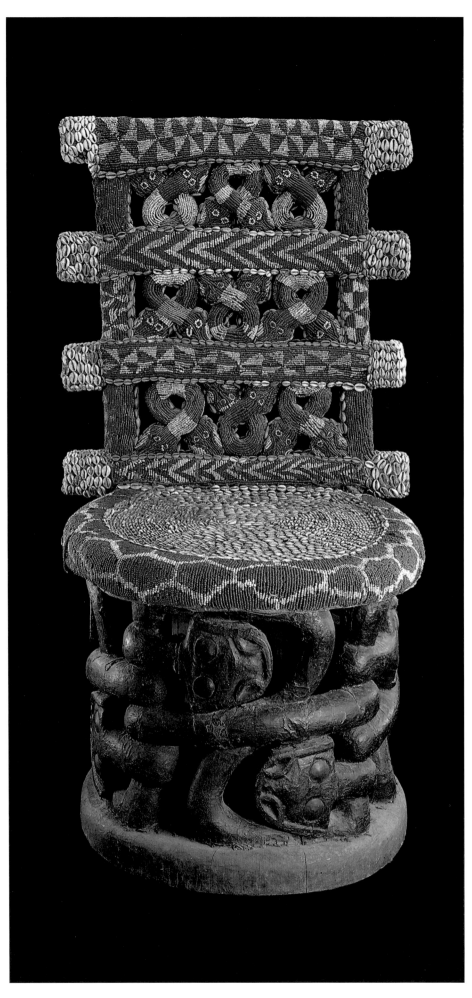

116 Highbacked Chair

Bamun, Cameroon

Wood, beads, cowries, hammered copper leaf;
height, 120 cm

This sculpted chair, made from a single piece of
wood and decorated with beads, cowries, and
hammered copper leaf, is reminiscent, in the
shape of its back, of the traditional raffia bamboo
chair *ru-monjuono*, a near relative of which is
also found among the Fulani. A similar example,
with the same motifs of two-headed snakes (a
royal emblem), is found in the Rautenstrauch-
Joest Museum in Cologne. Seats of this type,
made during the reign of the Mfon Njoya
("king" or "sultan"), do not appear to have been
intended for the king; they were, rather, for the
second personality of the state, the Queen-
mother Njapndounke, who was the only other
person authorized to use such a throne. She is
shown in a photograph taken by Lutz in 1960
next to a similar piece of furniture, with sculpted
double bells. It seems to have been the custom to
offer these seats to high ranking foreigners. A
1912 photo shows the Mfon on his monumental
throne; on his right is a stool with leopard cary-
atids reserved for his mother; on his left, the
German merchant Rudolf Oldenburg is seated
on a chair of this type, with sculpted figures
around the circumference. P. H.

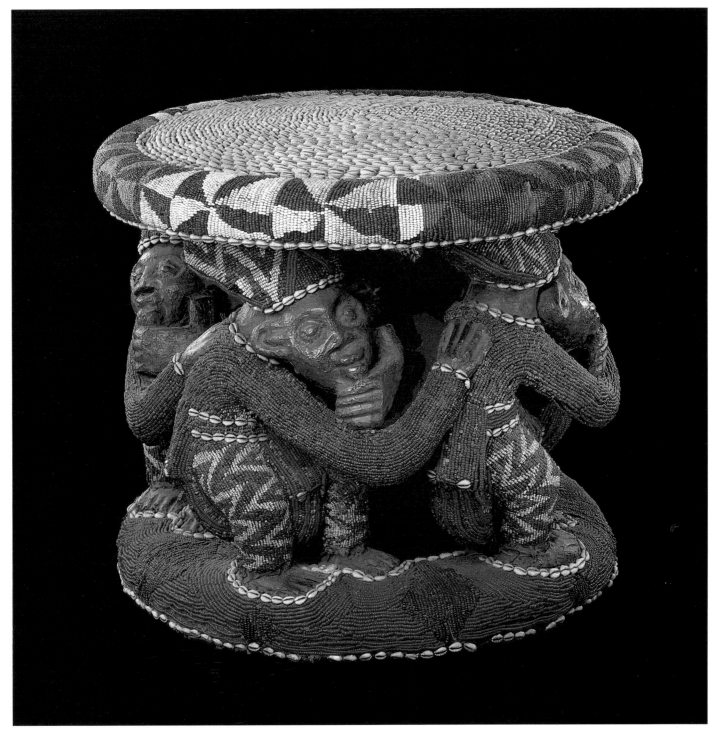

117 Prestige Stool

Bamun, Cameroon

Wood, cowries, beads, hammered copper leaf; height, 57 cm

This royal "traveling" stool (*rü-mfon*) was intended for more private use than the monumental throne *mandu-yenu*. It was given by the Mfon Njoya to his friend Captain Glauning, who was killed in a battle against the Tiv in 1908. Servants are represented as caryatids, walking in single file with their right hands on the shoulder of the man in front; as a sign of respect, they hold their left hands before their mouths. This motif is also found, though in a different treatment, on the footrest of the great throne. Here, the faces plated with copper leaf and the beaded hats seem more closely related to the an-thropomorphic masks displayed during the *njah* festival, which used to be held annually. The seat is covered with cowries, a sign of wealth and victory that also evokes prisoners' ransom; the beaded edge has a triangular pattern that recalls the markings of the royal leopard. P. H.

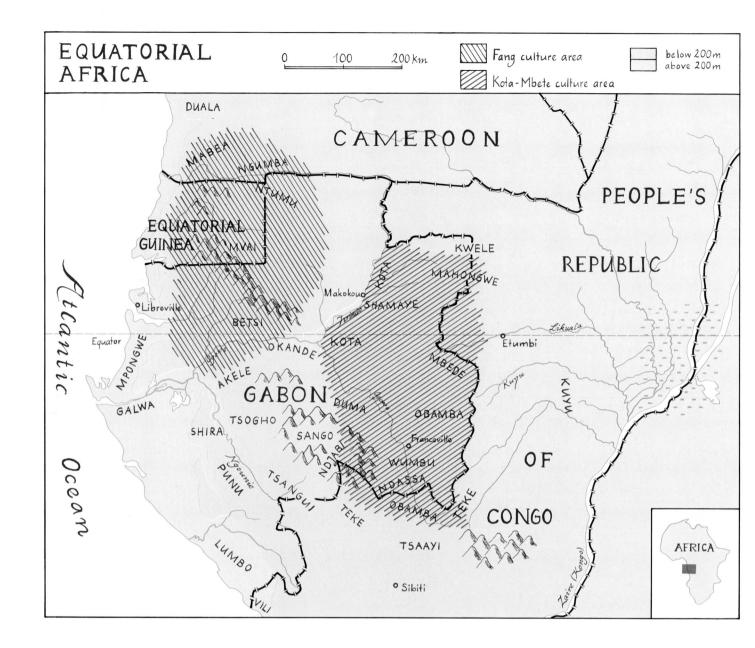

EQUATORIAL AFRICA

0 100 200 km

Fang culture area

Kota-Mbete culture area

below 200m
above 200m

DUALA

CAMEROON

PEOPLE'S

REPUBLIC

MABEA

NGUMBA

NTUMU

EQUATORIAL
GUINEA

MVAI

KWELE

MAHONGWE

Makokou

KOTA

SHAMAYE

Libreville

Atlantic Ocean

BETSI

Ogooué

KOTA

Ivindo

Likuala

Etumbi

MBEDE

Equator

MPONGWE

OKANDE

AKELE

Kuyu

KUYU

GALWA

GABON

DUMA

Ogooué

OBAMBA

SHIRA

TSOGHO

SANGO

Francevile

OF

PUNU

Ngounié

NDJABI

WUMBU

CONGO

TSANGUI

NDASSA

TEKE

OBAMBA

TEKE

LUMBO

TSAAYI

Sibiti

Zaïre (Kongo)

VILI

AFRICA

Louis Perrois

Atlantic Equatorial Africa

Landscape and Environment

On its Atlantic side, Equatorial Africa includes southern Cameroon, Equatorial Guinea, Gabon, and Congo-Brazzaville (People's Republic). This is an area of forest, called "rain forest" on account of the permanently hot and humid climate. This general picture has to be modified in the field, of course, since very specific and different environments are found juxtaposed within the vast Ogowe Basin complex. To the west lie lagoons and lakes interspersed with extensive swampy zones, stretching from the estuary of the Gabon to the Ogowe Delta and the flat coastline of Setté Cama. In the interior, several zones of high plateaus and forest-covered mountains range one after another. Finally, in the Ngounie and Upper Ogowe, a number of valleys give definition to the plains of open savanna that are cut by long strands of forest.

Thus, except in the rain forest area itself, which presents a homogeneous mass thinned out only here and there by gaps created by high-banked rivers, the landscape is not uniform. Everywhere the coast is very low, the narrow beach opening out to flood-zones dotted with mangrove swamps. The forest is almost impenetrable: in the west, especially along the rivers, human habitation is more in evidence, and we find second-growth forest, with dense, recent vegetation; in the center and east, the first-growth forest of tall trees remains – all animal life is concentrated high up in these trees, leaving a surprisingly open and light undergrowth below. Some regions present unexpected contrasts, for example the grassy hills of the Okanda above the mouth of the Ogowe and the hills of the Upper Ogowe, between Moanda and Franceville; or further east, the Bateke plateaus, where immense stretches of sand are dotted with sparse grasses, and a few thickets here and there signal the presence of a village.

Though basically hot and humid, the climate does vary, a higher incidence of rain being found in the northwest, in the region of Duala, Bata, and Libreville; less watered zones lie in the interior valleys, and the high plateaus and mountains are often cloaked in a thick fog that dissipates only in the afternoon heat. The climate offers little seasonal change and, though favorable to a luxuriant vegetation that grows very rapidly – and sometimes to striking proportions – it is unfavorable to man, both for agriculture and for communication. The soil is of poor quality and loses its fertility only a few years after the land is cleared; rivers and hunting paths have long provided the only communication routes. Hence, in both economic activity and social structure, life-styles have remained tied to lineal family groups; other methods of social organization, such as chieftaincies or kingdoms, were unable to develop in this environment. The coastal "kingdoms" – of the Duala or the Mpongwé, for example – were in reality only large villages without extensive territories.

In sum, apart from certain coastal valleys – for example, that of the Sanaga in Cameroon, at the northern edge of the great forest, or that of the Niari in the People's Republic of Congo – this entire region is given definition by the basin and multiple branches of the Ogowe, which, before the discovery of the River Congo (Zaire), was long thought to be the route into the heart of Central Africa.

Peoples: History and Life-Styles

The history of the peoples of this part of Africa was long preserved only in the oral tradition of the *nganga*, the initiates or chiefs. It is above all a history of migrations, for all these groups were seminomadic for a long time before they reached the West

African coast and settled in specific regions. The collection and analysis of oral traditions of identifiable groups have made it possible to sketch the major outlines of this history. Likewise, the study of institutions and the (comparatively recent) study of languages have helped to reconstruct the picture of these past civilizations.

In our present state of knowledge, which is still very fragmentary, we can distinguish three main periods in the history of the Ogowe peoples. The first, a period of ancient migrations, is known only from more-or-less mythical traditions; these migrations are said to have brought some of today's peoples from central Cameroon, southern Chad, and Western Sudan, others from the Sangha and from north of the sweep of the Congo, still others from Cabinda and Angola. The second is a period of migration, probably in the sixteenth and seventeenth centuries, of Kota and Mbete (or Mbédé) groups whose origin has been traced to the Oubangui region. The third is the period of the Fang migration in the nineteenth century, which led several currents of population, in small groups, from central Cameroon to the Ogowe. These three series of migrations, which had extremely complex ramifications, brought peoples whose common origin has only recently been established to regions that were generally uninhabited, though constantly traversed by the Pygmies, the Babongo, the Bakola, the Akowa, and the Bekouk, and subsequently settled by various Akele and Okandé groups.

Although the prehistoric settlement of the Ogowe basin is gradually being uncovered, an important hiatus remains between the period of Iron Age occupation and the appearance of the peoples known today, and we cannot rule out the possibility of a slow process of osmosis, in which the "migrations" mentioned might represent only the dynamic element of new arrivals imposing themselves on a substratum of different, but autochthonous, origin. The history of contacts, conflicts, and catastrophes, and the actual texture of the life of these civilizations, can only be reconstructed by ethnology, and then only for the last period, between 1850 and 1920; later on, tradition changes much more rapidly until it is completely transformed by modern life.

The cultural kinship of the peoples of the Ogowe – and, more broadly, of those of the Atlantic Equatorial Forest, from Duala and Yaoundé in the north to Pointe Noire in the south, from the coast of Gabon to the line of the Likuala in the P. R. Congo – can be appreciated if we compare them with the peoples of neighboring areas such as western Cameroon and Adamawa, the Central African Republic, and central Zaire. But it is impossible to say whether the forest environment or a more-or-less common origin has produced this relative uniformity.

The forest villages all resemble each other. The huts, generally small and rectangular, with two-plane pitched roofs of sewn leaves, are aligned on both sides of a path (today a dirt road or highway) that widens to form the village square. In the last century these villages were fortified with stockades and rows of traps, their exits barred by "guardhouses" that served as both meeting places and living quarters for warriors (fig. 62).

On the coast, as in the interior, the forest peoples' traditional economy was strictly conditioned by the hostile environment in which they lived; it was a rural, subsistence economy in which hunting, fishing, and food gathering had a preponderant importance when compared with the agriculture that was practiced on small plots surrounding the villages. When soils were judged too infertile, wildlife too scarce, or localities too infested by evil spirits, the chief would decide to leave with all his people to resettle elsewhere, several days' walk away, where he would be accepted or could impose his presence.

Another regional constant was the presence of traditional political and social structures which function at the level of the family lineages comprising a village. These families, whose chiefs had little authority, enjoyed more or less the same social status and constituted a framework of mutual support. In such an organization kinship counted – and still counts – more than anything else. The kinship system stresses the special relationship between members of a particular generation. For example, the mother and the "aunts," the mother's sisters and cousins, are all "mothers," with the same duties and ways of behaving towards all the children of the next generation, whether their own children or their nephews and nieces. The system of descent may be matrilinear, as among the Myènè, or patrilinear, as among the Fang.

Fig. 61 Recent Fang mask reminiscent of those of the So initiation society. (Photo: M. Huet, Agence Hoa-Qui, Paris)

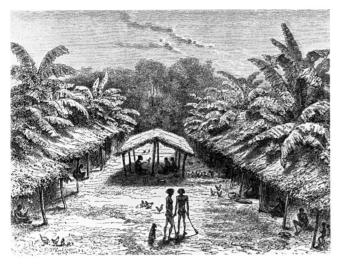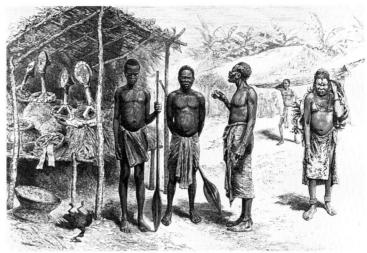

Fig. 62 Fang village of the last century, with the "palaver house" in the center (*Le Tour du Monde*, no. 2, 1878, p. 413)

Fig. 63 An open shelter housing reliquaries, seen by Brazza among the Ondumbo (Mindumu) of the Mpassa River, a tributary of the Upper Ogowe. Note the reliquary figures with small faces, similar to those found among the Sango and the Duma, who live further west. (*Le Tour du Monde*, no. 2, 1887, p. 328)

Initiation societies, which cut across family groups, bring the village's men and women together to perform rites of initiation and healing which attempt to master the forces of nature, using natural medicine, and other therapeutic methods. In central Gabon, the Bwiti society is restricted to men. Its initiations are painful, though they are eased by the use of *iboga*, a hallucinogenic plant also known today among the Tsogho, the Sango, and the Fang; in successive stages, the initiations lead to knowledge of man and the cosmos, of life and death, of reality and the supernatural, of everything important in the functioning of society. Not all the men become *povi*, or masters of the *ebandza* temple, a grade to which only a few venerable members accede; others remain ordinary initiates, *nyima-nakomvé*, and many have to content themselves with merely attending the ceremonies. Some of these societies are restricted to males, such as the Ngil and So (fig. 61) of the Fang and the Beti of Cameroon and northern Gabon, the Mwiri of the Sango and the Shira, the Mungala and the Ngoy of the Kota, and the Ndjobi of the Obamba; others, such as the Ndjembe of the Myene, the Ombwiri of the Lumbo, the Lisimbu of the Kota, are for women only.

The ritual practices of these societies – initiation, evocations to spirits, rites of healing, and so on – involve the use of symbols, often sculpted in wood, on figures, in the decorations of ritual huts, on masks, and as emblems of authority.

The family structure, which includes both the living and the dead, provides the framework for social life. Propitiation of ancestral spirits is at the center of all philosophic and religious preoccupations. In Equatorial Africa life is imbued with a sense of man's need for a constant dialog with the other world and with the deceased.

Reverence for the ancestors is evident both in the family and within the initiatory societies. Bones of the illustrious dead – chiefs, high-level initiates, women who bore many children, and others – were set aside after death, cleaned, and preserved. These relics were stored in bark boxes or woven baskets usually surmounted by one or more sculpted anthropomorphic figures (see fig. 63). These figures are among the masterpieces of African art. Byéri figures, both male and female, are found among the Fang; the Obamba created copper-plated effigies, *mbulu-ngulu*; small Mbumba busts were made by the Sango.

The sacred is everywhere, though it is often hidden beneath symbols decipherable only by the initiated. Nothing results from chance, hence everything has to be explained, good luck as well as bad, success and failure, birth and death. A huge company of shades is omnipresent in the universe of the living: domestic spirits, ancestral spirits, frightening natural monsters, discontented spirits of the recently deceased, and the spiritual counterparts of living beings. Hence the great importance, in this world, of divination, parapsychological practices, and other methods of wielding power over natural forces. Art, especially sculpture, though never perceived as "art", plays its part in this constantly regenerating mystical *élan*; it is, in fact, one of the main constituents of the symbols used everywhere to express animistic beliefs.

Southern Cameroon and Gabon

Although the delimitation of major stylistic zones is always artificial, the cultures of western Cameroon are usually grouped with the vast complex of those of southern Nigeria, those of the forests of southern Cameroon, south of the Cameroon hills, with the "Atlantic equatorial" group, and those of the right bank of the Congo with the cultures of Zaire.

The Cameroon Littoral: THE DUALA

The Duala have long been settled at the mouth of the Wouri, not far from the Cameroon hills, in a region of forests and swamps where the rains are extremely heavy almost the whole year long. Like the Grasslands peoples, they are organized in chieftaincies, but they already exhibit some characteristics of more southern peoples, among whom organization by lineage predominates, and to some of whom – the Koho and the Bassa of the lower Sanaga, for example – they are related. The fact that sculpted objects are known only among the Duala themselves does not rule out the possibility of discovering Bassa craftsmen and sculpture.

The Duala are skillful canoe paddlers, since the wide estuary of the Wouri readily lends itself to races organized during the great annual festivals. Canoes made from a single tree-trunk used to be decorated with tall figureheads, and veritable mini-epics were depicted in carved and painted wood. Also remarkable are the polychrome horned masks; they are highly stylized and decorated with geometric friezes. The art of the Cameroon littoral is still little known, both in itself and in relation to neighboring Beti styles.

118 Mask

Duala, Cameroon

Wood, black, red, and white pigment, and iron; height, 76 cm

Duala sculpture is known in the West only through the figureheads and paddles of racing canoes and a few polychrome horned masks, of which this is an especially interesting example.

The bovine theme, like that of the antelope or the horse in savanna areas, is widespread in Cameroon, especially in the grassland region of the west and northwest. Among the Duala, it is treated in a very geometric, even stylized, fashion.

Philip Fry has noted: "The painting of sculpted surfaces, in Africa, is an element of the overall conception of a work, not merely a 'decoration.'" In this dance mask, the "decoration," made up of several coats of paint over the face and horns, clearly reinforces the shapes and enhances their symbolic impact.

With respect to the conceptual treatment of volumes, the animal's head has a trapezoid shape, its very large ears at an oblique angle; this harmony of straight and oblique lines contrasts with the curve of the horns, the round eyes, and the generally circular motifs of the decorative friezes.

The precise function of these masks is not known, although they probably served to enhance the traditional chief's power and prestige. Unlike the figureheads, which are always anecdotal and realistic, the masks remain enigmatic, with a complex decoration that, as well as being aesthetic, has a symbolic meaning. L. P.

Lit.: Fry, 1970.

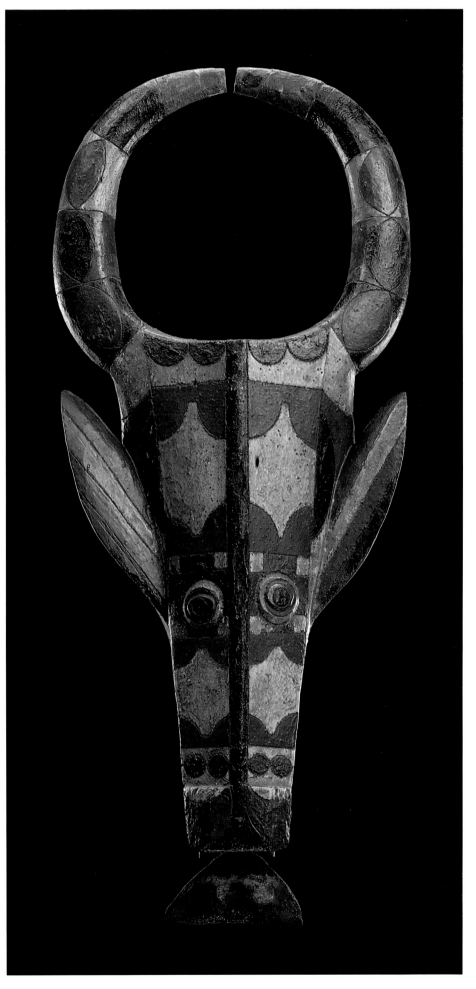

The Beti and the Fang of Southern Cameroon, Equatorial Guinea, and Gabon

The Fang comprise a number of peoples who today occupy the region between Yaoundé in Cameroon and Lambaréné in Gabon; their total number probably exceeds one million (fig. 64).

The Fang strictly speaking are only one of these peoples. The most important are: in the north, the Béti, who include the Ewondo, the Eton, and the Bané; in the Sangmélima region, the Bulu; the Ngumba around Lolodorf; the Mabéa on the coast, south of Kribi; the Mvai in the Ntem valley in both Cameroon and Gabon; the Ntumu on the right bank of the Woleu in Equatorial Guinea and around Oyem in Gabon; the Okak in southern Equatorial Guinea; the Mékény in the Médounen region of the Crystal Mountains; and, finally, the Bétsi in Gabon, between the estuary at Ndjolé on the Ogowe River, and the Nzama around the Ivindo River.

The Beti and the Bulu have produced only minor works compared to those of the southern Fang. Some groups have been "pahouinized" (the Fang were long called "Pangwe" in German, or "Pahouins" in French), like some of the Maka, who became the Ngumba and the Mabéa through assimilation; but whether the plastic styles that they have developed are more Maka or more Fang in nature is a moot point.

Given the wide dispersion of the villages, which, though now permanent fixtures, were periodically resited across the great forest for more than two centuries, these ethnic divisions, while convenient for westerners, are locally very blurred and never constituted fixed boundaries. Tribal entities intermingled to a large extent in a constant process of migration toward the southwest and the sea. Nevertheless, within each major region these ethnic poles do exist, and exhibit very specific cultural characteristics – for example, the well-documented evolution of the rituals of the So, the Melan, or the Byéri.

The Fang's principal sculptural expression takes the form of sculptures associated with propitiating ancestral spirits through the Byéri; each lineage group has one or more sculpted figures that "watch over" the relics of the deceased who are important to the group (fig. 65). Other figures, usually animals, were fashioned for

rituals like those of the So of the Beti; but these never attained the degree of perfection seen in the Byéri figures.

Fang statuary is divided into two major styles. The first, that of the northern Fang, exhibits a tendency toward elongated shapes; the second, that of the southern Fang, tends toward short, squat shapes and much heavier masses. These styles should be understood as poles of different volumetric tendencies, however, not as strict codes of practice. An abundance of transitional forms exists, corresponding to the social and cultural fluidity of these groups, who were constantly moving from place to place.

A number of substyles have been defined, corresponding to the geo-cultural situation at the end of the nineteenth century:

Northern Fang style

– Ngumba (southern Cameroon, near Lolodorf)
– Mabéa (southern Cameroon, Kribi)
– Ntumu (southern Cameroon near Ambam, northern Equatorial Guinea, northern Gabon)

Southern Fang style

– Betsi free-standing heads (valleys of the Okano, Ogowe, and Abanga)
– Nzama-Betsi (valleys of the Okano, Ogowe, and Abanga)
– Mvai (Ntem valley)
– Okak (southern Equatorial Guinea)

Statues from southern Cameroon, northern Gabon, and northeastern Equatorial Guinea can be identified by their thin and graceful trunks – often shaped like a bottle, with a prominent belly and protruding navel – to which rather skinny limbs, well set off from the body, are attached. The head is spherical, with a very broad, curved forehead jutting out above a heart-shaped face; the lines of the face, which has almost no chin, converge in a thin, unsmiling mouth. The coiffure, which is meticulously reproduced, is either helmet-shaped, with a central crest, or in vertical braids that hang down behind and on either side of the head. In the Ngumba substyle, metal – plaques usually of hammered iron, but sometimes of

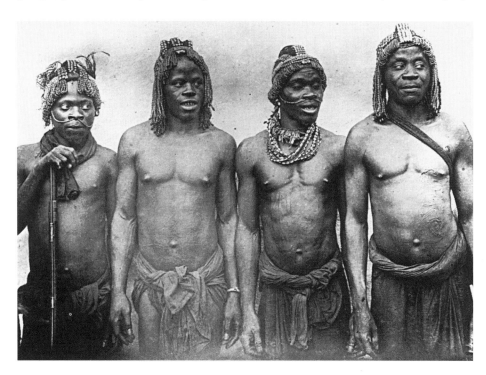

Fig. 64 Fang warriors. (Photo: Archives du Centre d'information missionaire, Paris)

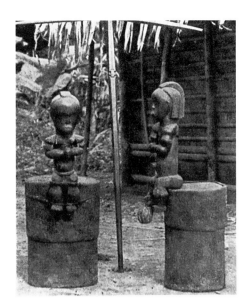

Fig. 65 Reliquary boxes containing bones of ancestors and surmounted by guardian figures in wood. (Photo: Hans Gehne, c. 1914; archives of the National Museum of African Art, Washington)

copper – is used systematically as a decorative element of the face and chest. The Ntumu substyle can be distinguished from the Ngumba by its more curvilinear masses and the satin-like quality of its surfaces, which attests to the artists' concern for finishing.

In Gabon and southern Equatorial Guinea, objects of much stockier appearance are found, figures with powerful, compact shapes, thick trunks, arms tight against the body, and massive bent legs that give an impression of monumental sturdiness. The limbs are nearly always treated in the same way, with strong, muscular reliefs indicating the biceps and calves.

Nzama-Betsi and Okak figures, with some variations in detail, contrast with Ntumu objects without being fundamentally different from them; such is also the case with Mvai figures, which are characterized by very large heads, three-crested coiffures, and bellies scarified with triangular motifs.

In an ethnomorphological study of a wide range of objects, the contrast between the northern and southern styles appears obvious, although the previous geographical/stylistic breakdown must have been quite different, depending upon the locations of the various groups in the nineteenth century. Significant variations attest to the artist's relative freedom to express a symbolic message, understood by the initiate, within a traditional framework much suppler than might have been supposed.

In addition to statuary and an abundance of furniture and furnishings – chiefs' staffs, stools, architectural elements, spoons, containers, and so on – all Fang groups have made masks, generally used in initiatory societies like the Ngil, the So, and, more recently, the Ngontang.

From objects known either in collections or through fieldwork, Fang masks may be classified schematically in four categories:

– Masks of the Ngil society: large, elongated white masks, whose drawn-out faces have a long nose and tiny mouth, attributes of the judiciaries of the Ngil, who are constantly searching for sorcerers and other social deviants to eliminate.

– Polychrome, horned masks of the So, seen by G. Tessmann in 1917 among the Ntumu of southern Cameroon; these are the oldest known Fang masks.

– White *ngon ntang* ("head of the white girl") masks: several ancient variants with only one face are known, some having been brought to Lubeck by Tessmann; others have two or, later, four faces. White is the color of the dead, and the mask represented the deceased's spirit that had returned among the living to protect them from the sorcerers' malefic acts. Today, the dance associated with this mask is no longer considered a religious ritual, having become an event of folklore.

– Finally, caricature masks. In their wild, disheveled expressionism, these masks personify a frightening character called Bikeghe or Bikereu, or sometimes Ekekek or Okukwé in the Lambaréné region. L. P.

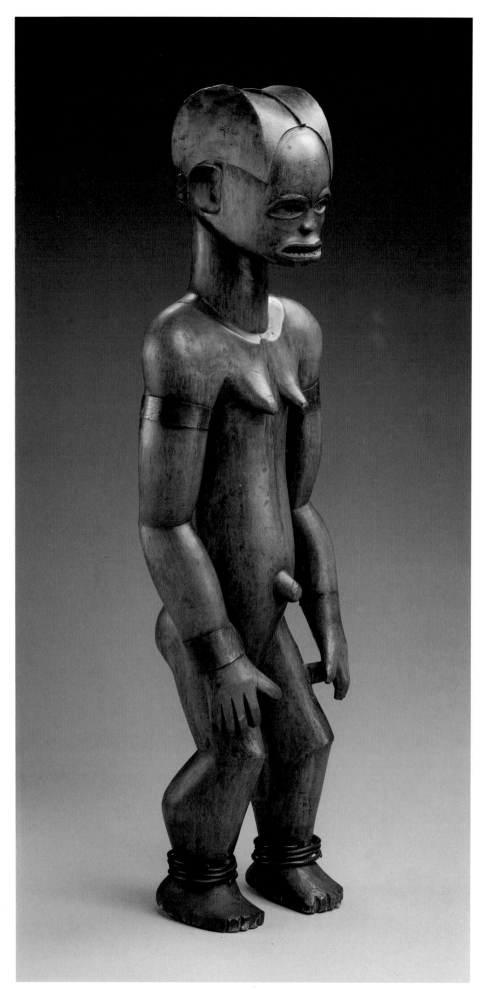

119 Reliquary Guardian Figure
(Fang) Mabéa, Cameroon

Wood, black dye, metal; height, 70 cm

The coastal peoples of southern Cameroon, Equatorial Guinea, and Gabon as far as Libreville, live within the cultural sphere of the Fang, although they are neither ethnically nor linguistically related to the Fang.

The Mabéa of Kribi, Lobé, Masuma, and Campo were originally an advance group of the Maka migration from eastern Cameroon, a migration provoked by the Baya, who were themselves displaced by the Fulani. The Fang, including the major subgroups of the Ntumu, the Mvai, the Okak, and the Betsi, arrived later, assimilating or displacing a number of settled populations, for example, the Benga, probably of Kota origin, who found themselves driven from the interior to the coast, as far as the Gabon estuary. Thus the Fang imposed their culture, their way of life, and – with greater difficulty – their languages on peoples as diverse as the Ndzem, the Ndzimu, or the Ngumba.

Given the knowledge presently available from scholarly literature, archives, and fieldwork, it is difficult to differentiate pre-existing elements (in the case of the Ngumba and the Mabéa, Maka elements) from those imported by the Fang; thus, specifically Maka, Ndzem, and Benga objects have not been identified.

The female figure of the Barbier-Mueller collection is a particularly good example of southern Cameroon sculpture of the nineteenth century, only a few pieces of which are known. It was found among the Mabéa, who had already adopted the beliefs of the Byéri cult.

The characteristics of this substyle are well-known: the patina does not ooze, and is light in color (here, reddish) in contrast to the patinas of the Ntumu and Betsi *éyéma-o-byéri* (plates 121, 122), which always are very dark brown or black; the head has reduced proportions – those of the Betsi are much larger – with the face set well forward; a helmet-shaped coiffure forms a kind of puffed-out bonnet; the domed forehead surmounts a sparsely modeled face, which features a very large mouth with visible teeth; the shoulders are treated realistically, and the shoulderblades and hollows of the collarbones are shown; the overlong arms are somewhat disproportioned, with palms turned toward the thighs; the legs have powerful thighs and calves. Arm and ankle bracelets are the sole ornaments.

Compared to Ntumu, Bulu, Okak, and – especially – Betsi objects, many of these Mabéa figures are quite large. With its mixture of idealized realism and schematism, which is also found among the Ntumu of Gabon and Equatorial Guinea, the Mabéa substyle is unique and recognizable; it has produced some of the masterpieces of the sculpture from Atlantic Equatorial Africa. L. P.

120 Head

(Fang) Nzama-Betsi, Gabon

Wood, brass nails; height, 36 cm

The chronological and stylistic precedence of Fang heads over the busts and figures has not been demonstrated. This type of object is found more in northern Gabon than elsewhere, in an area where full figures were also found. Both themes – isolated heads and entire figures – probably existed side by side, at least in the nineteenth century.

This particular head is crowned by a helmet-shaped coiffure of hanging braids (*bikoma*), and is considerably flattened at the back. The face itself is rather convex, almost heart-shaped, with a broad domed forehead; its axis is emphasized by the long, thin nose (like those on Fang masks) above the small, unsmiling mouth typical of this style.

Although the typified face framed by the two lateral braids, with its eyes of shiny metal nails, is made to be seen from the front, it can also be viewed from the back, where the care taken in the decorative treatment of the coiffure is obvious. The tuft of feathers – generally black or dark blue eagle or touraco feathers – is missing, with only the hole where it was attached to recall its original presence.

The wood, which is dense and very dark, exudes a resinous and sticky black liquid that gives a particular brilliance to the forehead and mouth.

Freestanding heads, like statues both large and small, were exhibited during initiations and propitiatory rituals of the Byéri cult. Apart from these occasions, reliquaries and sculptures were kept hidden. L. P.

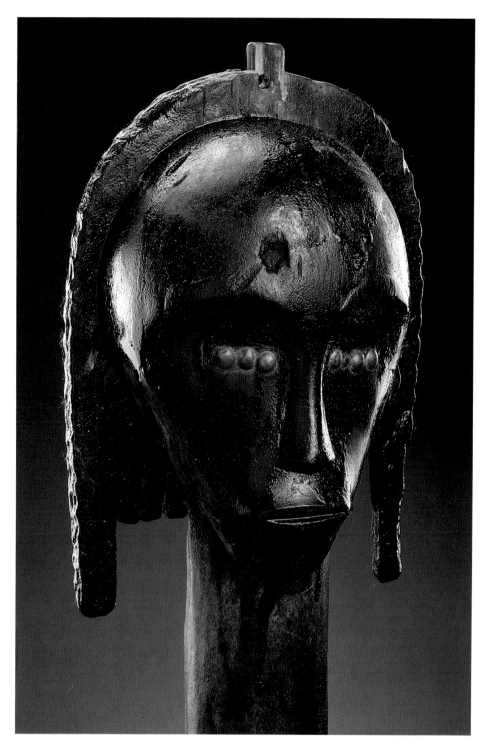

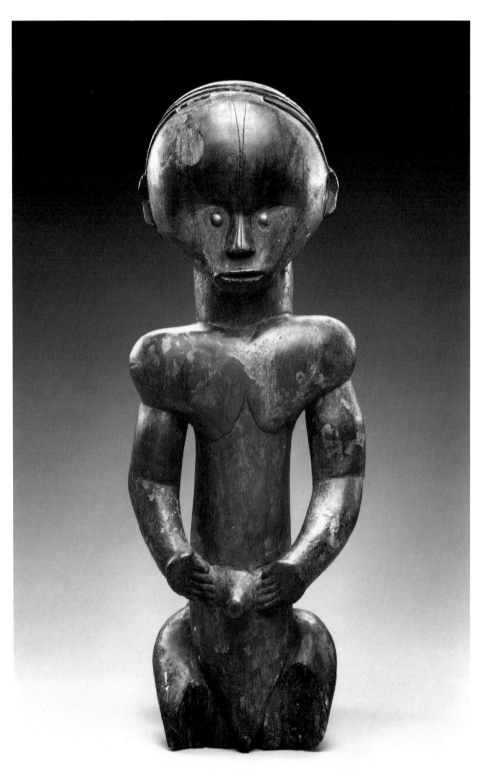

121 Reliquary Guardian Figure
(Fang) Ntumu, Gabon

Medium-weight wood, light patina (legs broken off);
height, 44 cm

This figure, missing its legs, is an *éyéma-o-byéri*, a ritual figure. In ancestor-worship, it served both as guardian of the important relics of the lineage (it was originally attached to the cover of a reliquary box) and as a symbolic substitute for skulls during propitiatory and initiatory ceremonies.

The beautifully treated head is almost spherical, with a prominent forehead and a braidless coiffure in the shape of a skullcap, rare in works of this style. Powerful shoulders and arms with well-defined musculature in the most classical Fang style contrast with the cylindrical trunk, also typical of the style.

These figures are ritual objects and have only a very relative value in relation to the relics, as can be seen clearly in photographs taken by Tessmann in 1907. The statues can be discerned lying in the dust, while skulls are reverently held up and named for the neophytes. After about 1910, the rituals of the Byéri (also called Mélan) cult were gradually abandoned in their original form, being replaced by other practices less frowned upon by the authorities. The syncretic Bwiti cult, which appeared a few decades later, has retained many of the symbolic elements of the Byéri that had adopted a more admissible form of traditional therapy. L. P.

Lit.: Tessmann, 1913, II, fig. 47.

122 Reliquary Guardian Figure

(Fang) Ntumu, Gabon

Wood; height, 54 cm

The Ntumu are the most important Fang group in a region that includes southern Cameroon, the continental part of Equatorial Guinea, and northern Gabon as far as the Ogowe.

The Ntumu substyle is chiefly characterized by elongation (sometimes truly extraordinary) of the shapes of the body, more or less accentuated by the proportions adopted, and by the treatment of the head, which has a hollowed face and protruding mouth.

In all Fang substyles, arms and legs are represented in the same way, the muscles always appearing fleshy and tensed. The posture of the body, especially of the legs, expresses a restrained but constant tension.

Here, the head is a remarkable interlacing of curves and straight lines, spherical surfaces contrasting with angular projections and reliefs with hollows. The symmetry, precise enough to be measured with geometric instruments (though the sculptor employed only his eyes and hands), demonstrates the artist's perfect mastery of both the material to be formed and the tools used – ax, knife, adze, and abrasive paper.

A small number of decorative motifs accentuate the edge of the helmet-shaped coiffure across the upper forehead and form a crescent-shaped line between the cheeks and the ears (the crescent is found frequently among the Ntumu Fang).

The absence of metallic decoration (except for the eyes) in this region is worth noting, since such decoration is the rule a little further north, in southern Cameroon. In contrast, all objects of the Byéri cult were decorated with necklaces, small chains, and, especially, feathers; a large tuft of feathers usually crowned the coiffure, attached by osier strips through a hole pierced in the central crest. Most objects brought back from Africa have lost these accessories, which were important decorative and symbolic elements in their original context. L. P.

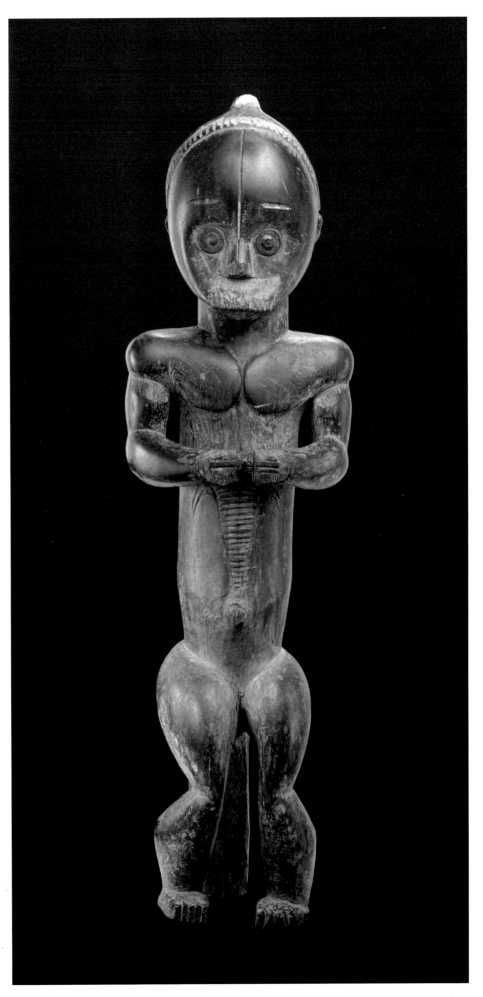

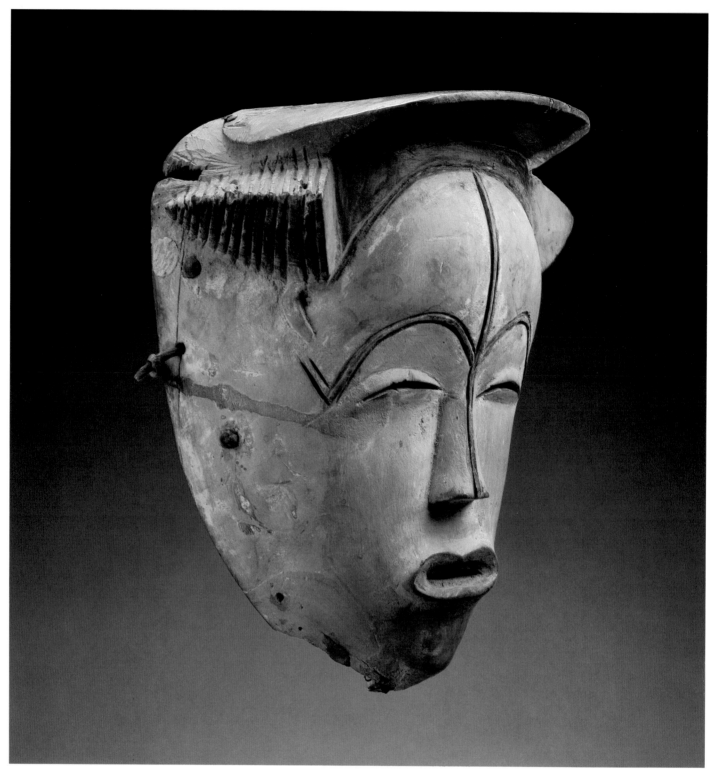

123 Mask

Fang, Equatorial Guinea/Gabon

Wood, kaolin; height, 24 cm

This mask can be identified as Fang, even though its design and certain details, especially the cap-shaped coiffure, the B-form mouth, and the slit eyes with arched lids, suggest an object from the Ngounie River region (Punu-Lumbo).

In fact, the mask must be viewed in three-quarter or full profile to appreciate the typically Fang morphology in the sinuous curve of the face and the thin, elongated nose and unsmiling lips. The coiffure recalls styles observed by nineteenth-century travelers both among the Ntumu of Equatorial Guinea and among the Betsi of Gabon. The Fang identification is decisively reinforced by the pyrograved scarifica-tions on the forehead and nose, and the vertical axis that transects the double arc of the eye-brows and appears black against the face whit-ened with kaolin.

This object provides a good illustration of the stylistic complexity of African art, in which in-fluences of other cultures can often be discerned within a collection of work that otherwise seems coherent. L. P.

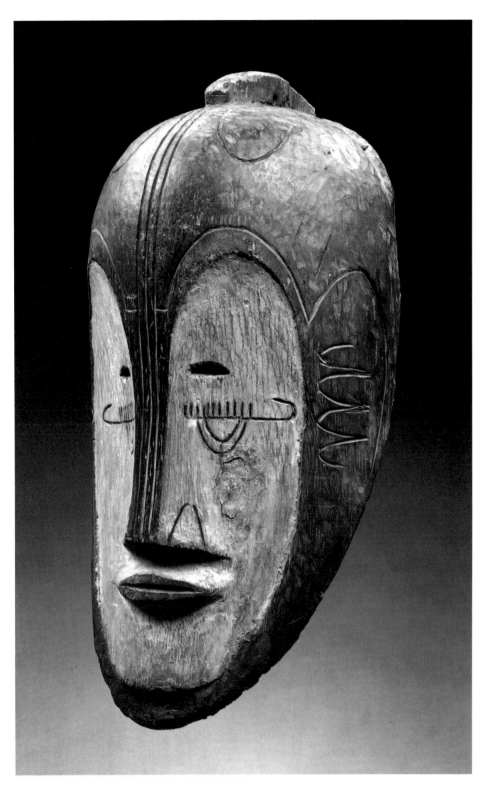

124 Ngil Mask

Fang, Gabon or Equatorial Guinea

Wood, kaolin; height, 44 cm

Ngil masks are among the most prestigious of African art works, even though little information is available about the few known pieces. The occasional descriptions of Ngil rituals (Tessmann, 1913; Okah, 1965) are generally silent about the appearance and precise role of wooden masks in ceremonies linked with initiation or with the restoration of the social order.

Ngil masks have a shape unlike those of the Ngontang masks and the former probably pre-

date the latter. The face is very elongated, with a domed forehead that is sometimes extended into a kind of skullcap shaped helmet, which allows the dancer to set the mask on his head. The long, narrow heart-shaped face has two eye-holes separated by a very long, narrow nose, and a tiny mouth with protruding unsmiling lips.

There are variations on this theme. Here, the mouth is located just below the nose, on a flat area forming the chin and shortening the usual perspective. The pyrograved scarifications below the eyes and on the temples recall motifs recorded by Tessmann among the Ntumu and the Mvai in 1907.

Masks of this ancient form have not been used since the beginning of the twentieth century; they have been replaced by other styles derived from them, like the Ekekek (bogeyman) and, to some extent, the Bikeghe. In all these styles, the use of the color white is noteworthy, a color that, in these regions, expresses the power of the spirits of the dead. L. P.

Lit.: Tessmann, 1913.

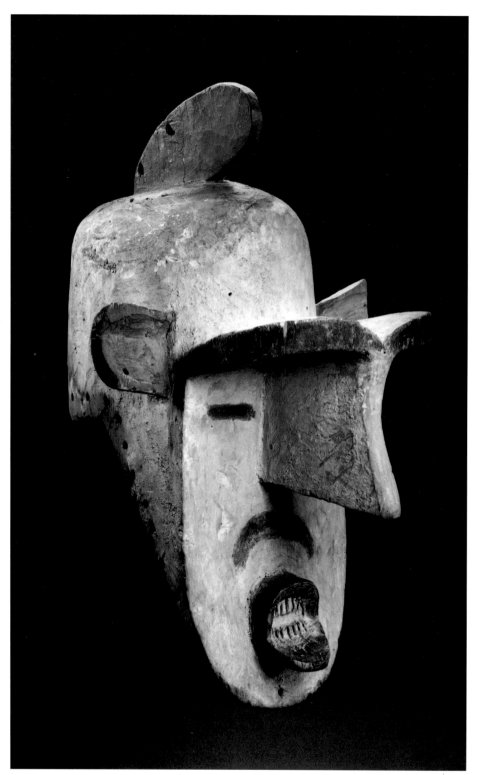

125 Bikeghe Mask

Fang, Gabon

Wood, kaolin and black paint; height, 53 cm

The Bikeghe or Bikereu mask, as it exists today in Gabon, particularly in the mid-Ogowe region, is a form derived from the Fang initiation masks seen by G. Tessmann about 1907 in Ntumu country. Through a progressive modification in the treatment of anatomical details, the morphological characteristics of the So and Ngil masks have evolved sometimes to the point of caricature, in a context of constant social and religious change.

The Bikeghe is both a human and an animal spirit. Here, a gorilla's sagittal crest, a white man's nose and moustache, and the big lips and toothy mouth of a malevolent being are all recognizable. The contrast should be noted between the serene aspect of "classical" Fang statuary, in which the attitudes represented are always very restrained, and that of masks that obviously seek to create an effect. Masks of the latter type have faces intended to inspire terror, or at least respect.

Sometimes attributed to the Aduma of the Ogowe because of the shape of its nose and its overhanging forehead, this mask is an intermediary type between those of the ancient cultures of central Gabon and those of the more recent Fang civilization. It is used today to enliven events that have no religious significance.

L. P.

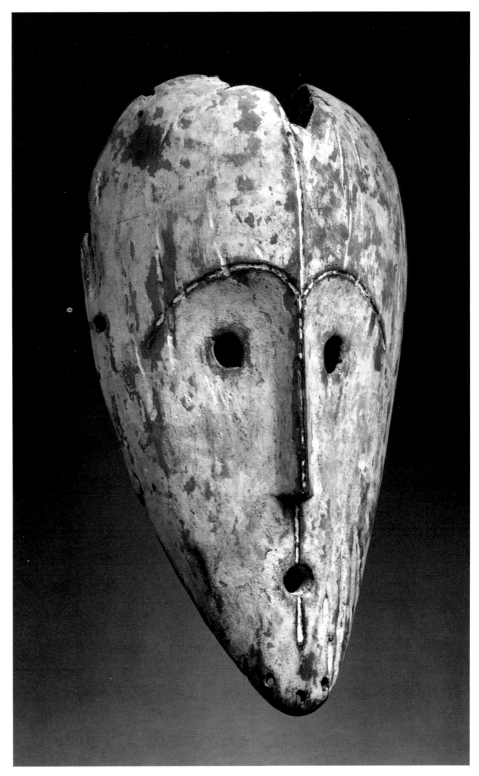

126 Mask

(Fang) Betsi (?), Gabon

Wood, kaolin, and white paint; height, 31 cm

Owing to its small size, and despite its elongated shape, this mask can provisionally be considered a variant of the *ngontang* mask, with features of the older *ngil* mask. It may reasonably be assumed, by analogy with similar masks collected in the 1920s in the Abanga and Okano region north of the bend of the Ogowe, that this specimen is of Betsi provenance.

The curved forehead and the slightly concave face are in the Fang style, as is the scarification that runs continuously along the forehead, nose, and lower part of the face and chin. In contrast, the eyes and the mouth are treated in an unusual fashion as simple round holes. L. P.

The Kwele

The Kwele of the upper Ivindo, about whom relatively little is known, live in the area around Mékambo. Like the neighboring Mahongwé, the Kwele live along both sides of the border between Gabon and the People's Republic of the Congo. These two groups, like the Obamba and the Kota, are thought to have come long ago from the northeast, having migrated southward from the Sangha basin in present-day Cameroon.

The rare masks that the Kwele have produced are reproductions of human and animal faces, very often heart-shaped. Other, helmet-shaped masks greatly resemble the *emboli* of the Kota. The Kwele share masks of this type with the Mahongwe, among whom the mask represents an owl. A. M. V.

Lit.: Siroto, 1969 and 1979.

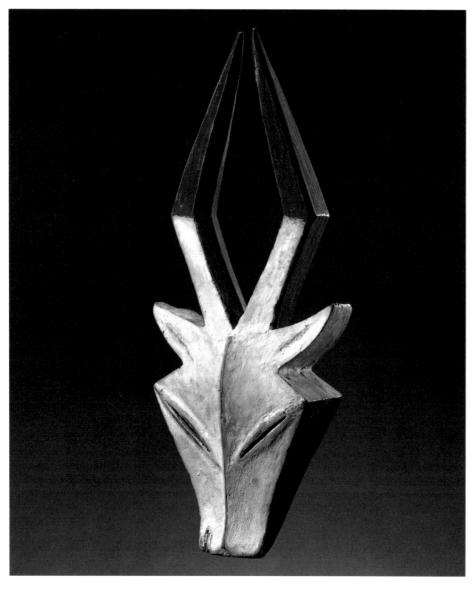

127 Mask
Kwele, Gabon

Wood, kaolin, and black paint; height, 38 cm

Compared with Fang, Punu-Lumbo, or Kota art, few objects of Kwele production are known. These are principally "masks" in the form of wooden face masks, most of which have never been used in dances, either because they were intended for another use or because the real masks have been kept hidden from overly curious whites. The Kwele produce several types of masks with vertical horns (or, at least, only slightly curved horns, in contrast to the masks with large, arched horns that sometimes completely surround the face). They are probably associated with animistic rituals invoking spirits of the forest. Little is known about Kwele beliefs; but these masks immediately bring to mind certain horned Fang masks of the So ritual that figure in initiations in nearby southern Cameroon; they are also reminiscent of Kota and Tsogho masks, also horned, found in Gabon.

This small example is of very high plastic quality, both in the great sensitivity displayed in the sculpting of the volumes and in the finishing of the surfaces. Angular (unlike a very rounded mask of the same type in the British Museum), yet delicately modeled, this refined work is organized obliquely on either side of a carefully controlled central axis.

Particularly when the mask is seen in three-quarters or in full profile, the rhythm of the planes, the curves, and the expanses of color – the white being heightened by the black – demonstrate the mastery of an artist in full possession of his creative means; with what are known to have been very limited tools, he has produced a work of outstanding quality. L. P.

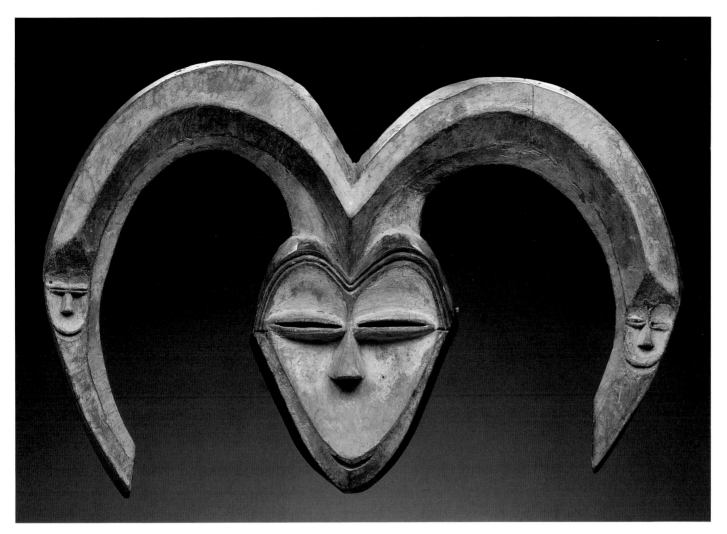

128 Mask with Curved Horns
Kwele, Gabon

Wood, kaolin, and black paint; height, 62.5 cm

This object was brought to Europe in the 1930s by the colonial administrator A. Courtois. It is similar in many respects to the large mask with a W-shaped headdress in the museum of La Rochelle in France.

The face, in the concave heart shape characteristic of the style, is flanked by two miniature faces in the same style, carved in the curved horns. The mask as a whole constitutes a remarkable harmony of curves broken only by the horizontal axis of the three pairs of eyes. Animal masks with antelope faces are familiar among the Kwele, but horned human faces have a different meaning, not yet fully understood. Almost nothing is known about the role of these masks, not even whether they actually danced or, since most do not have pierced eyes, served instead as emblematic representations and were displayed during certain ceremonies. The latter possibility does not appear to have been the case with this mask, which does have eyeholes, though it lacks holes for attaching the small raffia collar that is common to all the masks of the region. R. Lehnhard, who recently visited Souanké in Kwele country, told me that the only known contemporary uses of "masks" are their appearances in the initiation ceremonies for young people and at the conclusion of mourning. The objects are explained to the neophytes but do not act as dance masks properly speaking – a situation that corresponds to what I found in the Madjingo region of Gabon, north of Mékambo. L. P.

The Kota and the Obamba of Eastern Gabon

Schematically, the peoples of the Ivindo and the upper Ogowe are divided into three groups: the Kota proper, the Mbédé-Obamba, and the Duma-Ndjabi. Though of different linguistic origins, these three groups share certain cultural traditions.

The complex history of the region may essentially be summarized in the earlier migration of the Kota, spreading as far as the Congo (the Ndassa and the Wumbu) and leaving behind the Mahongwé, and the later Mbédé-Obamba migration, which was located further east and cut across the path of Kota migration at the level of Okondja, on the Sébé. Since the end of the seventeenth century, these various movements have complicated the ethnic map of Gabon and the northwestern Congo Republic, where the same groups are found.

The sculptures of these ethnic groups, which include figures that watch over reliquary baskets containing the bones of deceased ancestors, have been well known and appreciated since the beginnings of European interest in African art (fig. 66).

The sculptures, which are always anthropomorphic, have one face, with motif decorations in relief on the back, or two faces, especially in the Obamba substyle. The Mahongwé and Shamaye figures always have only one face, of a markedly ogival shape, very slightly concave, and decorated with horizontally applied, absolutely contiguous brass wires; the only anatomical details are the eyes and nose.

The extraordinary diversity of known objects from the Ivindo basin and the upper valley of the Ogowe bears witness to the boundless imagination of Kota artists, even though their range of expression has been limited to the ancestor figures that guard the family reliquaries. Unlike neighboring regions, for example, the Cameroon Grasslands, where ritual accoutrements of various kinds are found, these reliquary figures constitute practically the exclusive repertoire of symbols for ceremonial practices.

Morphological analysis of the many Kota sculptures has led to their classification in seven distinct categories that differ in terms of shape, though stylistic affinities may sometimes be seen across these divisions (fig. 67).

Categories I and II, in both of which large and small figures are found, are the Mahongwé and Shamaye Bwété, with brass strips.

Category III, a transitional shape, presents an oval face decorated with brass wires stapled horizontally, as in the north, but also has a transversal, crescent-shaped headdress as found to the south.

Category IV is the most "classical" and corresponds to Obamba production. Figures of this group are called Mbulu-Ngulu.

Categories V and VI, with or without crests, feature strongly curvilinear forms. The faces may be quite convex and realistic.

Finally, category VII is reminiscent of the Sango Mbumba, with a small, narrow face and a skull carved in the round.

Some unusual sculptures, completely authentic though rare, are busts with stylized arms in a lozenge pattern. Though they sometimes lack the brass decoration, they have completely "Kota" heads, with transversal crescent-shaped crests, lateral "helmet" coiffure with vertical pendants, protruding foreheads, etc. L. P.

Fig. 66 Reliquary boxes and baskets containing skulls of ancestors. The baskets (*mbulu*) are surmounted by wooden figures (*ngulu*) covered with sheets of copper. (Photo: From *Le Tour du Monde*, no. 2, 1888, p. 50)

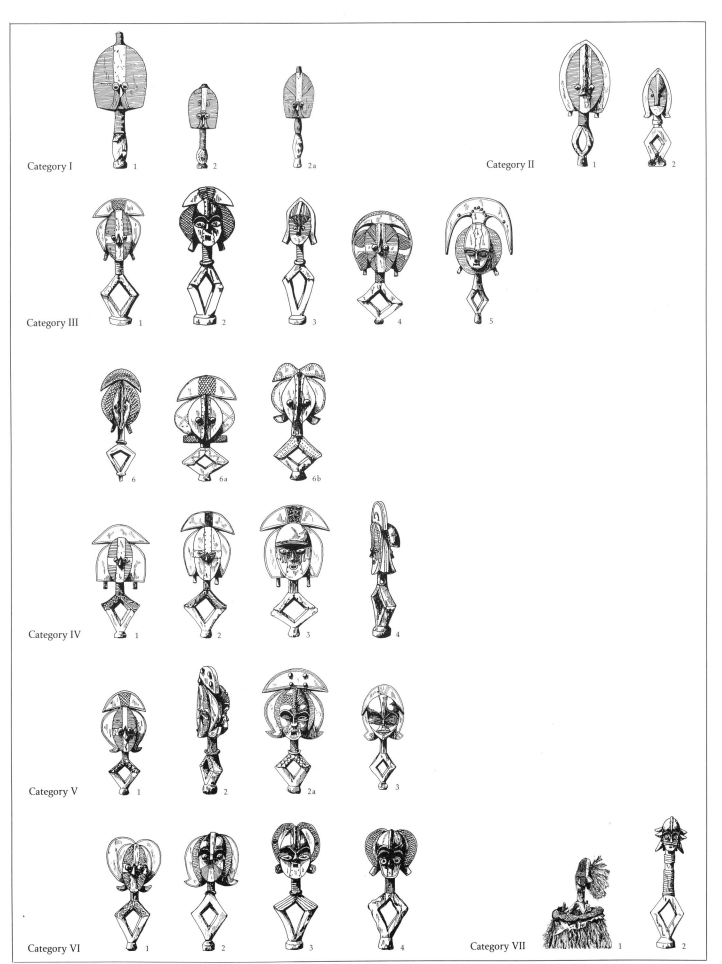

Category I 1 2 2a Category II 1 2

Category III 1 2 3 4 5

6 6a 6b

Category IV 1 2 3 4

Category V 1 2 2a 3

Category VI 1 2 3 4 Category VII 1 2

Fig. 67 Table of Kota styles by Domenico Terrana and Louis Perrois. (From Perrois, 1985, p. 51)

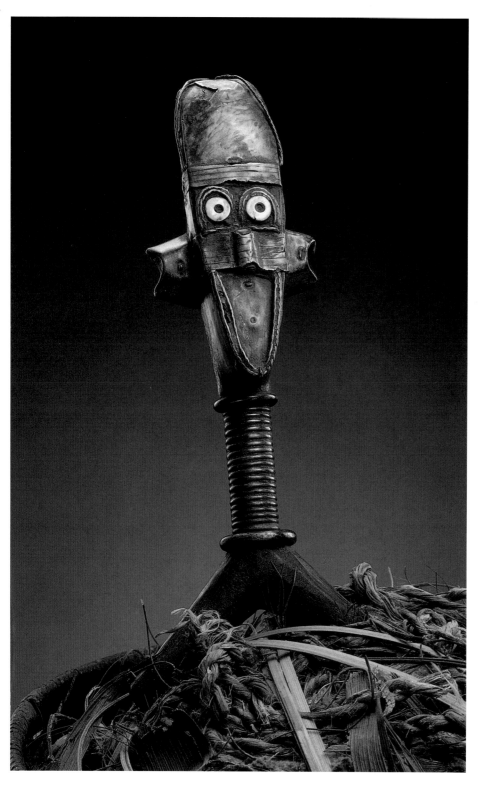

Sango *Mbumba* like this one are intermediary expressions between the sculptures of the central and littoral regions of Gabon, painted figures marked generally by an idealized realism, and the "Kota" styles of the Gabon-Congo region (Obamba, Mbédé, Ndassa, Wumbu, Shamaye, Mahongwé), an area of fully brass-plated, more or less abstract figures.

An examination of some reliquary baskets has shown that along with the pieces of skull, both large and small, they contained a range of small objects of a symbolic or specifically magical value – shells, cowries, dried plants, bones of animals such as rodents, and snakes.

The rituals associated with the *Mbumba* consisted of propitiatory offerings intended to appease the lineage's dead, who might still pose a danger to the living. The skulls were taken out of the baskets during initiations of young people, exhibited and identified before being anointed with sacrificial blood (usually of chickens). L. P.

129 Reliquary Basket, with *Mbumba* Figure

Sango, Gabon

Wood, brass strips, basket containing fragments of human skulls; height, 48 cm

Among the Sango and the Duma, as among the Tsogho, reliquary baskets are named *Mbumba*. The sculpted figure varies in appearance, being more or less stylized, from one area to another. It is treated more in the round by the Tsogho and other groups of the upper Ngounie; it is completely abstract in the area of the bend of the

Ogowe, around Lastoursville, where stylistic links with the Kota are obvious, for example, in the lozenge-shaped, brass decorations.

Here, the figure's face, neck, and "arms" are treated in a far from true-to-life fashion. The relative proximity of more naturalistic Tsogho, Ndjabi, and Tsangui styles underlines the extent to which Sango artists have developed their own ideas for objects having similar functions. The same tendency is seen in the regions immediately to the northeast, where Shaké, Shamaye, and Mahongwé sculptors have come up with some remarkable stylistic innovations.

130 Mbulu-Ngulu Reliquary Figure

Kota-Obamba, Gabon

Wood, copper, and brass; height, 41 cm

From its shape, decoration, style, and patina, this figure can be assigned to the Obamba/Mindumu substyle of the upper Ogowe, and probably dates from the nineteenth century.

Seen from the front, the silhouette is completely characteristic of a known stylistic variant (Perrois, 1985, Category V, variant 3; see fig. 67, p. 209), the typical features of which are: a narrow and curved transversal crest; a curved lateral headdress slightly flared at the ends; a convex-concave face with contrasting volumetric effect between the plain, domed forehead and the double hollow of the eye sockets; the sockets themselves originate directly at the bridge of the nose, suggesting a kind of mask through which large round eyes are peering; the mouth seems more like a gash across the bottom of the face than an anatomical attribute.

The creator of this figure was certainly an inspired sculptor and a master of his materials, as manifested by the rhythm and harmony of the volumes, the subtle dynamic of planes, elevations, and hollows, delimited by interlaced curves articulated along either vertical or horizontal rectilinear axes.

The decorative motifs employed are very simple: a double line of dots along the entire length of the headdress, reinforced by a third line at the lower ends; a diadem-shaped band framing the forehead, decorated with cuboid ornaments decreasing in size toward the temples. A large lozenge in low relief figures on the completely flat back, the center of which is pierced by several holes that probably held tufts of feathers, as is the case with all Gabon reliquaries. (These feathers were removed by whoever found the statue in the field or by collectors later, to make it "neater" and/or to avoid lending it an often insufficiently understood "ethnographic" value.)

This object can be located within a stylistic dynamic if we accept the theory that the curved lateral headdress with end flares is an evolution from the cylindrical, oblique pendants found on objects from the valley of the Sébé, a little further north. L. P.

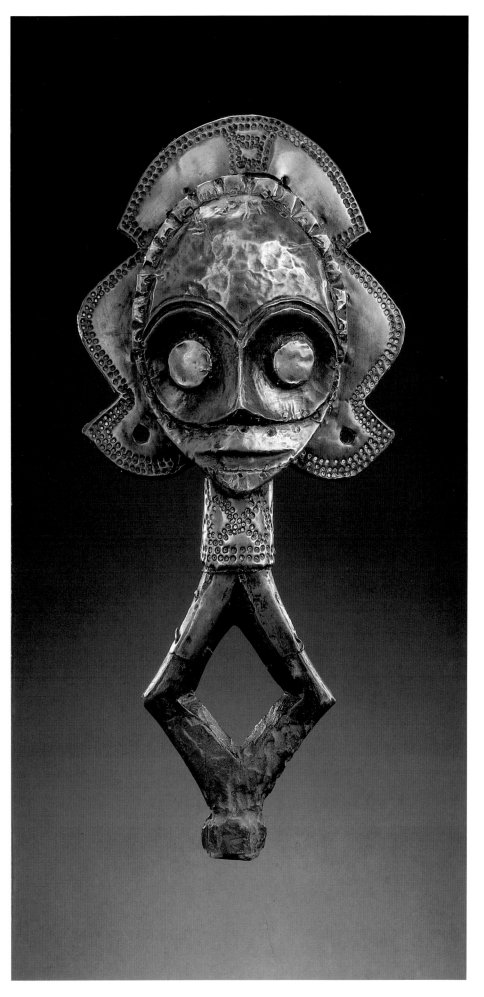

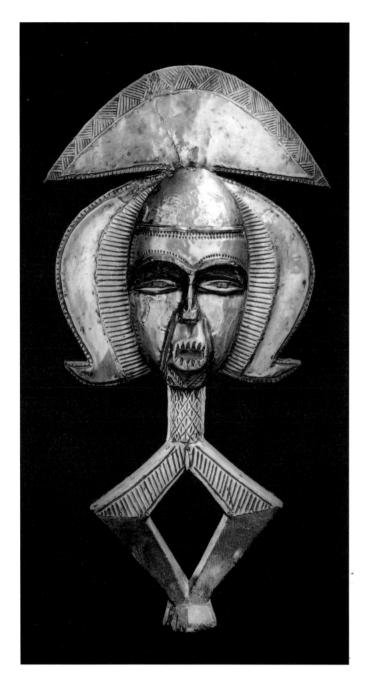

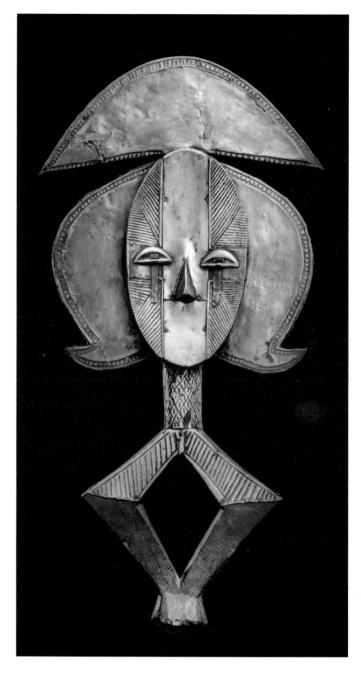

131 Janus-faced Mbulu-Ngulu Reliquary Figure

Kota (Ndassa-Wumbu), Gabon

Wood, copper, iron, and brass; height, 54 cm

Janiform representations are not unusual in Kota art, especially in the styles found in the south, among the Ndassa and the Wumbu of northwestern Congo.

The meaning of this double face remains enigmatic. Elsewhere, for example, among the Fang, multiplication of faces and eyes indicates that the mask is especially clairvoyant, that nothing escapes it, particularly in the domain of witchcraft.

Here, the two opposed faces are treated plastically in different ways. One is realistic and convex, with a domed forehead, a prominent nose, and a half-open mouth revealing pointed teeth; the other is schematized and concave, its only anatomical details being the eyes and the nose, which is tetrahedral. It has been suggested that the concave/convex opposition of faces may correspond to sexual differentiation; this remains hypothesis, however, since no reliable information has been found on the subject.

Stylistically, this object can be attributed to the Ndassa or Wumbu of southern Kota. It exhibits the characteristic large transversal crest and the curved lateral headdress with flared ends. The decorative patterns are meticulously carved both front and back, particularly along the top edge of the crest; large areas are left plain both on the headdress and on the face itself. The iron strips should also be noted; although suggestive of metallic "tears," they are more likely to represent scarifications that emphasize the penetrating quality of the figure's gaze. L. P.

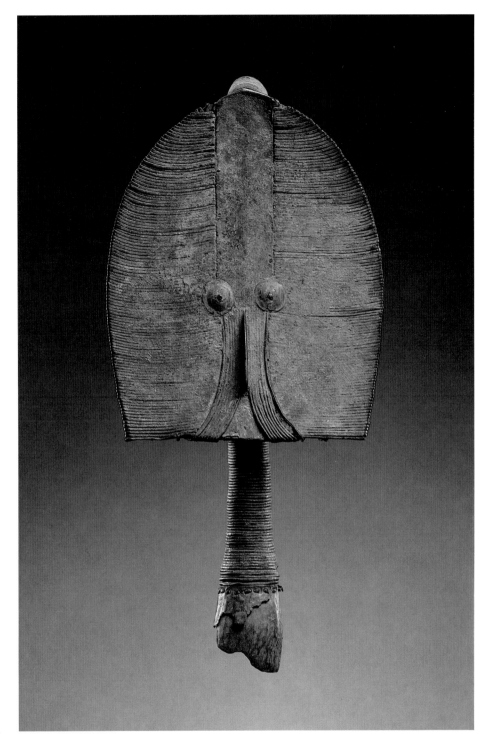

132 Bwété Reliquary Figure

Kota-Mahongwé, Gabon

Wood, brass; height, 38 cm

Because of their abstraction – often pushed to the limits of anthropomorphic form – reliquary figures of the Kota-Mahongwé of the Ivindo basin and the neighboring areas of the Congo Republic have fascinated admirers of African art ever since the early twentieth century. This interest also accounts for the innumerable fakes of Bwété figures that have been made, sometimes very skillfully. Indeed, authentic objects, like the one presented here, which are recognized as such by collectors and by the Gabonese who once used them, are very rare.

In Makokou, Mékambo, Kellé, and some other localities, these figures have always been known. They were – and are – considered dangerous to handle, because of their role in ancient funeral rites, even though these rites have completely disappeared today as a result of the socioreligious changes – some spontaneous, others provoked from the outside – of the last sixty years.

The figure shown here, like many of the most beautiful known pieces in this style, has an "excavation patina," which probably results from its having been hidden during a period of more than usually acute missionary activity, when figures were put in a clandestine burial place outside the village to save them from destruction, usually by fire. Europeans were not the only iconoclasts during these troubled times. Adherents of the syncretic, anti-witchcraft cult known as the *Mademoiselle* also went through the villages rooting out traditions that they considered bad, including everything associated with the Bwété, in both Gabon and the Congo.

The reliquary baskets, sometimes very large, contained the bones of the important dead of the lineage. They were surmounted by sculpted figures attached with fiber strips. During propitiatory or initiatory rituals, the skulls were taken out of the baskets, anointed with various substances of a symbolic or magical character, and exhibited before the neophytes. The sculptures themselves might be jiggled about like puppets to heighten the effect.

The Kota-Mahongwé carved two types of Bwété sculptures. The large type have ogival faces with eyes located more or less half way up; the small figures have generally reduced proportions and a more elaborate decoration, with eyes placed very low. The large figures represent the founding fathers, while the small ones depict less important individuals; all the sculptures had specific names, known to the whole village.

In areas of contact between ethnic groups, figures with strips in the Mahongwé style and plated figures in the Obamba or Sango styles were found in the same villages, as can be seen in illustrations in the review *Le Tour du Monde* of 1888. L. P.

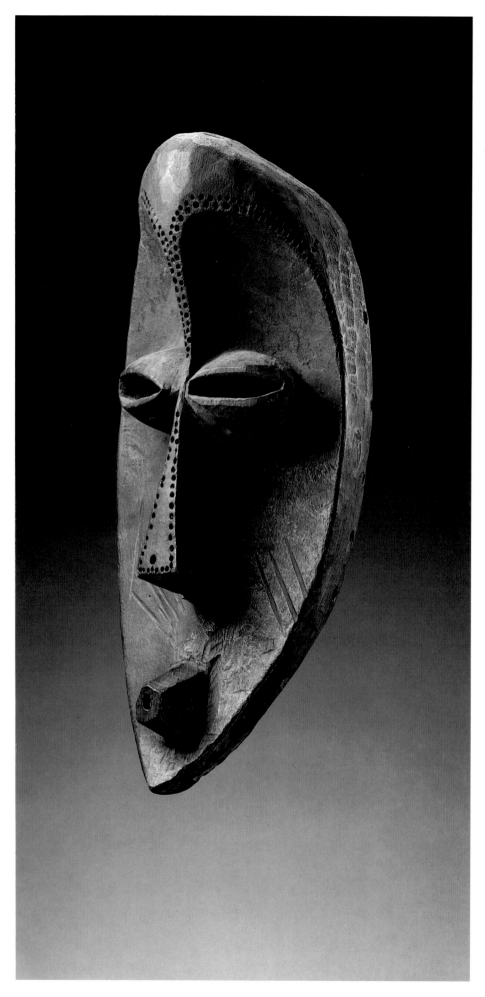

133 Mask

Mahongwé or *Ngare* (?), People's Republic of Congo

Wood. The face of this mask was formerly covered with a red mineral pigment; height, 35.5 cm

This mask, today a classic of African art, is believed to have been collected by the administrator A. Courtois in the village of Etoumbi, a small settlement located on the upper Likuala in northwestern Congo, between the more important localities of Makua and Kéllé. This is a region of mixed ethnic groups, including some Mboko, some Ngaré, and a few Mahongwé groups related to those in Gabon, further west.

A few other masks of the same style are known, notably one in the Brooklyn Museum; their origins, however, are unclear. And no mask – except for recent copies – is really similar to the famous one presented here.

Jean Laude relates that, according to Alfred Barr, former director of the Museum of Modern Art in New York, an Itumba mask of this style is supposed to have inspired Picasso in 1907 when he painted the famous *Demoiselles d'Avignon*. ("Itumba" is, according to Charles Ratton, a misspelling of "Etoumbi.") Picasso's face "with the wedge-shaped nose" would thus be one of the first examples of the "black" impact on modern European art. William Rubin has now established that "black art" had not yet influenced Picasso when he painted the *Demoiselles*; furthermore, this mask did not arrive in France until 1930. The Laude/Barr hypothesis is no longer supported today.

From a morphological point of view, the concave, heart-shaped face, the prominent, almond-shaped eyes, and the protruding nose recall the style of certain *mbulu* masks of the Ivindo Kota. The elongated form is akin to reliquary figures of the Shamaye, the southern neighbors of the Mahongwé.

Though it is now generally accepted that this series of masks belongs to Kota culture, our present state of knowledge does not permit us to attribute them to one or other of the several groups in the area – the Mboko, the Ngaré (related to the Mbochi and the Kuyu), or the Mahongwé proper. Thus it remains impossible to define these objects stylistically and historically, even though, as they stand, they are among the most remarkable works of the area.

L. P.

The Tsogho, Sango, and Ndjabi of Central Gabon

The sculpture of the coastal area and that of central Gabon are related to each other, though each has its own specific forms.

Because of the continuing great vitality of the Bwiti cult, the Tsogho/Sango stylistic homeland is the last in the region still to resist the influences of modern life. A male initiatory society, the Bwiti requires a full panoply of symbolic material for its rituals, from the architectural elements of the assembly hut (*ébandza*) – small columns, altars, central posts – to furnishings, statuary, and a wide variety of masks, most of them little known in the West (fig. 68).

The variety of Tsogho shapes contrasts sharply with the homogeneity of other mask styles of the Shira-Punu-Lumbo area. Tsogho statuary is characterized especially by the treatment of head and face, and also by the style of the shoulders and arms. Sango forms (except those of the Mbumba) are very similar. The double arch of the eyebrows, resting upon a small, flat, triangular nose, takes the form of an omega that emphasizes the slanted, almond-shaped eyes. The face is generally triangular and sometimes, especially on the panels of Bwiti altars, becomes a totally geometric decorative motif.

Only a few years ago, the Sango and the Vuvi still had magnificent doors on their huts, sculpted with symbolic motifs in low relief.

The Ndjabi mainly produce masks, both of the *okuyi* type and, more commonly, of the polychrome *mvudi* type that are found throughout the entire region, as far as the Téké plateaus to the east. L. P.

Fig. 68 Mbumba-Bwiti reliquaries of the Sango of central Gabon. (Photo: Monseigneur Augouard, c. 1900/10)

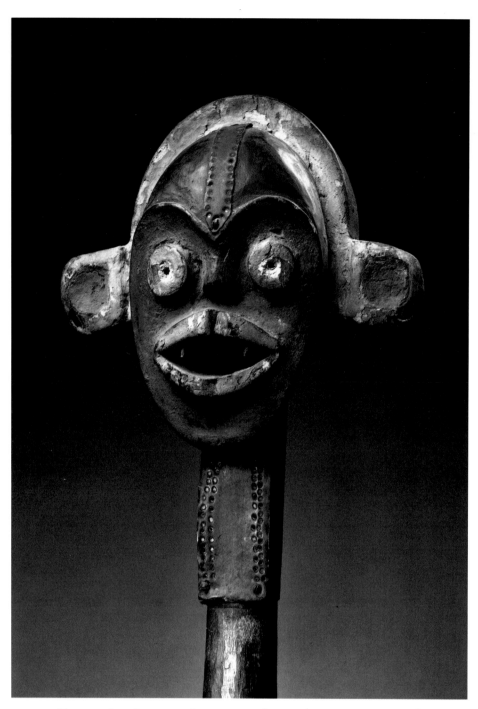

headdress is treated at the back in a streamlined style suggestive of Sango style. Thus, this sculpture is obviously close to Sango-Duma or even Kota forms.

Mombé ancestor worship is part of the rituals associated with the Bwiti, which itself involves a full range of socio-religious beliefs and practices specific to central Gabon and has given rise to a well-defined social hierarchy and to initiations, rites, therapies, and complex myths.

For almost a half-century, the Tsogho and Sango Bwiti has been spreading toward the coast and the mid-Ogowe region, where the Fang, among others, have adopted it, transforming it through the integration of elements of the *mé-lan* and the Byéri and of imported cultures such as Christianity, Freemasonry, colonial administration, and so forth.

Tsogho masks are still used in many traditional demonstrations, but the Mbumba ancestor figures have now practically disappeared.

L. P.

Lit.: Gollnhofer et al., 1975; Perrois, 1985, no. 30, p. 204.

134 Head from a *Mbumba Bwiti* Reliquary
Tsogho, Gabon

Wood, red, black, and white (mineral pigments), metallic decoration; height, 36.8 cm

The anthropomorphic statues that surmounted the reliquary baskets (*Mbumba Bwiti*) found in most populations of southern and central Gabon can be classified in several types. They may appear as busts or, like this one, as heads alone on a long neck; this latter type is found frequently among the Sango and the Duma and occasionally among the Tsogho. On the western edge of the area in which the Kota and Mbédé cultures are dominant, Sango sculptures are usually (though not always) completely covered with brass strips, and Tsogho heads are painted. Among the Tsogho, the decorative use of metal plate – brass or, more rarely, iron – on wooden

sculpture is discreet, even exceptional, except on the *Mbumba*, where a decoration on the forehead may complement the ocher coloring of the face. Some heads are carved in the round with ample volume; others are treated in a more schematic fashion, as here.

A number of formal details of other provenance are found in this object, which is probably Tsogho. The concave-convex volume of the face, created by the domed forehead and hollowed lower part, recalls the neighboring styles of the Kota of the upper Ogowe. The eyes, usually slanted and almond-shaped, are here round, like those of the reliquary figure in Plate 130; the neck, often cylindrical, is here rectangular, and decorated with a metal plaque. The ears stick out markedly on each side of the head, as on many figures of the region; the large, half-open mouth has pointed teeth and thick lips; the

135 Figure

Tsogho, Gabon

Wood, red, black, and white polychrome, cloth;
height, 53.4 cm

Ghéonga figures are very numerous in Tsogho
country. As I found while doing research in the
Mimongo region in 1970, it is not at all uncom-
mon for five or ten of them to be stored in an
ébandza (in the sacristy, not in the main area,
where nothing is kept between celebrations).

These figures are commemorative representa-
tions possessing little, if any, sacred character;
they may acquire prophylactic power if a magi-
cal medicinal "charge" is imparted to them.
Many figures are hastily sculpted and are often
poorly finished.

Both in its general form and in its details, this
specimen is particularly well executed. The
trunk is typically Tsogho in treatment, with the
shoulders slightly raised and pushed back to give
an air of tension to the chest. The upper arms
are longer than the forearms, which are held
away from the body and over the front of the
belly, with the hands closed in a ritual gesture.
Both belly and navel are prominent, but the
breasts, with darkened nipples, are hardly out-
lined.

The figure is painted ocher, with just a few
touches of white kaolin and black to bring out
important details – hands, breasts, eyes, and
coiffure.

The treatment of the head is quite original.
The long face with its half-open mouth has a
tense expression; the black pupils of the
almond-shaped eyes seem to leap out from the
white background of the iris; above the large,
rimmed ears the hair is stylized in flattened,
black and white braids. In sum, this is a very
classical Tsogho object of unusually strong
sculptural refinement. L. P.

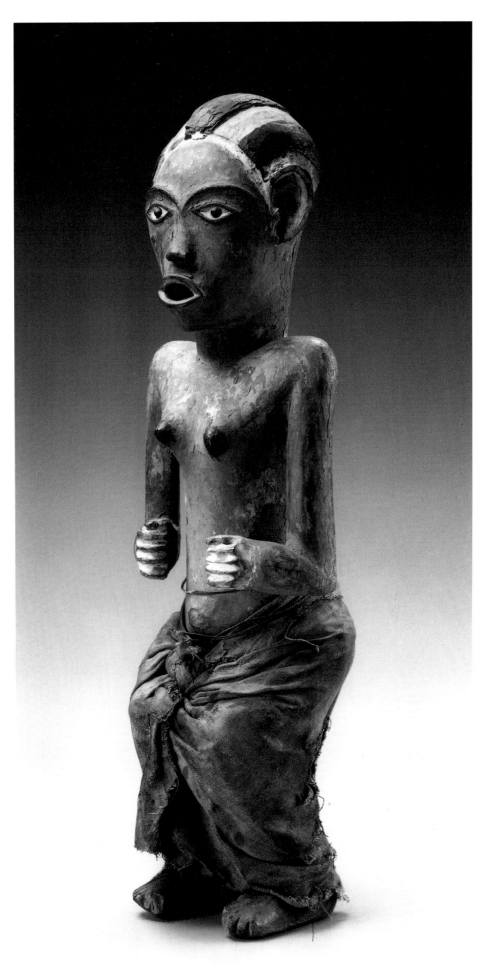

From the Myènè to the Shira-Punu-Lumbo of Southwestern Gabon

What is known of the Myènè may be reduced essentially to the Okukwé masks of the Galoa, from the lake district of the lower Ogowe (fig. 69).

A misunderstanding about "Mpongwé" masks should be cleared up. These white masks, which originated in the Ngounie region, were made by the Shira, the Punu, and the Lumbo, but they were long attributed to the Mpongwé, even though this group has not made masks for over a century and a half. The error in identification stemmed from the fact that the first of these "white" masks were bought by Mpongwé traders, who then took pains not to reveal where they had come from.

The sculpture of southern Gabon is rich in different forms, from the now lost and forgotten Shira memorial effigies to Punu propitiatory statues and the power figures of the Lumbo and the Vili. The crafting of utility articles is also well developed among these populations, and white masks are a specialty.

All these objects are highly refined, sometimes to the point of mannerism, with delicately-featured faces and carefully polished and painted surfaces. These peoples obviously possess a sure taste for beauty, even in utility articles. This taste is likewise attested to by the various women's hairstyles, which are replicated in the wooden coiffures of the masks.

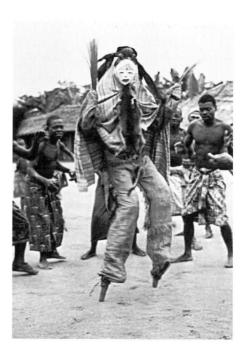

Fig. 70 Dance of the Okuyi mask among the Punu. The dancer is on stilts. (Photo: M. Huet, Agence Hoa-Qui, Paris)

The forms of mask show evidence of reciprocal influence. Thus, the stylistic homeland of what are termed the "white masks of the Ogowe" starts in the Lambaréné region in the north, where the Galoa, the Enenga, the Djumba, the Pindji, and the Iuli of Lake Zilé are found; they spread to the Congo Republic in the south, encompassing the Lumbo, the Vili of the Kwilu, the Punu, and the Tsangui; and toward the east and interior, among the Tsogho, the Sango, the Ndjabi, the Tsangui, and the Vuvi, and even to the Wumbu, who are of Kota origin. Vili polychrome masks, very realistic in treatment, are probably also linked to this group.

The oldest known white masks are in fact curiously two-colored, with an ocher forehead and a white face; they are also characterized by visor-shaped coiffures. Another, equally old type has a chin-strap in the collar that serves as a kind of handle. However, the most common white masks have faces surmounted by coiffures in the form of buns, generally a high, central bun with small, lateral braids; several variants of this mask are known (fig. 70).

Both Ndjabi and Tsangui objects are easily recognizable. Those of the Ndjabi have reduced proportions, coiffures with a split bun, mouths with thick lips, streamlined chins. Tsangui faces have horizontal scarifications. Among the Vuvi, the face is simplified to the point of becoming no more than a flattened oval. L. P.

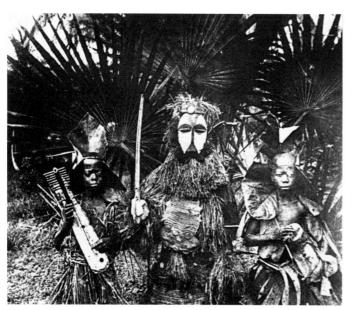

Fig. 69 Okukwé masks of the Galoa of the Lambaréné region (Photo: Father Trilles, 1903)

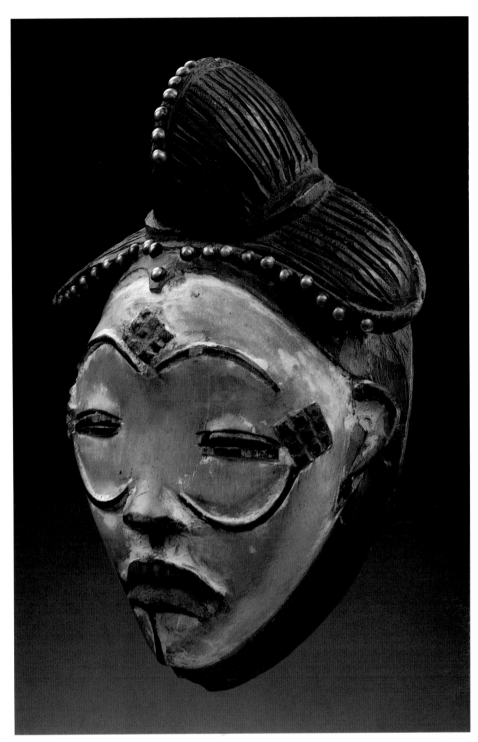

136 Mask
Tsangui, Gabon

Wood, black and red pigment, brass nails;
height, 30 cm

Tsangui forms can be recognized, firstly, by a particular articulation of facial volumes – the broad forehead standing out above a rather small face that ends in a streamlined chin – and, secondly, by a highly typical decorative motif of horizonal polychrome scarifications on the forehead and cheeks. As in all styles, variations are found but nevertheless, nearly all Tsangui masks correspond more or less to this pattern.

This object represents a transition between the styles of the Shira-Punu-Lumbo of the littoral and those of the interior. Generally Punu in form, the face is made up of three elements: the narrow forehead surmounted by a saucer coiffure with a braided bun along the crown; a large mouth in strong relief, with lips that curve downward over the smooth chin; and, between these two poles, the slightly convex eyes with lids in low relief, are delimited by the double curve of the eyebrows and the inverted geometric motif in the form of curved scarifications running across the cheekbones.

Both the diamond shaped scarification patterns on the forehead and temples and the coiffure with central bun and lateral braids, are typical of Punu-Lumbo practices. The articulation of the volumes of the coiffure is handled with great elegance; and, as is generally the case in Kota areas further to the east, it is decorated along the edges with a row of round-headed brass nails. Seen either from the front or in profile, this mask is remarkable for its interplay of curves and fine symmetry.

It should be kept in mind that these objects, here viewed under spotlights, were never seen this way in their original locale. The Okuyi mask is worn by a stilt-dancer and is almost hidden beneath a mass of cloth and raffia. It embodies the spirit of a dead person and appears chiefly during mourning ceremonies, often in the dim light of dawn or dusk. This may explain why the face always presents a fixed expression of sad, austere serenity, despite the kaolin-painted, idealized beauty. L. P.

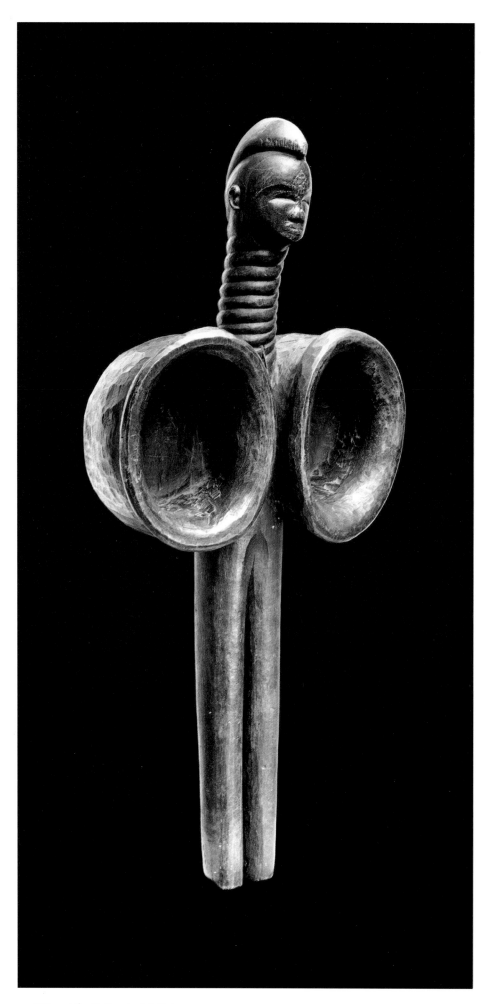

137 Forge Bellows, with Anthropomorphic Figure

Shira-Punu, Gabon

Wood; height, 62 cm

Quite a number of forge bellows from Gabon are known, but on the decorative level few have the plastic quality of this one, which is a veritable work of art. The bellows had considerable cultural importance, since it was both a tool of trade and a symbolic figurative sculpture. Objects of this type are found among the Fang of northern Gabon as well as in the Shira-Punu-Tsogho area of the southern Ogowe.

Among the Tsogho, the bellows – called *okuka*[1] – are part of the ritual of the Bwiti. During the initiation of young people, the *évovi* explain to the neophytes that the bellows are both woman – since the hole through which air is drawn in is a vulva from which life emerges – and man – since the two skin-covered chambers are testicles and the tip is a penis. A similar symbolism is found among the Shira-Punu-Lumbo, from whom this specimen probably comes.

It is carved from hardwood, and has acquired a dark, glossy patina through extensive use. The sculpted head decorating the end of the bellows is in the Punu style, with a caterpillar coiffure, a domed forehead ornamented with the characteristic motif of nine lozenge-shaped scales, and delicately arched eyes. The neck, like some chiefs' staffs, has spirals around it, a motif common throughout this region.

The bellows are everywhere made by men, who keep them out of the view of women and children. Indeed, a sexual emphasis can be seen in all the activities associated with the mining and working of iron in Gabon: the smiths' prolonged periods of sexual abstinence; assistance from prepubescent boys; use of "medicines" of female origin; symbolic figures of an obviously sexual significance, and so on. L. P.

1 The forge bellows are named *nkom* among the Fang, *okumba* among the Teke, *iguwa* among the Myènè, *loba* among the Ndjabi.

Lit.: Collomb, 1977; Perrois, 1985, no. 28, p. 200.

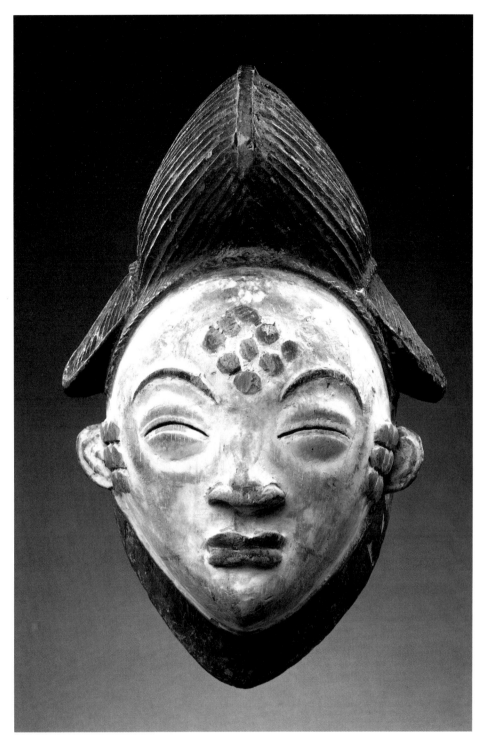

138 Okuyi Mask

Punu-Lumbo, Gabon

Wood, kaolin; height, 28 cm

We may use the term "classic" for the white masks of the Ngounie River region, if what is understood thereby is developed art form in which technical quality, rationality, and harmony are allied. From this perspective, the present specimen is an illustration of one of the classic styles of black African art.

It should be noted that the equilibrium of forms is not the same in all the varieties of white masks (so called from the white background decoration on their faces): forehead, coiffures, and face never have the same relative proportions. Here, there was some concern for realism on the part of the artist, who, while wanting to represent a female figure, also wanted to idealize her. The coiffure is very wide, with large central bun that contrasts with the small lateral braids. The broad face, with prominent cheekbones, is proportioned to the domed forehead, and all the other anatomical details are distributed regularly over the entire facial surface. The coffee-bean eyes are finely incised between opposed curves, the nose is rimmed on the sides, and the relatively small mouth has lips carved in heavy relief. The ears stand out clearly on the sides of the head, and the red coloring of the scale-shaped scarifications on the forehead and temples is striking.

It is not entirely certain that masks with these scale-like scarifications are always female, since information on this subject varies. The dance, of course, is restricted to men, although the village public may watch it without difficulty at more or less close range.

The hairstyles of the Okuyi masks recall the way Galoa, Shira, and Punu women did their hair at the beginning of the century. The central bun was a montage of braided hair over fiber stuffing. Here, thin lateral braids and a plaited transverse band across the top of the forehead are to be seen. In the nineteenth century, the art of hairdressing was highly developed throughout this region. Some of its multiple variations are known through the sketches of travelers, who were all surprised at the elegance of these hairstyles, often complemented with necklaces, small chains, and decorated wooden combs.

The sculpture of the Punu and the Lumbo reflects a constant concern for beauty and balance, elements sought after both on the level of volumetric structure and anatomical detail. The artist seems to have learned patterns first, and to have expressed himself through a range of predetermined forms; yet he also seems on occasion – as here – to have transcended the stereotypes through his perfect mastery of techniques and material. Imagination and spontaneity are not often evident in works of this style, and the touches of refinement usually strike us as artificial.

L. P.

The Kuyu

Living isolated on a plateau crossed by the Kuyu River, a tributary of the Likuala, the Kuyu are related to the Mbochi and their neighbors the Makua.

Their best-known sculptures are puppet-type heads that are used like certain dance headdresses of the Cross River region and are brought out during ceremonies called *ebokita*.

Much rarer are complete human figures, particularly those in the form of "mother and child" (fig. 71); their relationship to the *ebokita* dances is not certain. A. M. V.

Fig. 71 Marionette worn by a dancer at an *ebokita* ceremony.
(Photo: M. Huet, Agence Hao-Qui, Paris)

139 Figure
Kuyu, Lower Congo

Wood and pigment; height, 67 cm

This sculpture of a standing woman with small figure attached is a culturally puzzling, though visually eloquent, piece. The two prevalent colors of its polychrome, ocher and white, stand for the leopard in the attire of Kuyu male and female leopard associations. The blue, distributed in smaller touches on the carving, also occurs in Kuyu color schemes, although information on its symbolism is not available. The almost cylindrical shape of the figure may well refer to visual correspondences between canoe, coffin, drum, and snake, all of which are employed in one way or another in initiation and burial ceremonies of the leopard and snake associations. These elitist lodges controlled society on the eastern and western banks of the Kuyu River to such an extent that, in the colonial period, they were blamed for terrorism. Nevertheless, the sculpture can be convincingly associated neither with these associations' rituals as recorded, nor with any facet of the theme of female-genetrix social continuity, since Kuyu society and its associations follow the father's line.

The rendering of the limbs is subordinated to the roundness of the figure's torso: the legs reiterate the basic cylinder, and the plasticity of the arms is kept to a minimum so as not to interfere with this underlying form. The representation of space apparent in the small figure attached to the female torso – it offers simultaneous front and side views – and its low relief also conform to the overall shape. Z. V.

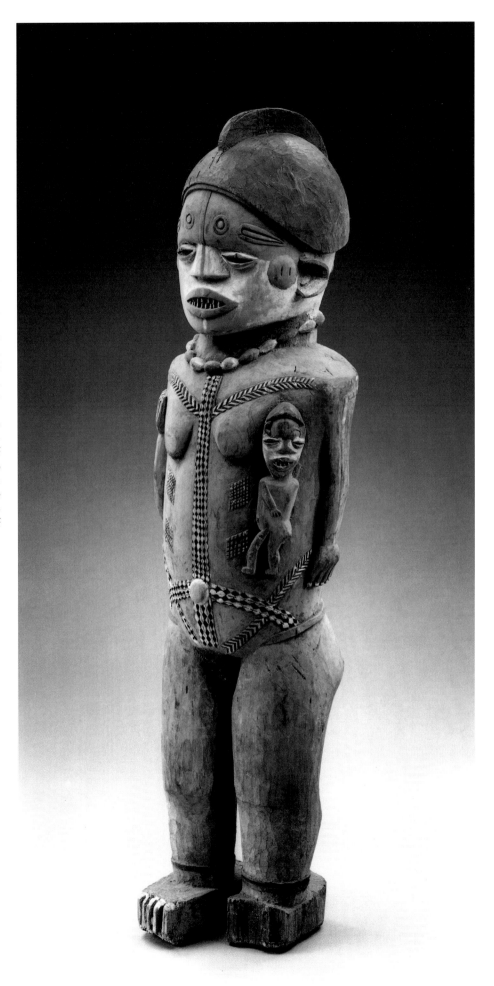

The Teke

Having long ago arrived from the north, the Teke occupy a vast area stretching from Malebo Pool (formerly Stanley Pool), the great basin formed by the Zaire River, to the border of Gabon.

The eastern Teke, also called Tsaayi, live near the source of the Ogowe; they alone use masks. Inhabitants of the savannas, they are fundamentally different from such forest peoples as the Chamba and from the various Kota groups, such as the Ndassa and the Wumbu. The latter group settled quite recently among the Tsaayi, as a result of a progressive movement toward the south subsequently encouraged by the French colonial administration.

It is possible that the round *kidumu* mask (fig. 72) is a two-dimensional version of Kota reliquary heads, whose domed foreheads protrude over a somewhat concave face. In any case, it bears no stylistic relationship to the art of other Teke groups who have no contact with the Gabonese peoples of the Upper Ogowe.

A. M. V.

Lit.: Dupré, 1968.

Fig. 72 *Kidumu* mask of the Tsaayi. (Photo: M. C. Dupré)

140 Mask
Teke-Tsaayi, Lower Congo
(Upper Ogowe area)

Wood; height, 34 cm

Of all Teke masks, the one in the Barbier-Mueller collection is – along with the one in the Museum of Ethnography in Stockholm – the only example of an almost perfectly symmetrical composition. Corresponding motifs appear on both sides of the central line that divides the two equal halves. An approximation of a nose surmounts the lower half, which is recessed. Two slits pierced on either side of the nose allow the dancer to see. The outer edge, also recessed, is pierced by a number of holes that were used to attach a decoration of feathers and raffia fibers that concealed the dancer's head. Unlike masks brought to Europe before 1920 (including the one in Stockholm and one belonging to the painter and sculptor Isaac Pallès), this mask has not deteriorated and was probably acquired while it was still in use.

The date and place of acquisition are unknown. The painter André Derain was its first European owner. In the great upsurge of new creation that followed the independence of the Congo, related *kidumu* masks again appeared in Teke country among the Tsaayi; many of these resemble the mask in the Musée de l'Homme and the one belonging to Pallès. Yet, despite a number of photographs and sketches that circu-

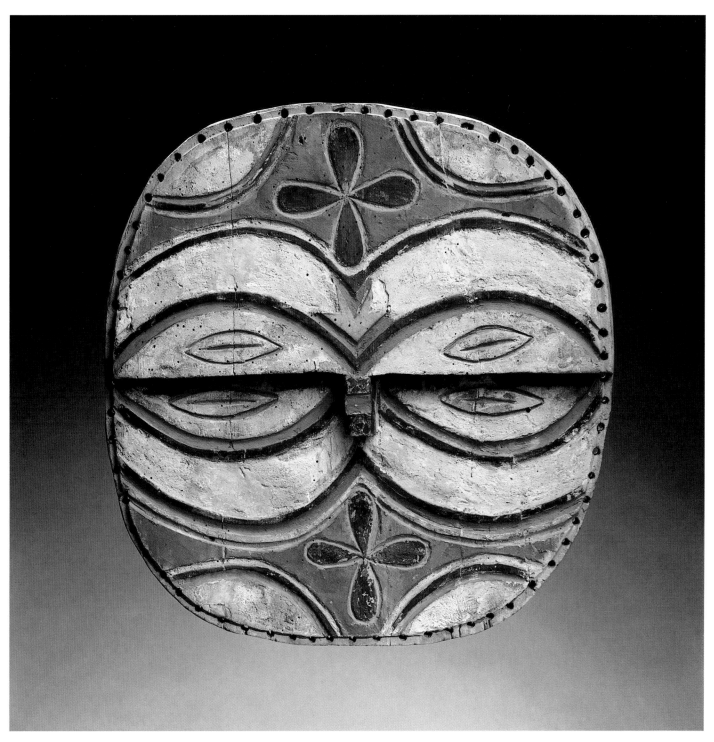

lated among sculptors, masks like this one – with its symmetry and its motif in the shape of a four-petaled rosette – did not reappear, and it is unlikely that it came from Tsaayi country.

Still, it is very close to the Tsaayi style. Firstly, because no similar mask exists anywhere in central Africa; and then because certain of its particularities are found, here and there, on *kidumu* masks. Localization of examples having points of resemblance with this one suggests that, like the Stockholm mask, it came from the region extending more than 200 kilometers south of Tsaayi country. It still cannot be positively affirmed, however, that it belongs to the *kidumu* family or has the same political uses or symbolic signifcance.

Kidumu was "invented" in northwestern Tsaayi country. Toward the middle of the nineteenth century, the master metallurgist of the region sent a young relative south, with two balls of raw iron to pay for his apprenticeship. On his return, the young man sculpted his first mask from memory. A rapid diffusion of masks followed, accompanied by successive modifications. Through these modifications, it is possible to trace the gradually changing rules of graphic syntax, right up to new creations that followed the country's independence.

The motif of a four-petaled rosette is never used in Tsaayi masks. However, on masks of an early type, a motif of four triangles joined at their apexes and surrounded by two concentric circles is found at the same spot on the lower half of the mask. This motif, called either the python or the centipede, may indicate the rotating movement that is an important part of *kidumu* demonstrations. The arrow pointing toward the nose seems to date from after the purchase of the mask, when splits in the wood had to be painted over. The large white areas, which emphasize the ellipse of the "eyes," also conceal incisions in the wood that were differently colored originally. The whole question is very problematical, since the object arrived in Europe without collection information.

M. C. D.

Lit.: Dupré, 1984.

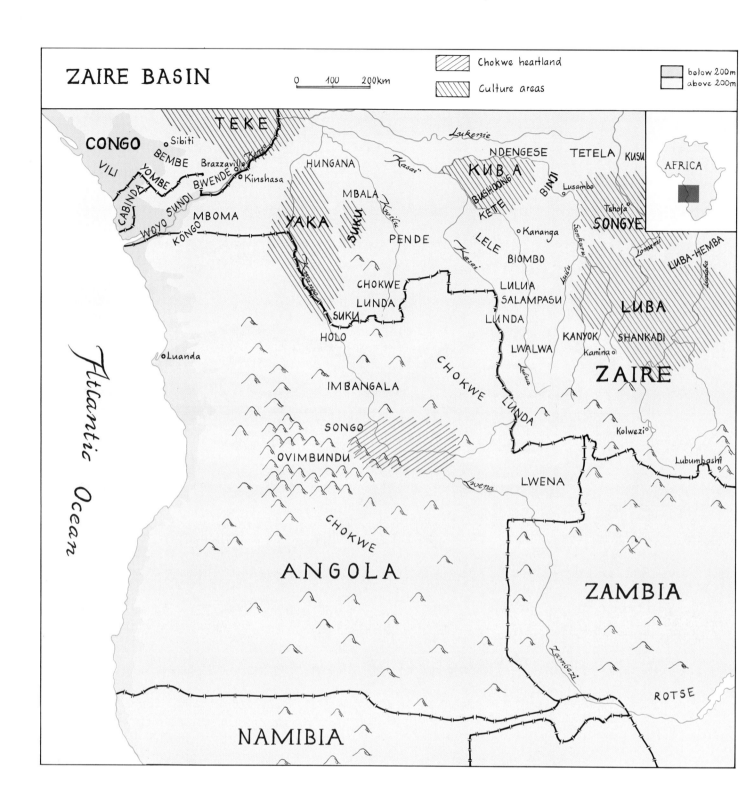

ZAIRE BASIN

0 100 200km

Chokwe heartland

Culture areas

below 200m
above 200m

AFRICA

CONGO

TEKE

VILI

BEMBE

o Sibiti

Brazzaville

Kasai

HUNGANA

Lukenie

NDENGESE TETELA KUSU

KUBA

Lusambo

BUSHOONG

KETE

BINJI

SONGYE

Tshofa o

YOMBE

CABINDA

BWENDE

Kinshasa

WOYO SUNDI

MBOMA

KONGO

YAKA

MBALA

SUKU

PENDE

Kwilu

Kasai

LELE

o Kananga

BIOMBO

LUBA-HEMBA

Lomami

CHOKWE

LUNDA

SUKU

HOLO

LULUA

SALAMPASU

LUNDA

LUBA

Lubilo

Sankuru

LWALWA

KANYOK

SHANKADI

Kamina o

o Luanda

Atlantic Ocean

IMBANGALA

SONGO

OVIMBUNDU

CHOKWE

LUNDA

Luba

CHOKWE

ZAIRE

Kolwezi o

o Lubumbashi

Lwena

LWENA

ANGOLA

ZAMBIA

Zambezi

ROTSE

NAMIBIA

François Neyt

The Zaire Basin

At the very heart of the African continent lies a vast geographic depression, an area of some 750,000 square kilometers that has, through its flora and fauna, exerted a great influence on the lives of the peoples who inhabit the region, their cultural identities, and the artistic forms which they create to express their beliefs. This formidable forest domain is surrounded by the plains of the Uele, the Kasai, and the Shaba that rise in the north and south. In the east, forestial growth is punctuated by mountains and great lakes. On the edges of the swamps and marshy areas grow all manner of fungi, bushes, and medicinal plants, which are assiduously gathered by the Pygmies and such clearing-dwellers as the Lega of the Elila Lulinda region. Gigantic trees strain toward the sun, marvelous signs of living energy and permanence, their branches alive with the cries of playful monkeys and the varied song of brilliantly colored birds.

A majestic, powerful, life-giving river, the Zaire (Congo), encloses within a mighty curve an area of some 3,684,000 square kilometers. One third of its course lies in the Northern Hemisphere, two thirds in the Southern; its catchment area extends from the wooded savannas inhabited by the Luba and the Luba-influenced peoples of the Shaba, over the forest domains of the Lulua, Kuba, Pende, Mbala, Suku, and Yaka, to the Kongo territories of the Atlantic coast.

Water and nature have exerted a major influence on both the forest cultures and the great savanna kingdoms. These societies perceived in the flora and fauna the renewal of the seasons, the continuation of life, and the favor of spirits and of a supreme being, who gives the harvest and otherwise dispenses food. The cultural products of these peoples are seen in a new light when an inventory is compiled of the elements the sculptors have drawn from the plant and animal environment. Indeed, artistic production in Zaire finds an inexhaustible source of materials in the soil, the flora, and the fauna: straw, raffia, vegetable fibers, fruits and seeds, leaves, wood, steatite, lime, red and yellow ocher, black dye, resins, palm oil, shells, ivory, feathers, snake skin, monkey and other animal fur, teeth of wild animals, antelope and buffalo horns, and tortoise shells and pangolin scales (see fig. 73).

Thanks to the all-important Zaire River and its drainage network, lakes, and swamps, trees and water have become powerful symbols that have left an indelible stamp on the mythical thought and cultural history of Zaire. This is well illustrated by Kongo cosmogony, in which the universe is encircled by water, called *nlangu, mbu*, or *kalung*, that is, both the sea of the dead and ultimate, eternal life. Just as infinite waters contain and surround the world, so the rainbow protects the world against malevolent rains. Sun, moon, stars, and meteors also follow a circular route around the earth, beginning their orbit beneath the sea, then moving toward the visible, upper world.[1] Similarly, the individual is a microcosm of the universe. Each person's physical, mental, and spiritual attributes are linked to universal substances; bodily fluids such as blood, mother's milk, and sperm participate in the substance of *kalunga* (God, the Infinite), and are thus considered sacred.

According to Kongo myth, a single being, Mahungu, existed in the beginning in this water-surrounded domain where the Tree of Life, "God's palm-tree,"[2] was planted. In himself, Mahungu possessed both femininity and masculinity, both the sweet breath of life and violent destructive power. Similar to the perfect being described in Plato's *Symposium*, Mahungu lived in total happiness, experiencing neither suffering nor jealousy nor hatred; he was complete in every way. But the Tree of Life set the stage for the differentiation of the sexes. In a moment of weakness, Mahungu approached the Tree and walked around it, trying to see more closely into the meaning of things. The moment he turned around the Tree, he was split in two. Thus

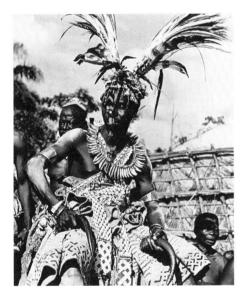

Fig. 73 *Labot latwool* royal costume of the Kuba of Zaire. (Photo: A. Turconi)

1 The world is divided into the upper world, inhabited by humans, and the subterranean world. Here we have adopted the Kongo cosmology described by Fu Kiau Kia Bunseki-Lumanisa, 1969, p. 5 ff.

2 Tree resembling a palm-tree, *mutimpungu* or *ba dia nsambi*. See Fu Kiau Kia Bunseki-Lumanisa, 1969, pp. 111-13.

created, man and woman became aware that they no longer constituted a single entity and were overcome by sorrow at having lost their state of perfect being. After due reflection, they decided to walk around the Tree again, in the opposite direction;[3] having done this, they realized that they still were two beings, man and woman, and from that moment on, woman has sought man as part of herself and man has sought woman, for they need each other to complete and help each other. "The idea of marriage was born of this complementarity between man and woman, man being identified with strength, drawn towards whatever evokes violence, war, destruction, hunting, characterized by courage and impulsiveness, woman being identified with gentleness, symbolizing calm, sensitivity, and fear in the face of terrifying creatures."[4]

This Kongo myth is an active archetype; cultural realities are expressed through the spoken word and through sculptural forms. References to human sexuality are omnipresent in Zairean sculpture, in the art of both the forest and of the great savanna kingdoms. The zoomorphic representations and geometric motifs of the sculpture, borrowed from nature or from basketry, emphasize man's link with nature. The monkey-faced Vili sculpture, the Kongo double-headed dog, the Tetela mask, the Tabwa buffalo mask (fig. 74; pl. 180), the Bembe mask: all represent either spirits in contact with human culture or metamorphoses of human behavior.

The symbol of the Tree is omnipresent in the mythic thought of these peoples. In some Pende villages of the Kasai region, the central support post of the *gisendu* sanctuary represents the cosmic axis around which the world becomes inhabitable.[5] A column some five to eight meters high, it is planted at the center of the building in a hole called *vumo* (belly), in which, long ago, human blood and libations were poured, along with life-giving roots and plants; its top, called *mutue* (head), was crowned with the skull of a sacrificial victim. A true cosmic pillar linking the upper and lower worlds, this trunk creates a living environment around itself that is humanized, organized, protected, consecrated, in contrast to the undifferentiated, unknown, dangerous spaces of nature. The creation of a Pende village reenacts in its own fashion the creation of the world. In the great savanna kingdoms, the Tree plays a considerable role, its multiple significances linking the visible and the invisible, high and low, the cycle of the seasons and time, man and woman.

In the Kongo cosmogonic story, as in the foundation ritual of a Pende village, the Tree is the intermediary between heaven and earth, the preferred place for the spirits of nature to appear. Through the abundance of its fruits and flowers, sap and leaves, through the nourishing and protective character of its wood, it is a maternal symbol. Among the Luba and Hemba the Tree is an icon that evokes the presence of ancestors. Through the rhythm of the seasons translated by its foliage, the Tree becomes an ambiguous symbol of death and of life's continual rebirth.

All Zairean sculptures reflect an aspect of the Tree of Life. It occupies a central place in religious rites; indeed, sexual abstinence is required of the sculptor before he makes the first cut in the pole, which will later be planted in order to determine whether a chosen site is propitious for the establishment of a village. The Hemba use *Chlorophora excelsa*[6] for their ancestor figures, as this tree is for them mysteriously linked with earlier generations. The Luba carve from the wood of *ficus* because it is associated with wisdom and divination, and the Songye use certain woods that secrete fluids for statues thought to spit forth truth. *Crossopterix febrifuga* is the wood preferred by Kuba sculptors, while the Luba sculpt from the wood of the *Ricinodendron*. The majority of Teke figures are also carved of wood possessing magical and religious significance.

If we could walk around a tree of the Equatorial Forest, we might begin to understand the spirit that has presided over wood carving in Zaire's various societies. The artistic forms emanating from this spirit encompass the four categories of human experience: nature, tradition, society, and the individual.[7]

Nature is where African man first meets the unknown. The mysterious, all-powerful forces emanating from it inspire surprise, fear, and rapture. When the clans of the Tabwa, coming from the Indian Ocean, first trod upon the lands of the high plateaus in the east, they called these lands *pelobela*, meaning a place of marvels, where earth

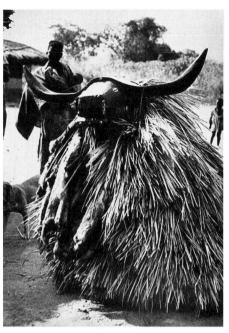

Fig. 74 Buffalo dance mask, photographed in 1974 in the village of Kaoma. The mask has two handles cut into its edges and is held horizontally above the dancer's head. (Photo: M. Felix)

3 Among the Peul, he who invokes the genii and the spirits retires beneath a large, isolated tree that he walks around several times. See Le Pichon, n. d., p. 678.

4 Fu Kiau Kia Bunseki-Lumanisa, 1969, p. 5 ff.

5 Personal communication from Malutshi; for more details, see Eliade, 1965, p. 25 ff., and 1952, p. 65 ff.

6 This is the *muyumbo* tree, well known throughout southeastern Zaire, from the Hemba and Luba to the Pende of the Kasai region.

7 Buakasa, 1978, p. 27.

8 Remark reported by Vogel, 1985, p. xiii, citing McNaughton.

9 Fagg, 1980, p. 152.

10 The position of the hands on the belly is found again in cult figures from the Kwango-Kwilu region (pl. 153) and, of course, in the Chokwe region (pl. 155). See Mukenge, 1967, p. 31.

and sky are joined. Natural phenomena – sun and moon, stars and the milky way, night and day, storms, thunder and lightning, fantastic rocks and rushing streams, clumps of trees, remarkable animals – become metaphors of human behavior or signs that nature is inhabited by forces that come from elsewhere and reveal themselves in the guise of spirits. The sun and moon are often symbolically represented on Chokwe and Lwena masks (pl. 160); among the Luba and the Hemba, the lozenge evokes fertility produced when the "new moon" and the "earth" come together, while a cross indicates high and low, east and west.

According to one West African initiate, a certain animal-shaped mask "is made to resemble an animal, but it is not an animal, it is a secret."[8] Just as the mythical being that brought agriculture to the Bamana is venerated in the dance of the Tyi Warra masks, the Tabwa buffalo mask (pl. 180) evokes the creative, fecund energy through which the lineage protects and perpetuates its tradition.[9] The founding ancestors, those who have given life and tradition to families and protected them, reside mysteriously at the very center of nature's fearsome, magic space. A link like the umbilical cord that once tied a baby to its mother ties the Black African to his or her ancestors. The gesture of Tabwa (pls. 181, 182) and Hemba ancestor statues (pl. 178) and of certain Songye cult statues (pls. 169, 173), where the standing figure places his hands around the umbilical zone, has long been puzzling; the clearest explanation of the gesture is provided by the Luba of the Kasai, where the word *difu* (belly) designates a link in the chain of lineage.[10]

Far from being severed at the moment of death, the cord uniting the Black African to his ancestors continues through a familial and sacred relationship. Hemba sculpture (pl. 178) masterfully renders the deceased chiefs in the effigies that lie in the semi-

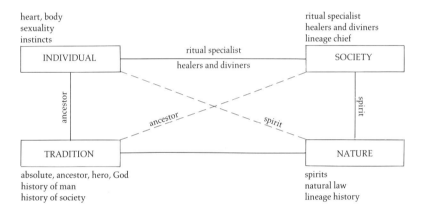

darkness of funeral huts; each ancestor is counted, named, and located in time. Among the Hemba, the ancestor's eyes are half-closed, as if opened upon another world (pl. 178); among the Tabwa (pls. 181, 182), open eyes indicate that the ancestors keep a close watch over the living (pl. 179). The symbolism is reversed, but the existential reality is common to both.

Ancestors, and traditions cultivating them, are omnipresent in the life of families and social groups among the peoples of Zaire. Rites and sacrifices, songs and dances, and masked performances evoke their presence, and are performed in their honor. Among the western Pende of the Gungu region, ancestors are summoned by various masks, while among the Bembe they are called forth at nightfall by the sound of great anthropomorphic horns.

In addition to these plastic creations linked to spirits of nature and to ancestors and their traditions, a great many sculptural representations are associated with various social and public institutions. In simple and clear forms, cult masks and figures perpetuate the symbolism of the secret societies through which, step by step, the initiate discovers the educational, judicial, and religious character of his group's identity. Frequently, the most powerful forms, and those most often admired in Western museums, remain uninterpretable even within the society in which they were created. At the heart of the Equatorial Forest, sculptors repeated the same traditional gestures, frequently adding personal innovations. Their creations reveal to

the world the hard-won victory of man and his culture – a culture that bears the imprint of infinity – over the ever-menacing, formidable forces of the forest.

The plains north and south of the Zaire Basin favored agricultural development. The sowing of millet, for example, is common from the Luba to the Pende, and caused an increase in population, especially along the Kasai. This led to the constitution of vast kingdoms, such as those of the Teke, the Kongo, and the Kuba. The social, political, and religious traditions of these regions gradually became more and more complex, and more broadly organized social institutions emerged. The history of the societies is colored by transient contacts with the cultural institutions of neighboring peoples.

So-called accumulative cultures developed in these great kingdoms, characterized by multiform, sometimes even contradictory, artistic creations in new, simple, more strongly defined sytheses. Female figures holding bowls (pl. 177) and Luba bow-and-arrow stands (pl. 174); caryatid-seats of the Hemba, the Luba, the Chokwe, and the Songye; cult statues of the Kuyu, the Hongo, the Yaka, the Suku, the Mbala, and the Lulua; scepters and fly-whisks, funeral statues and huntsman figures, dance, circumcision, and initiation masks: all these are expressions of different social institutions, marking out the life of the social groups as it relates to the individual, the ancestors, and nature.

The fluctuations of history have played a considerable role in the emergence and the decline of institutions and in the plastic forms dependent upon them. Certain mask societies, imbued with sacred symbolism, have sometimes become dance groups that invite the crowd to a festival, spectacle, or game. Thus, on the outskirts of Kinshasa some Pende dance groups perpetuate, after a fashion, the great Pende mask traditions of the Katundu region and, like the Luba and the Songye, illustrate the etymology of the mask Kifwebe, created to "chase death away."[11]

In the traditional art of the Equatorial Forest, figurative sculpture mirrors the image of man. Both men and women bear on their bodies many of the same marks seen on sculpture; both are similarly scarified, painted, and otherwise ornamented. Among the Luba, a simple bead necklace can evoke the history of a lineage, one person being represented by each glass bead. Colors are symbolic; and a broken necklace is a source of misfortune. The object that is sculpted with love becomes the carrier of presence, communication, participation; every decoration becomes a sign, and the sign is the carrier of the message. In Zaire as elsewhere the object is presented as an ideogram: its image and sign are visible and its beauty can be appreciated, but its language is not accessible to all.

Removed from its original context and presented under the spotlights of the Western world, the African art object often appears immobile, in an inert space, marked by ownership. In this context, "a mask that does not dance and is bereft of its red trappings is no more than a piece of dead wood." However, it was originally part of a universe in which the spirits of nature, ancestors, social institutions, and the individual were constantly united. One by one, we must reexamine the multiplicity of forms and styles in the arts of Zaire, a multiplicity evoked in the Kongo myth of the man and woman who seek their unity by going around the Tree; for every artistic phenomenon, whether in the forest cultures or in the traditions of the great savanna kingdoms, expresses in its particular way man's tireless quest for an essential unity.

True initiation in Zaire is passed on orally, and an object always refers back to a spoken word, myth, or tradition. Every sculpture implies a message and an initiation; conversely, every myth or tradition gives birth to a concrete image and a visible sign. Consequently, the art objects of Zaire are the embodiments of signs, in a mystical sense that transcends mere imagery; but at the same time they radiate a simple and sacred beauty. The signs can be understood only within a history of a specific culture, and it is important to contextualize them within the life of the traditional society, a life with periods of germination, cultural flowering, decadence, and, occasionally, resurgence.

This does not mean that our feeling of awe in the face of objects so evidently charged with mysterious significance should blind us to the qualitative differences between one work and another. Good workmanship and artistic merit are concepts by no means alien to the original creators and users of these sculptures; the dignitaries of

11 A possible etymology of the word *kifwebe* is "that which chases away, sets at a distance, puts death to flight" (which corresponds to the mask's function). Personal communication from Mme. Faik-Nzuji.

the various social institutions, and others who could afford it, naturally sought out the most renowned masters when they wished to commission a cult object or a more utilitarian artifact. Of course, the criteria that guided them in assessing artistic value were not necessarily the same as ours; however, this brief introduction may help us to attune our aesthetic sense gradually to this new world of images and meanings, and to begin to see the objects exhibited here with the eyes and the soul of those by and for whom they were created. As our empathy grows, we will also be able to recognize archetypes and trace the development of styles, and will not be fooled by the "cheap reproductions" that one must expect will be produced in increasing numbers as the area is opened up for tourism.

For the man or woman of Zaire, a work of art is more than an ornament or an aesthetically enhanced object of practical use, more than a representation of familiar or imaginary entities: it echoes on a visual plane the traditions that have been handed down to him orally by his grandparents and parents and ritually in his initiation society, it speaks to him of the basic truths of life, which are so often shrouded in mystery and can thus only be hinted at by way of symbols. Bearing this in mind, we shall be better able to appreciate the impact that African art has had on Cubists, Expressionists, and many other artists of our twentieth-century Western world in their quest for the reality behind the appearance, for an art that conveys the essence rather than the image of life.

Peoples of the Lower Zaire and the People's Republic of Congo

The different groups making up the Kongo people are found around the mouth of the Zaire River. They are among the most numerous and culturally richest of African peoples.

When, in 1482, the Portuguese Diego Cão first saw the great river, he found also a powerful kingdom whose authority stretched far inland, since it counted the Teke of the Stanley Pool among its vassals. The Kongo king, whose capital was in the north of present-day Angola, soon converted to Christianity, but traditional beliefs remained strong nonetheless.

Among the best known sculptures of the lower Zaire are the *nkondi*, statues bristling with nails, two examples of which are included here. Less brutal, but also less expressive, are works attributable to the members of the Kongo people living farthest from the coast, the Yombe.

The Woyo, the Mboma, and other groups, even the Vili, who live along the Gabon border, also lie within the Kongo cultural horizon. All make ancestral effigies; but in even greater numbers they produce magically charged sculptures called *nkisi* (power figures), which may also be natural rather than man-made objects (fig. 75). These "fetishes" are used by ritual specialists known as *nganga*.

Finally, Kongo art has produced a large number of extremely refined figurative sculptures, such as scepter handles, whisks, and canes. These are portraits of ancestors, most often women, ancestral mothers who wear the distinctive scarifications of the ethnic group.

Northeast of the great Yombe forest, traditions which honor lineage ancestors are found in much the same form among the Bembe of the Peoples's Republic of Congo (formerly the French Congo). Not to be confused with the Bembe or Wabembe who live northwest of Lake Tanganyika, these people speak a Kongo dialect. They make small figurative sculptures – rendered sacred through the insertion of a magic "charge" into the anus – which are effigies of the dead, represented with objects symbolizing former personal attributes in their hands – for example, guns and containers for magic material. The bellies of these small figures are often adorned with complex scarification patterns.

The Bwende, nearer the Zaire, are closely related to the Bembe, and their small figurative sculptures serve a similar function, whereby reverence for ancestors always goes hand in hand with magical potency. A. M. V.

Lit.: Lehuard, 1977.

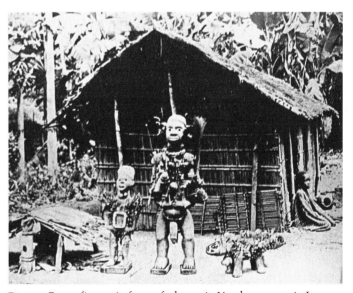

Fig. 75 Power figures in front of a house in Yombe country in Lower Zaire. (Photo: From Maes, 1955, p. 10)

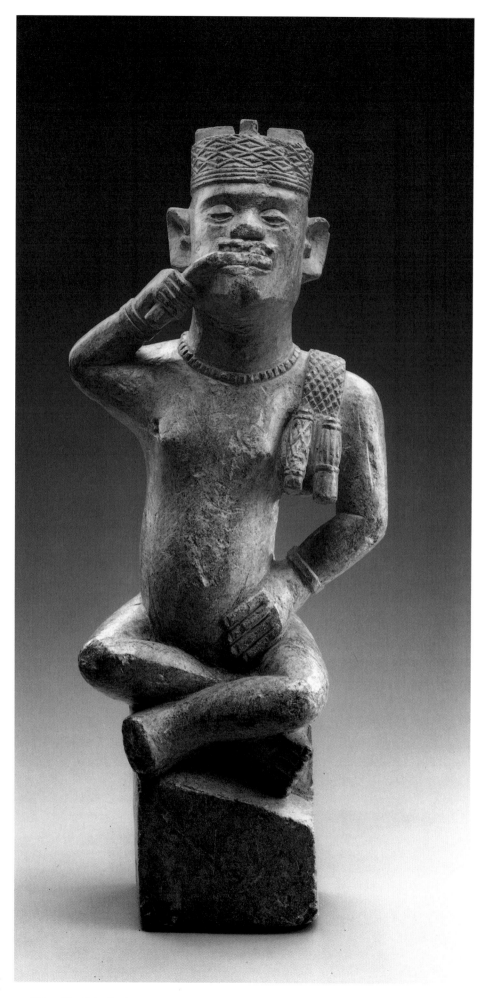

141 Tomb Figure

Kongo, Lower Zaire

Steatite; height, 49 cm

Four important attributes and the posture iden-
tify this figure as a Kongo leader. The cap/crown
(*ngunda*) topped by four leopard teeth, the neck-
piece, armlets, and band are documented as lead-
ership insignia in the Kongo region since the
seventeenth century. The date of the earliest
Kongo tombstones nonetheless remains unclear,
and no available evidence supports the opinion
held earlier that the Kircher collection in Rome
possessed stone sculptures from the Kongo in
the seventeenth century. The first six stone fig-
ures documented by accession data in the Pigo-
rini Museum arrived in Rome as late as 1889.
The bulk of Kongo tombstones was brought
from Africa in the 1950s, although several
museums, such as those in Leyden and Ter-
vueren, had acquired examples at an earlier date.

The terms *mintadi* and *n'tadi*, used widely in
the literature on these tomb sculptures, denote,
in fact, a variety of stones related to leaders'
burials. On the other hand, figurative carvings
like the present one are usually referred to by
the Bakongo as *tumba* (image). As on some
other tombstones, the figure bears traces of red
pigment. Numerous marks on the sculpture
point to the use of traditional tools, unlike the
more recent *mintadi*, which were produced com-
mercially in Zaire by African carvers, including
some academic artists, and which flooded the
market in the 1970s. Z. V.

Lit.: Maes, 1938, pp. 130-40; Maesen, 1969; Verly,
1955; Grotanelli, 1965, p. 677; Volavka, 1981, pp. 43-51.

142 Ancestral Figure Seated on a Chest

Bembe, People's Republic of Congo

Wood and beads; height, 28 cm

The material (hardwood) and meticulous execution classify the sculpture as the work of a Bembe carver. The angularity of shapes and the tendency to divide up the human figure into individual elements suggest, however, a creative environment subject to other influences as well. Artworks and artifacts to be found in the Sibiti and Komono regions, which are also inhabited by the Teke and other peoples, exhibit a similar inclination toward geometrical order. The pierced nose, too, points to a connection with the region west of Bembe country proper, where the custom of wearing nose rings was noted in the 1870s.

The figure is seated on a chest, inside which is a sealed receptacle made of malleable material incorporating imported beads and brass studs. Possibly containing such relics of the dead as pieces of epithelium, nails, or hair, the sculpture is both a reliquary and a commemorative image of the dead. Z. V.

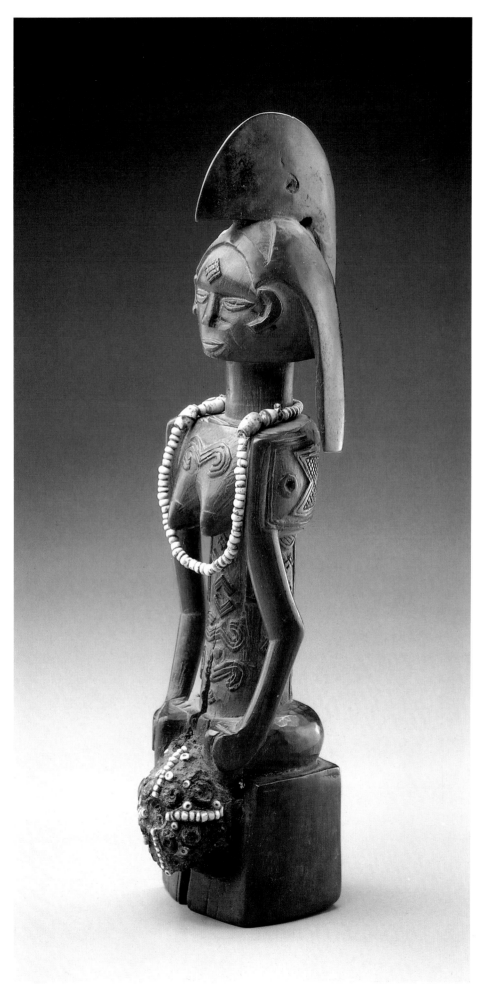

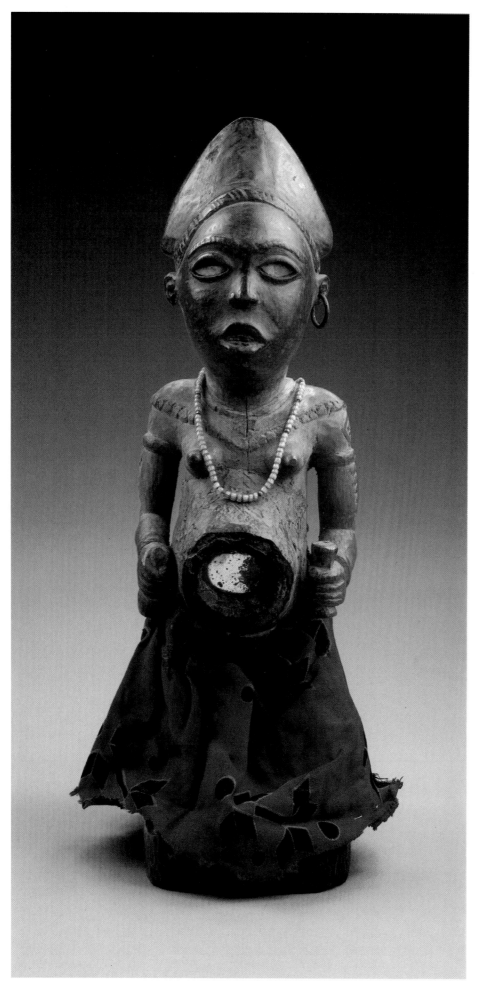

143 Figure

Kongo, Lower Zaire

Wood, pigment, red cloth, mirror, beads, and metal;
height, 28 cm

A fine example of Kongo artwork, the sculpture
bears testimony to the passing of time. Most
nkisi figures underwent material and, conse-
quently, aesthetic changes as long as they were
in active use; they are thus records of history
(see Volavka). However, I believe that this
standing figure was made, not as a *nkisi*, but
rather as an effigy commemorative of an ances-
tress revered as the female founder of a lineage.
As a rule, such a sculpture – called by infor-
mants *ngudi* (mother or lineage) – was kept in a
basket (*ntende*) together with other relics of kin-
ship. On occasions of communal importance,
such as the emergence of nubile women from
their premarital seclusion, the sculpture may be
taken out to appear in a dance. Nowadays, in the
absence of old artworks, women can even be
seen dancing with a commercial sculpture in-
stead.

In cases of collective hardship and disaster,
and after other avenues of remedy have been
explored, the priest may be asked to strengthen
one of the chief's emblems or the effigies of
founding ancestors. It was presumably on such
an occasion that the present figure received its
red skirt, receptacle, bead necklace, and yellow
(oxidized red?) pigment. Z. V.

Lit.: Volavka, 1972, pp. 52-59.

144 *Nkisi* Figure

Vili, People's Republic of Congo

Wood, with traces of kaolin; height, 25 cm

The rather unusual sculpture of a standing fig-
ure chewing a kola nut has an opening in the
stomach and another at the top of the skull.
Traces of material used to seal the receptacles,
and the presence of white pigment impastoed on
their insides, indicate that the sculpture func-
tioned as a *nkisi*. Receptacles were often emptied
when a piece was removed from use. The head is
disproportionately large in comparison with the
rest of the figure and shows features uncommon
to anthropomorphic figures and suggestive of a
face mask. Despite the skull receptacle, the head
was not designed to be topped by a cap, and this,
together with the lack of symbols of rank, de-
monstrates that the *nkisi* was not associated with
leadership. The sculpture is most probably the
image of a priestly person wearing a Ndunga
mask. Ndunga are large face masks that were
employed in the old Ngoyo kingdom by male
members of the Ndunga priestly association in
their interventions against lawbreakers. Z. V.

Lit.: Volavka, 1976, pp. 28-43.

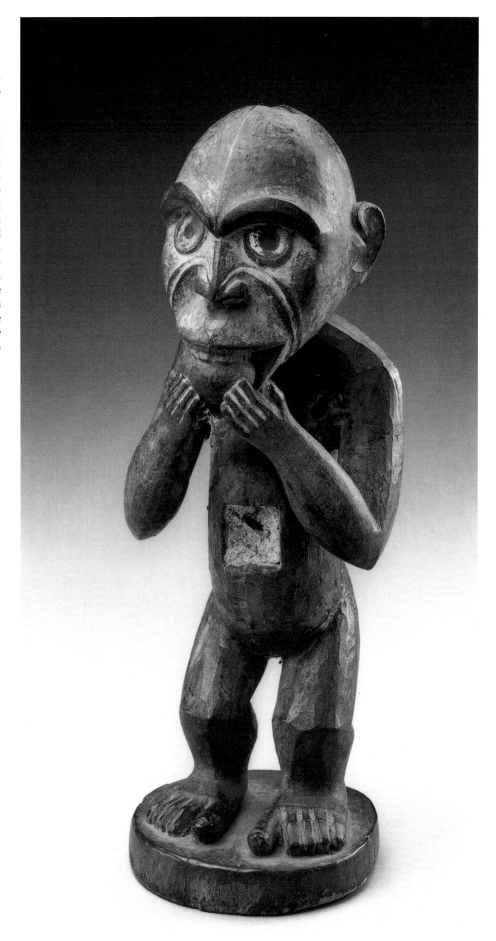

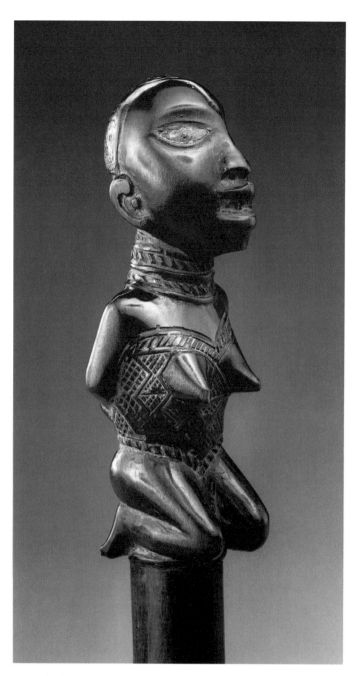

145 Whisk

Yombe, Lower Zaire

Wood, with traces of kaolin, and hair from the tail of an animal; height, 17.5 cm (figure)

A work of fine visual properties, this whisk, carved of hardwood and topped by a female figure, is in several ways a puzzling object. Unless the image was the finial of a staff that was subsequently supplied with hair from an animal's tail in order to change it into a whisk, the figure is placed upside down, since the whisk, a crucial emblem of Kongo leadership, is displayed by the leader with the tail upward. Another (apparent) discrepancy lies in the iconography of the figure: although richly equipped with neckpiece, band, scarification, and elaborate coiffure, the woman is depicted with her hands tied together, like a prisoner. Her apparel and pose identify her as a bride, and the generic name of the image is *kikumbi* (virgin, nubile woman). The shallow relief of the carving bears traces of red pigment – presumably vegetal *tukula*, the conventional makeup of virginal brides during premarital seclusion. According to my findings, tied hands are a Kongo metaphor for the loss of status as a person, that is, for slavery. Earlier ethnographic research noted that young female slaves were favored as brides for the leader's uterine nephews. Children from such marriages remained with the groom as his "human treasure." Lineages that originated in the womb of a slave bride therefore have a slave in their heraldry.

Since the whisk is a transmissible emblem, surviving specimens are usually quite old, with dark patination and wear that results partly from the leader's holding the whisk with most of the figure in the palm of his hand. Z. V.

146 Staff or Whisk Finial

Yombe, Lower Zaire

Ivory; height, 15 cm

With a minimum of attributes, the meaning of the figure is conveyed by economical visual means in a clear, yet subtle, language. Like other Kongo female effigies, this image of a wife is neither a portrait nor a symbol of a particular wife of the emblem bearer. It depicts a type rather than an individual; hence the austerity of the image, with its lack of any individual attributes. While tradition sometimes attaches the names of queens to such images, to see them solely as illustrations of historical personalities or facts is to interpret them on a superficial level. Art historical analysis and multiple field testing and countertesting bring to light semantic layers that reveal the images to be mementos of social acts that were codified into myths and given personal names. This particular memento concerns a consecrated Lemba marriage, which forges together a couple through an unbreakable bond of female fidelity. One of the signs of marriage, the "tribute to four corners," is incised twice on the front of the figure's torso, and the Lemba sign, an armlet, is engraved on her left wrist. Z. V.

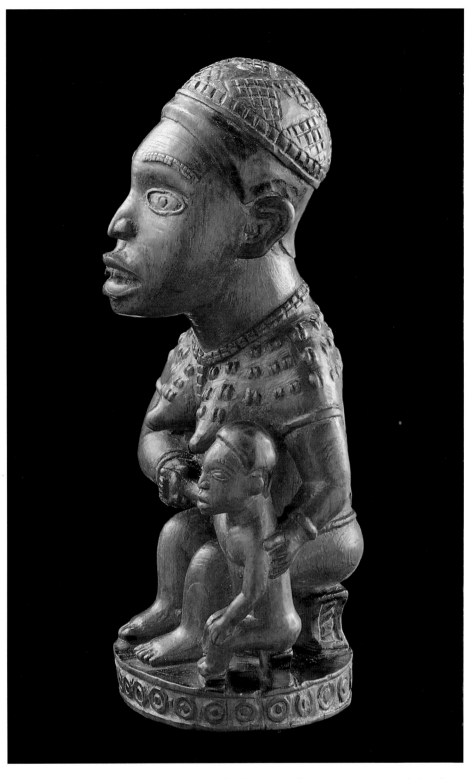

147 Staff Finial

Yombe, Lower Zaire

Wood; total height, 23 cm

As with other insignia of Kongo leadership, the staff – and especially its finial – is executed with considerable care and the utmost finish. Yet as in Kongo art in general, cultivated treatment does not preclude formal irregularities. These are apparent here both in such details as the unevenness of the circular plinth and in the composition as a whole, with the breasts of the main figure shifted to the left-hand (female) side and its legs to the right-hand (male) side of the central axis. Form thus elaborates on ideology rather than conforming to the rules governing the imitation of natural appearances.

Although female in appearance, the main figure is also supplied with male attributes – for example the crown (*ngunda*), the principal emblem of male leaders. The literature on this type of effigy usually refers to the small figure as a child. Early fieldworkers noted that the icon stood for the "clan mother," but later writers have favored a more European-minded explanation of the couple as "mother and child" or "motherhood."

The Kongo themselves call this iconographic type by various names, all of which indicate conclusively that it represents a genetrix, the mythical ancestress of a clan. The relationship of the two figures is thus that of genetrix and descendents rather than that of a particular mother and child. Z. V.

Lit.: Maes, 1938, p. 177.

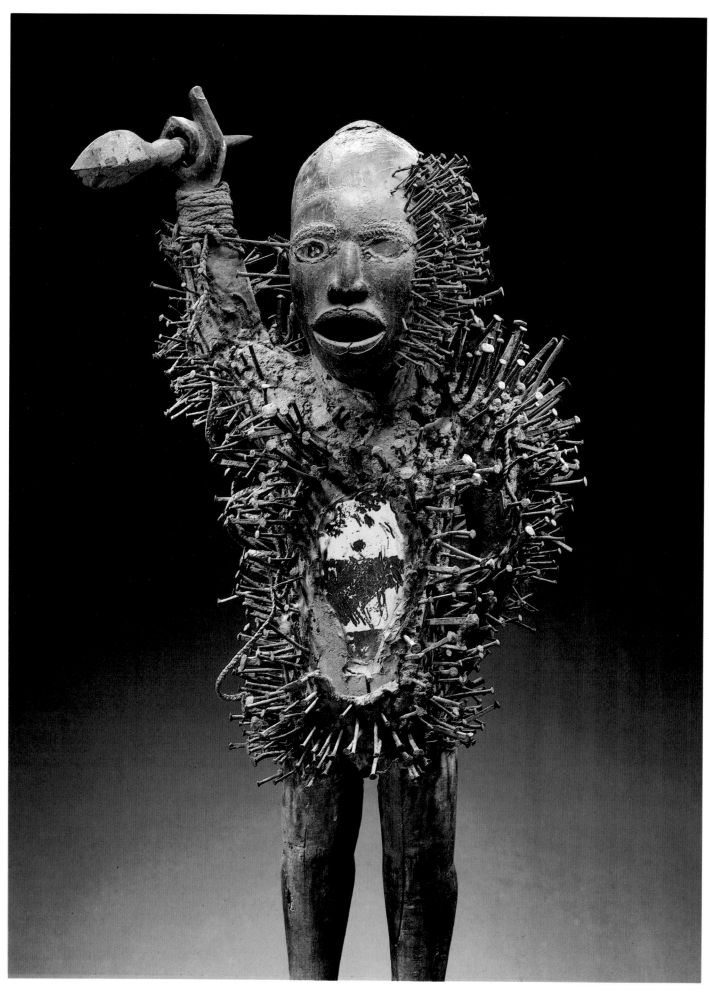

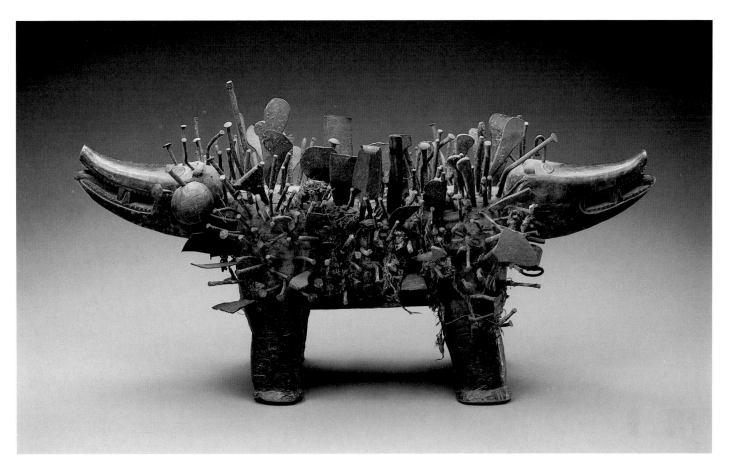

148 Power Figure (*nkondi*)

Kongo, Zaire

Wood, nails, metal pins, and cloth; height, 97 cm

149 Power Figure (*nkondi*) in the Form of a Two-Headed Dog

Kongo, Zaire

Wood, nails, and iron blades; length, 67.5 cm

Zinkondi (singular, *nkondi*) constitute one of the more misunderstood provinces of African art. Even at this late date scholars persist in calling them "nail fetishes," in spite of the fact that these standing images are often studded with blades and other symbolic insertions as well as nails.

Reliable field data, going back to the turn of the century, establishes that the functions of such objects are various, but that they generally relate to moral intimidation, either mystically imbued or enacted. As a *nkisi* (charm, medicine of God), the *nkondi* is believed to be animate, its spirit generated and admonished by medicines (*bilongo*). It is alerted by the shock of metal insertions: each blade, knife, or pin summons the *nkondi* to moral duty. The moral, public function of the *nkondi* includes such serious matters as military agreements, penal regulations, oaths of innocence, and moral or jurisprudential divination. *Zinkondi* will protect an innocent person, but if it turns out that the person was guilty, they will seek him out and punish him with sudden death or illness.

In the process of mastering the art of the *nkondi* and its powers (*kinganga nkondi*), the ritual expert must memorize the nuances and precise histories attaching to every single blade or nail. Since each conceals a message of agreement, it is crucial not to remove the wrong nail when a sorcerer (*nganga*) is asked to cancel a vow or annul a previous deed.

The *nkondi*'s open mouth attests to the belief that a proper mediator between the living and the dead speaks volubly and constantly on behalf of justice. The presence of a mirror on the belly of the image shows that the *nkondi* is armed with a flashing instrument of surveillance, able to plot the movements and intentions of jealous, dangerous persons.

A wealth of differently shaped blades covers the double-headed dog *nkondi* (cat. no. 149). These blades code different issues and situations, representing a concentration of moral assertion and menace. Like the dogs that protect our houses, *zinkondi malanda* (one who follows) detect dangerous situations. R. F. T.

Ethnic Groups of Southwestern Zaire

The Yaka, numbering about 300,000, and the Suku, about 80,000, are the two most important of the ethnic groups settled on the savannas stretching between the Kwango and the Kwilu, two left-bank tributaries of the Zaire, in southwestern Zaire. The Suku live on both sides of the Angolan border.

Both these peoples speak dialects belonging to the Ki-Kongo group of Bantu languages. And the Suku claim to be of Kongo origin, though their royal line also claims to be related to the Lunda king of *Kapanga*. What is certain is that older settlement of the region was disrupted at the beginning of the eighteenth century by the arrival of the conquering Luwa, a branch of the Lunda. According to A. Bourgeois, "the Luwa conquest...considerably influenced...the organization, terminology, and rituals of political power among the Yaka and the Suku, although a few matrilinear pockets retained their status as the land's first owners."

The art of divination is very widespread and has prompted the creation of a variety of accessories, but of only one type of sculpture, in the form of a small wooden drum with a slit in the sounding box. The numerous figurative sculptures are used as containers or holders for ritual medicinal preparations. Their size varies from 7.5 to 76 centimeters in the examples studied by Bourgeois, who writes: "Without the medicines that are attached to the image or placed in a cavity of its belly...the image has no meaning at all for the Yaka and the Suku." Each category of figure has a name and a clearly defined function (fig. 77).

The initiation of young boys is marked by circumcision and a number of ordeals. The novices receive instruction in story-telling, singing, and dancing. Different masks are used, depending on ethnic group and subgroup. The mask is a charm insuring the initiate's protection and his future fertility. Some masks are shared by the Suku and the Yaka, but others are proper to only one group or subgroup.

Aside from within a few exceptional Yaka enclaves, only the Suku use the helmet masks (fig. 78), whose source lies to the east, among the Kwese and the western Pende. The best known of the masks of this region is the *kholuka* of the northern Yaka, of which a particularly elaborate example is reproduced here. Its base, a wickerwork frame coated with resin, is typical of ethnic groups living in southwestern Zaire and northern Angola and is found again, for example, among the Chokwe.

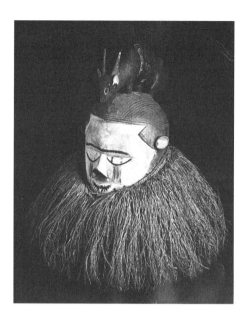

Fig. 78 Helmet mask of the Suku. Height, 40 cm. Barbier-Mueller Collection

The Pende are western neighbors of the Suku, separated from them by the Kwese and the Mbala (though, given the intermixing of these groups, it is impossible to locate them geographically with precision). Two distinct Pende groups can be distinguished: the western, on the Kwilu, and the eastern, on the Kasai; both apparently migrated from Angola in the late eighteenth and early nineteenth centuries. Their sculptors are often blacksmiths. The style of the western Pende is represented here by the "executioner" mask; that of the eastern Pende includes monumental statuary and helmet masks like the one here seen in action (fig. 79).

A. M. V.

Lit.: Bourgeois, 1984, pp. 32, 38; Cornet, 1972, p. 103.

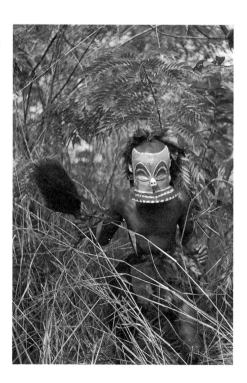

Fig. 79 Helmet mask of the eastern Pende. (Photo: M. Huet, Agence Hoa-Qui, Paris)

Fig. 76 *Mbwoolo* figures in the Biteke village of Kimbuku. (Photo: Agence Hoa-Qui, Paris)

Fig. 77 Power figures in front of a Yaka hut. (Photo: A. Bourgeois, 1976)

150 Mask

North Yaka, Zaire

Wood, cane, raffia cloth, and raffia fiber; height, 70 cm

This fine example of a leading northern Yaka mask belongs to the series used in coming-out festivities of *n-khanda* initiation and during the subsequent dance tour. The surmounting mannequin-like figure, with its carved head, hands, and feet, and prominent phallus, is typical of *kholuka* masks. The explicit eroticism of the figure and the upturned nose, apart from containing an element of erotic humor, refer to magico-religious concern for the fertility of the newly initiated and for solidarity between recently initiated and adult males. A. P. B.

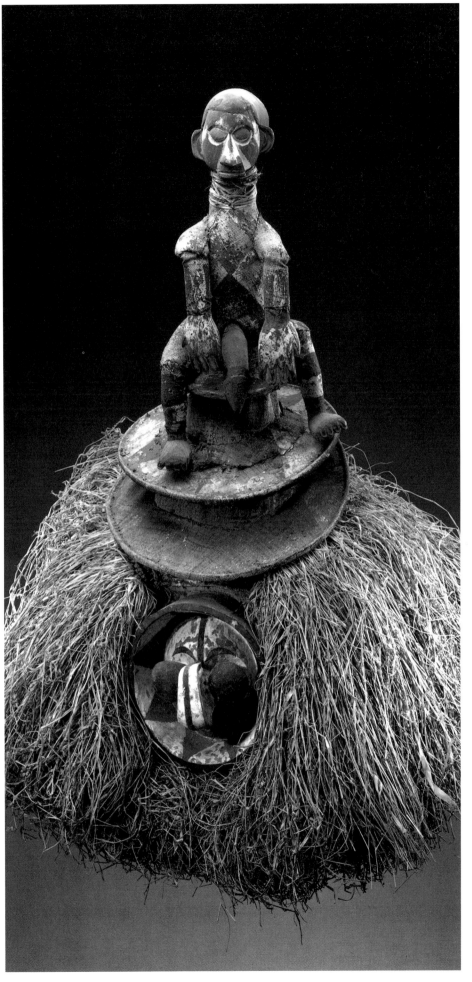

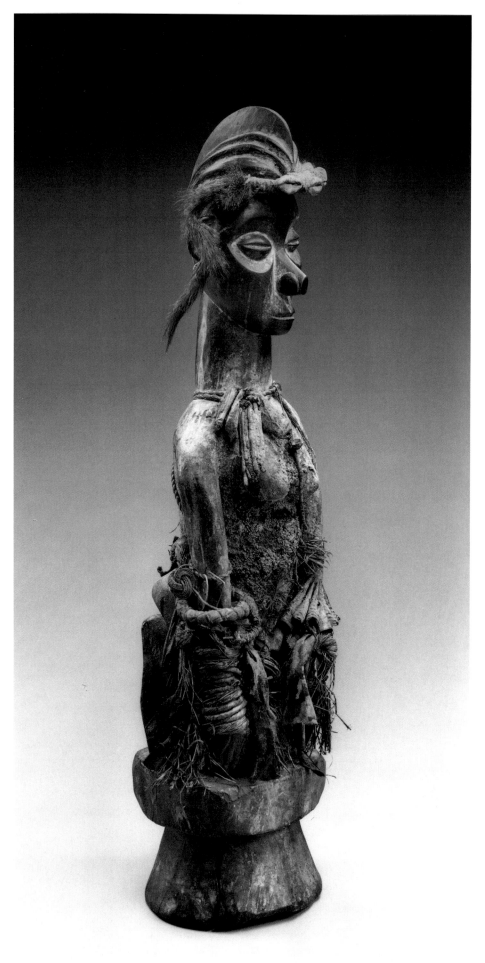

151 Figure

East Kongo or *West Yaka*, Zaire

Wood, raffia, and feathers; height, 69 cm

Carvings by eastern Kongo subgroups such as the Lula, Nkanu, Zombo, and Sosso are often attributed to the Yaka populations, who dwell further to the east. One distinguishing characteristic of figures from the Angola-Zaire border area is the proliferation of magical packets and attachments. From what is known, such figures were used by *nganga* specialists in healing rituals that required the patient to undergo isolation and exposure to a variety of power-laden objects. A. P. B.

152 Figure

Suku, Zaire

Wood; height, 31.6 cm

This is an outstanding example of a Suku stand-
ing male figure, the torso characteristically
swelling from the neck downward to create a
bulbous form with encircling ridge at its lower
extremity. The shoulders disappear in the direct
attachment of the arms at the rear of the upper
torso. Detail is given to the head by laterally
projecting ears and an expressive mouth. Be-
neath the mouth, the hands hold a lozenge-
shaped form where they more commonly touch
a beard.

Suku figures served as supports for magical
preparations that were attached to, or hung
from, the image during one of several magical
rites led by a *nganga* specialist. Their imagery
refers to elders in their role as interveners
against misfortune, sickness, and death in both
the remote past and the present. A. P. B.

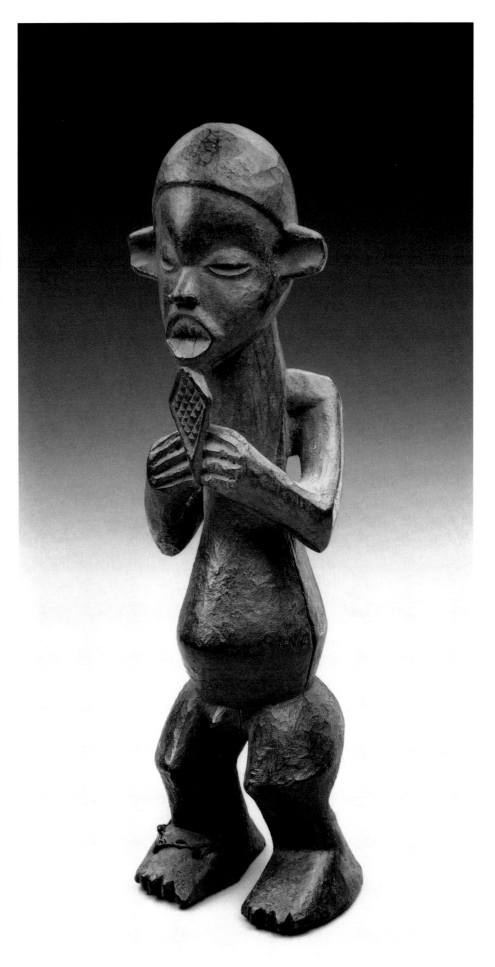

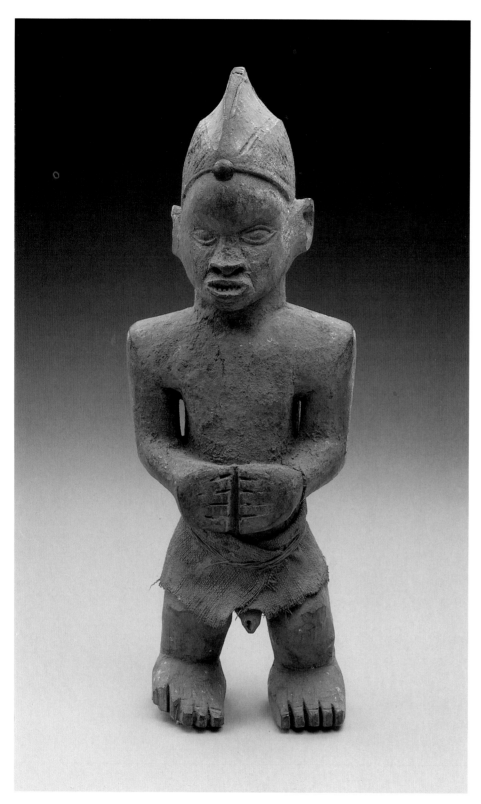

153 Figure

Mbala, Zaire

Wood and pigment; height, 29 cm

This standing Mbala male figure is by the same hand as two documented examples in the Kongo-Kwango Museum, Herverlee, Belgium, which are said to have been carved by the Mbala sculptor Mulepi. Both were collected in the early 1930s in the Kwilu River area, between Lusanga and present-day Bulungu.

Mbala figures were used as magical objects in various ritual institutions, such as *pindi, kiluba, kosi, matombo, koti,* and *wamba.* Such rituals required isolation and exposure to sculptured figures that were charged with curative and protective powers. Their imagery probably refers to auxiliary members of a chief's household – for example, drummers, diviners, or maternity groups who, for traditional Mbala, signified life and its processes. A. P. B.

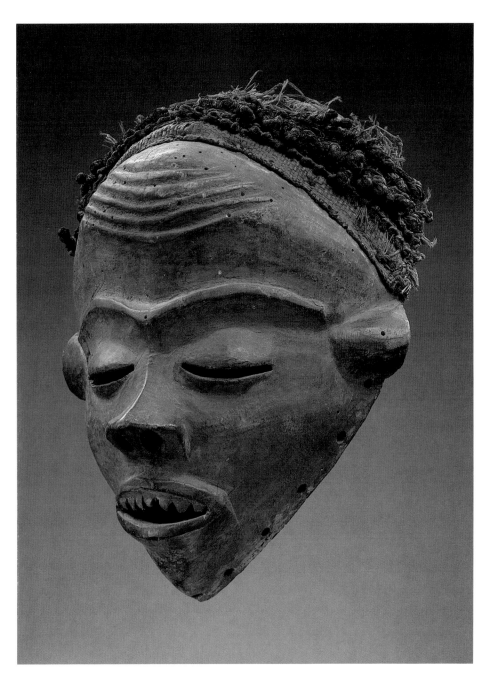

154 *Gabundula* or Executioner Mask
Western Pende (Bandundu), Zaire

Wood, hair of blackened raffia fibers, red, white, and black pigments; height, 23 cm

The *gabundula* or executioner mask, one of the *mbuya* masks, represents the executioner of the witchdoctor society. He is called *kodi dia nganga*. The wrinkles (*mifunyi*) on his forehead symbolize his fearsome character.

It should be noted that *mbuya* masks represent individuals from various spheres of life; for this reason, they are not only used in circumcision rituals.

This western Pende mask has been incorrectly identified as *kinjinga (ginjinga)*, and been attributed to the (eastern) Pende of the Kasai.

M. M. S.

Lit.: Fagg, 1980, p. 23.

Ethnic Groups of Angola

The most important and best-known of Angolan ethnic groups is certainly the Chokwe (or Watchiwokoué or Ciok). Roughly a quarter of this people of about a million lives in Zaire, between the Kwilu and Kasai rivers and as far east as the Lulua and Sankuru rivers. Anthropologically, they constitute a heterogeneous group who originated from the region of the headwaters of the Kwango, Kasai, and Lwena.

Long vassals of the Lunda and ruled by Lunda chieftains, the Chokwe began their emancipation in the first half of the nineteenth century. They were not slave traders, but were skillful hunters who supplied ivory to the coastal peoples. Subsequently they became rubber producers, after which their territorial expansion became rapid. The Lunda, who were alone in northeastern Angola about 1850, were invaded by the Chokwe, who succeeded in taking the Lunda capital and establishing their domination over the region west of the Kasai.

The Chokwe believe in the existence of a supreme being, but they do not workship it in a particular way and its image is never sculpted. In contrast, different categories of supernatural beings – *mahamba* and *akishi* – are represented by figurative sculpture in both clay and wood and by masks. The faces of the masks represent male and female ancestors; they are carved in wood or modeled in resin on basket frames (fig. 80).

The statues may represent either *mahamba*, symbols of the depersonalized spirit of the ancestor of the lineage, or *wanga*, who give protection against evil powers, or they may be *tuponya*, portraits of ancestors of a single family. *Tuponya* (singular, *kaponya*) is also the term applied to any human figure.

Chiefs are often represented seated or playing a musical instrument. Their portraits decorate magnificent tobacco boxes, and their scepters are among the most remarkable African sculptures. They also appear among the multiple motifs that decorate the beautiful chairs inspired by older Portuguese models, on which scenes from daily life are also seen.

Except for the Lunda, other Angolan ethnic groups do not have as rich an artistic iconography; they often bought sculptures that they needed from their Chokwe neighbors. Still, beautiful Ovimbundu and Songo sculptures are known, as well as remarkable Songo chairs, and a rare example is included here of the art of the Imbangala, a little-known group that served as a trading link between the Chokwe and the coastal peoples who were in contact with European merchant-ships. Finally, among the Lwena are found masks highly similar to those of the Chokwe, to whom this group is culturally very close. A. M. V.

Lit.: Bastin, 1982, pp. 29, 106.

Fig. 80 Large *kalelwa* mask of resin attached to a rattan frame. (Photo: Archives du Musée de Dundo)

155 Figure
Chokwe, Angola

Wood; height, 33 cm

Chokwe sculptural traditions flourished during the nineteenth century when the courts of the various chieftaincies established themselves at the headwaters of the Kwango and Kasai in central Angola, prior to the Chokwe expansion into Zaire and Zambia. In the period prior to this expansion, which ultimately resulted in a disruption, the sociopolitical structure was relatively stable. Divine sovereigns were the primary patrons for an art imbued with dynamism and power. The expressive force seen in Chokwe art, carved with great attention to detail, reflects actual Chokwe customs since nineteenth century Chokwe aristocracy preferred long fingernails and well-groomed hands. Based on formal characteristics, this object can be classified in the Mussamba substyle, originating from the headwaters of the Kwango, and it can be compared to two effigies of the culture hero Tshibinda Ilunga. In all three works the face is prognathous, and other physiognomic traits are similar: the protruding ears are obliquely stylized; the clavicles define a double arc at the top of the chest; the shoulders are emphasized by circular grooves; the hands, fingers spread, are boldly held forward; the legs bend markedly at the knees; the tops of the feet are almost completely flat. The works are probably by the same artist, or, at least, from the same workshop. Among the works created by Chokwe artists it is not unusual to be able to identify a set of works which have all been produced by a single artist or workshop. They are still expert artisans today, carving combs, pipes, tobacco boxes, staffs, etc. Earlier, they worked for elegant and sophisticated courts, where they were expected to create commemorative figures and prestige objects intended for display; such objects were commissioned from artists who developed personal reputations according to the degree of imagination and innovation with which they imbued their work. Certain themes are repeated, for example, chiefs standing, chiefs saluting on the rungs of a European style chair, and caryatid motifs, but the artist was able to impose his personal touch.

The lines of the coiffure of this female figure reproduce the *mahenga* design, which is characterized by curves and sinuosity, a frequent motif of the Chokwe decorative repertory. Such motifs have the force of ideograms; though their names are abstract, they allude to the human, animal, vegetable, and supernatural worlds. The sun, the moon, and the stars are represented on objects intended for both ritual and profane use.

<div align="right">M. L. B.</div>

Lit.: Bastin, 1978, plates XI, XII.

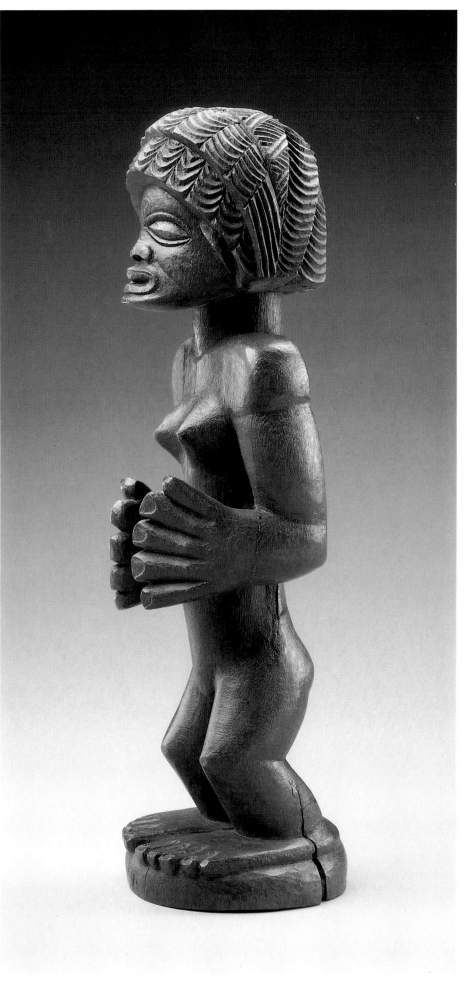

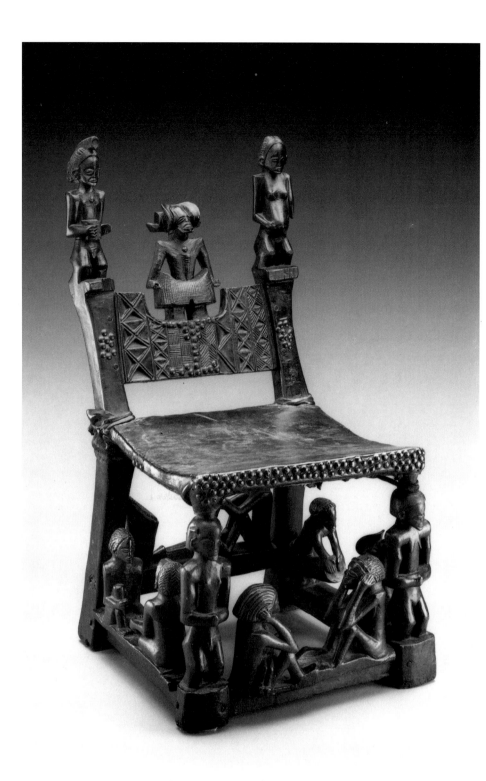

round which depicted the principal stages of human life or everyday activities.

The small chair in the Barbier-Mueller collection appears to date from the nineteenth century. It is a mortise and tenon construction with a leather seat; the scenes decorating it are at once classic and highly individualized. Two ancestral figures crown the uprights, and in the middle of the backrest is sculpted a standing figure wearing the mask representing the spirit of wealth, Cihongo, recognizable by his fan-shaped coiffure and the fringed, hoop-like belt (*cikapa*). The backrest is decorated with admirably executed geometric motifs of an ideographic nature: on the front "network of canary cages," "tortoise shell patterns", and *mahenga*, parallel lines; on the back, the "spiral bracelet *cijingo.*"

Two guardian caryatids form the front legs, genre scenes decorate the rungs. None are alike. In front, two women lament, the one on the left holding a sick or dead child in her lap. On the right, a Mungenda dance mask, accompanied by a drummer, bares his genitals. On the left, two seated figures face each other. On the back stretcher, a blacksmith's assistant operates a bellows equipped with two leather drums; the high cylindrical furnace is the traditional evocation of the female torso, which will give birth to molten metal at the end of the smelting process.

This beautiful chair is magnificently sculpted and is decorated with the precious imported brass nails that were the "gold" of the Chokwe.

M. L. B.

Lit.: Bastin, 1982, figs. 171, 180, and 1961, figs. 182-84.

156 Chief's Chair

Chokwe, Angola

Wood, leather, brass nails; height, 61.3 cm

Beginning in the second half of the eighteenth century, the Chokwe of central Angola had contacts with the trading caravans that crossed the southern part of the country from Benguela to the upper Zambezi. Thus, they saw the European chairs of the period, and their skillful artisans quickly imitated the foreign model.

The ancient style of the chief's seat was a small, round stool with legs that curved inward,

a style used down to the present day (Bastin, 1982, fig. 171). This stool was elegant, but also solidly built as it had to support the weight of the sovereign, a man ideally of ample proportions symbolizing health and prosperity.

The earliest replicas of the European chair were made of single pieces of wood and were about the same height as the stools (Bastin, 1982, fig. 180). Working with mortise and tenon, the Chokwe were soon able to fashion chairs of normal height, and their Chokwe sculptors brought a unique originality to these objects of prestige, decorating their rungs with sculpture in the

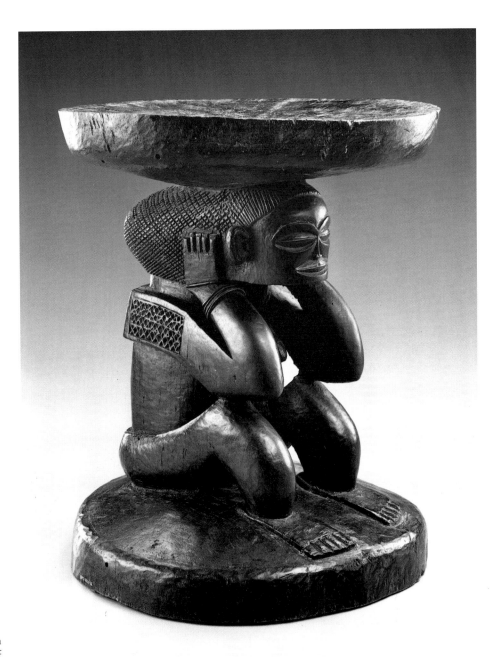

157 Caryatid Stool
Chokwe, Zaire

Wood; height, 39 cm

The caryatid is an extremely old theme in Chokwe plastic art; yet virtually no examples of a caryatid supporting a seat on its head are known from the last century, even though such objects are found frequently among the Luba and occasionally among the Pende. Two Chokwe examples that do date from the nineteenth century are kept in the Museum of Anthropology in Porto; they present figures sculpted in the round that support a seat on their knees. Both were collected in Angola, in the Moxico region south of the headwaters of the Kasai; each represents a seated woman whose head and shoulders rise above the rear of the seat, forming a back. Thus, it may legitimately be assumed that the Chokwe adopted the caryatid stool with the seat on its head only after their expansion northward, which brought them into contact with new neighbors.

The present stool features the figure of a woman with a strong, well-built body; she is seated, her elbows on her knees, her hands raised behind her ears in a gesture of lamentation. She represents the lineage ancestor who wants to be venerated by her descendants;

should they neglect her cult, they risk being struck by illness or misfortune. Evidence of veneration is found on a similar piece in the museum of Tervueren in the form of traces of sacred white clay (*pemba*) that has been spat on the face.

This beautiful example from the Barbier-Mueller collection is virtually identical to a work in the Cleveland Museum of Art. Both pieces have the same doubled-up, powerful appearance; the stylization of their facial features is identical, and the chevron-shaped decoration (*mahenga*) embellishing the shoulders is also the same. The seat is decorated with brass nails; in our example, the caryatid wears a bracelet. It seems certain that both sculptures were done by the same hand.

These are not the only works of this type that display a definite kinship of expression. A small masterpiece, a female caryatid stool, in the Tervueren museum was collected before 1946 by

T. Fourch, in the Kasai region of Zaire. Additional geographic information comes from a file of the same museum, dated 1930, in which J. Verbist gives Kandale on the upper Kwilu as the origin of a stool with caryatid, male this time. If the general appearance is the same, some differences can be seen in facial details, which are somewhat more naturalistic. The well-known stool with a male caryatid in the Rietberg Museum in Zurich exhibits a number of similarities to the Geneva specimen, which can also be compared to the female figure on a stool in the Buffalo Museum of Science.

On the evidence available, we may date these works in the period of Chokwe expansion in the late nineteenth century; the cradle of the style seems to have been the area between the Kwilu and Kasai rivers in Zaire. M. L. B.

Lit.: Bastin, 1982, figs. 175, 179; Leuzinger, 1963, p. 209; Olbrechts, 1946, and 1959, fig. 45.

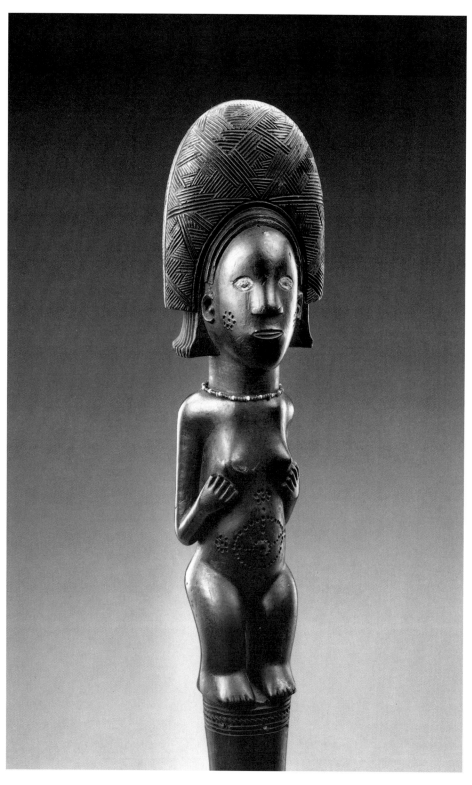

styles: the one on this sculpture is comparable to the male coiffure in an engraving published by Capello and Ivens.

The female figure which surmounts this staff stands with her hands drawn toward the breasts, and with her feet resting on a small, grooved molding. The proportions are classically African: the full, smooth forms of the body evoke health and prosperity. Tattoo patterns are incised in fine detail. The coiffure is precisely rendered. A large, transverse bun crowns the thin braids that spread out around the neck; the band across the forehead surmounts the full oval of the face like a diadem.

The marvelous tactile effect of this artistic creation is accentuated by its deep glowing patina, which gives it a precious and sensual quality which it probably already possessed when it left the sculptor's hand but which increased through use. To enliven the facial expression, the eyes have been deliberately left uncolored. A necklace of small, multicolored beads subtly enhances the general effect. M. L. B.

Lit.: Bastin, 1982, fig. 27.

158 Staff
Ovimbundu, Angola

Wood, traces of kaolin, beads; height, 55 cm

The Ovimbundu live on the Benguela plateau, the most densely populated area of Angola. This extensive territory is divided into major chieftaincies that were set up several centuries ago by emigrant chiefs of Lunda origin; the largest are Bailundu, Bié, Wambu, Tshiaka, Ndulu, Ngalangi, and Kakonda. Relatively few examples of Ovimbundu sculpture are known in Western collections. In 1949, Robert Verly brought some beautiful works back to Belgium. They are most notable for their unusual anatomical proportions, generally more slender than those found in other African figurative sculpture and a concern for asymmetry is also frequently apparent. The effects of having been repeatedly rubbed with oil, which indicates a ritual function, sometimes enhance the surfaces of these objects. The hairstyle most commonly seen on the female figures features lateral braids tied together; the carvers have stylized this in a horse-shoe shape going down the back of the neck. Each region, however, has its own hair-

159 Harp Handle in the Shape of a Human Head
Imbangala, Angola

Wood, nails, buttons, beads, cotton; height, 23 cm

The Imbangala live to the west of the Chokwe, between the Kwango and its left-bank tributary the Lui. Ancestors of their chiefly lineage called "Jagas," included the famous Tshinguli, brother of Lweji, whose exodus with his followers from the Lunda capital toward the Atlantic coast took place about 1600. Kasanji was the most famous "Jaga"; in his territory a large and prosperous market developed, where European products were exchanged for others coming from the interior. Flourishing commercial relations existed with the capital of the Lunda emperor Mwata Yamvo, east of the Kasai; they grew in importance after the voyage of exploration of the *pombeiro* mulattoes, the first to cross the African

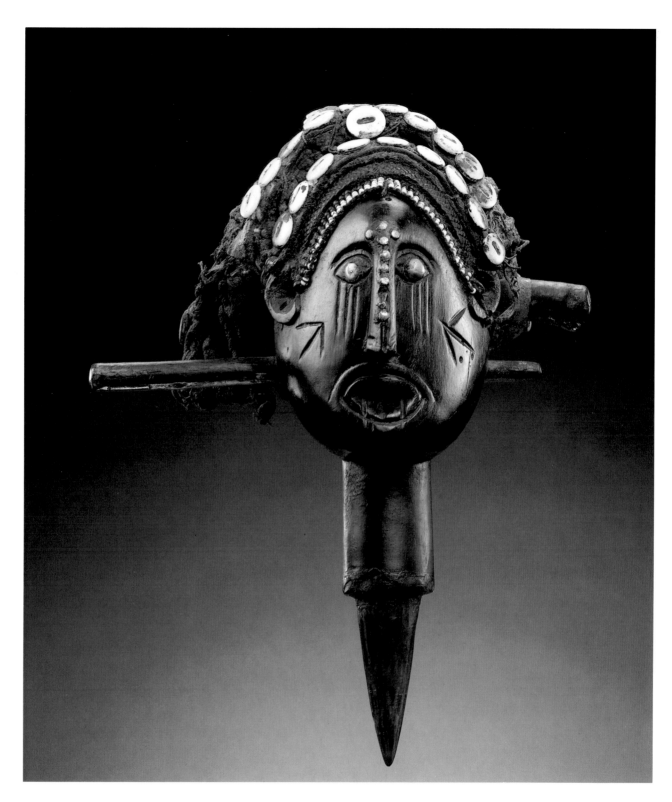

continent from Angola to Mozambique (1802-1814). The Imbangala are first and foremost traders.

In a letter of October 8, 1969, J. C. Miller, who lived among this people for some time, reports that their art is inspired by that of the Chokwe, from whom they obtained wooden pipes and their chiefs' ceremonial staffs. However, the Imbangala did create their own musical instruments: anthropomorphic cordophones called *kakosha*. A complete specimen of this instrument, in perfect condition, is illustrated in Bastin, 1961, pls. 230-2. They take the form of a

standing woman whose hands are placed on her breast and whose body constitutes the sounding-box. Two fiber cords, tightened by pegs, run from her mouth to a ring attached between the legs. The strings are played with a bow. The bow itself is curved and strung with a hemp fiber; a spherical fruit of the *Rubiaceae* family is affixed to the middle of the bow and serves as a rattle to accompany the playing of the *kakosha*.

Two complete instruments of this type are conserved at the headquarters of the Holy Spirit Missionaries in Carcavelos in Portugal (B VI-11 and B VI-14). They do not, however, possess the

splendid patina of the cordophone head in the Barbier-Mueller collection.

This head is lavishly decorated. Brass nails enhance the eyes, while other nails sketch a tattoo on the forehead and nose. Arrow-shaped scarification marks are engraved on the cheeks. The coiffure of cotton braids is decorated with two rows of white buttons. A narrow band of blue, white and yellow beads outlines the sculpted diadem. This work is a fine example of a rare sculpture type. M. L. B.

Lit.: Bastin, 1961, pls. 230-232.

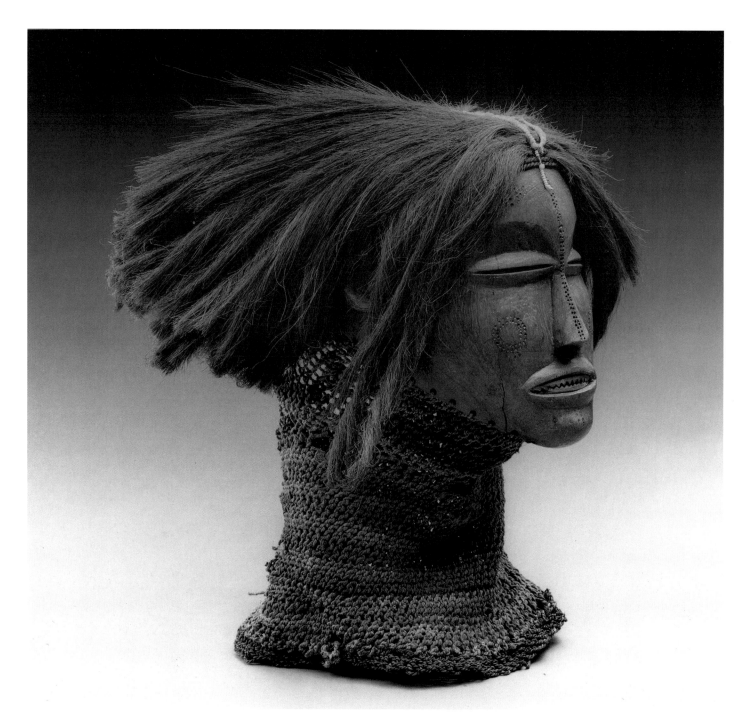

160 Mask

Lwena, Angola

Wood, sanseveria fiber, raffia, small white beads;
height, 24 cm

Like the Chokwe, Lwena society was founded by
chiefs of Lunda origin at the end of the sixteenth
century. The two peoples speak clearly related
languages, and their art, while having evolved
separately, has numerous points in common. A
matrilinear society like the Lunda, the Lwena
were ruled by female chiefs rather than ambi-
tious and autocratic male chiefs, and their figur-
ative sculpture mainly consists of female im-
ages. Everything about it emphasizes discretion,
harmony, symmetry, and curvilinear forms.

Chokwe female masks are exclusively facial;
the structure of Lwena masks is more complex.
In our specimen, the arched ear, located some
way from the eye, is sculpted at the angle of the
very long jawbone that forms the base of the
head, but this is the only incongruous note in a
work that otherwise has all the qualities of
youth and harmony. The skin is softly textured,
the features are regular and the scarification
marks delicately engraved. The sharpened teeth
– an ethnic mutilation common among the
Lwena, who are fishermen, recall the compli-
ment addressed to local beauties: "Your teeth
are like those of the *kasangi* fish in the river."

The Lwena wear their hair in long, fine braids,
unlike the Chokwe, whose coiffure takes the
form of short braids coated with red clay and
worn as a large band over the forehead. The
Lwena of the upper Zambezi reproduce their
hairstyle with smooth strands of sanseveria, as
can be seen on many *pwevo* female masks. A
final note of elegance is added by the discreet
decoration of small white beads running back
across the head from the forehead.

In Angola, the mask's dance is simple and
stylish. But emigres in Zambia have their own
way of exhibiting this type of mask. The dancer
performs on a rope stretched 10 meters above the
ground between two tall poles.

M. L. B.

Lit.: Fagg, 1968, fig. opposite plate 237.

The Kuba

The Kuba kingdom in western Kasai took final shape in the early seventeenth century, when various forms of existing art were united and put at the service of power and wealth (fig. 81). The kingdom reached its peak in 1850-99, as did the arts associated with it. These were focused mainly on the courts of chiefs and kings, where a profusely decorated, secular art flourished in which innovative graphic motifs were valued most. Further focuses were boys' initiation ceremonies and funerals, in which the same masks played a role.

The Kuba kingdom included some nineteen ethnic groups, of which the Bushoong and Kete were the most numerous. In most respects the ethnic groups are irrelevant to the distribution of artistic styles and images. Stylistically, Kuba arts encompassed those of many peoples who lived on the borders of the kingdom, especially in the west and north, so that the Wongo, Lele, Byumba, Ooli, Ekolombi, and other peoples along the northern bank of the Sankuru, as well as the Binji to the east of the kingdom, may be included in a wider definition of Kuba art. J. V.

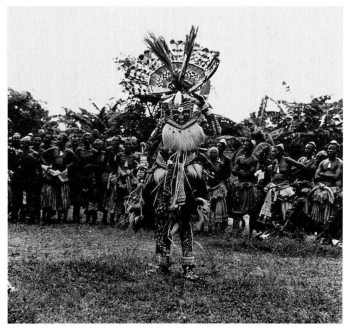

Fig. 81 *Moshambwooy* dance mask at the royal court of the Kuba. (Photo: A. Turconi)

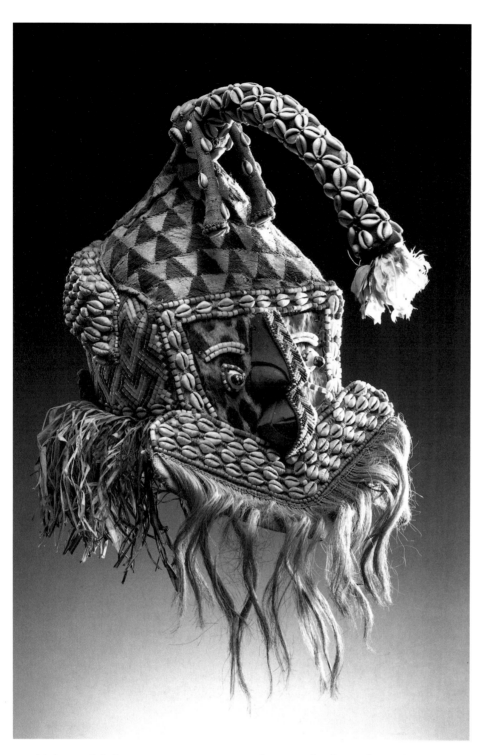

order to determine whom he should punish. The mask became an instrument of royal power, and ever since that day the chiefs have always presented themselves to their people in the costume of *moshambwooy*.

The *moshambwooy* and the *mukyeem* masks are similarly constructed except that *moshambwooy* masks lack the frontal projection of the *mukyeem* masks. They are made in royal workshops, according to the monarch's specifications and under his personal supervision. One mask was redone five times because it failed to please the king! Its various components – face, neck cover, semicircular crown, sculpted nose, etc. – are made separately, decorated with beads and shells, and then put together.

Fagg believes this mask to be quite old. He calls attention to the care with which the small triangles of beaten bark cloth have been sewn together to form the top-piece, a practice that was abandoned at the beginning of this century.

<div align="right">A. M. V.</div>

Lit.: Torday, 1910, p. 237; Cornet, 1982, pp. 256, 257 ff.; Fagg, 1980.

161 *Mukyeem* Mask
Kuba, Zaire

Raffia, fiber, imported beads, cowries, and wood; height, 43 cm

The *mukyeem* mask is frequently confused with the *moshambwooy* mask, which it greatly resembles but which is peculiar to the Bushoong. The *mukyeem* is characterized by a long, cylindrical frontal projection like an elephant's trunk, that surmounts it and arches forward over the forehead; the function of the *mukyeem* is not really known, but is probably similar to that of the *moshambwooy*.

The latter mask has been extensively studied among the Bushoong, the largest of the Kuba subgroups; all Kuba peoples pay homage to the king of the Bushoong. The legend surrounding the mask is reported by Torday. A water-spirit (*ngesh*) called *moshambwooy* once terrorized the Kuba and was responsible for terrible illnesses, including blindness. A man encountered it in the bush one day, but he was unable to describe it to the king, who requested that the man withdraw to his quarters to fashion a costume of fibers and bark cloth in the image of the *ngesh*. Upon seeing the costume, the king seized it and disappeared, reappearing disguised, inspiring fear in his subjects, who recounted this strange apparition to him when he returned. The king then explained that the spirit *moshambwooy* had come to check on each person's behavior, in

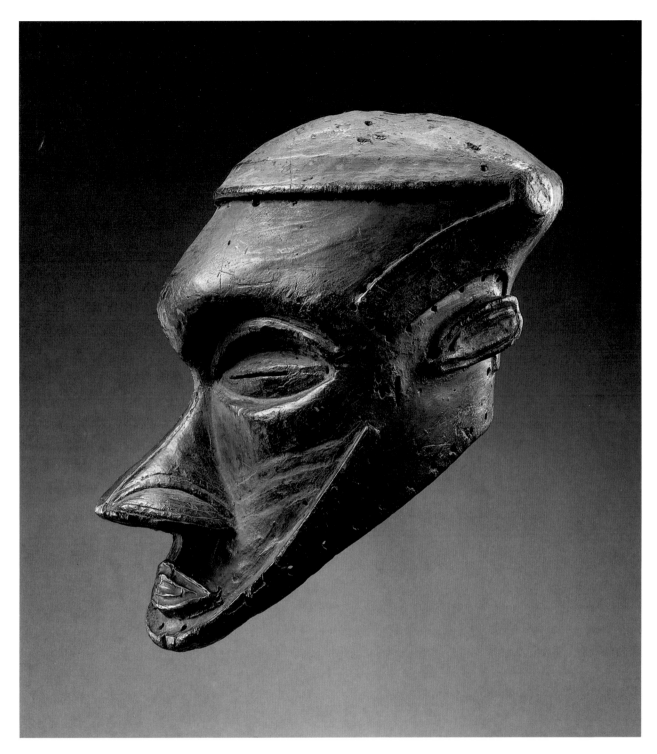

162 *Bwoom* Mask
Kuba, Zaire

Wood and pigment; height, 40 cm

This *bwoom* mask lacks coloring, as well as its headdress of hair feathers, textile cap, and complex costume with green leaves. Of rural Bushoong origin, its style is classical, its execution simple. Special features are the ears in the royal "Y" style and the absence of facial decoration, except for three slanted lines, a detail usually reserved for other types of mask. The significance of *bwoom* varies with context. On its own, it represents a nature spirit in the shape of a pygmy, while at court dances it is the commoner competing with the king for a woman and in boys' initiation ceremonies one of the village leaders. The name itself probably means "divination." Clearly, *bwoom* was once a mask with a religious role. Kuba tradition remembers that it was adopted at court in about 1800, since when it has acquired a number of complex functions there. As a spirit mask it was much older, however, and that role explains its wide distribution. J. V.

Lit.: Cornet, 1982, pp. 264-70.

The Lulua

The diversity of Lulua art reflects the great independence enjoyed by the various peoples descended from the Luba who in recent times became their worst enemy.

For modern-day political reasons Lulua has been substituted for the different names of smaller ethnic units which spread out over a large area of the province of Western Kasai, around the major city of Kananga.

The Lulua (also called Bena Lulua) have never succeeded in forming a strong, structurally organized state, unlike their neighbors to the north and east, the Kuba and the Luba. In about 1870, however, the chief Kalamba Mukenga did succeed in uniting several Lulua chieftaincies under his authority. He also attempted to introduce a religion founded on the smoking of cannabis, and he had many of the ancient sculptures destroyed, deeming that they stood in the way of the adoption of his new religion.

The largest figures represent ancestors; they are sometimes represented holding a cup. The majority of Lulua sculptures are smaller, between 10 and 20 centimeters in height; they are called *mbulenga* and are thought to confer beauty and good luck. They are used in traditions which vary from people to people, although throughout the region these figures are associated with protective spirits. Many are used to promote fertility in women. J. C.

163 Figure

Lulua, Zaire

Wood, traces of pigment; height, 31 cm

Lula figurative sculptures have fundamental associations with various cults. Their beauty is essential to their effectiveness, thus the sculptor strives to show off the physical features advantageously: the eyes, the elongated neck, and the many tattoos that were considered to enhance the aesthetic effect. Scarification marks were predominantly curvilinear.

Figures were rubbed with a finely powdered red wood and coated with oil, or sometimes kaolin, a practice that explains the marvelous patina of some Lulua works. J. C.

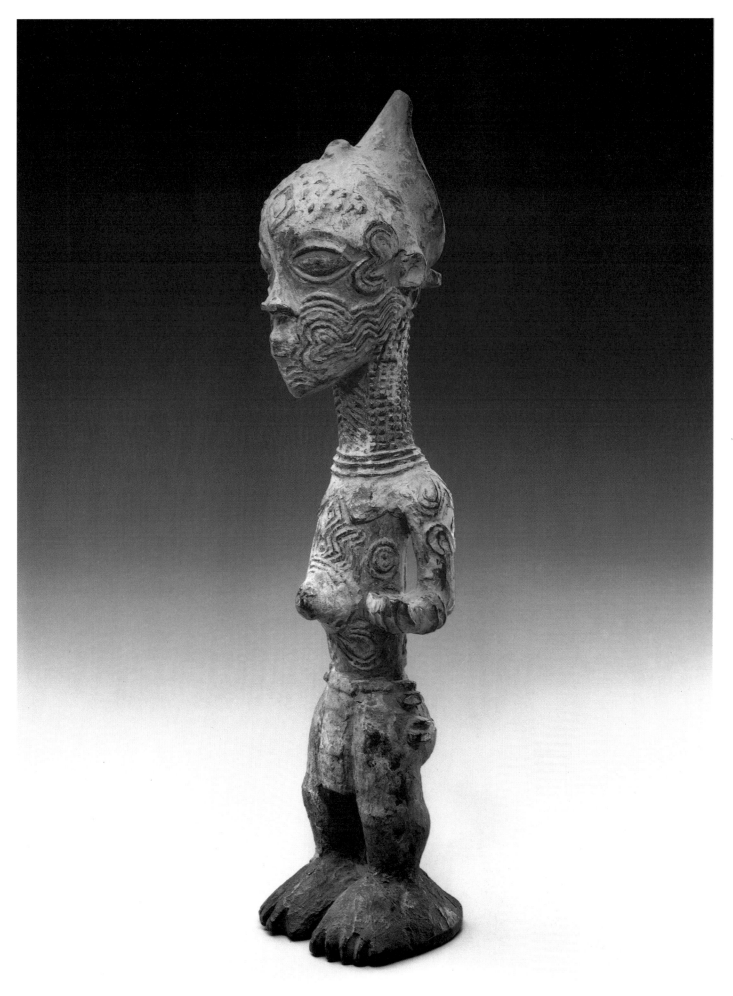

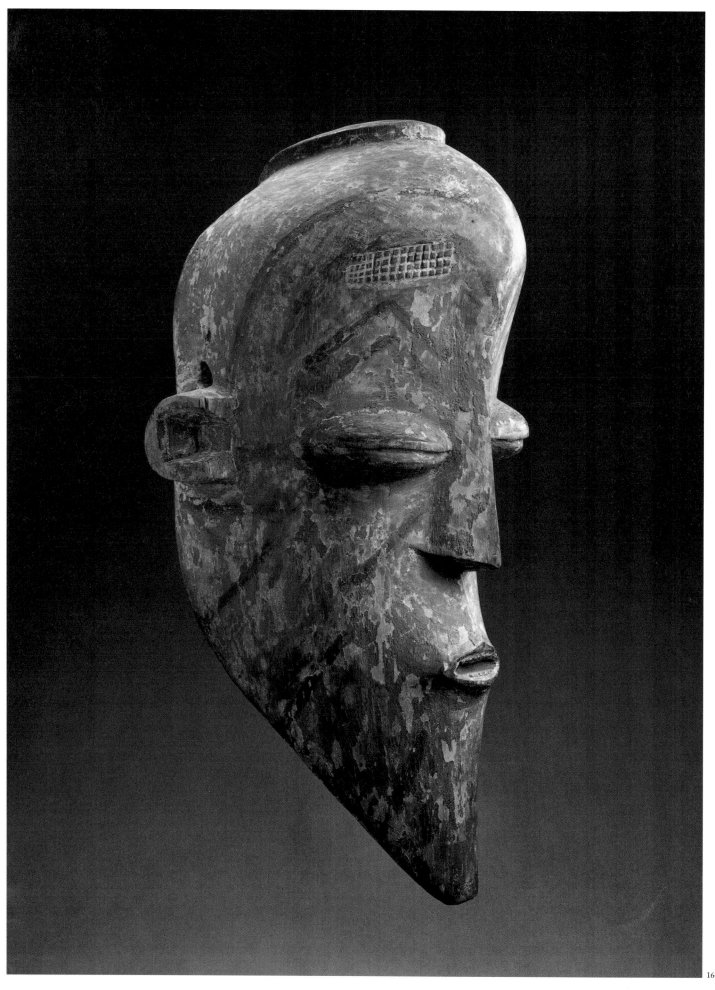

164

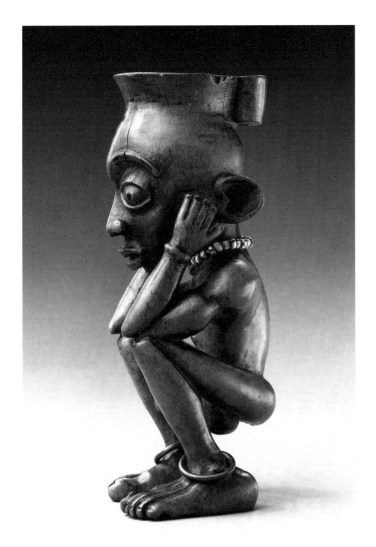

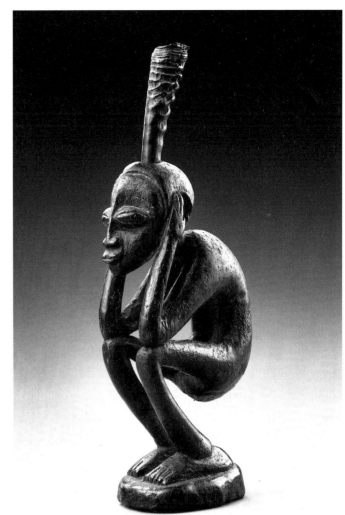

164 Mask

Lulua, Zaire

Wood, with traces of white and red pigments;
height, 43 cm

The formal variety of the few masks that have
been preserved attests to the varied influences
experienced by the Lulua in the course of their
historical peregrinations. The general shape of
this particular mask is reminiscent of certain
Kete masks.

The protruding eyes are characteristic of the
style, appearing on a number of figures The
forehead is high and domed. Painted highlights
enliven large areas of the surface. J. C.

165 Tobacco Mortar

Lulua, Zaire

Wood, beads, and metal rings; height, 12.8 cm

This mortar is in the shape of a crouching figure
with arms resting on his knees and hands held at
the level of the ears. The receptacle itself has
been hollowed out of the head, which has conse-
quently been given greatly increased propor-
tions. The edge of the mortar curves outward, at
the back there is a peg for the attachment of a
lid.

The eyes bulge out of their sockets beneath
the eyebrows carved in relief; the eyelids are
clearly shown, and the pupils are marked by
small, dark circles. The nose and the half-open
mouth are emphasized as much as the eyes. The
ears are large and rounded.

The neck is decorated with small beads. The
arms are sculpted with great care, particular de-
tail being shown on the hands. Each wrist sports
a bracelet carved out of the wood.

Below prominent genitals, large feet ensure
the stability of this beautiful little statue, and
display the same refinement of detail as the
hands. Brass rings encircle the ankles.

Mortars in the shape of a crouching figure are
found frequently among the Lulua. They were
undoubtedly associated with the cannabis cult.
 J. C.

166 Figure

Lulua, Zaire

Wood, traces of white and red pigments; height, 24 cm

Crouching Lulua figures are very numerous,
especially in the eastern part of their territory.
They in fact exemplify a hybrid style, and this
figure is similar to works attributed to the
Nsapo-Nsapo, a Songye group that moved deep
into Lulua country in the last quarter of the
nineteenth century. Another constant theme in
Songye art is the antelope horn stuck in the
skull; it was intended to contain magical mate-
rials.

Made up entirely of curves, this figure pres-
ents a great unity of volumes and is evidence of a
fine sense of balance. J. C.

The Biombo

This small people forms a kind of link between the Kuba on the one hand and the Shilele and the Pende on the other, although they have generally remained under the hegemony of the Kuba. They are best known for their masks.　J.C.

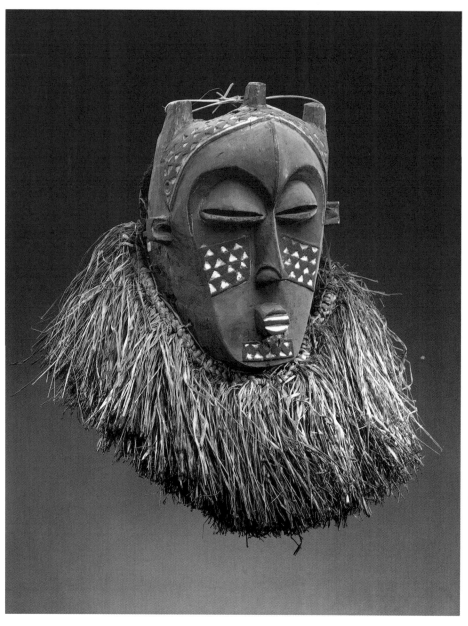

167 *Tshioana* Mask
Biombo, Zaire, Ngandu village

Wood, red pigment with traces of black and white, fiber, and raffia; height, 33 cm

The shape of this object is that of Kuba helmet masks, but its detail is closer to the features of Pende masks, especially that of the eastern Pende. This is evident in the presence of a large raffia-fiber collar and the conception of the triangular mosaic decoration in red, white, and black. The black and white motifs are harmoniously arranged in three areas – the top of the head, the cheeks, and the chin. The volumes of the mask are meticulously well-defined, and its ears are similar to those of Pende masks.

Today, a better understanding of intermediary populations made up of southern groups of the Bashileele has introduced a new element into the study of this particularly original and productive artistic area of Zaire.　J.C.

The Tetela

The Tetela have been partially assimilated by the Mongo. Some have adopted Arab customs and have relinquished their sculptural traditions. What little is known of Tetela art testifies to a history of complex cultural exchange and social interaction.　J.C.

168 Mask

Tetela, Zaire

Wood, black and white pigments, remnants of a fiber dance-costume; height, 69 cm

Tetela masks are very rare and were generally collected long ago. The majority of known Tetela masks have numerous notchings, highlighted in white, decorating the entire face.

The great Songye people who live just south of the Tetela, seem to have influenced the unusual forms of this mask. The face is structured by four carved bands of black and white squares, one at the level of the eyes, a second centered between nose and mouth, the other two framing the sizeable chin.

The fiber attachments recall – as, indeed, does the mask itself – the abundant production of Luba "white masks," which are also formally related to Songye masks. This is a reason for questioning the Tetela origin of the piece.　J.C.

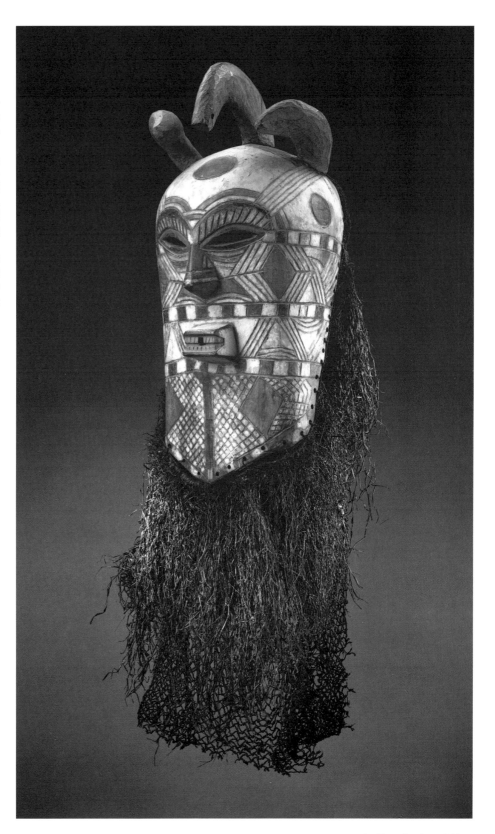

The Songye

The Songye are a numerous, dynamic people inhabiting an extensive region through which flows the Lomami River, a tributary of the Zaire. Political administration lies mainly in the hands of a central authority who is assisted by a body of civil servants. In addition, there are religious societies, the best known being the Bukishi. The primary objective of these societies is the cultivation of traditional customs. Sorcery plays a considerable role in Songye society; in fact, the *munki,* power figures and other power-charged objects are much more important than ancestral effigies.

Though extremely numerous, Songye works generally exhibit the same rather narrowly defined set of artistic conventions and aesthetic features. Olbrechts writes: "It is not possible to establish a boundary separating the Songye and the Luba style." Other authors have also seen stylistic affinities between the Songye and the Luba; Neyt maintains that the headrest, the caryatid seat, decorated shields, and other objects were introduced to the Songye by itinerant craftsmen, sometimes coming from localized groups like the Nsapo-Nsapo and the Lulua, sometimes from larger cultures like the Luba.

The Songye sculptures usually represent a standing male figure. Power-charged substances are either placed in gazelle horns inserted into the head of the figure or are added to a cavity in the body. The potency of these power-charged substances, called *bi-jimba,* may be increased through the addition of other materials, animal skins, or snake skins that clothe the figure.

It has been suggested that the best known of Songye masks, the *kifwebe,* is a largely commercial product with little or no authentic tradition. The first masks of this type were collected in the 1920s, and some had never been worn (examples in Tervueren).

On a stylistic level, it is difficult to distinguish the sculptures of the central Songye (Kalebwe) from those made by the eastern Songye. The majority of Songye sculptures in Western collections are of Kalebwe origin. It is interesting to note that, according to van Overbergh, the eastern Songye criticized the Kalebwe for letting themselves be overly influenced by the Luba. A. M. V.

Lit.: Cornet, 1972, p. 238; Olbrechts, 1959, p. 75; Neyt, 1981, p. 266; Hersak, 1985; Overbergh, 1908.

169 Figure

Songye, Zaire

Wood, beads, and metal pendants, leather;
height, 64 cm

This female figure was subsequently masculinized. The face is typical of a particular Songye substyle characterized by the treatment of the mouth. The Songye used to shave off the hair, above the forehead, as seen here. In addition, the ears are characteristically carved as a prolongation of the line of the jaw. Scarifications on the breasts and around the navel are less typical of the particular Songye substyle. Other characteristic features are the very short arms, the stylization of the fingers, and the large feet.

J. C.

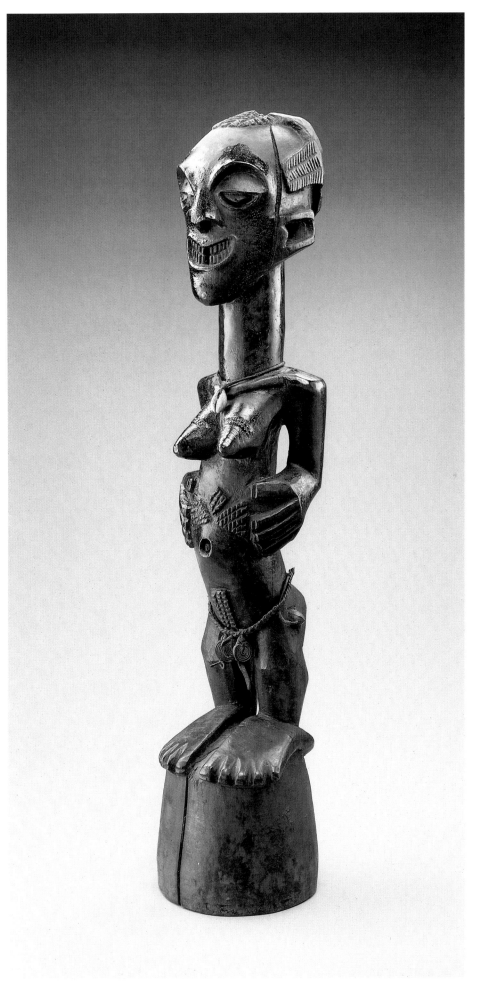

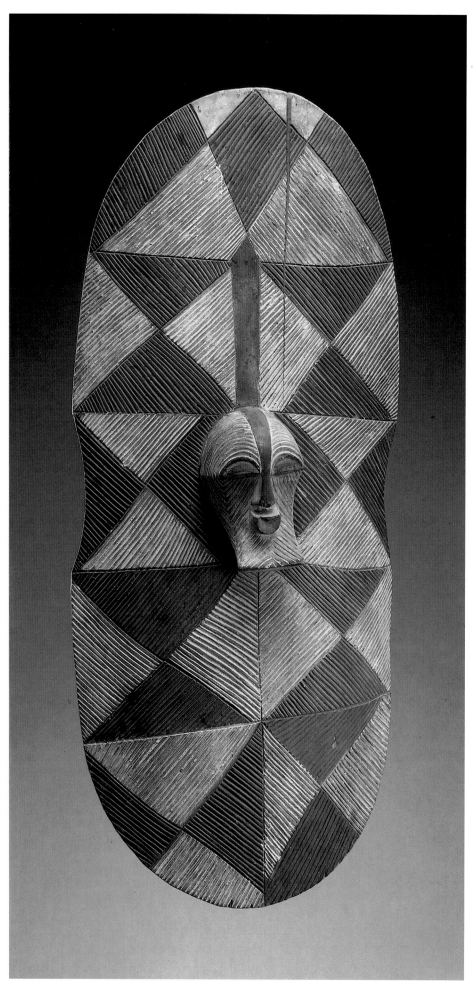

170 Shield

Songye, Zaire

Wood, black and white pigment; height, 76.5 cm

The Bwadi ka Kifwebe is a secret society that is especially strong in eastern Songye territory. It possesses special huts where masks are kept. On the walls are hung variously shaped wooden shields, at the centers of which are found miniature representations of masks. These miniature masks act as guardians of the hut.

The sculptor has admirably transposed the most characteristic volumes of the large masks, namely, the rounded mass of the skull, continued in the concave face, the mouth in relief, and the nose, which is extended upward by a black stripe that optically links the mask to the shield, which is patterned with large hatched triangles. J. C.

171 Mask

Songye, Zaire

Wood, traces of white pigment; height, 34 cm

The *kifwebe* mask is the representation of a spirit, and is usually worn with a fiber costume. Mestach points out that this type of mask comes from the right bank of the Lomami, from a region extending to the Luba border. The Luba are known to possess striated white masks that are quite similar, though more harshly geometric.

This example, made of very hard wood, approximates the classic type, in which eye sockets, nose, and mouth are especially emphasized by markedly geometric shapes. The striated decoration is also the rule. Since it lacks a crest, the mask is probably female, an interpretation confirmed by the white coloring of the multiple striations. J.C.

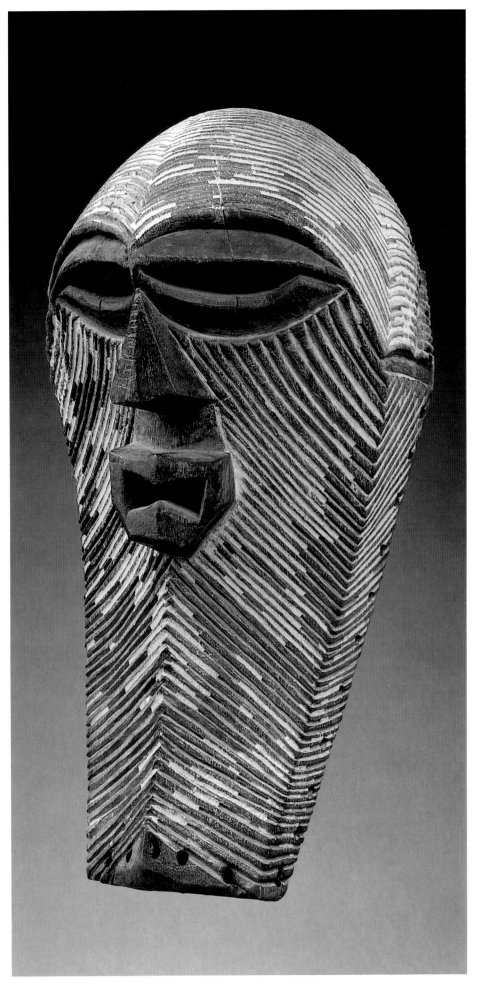

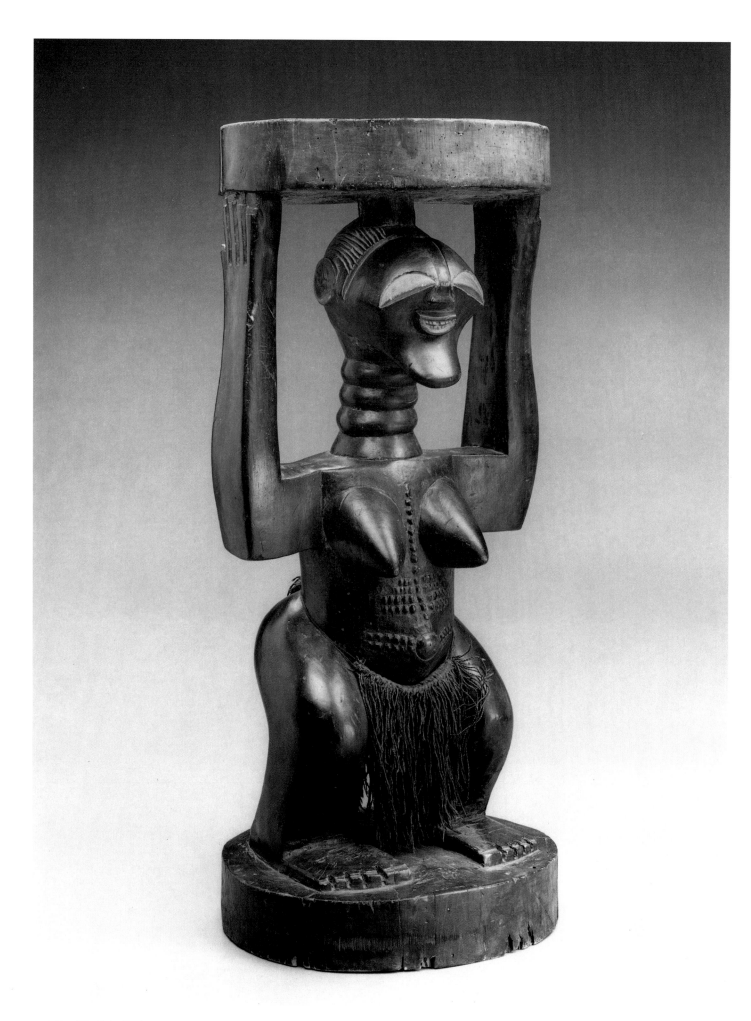

172 Chief's Stool

Songye, Zaire

Wood, traces of black and white pigment, fiber;
height, 69 cm

Caryatid stools are found over the whole of
southeastern Zaire, the most famous being those
of the Luba and the Hemba. They have exerted a
wide influence, as seen in this example of a rare
Songye seat.

The work is of an extraordinary freedom and
inventiveness. As is usually the case, the figure
is female, and the sturdiness of her body is re-
lated to the function of supporting the seat.

The head is a remarkable plastic creation, with
the eyes and the mouth (located high up on the
face, above a long chin) carved in an unusual
fashion. Though the arms are summarily rough-
hewn, the treatment of the breast and the qual-
ity of the many scarifications are worthy of
note. The powerful legs and pelvis give the fig-
ure a sturdiness rarely found in this type of
sculpture. J. C.

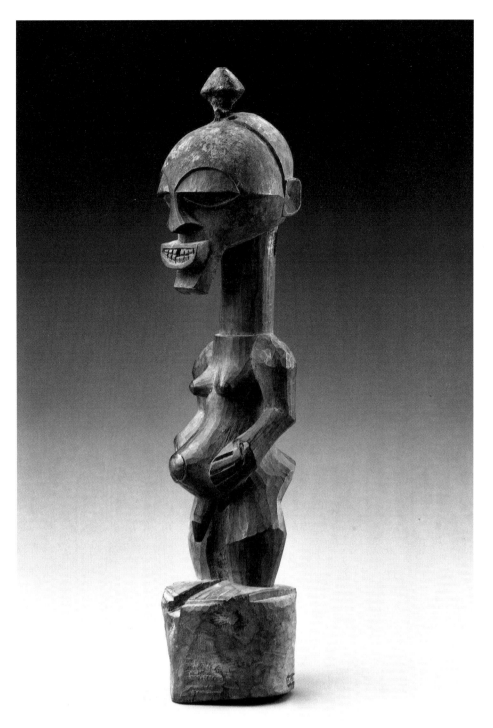

173 Power Figure

Songye, Zaire

Wood, traces of white pigment, metal nails;
height, 25.5 cm

An obvious link exists between the shape of
masks and the analogous forms seen in the faces
and heads of figurative sculpture. Sculpture
found in Western collections often lacks the
magically charged additive materials that once
adorned them. In fact, a ritual specialist is cus-
tomarily asked to deactivate or neutralize the
power of a figure by ceremonially tearing off its
insignia of power before it is turned over to a
foreign art enthusiast.

The figure is often surmounted by a horn,
which is an important factor in its effectiveness.
Sometimes, as in Lulua figures, the sculptor
stresses the navel as the prime receptacle of cos-
mic forces. The overdeveloped breasts of this
male figure are not an indication of hermaph-
roditism, but merely for plastic effect. J. C.

The Luba and Luba-Influenced Ethnic Groups

The great Luba people is divided linguistically into three subgroups: the Luba of the Kasai, the Luba of Katanga, and the Luba-Hemba.

The Luba kingdom is said to have been founded – when, is uncertain – by the legendary hero Kalala Ilunga. According to legend, he annexed lands of the Chief Kongolo, who had founded a kingdom on the left bank of the Lualaba River and united a number of small Bantu chieftaincies, thereby creating the embryo of what was to become the Luba empire. After Kalala Ilunga, the king, called *bulopwe*, was considered a divine figure possessing supernatural powers.

Fig. 82 Luba chief, sitting on a caryatid stool. (Photo: From Rätzel, 1887, p. 552)

Beginning in the eighteenth century, the Luba colonized neighboring lands. In the Kasai, they moved toward the Sankuru River and subsequently southward toward Kamina on the left bank of the Lomami, where they are known as the Shankadi Luba. They also greatly influenced the peoples living along the northern Zaire, who became known as the Luba-Hemba (a term designating the eastern Luba, not the Hemba strictly speaking, who have been studied by Neyt). However, as Cornet has pointed out, these names are imprecise, since in reality boundary lines do not exist and the cultural histories of these various populations are inextricably tangled.

This intermixing is no less evident in artistic styles. Even though the famous *kifwebe* masks with striated faces (a strictly Songye example is included here, pl. 167), are also known among the Luba, Neyt says that "a study of the ethnomorphology of the masks, of the language used by the Luba in songs and *kifwebe* rituals, and of arguments from oral traditions all clearly demonstrate that these masks have a Songye origin." Was the *bulopwe* Kongolo, whose domain was taken over by the founder of the Luba empire, perhaps of Songye origin? There are also oral traditions associating the royal family with the Kunda ethnic group, itself part of the Boyo, whose magnificent statues seem to be a link between Luba-Hemba art and the art of the Bembe. Neyt also mentions categories of objects that indicate original cultural development within an ethnic group: the large Boyo and Hemba statues, the janiform Hemba figure *kabeja makua*, and the Shankadi *mboko* bowls. The extent of Luba influence can be well gauged by the distribution of typical artefacts, such as the caryatid seat (fig. 82).

Delicately modeled curvilinear forms and a serenity of expression characterize the art of Luba peoples, as described by Olbrechts: "Most Luba sculptures enchant the viewer with their charm, distinction, and gentleness. The figures are usually either standing or seated with introspective-looking, heavy lidded eyes. The sculptors seem to have realized that the grave, hieratic appearance of these sculptures is, in its immobility, far more moving than any gesture or dramatic, spectacular expression." A. M. V.

Lit.: Cornet, 1972, p. 192; Neyt, 1981; p. 236f.; Olbrechts, 1959, p. 66.

174 Bow Stand

Luba-Hemba, Zaire

Wood, metal; total height: 107 cm; height of figure: 67 cm

Just as the Luba epic, the *kasala*, preserves the memory of words and images of generations long past, so the Luba-Hemba bow stand embodies symbols with multiple meanings that go back to the beginnings of history. Kalala Ilunga, founding hero of the *kasala*, is the eminent hunter to whom this bow stand refers.

The Luba-Hemba have two types of bow stands, one of wood, the other of metal; the metal stand is made of three or more branches without iconographic decoration. These stands are found in southern Luba country, and as far as Lake Banguelo and Lake Malawi, areas inhabited by the Bemba, the Unga, and the Bisa, who say that stands of this type are of Luba origin. They are also found further north in the Maniéma area, among the Boyo. The bow stand would thus seem to be an artefact with a long historical tradition.

Chief Kifwa, from the Ankoro district at the mouth of the Luvua, possessed metal bow stands called *lwanda lwa kilonda* ("bow and arrow receptacle, or support") or *kitanda kya masala*, a [bow and arrow] bed of feathers (made from sacred red parrot feathers).

Religious symbolism is found not only in the red parrot feathers but also in the fact that the stands were placed on the graves of the kings, and were wrapped in matting to hide them from view when a chief went on a journey. They were an important sign of royal power and were carefully guarded, in special houses, by hereditary guards. The bow stand was sometimes placed in front of the chief's residence at nightfall, more to ward off evil spirits than to protect against potential enemies.

On the bow stand shown here, the eternal Luba woman stands beneath the trident decorated with triangular motifs; in her mien can be seen the wisdom that dwells behind the great arch of her domed forehead. As the mother, she symbolizes fertility for her people, visible in the lozenge scarifications that surround her navel and through the representation of genitals beneath the curving *mikoono* scarifications. A series of *malonda* lozenges covers the shoulder blades, lower back, and ankles. Everything about her signifies life: she is the mother, the unifier and source of her people, here presiding over symbols of hunting, power, and the sacred.

F. N.

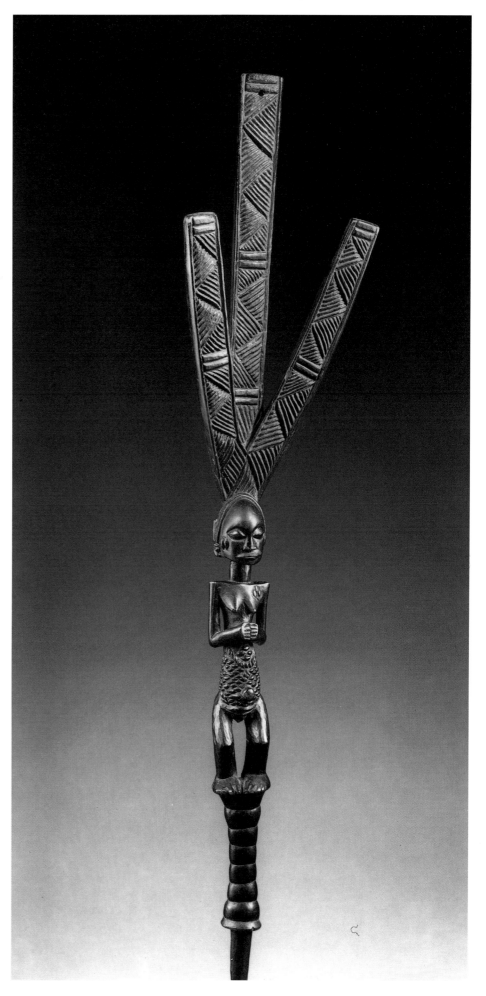

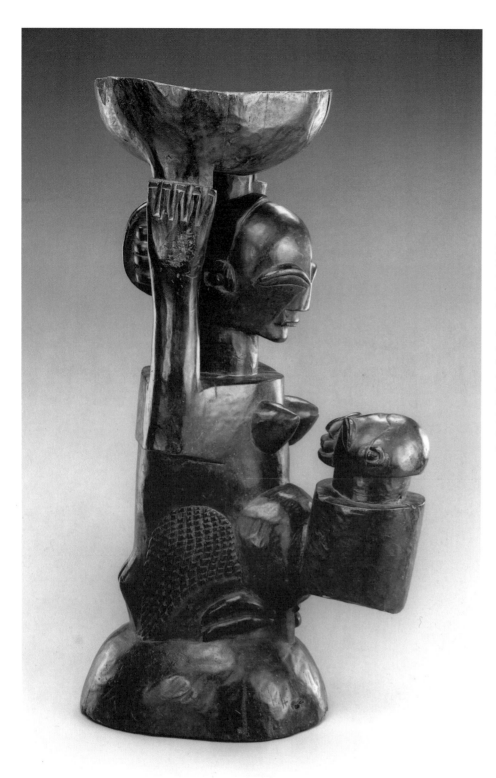

form on any other piece – signifies the profound sense of continuity provided by the Luba mother.

The Luba-Shankadi have produced a great many female figures carrying bowls, the famous *mboko*, with a carved child's head serving as the lid. And the mother-and-child theme, on ancestral statues and caryatid stools, is known not only among the Luba-Shankadi and the Luba-Hemba but also among their immediate neighbors, the Songye.

The work shown here, probably carved in ricinodendron, is the product of a sculptor's workshop that is easily identifiable from a pair of ancestor-figures, two caryatid stools, and a pipe in the Musée Royale de l'Afrique Centrale in Tervueren. As Richard Burton pointed out, this style derives from the village of Katompe in the chieftaincy of Paye, on the northern borders of Luba territory. The cruciform hairstyle, with four vertical bands running over four horizontal ones, is a sign of high-ranking status. Right-angles define neck, shoulders, and arms. The overlarge eyes are surmounted by protruding eyebrows. The prominent mouth is reminiscent of Songye practice. On the cylindrical trunk with its conical breasts, the scarifications – lozenge-shaped (*malonda*) or elongated and curving (*mikoono*) – emphasize the importance of fertility in the Luba culture. F. N.

175 Caryatid Stool

Luba-Hemba, Zaire

Wood; height, 62.8 cm

The woman plays an important role in Luba society. In this striking and unusual sculpture, the child leaves its mother's belly only to turn resolutely toward her. The sculptor has grasped, and given expression to, the profound tie that binds mother and child in every Luba family. The mother is more than the giver of life, she is the figure to whom all turn to find their human and cultural identity.

The presence of the female figure on caryatid stools (*kihona*) verifies the importance of women in Luba society. In this context the female figure brings her clan and family together under the chief's authority. She watches over personal relations, listens to people's problems, resolves conflicts. The baby seeking his mother's guidance in this sculpture could almost be the chief himself; in fact, the maternal uncle or sometimes the woman herself – especially among the Kunda – makes the decisions in the village.

In this sculpture, from a very old French collection, the child's presence – unknown in this

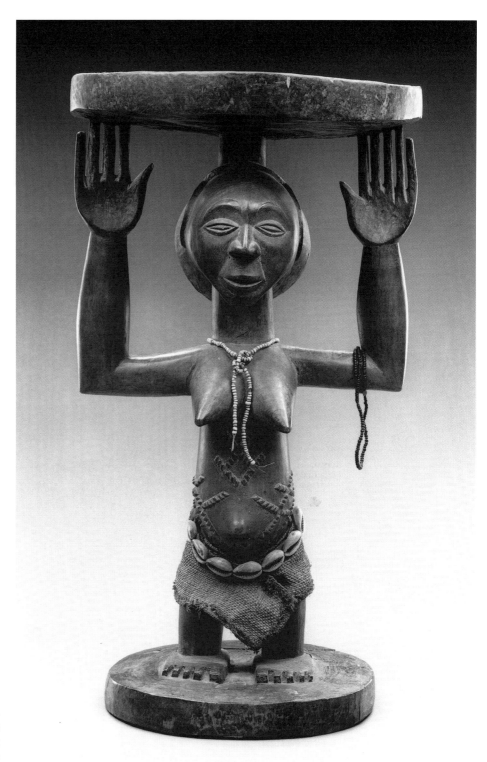

176 Caryatid Stool

Hemba, Zaire

Wood, beads, cowries, raffia cloth; height, 44.5 cm

This majestic figure of a woman emanates wisdom for all of her children who come before her to receive justice; the primordial woman, her palms turned forward, bears the weight of governmental authority and responsibility for her clan.

In the eighteenth and nineteenth centuries the Luba empire expanded, and the distribution of female caryatid stools marks the boundaries of this expansion. They are found among the Kanyok and the Chokwe to the west and south, among the Hemba, the Bangubangu, the Zula, and the Zimba in the northern part of the Shaba, and in the Maniéma, still further east, as far as the shores of Lake Tanganyika. In every village and clan, the caryatid seat demonstrates that all authority goes back to the Luba king and, through him, to the female who is the source of life.

Sculpture workshops are numerous and sculpted works abound along the banks of the Lukuga, which flows from Lake Tanganyika to the Zaire. North of the Lukuga, prestigious ancestor figures can be found sleeping in the shadows of Hemba houses. The women sculpted on caryatid stools neither kneel nor crouch, they stand in sovereign dignity, enhancing the chief's authority by their presence. Below almond-shaped eyes, the prominent mouth is open to enunciate the Word. The coiffure featuring a central, circular bun, emphasizes high social rank.

The arms and the long hands, suggestive of the famous *buli* style, form, with the seat, a large square, which evokes the stability of established authority. The load is convincingly distributed through the body and down to the sturdy legs.

Bead necklace, scarifications, and cowrie shell belt enhance the prestige of this symbol of symbols, the very origin of clan and family, the means of transmitting vitality and power from generation to generation. Here woman gives concrete form to the meaning of honor and justice, and life and death. F. N.

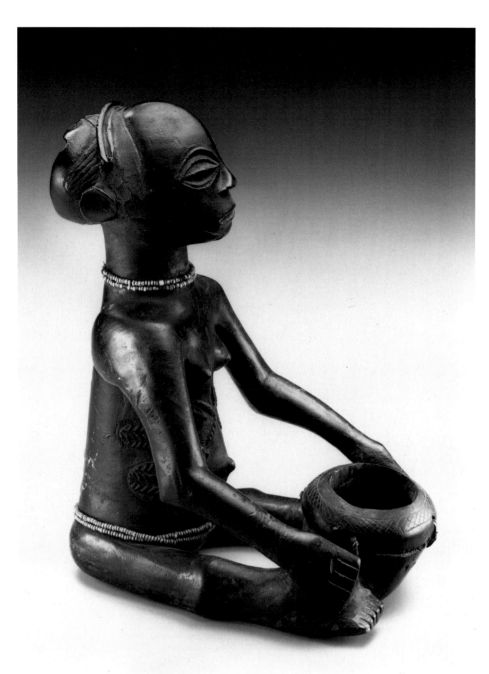

transport her to the celestial crossroads of tradition and ancestral spirits, where she interprets signs which foretell the waxing and waning of political power and prosperity. Perhaps it is not too fanciful to suppose that this crossroads is symbolized by the cruciform coiffure turned towards the east. F. N.

177 Figure with a Ceremonial Bowl
Luba-Hemba, Zaire

Wood, beads, metal ring; height, 28 cm

The woman is seated directly on the ground, holding a sacred vessel between her hands and legs. Her social standing among the Luba-Hemba is attested by the cruciform coiffure, the diadem complemented on the left side (the side of female descent) by a row of beads and a metal ring, the chains around neck and waist, and the rhomboid scarification reliefs.

The face has a grave, even dramatic, intensity. The eyes are open in order to impart a sacred gaze upon those who came to her. The vessel, inspired by the gourd in the myth of origins, has the form of a full-bodied bowl; it is the sacred vessel of the spirit that presides over power, *vidye wa bulopwe*. The white earth it once con-

tained came from the great spirits. The mere possession of the ceremonial bowl (*mboko*) is a sign that its owner has been chosen by the spirit, the *vidye*, since "the chief and the spirit are to each other as husband and wife."

The image of the woman holding a bowl is used chiefly in divination, in which the spirit takes possession of the chief. The chief's mother and her descendants frequently watch over the divination; in this way, she secretly exercises her religious ascendance over political power, which she tempers according to the will of the spirits. Not surprisingly, the woman carrying the bowl is associated with fertility, birth, the new moon, and blood.

The Luba woman holding the sacred vessel sits at the intersection of the world's events. On evenings of the new moon, she calls upon the *vidye* spirits, who take possession of her and

178 Ancestor Figure

Hemba, Zaire

Wood, raffia; height, 75.5 cm

Jealously guarded, the ancestor stands in the gloom of the funeral building, which has the shape of a beehive, or of a chief's mausoleum. Firmly planted on his legs, he has his hands on his bulbous belly near the navel, in a veiled evocation of the transmission of life through the woman and, above all, of the tie of blood indicated by the umbilical cord. The noble head, with its strong, domed forehead, is the dwelling-place of spirit and wisdom. The four-part cruciform hairstyle is held up by a square of raffia; bearing the imprint of the major styles of the southern Niembo, it emphasizes the high princely rank of the great Hemba families of the Mbulula region. The face is refined and distinguished, framed by a diadem decorated with lozenges and a finely sculpted narrow beard. The mouth is carefully traced; the aquiline nose extends the plane of the forehead and transects the eyebrows, which are carved in the form of arches to give added importance to the eyes.

The eyes, closed to this ephemeral world, are open to the invisible realities of the present and the future. The owner of the statue softly calls his ancestors by name when he venerates them and offers them the required propitiation through the intermediary of the spirits of the janiform power figure *kabeja*. Thus each ancestor is named, counted, and situated in time and in the history of his family. Some princely families possessed as many as ten or twenty of these funeral effigies. While prayers and invocations were meant to link spiritual and metaphysical realities, they also served as praise, intercession, and supplication to protect and watch over the family and its possessions; the ancestors were understood as so many notches on a genealogical tree, emphasizing the family's great nobility, its prosperity, its right to possess the lands that it cultivated as its own. Hence, the effigy is part of a system of worship founded upon both belief in an afterlife and a system of kinship and property. F. N.

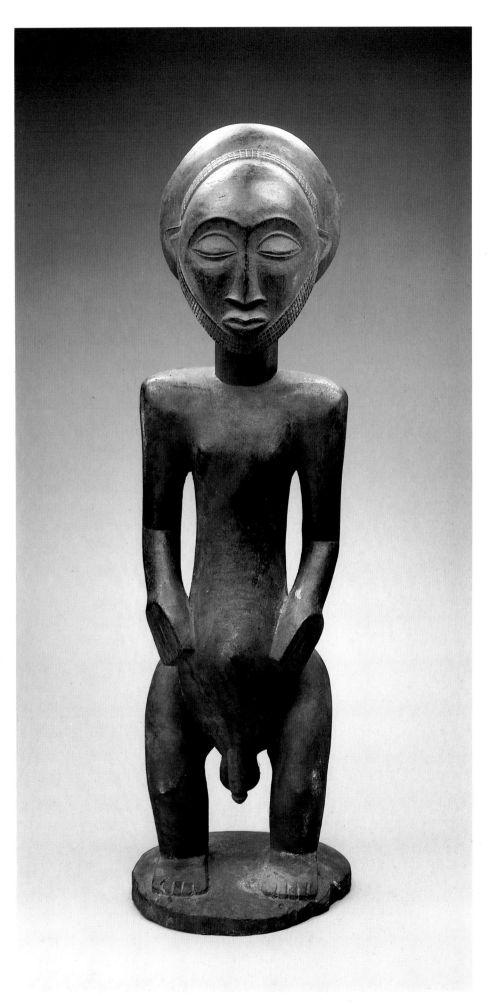

The Tabwa

The Tabwa are a broadly defined ethnic group numbering approximately 200,000 who live mainly in eastern Zaire and Zambia, in the areas bordering Lake Tanganyika. Their rich cultural history and visual arts reflect contacts with larger neighboring groups, such as the Luba, in both style and object type. The Tabwa utilized a great variety of sculptural forms. These include figures, masks, decorated implements of various kinds, and musical instruments.

E. M. M.

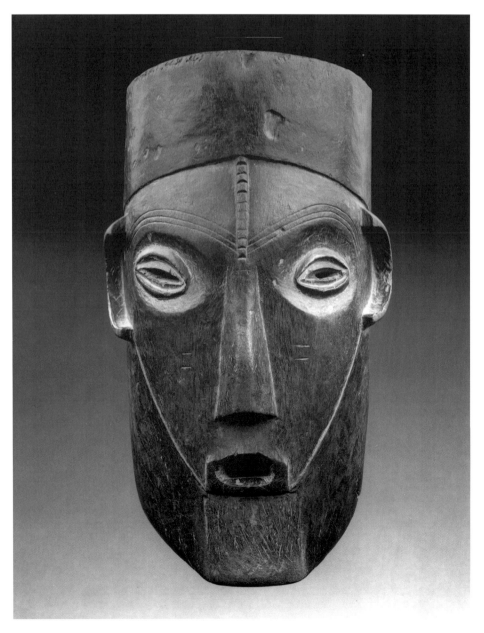

179 Mask

Tabwa (?), Zaire

Wood and pigment; height, 32 cm

While the overall shape of this mask is different from the few documented Tabwa anthropomorphic face masks, certain elements of its physiognomy and decoration do support an attribution to this broadly defined ethnic group, whose sculpture is characterized by a variety of representational styles. The oval eyes, shaped like coffee beans or cowrie shells, are typical of Tabwa sculptures, as are the long, triangular nose, the open, pursed mouth, and the C-shaped ears. Another distinctive Tabwa characteristic is the elaborate facial scarification pattern, consisting of a line down the center of the forehead, one line across the brow, and lines connecting the ears to the corners of the mouth. The most individual aspects of the mask are the square plane of the chin and the round, flat-topped cap that is evidence of an acculturated sartorial fashion borrowed from the important Islamic presence in this part of Africa.

E. M. M.

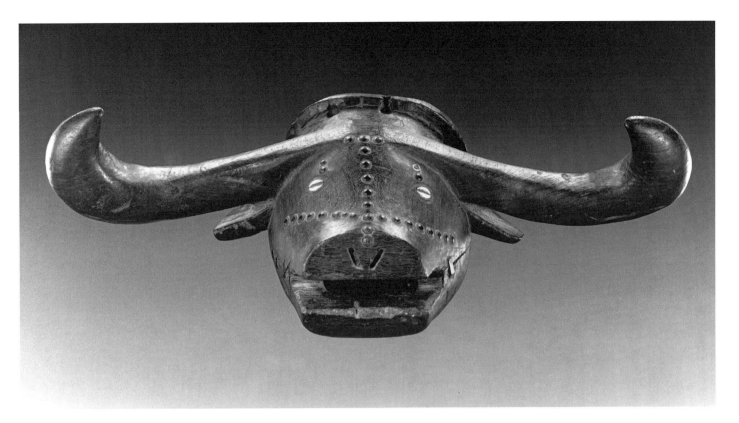

180 Buffalo Mask

Tabwa, Zaire

Wood, cowrie shells, and nails; width, 73 cm

This sculptural evocation of the buffalo's agressive power and grace is one of approximately fifteen masks of the type collected among the Tabwa. The buffalo is the only animal depicted in Tabwa masks and may personify male power as a counterpart to the female presence of the even rarer anthropomorphic masks. Frequently hunted during the nineteenth century, the buffalo has a rich and varied role in Tabwa culture. This prime example of the standard form emphasizes the expression of power through the thick neck, massive head, and widely curving horns typical of the African buffalo. The open mouth and flared nostrils are another observed characteristic of alertness and agression. The intense, hypnotic stare common to Tabwa buffalo masks is achieved by using large, white cowrie shells to represent the eyes. A star-shaped pattern of brass tacks down the forehead and across the face refers to facial scarification designs popularly used by men and women until the beginning of the present century. Field photographs show that the mask is held in front of the face, while the dancer's body is covered with a thick costume of raffia and animal pelts (see fig. 74, p. 232). E. M. M.

Lit.: Maurer, 1985, pp. 162-63, 252-53, pl. 53a, no. 227.

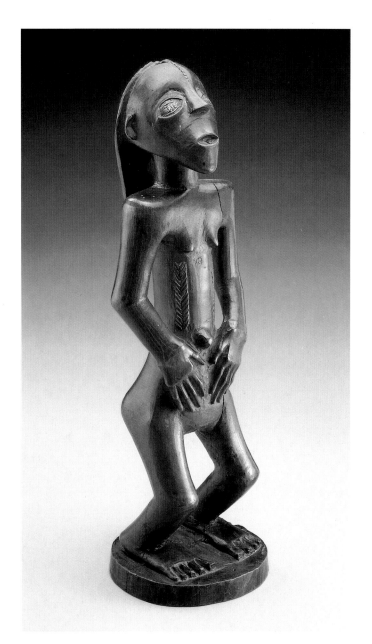

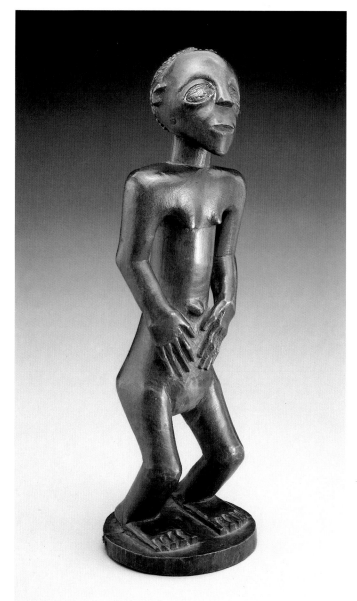

181/182 Pair of Figures

Tabwa, Zaire

Wood and brass wire; heights, 32 cm (no. 181) and 30 cm (no. 182)

Pairs of figures are often found in Tabwa sculpture, ranging from the famous images of Kansabala and his wife taken as military trophies by Emile Storms in 1884 to the more conventionally anthropomorphic couple in the Metropolitan Museum of Art. As ancestor figures (*mikisi mihasi*), these figures represent the archetypal man and woman, the principal characters of a chief's lineage. Most pairs therefore personify male and female, husband and wife, a gender identification made difficult in the present case by the lack of defined sexual organs. As Tabwa sculptors customarily included an anatomically detailed representation of the figure's sex, it may be assumed that these pieces have had their sexual parts removed to avoid offending the sensibilities of Western collectors. A clue to the gender of the figures may be found in the coiffures, which were well known for their elaborate decoration. The round, cap style was worn by all women and some men, while the elaborately braided pendant-tress seems to have been the prerogative of men. With its long triangular pendant of hair, the larger of the two present figures is thus the male, who also has personal decorations consisting of a line of scarification down the middle of the forehead and a row of chevron-shaped scars arranged vertically beneath the right breast. This pattern is a variant of the design known as *balamwezi*, a serial arrangement of regular triangles used as the basic Tabwa symbolic design on virtually all of their objects and on their bodies. *Balamwezi* means "the rising of the new moon," a phrase that characterizes the difficult decisions that must be taken in everyday life and their reflection in the larger aspects of the world. The sculptor who carved this pair of figures possessed a quite individual style that emphasized the upward tilt of the expressively carved head and the unusually well articulated fingers and toes. The sense of liveliness produced by these features is reinforced by the deeply sprung knees and the powerful legs of the dancer. E. M. M.

Lit.: Maurer, 1985, pls. 7, 8, 14, 15, no. 61.

The Bembe

The patrilineal Bembe, who live mainly in the highland savannas west of Lake Tanganyika, are related historically to the Lega. As they migrated westward, they incorporated and assimilated numerous influences from preestablished groups (known as pre-Bembe) of diverse origin, such as the Pygmies, archaic Bantu, Binji, Lunda, and Luba. The many regional diversities of Bembe culture also affect the distribution of artworks. The major art-sponsoring and art-using institutions include the ancestral lineage cult, water spirit cults, voluntary associations such as Alunga (fig. 83), Rlanda, and Bwami, and the young men's circumcision rites. D. P. B.

Fig. 83 Initiate of the Alunga society explaining the symbolism of the *echwaboka* mask. (Photo: P. P. Gossiaux, c. 1970)

183 Mask
Bembe, Zaire

Wood and pigment (lower section probably cut off following damage); height, 24 cm

This plankboard mask, called *eluba* or *emangungu*, is one variety of a type used in young men's puberty rites *(butende)* among southwestern Bembe groups. The mask is worn fixed on top of a large banana leaf and banana bark-strip costume, or is sometimes attached to a cone-shaped hat of bark. During the seclusion period, young initiates don the mask when they pay incognito visits to the village to beg for food. In parts of southern Bembe country similar shieldlike masks were attached to offering tables on which libations were made to deceased relatives. D. P. B.

Lit.: Biebuyck, 1972, pp. 79-80, and 1981, pp. 24-27.

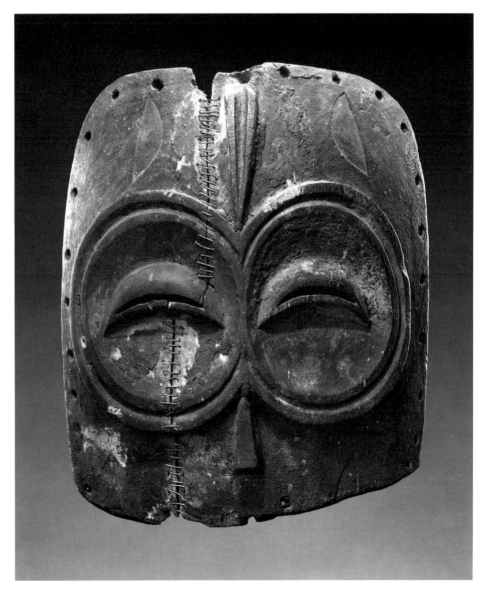

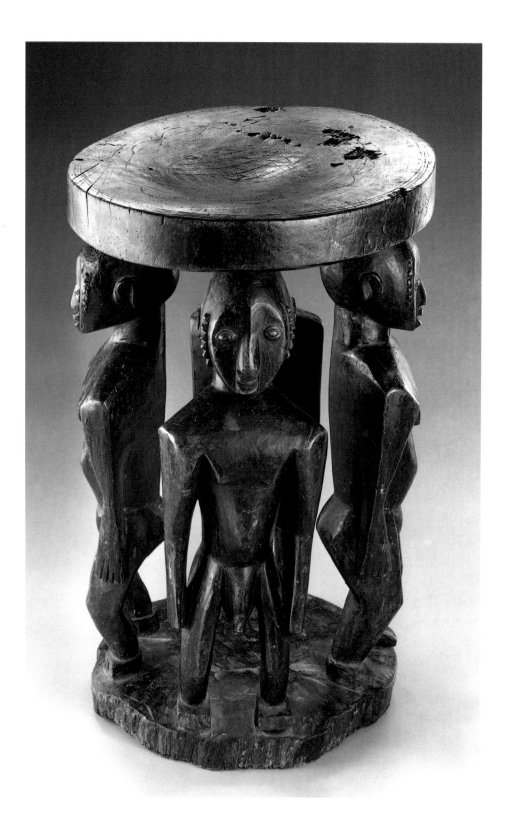

184 Caryatid Stool
Pre-Bembe (?), Zaire

Wood; height, 55 cm

Many of the morphological features of this stool (for example, the heart-shaped concave faces, the angular bodies, and the two slightly concave spheres interconnected by four supports) point to an area where Lega, Bembe, and pre-Bembe artistic traditions intermingle. This type of stool, referred to as *kihoma*, belonged among the paraphernalia of autonomous chiefs. D. P. B.

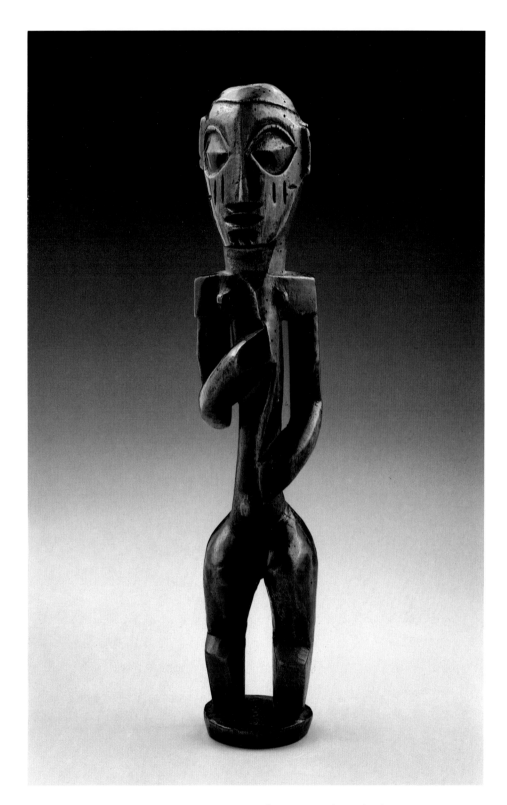

185 Figure

Bembe, Zaire

Wood; height, 27.7 cm

The angular, standing figure shows the large, oval-shaped eye sockets, slit eyes, and asymmetrical arm arrangement typical of Bembe and pre-Bembe statuary. The tight skullcap, in very low relief, indicates that this sculpture may be linked with the Bwami association, which exists among the Lega, Bembe, and other groups in eastern Zaire. This type of figure, called *ase'a* and made of wood and sometimes ivory, appears at the highest levels (*bukila bwa ngwe* and *biciba*) of the Bwami initiations as an illustration of legal and moral principles. The figures are owned by the male incumbents of the supreme grades.

D. P. B.

Lit.: Biebuyck, 1972, 1981, and 1986, pp. 221-27.

The Lega

The Lega, who live in the forest regions of eastern Zaire, have a sophisticated socio-ritual organization that is based on an extended set of patrilineal, affinal, and cognate individual and group relationships, as well as on male and female initiation into the voluntary association called Bwami (fig. 84). This association monopolizes the artistic production of the Lega people. Anthropomorphic, zoomorphic, and skeuomorphic artworks made of wood, ivory, bone, and other materials are used mainly as tools to convey initiation knowledge, as emblems of grade and seniority status, and as concrete expressions of solidarity and continuity between living and dead initiates and groups of initiates. D. P. B.

Fig. 84 Public display of small masks of the Bwami society. (Photo: D. Biebuyck, 1952/1954)

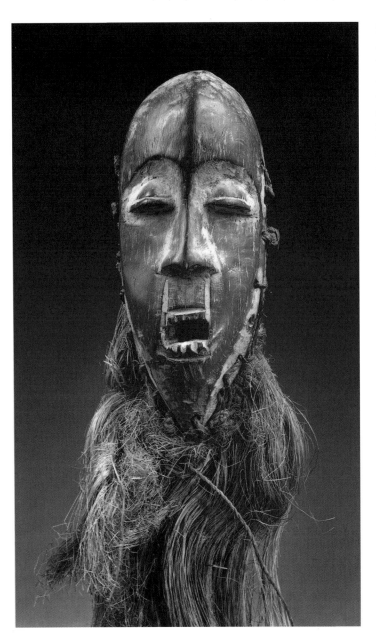

186 Mask
Lega, Zaire

Wood, pigment, and raffia fiber; height, 18 cm (without beard)

The oval-shaped mask with concave face has slit eyes, a prominent nose with a fine ridge, and an open mouth with an indication of teeth. A large fiber beard (*luzelu*) is attached to holes on the sides of the mask. Male initiates of the second highest grade (*lutumbo lwa yananio*) of the Bwami association own such wooden masks, which are called *lukwakongo*. They use them in numerous ways (held in the hand, under the chin, and so on, but not in front of the face) in several initiation rites. The mask is not named for a particular ancestor, but suggests death and the linkages between living and dead; the beards are symbolically associated with elders and senior initiates. D. P. B.

Lit.: Biebuyck, 1973, pp. 210-14, and 1986, pp. 128-50.

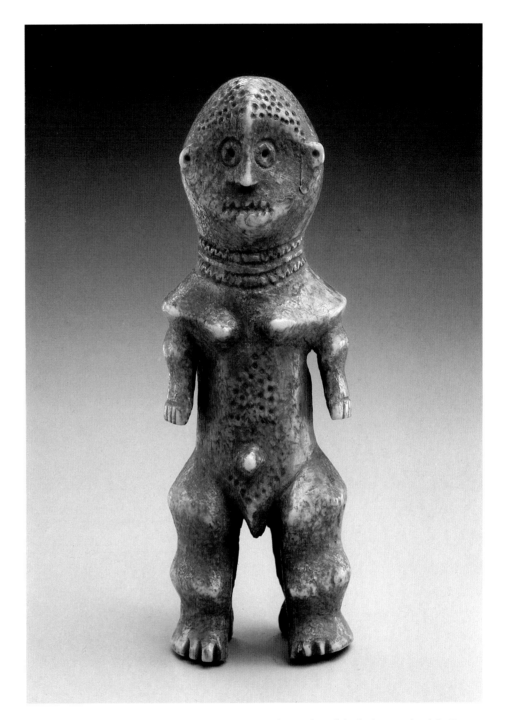

187 Figure
Lega, Zaire

Ivory; height, 15 cm

The standing figure, with short arms and an indication of small breasts, is reminiscent of a distinctive stylistic subgroup that is marked by rounded features. Such figures are owned by a male member of the highest grade of the Bwami association. Generically called *iginga*, their precise meaning is known only in the initiation context, in which they are always related in a positive or negative formulation to the value system of the association. D. P. B.

Lit.: Biebuyck, 1973, pp. 218-20, and 1986, pp. 39-98.

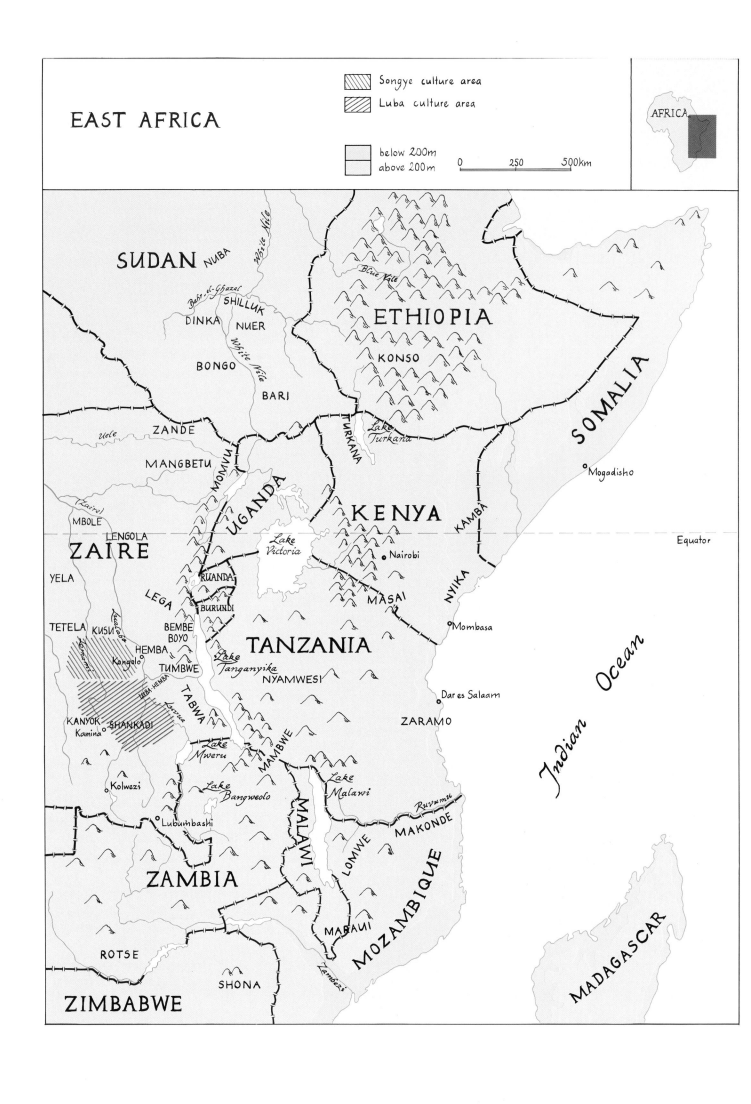

EAST AFRICA

Songye culture area
Luba culture area

below 200m
above 200m

0 250 500km

AFRICA

SUDAN NUBA

White Nile

Bahr-el-Ghazal SHILLUK

DINKA NUER

White Nile

BONGO

BARI

Blue Nile

ETHIOPIA

KONSO

SOMALIA

Uele ZANDE

MANGBETU

Lake Turkana

TURKANA

Mogadisho

(Zaire)

MBOLE

LENGOLA

ZAIRE

YELA

LEGA

KENYA

Nairobi

KAMBA

NYIKA

Equator

RUANDA

BURUNDI

Lualaba KUSU

TETELA

Lomami

BEMBE
BOYO

HEMBA

Kangolo

TUMBWE

Lake Tanganyika

TANZANIA

MASAI

Mombasa

Lualaba

LUBA-HEMBA

KANYOK SHANKADI

Kamina

TABWA

Luvua

NYAMWESI

Dar es Salaam

ZARAMO

Kolwezi

Lake Mweru

MAMBWE

Lake Bangweolo

Lake Malawi

Ruvuma

LOMWE MAKONDE

Lubumbashi

ZAMBIA

MALAWI

MOZAMBIQUE

Indian Ocean

ROTSE

MARAUI

Zambezi

SHONA

ZIMBABWE

MADAGASCAR

Enrico Castelli and Gaetano Speranza

East Africa

Most anthologies of African sculpture limit their analyses to West Africa and the Zaire (Congo) Basin, though they may make a brief excursion to Angola and the borders of Tanzania in order to include the Chokwe and the Tabwa, and present a Makonde mask, a Zulu statue, or a Madagascar effigy post in their final pages. This approach suggests that there are regions where sculptural output has been less abundant and of poorer quality. This apparent poverty has been attributed to the influences of the pastoral Nilotic and Kushite populations that not only did not produce sculpture, but also scorned any activity not related either to raising livestock or waging war; or to the influence of Islam, which imposes strictly abstract forms on the visual arts; or to wars and migrations, which impeded the consolidation of cultural and plastic models; or to the slavery that destroyed or debilitated entire cultural areas. These elements have certainly been determinants in the history of East Africa; but the conclusions usually drawn from them need to be reconsidered.

The problem presented by the region is not so much the absence or poverty of its artistic expressions as the small number of studies devoted to the artistic attitudes prevailing there. In Europe, since the beginning of the twentieth century, "African art" has been essentially identified with sculpture, while the study of oral traditions, traditional music, dance, architecture, and even of the "lesser" arts, such as pottery, beadwork, basketry, and weaving, have been either totally neglected or left to specialists. In this "artistically depressed" region, however, such forms of expression are of fundamental importance, and studies devoted to the region's culture cannot ignore them. And, even in the field of sculpture, a careful analysis of museum records and bibliographic information reveals a varied production that is, it should be emphasized, of excellent quality. We need only look, for example, at the exceptional Bongo effigy post (pl. 194) and the astonishing ax handle from Malawi (pl. 200).

The region in question is immense, extending from the desert fringes of the eastern Sahara, along the edges of the Equatorial Forest, and as far as the Zambezi in the south. Ethnically it presents a great variety, since the principal African stocks are represented here: Bantu, eastern Sudanese, Nilotic, Kushite, and Pygmy. Its chief characteristic, however, is that it is a region of mixed cultures. Here more than elsewhere different cultures have converged, and here more than elsewhere the conflict between nomads and sedentary peoples goes back to ancient times, and the variety of cultural and artistic production is much greater. Within the region, three style zones may be distinguished, though we cannot speak of complete homogeneity within each. Beginning in the west, the first zone comprises the territories of northern Zaire, the Central African Republic, and southern Sudan; the second stretches from southern Sudan and Ethiopia across Uganda and Kenya to Tanzania; the third begins in southeastern Zaire and extends through Tanzania and Malawi to Mozambique.

The first zone is characterized by the confluence of eastern Sudanese culture and the Bantu culture of the Zaire Basin. Northern Zaire is also included in this zone because of the presence there of Sudanese populations that have, in successive waves, superimposed themselves upon the autochthonous Bantu populations, whom they have frequently dominated.

Both linguistic and cultural factors link the basin of the Bahr-el-Ghazal, inhabited by the Bongo, to those of the Ouelle, inhabited by the Zande (fig. 85), the Mangbetu, and the Boa, and of the Oubangui, inhabited by the Nzakara, the Ngbandi, and the Ngbaka. Among the most ancient works of these ethnic groups, familiar since the last

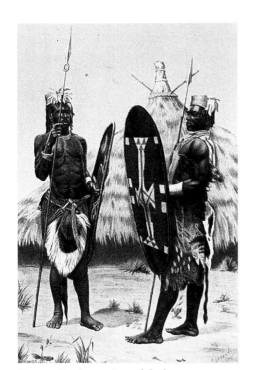

Fig. 85 Zande warriors of the last century. (Photo: From Rätzel, 1887, facing p. 526)

century, the great Bongo anthropomorphic statues should be cited, along with the sculpted harps of the Zande and the carvings of the Mangbetu; also important are a number of everyday objects sketched after 1870 by Schweinfurth, who first used the term "African art" with reference to the artistic production of this region. Alongside the production of what might be called "classical" works, new and unfamiliar object types appeared at the beginning of this century: the masks and figures associated with the spread of the secret Mani sect in Zande territory; anthropomorphic Mangbetu terra-cottas; figures of characteristically angular style found on Sudanese territory and attributed to the Zande.

Instead of proceeding through an enumeration of styles found in this region, it seems preferable to draw attention to a few aspects of particular interest.

The Bongo present the typical case of a rich sculptural production that is only occasionally featured in publications on African art. In addition to the better-known memorial effigies (to which we shall return), we should remember their great horns, used to project the voice, which often have one end sculpted in the shape of a head; also, their elegant stools, their whittled pipes, and their rich output of iron work.

The sculpture of the Mangbetu (Ngbetu) presents a stylistic homogeneity that has made them for us the most famous of the populations of northern Zaire. Their clearly defined artistic code permits no doubt about the identification of their figural production, yet it does not shackle individual expression in the least. Able to test their skills on a variety of objects, such as harps with soundboxes made of bark and elaborate knife handles with large-scale figuration, Mangbetu artists have exercised complete freedom of expression in disposition of volumes, in fineness of workmanship in even the smallest of objects, and in the clever use of patina to accentuate shapes. In the absence of masks in Mangbetu output it is possible to see a confirmation of their roots in Sudanese culture.

The sculpted harps found in a zone extending from northern Zaire to Gabon raise questions of possible influences between different centers of production. Especially in the case of Zande harps (fig. 86), most scholars maintain that they are derived, like most of Zande sculpture, from that of the Mangbetu; this argument reflects the generally held theory of Kongolese influence, through the Mangbetu, on all sculpture of the region. There is, however, a rich variety of local styles, ranging from the most detailed realism to the most extreme stylization, as among the Nzakara of the Central African Republic; Mangbetu style, as has already been mentioned, seems much more uniform and codified. Moreover, while Zande harps are surmounted by a sculpted head, Mangbetu harps also present a complete human figure (pl. 189) as the handle, and it is puzzling that the Zande should have followed only one of the models offered by their Mangbetu neighbors. On this subject, it is worth noting that insignia staffs surmounted only by a sculpted head are known not only among the Zande themselves but also among other eastern Sudanese and Nilotic peoples.[1] Thus, as an explanation of the stylistic origin of Zande harp sculpture, the hypothesis of Kongolese influence that passed indirectly through the Mangbetu might plausibly be replaced by one that assigns the Zande to the Sudanese cultural sphere.

Another question about the plastic art of the region is posed by the appearance in the course of this century of the "Yanda" sculpture characteristic of the Mani initiatory sect, anthropomorphic figures and highly stylized masks that have no association whatever with the "classical" formal expression of Zande art. Different interpretations have been offered to explain this stylistic opposition. According to one view, the classical sculpture was produced for use by the aristocracy (vungara) and was thus a court art, while Yanda sculptures appear to be more "popular" productions, stemming from a movement opposed to the dominant nobility. The interpretation of Father Cornet, however, emphasizes the predominance throughout Africa of "abstract" representations in works consecrated to impersonal forces; according to this theory, the figures in question represent and borrow the name of Yanda, the sect's protector spirit.

The second stylistic zone reflects the cultural hegemony established by Nilotic and Kushite herdsmen, in the course of their migrations southward, over the sedentary populations of Bantu origin. Beginning in the White Nile Basin, this zone extends across the entire region of the Great Lakes, reaching into Kenya and Tanzania in the southeast. The disdain found in every pastoral population for any manual activity not

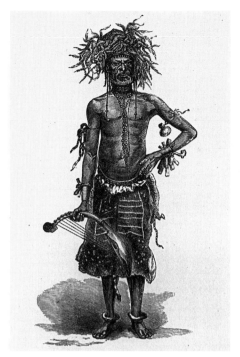

Fig. 86 Itinerant Zande singer with his characteristic harp, decorated with a sculpted human head. (Photo: From Schweinfurth, 1873, vol. I, p. 413)

1 One could cite, for example, the staffs of the Bari or the Lotuko, who were not subjected to Kongolese influence.
2 The ethnographic literature provides considerable evidence of tombs surmounted by notched poles, which are found as far away as Zaire and Chad; in the Sudan, they are found among the Bari, the Abukaya, the Acholi, the Lango, the Mittu, etc. (see Seligman, 1932).
3 Leuzinger (1959, pl. 62) records two stake figures cut off at the level of the chest.

Fig. 87 Shilluk pipe from the Upper Nile. Terra-cotta and skin. Length, 24 cm. Barbier-Mueller Collection

Fig. 88 Tomb with anthropomorphic memorial effigies in the Bahr-el-Ghazal region (Upper Nile). (Photo: From Schweinfurth, 1873, vol. I, p. 275)

Fig. 89 Anthropomorphic memorial effigies of the Konso of Ethiopia. (Photo: E. Castelli)

directly related to cattle-raising was often carried over in to agricultural cultures, and hindered artisan families and especially smiths, the usual focal points of plastic traditions, from achieving the independence and power that they enjoy in western parts of the continent. Among Nilotic peoples body and facial painting, scarification, hair ornamentation, the use of headgear and feathers, all constitute important fields of artistic expression; examples include the splendid Lotuko and Masai hairstyles, and the chignons of the Turkana and the Suk: quantities of clay are worked into the hair, sun-dried, and dyed. Wood sculpture is not unknown – we might mention the variously shaped headrests, containers, staffs, and so on – but figural sculpture is practically nonexistent, save for some exceptions like calabash masks, the zoomorphic pipes of the Shilluk (fig. 87), and other, rarer examples of sculptured heads.

In contrast, an amazing figural output is found among certain sedentary populations either of Kushite language, such as the Konso of Ethiopia, or of Bantu origin, such as the Nyika groups of Kenya, whose production is so concentrated on vertically oriented sculptures that Eckhart von Sydow has termed this regional sculpture "pole-type" or "tree-type" (Pfahlplastik, Baumplastik). We shall look at two interesting points in connection with these sculptures: first, their group organization as a set of funeral monuments with a clearly enumerative function; second, their continuity or discontinuity across different zones of influence.

The stake memorials take one of two forms: they are either groups of forked poles with notches cut in them, such as are found among Sudanese peoples everywhere, or they are human figures set up in single rows, such as are found especially among the Bongo, the Konso, and the Nyika (fig. 88). As Schweinfurth first demonstrated with respect to the Bongo, the notches on the pole represent either the number of animals owned by the deceased or the quantity of game he had killed. Among the Konso, the personages beside the central figure of the deceased represent his wives and the enemies he has killed, while the slain animals lie at his feet.[2] The Nyika only erect an effigy of the deceased on his tomb; but if the family group migrates, they set up a new effigy of the deceased in the new settlement, surrounded by smaller representations of his wives and children. Today, the only traces of the spatial arrangement of these monuments are to be found in archaeological and ethnographic records, and the only pieces found in museums or in publications on African art are isolated stake elements; such a presentation both obscures their role as the enumerative representatives of the deceased's power and, from an aesthetic point of view, deprives them of the undeniable formal value that stems from their being grouped together.

The hypothesis of a certain cultural homogeneity of these funeral monuments (fig. 89) might appear to be supported by factors such as their compositional complexity and enumerative character, both found in a very widespread region stretching as far as the Sara of Chad.[3] Nevertheless, certain stylistic differences should be mentioned, such as the Nyika's plank-shaped funeral sculptures (fig. 90) and their use of triangular frieze decorations, a characteristic also found in the funeral sculpture of Madagascar, which was subject to Indonesian influence. Traces of ancient megalithic sculptures are found all along the geographical band that stretches across Africa from

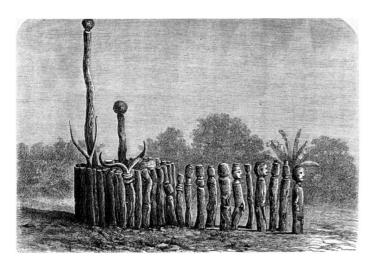

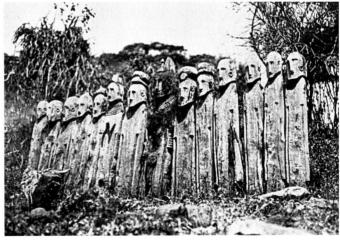

southern Ethiopia to the Mauritanian desert;[4] the most important of these is the group of about ten thousand phallic monoliths, ranging from one to five meters in height, found in southern Ethiopia. These fragments are also arranged in a single row, raising the possibility that the wooden funeral monuments described above might be derived from similar megalithic groups that have been lost in African prehistory.

The third stylistic zone, long peopled by the Bantu, links southeastern Zaire, through Tanzania, Zambia, and Malawi, with Mozambique, the Zambezi river forming its southern border. It presents a variegated ethnic picture as a result of historical events. The pressure of eastern Nilotic and Hamitic populations coming from the north, with the attendant conquests and migrations, was felt throughout the entire zone and had consequences that extended beyond the line of the Zambezi. The zone was also traversed by ancient trade routes linking the coast of the Indian Ocean to the region of the Great Lakes and the jungles of Zaire. Various wares were transported along these routes; shells and glass trinkets were carried from east to west, while ivory in particular traveled in the opposite direction. Carried on by Arab merchants from Zanzibar, this trade had grown tremendously by the end of the nineteenth century, completely altering the areas through which it passed. Along the entire length of these ancient trading routes are found numerous traces of stylistic affinities linking Kongolese Luba and Tabwa sculpture to the Nyamwesi, the Hehe and the Zaramo of Tanzania, to the Lomwe and the Maraui of Malawi, and finally to the Yao and the Makonde of Mozambique.[5] Concrete examples of this continuity are provided by the examination of a number of specific objects.

Similar workmanship is found in the Tabwa, Nyamwesi, and Hehe high-backed chairs made from single pieces of wood and embellished with geometric decorations and human figures in low or high relief. Representations of the human – especially the female-figure present morphological characteristics that are linked in a continuous chain from the Luba and the Tabwa to the peoples of Malawi; thus, typical features of Lomwe and Maraui figures – shoulders thrust forward, arm positions, thin legs and arms, protruding posterior – are also found in Tabwa sculpture. The calabashes, horns, and staffs used in traditional medicine, surmounted by sculpted heads or complete human figures, are found all along a coastal zone inhabited by the Mawia, the Makonde, the Zaramo, and the Nyika; these objects present formal characteristics resembling those of analogous Tabwa and Luba objects. And the image of two superimposed human figures, one carrying the other on its shoulders, is found among the Makonde as well as among the Hemba, the Kusu, and the Tabwa.

The objects presented in this section are not intended to constitute an exhaustive iconographic documentation of the region. Rather, it is hoped that they will increase awareness of the existence of a varied East African sculpture of great quality, and will serve to illustrate some of the intriguing questions raised by this art.

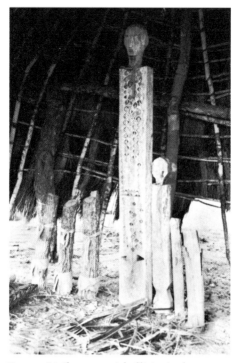

Fig. 90 Nyika memorial effigies in the coastal region of Kenya. (Photo: E. Castelli)

4 The westernmost of the stone funeral monuments has been found in the Mauritanian desert; its central stone is the highest (see H. Nowak, S. Ortner, and D. Ortner, *Felsbilder der spanischen Sahara* [Graz, 1975]).

5 Objects are also found in the region which constitute exceptions to this "stylistic affinity," such as the famous, though rare, metal animals found in the last century in the kingdom of the Karagwe.

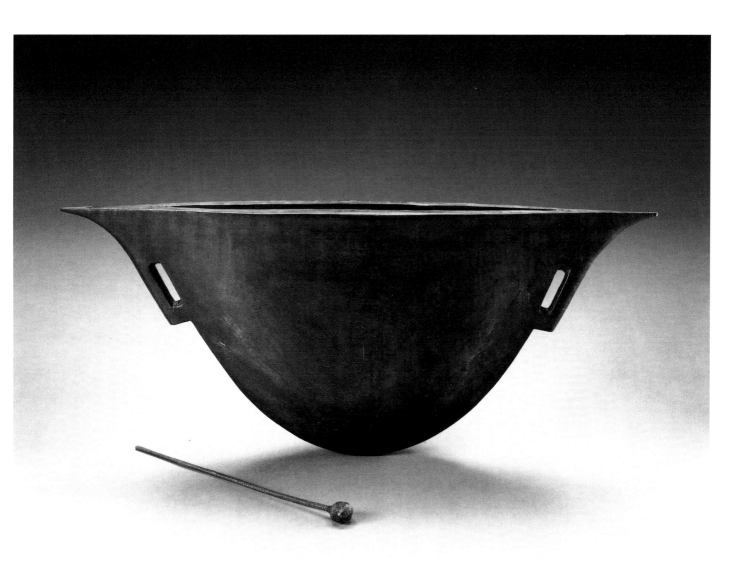

188 Slit Gong

Momvu, Northeastern Zaire

Wood; 36×81×15 cm

The two symmetrical sides of this gong, when struck with the rubber-covered wooden mallet, produce tones of the same pitch. This was a portable instrument, suspended from the player's shoulder by a strap passing through one or two rectangular handles; it could thus be struck on one side only. Another type of slit gong, placed on the ground, could be struck on both sides and produced tones of different pitch.

Portable gongs were used by groups of players who followed military expeditions to provide communication. They are known throughout Zaire, different shapes being found in different regions.

Momvu drums have a squat bell shape that ends in two tapered points; they have two rectangular handles, unlike the portable drums of the neighboring Mangbetu, which have a similar shape but lack the tapered ends, and have only a single handle at the apex of the bell.

E. C./G. S.

Lit.: Boone, 1951; Baumann, 1927; Maes, 1912.

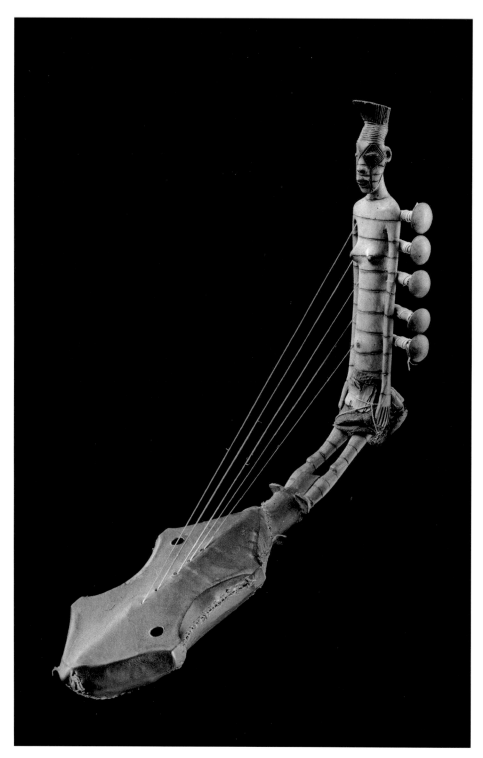

189 Five-string Arched Harp

Mangbetu, Northeastern Zaire

Wood with fibers, leather, bark; length, 68 cm

The wooden, lozenge-shaped sounding box has rounded ends and concave sides; it has a skin diaphragm on the underside. An arched wooden neck, the lower section of which is also covered with skin, is inserted into the sounding box. Five wooden pegs tighten the strings (restored), which are fastened to a tail-piece of inlaid wood, under the skin, against a sounding board pierced by two small, circular sound holes.

The human figure constituting the scroll of the instrument is treated with remarkable realism, underlined by the use of a fiber and bark cloth (*negwe*) skirt.

The elongated bust supports a head whose artificially extended skull ends in the coiffure typical of women of high rank.

Pyrograved lines represent the variety of geometrical body ornamentation customary among the Mangbetu. The arms hang freely from the body, and the eyes are accentuated by hatching that echoes the bold angles of the coiffure. E. C./G. S.

190 Figure

Mangbetu, Northeastern Zaire

Wood, beads; height, 61.7 cm

Mangbetu figures are not numerous. The refinement of their forms indicate that they were intended for the nobility, though their specific purpose is unknown.

This sculpture offers a particularly beautiful example of this classic art. No acute angle interrupts the flow of the different parts as they delicately succeed each other: chest, elbows, navel, knees, calves, all play their part in the metrical composition, anatomical precision being a subordinate consideration. The weft of very fine incisions enhances the formal unity of the sculpture.

Two features of this work not usually found in Mangbetu sculpture are the bulging eyes with glass beads and the angular treatment of the arms and legs, although these characteristics are also found in the magnificent double-headed harp in the Rietburg Museum in Zurich. In fact, a number of other analogies between these two sculptures could be pointed out, e.g., the same volumetric treatment of the head, the pointed chin, the flat nose above a small mouth, the particular way of relating the ears to the hair. Such analogies suggest that both works are by the same hand or, at least, from the same workshop.

E. C./G. S.

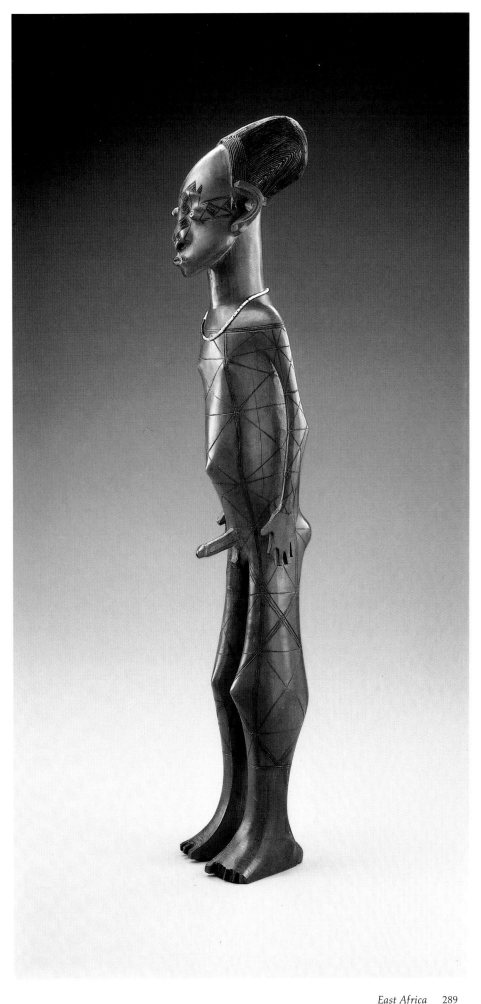

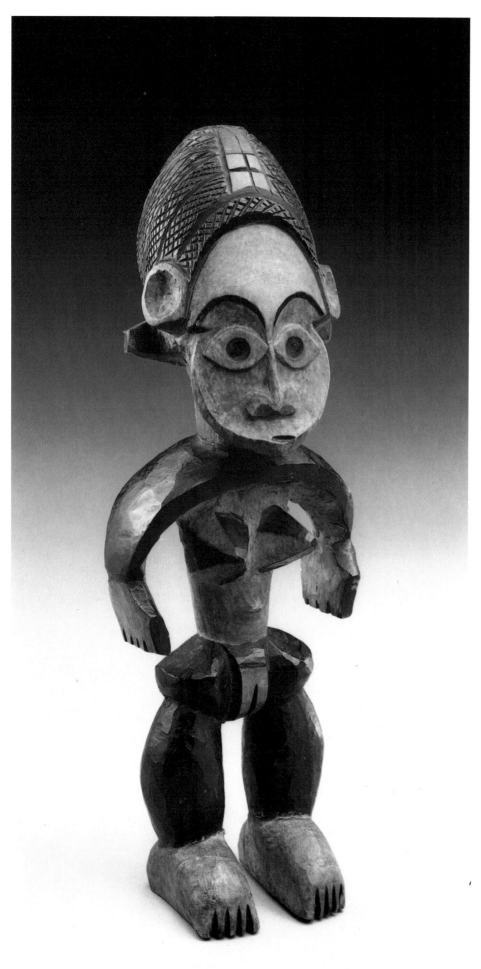

191 Figure

Zande, Northeastern Zaire

Wood, black pigment; height, 22 cm

This type of sculpture appeared at the beginning of the century (a similar one is in the Pitt Rivers Museum, Oxford); its center of production was probably the Sudanese part of Zande territory. Stylistically, the figures are characterized by an alternation of light and dark surfaces that accentuates the rhythm of the volumes; they are radically different from classic Zande sculpture, exemplified by the representation of human heads on harp necks.

This specimen harmoniously combines all the elements of the style. It has a lightly hollowed face ending in a very small mouth, which contrasts with the large eyes; these, in turn, are accentuated by the broad curve of the eyebrows. The ears are located above the level of the eyes and are contiguous with the helmet-type coiffure, which ends in a kind of flat slab at the back.

The body is composed, with no great regard for realism, of an assemblage of shapes. Arms and shoulders form a single mass, while the upper part of the trunk, with its pyramid-shaped breasts, is clearly differentiated from the block of the pelvis. E. C./G. S.

192 Figure

Zande, Northeastern Zaire

Wood, red pigment, beads; height, 11.7 cm

The Mani initiatory sect, which originated in the Congo River area, spread through the entire Zande cultural area in the early years of the twentieth century. Its expansion was opposed by the Zande princes and the colonial powers because it was sympathetic to social change and fired feelings of revolt among those sectors of the population that had always been excluded from the exercise of power, for example, women, who were allowed to participate in the meetings of the sect.

The term *yanda* was used to designate both the protecting spirit of the sect and its wooden figures, which are anthropomorphic and, less frequently, zoomorphic.

All the characteristic elements of the type are found in this balanced sculpture: shrunken legs, often replaced by a conical base, a cylindrical body, a pronounced navel, an abundance of beads or metal rings. A broad furrow runs over the head; on either side, cylindrical elements simulating ears allow for the application of glass beads. Frontal ridges on the trunk represent arms, framing and emphasizing the protruding navel that is the central feature of the composition. E. C./G. S.

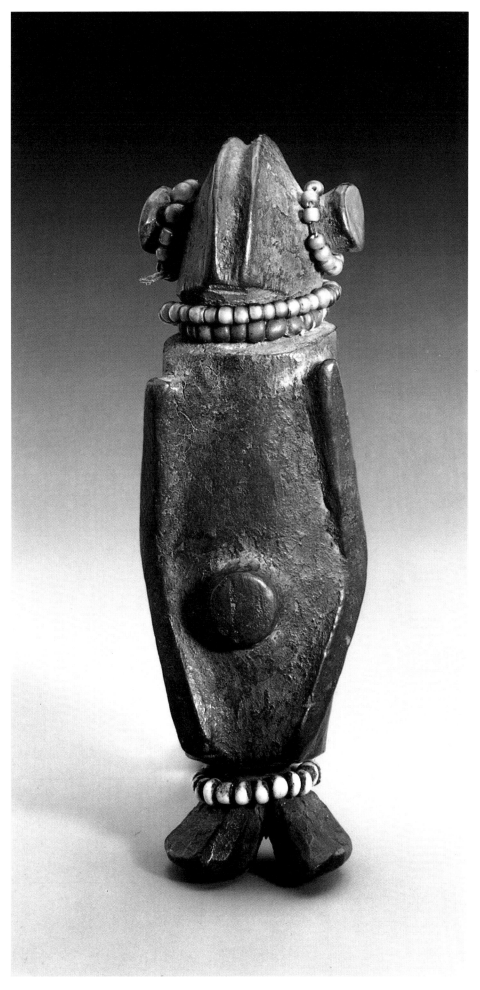

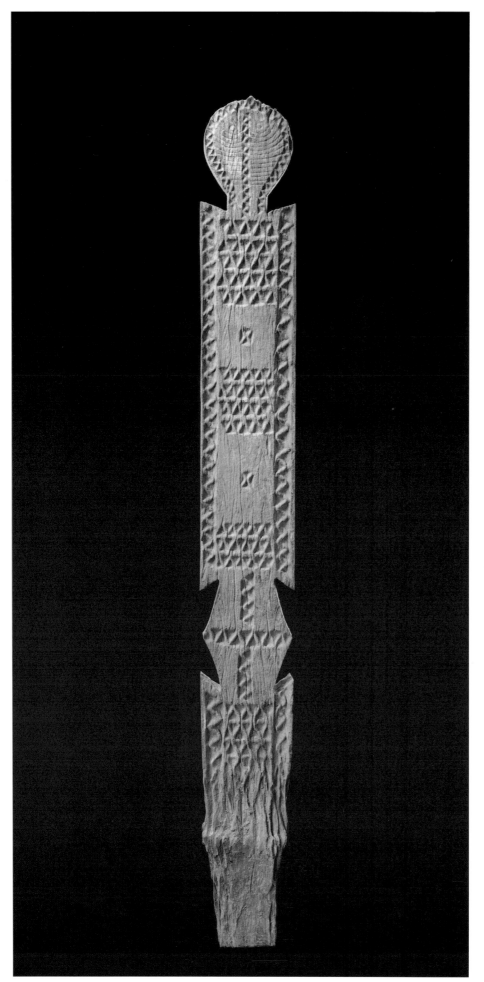

193 Memorial Effigy

Nyika (Chonyi), Kenya

Wood; height, 154.5 cm

Memorial effigies are found in interior regions of Kenya among all the Bantu populations of the Nyika group, which includes the Chonyi, the Kauma, the Ribe, the Gyriama, the Duruma, the Pokomo, and the Kamba. The zigzag patterns carved in low relief on the surface of this sculpture are characteristic of the style of the Chonyi, to whom this work can be attributed.

The markedly geometric composition is further refined by the sharp angles that define the surfaces. The figure is divided into sections which are freely adapted from the human form. The alternation of carved motifs and flat surfaces is found in a different rhythm on the back.

The head, which has the only curved lines of the whole figure, ends elegantly in a point. The eyes are only faintly indicated above the concentric grooves that make up the face; grooves also appear on the reverse side, parallel to the edge and ending at the neck, as though they represented hair.

The erosion of the wood, the traces of white and yellow, the use of Western tools (saw and chisel), all suggest that this object was sculpted and erected between 1900 and 1920. E. C./G. S.

Lit.: Adamson, 1967; Champion, 1967; Kecskési, 1982, p. 400 f.

193

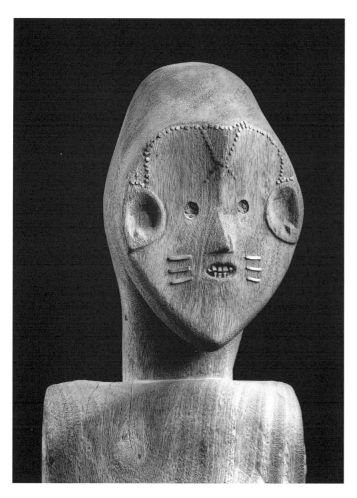

194 Memorial Effigy

Bongo, Sudan

Wood, metal; height, 200 cm

This memorial effigy representing an ancestor probably dates from the nineteenth century, before the Bongo, an ethnic group of the southern Sudan, were dispersed by Arab and Nubian raids. It shows traces of savanna fires, and the original surface of the outside of the arms are weathered.

The artist has forcefully represented the face on a slightly concave and heart-shaped surface, with hollowed-out ears, round eyes (originally with inlaid pupils), and a small mouth with metal teeth. Scarifications are reproduced with metal strips.

This expressive liberty taken by the artist accords harmoniously with the rest of the figure, which is treated with greater realism. The curve of the back, the gentle line of the body, with the navel barely indicated – all make up a balanced whole and endow the statue with an imposing charisma. Its elongated body is animated by the grain of the wood itself. A series of metal nails forms the contour of the hair, suggesting that the figure was originally decorated with a headdress. E. C./G. S.

Lit.: Kronenberg 1981; Schweinfurth, 1873 and 1875; Kecskési, 1982, p. 400 f.

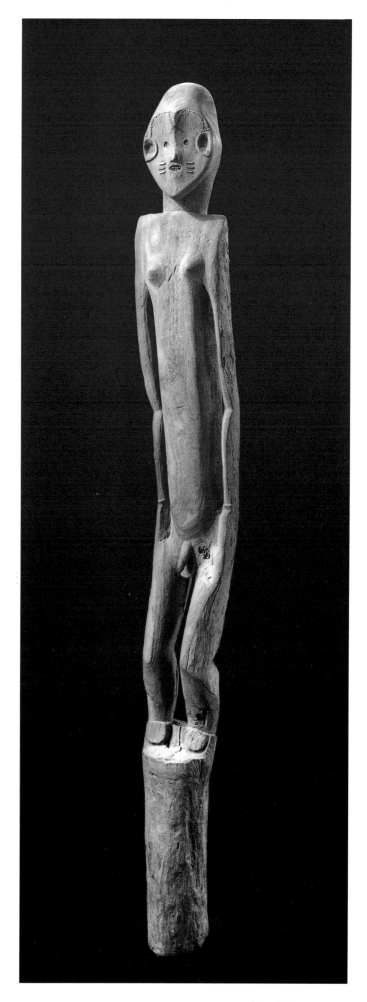

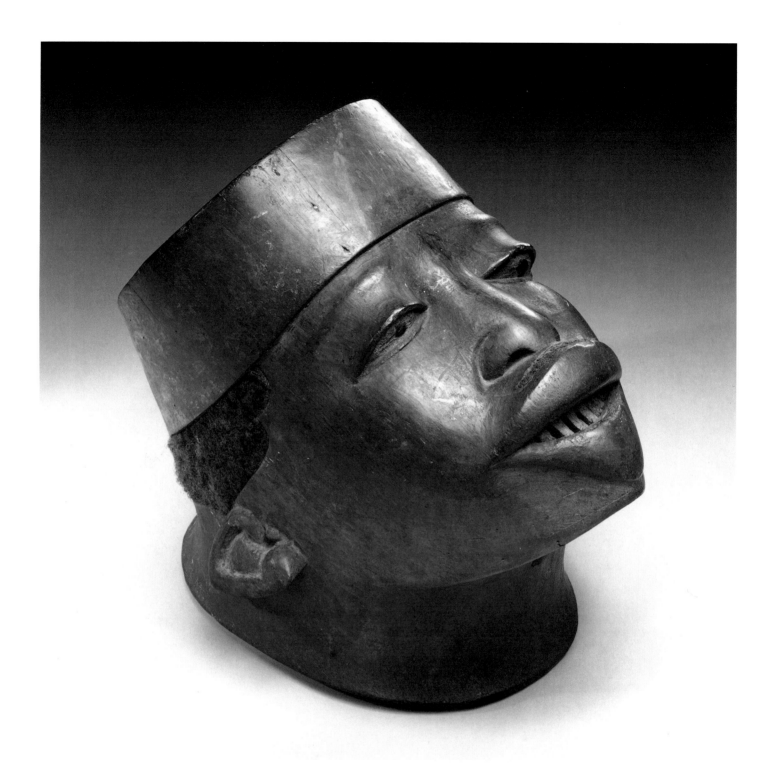

195 Helmet Mask

Makonde, Mozambique

Wood, pigment, wax, human hair; height, 30.5 cm

This helmet mask exemplifies the most recent type of traditional Makonde mask, a realistic and caricatural type. Until the 1960s, masks of this type (*lipiko*) were worn during male initiation festivals by a dancer who looked out through the mouth opening. A string passing through a hole in the back of the neck made it possible to attach the complicated costume that completely covered the dancer's body to the rim of the mask.

This specimen may represent a caricature of a Black convert to Islam, a strong and arrogant figure, emblematic of the conflicting relationships that opposed the Makonde to the emissaries of the merchants and Moslem slave traders along the coast. The typical tribal scarifications found on many pieces are absent.

The mask is made of a soft, lightweight wood, a material that allowed the inside of the object to be completely hollowed out with a long-handled knife.

The accentuation of the lips gives a strong expressive element to the mask. In contrast, the hair and moustache are actually made of human hair, and this realistic note is heightened by the finely rendered curve of the powerful neck, the deep and delicate incisions of the nostrils, and the sharp angle of the jaw. E. C./G. S.

Lit.: Dias, 1964.

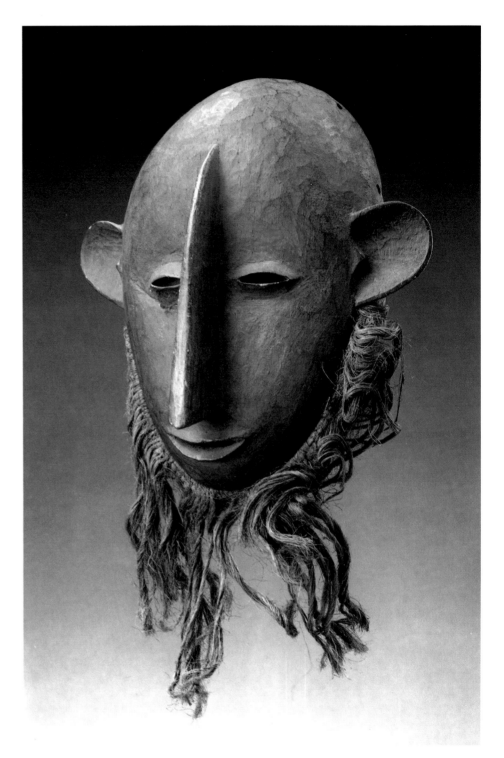

196 Mask

Makonde, Mozambique

Wood, red pigment, plant fiber, wax; height, 21.5 cm (without beard)

This type of mask was worn by the men during coming-of-age festivals. Though unquestionably of Makonde origin, it presents a number of unique characteristics. The oval shape is typical of the oldest known Makonde masks, but certain anatomical details found on other works of the same period are absent, for example, hair, eyelashes, and eyebrows; in addition, the long narrow shape of the eyes and mouth is uncommon; other Makonde masks have round eyes and a round mouth.

The convex oval shape of the mask is divided by the vertical bridge of the nose. The ears, set far apart, accentuate the lines of the sculpture through their geometric shape.

Two pieces of glass are fixed with wax in the eyeholes on the inside of the mask; wax has also been used to fill a cut in the mask at the level of the left eye. The beard of plant fibers is attached in a groove cut in the lower edge of the mask.

E. C./G. S.

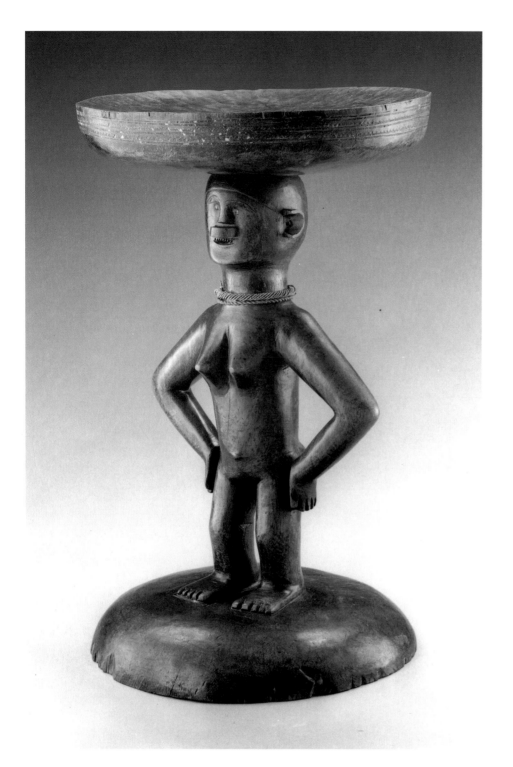

197 Caryatid Stool

Makonde, Mozambique

Wood, beads; height, 48 cm

The female figure of this caryatid stool presents a number of elements characteristic of Makonde sculpture, for example, the spherical head, the lip plate (*'ndona*), the scarifications on the temples, and the pierced ears.

The body of the figure, which is strictly vertical, acquires an even more powerful appearance from the lozenge shape formed by the arms, which counter-balance the seat that surmounts the figure's head. It should be noted that the hands do not touch the body, a feature that adds to the appeal of the sculpture, as does the fine decorative frieze of triangles along the edge of the seat. E. C./G. S.

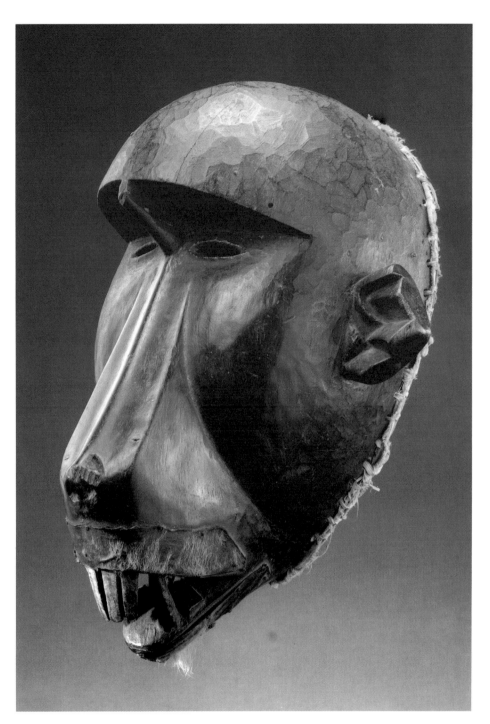

198 Mask
Makonde, Mozambique

Wood, skin, fibers; height, 24.8 cm

Since few monkey masks are known, the attribution of this one – apart from what is known about its acquisition – is based on the oval shape of the rim, the shape of the slightly protruding eyes (identical to those in plate 196), and the regular, parallel traces of cuts that can be seen on the inside. The treatment of the ear, however, constitutes a strange element, not found on any other known Makonde mask.

The extraordinary vigor of this face comes from the succession of flat and convex surfaces that start at the root of the nose; this vigor is emphasized by the thrust of the protruding mouth, with its open jaws and powerful teeth.

The surfaces, whose convex quality is strongly emphasized, were fashioned with an adze, then carefully polished and painted black. Pieces of untanned skin that is still covered with hair are attached to the mouth with nails; traces of wooden nails that outline the contour of the head indicate that it was originally covered with a similar decoration.

Traces of cotton cloth, part of the costume that entirely covered the dancer's body, are still attached to the mask with strips of plant fiber.

E. C./G. S.

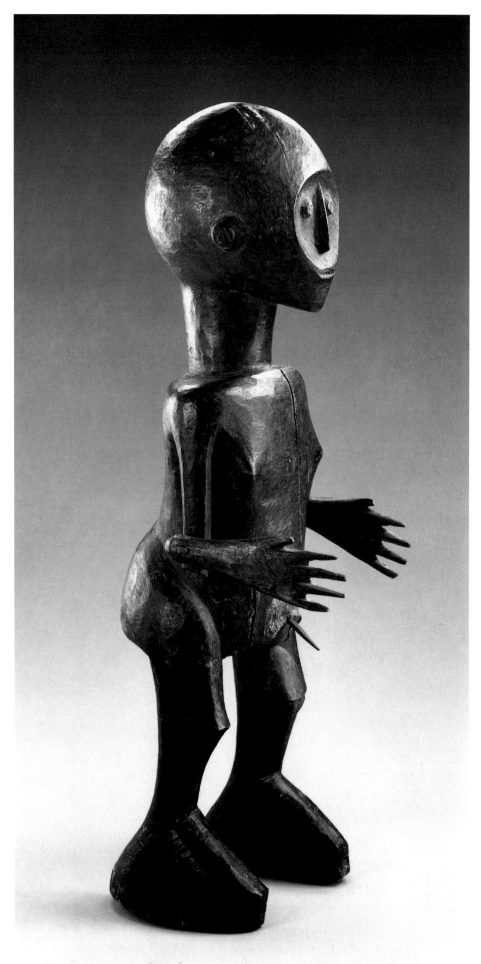

199 Figure
Zaramo, Tanzania

Wood, iron nails, traces of white pigment;
height, 65.5 cm

The way in which arms and legs are attached to
the body with square nails is one of the charac-
teristics of Zaramo sculpture, found especially in
the sculptures collected by Stuhlmann in 1899
and kept today in the museums of Berlin and
Hamburg; it is a characteristic that can probably
be attributed to the influence of Arab wood-
working on the Zaramo. In this sculpture, the
forearms and genitals (missing) were nailed to
the body. Also characteristic is the shape of the
hands and tapered fingers.

The figure is heavily built. The short trunk is
enlivened by the placing of the sturdy legs to-
ward the back; they end in large, club-type feet.

The head is spherical, with a concave surface
for the face, which consists of a triangular nose,
protruding eyes, and a slit of a mouth.

Faint traces of white on the head indicate a
ritual aspersion of the statue, which would con-
firm the funerary use of these sculptures sug-
gested by Fagg. E. C./G. S.

200 Ax Handle

Lomwe (?), *Maraui* (?), Mozambique (?),
Malawi (?)

Wood, copper, beads, metal inlay; height, 31.9 cm

This ax handle, unique of its kind, is difficult to
identify since it lacks the blade that might have
provided additional clues. Some elements, e. g.,
the coiffure and the forward position of the
shoulders, are comparable to similar elements in
Tabwa and Maraui sculpture. But the round,
slightly concave face with its triangular nose,
faint mouth, and round eyes are reminiscent of
formal characteristics of Lomwe sculpture. The
"aesthetic" region of origin of this piece can be
postulated as the area where Tanzania, Mozam-
bique, and Malawi meet.

The dark, very hard wood, which might be
ebony, is rarely used in traditional sculpture; in
this object, its fragility is confirmed by the old
break in the thin legs, elegantly repaired with
copper wire.

The brittle material, its reduced dimensions,
and comparisons with similar objects from the
same region suggest that this is a ceremonial ax,
not one intended for actual use. This hypothesis
is reinforced by the elegance of the sculpture, in
which the tension of the body is counterbalanced
by the sharp angles of the small arms and the
legs. E. C./G. S.

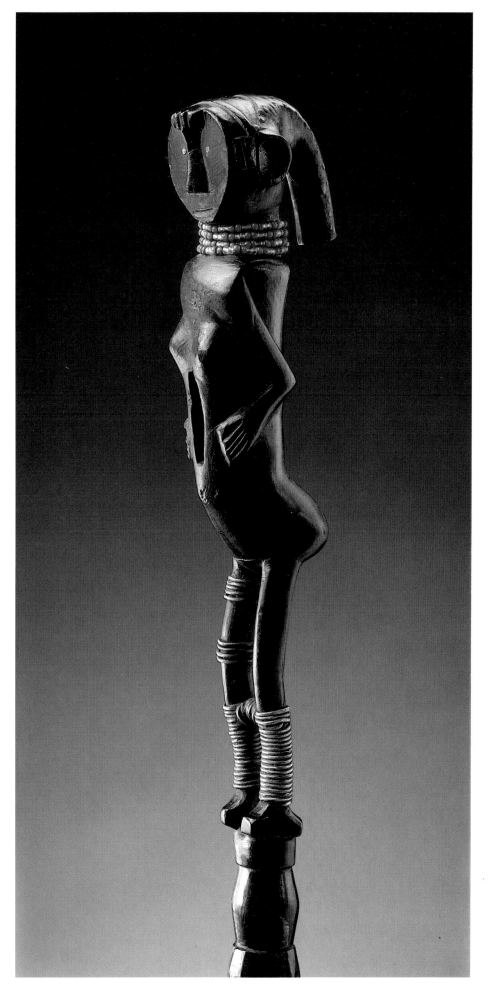

List of the Objects

1
Figure
Region of Djenne, Mali
1004-78
Thermoluminescent dating: 550 (±80) years old

2
Figure
Region of Djenne, Mali
1004-95
Thermoluminescent dating: 815 (±125) years old

3
Figure
Region of Djenne, Mali
1004-62
Thermoluminescent dating: 700 (±80) years old

4
Figure
Region of Segou, Mali
1004-131

5
Pendant
Djenne, Mali
1004-125

6/7
Tellem Figures
Dogon, Mali
1004-13, 1004-3
Acquired by Josef Müller, c. 1950

8
Hogon's Ceremonial Container
Dogon, Mali
1004-33
Formerly Charles Ratton and Frédéric R. Pleasants Collection

9
Pendant
Dogon, Mali
1004-4

10
Bound Figure
Dogon (?), Mali
1004-129

11
Walu Mask, Oryx
Dogon, Mali
1004-8
Acquired by Josef Müller before 1939

12
Equestrian Figure
Dogon, Mali
1004-16
Acquired by Gertrude Dubi-Müller from Charles Ratton before 1940

13
Ceremonial Container
Dogon, Mali
1004-27
Acquired by Josef Müller, c. 1950

14
Granary Door
Dogon, Mali
1004-48

15
Tyi Warra Headdress
Bamana (Bambara), Region of Beledugu, Mali
1004-100
Acquired by Josef Müller, c. 1950

16
Tyi Warra Headdress
Bamana (Bambara), Mali
1004-36
Acquired by Josef Müller from Antony Moris before 1939

17
Figure
Bamana (Bambara) or *Malinke*, southern Mali
1004-6

18
Figure
Mossi, Burkina Faso
1005-3
Acquired by Josef Müller, 1968

19
Nwantantay Plank Mask
Bwa, Burkina Faso
1005-10
Acquired by Josef Müller, c. 1953

20
Wan-Balinga Mask
Mossi, Burkina Faso
1005-12
Acquired by Josef Müller from Charles Vignier before 1939

21
Diviner's Figure
Nuna, Burkina Faso
1005-4

22
Hornbill Mask
Tusyan, Burkina Faso
1005-11
Acquired by Josef Müller from Robert Duperrier, Paris, 1968

23
Figure
Senufo, Cote d'Ivoire
1006-1
Procured in the late 1940s by Father Clamens, then taken to Europe by Emil Storrer. Acquired by Josef Müller, c. 1950.

24
Helmet Mask with Figure
Senufo, Cote d'Ivoire
1006-36
Acquired by Josef Müller before 1952

25
Diviner's Figure
Senufo, Cote d'Ivoire
1006-13
Acquired by Josef Müller before 1939. An old label indicates that the sculpture was procured in 1913.

26
Nursing Female Figure
Senufo, Cote d'Ivoire
1006-5
Acquired by Josef Müller before 1939

27
Face Mask
Senufo, Cote d'Ivoire
1006-37

28
Waniugo Janus Mask
Senufo, Cote d'Ivoire
1006-10
Acquired by Josef Müller from Emil Storrer, 1952/1953

29
Bas-relief Door
Senufo, Cote d'Ivoire
1006-19
Acquired by Josef Müller before 1952

30
Kafigelejo Figure
Senufo, Cote d'Ivoire
1006-31B
Acquired by Josef Müller before 1952

31
Bedu Mask
Hwela, Cote d'Ivoire
1008-12

32
Face Mask
Ligbi, Cote d'Ivoire
1006-38
Formerly Charles Ratton Collection, Paris

33
Hornbill Mask
Ligbi, Cote d'Ivoire
1006-56

34
Pair of Memorial Effigies
So-called *Komaland culture*, Ghana
1009-111 A, B
Thermoluminescent dating: 630-960 years old

35
Sono (Iron Staff)
Soninke, Guinea-Bissau
1001-32

36
Nimba Mask
Baga, Guinea
1001-1
Acquired by Josef Müller, c. 1950

37
Drum
Baga, Guinea
1001-14
Acquired by Josef Müller from Olivier Le Corneur, 1955

38
Snake Emblem *(Bansonyi)*
Baga-Foré, Guinea
1001-21

39
Helmet Mask
Mende or *Vai*, Sierra Leone
1002-11
Acquired by Josef Müller before 1939

40
Figure
Baga, Guinea
1001-3
Formerly Maurice de Vlaminck Collection.
Acquired by Josef Müller in the 1930s.

41
Figure
Kissi, Sierra Leone
1002-2
Acquired by Josef Müller before 1939

42
Figure
Kissi, Sierra Leone
1002-3
Acquired by Josef Müller before 1939

43
Head
Supi (?) (Proto-Temne), Sierra Leone
1002-1

44
Geh Naw Mask
Bassa, Liberia
1003-33

45
Mask
Loma, Liberia
1003-16
Formerly Philippe Guimiot Collection, Brussels

46
Mask with Female Face
Grebo, Liberia
1003-10
Acquired by Josef Müller before 1942

47
Gunyegè Mask
Dan, Liberia/Cote d'Ivoire
1003-14

48
Racing Mask
Dan, Liberia/Cote d'Ivoire
1003-3
Acquired by Josef Müller before 1939

49
Actor's Mask
Dan, Liberia/Cote d'Ivoire
1003-8
Formerly René Rasmussen Collection

50
Mask
Dan, Liberia/Cote d'Ivoire
1003-11
Acquired by Josef Müller before 1942

51
Lü mè Figure
Dan/Kran, Liberia
1003-5
Acquired by Josef Müller before 1939

52
Ma kpon Game
Dan, Liberia
1003-32

53
Figure
Bété, Cote d'Ivoire
1008-14
Formerly Félix Fénéon, Dr. Stephen Chauvet, Maurice Ratton, and Morris Pinto collections

54
Heddle Pulley
Guro, Cote d'Ivoire
1008-10
Formerly Félix Fénéon, Dr. Stephen Chauvet, Maurice Ratton, and Morris Pinto collections

55
Figure
Guro, Cote d'Ivoire
1007-1
Acquired by Josef Müller before 1939

56
Zamblé Mask
Guro, Cote d'Ivoire
1007-10
Acquired by Josef Müller before 1930

57
Gu Mask
Guro, Cote d'Ivoire
1007-9
Acquired by Josef Müller before 1930

58
Djé Animal Mask
Guro, Cote d'Ivoire
1007-25
Acquired by Josef Müller before 1942

59
Djé Mask
Yaure, Cote d'Ivoire
1007-23
Procured by Emil Storrer in Yauré country, c. 1950

60
Divination Figure
Baule, Cote d'Ivoire
1007-105
Acquired by Josef Müller before 1939

61
Figure
Baule, Cote d'Ivoire
1007-68
Formerly Olivier Le Corneur Collection

62
Figure Seated on an Animal
Baule, Cote d'Ivoire
1007-82
Acquired by Josef Müller before 1939

63
Portrait Mask
Baule, Cote d'Ivoire
1007-5

64
Twin Mask
Baule, Cote d'Ivoire
1007-65
Procured c. 1935. Formerly Roger Bédiat
Collection

65
Goli Dance Mask
Baule, Cote d'Ivoire
1007-21
Formerly Charles Ratton Collection, Paris

66
Djé Mask
Yaure (?), Cote d'Ivoire
1007-60
Acquired by Josef Müller before 1939

67
Buffalo Mask
Baule, Cote d'Ivoire
1007-28
Acquired by Josef Müller from Antony Moris
before 1940

68
Door
Baule, Cote d'Ivoire
1007-3
Acquired by Josef Müller before 1939

69
Vessel for Mouse Divination
Baule, Cote d'Ivoire
1007-148
Procured in the 1930s by Hans Himmelheber,
the official agent of the distinguished antique
dealer Charles Ratton. Formerly Charles Ratton
Collection, Paris

70
Figure
Baule, Cote d'Ivoire
1007-53
Acquired by Josef Müller before 1939

71
Figure
Ebrie, Cote d'Ivoire
1007-12
Acquired by Josef Müller before 1939

72
Royal Memorial Head
Southern Akan, Ghana
1009-6

73
Akuaba Figure
Akan, Ghana
1009-16

74
Pendant Mask
Edo Kingdom of Benin, Nigeria
1011-104
Formerly Comte Baudoin de Grunne Collection

75
Plaque with two Chiefs
Edo Kingdom of Benin, Nigeria
1011-101
Formerly Louis Carré and Ernest Ascher collec-
tions. Acquired by Josef Müller before 1939.

76
Gelede Mask
Yoruba, Nigeria
1010-1
Acquired by Josef Müller before 1942

77
Veranda Post
Yoruba, Nigeria
1011-2A

78
Gelede Mask
Yoruba, Nigeria
1011-16
Acquired by Josef Müller from Antony Moris
before 1939

79
Gelede Mask
Yoruba, Nigeria
1011-6

80
Figures on Staffs
Yoruba, Nigeria
1011-34A, B, C, F

81
Shango Staff
Yoruba, Nigeria
1011-3
Acquired by Josef Müller before 1950

82
Mask
Urhobo, Nigeria
1012-2

83
Igodo Headdress
Ijebu Yoruba, Nigeria
1012-3

84
Mother with Child
Urhobo, Nigeria
1012-8
Formerly Philippe Guimiot Collection, Brussels

85
Head (fragment)
Nok, Nigeria
1015-7

86
Figure
Igbo (?), Lower Cross River, Nigeria
1015-23

87
Carved Stone Monolith (*Akwanshi*)
Ejagham (?), Cross River region, Nigeria
1015-38

88
Carved Stone Monolith (*Akwanshi*)
Ejagham (?), Cross River region, Nigeria
1015-9

89
Part of a Dance Headcrest
Boki, Nigeria
1015-54

90
Dance Headdress
Ejagham, Middle Cross River, Nigeria
1015-50

91
Ivory Horn with Sculpture of a Human
Head
Annang (?), Nigeria (?)
1015-33
Acquired by Josef Müller before 1939

92
Headdress
Idoma, Nigeria
1014-10

93
Spirit Figure (*Anjenu*)
Idoma, Nigeria
1014-9

94
Headdress in the Form of a Female Figure
Igbo (?), Nigeria
1014-3

95
Face Mask
Annang, Nigeria
1014-13

96
Crest Mask
Igbo, Nigeria
1014-15

97
Mask
Igbo, Nigeria
1014-65

98
Face Mask
Annang, Nigeria
1013-2

99
Face Mask
Ogoni, Nigeria
1013-3

100
Face Mask
Ibibio, Nigeria
1014-66

101
Bush Cow Crest
Kantana, Nigeria
1015-2

102
Figure
Tiv, Nigeria
1015-1

103
Figure
Kantana or *Montol*, Nigeria
1015-4

104
Figure
Bura (?), Nigeria
1015-17

105
Mask
Yukuben, Nigeria
1015-22

106
Figure
Jukun, Nigeria
1015-5

107
Figure
Mumuye, Nigeria
1015-41

108
Pipe
Mumuye, Nigeria
1015-53

109
Headdress
Mambila, Cameroon
1018-76

110
Ancestor Figure
Mambila, Cameroon
1015-3

111
Figure
Gbaya, Eastern Cameroon
1018-71
Acquired by Josef Müller before 1939

112
Janus-Faced Crest Mask
Bangwa, Cameroon
1018-65

113
Ku N'gan Fecundity Figure
Bamileke, Cameroon
1018-78

114
Ngoin Mask
Western Grasslands, Cameroon
1018-43
Acquired by Josef Müller before 1939

115
Prestige Stool
Kingdom of Oku (?), Cameroon
1018-59

116
Highbacked Chair
Bamun, Cameroon
1018-21

117
Prestige Stool
Bamun, Cameroon
1018-73
Given to Captain Glauning by the Mfon Njoya
at the beginning of this century. Purchased from
Glauning's brother in Berlin in the early 1920s by
A. Speyer. Formerly Charles Ratton Collection,
Paris.

118
Mask
Duala, Cameroon
1018-2

119
Reliquary Guardian Figure
(Fang) Mabéa, Cameroon
10919-5
Acquired by Josef Müller from Charles Ratton,
1939

120
Head
(Fang) Nzama-Betsi, Gabon
1019-13A
Acquired by Josef Müller from Antony Moris,
1939

121
Reliquary Guardian Figure
(Fang) Ntumu, Gabon
1019-34
Acquired by Josef Müller before 1939

122
Reliquary Guardian Figure
(Fang) Ntumu, Gabon
1019-6
Acquired by Josef Müller from Antony Moris,
1939

123
Mask
Fang, Equatorial Guinea/Gabon
1019-16
Acquired by Josef Müller before 1942

124
Ngil Mask
Fang, Gabon or Equatorial Guinea
1919-14
Acquired by Josef Müller from Charles Vignier,
c. 1935

125
Bikeghe Dance Mask
Fang, Gabon
1019-20
Acquired by Josef Müller from Charles Ratton
before 1939

126
Mask
(Fang) Betsi (?), Gabon
1019-76

127
Mask
Kwele, Gabon
1019-49

128
Mask with Curved Horns
Kwele, Gabon
1019-15
Procured by Aristide Courtois before 1930.
Acquired by Josef Müller from Charles Vignier,
1939.

129
Reliquary Basket, with *Mbumba* Figure
Sango, Gabon
1019-77

130
Mbulu-Ngulu Reliquary Figure
Kota-Obamba, Gabon
1019-4F
Formerly Olivier Le Corneur Collection, Paris

131
Double-faced Mbulu-Ngulu Reliquary
Figure
Kota (Ndassa-Wumbu), Gabon
1019-4H

132
Bwété Reliquary Figure
Kota-Mahongwé, Gabon
1019-68

133
Dance Mask
Mahongwé or *Ngare* (?), People's Republic of
Congo
1021-33
Procured by Aristide Courtois before 1930. For-
merly Charles Ratton Collection, Paris. Owned
by The Museum of Modern Art, New York,
1939-84.

134
Head of a *Mbumba Bwiti* Reliquary
Tsogho, Gabon
1019-53
Procured between 1927 and 1936 by Baron Rang
des Adrets. Formerly Sommer Collection.

135
Figure
Tsogho, Gabon
1019-64

136
Mask
Tsangui, Gabon
1019-66

137
Forge Bellows, with Anthropomorphic
Figure
Shira-Punu, Gabon
1019-21
Formerly Antony Moris Collection (exhibited at
The Museum of Modern Art, New York, in
1935). Acquired by Josef Müller, 1939.

138
Okuyi Mask
Punu-Lumbo, Gabon
1019-31
Acquired by Josef Müller before 1939

139
Figure
Kuyu, Lower Congo
1021-10
Acquired by Josef Müller from Charles Ratton
before 1939

140
Mask
Teke-Tsaayi, Lower Congo
(Upper Ogowe area)
1021-20
Formerly A. Derain Collection. Acquired by
Josef Müller from Charles Ratton, 1939.

141
Tomb Figure
Kongo, Lower Zaire
1021-17
Formerly Essayan Collection, Paris

142
Ancestral Figure Seated on a Chest
Bembe, People's Republic of Congo
1021-12
Acquired by Josef Müller before 1939

143
Figure
Kongo, Lower Zaire
1021-11
Procured c. 1900. Formerly St. Peter Clavier-
Sodalität Mission, Fribourg

144
Nkisi Figure
Vili, People's Republic of Congo
1021-16
Formerly Dr. Stephen Chauvet Collection.
Acquired by Josef Müller before 1939.

145
Whisk
Yombe, Lower Zaire
1021-22

146
Staff or Whisk Finial
Yombe, Lower Zaire
1021-27

147
Staff Finial
Yombe, Lower Zaire
1021-31

148
Power Figure (*nkondi*)
Kongo, Zaire
1021-5
Procured c. 1905. Formerly St. Peter Clavier-
Sodalität Mission, Fribourg

149
Power Figure (*nkondi*) in the Form of a
Two-Headed Dog
Kongo, Zaire
1021-35
Procured c. 1905. Formerly St. Peter Clavier-
Sodalität Mission, Fribourg

150
Mask
North Yaka, Zaire
1026-99
Acquired by Josef Müller before 1939

151
Figure
East Kongo or *West Yaka*, Zaire
1026-174

152
Figure
Suku, Zaire
1026-154

153
Figure
Mbala, Zaire
1026-15
Acquired by Josef Müller before 1939

154
Gabundula or Executioner Mask
Western Pende (Bandundu), Zaire
1026-26
Formerly Charles Ratton Collection, Paris.
Acquired by Josef Müller in 1939.

155
Figure
Chokwe, Angola
1028-7
Acquired by Josef Müller before 1939

156
Chief's Chair
Chokwe, Angola
1028-31
Formerly Van der Straete Collection, Brussels

157
Caryatid Stool
Chokwe, Zaire
1028-26
Formerly Payen Collection, Antwerp

158
Staff
Ovimbundu, Angola
1028-1
Acquired by Josef Müller before 1939

159
Harp Handle in the Shape of a Human
Head
Imbangala, Angola
1026-170

160
Female Mask
Lwena, Angola
1028-21

161
Mukyeem Mask
Kuba, Zaire
1026-102
Acquired by Josef Müller before 1942

162
Bwoom Mask
Kuba, Zaire
1026-61

163
Figure
Lulua, Zaire
1026-16
Acquired by Josef Müller before 1939

164
Mask
Lulua, Zaire
1026-30
Formerly Charles Ratton and André Lhote collections. Exhibited at The Museum of Modern Art, New York, in 1935. Later owned by Olivier Le Corneur.

165
Tobacco Mortar
Lulua, Zaire
1026-181

166
Figure
Lulua, Zaire
1026-11
Formerly Essayan Collection, Paris

167
Tshioana Mask
Biombo, Zaire, Ngandu village
1026-35
Acquired by Josef Müller from Charles Ratton, 1939. Probably procured for the latter by H. Himmelheber.

168
Mask
Tetela, Zaire
1026-44
Formerly Hartert Collection, Lodève (France)

169
Figure
Songye, Zaire
1026-14
Formerly Maurice de Vlaminck Collection. Acquired by Josef Müller before 1939.

170
Shield
Songye, Zaire
1026-111
Acquired by Josef Müller before 1939

171
Mask
Songye, Zaire
1026-110

172
Chief's Stool
Songye, Zaire
1025-16
Acquired by Josef Müller before 1939

173
Power Figure
Songye, Zaire
1062-54
Formerly Hartert Collection, Lodève (France)

174
Bow Stand
Luba-Hemba, Zaire
1025-1
Formerly Geneviève Rodier Collection

175
Caryatid Stool
Luba-Hemba, Zaire
1026-159

176
Caryatid Stool
Hemba, Zaire
1025-4
Acquired by Josef Müller before 1939

177
Figure with a Ceremonial Bowl
Luba-Hemba, Zaire
1026-116
Acquired by Josef Müller before 1939

178
Ancestor Figure
Hemba, Zaire
1026-90
Taken to France before 1937. Formerly M. Lanternier Collection.

179
Mask
Tabwa (?), Zaire
1027-5

180
Buffalo Mask
Tabwa, Zaire
1026-58

181/182
Pair of Figures
Tabwa, Zaire
1026-157 A, B
The sculptures belonged to a religious congregation during the first quarter of this century; hence the removal of the genitals (information provided by André Fourquet, Paris).

183
Mask
Bembe, Zaire
1026-39
Acquired by Josef Müller before 1939

184
Caryatid Stool
Pre-Bembe (?), Zaire
1026-180

185
Figure
Bembe, Zaire
1026-171
Formerly Ginsberg Collection, New York

186
Mask
Lega, Zaire
1026-3

187
Figure
Lega, Zaire
1026-36
Acquired by Josef Müller before 1939

188
Slit Gong
Momvu, Northeastern Zaire
1026-114
Acquired by Josef Müller before 1942

189
Five-string Arched Harp
Mangbetu, Northeastern Zaire
1926-115
Acquired by Josef Müller before 1942

190
Male Figure
Mangbetu, Northeastern Zaire
1026-163

191
Figure
Zande, Northeastern Zaire
1027-38

192
Figure
Zande, Northeastern Zaire
1026-112
Acquired by Josef Müller from Charles Ratton before 1939

193
Memorial Effigy
Nyika (Chonyi), Kenya
1027-14

194
Memorial Effigy
Bongo, Sudan
1027-1

195
Helmet Mask
Makonde, Mozambique
1027-49

196
Mask
Makonde, Mozambique
1027-2
Procured by Captain Seyfried, 1906. Formerly
Linden-Museum, Stuttgart.

197
Caryatid Stool
Makonde, Mozambique
1072-6

198
Mask
Makonde, Mozambique
1027-42

199
Figure
Zaramo, Tanzania
1027-50

200
Ax Handle
Lomwe (?), *Maraui* (?), Mozambique (?),
Malawi (?)
1027-40

Bibliography

Adam, Leonhard. *Primitive Art*. London, 1940.

Adamson, J. *The Peoples of Kenya*. London, 1967.

Adepegba, Cornelius O. "A Survey of Nigerian Body Markings and their Relationship to Other Nigerian Arts." Ph.D. diss., Indiana University, 1976.

Agthe, Johanna. *Afrika-Sammlung 1: Luba Hemba – Werke unbekannter Meister/ Sculptures by Unknown Masters*. Frankfurt am Main, 1983.

Allison, Philip. "Carved Stone Figures in the Ekoi Country of the Middle Cross River." *Man* 62 (1962), pp. 17-19.

—. *African Stone Sculpture*. London and New York, 1968.

—. *The Cross River Monoliths*. Lagos, 1968.

Amankulor, J. Ndukaku. "The First All-Ngwa Cultural Festival." *African Arts* 10, no. 2 (1977), pp. 36-37, 66 ff.

Anquandah, J., and L. van Ham. *Discovering the Forgotten "Civilisation" of Komaland, Northern Ghana*. Amsterdam, 1986.

Azais, R. P., and R. Chambard. *Cinq années de recherches archéologiques en Ethiopie, province du Harar et Ethiopie méridionale*. Paris, 1931.

Barbier, Jean Paul. *Art du Nagaland/Art of Nagaland*. Geneva and Los Angeles, 1984.

Barbier-Mueller Collection, exhibition catalogues:

—. *Exotische Kunst aus der Barbier-Mueller Sammlung: Amerika, Afrika, Südsee*. Geneva, 1981.

—. *Art du Nagaland*. Geneva, 1982.

—. *Musée Barbier-Mueller 1977-1982*. Geneva, 1982.

—. *Westafrikanische Tage 24.4.-31.5.82, Ingelheim am Rhein*. Geneva, 1982.

—. *Art ancien du Mali*. Geneva, 1984.

—. *L'ivoire, or blanc de l'Afrique Noire, 1983-1984*. Geneva, 1984.

—. *Magie en Afrique Noire 1986-1987*. Geneva, 1987.

Bascom, William. "A Yoruba Master Carver: Duga of Meko." In *The Traditional Artist in African Societies*, ed. W. L. D'Azevedo. Bloomington, 1973.

Basden, G. *Niger Ibos*. London, 1938.

Basler, Adolphe. *L'Art chez les peuples primitifs*. Paris, 1929.

Bassani, Enzio. "Sono from Guinea Bissau." *African Arts* 12, no. 4 (1979), pp. 44-47.

—. "Un Cimier Bambara." *Bulletin du Musée Barbier-Mueller* 15 (1982-83), pp. 1-3.

Bastin, Marie-Louise. *Art décoratif Tshokwe*. 2 vols. Lisbon, 1961.

—. "Un masque en cuivre martelé des Kongo du nord-est de l'Angola." *Africa-Tervuren* 7, no. 2 (1961), pp. 29-40.

—. *Statuettes Tshokwe du héros-civilisateur "Tshibinda Ilunga."* Arnouville, 1978.

—. *La Sculpture Tshokwe*. Meudon, 1982.

—. *Sculptures angolaises*. Geneva, 1982.

—. *Introduction aux arts d'Afrique Noire*. Arnouville, 1984.

Baumann, Hermann. "Die materielle Kultur der Azande und Mangbetu." *Baessler Archiv für Völkerkunde* 11 (1927), pp. 1-131.

—. *Die Völker Afrikas und ihre traditionellen Kulturen*. Studien zur Kulturkunde, vol. 1. Wiesbaden, 1975.

Baumann, H., and D. Westermann. *Les peuples et les civilisations de l'Afrique suivi des langues et de l'éducation*. Paris, 1948. 2nd ed., 1962.

Berjonneau, Gérard, and Jean-Louis Sonnery. *Chefs-d'œuvre inédits de l'Afrique Noire*. Paris, 1987.

Bernatzik, H. *Geheimnisvolle Inseln – Tropen Afrikas: Frauenstaat und Mutterrecht der Bidyogo*. Berlin, 1933.

Biebuyck, Daniel P. "Bembe Art." *African Arts* 5, no. 3 (1972), pp. 12-19, 75-84.

—. *Lega Culture: Art, Initiation, and Moral Philosophy among a Central African People*. Berkeley and Los Angeles, 1973.

—. *Statuary from the Pre-Bembe Hunters: Issues in the Interpretation of Ancestral Figurines Ascribed to the Basikasingo-Bembe-Boyo*. Tervueren, 1981.

—. *The Arts of Zaire*. 2 vols. Berkeley, Los Angeles, and London, 1985 and 1986.

Binet, J. *Sociétés de dance chez les Fang du Gabon*. Paris, 1972.

Binger, Louis-Gustave. *Voyage du Niger au golfe de Guinée par le pays de Kong et le Mossi*. Paris, 1892.

Bleir, Suzanne Preston. *Africa's Cross River: Art of the Nigerian-Cameroon Border Redefined*. New York, 1980.

Boone, O. *Les tambours du Congo belge et du Ruanda-Urundi*. Tervueren, 1951.

Boston, J. *Ikenga Figures among the Northwest Igbo and the Igala*. Lagos, 1977.

Bourgeois, Arthur P. *Art of the Yaka and Suku*. Meudon, 1984.

Boyer, Alain-Michel. "Miroirs de l'Invisible." *Arts d'Afrique Noire* 45 (1983), pp. 21-34.

Brain, Robert, and Adam Pollock. *Bangwa Funerary Sculpture*. London, 1971.

Bravmann, René. *Open Frontiers: The Mobility of Art in Black Africa*. Seattle, 1973.

—. *Islam and Tribal Art in West Africa*. Cambridge, 1974.

Brett-Smith, Sarah. "Bamanankan Ka Gelen." *Bulletin du Musée Barbier-Mueller* 2 (1987), pp. 3-15.

Brincard, Marie-Thérèse, ed. *The Art of Metal in Africa*. New York, 1983.

Buakasa, Tulu kia Mpansu. "L'impact de la religion africaine sur l'Afrique d'aujourd'hui." In *Religions africaines et Christianisme: Colloque International de Kinshasa*, vol. 2. Kinshasa, 1978.

Burssens, H. "Enkele Zande-maskers uit Uele." *Congo-Tervuren* 6, no. 4 (1960), pp. 101-8.

—. *Yanda-beelden en Mani-sekte bij de Azande (Centraal-Afrika)*. Annales du Musée Royal de l'Afrique Centrale, vol. 4. Tervueren, 1962.

Burt, E. C. *An Annotated Bibliography of the Visual Arts of East Africa*. Bloomington, 1980.

Butor, Michel. *Le Congrès des Cuillers*. Geneva, 1986.

Capron, Jean. *Communautés villageoises bwa, Mali, Haute-Volta*. Paris, 1973.

Carroll, Kevin. *Yoruba Religious Carvings*. New York, 1967.

Castelli, E. *Orazio Antinori in Africa Centrale: 1859-1861*. Perugia, 1984.

Chaffin, Alain and Françoise. *L'Art Kota: Les Figures de Reliquaire*. Meudon, 1980.

Champion, A. M. *The Agiryama of Kenya*. Royal Anthropological Institute, Occasional Paper no. 25. London, 1967.

Chappel, T. J. H. "Critical Carvers: A Case Study." *Man* 7, no. 2 (1972), pp. 296-307.

Chevalier, A. *L'Afrique centrale française: Récit du voyage de la mission Auguste Chevalier*. Paris, 1907.

Cole, Herbert M., and Chike C. Aniakor. *Igbo Arts: Community and Cosmos*. Los Angeles, 1984.

Cole, Herbert M., and D. H. Ross. *The Arts of Ghana*. Los Angeles, 1977.

Colle, R. P. *Les Baluba, Congo Belge*. 2 vols. Brussels, 1913.

Collomb, G. *Fondeurs et Forgerons dans le bassin de l'Ogooué*. Libreville, 1977.

Cornet, Joseph. *Art de l'Afrique Noire au pays du fleuve Zaïre*. Brussels, 1972.

—. *Art royal Kuba*. Milan, 1982.

Dark, P., and W. and B. Forman. *Die Kunst von Benin*. Prague, 1960.

Delafosse, Maurice. *L'Art ancien dans l'Afrique Occidentale*. Paris, 1922.

Delange, Jacqueline. *Arts et peuples de l'Afrique Noire*. Paris, 1968.

Delobsom, A. A. Dim. *L'Empire du Mogho Naba: Coutumes des Mossi de la Haute-Volta*. Paris, 1932.

Dias, J. and M. *Os Macondes de Moçambique*. Vol. 2: *Cultura material*. Lisbon, 1964.

Dieterlen, Germaine. *Les Ames des Dogons*. Paris, 1941.

—. *La serrure et sa clef*. Paris, 1970.

—. *Le titre d'honneur des Arou*. Paris, 1982.

Dittmer, Kunz. *Die sakralen Häuptlinge der Gurunsi im Obervolta-Gebiet*. Hamburg, 1961.

Drewal, H.J. "Flaming Crowns, Cooling Waters: Masquerades of the Ijebu Yoruba." *African Arts* 20, no. 1 (1986), pp. 32-41, 99-100.

Drewal, H. J. and M. T. *Gelede: Art and Female Power among the Yoruba*. Bloomington, 1983.

Dupré, Marie C. "A propos d'un masque des Téké de l'ouest." *Objets et Mondes* 8, no. 4 (1968), pp. 295-310.

—. "Naissances et renaissances du masque Kidumu: Art, politique et histoire chez les Téké Tsaayi, République populaire du Congo." *Paris* 5 (1984).

Einstein, Carl. *Negerplastik*. Leipzig, 1915. 2nd ed., Munich, 1920.

Eliade, Mircea. *Images et symboles*. Paris, 1952.

—. *Le sacré et le profane*. Paris, 1965.

Elisofon, E., and W. Fagg. *The Sculpture of Africa*. London, 1958.

Ethiopie d'aujourd'hui. Paris, 1975.

Eyo, Ekpo. *Two Thousand Years of Nigerian Art*. Lagos, 1977.

Eyo, Ekpo, and Frank Willert. *Treasures of Ancient Nigeria*. Detroit, 1980.

Ezra, Kate. *A Human Ideal in African Art: Bamana Figurative Sculpture*. Washington, 1986.

Fagg, Bernard. *Nok Terracottas*. Ethnographica for the National Museum. Lagos, 1977.

—. *Nok Terracottas*. London, 1978.

Fagg, William. *Nigerian Tribal Art*. London, 1960.

—. *Afrique: Cent tribus, cent chefs-d'œuvre*. Berlin, 1964.

—. *Sculptures africaines*. Paris, 1965.

—. *Tribes and Forms in African Art*. New York, 1965.

—. *African Tribal Images*. Cleveland, 1968.

—. *Masques d'Afrique des collections du Musée Barbier-Müller*. Geneva, 1980.

—. *African Majesty: From Grassland and Forest – The Barbara and Murray Frum Collection*. Toronto, 1981.

Fagg, William, John Pemberton 3rd, and Bryce Holcombe. *Yoruba Sculpture of West Africa*. New York, 1982.

Fagg, William, and Margaret Plass. *African Sculpture: An Anthology*. London, 1964.

Fischel, Evelyn. *The Art of Metal in Africa*. New York, 1983.

Fischer, Eberhard, and Hans Himmelheber. *The Art of the Dan in West Africa*. Zurich, 1984.

—. *Die Kunst der Guro, Elfenbeinküste*. Zurich, 1985.

Forde, D., and G. I. Jones. *The Ibo and Ibibio-Speaking Peoples of South-Eastern Nigeria*. Ethnographic Survey of Africa: Western Africa, part 3. Oxford, 1950.

Foss, Perkins. "Festival of Ohworu at Evwreni." *African Arts* 6, no. 4 (1973), pp. 20-27, 94.

—. "Urhobo Statuary for Spirits and Ancestors." *African Arts* 9, no. 4 (1976), pp. 12-23, 89-90.

Frobenius, Leo. *Kulturgeschichte Afrikas*. Zurich, 1933. 2nd ed., 1954.

Fry, Jacqueline. "Impossibles généralisations sur les arts traditionnels en Afrique sub-saharienne." *L'Ecrit-Voir* 6 (1985).

Fry, Philip. *Œuvres africaines nouvelles*. Paris, 1970.

Fuhrmann, Ernst. *Afrika*. Kulturen der Erde. Hagen and Darmstadt, 1922.

Fu-Kiau Kia Bunseki-Lumanisa, A. *Le Mukongo et le monde qui l'entourait: Cosmogonie-Kongô*. Kinshasa, 1969.

Gaffé, R. *La sculpture au Congo Belge*. Paris, 1945.

Gardi, Bernhard. *Zaire: Masken, Figuren*. Basel, 1982.

Gebauer, Paul. *Art of Cameroon*. New York, 1979.

Geluwe, Huguette van. *Tabwa*. Tervueren, 1986.

Germann, Paul. *Das plastisch-figürliche Kunstgewerbe im Grasland von Kamerun*. Leipzig, 1920.

Gillon, Werner. *Collecting African Art*. London, 1979.

Glaze, Anita J. "Woman Power and Art in a Senufo Village." *African Arts* 8, no. 3 (1975), pp. 24-29.

—. "'The Children of Poro': A re-Examination of the Rhythm-Pounder in Senufo Art, its Form and Meaning." *Bulletin du Musée Barbier-Mueller* 20 (1983), pp. 1-6.

—. "Dialectics of Gender in Senufo Masquerades." *African Arts* 19, no. 3 (1986), pp. 30-39, 82

Goldwater, Robert. *Bambara Sculpture from Western Sudan*. New York, 1960.

—. *Senufo Sculpture from West Africa*. New York, 1964.

—. *Primitivism in Modern Art*. London, 1986.

Gollnhofer, O., P. Sallée, and R. Sillans. *Art et artisanat Tsogho*. Paris, 1975.

Greenberg, Joseph H. *The Languages of Africa*. Bloomington, 1965.

Griaule, Marcel. *Masques Dogons*. Paris, 1938. Repr. 1963.

—. *Arts de l'Afrique Noire*. Paris, 1947.

—. *Dieu d'eau: Entretiens avec Ogotemmêli*. Paris, 1948.

Griaule, M., and G. Dieterlen. *Le Renard Pâle*. Paris, 1965.

Grottanelli, Vinigi. "Leben, Tod und Jenseits in der Glaubensvorstellung der Nzima." In *Réincarnation et Vie Mystique en Afrique du Nord*. Travaux du Centre d'Etudes supérieures spécialisées d'Histoire des Religions de Strasbourg, 69-86. Paris, 1965.

Grunne, Bernard de. *Terres cuites anciennes de l'Ouest africain*. Publications d'Histoire de l'Art et de L'Archéologie de l'Université Catholique, vol. 22. Louvain-La-Neuve, 1980.

Guillaume, Paul, and Thomas Munro. *La Sculpture Nègre Primitive*. Paris, 1929. Translated as *Primitive Negro Sculpture*. New York, 1968.

Hallpike, C. R. *The Konso of Ethiopia*. Oxford, 1972.

Harter, Pierre. *Arts anciens du Cameroun*. Arnouville, 1986.

Hébert, Jean. "Les Noms en pays toussian." *Notes Africaines* 84 (1959), pp. 110-13.

—. "Du Mariage toussian." *Notes et Documents de l'I. F. A. N.* 23, nos. 3-4 (1961), pp. 697-731.

—. "Note additive sur les devins en pays toussian." *Notes Africaines* 107 (1965), pp. 93-95.

—. *Esquisse de l'histoire du pays toussian (Haute-Volta)*. Bobo-Dioulasso, 1976.

Hersak, D. *Songye Masks and Figure Sculpture*. London, 1985.

Herskovits, M. J. *Dahomey: An Ancient West African Kingdom*. 2 vols. New York, 1938.

Himmelheber, Hans. *Negerkünstler*. Stuttgart, 1935.

—. *Negerkunst und Negerkünstler*. Brunswick, 1960.

Himmelheber, H. and U. *Die Dan: Ein Bauernvolk im westafrikanischen Urwald*. Stuttgart, 1958.

Hirschberg, Walter. *Völkerkunde Afrikas*. Mannheim, 1965.

Holas, B. *Sculpture sénoufo*. Abidjan, 1964.

—. *L'Image du Monde Bété*. Paris, 1968.

—. *L'Art Sacré Sénoufo*. Abidjan, 1978.

Holý, L., and D. Darbois. *Masks and Figures from Eastern and Southern Africa*. London, 1967.

Horton, R. *The Gods as Guests*. Lagos, 1960.

—. "The Kalabari Ekine Society: A Borderland of Religion and Art." *Africa* 33, no. 2 (April 1963), pp. 94-114.

Huet, M. *The Dance, Art and Ritual of Africa*. New York, 1978.

Izard, Michel. *Introduction à l'histoire des royaumes mossi*. Recherches Voltaïques, vols. 12, 13. Paris and Ougadougou, 1970.

—. *Gens du pouvoir, gens de la terre*. Paris, 1985.

Jones, G. I. "Sculpture of the Umuahia Area of Nigeria." *African Arts* 6, no. 4 (1973), pp. 58-63.

—. *The Art of Eastern Nigeria*. Cambridge, 1984.

—. "History of Eastern Nigeria." Unpublished typescript.

Kasfir, Sidney L. "The Visual Arts of the Idoma of Central Nigeria." Ph.D. diss., University of London, 1979.

Kecskési, Maria. *Kunst aus dem Alten Afrika.* Innsbruck, 1982. Translated as *African Masterpieces and Selected Works from Munich: The Staatliches Museum für Völkerkunde.* New York, 1987.

Kerchache, Jacques. *Chefs-d'œuvre de l'art africain.* Grenoble, 1982.

—. *Scultura Africana.* Rome, 1986.

Kjersmeier, Carl. *Centres de Style de la Sculpture Nègre Africaine.* 4 vols. Paris and Copenhagen, 1935-38.

—. *African Negro Sculpture.* London, 1947.

Klever, Ulrich. *Bruckmann's Handbuch der afrikanischen Kunst.* Munich, 1975.

Kochnitzky, Léon. *Negro Art in Belgian Congo.* New York, 1948.

Koloss, Hans-Joachim. *Zaire: Meisterwerke afrikanischer Kunst.* Berlin, 1987.

Krieger, K. *Westafrikanische Plastik.* 3 vols. Veröffentlichungen des Museums für Völkerkunde, n. s. 7, 17, and 18, Abt. Afrika 2, 4, and 5. Berlin 1965-69.

Kronenberg, W. *Die Bongo: Bauern und Jäger im Südsudan.* Wiesbaden, 1981.

Laude, Jean. *Les Arts de l'Afrique Noire.* Paris, 1966.

—. *La Peinture française (1905-1914) et "l'Art nègre."* Paris, 1968.

—. *African Art of the Dogon: The Myths of the Cliff Dwellers.* New York, 1973.

—. *Vingt-cinq sculptures africaines.* Ottawa, 1978.

—. "Ethnologie et histoire de l'art." *L'Ecrit-Voir* 6 (1985), p. 69.

Le Moal. *Les Bobo: Nature et Fonction des Masques.* Paris, 1980.

Le Pichon, A. "Fonction prophétique et fonction poétique (Le sacrifice du Fils et l'enfant prophète)." 2 vols. Ph.D. diss., Université de Bretagne occidentale, n. d.

Lehuard, Raoul. *Les Phemba du Mayombe.* Paris, 1977.

—. *Fétiches à clous du Bas-Zaïre.* Arnouville, 1980.

Leiris, M., and J. Delange. *Afrique Noire: La création plastique.* Paris, 1967.

Lem, F. H. *Sculptures Soudanaises.* Paris, 1948.

Leuzinger, Elsy. *Afrika: Kunst der Negervölker.* 5th ed. Baden-Baden, 1959.

—. *Afrikanische Skulpturen/African Sculpture.* Zurich, 1963.

—. *Die Kunst von Schwarz-Afrika.* 2nd ed. Recklinghausen, 1976.

—. *Kunst der Naturvölker.* Propyläen-Kunstgeschichte, suppl. vol. 3. Oldenburg, 1978.

Lommel, Andreas, ed. *Afrikanische Kunst.* Munich, 1976.

Luschan, F. von. *Die Altertümer von Benin.* Berlin, 1919. Repr. New York, 1968.

Maes, J. *Les tam-tams du Congo Belge.* Louvain, 1912.

—. *Kabila: En Grafbeelden uit Kongo.* Tervueren, 1938.

—. *Fetishen of tooverbeelden uit Kongo.* Tervueren, 1955.

Maesen, A. *Art of the Kongo.* Minneapolis, 1969.

Mansfeld, Alfred. *Westafrika aus Urwald und Steppe zwischen Crossfluss und Benue.* Munich, 1928.

Mauny, R. *Tableau géographique de l'Ouest africain au Moyen Age.* Amsterdam, 1967.

Maurer, Evan M. *Tabwa: The Rising of the New Moon; A Century of Tabwa Art.* Washington, 1985.

Meauzé, Pierre. *African Art.* Cleveland, 1968.

Meek, C. K. *Tribal Studies in Northern Nigeria.* 2 vols. London, 1931.

Meneghini, Mario. "The Grebo Mask." *African Arts* 8, no. 1 (1974), pp. 36-39.

Meyer, Piet. *Kunst und Religion der Lobi.* Zurich, 1981.

Muensterberger, W. *Universalité de l'art tribal.* Geneva, 1979.

Mukenge, L. "Croyances religieuses et structures socio-familiales en société Luba." *Cahiers économiques et sociaux* 5, no. 1 (1967), pp. 3-94.

Murdock, George P. *Africa: Its Peoples and their Culture History.* New York, 1959.

Murray, K. C. "The Chief Art Styles of Nigeria." In *Première Conférence Internationale des Africanistes de L'Ouest.* Offprint from vol. 2 of conference report. Dakar, 1951.

—. *Dances and Plays.* N. p., n. d.

—. "Research Notes on Nigerian Art & Material Culture." Unpublished typescript in the National Museum, Lagos.

Neaher, N. C. "Bronzes of Southern Nigeria & Igbo Metalsmithing Traditions." Ph.D. diss., Stanford University, 1976.

—. "Awka who Travel: Itinerant Metalsmiths of Southern Nigeria." *Africa* 49, no. 4 (1979), pp. 352-66.

Neyt, François. *La grande statuaire Hemba du Zaïre.* Louvain, 1977.

—. *L'art Eket.* Paris, 1979.

—. *Arts traditionnels et histoire au Zaïre.* Brussels, 1981.

Neyt, François, with Andrée Désirant. *The Arts of the Benue.* Thielt, 1985.

Nicklin, Keith. "Nigerian Skin-Covered Masks." *African Arts* 7, no. 3 (1974), pp. 8-15, 67-68, 92.

—. *Guide to the National Museum, Oron.* Lagos, 1977.

—. "Archaeological Sites in the Cross River Region." *Nyame Akuma* 16 (1980), pp. 17-23.

—. "The Cross River Bronzes." In *The Art of Metal in Africa,* ed. Marie-Thérèse Brincard, pp. 47-51. New York, 1983.

—. "An Anthropomorphic Bronze from the Cross River Region." *Bulletin du Musée Barbier-Mueller* 16 (1982-83), pp. 1-4.

—. *Ekpu: The Ancestor Fiures of Oron, Southeast Nigeria.* London, forthcoming.

Nicklin, K., and S. J. Fleming. "A Bronze 'Carnivore Skull' from Oron, Nigeria." *Masca Journal* 1, no. 4 (1980), pp. 104-5.

—. "Analysis of two Bronzes from a Nigerian 'Asunaia' Shrine." *Masca Journal* 2, no. 2 (1982), pp. 53-57.

Nicklin, K., and J. Salmons. "Cross River Art Styles." *African Arts* 18, no. 1 (1984), pp. 28-43, 93.

Northern, Tamara. *Royal Art of Cameroon.* Dartmouth, 1973.

—. *The Art of Cameroon.* Washington, 1984.

Olbrechts, F. M. *Plastiek van Kongo.* Antwerp and Brussels, 1946.

—. *Les arts plastiques du Congo Belge.* Antwerp and Brussels, 1959.

Overbergh, Cyrille van. *Les Basonge.* Brussels, 1908.

Pageard, Robert. "Recherches sur les Nioniossé." *Etudes voltaïques* 4 (1963), pp. 5-71.

Pâques, Viviana. *Les Bambara.* Paris, 1954.

Park, Mungo. *Travels in the Interior District of Africa.* London, 1799.

Partridge, C., et al. *Cross River Natives.* London, 1905.

Paulme, Denise. *Les Civilisations de l'Afrique.* Paris, 1953.

—. *Les sculptures de l'Afrique Noire.* Paris, 1956.

Perrois, Louis. *Les Bwété des Kota-Mahongwé.* Libreville, 1969.

—. *La statuaire Fang du Gabon.* Paris, 1972.

—. *Arts du Gabon.* Paris, 1979.

—. *Art ancestral du Gabon dans les collections du Musée Barbier-Mueller.* Geneva, 1985.

—. *Ancestral Art of Gabon.* Dallas, 1986.

Piaggia, C. *Nella terra dei Niam-niam: 1863-1865.* Lucca, 1978.

Picton, John. *Unpublished Field Reports in the Nigerian Museum.* Lagos, 1984.

Preston, George Nelson. *Sets, Series and Ensembles in African Art.* New York, 1985.

Radin, Paul, and James J. Sweeney. *African Folktales and Sculpture.* New York, 1952.

Ratton, Charles. *Masques africains.* Paris, 1931.

Rattray, R. *Religion and Art in Ashanti.* 2nd ed. London, 1954.

Rätzel, F. *Völkerkunde.* Leipzig, 1887.

Richter, Dolores. *Art, Economics, and Change: The Kulebele of Northern Ivory Coast.* La Jolla, 1980.

Roberts, Allen. "Les arts du corps chez les Tabwa." *Arts d'Afrique Noire* 59 (1986), pp. 15-29.

Roy, Christopher D. "Mossi Zazaido." *African Arts* 13, no. 3 (1980), pp. 42-45, 92.

—. "Mossi Dolls." *African Arts* 14, no. 4 (1981), pp. 47-51, 88.

—. "Mossi Masks in the Barbier-Müller Collection." *Bulletin du Musée Barbier-Mueller* 12 (1981), pp. 1-4.

—. "Mossi Chiefs Figures." *African Arts* 15, no. 4 (1982), pp. 52-59, 91-92.

—. "Mossi Weaving." *African Arts* 15, no. 3 (1982), pp. 48-59, 91-92.

—. "Mossi Mask Styles." *Iowa Studies in African Art* 1 (1984), pp. 45-66.

—. *Art and Life in Africa: Selections from the Stanley Collection.* Iowa City, 1985.

—. *The Art of the Upper Volta Rivers.* Meudon, 1987.

Rubin, William. *"Primitivism" in 20th Century Art.* New York, 1984.

Salmons, Till. "Mammy Wata." *African Arts* 10, no. 3 (1977), pp. 8-13.

Savary, Claude, ed. *Dahomey: Tradition du peuple fon.* Geneva, 1975.

—. *Sculptures d'Afrique 1977.* Geneva, 1977.

Schädler, Karl-Ferdinand. *Afrikanische Kunst.* Munich, 1973.

Schmalenbach, Werner. *Die Kunst Afrikas.* Basel, 1953. Translated as *African Art.* New York, 1954.

Schwartz, Nancy B. *Mambilla: Art and Material Culture.* Milwaukee Public Museum Publications in Anthropology. Milwaukee, 1976.

Schweeger-Hefel, A. M., and W. Staude. *Die Kurumba von Lurum: Monographie eines Volkes aus Obervolta.* Vienna, 1972.

Schweinfurth, Georg. *The Heart of Africa ... 1868-1871.* 2 vols. London, 1873.

—. *Artes Africanae: Abbildungen und Beschreibungen von Erzeugnissen des Kunstfleisses centralafrikanischer Völker.* Leipzig and London, 1875.

Segy, Ladislas. *African Sculpture Speaks.* New York, 1952.

Seligman, C. G. and B. Z. *Pagan Tribes of the Nilotic Sudan.* London, 1932.

Sieber, Roy. *Sculpture of Northern Nigeria.* New York, 1961.

Sieber, Roy, and A. Rubin. *Sculpture of Black Africa: The Paul Tishman Collection.* Los Angeles, 1968.

Siroto, Léon. "Masks and Social Organization among the Bakwele People of Western Africa." Ph.D. diss., Columbia University, New York, 1969.

—. "Afrikanische Kunst." *African Arts* 10, no. 4 (1977), pp. 38-51.

—. "Witchcraft Belief in the Explanation of Traditional African Iconography." In *The Visual Arts,* ed. J. M. Cordwell, pp. 241-91. The Hague, 1979.

Sweeney, James J. *African Negro Art.* New York, 1935.

Sydow, Eckart von. *Kunst der Naturvölker: Sammlung Baron Eduard von der Heydt.* Berlin, 1932.

—. *Die Kunst der Naturvölker und der Vorzeit.* Propyläen-Kunstgeschichte, vol. 1. 4th ed. Berlin, 1938.

—. *Afrikanische Plastik.* Berlin, 1954.

Szalay, Miklós. *Die Kunst Schwarzafrikas.* Zurich, 1986.

Talbot, P. A. *In the Shadow of the Bush.* London, 1912.

Tauxier, Louis. *Le Noir du Soudan.* Paris, 1912.

—. *Le Noir de Yatenga.* Paris, 1917.

—. *Nègres Gouro et Gagou.* Paris, 1924.

—. *L'Empire du Mogho Naba: Coutumes des Mossi de la Haute-Volta.* Paris, 1932.

—. *Histoire des Bambara.* Paris, 1942.

Tessmann, G. *Die Pangwe.* 2 vols. Berlin, 1913.

—. *Die Baja.* Stuttgart, 1934.

Thiel, Jörg F. *Was sind Fetische?* Frankfurt am Main, 1986.

Thilmans, G., C. Descamps, and B. Khayat. *Protohistoire du Sénégal.* Mémoires de l'Institut fondamental de l'Afrique Noire, vol. 91. Dakar, 1980.

Thompson, Robert Farris. *African Art in Motion.* Washington, 1974.

Timmermans, P. "Les Lwalwa." *Africa-Tervuren* 13, nos. 3-4 (1967), pp. 73-90.

Torday, E. *Notes ethnographiques sur les peuples communément appelés Bakuba ...* Tervueren, 1910.

Vansina, Jan. *Le royaume Kuba.* Tervueren, 1964.

—. *Introduction à l'ethnographie du Congo.* Kinshasa, 1965.

—. *Art History in Africa.* London, 1984.

Verly, Robert. "La statuaire de pierre du Bas-Kongo (Bamboma-Mussurongo)." *Zaire* 9, no. 5 (1955), pp. 451-528.

Vogel, Susan M. "Art as an Expression of a Baule World View." Ph.D. diss., New York, 1977.

—. *Beauty in the Eyes of the Baule.* Philadelphia, 1980.

—, ed. *For Spirits and Kings: African Art from the Paul and Ruth Tishman Collection.* New York, 1981.

—. *African Aesthetics: The Carlo Monzino Collection.* Venice, 1985.

—, ed. *Perspectives: Angles on African Art.* New York, 1987.

Vogel, Susan M., and Francine N'Diaye. *African Masterpieces from the Musée de l'Homme.* New York, 1985.

Volavka, Zdenka. "Nkisi Figures of the Lower Congo." *African Arts* 5, no. 2 (1972), pp. 52-59.

—. "Le Ndunga: Un masque, une institution sociale au Ngoyo." *Arts d'Afrique Noire* 17 (1976), pp. 28-73.

—. "Insignia of Divine Authority." *African Arts* 14, no. 3 (1981), pp. 43-51.

Volprecht, K. *Sammlung Clausmeyer: Afrika.* Ethnologica, n. s., vol. 5. Cologne, 1972.

Wassing, René S. *Die Kunst des Schwarzen Afrika.* Stuttgart, Berlin, Cologne, and Mainz, 1977.

Willett, F. *Ife: Metropole afrikanischer Kunst.* Bergisch-Gladbach, 1967.

—. *African Art: An Introduction.* London, 1971.

Wingert, Paul S. *African Negro Sculpture.* San Francisco, 1948.

—. *The Sculpture of Negro Africa.* New York, 1950.

Zahan, Dominique. *Antilopes du Soleil: Arts et Rites Agraires d'Afrique Noire.* Vienna, 1980.

Zwernemann, Jürgen, and Wulf Lohse. *Aus Afrika: Ahnen – Geister – Götter.* Hamburg, 1985.

Index of Tribes and Cultures